P9-DFF-725

ALSO BY JED PERL

Paris Without End

Gallery Going

Eyewitness

New Art City

Antoine's Alphabet

Magicians and Charlatans

CALDER

CALDER

THE CONQUEST OF TIME

The Early Years, 1898–1940

Jed Perl

Alfred A. Knopf | *New York* | *2017*

THIS IS A BORZOI BOOK
PUBLISHED BY ALFRED A. KNOPF

Copyright © 2017 by Jed Perl

Library of Congress Cataloging-in-Publication Data
Names: Perl, Jed.
Title: Calder : the conquest of time : the early years, 1898–1940 / by Jed Perl.
Description: First edition. | New York : Alfred A. Knopf, 2017. | Includes
bibliographical references.
Identifiers: LCCN 2016054731 | ISBN 9780307272720 (hardcover) |
ISBN 9780451494214 (ebook)
Subjects: LCSH: Calder, Alexander, 1898–1976. | Sculptors—United States—Biography.
Classification: LCC NB237.C28 P47 2017 | DDC 730.92 [B] —dc23
LC record available at https://lccn.loc.gov/2016054731

Manufactured in Germany
First Edition

To the memory of Carol Brown Janeway

She is playing like a child
And penance is the play,
Fantastical and wild
Because the end of day
Shows her that some one soon
Will come from the house, and say—
Though play is but half done—
"Come in and leave the play."

—WILLIAM BUTLER YEATS, "Upon a Dying Lady"

CONTENTS

CALDER

"I WAS FRAMED"

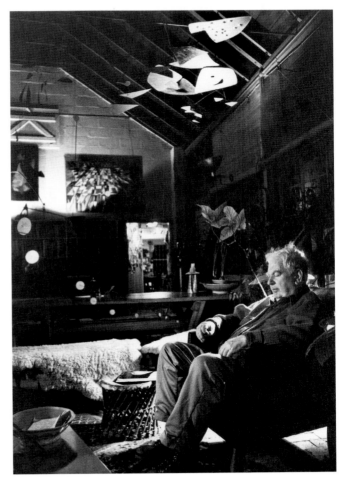

"I wasn't brought up—I was framed." With these seven words, Alexander Calder summarized his early years, giving his memories some of the same precision, grace, depth, wit, and aplomb that animated his art for half a century. There was a literal sense in which Calder was framed, for both of his parents were artists who used their handsome, sturdy young son as a model. There were also other, deeper implications to this haiku-like pronouncement, which Calder inscribed at the top of an empty sheet of paper amid a sheaf of autobiographical ruminations that date from the 1950s, when he was already middle-aged.[1] Calder's passionate pursuit of a truly modern expression—in works large and small produced in the United States and in France—was prefigured by his parents. They were Francophiles, cosmopolitan in their artistic outlook, as their son would be. They, too, were committed to the promise of a new art, even if their son's generation eventually eclipsed theirs, leaving much of the work of Calder's father, Alexander Stirling Calder, looking old-fashioned.

Calder's mother, Nanette Lederer Calder, was a portrait painter with a wonderfully fluid, quietly dramatic style. She devoted many canvases to her

Calder in his house in Roxbury, Connecticut, 1964. Nanette Lederer Calder's portrait of her son around the age of six hangs on the far wall. Photograph by Ugo Mulas.

Nanette Lederer Calder.
Calder in Scottish Cap
and Cape, *c. 1904.*

children, not only her son, who was born in Philadelphia in 1898 and who would eventually be known to the whole world as Sandy, but also his sister, Peggy, born in Paris two years earlier. A portrait of Calder that his mother painted when he was six or so hung prominently in his house in Roxbury, Connecticut, for many years. It hovers in the background of a dramatically lit interior by the Italian photographer Ugo Mulas; the foreground is dominated by the altogether grown-up Calder, seated in an armchair beneath one of his mobiles, his eyes closed, perhaps taking a nap, as was his wont. In Nanette Calder's marvelous, dreamy composition, her son is seen in profile, wearing a cape and a tartan cap given to him by his paternal grandfather, who had grown up in Scotland. Sandy looks like a figure out of a fairy tale, a little prince facing a promising future.

Calder's father—who eschewed the Alexander that he'd inherited from his father and gained a considerable reputation as A. Stirling Calder—devoted most of his energies to large-scale public works. But he scored a significant success with *Man Cub*, a statue of his son, Sandy, at the age of three, standing buck naked, his feet firmly planted on the ground, an orange clenched in his right hand. The "lusty boy," as *Man Cub* was described soon after it was finished, is a baby Hercules with a surprisingly gentle face.[2] That face reappears, with the baby fat nearly gone, in *Laughing Boy,* a head Stirling modeled when Sandy was seven. Here Sandy, with cupid lips, mischievous eyes, and a cap of thick, unruly hair, brings to mind a young satyr or a budding Bacchus. In Stirling Calder's work, Nanette's little prince is reimagined as a mythical being—the young powerhouse, the genial charmer—and the classical sources suggest, if not for Sandy's father then certainly for us, what will turn out to be the boy's more than natural powers.

No wonder Alexander Calder always felt extraordinarily special, even long before he distinguished himself in any significant way. As a grown man, Calder sometimes complained about the time he had spent holding still while his mother put him in a frame or his father put him on a pedestal; he griped that he had been paid a mere twenty-five cents for two hours of work.[3] Referring to his uncertain professional path in his early twenties, when for a time he made a stab at a career in engineering, he speculated that the boredom of modeling for his parents "must have been what drove me away from 'Art.'"[4] The way he inscribed the word *Art* in his autobiographical notes, with the *A*

capitalized and the three letters enclosed in quotation marks, suggested a certain irony about his parents' attitudes. Their aestheticism was surely too much a matter of old-fashioned idealism to appeal to their son, who even in his most austerely visionary works always insisted that his visions have an immediacy, a grounding in the here and now. Nevertheless, there could be no question that *Art*—the whole passionate adventure of *la vie bohème*, which had brought Stirling and Nanette together and held them together for more than fifty years—was the great edifice in which Calder was born, the world he first knew. By turning his energies to the life of art, he was following in his father's footsteps, answering the siren call of the imagination.

The glorious trap—the trap of the artist's life or, at least, the creative life—had been set when Calder was a boy. And the origins of that trap went even further back than Stirling and Nanette Calder, for Stirling's father, Alexander Milne Calder, was also a sculptor. Although he didn't himself live what might be called a bohemian life, he was certainly familiar with all the risks and excitements of the artistic vocation. France, where *la vie bohème* was invented, was a theme in the life of the Calder family long before Sandy had his early critical triumphs in Paris in the late

A. Stirling Calder. Man Cub, *c. 1901.*

1920s. Stirling and Nanette had both studied there, and they'd returned to Paris almost immediately after they were married in 1895, much as Calder and his wife, Louisa, would immediately after their marriage thirty-six years later. The connection with Paris was also a connection between Calder and his grandfather, because two decades before Stirling and Nanette had lived there, Alexander Milne Calder, having completed his studies in Edinburgh and not yet embarked on his American career, had made his own pilgrimage to the City of Light. For Stirling and Nanette, Paris was the promised land. So it would be for their son. Alexander Calder is one of those rare American creators whose immersion in the Old World only served to clarify his sense of himself as a product of the New World.

Stirling once wrote that his son, after trying to settle down as an engineer, had "succumbed to the inevitable hereditary attraction."[5] That frame-up, if you will, was not unfamiliar to Stirling, who had dreamed of being an actor or maybe even a soldier before he enrolled in the Pennsylvania Academy of the Fine Arts in 1886, thereby taking up his father's career. Calder's sister remembered their father and grandfather deep in conversation about sculpture in the years when Calder was a little boy, and how "because the two men had very different attitudes toward their work"—Milne was the prag-

A. Stirling Calder.
Laughing Boy, *c. 1905.*

matist, Stirling much more the aesthete—"the discussions often became quite heated. I can still hear Grandfather saying skeptically, 'Ah hae me doots.'" But Calder's grandfather also felt great sympathy for his aestheticizing son, and their discussions "usually ended with shared laughter and an affectionate clap on the back."[6] No doubt Calder was reacting against his father's intricate disquisitions when he consistently favored blunt comments about his own work or, better yet, no comment at all. "It takes the edge off things, to discuss them," Calder once wrote.[7] And he could certainly be sardonic about the weight of family and tradition. "When I was a small boy, + people asked my name," he recalled, "I would say 'A— C—, 3rd living and 9th dead.'"[8]

In *The Coast of Bohemia*, the novel William Dean Howells published in 1893, when Stirling Calder was just starting out as an artist, the hero, a painter by the name of Ludlow, wonders whether a truly refined art can ever achieve broad popularity in the United States. "It's easy enough to prove to the few that our life is full of poetry and picturesqueness," he muses, "but can I prove it to the many? Can the people themselves be made to see it and feel it? That's the question."[9] That same question was raised by the monumental public sculptures created over a period of seventy-five years, first by A. Stirling Calder, and then by his son, Alexander Calder. They both aimed to give the most sophisticated art a popular appeal. Calder's later public masterworks—among them *Flamingo* (1973), the immense, brilliant red stabile juxtaposed with Ludwig Mies van der Rohe's dusky minimalist architecture in downtown Chicago—set a standard for public art that easily eclipsed Stirling's marble statue of George Washington on the arch in New York's Washington Square Park or, going back even further, Alexander Milne Calder's huge bronze statue of William Penn atop Philadelphia's City Hall. Stirling's monuments are by no means inconsiderable achievements, but for anybody who views them from the far side of an artistic revolution that Calder helped bring about, they can suggest the sculpture that Ezra Pound condemned in *The Little Review* in 1921 as "just mashed popatoz and the fog end of the last century's allegory."[10]

There is a physics of biography, one that involves the facts and how they

are related to one another. And there is a metaphysics of biography, especially the biographies of creative spirits, that involves determining how the facts of the artist's life somehow fuel the imaginative life. In Calder's case, there is reason to believe that the gleeful fearlessness that animated everything he ever did would have been unimaginable in an artist who didn't carry within himself, as part of his heredity, the sculptor's formal powers. Family mattered. For Calder's close friend the writer Malcolm Cowley, who had been in Paris in the 1920s and had written a famous book about those times, *Exile's Return: A Literary Odyssey of the 1920s,* Calder's feeling for artistic freedom couldn't be separated from his feeling for family. "The Noble Savage—if we borrow that French notion of Sandy—had his own fixed system of values," Cowley wrote. "Wife, children, parents, friends—freedom, justice, invention, playfulness, naturalness—those persons and qualities were absolute goods to be achieved or defended."[11]

Alexander Milne Calder had established once and for all for the Calder men, way back in the 1870s, the habit of sculpture, the invention of forms in three dimensions as an essential human activity. In the first quarter of the twentieth century, Stirling was discussed in the art magazines as a figure to be reckoned with; he was an admirer of the art of Rodin who wanted to revitalize the classical tradition. As for Calder's work—so fluid, so open, as much a matter of voids as of volumes—it is both a spectacular riposte to the Victorian addiction to the solidity of sculpture, which his grandfather and then his father had embraced, and a reaffirmation of the enduring artistic power of the third dimension, reframed in the language of a new age.

PHILADELPHIA

I

Alexander Calder was born in Philadelphia in the summer of 1898. There is some uncertainty as to the date of his birth. Although for decades he and his family celebrated his birthday on August 22, when Calder obtained a copy of his birth certificate from the city of Philadelphia in 1942, the date he found there was July 22. Peggy, Calder's sister, remembered their mother, who was in her seventies at the time, being "flabbergasted" when the official birth certificate appeared.[1] How could she not know the date of her one and only son's arrival in the world? A further investigation of the matter, some decades after the artist's death, has left little doubt that Calder's mother was right. It seems that a mistake had been made by Dr. George Stewart, the friend of the family who delivered the boy, when he registered the birth with the city. Calder was nothing but amused by the whole business. As Peggy recalled, he figured it was better to have been born twice than not at all, and he "solved the problem by having two birthdays."[2] That didn't surprise anybody who knew Sandy Calder. He liked a rip-roaring evening with friends as much as a long day in his studio. The more parties, the better.

If the mystery of the birth certificate has lent an almost farcical element to Calder's beginnings, the truth was that his arrival in the world wasn't easy, at least not for his mother. Both of Nanette's babies were large. Peggy, born in Paris two and a half years earlier, had been nine pounds. Nanette remembered an agonizing night in their Paris studio, with an unsympathetic doctor and nurse doing little to ease her pain, after which the doctor took all their money. Sandy's birth was more daunting still. Peggy, a very young girl at the time, was sent next door to stay with the German couple who occupied the other half of the stone house on the outskirts of Philadelphia where the Calders were living. "Father," Peggy reported in her memoir, no doubt

having heard all this much later, probably from her mother, "had to be pressed into service to administer chloroform drop-by-drop onto gauze over the nose of his pain-racked wife—a harrowing experience for such a retiring, sensitive man." The eleven-pound baby would not emerge. Fortunately, Dr. Stewart was on hand, and unlike the doctor two years earlier in Paris, he was no stranger; the Calders would remain friends with him and his wife and their three children. A forceps delivery was deemed necessary. Such deliveries were quite risky. So it was no surprise that when the enormous child had been safely brought into the world and Nanette had come through the harrowing ordeal, Stirling announced that this "would be their last child"—at least that was what Peggy reported in her memoir.[3] Did Stirling make that pronouncement then and there? Or did he make it sometime later, when it had become clear that the forceps delivery had left Nanette with troubles that would cause her discomfort for quite a few years, troubles that had already begun with Peggy's birth?

What is clear is that on a summer day in 1898, the Calder family was complete. It was very different from the families in which Stirling and Nanette had grown up. Stirling was the oldest of six boys. Nanette was the

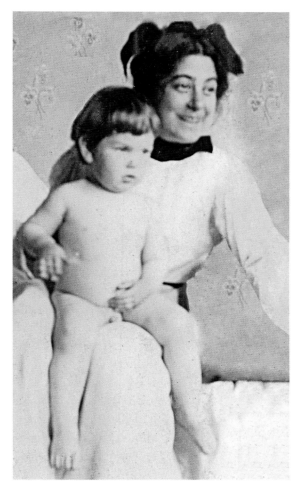

Calder with his mother, c. 1900.

youngest, with four older brothers. Those were quintessential nineteenth-century families, with plenty of children to receive the largesse of a prosperous Victorian paterfamilias. The Calders were a modern family, carefully planned, at least so it seemed: a pair of couples, the mother and father mirrored by the sister and brother. Did it ever occur to the Calders that the woman in each couple was a little older? As a girl, Peggy certainly sought to protect her brother and nurture his gifts, much as she saw her mother protecting and nurturing her father. If in their early years the children sometimes watched their mother act as a handmaiden to their brilliant, neurotic father, so in later years they all watched as Sandy, who was the littlest, turned out to be the biggest, which was, of course, what he had been at the outset, when he'd emerged from his mother's womb, an eleven-pound bruiser.

II

Although the Calders left Philadelphia for good in 1906, and many of Sandy's strongest childhood memories were of years spent in California and New York, the family nevertheless had deep roots in the City of Brotherly Love. Sandy's father had been born and grown up in Philadelphia, and his mother had lived there for a period as a child. Both of Sandy's parents attended the Pennsylvania Academy of the Fine Arts. For Stirling and several of his artist friends, including Robert Henri, William Glackens, and John Sloan, Philadelphia was the starting point, the place from which they launched themselves on highly successful careers in New York. In later years, they looked back on their time in Philadelphia with a mixture of gratitude, skepticism, and nostalgia.

Philadelphia, in the years when Calder's parents were coming of age, was full of opportunities for the artistically inclined, but without New York's swagger and sharp edges. The music critic James Gibbons Huneker, a contemporary of the Calders', started out in Philadelphia and then moved to New York, and his impressions of his old Philadelphia stomping grounds in a memoir, *Steeplejack,* were probably not all that different from theirs. The Calders may have known Huneker; he certainly knew some of their friends. Huneker observed that after "the huge clatter of New York," there forever remained "something mellow and human about the drowsy hum of Chestnut, the genteel reaches of Walnut, the neat frontage of Spruce Streets." Huneker was sometimes reminded of Philadelphia when he was in London or The Hague, and he spoke of a "curious mental transposition of cities and the sensations aroused by them; particularly the slightly perverse wish to be at home when in Europe." It could be that for Stirling and Nanette, as for Huneker, Paris, surprisingly, left one hankering for Philadelphia—and vice versa. "I longed for Paris when I returned to Philadelphia," Huneker continued, "and I perpetually saw 'European' in the most ordinary and domestic things." It was all more than a little absurd, he concluded. "That way lies cosmopolitanism, and cosmopolitanism has played the devil with my life."[4] Cosmopolitanism would be a force to be reckoned with in the lives of Stirling and Nanette and their son.

Huneker titled one of his collections of essays about the artistic life *Bedouins,* and Peggy and Sandy remembered their early years in Philadelphia as rather nomadic, with the family at one time or another occupying domiciles that suggested either considerable prosperity or something close to poverty. That isn't surprising, considering how uncertain the beginning stages of even a highly promising artist's career can be. But for the children of an

artist—indeed, for the offspring of two artists—a father's bumpy beginnings can also feel wonderfully adventuresome. Even when the Calders weren't traveling at all, there was an amplitude—an imaginative cosmopolitanism—about the life they were living. Some prosperous Philadelphians were by no means indifferent to cultural experience—Huneker had spoken of the city's "oiled wheels"—and as time went on, Peggy and Sandy became aware that among the young men and women Stirling and Nanette had known in and around the Penn-

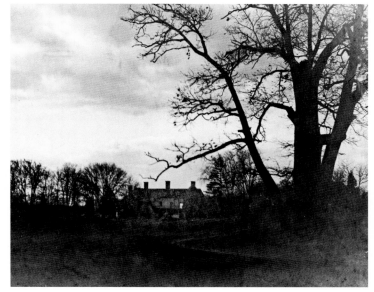

The house where Calder was born in Lawnton, Pennsylvania, 1898.

sylvania Academy, there were a number who were quite willing to lend a hand to the struggling sculptor and his family.[5] One year, Theodora Burt, an artist friend with whom Nanette had spent time in Paris, offered the family the gardener's cottage on her farm in a ravishing spot in rural Pennsylvania. And John Lambert, a wealthy painter Stirling knew from his student days at the academy, would provide critical financial assistance later on.

The house in which Sandy was born was a very nice spot indeed, and by no means the last place where Stirling and Nanette, whatever their restricted funds, would be able to live in style, even if a somewhat improvisational, bohemian style. It was in Lawnton, a suburb eventually absorbed by Philadelphia, and looks from the few photographs that survive to have been beautiful—"very handsome," as Calder commented years later.[6] His assessment was probably based on a photograph, as he would have been too young for anything but the vaguest memories. The family occupied half of a romantic stone structure; it had four prominent chimneys and was framed by large, marvelous old trees. The interiors were appealingly simple, the clean-lined woodwork and furnishings in keeping with the pared-down sensibilities of the Arts and Crafts movement, which was then in its heyday—and which would shape some of Stirling's early work, with stylized animal and vegetal forms recalling French medieval stone carvings and Irish illuminated manuscripts. Calder had a memory of that stone house deep in the snow, and how his uncle Ron, one of Stirling's brothers, came to see them: "It had snowed so much that Uncle Ron had to spread out his overcoat and creep

over it to reach the house."[7] That bit of everyday pageantry stuck in Sandy's mind.

From Lawnton, they moved back into Philadelphia so that Stirling could be closer to his studio. For a time, their living situation was pretty bleak: a small apartment that backed onto a railroad yard in what Calder remembered as a very poor neighborhood. Around 1903 or 1904, they were lent a quite luxurious establishment in Strafford, on the Main Line, by Dr. Richard Hart, a friend who was traveling abroad. Sandy, five or so at the time, was already mechanically or even scientifically inclined. Among the striking aspects of the early pages of Calder's account of his own life—*Calder: An Autobiography with Pictures* was published in 1966—are his clear-eyed impressions of mechanisms, machines, and more generally the way things work. He remembered how Dr. Hart's icehouse functioned: "Slabs of ice one foot thick were stacked in a large cellar, with sawdust between the slabs and straw over them. The ice would keep during the whole summer. You'd climb down a ladder and walk over the straw in the darkness. It was mysterious and cool on the warmest summer days." Calder described the door of his father's studio, which "opened with a long chain." He recalled slot machines, heaped in an empty lot near the sad apartment that backed onto the railroad yard. They had been abandoned there after being confiscated by the police, who later returned and smashed the wonderful machines to smithereens. Calder also savored an early ride in a car belonging to Dr. Stewart, and how "the machine broke down, which made it an even more thrilling experience."[8] If the automobile's engine needed to be repaired, Sandy might have had a chance to see how that was done.

The significance of these early interests cannot be underestimated. Mário Pedrosa, a Brazilian art critic who many decades later became a good friend of Calder's, argued that the young boy's mechanical enthusiasms marked a first turning away from the clay his parents had given him to play with. "Like any good American child at the start of the century," Pedrosa theorized, Sandy was focused "on the new gods of the age: the machine—the car, the gramophone, the cinema. I would wager that he would have exchanged any statue in the world, his father's, grandfather's or even Michelangelo's works, for one of those fantastic automobiles." Pedrosa imagined an automobile, no doubt much like Dr. Stewart's, "which clattered by making a god-forsaken noise, as if on the verge of euphoria, trembling with irresistible and irrepressible possibilities."[9] That clattering, trembling automobile was much more than a means of getting from one place to another. It was the advance guard of a new, radical art, the godforsaken noise a clarion call that would be answered thirty years later by the gentle clanging of Calder's mobiles as they circulated in space.

III

The Philadelphia home that was a constant in Sandy's and Peggy's childhood was the home of their paternal grandfather, Alexander Milne Calder, and grandmother, Margaret. By the time Sandy and Peggy were born, their mother's parents were no longer alive, one of her four brothers had already died, and the other three were firmly established in the Midwest. It was Stirling's side of the family that provided a sense of stability, with all the charms and difficulties that implied. Nanette, who had lost her own mother when she was eight, once told her daughter that she had hoped to find some maternal warmth in Stirling's mother but soon enough realized that this was not to be. Peggy speculated that "probably Grandmother Calder could not easily admit another female to the household of men she was used to running without challenge."[10]

Calder and Peggy, c. 1900. Photograph by Eva Watson-Schütze.

Alexander Milne Calder responded with affectionate spontaneity to his daughter-in-law and to Peggy and Sandy, who would be his only grandchildren. Then there were Stirling's brothers, the five boys born after him, some of whom were still at home, and who developed playful relationships with Sandy and Peggy. Ralph, Stirling's youngest brother, who for a time would have a successful career designing decorative plasterwork for some of the major American architectural firms, was remembered by his niece as teasing her and Sandy "over Grandfather's protests until we joined him in daredevil flights down the long polished banister from the second floor to the first." Their grandfather, who died in 1923, when Peggy and Sandy were in their twenties, was a benign, loving presence. After his grandchildren graduated from college, he observed, "Tis grand that noo oor laddie an' oor lassie baeth hae diplomas frae universities."[11] Although by then a successful man, he still had the immigrant's reverence for the achievements of the following generations, which he had always hoped would include a degree from a good college or university. Milne left Sandy $500 when he died. Sandy remembered living on that money in his father's studio in New York during the summer of 1924, while his parents

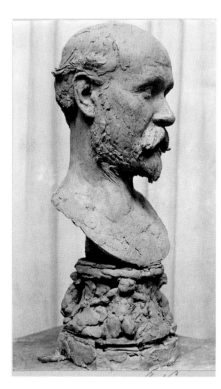

A. Stirling Calder. Portrait of Alexander Milne Calder, *c. 1905.*

were in Europe. That was the first concentrated period that Calder devoted to the life of art, and it was subsidized by his grandfather.[12]

Alexander Milne Calder was a self-made man. He was determined, pragmatic, optimistic, at times playful, dignified but also fundamentally modest. He had been born in Aberdeen, Scotland's third-largest city, in 1846. Aberdeenshire was the center of the granite trade in Scotland, having supplied London with its paving stones since the eighteenth century, so that stone, the very substance of sculpture, could be said to have been Milne's birthright. Many sculptors in nineteenth-century Scotland came from families of skilled craftsmen or had started out life with the idea of learning a craft, and Milne, whose father seems to have been a tombstone cutter, fit the pattern. In Edinburgh, Milne studied with John Rhind, a well-known sculptor but by no means the best-known sculptor in Scotland at the time; Rhind was the son of a master mason from a family that had worked in Banff since the early eighteenth century. After leaving Edinburgh in 1868, Milne lived and studied briefly in Paris and in London, where he worked in some low-level capacity on the early stages of the Albert Memorial. In later years, he sometimes said that his decision to cross the Atlantic had been "a prank."[13] That was probably little more than an attempt to leaven the hard fact that if he had remained in Scotland, where the supply of sculptors far outnumbered the demand, he would have had little chance of succeeding in his chosen profession.

There can be no doubt that Milne was as clear-eyed as he was ambitious, and understood full well that he was very far from being the best trained or most gifted sculptor of his generation. He may have headed to Philadelphia because he'd been told that there were relatively few sculptors in the city at the time. He may also have been aware, before or at least soon after his arrival in the United States, that one of the most important architects working in Philadelphia, John McArthur Jr., had emigrated from Scotland as a boy—and therefore might be inclined to give some work to another son of Scotland. Either just before or soon after coming to the United States, Milne married Margaret Stirling, whose family was from Glasgow.[14] Milne's eldest son received his mother's maiden name, and Stirling and Nanette, in turn, named their daughter Margaret. Margaret Stirling was a rather beautiful woman, with fine, almost aristocratic features, but she was not an easy person, and the marriage was full of conflict. She was, Peggy explained, "a

dour, austere woman for whom the term up-tight should have been invented. She maintained that each of her six sons was the result of rape."[15]

Malcolm Cowley described his friend Calder's paternal grandmother as "a virtuous old dragon"—an impression he must have gathered from Nanette in her later years, when she was living with the Calders.[16] Peggy never forgot the pall her grandmother cast over the house on North Park Avenue. The house was tomblike: "Inside a long dark hall, lit by a gasjet and covered wall to wall, a red carpet led past the closed doors of the parlor, which we were forbidden to enter without an adult. Its 'Empire' furniture, upholstered in red velour, was usually under protective linen covers." Peggy speculated that her brother's memories of this uninviting setting led to what she referred to as his "distaste for things that cannot be used and enjoyed for what they unadornedly are." Milne, high-spirited and playful, must have felt uncomfortable in that dour atmosphere.[17] At least three of Stirling's five brothers never married, and one wonders if the stresses in the relationship between Milne and Margaret scared their sons away from even the possibility of a happy union. Three of the boys did, however, follow in their father's footsteps: Stirling as a sculptor; Norman as a painter; and Ralph as a specialist in architectural decoration.

Although Milne lived in Philadelphia for more than half a century, the success he achieved as an American artist never dampened his passion for his Scottish homeland. A somewhat dandyish man with a neatly clipped beard, he wore elegant suits of Scottish tweed, and to the end of his days he preserved the accent of his native land and quoted lines from Robert Burns. In the summers he would go back to Scotland, to visit a brother and do watercolors of the landscape, works that haven't survived but suggest his fondness for a tradition of landscape painting that had long flourished in Scotland. Returning from one of his trips, he was full of excitement at having met the Scottish singer Harry Lauder. As his son and two grandchildren waited with him for his luggage, he sang "My Scotch Bluebell" and did a few steps of the Highland fling. He came back from his summers alone in Scotland feeling lighthearted, but the feeling didn't last. As Stirling once said to his wife, contemplating Milne's good cheer on his return from the ancestral land, "Poor devil, he'll get over that once he gets into the gloomy atmosphere at home."[18]

In the parlor of his home in Philadelphia, Milne kept a four-foot-high statue he had made of Alexander Wilson, a Scottish dialect poet, ornithologist, and bird painter. Not unlike Milne, Wilson had been born in humble circumstances. He had come to America after, as Milne told his granddaughter, "lampooning the mill owners in a bitter labor dispute." In 1814,

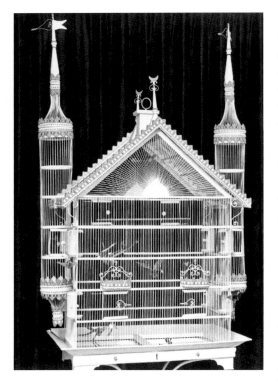

The Victorian birdcage belonging to James Thrall Soby, with the metal birds Calder made for it in the early 1950s.

Wilson published the nine-volume *American Ornithology*, regarded as the precursor of John James Audubon's work. Milne shared with his countryman a special feeling for birds. When Peggy and Sandy visited their grandparents' house, they liked to go up to the sitting room at the back of the second floor, where Milne kept canaries, which his granddaughter remembered "trilling defiance of one another from different corners of the room."[19]

Calder may have been reminded of his grandfather's birdcages many years later, when he saw an elaborate nineteenth-century cage in the Connecticut home of a friend, the collector and curator James Thrall Soby. Such birdcages were objects of fascination in artistic circles at the time. The wealthy artist and poet Dwight Ripley and his partner, the botanist Rupert Barneby, important figures in bohemian New York in the 1940s and 1950s, owned some impressive examples. And the poet Elizabeth Bishop, who was a friend of Calder's, had an elaborate Brazilian cage, but she abandoned any hope of using it for birds, as they got trapped in the turrets and hurt themselves. Soby had the same problem with his cage. "I had live birds in it at first," Soby later recalled, "and then I gave up because the birds were always getting caught in the cage's turrets and could only break free by injuring a leg or wing." When Calder saw the birdcage without any birds, Soby explained, he said that an empty birdcage was "useless if not sinful and promptly made me a set of new birds from Medaglia d'Oro coffee tins."[20] Could it be that as he worked on these charming, highly colored metal creatures for Soby's Victorian birdcage in the 1950s, Calder remembered the cages full of canaries, trilling defiantly, that Milne had kept in the second-floor sitting room in his house in Philadelphia?

Calder would always be fascinated by birds of all kinds. In the late 1920s, he made wire cigarette holders in the shapes of birds. When he was getting to know the philosopher Jean-Paul Sartre after World War II, he gave him a mobile entitled *Peacock* (1941), which Sartre described in the extraordinary little essay he devoted to Calder's work. Sartre wrote, "My bird flies, floats, swims like a swan, like a frigate. It is one, one single bird. And then, suddenly, it breaks apart and all that remain are rods of metal traversed by futile little tremors."[21] Over a period of a couple of decades, Calder made a number of more readily recognizable birds—much larger, more elaborate

versions of the birds he devised for Soby's cage—out of bits and pieces of coffee cans and beer cans, with the brilliantly printed surfaces serving as the bird's luxuriant plumage. When, in 1968, Calder mounted what he called a "ballet without dancers," *Work in Progress,* at the Rome Opera House, one scene in the nineteen-minute multimedia performance was devoted to the feathered kingdom.

IV

By the time Alexander Milne Calder died in 1923, he had been living in Philadelphia for fifty-five years. Whatever the conflicts between Milne and his wife, he was a man of steady, determined habits, and his marriage was an enduring union, as would be those of his son and his grandson. Milne was equally dedicated to Philadelphia's City Hall, where he labored for more than two decades, overseeing the production of some 250 sculptures, and in the process providing his family with a very comfortable life.

Calder. A selection of the metal birds that Calder made for Soby in the early 1950s.

The new City Hall, which was designed by John McArthur Jr. and began to go up in the early 1870s, was meant as a secular palace to rival in extent and grandeur the Louvre. There was a stubborn romantic craziness about the pileup of pedestals, pillars, pediments, mansard roofs, and chimneys that McArthur brought together on this demented wedding cake of a building. The four façades enclosed a grand central courtyard that was approached through a series of dramatic arcades. The central tower was meant to be the tallest structure in the world, although during construction it was superseded by the Eiffel Tower and the Washington Monument. Milne responded to McArthur's extravagant architectural vision by bringing his own extravagant energies to the rendering of hundreds of figures that were by turns naturalistic, classical, historical, and allegorical. No part of the vast building was neglected. Placed near the sheriff's cellblock were allegories of Pain and Sorrow and impressions of ferocious animals, meant to warn the inmates of the punishments awaiting those convicted of a crime in City Hall's vast courtrooms. During the years the building was under construction, one of those courtrooms served as Milne's studio.

Looking at the work of Calder's grandfather at City Hall, you can see that

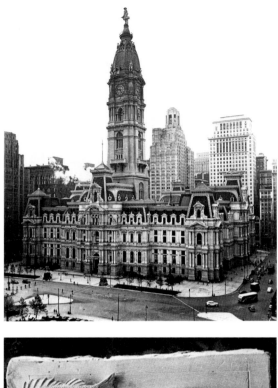

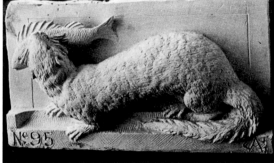

Milne lacked the refined grasp of anatomy and subtle feeling for classical form he would have needed to mount a successful career in London or Paris. In Philadelphia, he found acceptance as a member of an informal Scottish brotherhood, which included not only the architect of City Hall but also the owners of Struthers Stoneyard, who supplied the raw materials for this vast, seemingly endless project. If there is a certain charm about some of Milne's less than successful efforts to follow the Victorian sculptor's rule book, it's because the plainspokenness of his approach gives the pompous subjects a measure of folk-art forthrightness. This mingling of directness and even playfulness in Alexander Milne Calder's sculpture from time to time brings to mind the work of his infinitely more sophisticated grandson. With Milne, of course, you're not always sure whether certain sculptures are intentionally or inadvertently comic, but the spirit of fantasy and play is there in any case. When Milne conceived the many animals that decorate the building—and here he seems to have allowed his imagination to run riot—the results were both weird and hilarious. There is, for instance, a group of otters arranged to look as if they're emerging from burrows carved into the stone itself, which might have tickled Sandy Calder's taste for crazy fun.

Close to 150 years after he began working at City Hall, Alexander Milne Calder's achievement remains absolutely a part of the fabric of Philadelphia. Milne's involvement at City Hall culminated with the commission in 1886 for the thirty-seven-foot-high bronze statue of William Penn that tops the dome and, indeed, presides over the entire city. In 1888, he produced a nine-foot-high clay model of the gentleman in his long coat with its elaborate buttons; the twenty-seven-ton statue was cast at the Tacony Iron and Metal Works in Philadelphia. But in 1894, when this gigantic image of William Penn was at last mounted on the dome, it was set the wrong way round—at least so Milne believed—with the result that Penn's face is in shadow most of the day. Some felt this was simply an error,

but others believed it was intentional, a slight to Milne; his collaborator and fellow Scot, John McArthur, had died in 1890 and been replaced by fresh architectural talents, who apparently didn't care for Milne's work. Whatever the reason, the botched installation of William Penn was something Milne regretted to the end of his days, repeating, so his granddaughter recalled, Robert Burns's "The best laid schemes o' mice an' men / Gang aft a-gley."[22] The distinguished art historian Wayne Craven, in his book *Sculpture in America*, wrote of Milne that "the great pleasure of his last years was in watching his son, Stirling, rise to a prominence in America's sculptural activities that he himself never experienced."[23]

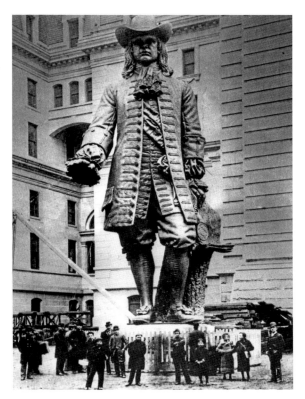

Alexander Milne Calder. William Penn, c. 1886–94. Seen before it was mounted on the top of the Philadelphia City Hall.

V

Stirling Calder completed his studies at the Pennsylvania Academy of the Fine Arts in 1890, only eight years before his son was born. The academy, the oldest art school in the United States, was woven through the lives of the Calder family, all the way down to Sandy, who never studied there but did begin to participate in the institution's annual exhibitions in the 1940s. Sandy's parents had met while they were both studying there. And Sandy's grandfather, long after he was in charge of the sculpture program at City Hall, attended classes at the academy, perhaps recognizing that his education back in Europe had hardly equipped him for the enormous challenges he now faced. When, in 1876, the academy moved to a new building on North Broad Street, it was almost literally in the shadow of City Hall. Milne would have had no trouble slipping out of his studio and into a life drawing class or a lecture in a matter of minutes.

Stirling was sixteen, really still a boy, when he entered the academy in 1886, and he seems to have approached the experience with a certain diffidence. He later said that at the time "all my heroes were on the stage," confessing a passion for the theater that he would pass on to his son, whose career would be studded with theatrical experiments, of which the *Cirque Calder* (1926–31) is only the best known. In his youth, all Stirling wanted, by his

own testimony, was "to frequent the theater, becoming a solitary gallery god thinking in blank verse, with the great actors of the day, Irving and Terry, Mary Anderson, Maurice Barrymore, Forbes Robertson, Joseph Jefferson, Creston Clark, the Barretts, Julia Marlowe, John Hare, E. S. Willard, and a host of others. . . . I suppose," he speculated, "native shyness was the reason why I did not try to become an actor."[24] The theater was not the only other career that tempted him. Stirling told one journalist—perhaps not entirely seriously; one doesn't know—that what he had really wanted was to be a soldier, but that West Point had proved impractical. Maybe, again, it was his shyness that stood in his way. He certainly had the looks for the stage—or for a military uniform. Stirling was a strikingly handsome young man. In a photograph with his family taken around the time he entered the academy, he stood near his mother, whose long, eloquent eyes and good cheekbones he'd inherited. Stirling's head is tilted slightly upward, his eyes are looking into the distance, a lock of hair falls across his brow. He's the poetic figure in the Calder family.

If Stirling was indeed backing his way into the study of sculpture, it's not difficult to see why. There was perhaps something a little deflating about taking up this profession he had witnessed since infancy, when he'd had, as a journalist later observed, "a nursery in a studio, and a lump of clay as a plaything."[25] Stirling recalled with wry humor how pleased he had been to be put in charge of the horse used as a model for the equestrian statue of the Civil War hero General George Meade that his father was making for Fairmount Park. At least, Stirling was pleased until he discovered that his duties included what he remembered as "cleaning up the steaming piles of manure the horse left on the studio floor each day."[26] Even so, an inexorable force was drawing Stirling to the art of sculpture. With Stirling, as with his son a generation later, once he had taken the first steps as an artist, everything fell into place. He almost immediately made good friends at the academy. And pretty soon he was regarded as an artist with a future. In his second year of study, two of his portrait heads were accepted for the academy's fifty-seventh annual exhibition. Stirling was given a job as demonstrator of anatomy at the academy in 1889–90, assisting in the dissecting room and offering presentations to complement the regular anatomy lectures. Fifty years later, he would write that at the academy he "received ineffaceable impressions that have colored my life. There I formed habits of thought that have persisted. There I received a broad generous opportunity that has left me poor, but free."[27]

Entering the academy the same fall as Stirling was Robert Henri, who shared his love of the theater. Henri, a born leader, in no time became the cen-

ter of a group of young Phila-
delphia artists, some studying at
the academy and some already
embarked on careers as news-
paper and magazine illustra-
tors. Within twenty-five years,
they together took New York
by storm. The best-known
members of the group—along
with Henri, they included John
Sloan, William Glackens, and
Everett Shinn—became lib-
erators of American art. They
infused everyday subjects with
painterly panache and were
eventually known as the Ash-
can school, on account of their
gritty urban realism. Another
member of the group that gath-
ered around Henri was Charles
Grafly, a sculptor who was two
years ahead of Stirling at the
academy and for the next fif-
teen or so years would be, as
Stirling once wrote, his "partic-
ular and most intimate profes-
sional friend."[28] Robert Henri
became a beloved teacher at the

*Margaret Stirling Calder
with her sons Stirling,
Charles, and Ralph,
c. 1887. Stirling is standing
in the center.*

Art Students League in New York; his thoughts were eventually collected
in *The Art Spirit*, one of the most successful books by an American painter.
"The *student* is not an isolated force," Henri announced, articulating a vision
that must have been grounded in his experience with friends such as Calder,
Grafly, Sloan, and Shinn. The student, Henri continued, "belongs to a great
brotherhood, bears great kinship to his kind. He takes and he gives. He ben-
efits by taking and he benefits by giving."[29]

We see the bonds of that brotherhood being formed in photographs from
the 1880s, when Henri and his friends were at the academy. Here are Henri
and Stirling in the dissection room, learning anatomy firsthand. And, in a
more playful mood, we see the boys fooling around with a skeleton, which
Stirling holds as if he were echoing the pose of Michelangelo's *Pietà*, with

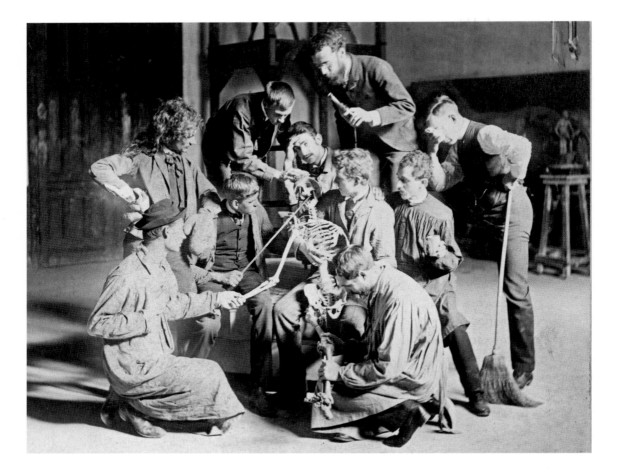

Stirling Calder, Charles Grafly, Robert Henri, and their friends at the Pennsylvania Academy of the Fine Arts, c. 1887. Stirling Calder is holding the skeleton; Henri kneels wearing a hat; Grafly is to the left in what looks like a fright wig.

Stirling as the Madonna and the skeleton as Christ, while Grafly, in what looks like a fright wig, stands to one side.

VI

In Philadelphia, the brotherhood was also a sisterhood. The city was home to the Philadelphia School of Design for Women. And the Pennsylvania Academy of the Fine Arts was welcoming to women, already claiming among its graduates the portrait painter Cecilia Beaux, who had built an enormously successful career. No doubt it was the academy's reputation as a place friendly to women that attracted Calder's mother, Nanette Lederer, who came to Philadelphia from Milwaukee in 1888 to study painting. When Stirling first met her—as family legend had it, "over a cadaver" in a class at the academy—her dark eyes and hair and forthright, free-spirited style

might have reminded him of one of his favorite actresses, the raven-haired, almost boyish Julia Marlowe.[30]

Nettie, as she was known in her family, was four years older than Stirling. She had been born in Milwaukee in 1866, the only daughter and the youngest of five children of Abraham and Doreth Lederer. Her mother died in 1874, and she was sent to Philadelphia to live with Doreth's sister, Flora Gunsen-hauser Feldman, and her husband and their daughter Ida. Nanette also had an uncle in Philadelphia, Doreth's brother, Hyman Gunsenhauser. A much adored youngest child and only daughter, Nettie suddenly found herself part of a family in which she didn't exactly belong, and in later years she remembered her time as a child in Philadelphia as something of a nightmare, a dark passage in a Cinderella story. But whatever the travails of life with the Feldmans, when Nanette, at the age of sixteen, finally persuaded her father to let her return to Milwaukee, the Midwest was not much better. Her father and some of her brothers were living what amounted to a bachelor existence. Nanette was embarrassed by her brothers' casual relationships with women they had no intention of marrying. To Nanette, a young woman of artistic inclinations who yearned for a life of bohemian independence, the behavior of her older brothers, young businessmen with loose morals and conventional ambitions, must have seemed at best alien, at worst hypocritical.

The Lederers were Bavarian Jews. Abraham had arrived in the United States in 1842 at the age of twenty-one and first may have settled in Hudson, New York, along with two brothers and a sister. His marriage to Doreth Gunsenhauser was a love match, initially resisted by relatives who had meant her to find, with the help of her prosperous Philadelphia relatives, a husband who was already well established. "They knew what they wanted," Nanette would write about her parents late in her life, perhaps seeing in her mother's headstrong spirit the origins of her own.[31] Abraham and his two brothers, Isaac and Martin, stuck close together. They were in business in Albany by 1849, where they operated a dry goods business. In the early 1860s, Abraham and Martin moved to Milwaukee. There Abraham once again started out in the dry goods business. Over the following quarter century, he built a highly successful career in the insurance and real estate businesses and became a figure of some consequence in Milwaukee's Jewish community. Of his four sons—Jacob, Isaac, Nathan, and Philip—one seems to have become a carpenter while the three others were involved in business of one kind or another; family members moved to Chicago and the Minneapolis–St. Paul area. Sandy and Peggy remembered the Lederer cousins as their wealthy relatives, children with elaborate toys that their own family, on an artist's budget, could never hope to match. Around the time he was ten, Sandy

received a wonderful gift from the Midwest, a mechanical train running on a one-and-a-quarter-inch track.[32]

The business success of her midwestern family was something Nanette was all too happy to trade for the life of the imagination and whatever insecurities were involved. She certainly wasn't inclined to talk much about her early years. Sandy's daughters, who knew their grandmother quite well, came away with little sense of her family background or history. Perhaps life in Milwaukee was something Nanette preferred to forget. But for a young woman with artistic leanings, that city on the shores of Lake Michigan, sometimes called the Athens of the Midwest, was by no means a bad place to grow up. German immigrants had made the place a center of sophisticated musical life, and there was a native school of landscape painting, which some have seen as a midwestern parallel to the Hudson River school. In photographs from her later teenage years, when Nanette was back in Milwaukee, the dark-haired young woman posed as a free-spirited Gypsy with a tambourine and as a muse in flowing Grecian robes. Nanette, after a battle with her father, who secretly played the violin, was allowed to take piano lessons. Given her determination in her early twenties to leave the Midwest and study painting, one would assume that she had some contact with the city's artistic circles, including a certain amount of solid instruction in the pictorial arts.

Well before Nanette left Milwaukee, whatever feeling she had for her Jewish background had probably faded, as it seems it was fading among her brothers who remained in the Midwest. Sometime in the 1920s, after preparing creamed turkey for dinner, Nanette did allude in a letter to her daughter to how her family had kept a kosher home, preserving the traditional division between milk and meat, "creamed food being tabooed," as she explained.[33] In Nanette's case, one imagines that Judaism and Jewish practice were replaced, as they were for many other educated Jews, by an embrace of progressive ideas and an artistic and intellectual world that had become available to them only in the liberal climate of the nineteenth century. In letters to Peggy and Sandy written during a trip to Europe in 1924, Nanette referred to a couple of women she and Stirling had met as "Hebraic ladies from Baltimore"—which suggests that she didn't see herself as anything of the kind.[34] Of course, one also feels sure that whatever the strength of Alexander Milne Calder's Scottish Presbyterian roots, Stirling had not grown up in a religious home. For Stirling and Nanette, religion was not what consecrated a marriage. I seriously doubt that Nanette placed any store in the fact that according to Jewish law, which traces religious identity through matrilineal descent, her children, Peggy and Sandy, were in fact Jewish. It is interesting that Sandra, Calder's older daughter, recalls learn-

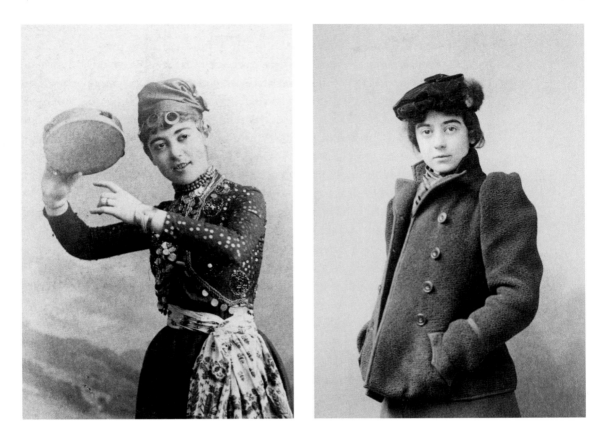

ABOVE, LEFT *Nanette Lederer photographed in a Gypsy costume in Milwaukee, c. 1886.*

ABOVE, RIGHT *Nanette Lederer, Philadelphia, 1892.*

ing that her father was Jewish only when she was a young woman, and then from the man she would marry, Jean Davidson, whose father, the sculptor Jo Davidson, was also Jewish.

If Judaism was always a thread in the fabric of Sandy Calder's life, it was a thread more often than not woven so deep as to be nearly invisible and, although never exactly denied, only rarely brought all the way to the surface. It's difficult to say what their neighbors knew or imagined about Calder's background in the 1930s and 1940s, when Sandy and his wife, Louisa, were living in western Connecticut, where anti-Semitic feeling was deeply ingrained. Louisa's distinguished New England pedigree may have carried all before it; her mother was a Cushing with the lineage to be a Daughter of the American Revolution, and Louisa had a plummy Boston Brahmin accent. Late in life, when Nanette was living in Connecticut with her son and her daughter-in-law, she does seem to have turned to the Old Testament, reflecting in some notes written for her own edification on Moses as a heroic figure, a man of "knowledge and intuition"; she also copied out a passage from Isaiah.[35] But for Nanette, sacred texts most likely remained

literary or philosophic sources. Art was the religion to which the Calders—grandfather, father, mother, and son—dedicated their lives. "Life needs spiritual conviction outside the churches," Stirling wrote at one point. And in some notes highly skeptical of religion in general, Stirling observed that "the only true belief is the belief in truth—the belief of what we now know as truth and what we believe may yet be known."[36] Stirling's son, although not given to this sort of philosophizing, would have embraced the sentiment.

In her later years, Nanette probably believed that her life had only really begun in 1888, when she moved out of Milwaukee for good. Along with much else, she left behind the name Nettie. Her father had died suddenly the year before. Nanette waited through the months that his will took to wind its way through probate court, determined to collect her inheritance and strike out on her own as an artist. She recalled later on that the money that came to her was actually from her mother's estate, "from a rich uncle banker in Bayreuth."[37] Against the advice of her brothers, who wanted her to make a conventional marriage in their circles in Milwaukee, she set out for Philadelphia and then for Paris and the Académie Julian, a destination for many students at the Pennsylvania Academy. In Paris, she lived with a group of art students, among them Charlotte Harding, who for a time, before marrying, had a successful career as an illustrator for popular magazines. They traveled around Europe, admiring the Puvis de Chavannes murals in Lyon, taking in the spectacle of gamblers and gambling in Monte Carlo, and unforgettably arriving in Venice at the witching hour so that their first experience of the city would be by moonlight. Years later, Nanette remembered, "When you are 21 and have the opportunity to go to Venice you consult Baedeker—and Baedeker tells you to arrive at midnight with the full moon."[38] Returning from Paris to Philadelphia, Nanette continued to study painting and found work in a dress shop, where she was relied upon to give some fashionable panache to the ornaments on hats and other items of women's clothing.

For a photograph taken at the time, Nanette sported a strikingly tailored jacket and a small, elegant hat and exuded an aura of cool, Parisian chic. Although perhaps not conventionally beautiful, with her dark hair and dark eyes Nanette was a strikingly lovely, sexually seductive woman. Years later, John Sloan found himself spending an evening in New York with Louis Glackens, an illustrator who was the brother of the painter William Glackens. Louis spoke with considerable passion about having been smitten with Nanette Lederer in the years before she married Stirling. "The little old bachelor must really have been in love with her," Sloan commented in his diary.[39] Whatever troubles and challenges life brought—and she and Stirling certainly encountered their share of complications—Nanette always

remained in some sense a free spirit. A grandchild remembered her, at Stirling and Nanette's country house in Massachusetts, "walking through the orchard; her hair blowing in the wind, with the light flickering through it— and remarking, 'Oh la,' one of her favorite expressions."[40] Even in old age, there was something in Nanette of the brilliant young woman who all those years earlier had left Milwaukee to study painting in Philadelphia and Paris.

STIRLING AND NANETTE

I

Stirling and Nanette, joined in their passionate pursuit of a life in art, were very much contrasting personalities, emotional opposites united in a fin de siècle romance. In photographs, they projected a yin-and-yang eroticism, with something lush, easy, and impulsive about Nanette's looks set in relief by the dandyish elegance and aquiline cool of her husband. They were a striking couple. Stirling was lean, elegant, handsome, with hooded, almost Asian-looking eyes, light hair framing his brow, and a fine nose and mouth. Nanette was a brunette, with warm, penetrating eyes and a great pile of hair loosely arranged on top of her head and falling onto her neck. In a photograph of the two of them in their studio in Paris, probably in 1895—they had been married that February, and Peggy would be born the following year—Nanette is seated at a little desk while her husband, one hand on his hip, watches her as she writes. The studio is furnished with all the accoutrements of the bohemian life: the Oriental rugs and exotic hangings, the old furniture that doesn't exactly match, a casual, inviting setting in which the newlyweds could embrace all the excitements of art and love. He looks as dashing as the young man in the reproduction of a portrait by Titian that is tacked to the wall above his head. And there is also perhaps something Venetian about Nanette, with her abundance of dark hair contrasting with the pure white of her blouse.

In 1899, Stirling gave Nanette a copy of Bernard Berenson's *The Venetian Painters of the Renaissance,* a book that includes as its frontispiece another portrait of a young man by Titian. Berenson's great book, which can still be found on a shelf in the Calder house in Roxbury, Connecticut, is a wonderful token of their love affair. Berenson was a considerable figure in the art-for-art's-sake movement of the last years of the nineteenth century, an adviser

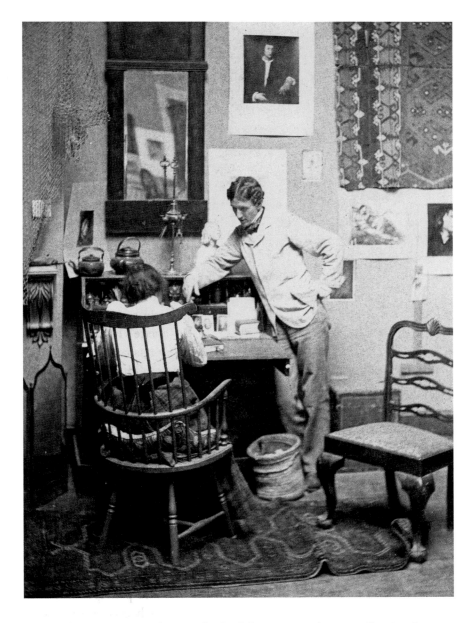

to Isabella Stewart Gardner as she built her extraordinary collection in Boston. He gave fourteenth- and fifteenth-century Italian art a new significance, emphasizing a formal beauty not only timeless but also startlingly modern. "All beautiful things belong to the same age," Oscar Wilde had written in 1891.[1] Those words, from an author with whom Berenson had been friends and whom he quoted, were also familiar to Stirling and Nanette.[2] In the 1940s, when Nanette read the text Calder's friend James Johnson Sweeney

Stirling and Nanette Calder in their Paris studio, c. 1895.

wrote for the catalog of his retrospective at the Museum of Modern Art, she informed her son that she was reminded of the writings of Oscar Wilde. She and Stirling had had a copy of Wilde's collection of essays, *Intentions,* when they lived in Paris—until, she was sorry to say, "your father lent it and always regretted it was not returned."[3] *Intentions*—a quartet of essays, including "The Decay of Lying" and "The Critic as Artist"—was one of the foundational texts of the modern movement. It was in "The Decay of Lying" that Wilde established the formalist ideal. "Art," he explained, "never expresses anything but itself. It has an independent life, just as Thought has, and develops purely on its own lines."[4]

Nanette was perfectly justified in seeing in her son and his friends the inheritors of this art-for-art's-sake tradition, which had had such a deep impact on her and her husband. In the collection of her husband's occasional writings, *Thoughts of A. Stirling Calder on Art and Life,* which Nanette privately published after his death, there were many passages in which Stirling zeroed in on the centrality of form. "The love of form is primitive," Stirling wrote, "an instinct shared by all men to a degree. The instinct of form is part of our very physique and the art that most purely embodies manifestations of this instinct is sculpture." In another passage, he announced that sculpture "is the expression of persistent individuality in form, and as such is fundamental, not ornamental."[5] Their daughter recalled heated conversations between Stirling and Nanette—he called her Net—about the relative significance of form and color. "Those flowers," she would say to him, "are so vibrant they make my heart sing. To me, their form is not as important as their color." To which Stirling would respond, "*You use* color to express form."[6] Whatever the particulars of Stirling and Nanette's arguments, they celebrated formal values as essential values, human values.

Of course, many artists and writers would agree that Oscar Wilde went too far when he declared that "Truth is entirely and absolutely a matter of style."[7] Stirling and, in turn, his son would resist the dangerously solipsistic extremes of art for art's sake, grounded as it was in the almost religious belief that form trumped or at least equaled content. But neither Stirling nor, later, his son would ever entirely deny formalism or even aestheticism their value, if only as bulwarks against philistinism. When the painter Henry McCarter, who had been a friend of Stirling's from their Philadelphia days, died in 1942, Stirling wrote—and he surely meant it as high praise—that "he was the last of the esthetes in the present deluge of noisy technicians, the plumbers and gasfitters of Art."[8] The remark curiously echoed, if not in its import then certainly in its comic turn of phrase, a comment Stirling's son had made to his friend James Thrall Soby in 1936. Sandy, worried

about being too closely associated with some particular group of artists, had insisted on making a clear distinction between his work and what he characterized as "the Surrealistes, the neo-romanticists, the concretionists, the automobilistes, or the garagistes."[9]

II

Van Wyck Brooks—a towering figure in the study of American literature and culture who was also a friend and admirer of Sandy Calder's—had dismissive things to say about the Pennsylvania Academy of the Fine Arts in a biography of John Sloan he published in the 1950s. Brooks announced that "the dark dank old Academy building was a byword among artists for whom it 'yawned like a tomb,' as one of them said,—a 'fusty fudgy place.' "[10] Perhaps that was how some of the artists remembered the academy in later years. But it was by no means the whole story. Sloan never lost his admiration for some of his teachers at the academy. Stirling and Nanette never lost their sense of the academy as one of the great forces in American art—and one of the great forces in their lives. Without a clear picture of what the Pennsylvania Academy of the Fine Arts represented in the 1880s and 1890s, it is difficult to see what kind of artist Stirling Calder really was.

In the catalog of the Museum of Modern Art's 1943 Calder exhibition—in the text that put Nanette in mind of Oscar Wilde's writing—James Johnson Sweeney described Stirling as "a National Academician."[11] That is true, in that he was a member of New York's National Academy of Design. But there is a problem with Sweeney's characterization, because it can leave a reader with the impression of an artist whose thinking was stuffy and academic, which wasn't the case. Stirling has also been described as "a sculptor in the Beaux-Arts tradition," by the curator Marla Prather in the catalog of the epochal retrospective she mounted at the National Gallery of Art in Washington, D.C., in 1998, a celebration of the centennial of Calder's birth.[12] Like Sweeney's characterization, Prather's, while by no means inaccurate, risks distorting Stirling's vantage point. Like so many of his friends at the Pennsylvania Academy, Stirling was in search of a fresh, original style—a new vision, anything but academic. "Purposes beget motives," he once wrote. "New motives replace old ones. Visions never before seen, but not therefore impossible, loom up. New channels for old impulses are found and that growth that is necessary to all art is assured."[13] If the most enduring of Stirling's works do not fulfill the promise of such a statement, these were nevertheless the ambitions he embraced as a student at the Pennsyl-

The staircase of the Pennsylvania Academy of the Fine Arts, designed by Frank Furness in the 1870s.

vania Academy and that sustained him throughout his career.

The academy had moved into a new building a decade before Stirling and Nanette and their friends, including Sloan and Henri, began studying there. It was an extraordinary building, designed in large part by Frank Furness, whose work at the academy and on the campus of the University of Pennsylvania established him as one of the late nineteenth century's formidable architectural innovators. The academy was an airy, light-filled, beguilingly idiosyncratic structure, the big, beautifully shaped spaces enriched with a great many bold, enchanting details. The metalwork on the central staircase demonstrated Furness's sense of fantasy in the abstraction of vegetal forms, embodying ideas derived from John Ruskin's teachings, but with a daring that prefigured the work of Louis Sullivan, who was a student of Furness's for a time and would, in turn, help shape Frank Lloyd Wright's vision. Like his near contemporary, the great Catalan architect Antoni Gaudí, Furness relied for some of his most striking effects on craftsmen who were themselves artists of a sort—minor poets in metal and stone. At the opening of the Pennsylvania Academy's new building, Furness's father, the Reverend William Henry Furness, gave an address in which he rejected the tendency to distinguish "the Beautiful Arts from the Useful" and wondered "what workman is not cheered in his work by handsome tools?"—a rhetorical question that Stirling's son might well have asked seventy-five years later.[14]

Stirling would always remember the special pleasure of hearing rehearsals of promenade concerts in the academy building, the sounds wafting up from the front galleries "to reach us as we worked in the sculpture class. It was charming."[15] During breaks in their classes, the students lounged at the foot of the stairs and Thomas Eakins, the artist and teacher who was already in his own day recognized as one of the great iconoclasts of Victorian Amer-

Thomas Eakins. Pastoral, *1883–84.*

ica, "often talked with us informally about methods and showed us a few simple gymnastic feats."[16] Eakins was forced to resign from the academy a few months after Stirling began to study there. He had been encouraging students of both sexes to observe the human figure with a frankness that upset the traditionalists. Many believed that Eakins had gone too far when he removed the loincloth from a male model in a class where women were present. Others viewed his forced resignation as an artistic martyrdom. Eakins's energy and independence certainly emboldened young Philadelphia artists, even when they reacted against some of his teachings. His stringent scientific approach alienated those who believed in the freedom of the imagination and preached the new gospel of art for art's sake. Looking deep into the faces of his fellow Philadelphians, Eakins produced dark-toned, brooding, strenuously naturalistic portraits. They reflected all the hopes, anxieties, and turmoil that animated late-nineteenth-century America.

Stirling later said that as a student he was "careless of instruction" and, in any event, was under Eakins's guidance for too short a time "to succumb to his mastership and charm." But he worked with Eakins long enough to quickly graduate from drawing from antique casts to the life class, and to be told by Eakins "to start painting immediately." Stirling's father had been proud to count Eakins among his friends, and if Eakins devoted most of his energies to painting, he also took an interest in sculpture, producing many works in plaster and clay. Eakins would most likely have known Stirling as Milne's son when the young man enrolled in the academy. Stirling recalled Eakins telling him, "Attack all your difficulties at once"—a very modern

A. Stirling Calder. The Last Dryad, *c. 1924.*

attitude, in the sense that it signaled a rejection of strict pedagogical systems.[17] There may also have been something in the almost painterly way in which Eakins handled clay—inspired, perhaps, by French examples—which was echoed in the freedom of Stirling's own method of working with sketchlike dabs of clay. As a student, Stirling signed the petition calling for Eakins's reinstatement at the academy. Years later, when Stirling was living in New York and was asked to contribute some ideas for a proposed exhibition of American sculpture of historical interest, he suggested "some unusual small bronze reliefs by Eakins."[18]

When Stirling was already out of the academy and beginning his career in Philadelphia, he was involved in a competition for a statue of Dr. Samuel Gross, whom Eakins had earlier painted in the midst of performing surgery. Stirling went with his friend Charles Grafly to visit Eakins in order to borrow some photographs of Dr. Gross. He recalled how "Eakins came into the parlor to greet us with a monkey on his shoulder. Perfectly unself-conscious, he was apt to be careless of formalities."[19] Grafly's daughter remembered that her father had found something "sustaining" in Eakins's "interest in portraying the depth of a personality." Grafly felt that Eakins "carried the personality of the sitter through an entire composition." And while Eakins may not have had "wealth, he had never bartered his ideals."[20] The photographs he took of young people in the nude, especially those of young men swimming together, suggested a yearning for erotic freedom that nineteenth-century Philadelphia could hardly accommodate. Stirling himself was criticized on more than one occasion for the frank sexuality of his studies of the female nude. In 1924, when his son was twenty-six and living at home or close to home and studying at the Art Students League, Stirling was being sued for $200,000 by the husband of a model who accused him of incorporating her facial features in a nude sculpture of *The Last Dryad* and thereby holding her "up to scorn."[21]

In the late nineteenth century, naturalism and symbolism, the truth of nature and the truth of art, were not always easy to disentangle; perhaps they were not really meant to be disentangled. Among the younger instructors at the academy whom Stirling remembered in later years was Thomas

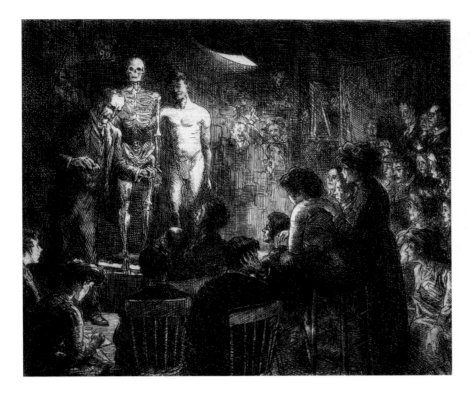

Anshutz, who had studied with Eakins. Anshutz's most famous painting, *The Ironworkers' Noontime* (1880), done while he was still working with Eakins, demonstrated a geometric lucidity and a pristine examination of the human form that felt very close to the master. But by the time Stirling was studying with Anshutz, he had moved away from Eakins's somber, scientific naturalism, to a more lyrical, poetic art. Anshutz believed, with Wilde, that an artist created life rather than copying life. He complained of Eakins's almost exclusive focus on "conscientiousness," of life studies that were "the result of following the eye mechanically" and lacked "one grain of true art."[22] This idea of "true art" was the touchstone for Stirling and his fellow students, but always mixed with the sobriety on which Eakins had insisted. Grafly, when he found himself in a Parisian classroom full of students far more experienced than he, began thinking that Anshutz would "smile to see the lack of construction but the *chic* visible in each."[23] It was only through an artist's commitment to construction—to the seriousness of his craft—that "true art" could be revealed.

But how exactly was truth to be revealed? The question was of capital importance to Stirling and also to his son, although Sandy Calder would doubtless have been more comfortable talking about honesty or directness

John Sloan. Anshutz on Anatomy, *1912. Thomas Anshutz, shown here giving an anatomy lecture in New York after 1900, had been a teacher greatly valued by Stirling Calder, Sloan, and Grafly at the Pennsylvania Academy of the Fine Arts.*

A. Stirling Calder. Walt Whitman, 1935.

than about truth. Certainly the revelation of truth had something to do with the artist's powers of observation and something to do with the power of the artist's imagination. Perhaps Stirling was thinking of the double-barreled nature of the creative act when, reflecting a half century later on his experience at the Pennsylvania Academy, he observed that "there must have been something of the spirit of Walt Whitman in the air."[24] Whitman, who had been friends with Eakins, was a beacon of fearless originality in the American arts of the late nineteenth century, a visionary romantic with an eagle eye for the rhythms of the modern world, a rhapsodist and a dreamer who could describe with perfect accuracy both the hurly-burly of Manhattan streets and the lilacs growing in front of an old farmhouse. Eakins painted the great poet's portrait and was a pallbearer at his funeral. Later in his life, Stirling made a clay study of a lithe, youthful Whitman, his arms raised as if stretching to embrace the world, an animal at his feet. Stirling included Whitman in a list of men he particularly admired, linking him with such turn-of-the-century freethinkers as Bertrand Russell, George Bernard Shaw, and Havelock Ellis.[25] There was nothing of the academician's conservative taste about this short list of literary and intellectual heroes.

III

Stirling shared many of his experiences as a young artist, both in Philadelphia and in Paris, with Charles Grafly, who was eight years older but also at the beginning of his career. Before entering the academy in 1884, Grafly had worked for a time at the stoneyard run by William Struthers, the Scot who'd supplied the raw materials for Milne's work at City Hall. Grafly may well have known Stirling's father before he met the son, and indeed Stirling may have known Grafly or known of him before they were at the academy. Grafly had studied with Eakins for several years. He was among the students

who for a time left to join a school Ea-
kins founded, but soon he was back at
the academy.

For Stirling Calder and Charles
Grafly, whose studies in Paris fol-
lowed what was a fairly conventional
academic path, there was neverthe-
less somewhere in their conscious-
ness the towering figure of Auguste
Rodin, who had produced a body of
work that no academy could easily
accommodate. Like Whitman, Rodin,
who turned fifty in 1890, was a cre-
ative spirit whose considerable fame
couldn't entirely be separated from a
bohemian disdain for the road most
traveled. For young sculptors of Stir-
ling and Grafly's generation, Rodin
showed the way beyond the old world
of classical and neoclassical carving in
wood and stone to the more Impres-
sionistic possibilities to be discovered
when building forms with clay.

In a photograph of Stirling's stu-
dio, taken in Philadelphia after 1900, a

*Stirling Calder in his studio,
c. 1903. A photograph
of Rodin's* The Age of
Bronze *hangs on the left,
next to the mantel.*

reproduction of Rodin's *The Age of Bronze* is pinned to the wall. *The Age of
Bronze*, the masterstroke with which Rodin first established himself at the
Salon in 1877, represents a powerfully built young man, his torso solid yet
mobile, his arms and head raised in a gesture of striving, of yearning. In a
memoir, Grafly's daughter recalled her father talking about the controversy
that surrounded *The Age of Bronze* when it was first exhibited; it had struck
many critics as overly literal, probably produced by means of a life cast
rather than the operations of the sculptor's own hands. "How ignorant were
those," she recalled her father saying, "who claimed that vivid impressions
of life could ever come from the process of life casting. The breath of life
was something that lay only within oneself, something that must grow with
the clay from the first foundation to the finished execution."[26] What Stirling
and Grafly may have seen in Rodin's work was what the poet Rainer Maria
Rilke described in the monograph about Rodin he published in 1903: the
animation of the surface that announced an epochal turn toward sculptural

Auguste Rodin. The Age of Bronze, *1875–76.*

fluidity, "this differently great surface, variedly accentuated, accurately measured, out of which everything must rise."[27]

Many years later, Stirling was shocked to hear a young English sculptor tell him that she was "all off Rodin."[28] In Rodin, Stirling glimpsed sculpture's hedonistic possibilities, what an American writer described in 1889 as Rodin's ability "to enjoy the pleasure of the soul as its emotion is passing out of the ends of his fingers into a piece of clay."[29] Sculpture must be sensuous, immediate—have a soulful physicality. In the 1940s and 1950s, Calder was himself caught up, at least tangentially, in a revival of interest in Rodin fueled by Curt Valentin, his dealer at the time. In 1950, Valentin mounted "The Heritage of Auguste Rodin," an exhibition that included work by a wide range of modern and contemporary sculptors, among them Stirling's son. Six years earlier, Calder had made a cycle of more than two dozen works in plaster that were cast in bronze; they are among the small group of works he did in this medium that so engaged his father. Although most of the bronze works Calder did in 1944 were abstract, a few were representational. These included *Acrobat*, *Dancer*, and some others with bodies composed of separate bronze elements that were articulated to create what amounted to bronze mobiles.

With their roiled surfaces, unexpectedly angled arms and legs, and powerful erotic presence, Calder's bronzes provoke comparison with some of Rodin's studies of dancing figures. I wonder if Calder knew a study of an acrobat by his father that brings to mind the series of studies of dance movements that Rodin produced toward the end of his life; a photograph of Stirling's *Acrobat* was owned by Jane de Tomasi, who had been a student of Stirling's and was friends with Sandy. It's true that in his *Autobiography* Calder made some dismissive comments about Rodin's marbles, saying they looked like "shaving cream."[30] But many people have regarded Rodin's bronzes as the greatest of his works. And Calder certainly knew and respected artists who admired Rodin. The painter André Masson, a close friend of Calder's in the 1940s, a little later wrote of Rodin's drawings, "These lines are truly 'lines of life'; his areas of color, movement itself."[31] There is reason to believe that the revolutionary fluidity of Rodin's sculpture, so admired by Calder's father, has a place in the prehistory of Calder's own triumphantly changeable art.

Charles Grafly was sixty-six when he died in 1929, struck by a hit-and-run driver as he crossed the street.[32] Although he and Stirling hadn't lived

Henri de Toulouse-Lautrec.
Reine de Joie, *1892.*

in the same city for nearly a quarter century, Stirling later wrote that they remained close until Grafly's death; they couldn't forget how their lives had been intertwined when they'd been starting out in Paris. Late in life, when Stirling wrote of being young and feeling "the pleasure of being an air-breathing animal—and a tobacco-smoking one at that!"—he invoked his European adventures. "I think of many fine such mornings years ago: swinging along the Strand in the adventurous air of London, and in Paris my long morning walk through the entire length of Rue Bonaparte"—to the École des Beaux-Arts, where he studied for a time.[33] Once, when Peggy was posing for Stirling while reading Radclyffe Hall's novel about a lesbian relationship, *The Well of Loneliness,* Stirling told her that his own live-and-let-live attitude had not blunted his instinctive outrage when he had been "accosted by a man on the Boulevard St.-Germain while on my way to meet your mother."[34] That little anecdote leaves us with a fleeting vision of the handsome young American aesthete turning heads as he strode along the Paris streets. As for Nanette, when her son was staying in a Parisian hotel in the early 1950s, she found herself remembering, "The first night I spent in Paris 1891 was in the rue de l'Université—but near Pont de l'Alma—I think your hotel further near Bon Marché."[35]

In the living room of the Calder house in Roxbury there have hung, for as long as anybody can remember, two of Henri de Toulouse-Lautrec's most important posters, *Reine de Joie* (1892) and *May Belfort* (1895). It's perfectly possible that they were purchased by Stirling and Nanette in Paris in the 1890s, enduring souvenirs passed from one generation of Francophiles to the next. Nanette, to the end of her life, would regard Bastille Day as a holiday not to be missed and sprinkle her letters with French phrases. "My food is good and the spirit of kindness is around—*c'est tout,*" she wrote in a letter from Oakland in the late 1950s.[36]

IV

For Stirling, the artistic education he received in Philadelphia and Paris in the 1880s and early 1890s was the preparation for a quarter century of growing renown. But for Nanette, whom Stirling, thinking of her when he first met her at the academy, always spoke of as "a brilliant student of painting," the question of vocation wasn't so easily settled.[37] Even the women in her circle who were most dedicated to their art found it difficult to know what to do with their desire for marriage and a family, as such commitments almost inevitably posed serious challenges to a continuing career in the arts. Charlotte Harding, the gifted illustrator who had been with Nanette in Paris, had studied with Howard Pyle and found work with major publications, including *The Saturday Evening Post* and *Woman's Home Companion*. But by 1913, only a few years after marrying a metallurgical engineer and having a daughter, she had given up her career. Nanette was confronting that predicament in the late 1890s, for however Stirling may have encouraged his wife's artistic ambitions, she was left, with little or no household help, to shoulder the responsibility for two small children and a home while her husband hustled to establish himself as a sculptor.

When Peggy published *Three Alexander Calders: A Family Memoir* in 1977, she wrote as if her mother, who had died in 1960, had never entirely resolved her dilemma. She spoke of Nanette as "subordinating her own talent and longings" and suggested that among the reasons for the despair that from time to time overwhelmed Nanette was her unsatisfied desire to have more fully or at least more consistently pursued her own painting.[38] Some may wonder, considering that the women's movement was in full swing by the time Peggy published her book, if Nanette's daughter made too much of her mother's conflicts about family and career. But such conflicts were definitely a subject of discussion among artists and bohemians in the later nineteenth century. They were among the themes of William Dean Howells's *The Coast of Bohemia*, published in 1893. That novel about a love affair between two painters concluded with their marriage and the reflections of Ludlow, the husband, on his wife's future. "He was strenuous that she should not, in the slightest degree, lapse from her ideal and purpose, or should cease to be an artist in becoming a wife." There was, Ludlow reflected, "no real need of that, and though it had happened in most of the many cases where artists had married artists, he held that it had happened through the man's selfishness and thoughtlessness." These would have been very much Stirling's thoughts at the time of his marriage to Nanette. And he might have resolved, as Howells's Ludlow had, that his wife "should not lose faith in herself from want of his appreciation."[39]

The Plastic Club
Exhibition ❧ ❧

From January Sixteenth to
January Twenty-ninth, INCLUSIVE,
at 10 South Eighteenth Street,
PHILADELPHIA, MDCCCXCIX.

Bertha Carson Day. Cover of the catalog of an exhibition at the Plastic Club in Philadelphia, 1899.

Nanette was clear-eyed about the situation. In 1929, she wrote a fascinating letter to her then-married daughter, who was still trying to pursue something of a career as an artist, or at least explore the possibility. Sandy's career was taking off, and Nanette couldn't help but lay out in the clearest possible terms the difference between the prospects for the men and the women in the family. "Peg," she wrote, "you will do just as I do—let the thing I want to do slide until it gets away from you unless you grow to be like your dad + Sandy—The work they want to do—<u>first</u>. We mothers + cooks + dishwashers! It does not make me any happier when Bill Drew"—this was a college friend of Sandy's—"tells me I am doing one job well and that's enough for anyone."[40] Nanette might have bowed to what seemed her fate, but she wasn't necessarily at peace with the situation. A decade earlier, a writer for a Los Angeles paper had reported about Nanette and her work—she was having a small exhibition—that at one point she had "almost decided to put aside brushes for clay entirely, when her husband declared she would better stick to paint, as they needed a painter in the family."[41]

Far from overestimating her mother's frustration when she wrote about Nanette in *Three Alexander Calders*, Peggy might not even have guessed the extent to which her mother had been caught up in the hopes for women's equality that stirred in the United States in the 1890s. In 1897, the year before Sandy was born, Nanette, along with Charlotte Harding, was involved in the founding in Philadelphia of the Plastic Club, which was to be dedicated to the needs of women artists. The name was based on the idea that while a work of art was in progress it was plastic— i.e., fluid—which, in turn, suggested that the role of women in American art might grow and change. The club was meant to offer women their own version of Philadelphia's Charcoal Club, where the men in Stirling's circle gathered. Nanette was on the admission committee of the Plastic Club for a number of years. From the early records of the club, it seems that only a small fraction of the members, something like a sixth, were married women.

Nanette's involvement certainly underscored her determination to pursue the life of art while grappling with all the responsibilities that came with a husband and two young children.[42]

In May 1898, when she was pregnant with Sandy, Nanette exhibited a couple of works at the Plastic Club, including *Mother and Child* and *Sketch for a Holy Family*. Whenever the pressures of family life allowed—and then well into her sixties and even beyond—Nanette pressed forward with her own life in art. Visiting London in 1924, she wrote to her daughter of her enthusiasm for J. M. W. Turner's watercolors and the work of Degas, Honoré Daumier, and William Blake—all artists who can be bold, unconventional, idiosyncratic. She also admired the work of the Pre-Raphaelites Dante Gabriel Rossetti and Edward Burne-Jones, perhaps attracted by their unabashed emotionalism, which by the 1920s seemed to some merely sentimental.[43] While Nanette Calder did paint landscapes and still lifes, what engaged her more than anything else was portrait painting. In addition to recording the changing physiognomies of her children and her friends, she accepted whatever commissions came her way. Her portraits have an easygoing power, an informality and vigor; they bear comparison with the finest early work of Sloan and Henri. Her brushwork is casual yet exact, just right to suggest the avidity with which her frequently youthful subjects were approaching life.

Stirling was far from the only person in their circle who admired her work and her judgment. When the Calders were living in New York in 1910, John Sloan recorded in his diary a visit Nanette paid to his studio; he didn't regard her reactions as insignificant. "I showed her some of my pictures," he wrote. "She seemed to be pleased with the work, the first she has seen of my studio for nearly six years."[44] Soon after that, Sloan spoke to the owner of the Macbeth Gallery, where he and many of his fellow Ashcan school artists exhibited. It seems that the gallery was planning to include some of Nanette's watercolors in an upcoming show.[45] In 1907, she had three works in the annual exhibition at New York's National Academy of Design; she sold a landscape, *In Southern California*, which was included in the academy's 1908 exhibition.

V

The earliest photographs of Sandy Calder were taken by one of the members of the Plastic Club, a photographer by the name of Eva Watson; she was later known as Eva Watson-Schütze, after her marriage to Martin

Calder and Peggy, c. 1900.
Photograph by Eva
Watson-Schütze.

Schütze, a professor at the University of Chicago. Her work caught the eye of Alfred Stieglitz just after 1900, and he included her photographs in his magazine *Camera Work* and in the important Photo-Secession exhibition at the National Arts Club in New York in 1902. Although Watson-Schütze was a professional portrait photographer, the playful intimacy of the photographs she took of Nanette and her two children suggests that this was a labor of love, or at least a commission that grew out of a friendship.

The setting for these photographs was probably the stone house in Lawnton, Pennsylvania, where Sandy was born. He is a year or two old, a sturdy boy with a great big round moon of a face. Nanette is dressed in a flowing robe, her dark hair piled casually on her head. The mellow soft focus and the warm tones of the prints give the photographs an inward-turning mood and suggest a rhapsodic, bohemian ambience. Watson-Schütze is attentive to the contemplative connection between the mother and the child as well as the gentle camaraderie of the little boy and little girl playing with their first toys. In one series of photographs, Nanette is seated in a chair, playing

with her young son, lifting Sandy up high, holding him close, amusing him by turning him upside down. Mothers, fathers, and children were among Watson-Schütze's favorite subjects, treated not sentimentally but for their true sentiment, something quietly passionate. This was a woman who had come of age in the Philadelphia shaped by Eakins, with his desire for radical honesty. Indeed, Watson-Schütze photographed her good-looking husband in the nude in the woods in Woodstock, New York, where they were involved with the Byrdcliffe Colony, an experiment in the Arts and Crafts movement inspired by William Morris's work in England.

Later, at the University of Chicago, Eva Watson-Schütze became the director of the Renaissance Society, which in the 1930s presented exhibitions of avant-garde art. She worked on many of those projects with Calder's friend James Johnson Sweeney, who at the time was at the very beginning of his career as a critic and curator. Calder would come to regard Sweeney, about whom we will hear a good deal later in our story, as among the most astute commentators on his work; as we have already seen, Sweeney organized

Nanette and Calder, c. 1900. Photograph by Eva Watson-Schütze.

JAMES JOHNSON SWEENEY

PLASTIC
REDIRECTIONS
IN 20TH CENTURY
PAINTING

THE RENAISSANCE SOCIETY OF THE UNIVERSITY OF CHICAGO

Cover of James Johnson Sweeney's first book, Plastic Redirections in 20th Century Painting, *published by the Renaissance Society in Chicago in 1934.*

Calder's enormously important retrospective at the Museum of Modern Art in 1943 and wrote the accompanying catalog. Sweeney's first book, a ground-breaking study of the beginnings of abstract art entitled *Plastic Redirections in 20th Century Painting*, was published by the Renaissance Society in 1934. In 1935, Sweeney organized an exhibition of Calder's mobiles at the Renaissance Society, one of the last shows, if not the very last, with which Watson-Schütze was involved before her death. In an unpublished autobiographical note, Calder recalled that Watson-Schütze "was partially invalid, but anxious to keep her finger in the pie."[46] Surely Watson-Schütze and Calder and his parents were aware of the astonishing fact that one of his first major exhibitions in the United States was mounted under the auspices of a woman who had photographed him when he was a babe in arms.

FATHER AND SON

I

By the time Stirling Calder turned thirty, in 1900, he had two young children and a wife to support, and what commissions were coming his way weren't enough to put food on the table and a roof over the family's head. Everybody agreed that he had a promising future, but that didn't pay the rent. Stirling's friend Charles Grafly had already begun to build a reputation as a teacher at the Pennsylvania Academy and beyond, assuring him of some sort of income even when commissions weren't forthcoming. Stirling, although he would find himself in academic settings over the years, never really established a reputation as a teacher. The longest stretch of steady teaching he did was from 1900 to 1905, at the Pennsylvania Museum and School of Industrial Art, in Philadelphia. But a job at what amounted to a technical college—where most students were hoping for careers designing textiles, ceramics, furnishings, architectural ornaments, or the like—doesn't seem to have been satisfying. Stirling left that position in 1905, after receiving a silver medal for his decorative statues at the Louisiana Purchase Exposition in St. Louis and a commission for a stone cross for the grave of William Joyce Sewell, a Civil War hero, in Camden, New Jersey. The Sewell cross is a work of considerable vigor and charm, its surfaces loaded with rigorously stylized

A. Stirling Calder standing beside his monument for the grave of William Joyce Sewell in the cemetery in Camden, New Jersey, c. 1905.

A. Stirling Calder.
Drinking cup for a fountain
for the University of
Pennsylvania, c. 1903.

figures, animals, and flowers that suggest Stirling's enthusiastic embrace of the phantasmagorical power of early medieval art. In Europe that same enthusiasm would soon enough have radical implications, pushing a new generation to entertain the possibility of a non-naturalistic art—even an abstract art.

Sandy was not quite five years old when the first major article about his father appeared in *House and Garden,* a magazine that covered developments in art, architecture, and design in Great Britain and the United States. L. R. E. Paulin, the author of the article, was clearly engaged, amused, even entranced by the work in Stirling Calder's studio. While there were some extraordinarily ambitious sculptures on display, what mostly seemed to hold the visitor's attention were impressive works in what was described as a "minor vein." These included urns, vases, a church lectern, and various decorative objects, all of which Paulin referred to as "pastime for Mr. Calder's fancy and fingers." The Stirling Calder who emerged in the pages of *House and Garden* had a taste for light, capricious effects. Two whimsical drinking cups, for a fountain for the University of Pennsylvania, had handles in the form of male acrobats; each figure was bent back double, so that his hands and his tippy toes, so close as to almost be touching, were together supporting the weight of his body. Stirling, his visitor reported, "is constantly jotting down notes of ideas that pass through his head."[1]

Stirling explained to the writer from *House and Garden* that there was more fun "in doing things that are matters of fancy than in anything else." He was dreaming up a design for a fountain with a tiny faun seated astride a large globe while wrestling with a pair of water snakes. Readers of *House and Garden* were told that "it is an article of Mr. Calder's faith that in this sort of thing the sentiment must be primarily playful, lively, fantastic."[2] This wasn't, of course, all that Stirling wanted to do. But there is a particular fascination about this salute to sentiments "playful, lively, fantastic," considering that it was said about the father of Alexander Calder, whose work can certainly be (among many other things) playful, lively, and fantastic. All this talk of "Mr. Calder's fancy and fingers" brings to mind his son's own remark, half a century later, that he always depended on "the twitching of my fingers—even naked (without pliers)."[3]

II

Although money was sometimes in short supply in the years when Sandy and Peggy were growing up, the life of the mind and the imagination was there to sustain them. Peggy recalled that their parents had "endless discussions about art and the relative importance of color and form which Sandy and I found deadly dull."[4] If the children thought their parents' conversations in part maddening and ridiculous, they were also bewitched, drawn into art's magic circle, from which neither of them ever strayed, at least not for long. Peggy, although she didn't have a full-fledged career

Calder, c. 1900. Photograph by Eva Watson-Schütze.

as an artist, taught children's art classes for many years and designed holiday cards and bookplates for friends and acquaintances. After Sandy's death, Peggy remarked that he had never lost "what Freud and Erikson call 'the radiant intelligence of the child.'" She believed that this core of "radiant intelligence" had a good deal to do with "our parents' encouragement and approval of his earliest efforts to make things, as well as their own absorption in art."[5]

The siblings had a very close bond; the separation of two and a half years thrust Peggy into the role of the protective big sister, which she eagerly embraced. For Peggy, Sandy would forever be the boy she had once upon a time held in a warm towel while Nanette got ready to nurse him. A little later, they bathed together in a tin tub. Peggy remembered watching Sandy, as "a sturdy boy of three, delight shining from his large gray eyes, turn a little horse-drawn cart over and over in his chubby hands. 'You always bring me something instringing,' he says to Mother and Father."[6] A day later, Nanette was dismayed to discover that he had detached the horse from the cart. But when Peggy pointed out that the horse could now carry a rider as well as pull the cart, Nanette fell in with the experiment, making a saddle for the horse out of some leather from an old shoe. Sandy, with a precocity that leaves one wondering if he actually was three at the time, contrived a harness out of string, with thin leather straps for the reins. At six or seven, Peggy recalled, Sandy was already "quite content to go off by himself for hours and

Nanette reading to her children, probably photographed by Charlotte Harding around 1905, when Harding was preparing the illustrations for Verses for Jock and Joan.

'make things.' His pockets were always filled with odds and ends: bits of string, unusual and interesting pieces of wood, glass, or stones. He would display his treasures at mealtime: 'Look what I found.' Mother would often make a face, recalling the conglomeration already stored among his belongings, while Father laughed, 'Scavenger!' "[7]

Sandy didn't speak as distinctly as his parents felt he should. He swallowed his words. Nanette kept insisting that he try harder to enunciate. But he never really did. This was the beginning of a conversational pattern that lasted a lifetime. Decades later, when Calder lived much of the time in France, French speakers sometimes blamed themselves for the trouble they were having with his English. But even native English speakers could be flummoxed by Calder's speech. People who knew him well suspected that there was a method to his mumbled, muddled repartee. One old friend remembers him making some incomprehensible response to a question he obviously didn't want to address. And then, moments later, when the subject turned to the billiards game he was playing, speaking with perfect clarity. All of which leads one to suspect that this minor speech impediment, whatever its origins, was at least as much psychological as it was physiological—a defensive maneuver of some sort. Calder's conversational tricks as a grown man were rooted in the verbal evasions that had irked his parents in his childhood. He turned whatever trouble he was having with his speech to his advantage. He became famous for keeping his own counsel.

III

In 1905, Charlotte Harding, Nanette's friend from their Parisian times, illustrated a book of poems by Helen Hay, the daughter of the secretary of state. Named for Hay's two children, *Verses for Jock and Joan* was about all the adventures they would have when they were a little older. The young models Harding chose to play Jock and Joan were none other than Nanette's children, Peggy and Sandy. Harding worked from photographs of the

Calder siblings that she most likely took herself; some of them still exist. In Harding's illustrations we see Peggy and Sandy playing and dreaming. In the illustration for Hay's poem "Speculation," one senses the deep bond between the two children, with Peggy and Sandy out-of-doors, among the spring blossoms. In another illustration, Sandy is in his playroom, where two boys are kneeling on the floor and playing with an elaborate model train and a host of other toys. Sandy stands at the back, self-contained, a little isolated, staring straight out at the viewer.

Nothing in *Verses for Jock and Joan* is quite so startling as the two-page spread dedicated to the circus. Here we find the little boy— I presume it is Sandy—in a billowing white clown costume with an elaborate red ruff; he has a goofy grin on his face, a cap made of newspaper on his head, and a hoop in his right hand. The boy is a hoot, with his gigantic head and saucer eyes. Here is a premonition of the grown-up, happy-go-lucky Sandy Calder of myth, urging the whole world to come out and play. Hay's poem could be an early announcement of the *Cirque Calder,* which would, a quarter century later, establish Calder in Paris.

Charlotte Harding's illustration for "The Circus" in Helen Hay's Verses for Jock and Joan, *published in 1905. Calder was probably the model for the clown.*

We're going to have a circus
At our stable pretty soon,
For Tommy Brown can kick as high,
Almost, as the moon.

The coachman's boy can jump and ride,
Paul can do a split;
And lots of us can "low trapeze"—
At least, a little bit.

Phil will take the tickets in
And give us all the money;
And I am going to be the clown—
He has to be so funny.[8]

Charlotte Harding followed the poem closely in her illustration; she set the ebullient boy clown in a stable, with children sitting on piles of straw and a curtain improvised from what looks like a tablecloth. She was interested in the many ways in which the circus, a world of make-believe, doubled as an alternate reality. Such concerns and ideas had already fueled the work of several generations of French creative spirits, including Daumier, Toulouse-Lautrec, Georges Seurat, and the poster artist Jules Chéret. Harding embraced this great tradition through the subtlety of her illustration, with its asymmetrical composition, surprising cropping of the spectators' bodies, and close attention to details of costume and setting. (One thinks again of the Toulouse-Lautrec posters in Calder's Roxbury living room, which almost certainly originally belonged to Stirling and Nanette.) Picasso's greatest treatment of the world of the circus, *Family of Saltimbanques*, was completed the year *Verses for Jock and Joan* appeared and would precipitate, seventeen years later, the opening of the fifth of Rilke's *Duino Elegies*, with its famous question: "But who are they, tell me, these Travellers even more transient than we are ourselves?" Four years after Rilke asked that question, Calder, then living in Paris, embarked on the *Cirque Calder*, his own response to the circus, that enchanted realm of clowns, jugglers, and acrobats.

IV

By the time *Verses for Jock and Joan*, with its idyllic portrait of the Calder children, was published in 1905, Stirling Calder was in his mid-thirties and well on his way to establishing himself as a sculptor of considerable distinction. Stirling's mother died that same year, without ever receiving medical attention. She had, her granddaughter recalled, "a superstitious dread of doctors." Peggy remembered her grandmother as an unsympathetic figure to the end, "laid out in an open coffin all done up in the best 'American Way of Death' style." Her children and even maybe her grandchildren were left with the sense of a woman who was ferocious even in death.[9]

For much of the previous year, Stirling himself hadn't been feeling well; he had a bad, persistent cough. In the spring of 1905, when the family was staying in the idyllic cottage that Nanette's friend Theodora Burt had lent them outside Philadelphia, the doctors arrived at a dreadful diagnosis: Stirling had tuberculosis. Stirling and Nanette were facing the abyss. For Nanette, the possibility of losing her husband has to have been terrifying, the financial perils compounded by less tangible but altogether deeper anxieties. She had already poured many of her own artistic hopes into his art

and his advancing career, and their marriage was the closest she would ever come to knowing a soul mate, both in art and in life. Traumatic loss was by no means unfamiliar to Nanette, who had seen her mother die when she was still a girl and had spent several unhappy years as an orphan of sorts, housed with relatives in Philadelphia. As for Peggy and Sandy, it's not clear what they knew or understood about their father's situation, at least initially. In their recollections, neither of them said anything about their feelings at the time—or even speculated as to their feelings. They proceeded directly to descriptions of the practicalities of the situation.

In Calder's *Autobiography*, his father's illness was described as "heart disease," not tuberculosis.[10] That may have been an error on the part of Calder's son-in-law Jean Davidson, who wrote down the stories that Calder related in a series of regular afternoon sessions; Davidson then edited them for the *Autobiography*. Davidson was an experienced journalist, so one imagines that if Calder had mentioned his father's tuberculosis in anything but the most cursory manner, he would have gotten it right. (He got most things right.) If there is some indication in the *Autobiography* of how traumatic Stirling's illness was for his son, it's oblique. Only a few paragraphs before discussing his father's illness, Calder described a traumatic incident when he thought he might lose his mother. One evening, when Peggy and Sandy were bickering, vying for their mother's attention, Nanette, Sandy recalled, "put on her cape and said she was leaving." Apparently she exited the house and proceeded down the street, with the children racing after her. "This put the fear of God into us, or of some other beastie," Calder observed. "There are few things in your life with another person that do something deep to you, and this was one. It could have shaken my love for her."[11] Perhaps it was really his connection with his father that Calder was thinking about when he remembered this decades later. It's interesting that Calder, confronted with his mother's withholding her love, turned the tables and argued that it was his love for his mother that was in the balance—a gift he could revoke. Could he have been wondering about his father's disappearing and considered revoking his love for *him*?

Tuberculosis was still very much a killer in the years when Stirling was diagnosed, though the prognosis could be very good if the disease was caught early, as appears to have been the case with Stirling. Edward Otis, in his 1909 book, *The Great White Plague: Tuberculosis*, observed that in the United States there were something like 150,000 deaths a year, "or one death about every three minutes."[12] The situation Stirling found himself in— gripped by the disease when he was in his mid-thirties, his career just taking off—wasn't unusual. Tuberculosis often attacked men "in the best years of

their life," as Otis put it.[13] The disease clutched "in its relentless grasp the young man just established in his profession."[14] Only in the 1880s had the infectious nature of tuberculosis first been understood, and the anxiety for the family must have been great, as tuberculosis was known to spread in families—not only directly, as one might imagine, through moist saliva, but in the dust or dirt that carried the dry bacilli. Sculpture, a profession that involved working amid a good deal of dust, certainly lent itself to the spread of the disease. Otis observed that there were particular dangers for "those employed where there is much dust, such as stone-cutters, knife-grinders, potters, dyers, wool-carders, cigarmakers, polishers, and the like."[15]

Spotless cleanliness obviously helped prevent the spread of the disease. In his *Autobiography*, Calder recalled how when he was beginning college, a decade later, his mother "inspected closely the dormitory where I was to live." He turned this into a bit of a joke on his mother, describing how one of the boys discovered Nanette poking around in the bathroom, where she "was satisfied that the toilet was clean enough for me."[16] Nanette was probably not as much of a nervous Nellie as her son made her out to be. She had seen her husband in the grip of the great white plague and meant to do whatever was in her power to protect her son.

V

The surest route to recovery from tuberculosis was an extended stay in a dry mountain climate. The Calders settled on the town of Oracle, Arizona, thirty-five miles from Tucson, a destination for tubercular patients since the late nineteenth century. Although their accommodations in Oracle were going to be far from luxurious, a long-term stay remained beyond the reach of most who came down with the disease. So how were the Calders going to pay for it? Because they were still pretty much living from hand to mouth, they had no alternative but to turn to friends. The painter John Lambert, who had been with Stirling at the Pennsylvania Academy and the Académie Julian, gave them $10,000.[17] The close-knit community that had grown up around the academy was sustaining the Calders. In February 1906, John Sloan, living in New York at the time, recorded in his diary that Robert Henri had sold a work by Calder to raise funds for the cure. Sloan commented that Calder was "in Arizona fighting tuberculosis—the money will help."[18]

Stirling was not going to be able to care for himself in Oracle, so Nanette planned to set out for Arizona with him. The children would have to remain in Philadelphia, at least for a while. Nanette, who had been motherless at

age eight, couldn't have been happy with the thought of leaving behind her children, then nine and seven, but she had no choice. They stayed with good friends of the family's: Charles Shoemaker, a dentist, and his wife, whom they called "Aunt Nan," a prosperous couple with a daughter who was younger than Peggy and Sandy and was also named Margaret but was known as Maggie. The house was luxurious, with a huge playroom where the Calders' toys were joined with Maggie's, so they had several Noah's arks and Sandy could at last leave his trains out all the time. The Shoemakers were artistic. Mrs. Shoemaker had a brother who was a sculptor. Charles Shoemaker, Calder recalled, "must have had some sense of humor: he enjoyed drawing and gluing elaborate valentines around the photos of friends and family members."[19] Of course, Peggy and Sandy's bighearted grandfather Milne was also in Philadelphia. A couple of Stirling's brothers were probably still in town, including the youngest, Ralph, who had encouraged his niece and nephew to slide down the banister in their grandparents' home.

Maggie had an enormous dollhouse, which her father had built for her. He also made furniture for the dollhouse out of fragrant cedar from cigar boxes, using what Peggy recalled as "a little jig saw with an eggbeater-like handle, which Sandy would turn while Dr. Shoemaker guided the wood." Maggie Shoemaker also had an elaborate toy circus. Peggy described this as consisting of "jointed wooden animals and clowns with slots in the hands or hooves, which could be made to bend and stand and to balance in various postures, even on their heads or hanging from a ladder." Together the children constructed zoos, farms, and forests for the animals, and took the animals for rides on Sandy's toy train.[20] The clowns and animals Peggy referred to were almost certainly parts of Schoenhut's Humpty Dumpty Circus, a toy that had been produced in Philadelphia beginning in 1903. Calder later cited the Schoenhut circus as one of the inspirations for his *Cirque Calder*. When he was starting out as an artist in New York in the mid-1920s and living for a time with his friends Alexander Brook and Peggy Bacon, he discovered that their children had a later version of the same Schoenhut's Humpty Dumpty Circus, and he customized some of the pieces for them. In his *Autobiography*, Calder recalled how he had "once articulated these things with strings, so the clown would end up on the back of the elephant." This was most likely in New York when he was twenty-seven or so, but he surely remembered the Schoenhut circus from Philadelphia when he was seven or eight.[21]

Calder's first preserved writings date from this challenging time, a couple of letters sent by the boy to his mother in Oracle, Arizona. In November 1905, he told her that he had gone to a fair and come home with a paint box and a little sewing basket and some other things. Some of what he wrote

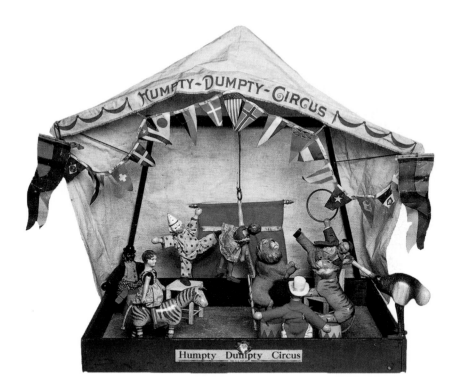

Schoenhut's Humpty Dumpty Circus, 1923.

OPPOSITE, TOP *Photographic postcard of Calder, sent to his parents in Oracle, Arizona, for Christmas 1905.*

OPPOSITE, BOTTOM *Calder. Bird Cigarette Holder, 1928. Wire, 6⅜ x 2 in.*

isn't easy to decipher, but the seven-year-old did declare, "I am a good boy. . . . I like my school and feel happy." He sent "Love and kisses for you and father."[22] What that school might have been, we don't know; neither Sandy nor Peggy mentioned it, and in her memoir Peggy recalled their "first regularly sustained schooling" as being a year or two later.[23] For Christmas, a photographic portrait postcard was sent west, with Calder looking straight out of the oval image. There's an open, unabashed, serene, fearless look about this boy with his big shiny eyes. His mouth—closed, set—has a certainty about it. Come February, he wrote to his mother that he was glad their father was better. "I am busy making valentines," he explained. "I hope you got the valentines, with love and hugs from all."[24]

Peggy remembered that they sent a good many drawings to their parents. "On dark, wintry afternoons, Sandy and I worked out a formula for drawing birds: one uninterrupted line flowed around the entire body, including in its journey the tail (a series of loops) and the wings (another series of loops)." When some of these creations were included in Peggy's weekly letter to Oracle, the children received considerable praise from their parents. After that, Peggy continued, "we experimented endlessly with the formula. Beginning with ducks, we soon found that, with simple adjustments, tur-

keys, geese, chickens, and other birds could all be drawn the same way."[25] These birds may foreshadow the bird forms Calder contrived from a single length of wire in the late 1920s and the birds in his drawings for an edition of *Fables of Aesop*, published in 1931. The hours in Maggie's magnificent playroom, Peggy believed, were later echoed in "the amplitude, the boundless universe of [Calder's] playful creativity."[26]

VI

For Peggy and Sandy, their parents' departure for Arizona and their months in the Shoemakers' home generated a certain excitement. Whatever fears they were grappling with passed relatively quickly, for by the early months of 1906 it was clear that the worst danger had passed, Stirling was on the mend, and the family was going to be reunited. The threat had been neutralized. If the experience had

any long-lasting impact on the incorrigibly optimistic Sandy, what he may have absorbed wasn't the trauma so much as the overcoming of the trauma. When the doctors decided that Stirling was no longer contagious and the children could join their parents, Nanette returned to Philadelphia to collect Peggy and Sandy and take them to Arizona. They were planning to live there together until the doctors agreed that Stirling, who had already gained thirty-five pounds, could safely leave Oracle. For the children—who, even if they had been missing their parents, had been enjoying themselves—the reappearance of their mother was a pleasant shock, the old maternal warmth again close enough to be felt. Their mother was utterly familiar but also somehow changed, having gained a good deal of weight from the Oracle diet, which was designed to bulk up the thin tubercular patients. Sandy had a bronchial cough, which, quite understandably, worried Nanette. He had been sleeping on the Shoemakers' unheated third floor. Peggy remembered her mother accusingly saying to her, "Peggy Calder! . . . I expected you to take care of your little brother!"[27]

We don't know whether Stirling and Nanette understood in the early months of 1906 that they wouldn't return to Philadelphia, except for brief periods of time. Many of their friends from the Pennsylvania Academy had already moved to New York. Perhaps that was already where they were headed—as soon as Stirling was well enough. As for Peggy and Sandy, probably all they knew was that they were setting off on an adventure. It began even before they arrived in Arizona, with the trip west. They had been prepared for the excitement of transcontinental train travel by the stories their mother had told them about her trip out with Stirling the previous spring. Sandy remembered years later that "Mother wrote to us about being able to see the locomotive when the train ran around a curve. There was a mechanical element in this picture which interested me, I suppose."[28] The train ride took five days. In Chicago, where there was a long stopover, Nanette took the children to the Art Institute of Chicago as well as the Field Museum of Natural History, which they liked more. Peggy and Sandy had already read the nature books of Ernest Thompson Seton, with their tales of hunters, adventurers, and animals out west; decades later, their battered copy of Seton's *Lives of the Hunted* was still sitting on a shelf in the home of one of Peggy's sons in the Berkeley Hills. On the train, they spent hours in the observation car watching antelope and the occasional fox or coyote—and found themselves covered with soot.

Peggy and Sandy were enchanted by the ingenuity of the train. For a child, the snug living arrangements were like a playhouse—an oversized toy, designed for adults. There were special string hammocks to hold your

coats, and the sleeping berths had curtains that could be buttoned shut. The catering system—about which Nanette had written them—was operated by the Harvey Company. In place of a dining car, the food was delivered to the train on trays at one station, with the empty trays removed at the next station. "We seemed to be living on trays in those days," Calder recalled in his *Autobiography.* He added, with his fondness for bilingual puns that lasted a lifetime, "tray *bien!*"[29] The two young children were embarrassed by a gentleman who made out with a blond woman on the observation platform. Half a century later, Peggy remembered how that dynamic duo became the scandal of the train. The lovers had been together when the cars bound for Kansas City separated from the main train to Los Angeles in the middle of the night, and the gentleman, in bed with his lady friend, found himself in Kansas City with nothing but his pajamas. Peggy and Sandy enjoyed this discombobulated world. It wasn't anything like life back in prim and proper Philadelphia.

Although Sandy recalled that their father met the train in Tucson, Peggy was probably right when she later wrote that they didn't see him until the next day, after the rugged, thirty-five-mile trip to Oracle in a horse-drawn coach. The awkwardness of the reunion was underscored by the beard their father had grown: he was scarcely recognizable. Even more disturbing was the ban the doctors had imposed on intimate contact between Stirling and his children. "We had to restrain our natural demonstrativeness," Peggy recalled, "for fear of contagion; kissing Father was strictly forbidden, and though he did his best with pats and tweaks to express his happiness at seeing us, the impact of this prohibition—in force for several years—was lasting."[30] To be denied, at the ages of eight and ten, any physical contact with their father would only have exacerbated their earlier impressions of Stirling as somewhat austere and aloof. Or perhaps the austerity and aloofness began with his illness. We will never know. In any event, it cannot have been easy to be living with a young father who had already experienced some of the terrors more familiar in old age. Or to know that even if you wanted to reach out to him, he was off-limits.

"Death stares us in the face," Stirling later wrote, "and the drunkard clutches for another drink, the painter for his colors, the sculptor for his elusive naked forms and sensuous shapes."[31] That might sound like a programmatic, fashionably dark-toned fin de siècle vision, except that death *had* stared Stirling in the face. In another passage in the writings Nanette collected after his death, Stirling wondered at the "men and women who have been tormented but still had enough ballast and energy to go on. . . . I would like to know why and how they held on, instead of giving in as I do nearly

every day."[32] Of course, Stirling did have the energy to go on. He scored a great many artistic triumphs after he left Arizona, with his tuberculosis cured. It may have been only decades later, when his professional fortunes were faltering, that he set his own struggles against such a bleak backdrop. But it was in Oracle that he first saw a promising future slipping away and found himself imagining, at least from time to time, that he might have no choice but to give in.

VII

If Stirling was feeling old beyond his years that winter in Arizona, a victim of the force he allegorized in sculpture as "cruel nature," for his children everything was new and enormously exciting. Life in Arizona, which didn't achieve statehood until 1912, marked a total break with the world they had known. Oracle was still rough and ready, still animated by the pioneer spirit. The Calders were staying on the 3N Ranch, owned by William "Curly" Neal and his wife, Annie, a couple who would become the stuff of legend. Though the Calders remembered Neal as African-American and Annie as Cherokee, they both seem to have had some African-American and some Native American blood. Neal had been born in 1849, and after his parents' early deaths, he somehow came under the tutelage of Buffalo Bill Cody, who was only three years older. Neal worked as a cook, had a business digging cellars, ran a stagecoach, and in 1885 won a contract with the United States Mail. A decade before the Calders arrived in Oracle, he'd built the Mountain View Hotel, soon recognized as one of the premier destinations for tubercular patients. The hotel was probably beyond the resources of the Calders, who stayed on the Neal ranch with a group of about ten patients who were fairly self-sufficient. They walked around with little paper-lined tin boxes in which they had to spit, so that the dry spittle could be collected and its bacilli analyzed. "Some of the boarders of the ranch lived in tents about eight feet long with a wooden floor," Calder recalled. "They often slept with their heads sticking out in the open for air, and it was not uncommon in the morning to see a cow licking a man's face."[33]

The Calders had a cottage of their own, where they took their meals. When they arrived, Stirling presented the children with a little black dog, which he had named Kohinoor, surely after the rich black of the pencils produced by the Koh-i-Noor company. They also had a burro, named Jack-O, and a white horse, Pico Blanco. Peggy and Sandy began by trying to keep up with whatever schoolwork they'd been doing back in Philadelphia, but soon

enough those efforts were aban-
doned. The ranch was educa-
tion enough. Peggy remembered
their playing with the Daly girls,
the daughters of a Native Amer-
ican woman who was married to
an Irish cowboy. He might have
been one of the two English
cowboys, a pair of brothers, who
Calder remembered worked the
ranch and conducted the cattle
roundup, complete with brand-
ings, which Sandy and Peggy
were there to see in the fall.
Sandy found it "most spectacu-
lar."[34] Not too much later, he and
his sister attempted to brand a
little stuffed horse, but they were
"too violent, and all the sawdust
stuffing came out."[35] It was one
of the tubercular patients, an old

Calder and Peggy in Oracle, Arizona, 1906.

man named Riley, who showed Sandy how to make a wigwam out of burlap
bags pinned together with nails. Smith, the ranch cook and man-of-all-work,
dyed his white hair brick red; he had a little piano and a sewing machine pur-
chased from a mail-order house. When Nanette asked him what he wanted
when she went back to Philadelphia to collect the children, she was told,
"Some plush." With his sewing machine, he made a cover for his piano and
ruffles for everything else in his cabin. He couldn't read music, but he could
play. Peggy remembered that she and her brother, snug in their beds, would
often hear "the thin tinkling of his piano and his quavering voice singing
'Nobody knows de trubble I've seen' in the dark silence of the plains"—an
image of the humblest music penetrating the quiet of the western nights that
brings to mind Willa Cather's memories of her own days as a child growing
up on the plains.[36]

Sandy caught horned toads and made carts of matchboxes with thread
harnesses. He and his sister had toad races, dangling flies in the direction
they wanted the toads to go. Nanette ordered nature books for the children,
including W. J. Holland's *The Butterfly Book* and Martha Evans Martin's *The
Friendly Stars* (although the publication date of Martin's book, 1907, suggests
that this may be a memory from slightly later). One cannot underestimate

The Kangaroo Rat

moonlight revellers have coats of darkness and become invisible at will.

"Indeed, I believe you would say the whole thing was a dream. But what about the lace traceries in the dust? They are there when the sun comes up next morning."

260

the impact such books had on Sandy's imagination. Perhaps his own stripped-down style as a draftsman was affected by dim memories of Ernest Thompson Seton's delicate, Japanese-influenced drawings of water currents, waving grasses, and bird tracks. Holland's *The Butterfly Book,* with its glorious color plates, inspired the siblings' collections of sulphur yellow and bright blue butterflies, and might lie behind the many butterfly-shaped pins Calder made in his later years. Martin's *The Friendly Stars* was a guide to the heavens that mingled astronomical analysis with discussions of the mythic and poetic origins of the constellations. Martin wrote of the Pleiades, "Minstrels and poets of the early days sang of their bewitchment and beauty, and many of the great poets, from Homer and the author of Job down to Tennyson and the men of our own day, have had their fancy enlivened by them, and in one form or another have celebrated their sweetness and mystery and charm. By men of fancy they have been compared to a swarm of fire-flies, to bees, to a rosette of diamonds, and to shining dewdrops, and by less ecstatic minds to a hen and chickens and the seven virgins."[37] Such thoughts and associations are part of the deep background from which Calder's mobiles—and indeed the "sweetness and mystery and charm" of Calder's mobiles—eventually emerged.

By the fall of 1906, Stirling was judged cured and the family was told they could leave Arizona. The eastern climate was still seen as a danger, so the plan was to temporarily head west, to Southern California. They were going to settle in Pasadena. The children weren't happy about leaving Oracle, that great, strange playground, a place unlike any they had known or, indeed, would ever know again. Although Calder was still a little boy, there is no reason to minimize the impact the raw American landscape had on an impressionable imagination. Twenty years later, Frank Lloyd Wright, whose Guggenheim

Museum was in 1964 the setting for one of Calder's most successful museum shows, arrived in Arizona; he would spend an increasing amount of time in the state and set up an outpost of Taliesin, his Wisconsin studio, which he dubbed Taliesin West. "Arizona seems to me the most beautiful part of this earth and the most unspoiled," he wrote in a letter in December 1928.[38] Wright fell in love with the drama of the landscape. "To these vast, quiet, ponderable masses made by fire and laid by Water—both are architects—now comes the sculptor—Wind. Wind and Water ceaselessly eroding, endlessly working to quiet and harmonize all traces of violence until a glorious unison is again bathed in the atmosphere of a light that is eternal."[39] Wright wrote that "Arizona character seems to cry out for a space-loving architecture of its own. The straight line and the flat plane must come here—of all places—but they should become the dotted line, the broad, low, extended plane textured because in all this astounding desert there is not one hard undotted line to be seen."[40] The oracular tone of Wright's prose would never be Calder's style, but something of the grandeur of that landscape—a world sculpted of light and wind, a new setting for the straight line and the flat plane—can be found in Calder's art.

Calder. Butterfly brooch, c. 1950. Brass and steel wire, 6½ x 5¼ in.

OPPOSITE, TOP *Drawing of animal tracks in Ernest Thompson Seton's* Lives of the Hunted, *1901, a book Calder and Peggy knew before they went to Oracle, Arizona, in 1906.*

OPPOSITE, BOTTOM *Illustration in W. J. Holland's* The Butterfly Book, *1898, which Nanette bought for Calder and Peggy while they were in Oracle, Arizona.*

PASADENA

The Calders at home in Pasadena, c. 1908.

I

Pasadena, where the Calders lived for three years, beginning in the fall of 1906, was a very young city, incorporated in 1886 and growing rapidly in the early years of the new century, with what Sandy recalled as "all the cement sidewalks of a real-estate boom."[1] The discovery of California's extraordinary agricultural potential was still relatively new. The orchards and fields that had first been cultivated to feed the men who came west for the Gold Rush of 1849 were now emerging as the apparently limitless natural resources that the West Coast would supply to the United States for much of the next century. Peggy, who had watched her mother nurse a few pots of geraniums on a windowsill back in Philadelphia, was amazed by the abundance of geraniums in full bloom around their first very modest Pasadena home, on Euclid Avenue. They had a new dog, Ursa Minor, perhaps named after one of the constellations they had learned about in *The Friendly Stars*. Later they lived in a less developed part of the city, in a barnlike house on Linda Vista Avenue overlooking the dramatic gorge known as the Arroyo Seco. Sandy loved foraging in the densely wooded slopes, amid a landscape that remains picturesquely unruly and overgrown even now, a hundred years later—and he paid for his adventures with a terrible case of poison oak.

After the dreamlike isolation of Arizona, where Sandy and Peggy had

been alone with their parents and the colorful western characters who eked out a living on the Oracle ranch, they now made the shift to going to school on a regular basis and figuring out how to become friends with the local children. Neither Peggy nor Sandy ever forgot the afternoon when they got into a fight with a neighborhood schoolmate, Cam Horrell, although Peggy remembered getting a bloody nose and Cam a black eye, while Sandy's recollection, characteristic of his instinctively benign spirit, was that nobody actually got hurt. Whatever the damage, it was a traumatic encounter, and their mother felt compelled to go and speak to the father of what Calder remembered as a tough family, with five or six children. To the well-brought-up Calders, the Horrells, who lived next door, were strangely anarchic, nothing like the people they knew back in Philadelphia. Mrs. Horrell was a southern lady who spent her days rocking listlessly on the veranda and barely paid attention to her children. Mr. Horrell was left to control his unruly brood. He had a hard time of it. The horse whippings he administered to the boys on Sundays shocked the Calders but seem to have left the Horrell children wilder than ever. Nanette, after being informed by Mr. Horrell that he couldn't control his children and she could do as she pleased, talked some sense into Cam Horrell, preaching love of one's fellow man. Somehow, Sandy and Peggy's mother managed to transform a threat and a bully into their protector. They found themselves, Peggy recalled, riding to school on the handlebars of Cam Horrell's bicycle.[2]

Although Stirling and Nanette worried, and not without reason, that the West Coast couldn't provide them with a community of like-minded, classically trained artists, they embraced the lively artistic life and local culture of Pasadena and Los Angeles.[3] They had musical evenings from time to time, among those in attendance being Clinton Balmer, an English artist probably best known as an illustrator in black and white; he also sang and played the cello. A decade later, Balmer made a powerful impression on Sandy when the young man attended drawing classes Balmer taught in New York. Social life was more loosely organized in California than it was back east, and the well-to-do easterners who were making their winter homes in Pasadena and whom the Calders got to know included some sophisticated, adventuresome folks, who were attracted not only by the climate but also by a part of the country rich in Hispanic and Native American traditions. There were Asian influences as well. Stirling found some of his most important commissions in California, first in Pasadena and later in San Francisco. Nanette produced much of her most powerful work while painting in California.

Stirling made a series of portraits of Native Americans that received considerable attention. The men who modeled for him—and also for Nanette,

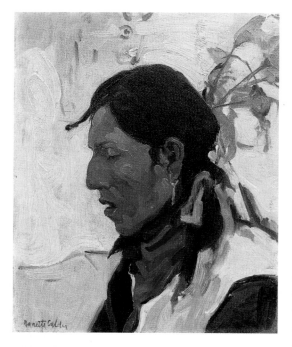

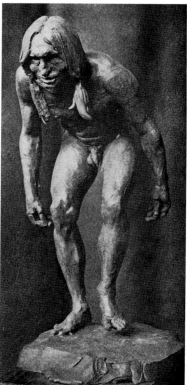

some of whose portraits were exhibited back east—were part of a Pasadena circus. Sandy and Peggy were impressed by their gentle character and fine sense of humor. "This revelation," Peggy later recalled, "along with our friendship in Oracle with the Daly girls"—whose mother was Native American—"made us ardent advocates of Native Americans."[4] Nanette had already, back in Oracle, surreptitiously photographed the Apache women. The Calders collected baskets and jewelry and developed a deep affection for the arts and crafts of the Southwest and of Native American culture more generally. Stirling once wrote that the "totem poles and carved panels of our Alaskan Indians are vigorous, purposeful works of art, skillfully simple and complete, without a trace of that forced aestheticism that is the disease of art."[5] Nanette, according to her daughter, became involved with A. C. Vroman, one of the great photographic interpreters of Native American life, in planning an international art exhibition.

II

Pasadena was one of the centers of the Arts and Crafts movement, with its revolutionary insistence on the symbiotic relationship between conception and execution. The movement had begun with the teachings of John Ruskin and William Morris in nineteenth-century England and by the turn of the century had spread across Europe and America. Stirling and Nanette knew a good many people in Pasadena who were involved with the movement, and the impact of their experimental spirit on Sandy's young, impressionable imagination cannot be underestimated. Throughout his career, Calder produced jewelry and household objects in which he renewed and revitalized the imaginative possibilities of the Arts and Crafts movement. I also see echoes of the Arts and Crafts movement, with its passionate embrace of the poetic power of the handmade object, in some of Calder's very greatest mobiles and stabiles.

Architects and designers in Pasadena were developing new ideas about architecture, furniture, metalwork, and tile making. Wherever the Arts and Crafts movement put down roots, the creative spirits who were involved looked for local sources of inspiration, which they believed had a particular freshness and immediacy. Much of the artistic ferment in Pasadena revolved around what came to be known as Arroyo Culture, promoted by a loose-knit society of artists, writers, and craftspeople who, as Kevin Starr wrote in *Inventing the Dream: California Through the Progressive Era,* "gloried in local circumstances: in Indians and Mexicans, in the blankets, pottery, jewelry, colors, and physical textures of Southern California as desert Spanish Southwest."[6] The Calders' second home in Pasadena, on Linda Vista Avenue, was at the center of the Arts and Crafts movement. They lived in what Calder remembered as a "very amusing" house: "It was made out of a barn with vertical siding and vertical strips nailed over adjoining planks. It belonged to a cultured woman whose name was Mrs. Masters."[7] This was exactly the kind of place that Starr wrote of bohemians building in the Arroyo Seco, "to embrace the symbol of desert wilderness and to glory in Southern California's resistant, elemental texture."[8]

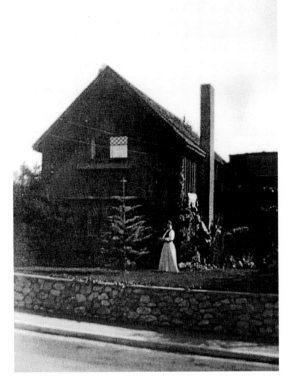

The house on Linda Vista Avenue, overlooking the Arroyo Seco, where the Calders lived in 1909.

In Southern California, Stirling made a relief portrait of John Ruskin, that formative figure of the Arts and Crafts movement, for a Mrs. Stilson, who was much involved in the local Ruskin Art Club. The movement, precipitated by Ruskin's far-reaching indictment of nineteenth-century culture and society, was part of a revolution in taste that Stirling and Nanette could not overlook. In the Calder home in Roxbury there is a copy of John Ruskin's *The Two Paths,* which contains the essay "The Unity of Art"; its bookplate reads "Nettie Lederer," a name Calder's mother rejected in favor of Nanette not long after moving to Philadelphia in her early twenties. Ruskin was a sworn enemy of everything in the arts that was codified or routinized, whether the schematic use of Roman or Renaissance architectural forms or the ever-increasing presence in homes of machine-made furnishings. The long chapter "The Nature of Gothic" in *The Stones of Venice,* where Ruskin urged his readers to study the carvings on the façades of the old

OPPOSITE, TOP *Nanette Lederer Calder.* Portrait of a Sioux, *c. 1908.*

OPPOSITE, BOTTOM *A. Stirling Calder,* A Dancing Sioux, *c. 1908.*

A. Stirling Calder. Ruskin, *c. 1908.*

cathedrals, became the rallying cry of the Arts and Crafts movement. "Examine once more those ugly goblins, and formless monsters, and stern statues, anatomiless and rigid," he wrote, "but do not mock at them, for they are signs of the life and liberty of every workman who struck the stone; a freedom of thought, and rank in scale of being, such as no laws, no charters, no charities can secure; but which it must be the first aim of all Europe at this day to regain for her children."[9] That search for freedom of thought in the handling of materials—and Ruskin's celebration of the intuitive relationship between the artistic idea and the artistic act—leads straight to Alexander Calder's vision of the creative act.

The Calders visited the pioneering Pasadena architectural team of Greene and Greene; at least we know that Nanette did, because her calling card is among the papers of the brothers, Charles Sumner Greene and Henry Mather Greene. The houses Greene and Greene were designing in Southern California are among the crowning achievements of the Arts and Crafts movement; they're every bit as compelling as the homes Frank Lloyd Wright was designing in the Midwest around the same time. Both Wright and Greene and Greene were reimagining Asian architectural traditions, with the natural beauty of local materials showcased in spaces that flowed casually, one into the other. Nearly as important as anything by Greene and Greene, at least for connoisseurs of turn-of-the-century domestic architecture in Pasadena, was a house on California Boulevard, just around the corner from the Calders' first modest place on Euclid Avenue, which had been built by Arthur Jerome Eddy. Almost from the moment they settled in Pasadena, the Calders were in contact with this wealthy Chicagoan, who was a lawyer and a patron of the arts. Eddy's house was large and low-slung, with dramatically fluid spaces, beamed ceilings, massive wooden furniture, and Native American rugs and baskets. The house was widely discussed at the time, both in Pasadena and beyond, and as a boy Calder certainly knew its warm, elegantly rough-hewn spaces.

Eddy had initially come to Pasadena for his wife's health. Sandy remembered that it irked his father that although Eddy was "very friendly," he "did not like and buy father's stuff." In his *Autobiography,* Calder speculated

that Eddy found Stirling's work a little behind the times, as he "frequented the modern Paris Group" and had even known Duchamp. But Eddy embraced Cubism and abstraction only around the time of the Armory Show, somewhat after he had been together with the Calders in Pasadena.[10] What Eddy did share with Stirling and Nanette was a great affection for Paris, where he had spent a good deal of time. He had bought a canvas by Manet in 1893, had had his portrait painted by Whistler, and was an admirer of Rodin, who made a bust of him.[11] Eddy published books on a variety of subjects, including *Delight, the Soul of Art: Five Lectures* and, in 1914, *Cubists and Post-Impressionism*, which included the first American account of the work of Kandinsky.[12] The two families were on fairly easy terms. Eddy commissioned Nanette to paint a portrait of his son—he took an interest in women artists—and made an effort to find her other commissions. According to Calder, Eddy "came from a fat family and

TOP *Lamps designed by Arthur Jerome Eddy for his house in Pasadena, c. 1906.*

ABOVE *Interior of Arthur Jerome Eddy's house in Pasadena, which Eddy designed with the architect Frederick Louis Roehrig, c. 1906.*

he did not want to become too fat himself." He could see that the young Calder was already a little on the heavy side, so he paid for Sandy and his sister to attend a physical fitness course at Mahoney's Gym, where he exercised.[13] When Calder didn't take to the boxing and swimming, he bought the boy a bicycle, which seems to have suited Sandy better.

Although the architect of record for Eddy's house was Frederick Louis Roehrig, Eddy himself was very much involved. In an article in *The Craftsman*, the essential journal of the Arts and Crafts movement, he described the design as an improvisational process.[14] "All lines and joints are wavy and irregular," he explained. "Generally speaking, beams were put in position

Calder. Dog, *1909. Brass sheet, 2¼ x 4½ x 1 in.*

and openings for doors and windows were made to meet the requirements of interior arrangements and to please the eye; the doors and windows themselves were shifted as often as three or four times until their position was satisfactory, quite regardless of drawings and blue prints."[15] One can imagine that this let's-try-it spirit was something Eddy described to Stirling and Nanette within earshot of Sandy, if not to the boy himself. That Eddy might have been interested in describing such an intuitive process to a child is quite possible. As he explained in a little statement titled "Sincerity in Art," published in *The Craftsman* the year before the Calders arrived in Pasadena, Eddy saw sincerity as the essence of art; he noted that it was a quality "natural to children" but "soon lost." "To be sincere is to be natural, to be honest, to be spontaneous, to be true to one's convictions and impulses"—to be, in other words, the kind of artist that Calder would eventually become.[16]

Within their infinitely more limited resources, the Calders created homes in Southern California that, not unlike Eddy's and those of other wealthier and better-established residents of Pasadena, aimed for an informal beauty. Peggy recalled "improvised" furniture: "orange boxes, painted, lined, and curtained, made bureaus."[17] They bought inexpensive Mexican chairs with laced rawhide seats and hung a few Japanese prints on the walls—some of which ended up in the Calder house in Roxbury. Simple economics were a factor in this rather austere décor, but there was also an idea of sweeping away the excesses of overstuffed Victorian taste. The same casual wicker chairs that appear in photographs of the Calders' house on Euclid Avenue were to be seen in the Eddy house, as well as in houses designed by Greene and Greene. Life was an improvisation.

III

Although Sandy was only eleven when the family left Pasadena in the fall of 1909, there is no question that Southern California's relatively freewheeling artistic culture had a lasting impact on him. One of Calder's great friends,

the curator and writer James Johnson
Sweeney, certainly meant to show-
case the early years in Pasadena when
he began Calder's 1943 Museum of
Modern Art retrospective with two
works done then or immediately
afterward. One was a crayon draw-
ing that the boy did in Pasadena in
1907; a self-portrait, it shows him
in the process of sawing a piece of
wood, his hammer, drill, and pliers
nearby. The other was a small *Dog* in
bent brass sheeting, which Calder's
parents remembered was completed
just before the family left Southern
California but may have in fact been

Calder. Self-Portrait, *1907.*
Crayon on paper, 6 x 9 in.

created soon after. Both works belonged to Calder's parents, and one would
assume that Calder approved of their lending them to the 1943 retrospec-
tive; Calder was very much involved in the planning of the show. After his
father's death, Calder kept *Dog*, together with another animal made of brass
sheeting, *Duck*, in his studio in an old cigar box that he'd marked "Sheet
Brass Dog + Duck."

What precisely Calder thought about these early works is impossible to
say. He wasn't given to what most people would describe as reflection or
introspection. At least, he wasn't inclined to admit to it. The closest he may
have ever come to confronting the enigma of his creativity and its possible
relationship with his family and his childhood and the Arts and Crafts move-
ment was in the notes he produced in the mid-1950s, not for publication but
for a friend, the writer William Garland Rogers. Bill Rogers was working on
a biographical manuscript that Calder and his wife eventually deemed not up
to snuff; it never saw the light of day. Calder's notes—which were returned
to him and preserved by this artist who didn't like to throw anything away—
were highly informal, sometimes consisting of little more than lists of names
of people Rogers ought to contact. But occasionally as he was jotting things
down, Calder couldn't help but give himself over to moments of introspec-
tion and even self-examination. One such moment was the extraordinary
comment with which we began, about Calder's not having been brought up
but having been framed.

Calder jump-started his notes for Bill Rogers with the simplest of decla-
rations: "I seem to have always liked + had toys."[18] Before mentioning his

parents, his sister, or even his own birth, he not only proclaimed his fondness for toys but presented a catalog of the ones he had in Philadelphia when he was two or three years old: a few lead soldiers and horses and wagons immediately came to mind. From the toys he had been given, Calder proceeded to his earliest adventures in making things, often toys of one kind or another. The little *Dog* and *Duck* he made of brass sheeting at the age of eleven were designed as gifts for his parents, so clearly intended as sculptures rather than as toys pure and simple. But they were nevertheless toylike in spirit and scale, and for that reason are worth regarding in the context of Calder's more general thinking about his early experiments. In any event, reading Calder's rapid-fire observation about his interest in toys, it's almost impossible not to be reminded of Baudelaire's observation that toys are always something more than toys. "The toy is the child's earliest initiation to art," Baudelaire wrote, "or rather for him it is the first concrete example of art."[19] Whether or not Calder had read or heard of Baudelaire's essay "A Philosophy of Toys," published in 1853, there can be little doubt that this was precisely how he felt when he composed his autobiographical notes for Bill Rogers.

Some twenty pages into the same manuscript, Calder found himself winding back to his starting point: his great fondness for toys. And there he made a most revealing remark, an admission of perplexity from a man who was reluctant to admit to anything except certainty. He wrote, "I'm still trying to get at 'evolution' [from] toys to sculpture."[20] Some ten pages later, he repeated this sentiment, writing: "Still after the Evolution."[21] By raising the whole question of his evolution—and, indeed, he entitled the manuscript "The Evolution"—Calder came as close as he ever would to confronting the origins of his imaginative life. In an evolutionary process everything is interrelated; a development is shaped by a series of pressures and counterpressures. (Calder's mobiles operate in a similar way.) Although Calder never said it in so many words, he obviously understood that any attempt to confront his beginnings involved entering a sort of house of mirrors where childhood and adulthood could not always be so easily disentangled. Considering how many of his most sophisticated sculptures contained toylike elements or aspects, he may have felt that his development never necessitated a rejection of his earlier self. He may have sought the grown-up Calder in the mirror and found there the child. That wouldn't have bothered him.

In 1952, Calder wrote a brief essay about the *Cirque Calder*, the miniature theatrical extravaganza with which he first established himself in Paris in the late 1920s. He observed that although as a child he had many toys, "I was never satisfied with them. I always embellished and expanded their

repertoire with additions made of steel wire, copper, and other materials."[22] Calder's restlessness fueled his experimental spirit, propelling the evolution that took him from toys to sculpture. Old toys precipitated new toys, and on and on until he arrived at the mature works he so often referred to not as sculptures but as "objects." However we frame Calder's evolution from toys to sculptures, it's an evolution that must be studied by anybody who sets out to tell the story of his life. And the little *Dog* and *Duck*, whether toys or toys for adults or something else entirely, are at the heart of that story.

IV

Childhood has always had a privileged place in the modern imagination, and Calder was neither the first nor the last artist whose development left his admirers wondering at the extent to which, as Wordsworth put it, "The Child is father of the Man." Sweeney was thinking along those lines in the catalog of the 1943 retrospective when he speculated that "if one can enjoy certain qualities that predominate in a toy, such as unfamiliar rhythms and provocative surprise, why should these features not be embodied in more ambitious esthetic expressions?"[23] But if a great many modern artists have seriously embraced what some might dismiss as childish things—toys, games, play of all kinds—Calder's embrace of toys, play, and the like was further complicated by his having grown up in an artistic household where it was taken for granted that such childish things had a more than childish value. Stirling, speaking to the reporter for *House and Garden* in 1903, had emphasized the importance of what might be dismissed as a child's concerns—"fun," "fancy," sentiments "primarily playful, lively, fantastic."[24] In a passage Nanette included in her posthumous book of Stirling's writings, he remarked of the many creations of the Greeks and Romans—"vases, urns, mirrors, utensils of the table, armour, braziers, lamps, furniture, the Tanagra statuettes"—that they were "little more than toys in one sense, yet many are triumphs of dignity and beauty."[25] Could it be that Calder, even at the age of ten, had been given by his parents the sense that child's play was also serious play?

Artists who grow up with a father or a mother who is an artist may well find their earliest gifts somehow magnified. Creative parents bring a seriousness to what others might regard as childish fancies. They embolden the young artist, creating conditions that eventually help transform fancies into masterworks. Calder was hardly alone in experiencing the benefits of a parent's creative embrace; in his case, the creative embrace of two parents.

Picasso's father, who taught painting in a provincial art school, was not a figure with anything like the sophistication of Calder's parents. But one wonders if without an artist for a father Picasso would have already, around the age of ten, been making the studies of bullfights that were, according to John Richardson, the art historian who has written the definitive biography, "the first step in Picasso's identification with the matador (the word means 'killer') and the bull."[26] Balthus, a contemporary of Calder's, grew up in a family even more artistically sophisticated than Calder's; his father was an art historian, painter, and set designer, his mother was a painter, and their friends included André Gide and Pierre Bonnard. At around the same age that Calder produced his remarkable little brass *Dog* and *Duck*, Balthus produced a series of ink drawings about a little boy and a cat that goes missing; they were published under the title *Mitsou*, with an introduction by no less a modern authority than the poet Rilke, a friend and lover of Balthus's mother's. *Mitsou*, with its children and cat and snug bourgeois interiors, prefigures much of Balthus's later work, just as Calder's *Dog* and *Duck* prefigure some of his. The child absolutely turns out to be father of the man.

"Mother and father," Sandy recalled in his *Autobiography*, "were all for my efforts to build things myself—they approved of the homemade." If he had been making things before, it was in Pasadena that his family began to recognize this as a self-conscious activity. The homemade was very much the spirit of the Arts and Crafts movement in Pasadena, whether in the elegantly custom-made furnishings of Eddy's house, with a massive, strikingly geometric dining table and chairs in pine and leather, or the painted orange boxes that functioned as furniture in the Calders' home. In their bedroom

in Pasadena, Peggy and Sandy made a mural of western scenes, with horses and cows of cardboard. Calder would forever remember the little house on Euclid Avenue as the place where "I got my first tools and was given the cellar with its window as a workshop." After the move to the Arroyo Seco, his workshop was a tent with a wooden floor, which reminded him of the improvised structures back in Oracle. Calder recalled with obvious pride how this workshop "became some sort of a center of attraction; everybody came in. Peggy once gave me a very nice pair of pliers at Christmas."[27] Toward the end of their time in Pasadena, Calder found that his efforts were even starting to be recognized by his schoolmates. He was "flattered" when an older boy looked at a blotting pad he had made, "displaying some interest"—perhaps a first gratification of the creative person's desire for recognition beyond the family circle.[28]

Fred has made many useful things for the house.
Just now, he is making a doll's bureau for his little sister. She likes to watch him.

Stirling and Nanette, by giving their son a workshop and a set of tools, were encouraging him to experience the creativity, grounded in freedom of thought, that Ruskin believed was the genius of the anonymous craftsmen of the Middle Ages. In his later years, Calder almost invariably referred to his studio as "my shop," suggesting that the grown-up artist wasn't so far from the boy at play in Pasadena—or from the ironmonger and the cobbler, who also worked in a shop rather than a studio, or, for that matter, from the medieval stonemason laboring in the shadow of the cathedral.[29] In the series *Text Books of Art Education*, written by Hugo Froehlich of Pratt Institute in Brooklyn and Bonnie Snow of the Minneapolis public schools and published in 1904, we find images of young boys in their workshops, one of which looks very much like Sandy's portrait of himself at the age of nine. It's not beyond possibility that Sandy knew the book, which reflected the Arts and Crafts movement's wide-ranging efforts to reshape childhood education in the wake of Ruskin's and Morris's ideas. Fred, the boy in his shop in *Text Books of Art Education*, is said to have "made many useful things for the house" and drawn "pictures of the tools he wished for a Christmas present."[30] Which brings us back to Sandy remembering Peggy having given him a pair of pliers as a gift.[31]

In Philadelphia, Stirling had lovingly mocked his son as a scavenger, on

Illustration in Hugo B. Froehlich and Bonnie E. Snow's Text Books of Art Education, *Book III, published in 1904.*

Calder. Untitled, c. 1942.
Sheet metal, colored glass,
wire, string, and paint,
32¾ x 24 x 10 in.

account of his pockets full of flotsam and jetsam. Just this sort of scavenging was advocated in books about children's activities written at the time, which embraced the experimental spirit of the Arts and Crafts movement. A. Neely Hall, in his 1911 *Handicraft for Handy Boys*, recommended projects that involved "old boards, grocery boxes, cigar boxes, barrels, tin cans, worn-out pans and tins, pails, broom-handles, spools, discarded clocks, broken chairs and other furniture, old hats and clothing, stovepipe, clothes-line, screen wire, and other things too numerous to mention."[32] Twenty or thirty years later, such found objects provided the raw materials for Calder and some of his avant-garde friends. Calder made this point in his autobiographical notes. "I have always had a fondness for old bits of iron (see <u>fork</u>), wire, cans, etc." He mentioned Kurt Schwitters, the Dadaist master of collage and assemblage, who created interiors he referred to as Merzbau. Calder pointed out that his own fondness for old bits of stuff was "much like Schwitters—Merzbild—'Merz' means a reject, what is cast off."[33] Calder would use found objects throughout his life, transforming an old spoon discovered in a dump site on the Roxbury property into the base for a tiny mobile and in 1936 contributing to an exhibition of Surrealist objects at the Galerie Ratton in Paris a mobile composed of bits of broken glass, shards of mirror, and two shell buttons. Sometime around 1940 he gave Alfred H. Barr Jr., the founding director of the Museum of Modern Art, a standing mobile that consisted of ten variously colored bits of broken glass arranged on nine wires and suspended from an armature that suggested some long-necked mythological beast.

Stirling and Nanette were determined to encourage in Sandy what was even then referred to as the "play-instinct." The "play-instinct," according to an article in *The Craftsman*, involved the child's mastery of imaginary forms, the manipulation of "the things that he has not, that he cannot handle or see," and thus a development of the ability to "build."[34] Building might also involve taking a toy to pieces "to gratify a scientific impulse"—the sort of investigation that Peggy described when Sandy separated the horse from the cart back in Philadelphia.[35] Much of Calder's later development is prefig-

ured in these turn-of-the-century books and magazines geared to the child's creative development. A manual devoted to "toys for the boy's workshop," published in 1912, contains instructions for making a flying top, a Happy Jack Windmill, a Paddling Indian Windmill, a running wheel with a moving figure, and different kinds of kites.[36] Who would not include such manuals among the deep sources of Calder's kinetic art? And who would not wonder, looking at a page dedicated to the "Rapid Sketching of Animals" in the series *Text Books of Art Education*, whether Calder had not seen this as a child and remembered it or something very like it when, in 1925, he was working on his first book, *Animal Sketching*? There's certainly a striking resemblance between the sketches in the textbook and the drawings in Calder's book.

V

There is some question as to exactly when and where Calder made the little *Dog* and *Duck* of brass sheet metal in which his mastery as a metalworker was so precociously prefigured. But whether they were done soon before or soon after the family left Pasadena in the fall of 1909, there is little question that they were a response to the Arts and Crafts movement. His parents' clear memory of the *Dog* having been done in Pasadena underscores the connection.[37] Standing less than three

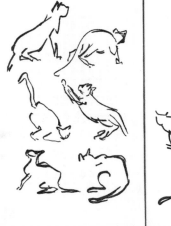

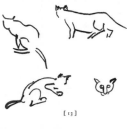

inches high, these two objects evince an impressive conceptual power in the planning, preparation, cutting, and folding of a single sheet of thin brass into dimensional forms quite as sophisticated as some of Calder's mature work. *Dog* is distinguished by the eloquent curves of thigh and belly and the bending back of the sheet brass to form the head. As for *Duck*, it's a work of abstraction—semicircular body, curved head, triangular tail—not so much a reduction of naturalistic form as a reimagining of form. It's elegantly engineered, with the metal bent back to give the tail a double thickness, and thus

TOP *"Rapid Sketching of Animals" in Hugo B. Froehlich and Bonnie E. Snow's* Text Books of Art Education, *Book III, published in 1904.*

ABOVE *Calder. Double-page spread in* Animal Sketching, *Bridgman Publishers, 1926.*

Calder. Dog, *1909. Brass sheet, 2¼ x 4½ x 1 in.*

Calder. Duck, *1909. Brass sheet, 1¾ x 4¼ x 2 in.*

OPPOSITE, TOP *Street number made of sheet copper by Douglas Donaldson for Ernest Batchelder's house in Pasadena, c. 1910.*

OPPOSITE, MIDDLE *Light fixture made of sheet copper by Douglas Donaldson for Ernest Batchelder's house in Pasadena, c. 1910.*

OPPOSITE, BOTTOM *Illustration of perforated metal lampshades in Frank G. Sanford's* The Art Crafts for Beginners, *published in 1904.*

add the weight that keeps the duck resting on its curved underside, rather than flopping forward. The only ornament is a punched hole to indicate the eyes. This *Duck* that rocks back and forth on its curved underside may be regarded as Calder's first kinetic sculpture.

One wonders what Sandy might have been seeing or whom he might have been paying attention to or learning from or even working with at the time. Stirling's major Pasadena commission was a vast architectural decoration for the new home of the Throop Polytechnic Institute, an institution of higher learning specializing in manual arts training; the school was beginning to move toward a focus on the sciences and would eventually become the California Institute of Technology—Caltech. Stirling knew some of the key figures at Throop, including the tile designer and theorist of design Ernest Batchelder and his friend the metalworker Douglas Donaldson. Might a bright, creatively inclined boy have been helped by his artistic parents to seek some guidance from Batchelder or Donaldson? To look at Batchelder's geometricized designs for animals, many published in articles in *The Craftsman* at the time the Calders were in Pasadena, is to see not the models for Sandy's work but designs that could have been suggestive.

Reading Batchelder's praise of what "Mr. Ruskin calls the 'infinite curve'—more subtle and with greater beauty than the circle," makes one wonder if Sandy heard such talk.[38] Peggy, in her memoir, was amazed that Sandy had "the coordination that led to drawing a curve so perfectly with

pen and ink, yet missed the curve of the ball so consistently"—he would never be much of an athlete.[39] Batchelder wrote of play as "the honest pride and enthusiasm in the work of one's hands" and entitled another article "The Arts and Crafts Movement in America: Work or Play?"[40] That brings to mind James Johnson Sweeney's subtitle, many years later, for an article about Calder: "Work and Play."[41] Douglas Donaldson was beginning to make some metal decorations for his friend Batchelder's home on the Arroyo Seco around the time the Calders left Pasadena. There are aspects of Donaldson's work with sheet copper that might lead one to imagine that he had given the young Calder some guidance, or at least that Calder had seen some of his work and set out to do something in the same manner. The metal street number by Donaldson, with its plainspoken geometric cutouts, could have attracted the boy. And although the lamps Donaldson made to Batchelder's designs were probably executed a couple of years after the Calders returned east, the cutout bird forms and the use of a punched circle for an eye certainly suggest that Sandy could have seen something similar.

We can't be sure that Sandy knew Donaldson and his work, but the impact of Arts and Crafts metalwork on Calder, then and later, cannot be overlooked. Making hinges, clasps, and other hardware for the Roxbury house thirty years later, Calder was recapitulating precisely the kind of elegant handiwork that had characterized the Eddy house in Pasadena and countless other Arts and Crafts homes large and small. Certain techniques used in Calder's mature mobiles, such as simple puncturings of the metal to create texture and transparency, are close to techniques presented in Arts and Crafts manuals, an example being the perforations of metal lampshades in a chapter on sheet metal work in the 1904 *The Art*

Crafts for Beginners. Peggy remembered that her brother "triumphantly returned to his basement workshop bearing armfuls of copper wire scraps"; they were the trimmings left in the streets by the men installing electrical lines. Peggy also pointed out that "some of the lockets and watches he made for my dolls in 1908 were spirals."[42] Copper was a key material of Arts and Crafts metalworkers, and spirals were ubiquitous in their work, not only in the hanging lanterns done by Dard Hunter between 1906 and 1908 at the Roycroft shop in East Aurora, New York, but in less well known work, such as a watch fob, made around 1900 by Madeline Yale Wynne in Massachusetts. Though there is no reason to imagine that Calder knew these works, it's surely possible that he knew ones like them.

But for students of the later Calder, perhaps the most startling of all the handiwork to be found in Los Angeles are the wrought iron ornaments on the great doors of El Alisal, the house built by Charles Lummis, the author, editor, collector, and pioneer in the study of Native American culture. It's almost certain that the Calders knew Lummis and visited him in the elaborate residence he was bringing to completion in the years when they were in Pasadena. When an article on Calder's work appeared in *Out West*, the magazine Lummis edited, it was written by the Frenchman Hector Alliot, whom Sandy remembered as a friend of the family's. Alliot was close to Lummis, was involved with the Southern California Ruskin Art Club, and was the first director of the Southwest Museum of the American Indian, founded by Lummis. Everybody knew Lummis. For the doors of Lummis's home, the artist Maynard Dixon designed massive hinges and an arabesque

of interlaced, serpentine curves that looks like nothing so much as a proto-type for the meandering knots, twists, and zigzags of some of the pieces of jewelry and smaller utilitarian objects that Calder produced in his maturity. Calder may well have known those doors when he was a boy. The visual echo is nothing less than astonishing.

VI

Alexander Calder's sheet brass animals may well deserve a place in the history of the arts in Pasadena. As for Stirling Calder's place in that history, it has long been acknowledged. The enormous bas-relief he produced for the Throop Polytechnic Institute was the largest public sculpture completed in Southern California at the time. The commission for the three spandrels, designed to crown the school's entrance, came to Stirling sometime early in 1909; they were unveiled in February 1910. The artist wrote that his allegorical scheme was designed to "broadly cover the whole field of human effort and intelligence under the heads—'Nature,' 'Art,' 'Energy,' 'Science,' 'Imagination,' and 'Law.'" The monumental reliefs were modeled in clay and then cast in concrete. The imagery was bold: Imagination embodied by a broad-chested, winged, Michelangelesque youth; Nature by Pan, as Stirling put it, "piping his gentle joy of life."[43] The Throop spandrels created something of a sensation, for they brought a new sophistication to public decoration in Southern California.

A. Stirling Calder. Relief sculpture for the Throop Polytechnic Institute spandrels, 1909.

The chairman of the board of the Throop Institute was Dr. Norman Bridge, perhaps the foremost expert on tuberculosis in Pasadena. He had made a name for himself in Chicago before contracting the disease and seeking treatment in California; it seems that Stirling had already been under Dr. Bridge's care before arriving in Pasadena. In an August 1906 letter, Stirling remarked that he now weighed 158 pounds and had been pronounced by Dr. Bridge as almost cured; whether Stirling visited him in Los Angeles or Dr. Bridge was in Arizona we don't know.[44] Dr. Bridge had made a fortune in oil, wrote extensively on tuberculosis, but also published books of aesthetic theory and was a major patron of the arts and sciences in Pasadena and Los Angeles. He would have felt a special sympathy for Stirling, for they had both seen their promising careers threatened at an early stage.

The trustees of the Throop Institute had initially hesitated at the $5,000 that Stirling Calder was asking for the spandrels. Some of them visited the artist's studio, among them Dr. Bridge. He said nothing and left. But the next day he returned to the studio and bought a head of an Indian for fifty dollars. When the board met to discuss the cost of the spandrels, Dr. Bridge said, "Gentlemen, if the essential question in your minds is the matter of expense, I have a check in my pocket for $5,000."[45] The Throop commission kept the Calders in Pasadena longer than they had planned. In November 1908, Calder had written to his friend John Trask, at the Pennsylvania Academy, "I am definitely planning to return next spring when I shall try to get even with my old friends."[46] He was aching to recover the competitive spirit that had animated his younger years in Philadelphia and Paris—and catch up with friends like Robert Henri and John Sloan, who were living in New York and building major careers. But by March 1909, the Throop commission was in hand. Nanette wrote to Trask, who was arranging for some of

her paintings of West Coast Native Americans and landscapes to be shown in Philadelphia. "I had been hoping to see you all soon," she said, "but this plum which has fallen into Calder's share will keep us here until the fall."[47]

The pomp and circumstance surrounding the inauguration of the Throop spandrels had to have been enormously gratifying for Stirling. Finally, he could put his illness behind him. He was back on track, ready to return to the East. That it had been Dr. Bridge, a fellow survivor of tuberculosis, who had written the check that made this major work possible must have given Stirling an extra lift. At the time of the inauguration of the spandrels, Stirling wrote of giving "plastic utterance to the aims and scope of the school." He went on to offer what amounted to a defense of the place of art in a democratic society, arguing that "true art is not ostentation, it is not for the merely wealthy anymore than it is for the very poor." Such art, he said, "is most supremely useful, as the bread you eat, or else all the great Art of the world has been in vain." Life, Stirling said, would be a poor thing without "the irrepressible optimism of Art."[48] David Starr Jordan, the president of Stanford University, was at the inauguration and echoed Stirling's words, observing that "Nature is life as it is. Art is what man can make of it."[49]

For Sandy, it was a very different Pasadena celebration, the Tournament of Roses, first staged in 1890, that was never to be forgotten. In 1900, the celebration, which was being held right near Throop, featured flower-covered floats, bronco busting, ostrich races, horse chariot races, and even a novelty race between a camel and an elephant. In his *Autobiography,* Calder remembered attending the Tournament of Roses on January 1, 1907, not long after the family's arrival from Arizona. In her memoir, Peggy described the Lucky Baldwin ranch's float the following year, "which paraded through the streets prior to the Tournament itself . . . drawn by six matched percherons." The centerpiece of the float was "a peacock constructed wholly of white flowers, with the tail made entirely of unbelievably fragrant lilies of the valley."[50] These were the days when Calder, like many boys, was fascinated by stories of the Knights of the Round Table; a drawing of Sir Lancelot by Sandy survives from Pasadena. Calder later recalled "a friend in Pasadena with whom I made armor and weapons from tin and wood, shields, breastplates, helmets, swords, lances; I even covered an old pair of my mother's gloves with tin scales. He was Sir Lancelot and I was Sir Tristan."[51] The friend was Chuck Hunt, the son of Myron Hunt, one of the architects of the Throop Institute. The Tournament of Roses must have impressed Sandy's young imagination as somehow echoing the ceremonies, competitions, and heroics of an earlier age. Peggy remembered how the morning after the tournament, Sandy was already busy sawing at six-thirty, making "horse heads from an

old wooden box and hammering them onto handles—Mother just managed to save the handle of her new broom."[52] These horses were mounted by the local children for jousting matches. Then Sandy proceeded to make chariots out of orange crates.

In the fall of 1909, the family headed back east, with Stirling almost certainly returning to Pasadena early the following year for the inauguration of the Throop spandrels. Nanette and the children settled temporarily in Philadelphia. Sandy was enrolled for at least a few months at the Germantown Academy. He stayed long enough to attend athletic events and admire the insignia of a rival institution, Penn Charter, whose colors were red, blue, and black. Years later, Calder told a friend, the curator Jean Lipman, that he found this "an amusing combination of colors. I still like it today."[53] The colors on banners and insignias would sometimes set Calder to thinking about surprising harmonies and dissonances and, later on, help shape the polychrome poetics of some of his abstract sculptures. Meanwhile, Stirling was scouting places for the family to live in the New York environs. In October, John Sloan recorded in his diary Stirling's unexpected appearance on his Manhattan doorstep. Sloan enjoyed talking with Stirling again. He thought his old friend looked quite well. "He has been out of things so long," Sloan observed, "that everything was news to him."[54] By some time in the first half of 1910, the family was living just north of New York City, in Croton-on-Hudson.

Pasadena was behind them, but its afterimages would be felt in Calder's work. The *Cirque Calder,* developed in Paris some twenty years later, concluded with a chariot race that must have contained memories of the Tournament of Roses in Pasadena; at least that was what Jean Davidson, Calder's son-in-law, believed. Over the years, Calder created a mobile entitled *Chariot* (1957), a two-part stabile of abstracted knights in combat entitled *Big Knight and Little Knight* (1963), and a series of gouaches and lithographs on the theme of knights in armor. If it was the Arts and Crafts metalworkers of Pasadena who introduced Sandy to the tools and techniques with which he created his greatest mobiles and stabiles, it was the Tournament of Roses that first suggested to him the theatrical pageantry that bore fruit in the ritualized comedy of the *Cirque Calder.*

CHAPTER 5

CROTON-ON-HUDSON

I

In 1909, Stirling's health was still regarded as fragile enough that he was advised to live outside New York City, free of the dirt and dust that may have made him susceptible to tuberculosis in the first place. That was why the family decided to settle in Croton-on-Hudson, an hour and a quarter up the Hudson from Manhattan. They rented a stone gatehouse on the elegant estate of a Mr. and Mrs. Stevenson for their home. When John Sloan visited some months later, he was impressed by the "fine, walled-in estate situated on a terrace made on what . . . had been a hillside." It was walking distance from the train stop in Croton-on-Hudson. There were, Sloan wrote, "beautiful formal grounds and gardens on the far side of which Calders occupy a fine two-story, broad, stone house."[1] Stirling's studio

Calder and Peggy in Croton-on-Hudson, 1910.

was in the garage, where he installed a skylight. There was also a room with fancy wallpaper that Nanette covered up so she would have a place to paint.

The Croton-on-Hudson place was definitely grand, with a stone wall that in some spots, Sandy recalled, was thirty-five feet high. A good-sized artificial pond, some eighty or a hundred feet square and two feet deep, was used

Cover of D. C. Beard's The Outdoor Handy Book, 1907.

for ice cutting but was also good for ice skating in the winter and sailing a snub-nosed boat in the summer. Sandy adored the pond. He speared frogs, caught newts, and studied the water life.[2] He fixed a long handle to a sieve to scoop up pollywogs, and he and his sister, as Peggy recalled, "learned to identify the dragon fly larva from the decorative yellow and green patterns on its torpedo-shaped body."[3] Mrs. Stevenson, Sandy wrote, "had an architectural mania." She oversaw the construction of a good many stone structures. She also liked the idea of having a sculptor on the premises. That was why the Calders were able to become tenants. As most of the men who did stonework for her were Italian, she entertained them during their lunch breaks by wheeling out her Victrola and playing Italian records. Sandy discovered that because the Stevensons were so wealthy, his presence on their estate gave him some sort of prestige at school, a stature, he confessed in the *Autobiography*, "I really did not rate."[4] The only drawback of the Stevenson place was that Mrs. Stevenson couldn't tolerate dogs, so Ursa Minor had to be left in Philadelphia with Grandfather Milne.

Sandy's adventures in the pond and more generally around the Croton-on-Hudson estate were abetted by a stout volume he had at the time and remembered so clearly that he referred to it by name in the *Autobiography*. This was D. C. Beard's *The Outdoor Handy Book*, subtitled *For Playground, Field, and Forest;* the cover and title page included pictures of boys bicycling, boating, flying kites, skating, playing hockey, and walking on stilts. The *Handy Book* was directed both to boys and to grown-ups who might be designing activities for boys. It was at once a how-to book and a sort of fantasy about the perfect boyhood, with chapters gathered into larger sections covering the four seasons and ranging from reminiscences of the author's boyhood playing marbles on Long Island to general practical advice ("good straight-grained pine wood is, without doubt, the best 'all-around' wood for a boy's use") to all sorts of instructions for how to play games and make a vast assortment of objects.[5] There was a whole chapter on stilts, including instructions for making them and a history of their use among the Japanese and the tattooed stilt walkers of the Marquesas Islands.

For anybody looking at *The Outdoor Handy Book* with Calder in mind,

the most striking chapter is the one titled "Malay and Other Tailless Kites," with its detailed instructions about making these fantasy objects that float through the air. The author describes the development of kites for various practical purposes, including the information that the United States Weather Bureau is trying to develop a kite capable of carrying an aluminum thermograph to a height of one thousand feet; there is a discussion of Chinese butterfly kites, and of the idea of connecting two or three kites to one another with one spine; and the reader is informed that the Boston Aeronautical Society offers prizes to kite fliers. "Here," Beard writes of the Boston Aeronautical Society, "is a chance for some bright American boy, some youthful Ben Franklin, to distinguish himself."[6] Particularly striking is an illustration captioned, "All the Novelties in the Air"; it shows ten or so fantastically shaped different kites attached to one another by strings and flying high above a little house. Turn the picture upside down and you have a Calder mobile of the

78 *Spring*

he should have a fine "stable" of kites of his own manufacture, and since from the authorities quoted it is evident that kites with tails can be made to fly tandem he can produce a great sensation by taking an example of all the different forms of kites and by sending up the largest one first. At-

FIG. 46.—All the Novelties in the Air.

tach the string of another to the first kite string and let it go. Let him pay out more line and hitch on another kite, and so on until he has a whole navy or zoölogical garden floating over the heads of the astonished spectators, and though he may discover no new law in science, he will have a "heap" of fun. (Fig. 46.)

ABOVE *Illustration of kites in D. C. Beard's* The Outdoor Handy Book, *1907.*

LEFT *Calder.* Untitled, *1941. Wire, wood, and paint, 36 x 50 x 31 in.*

1940s. Calder had a lifelong fascination with kites; when he went to India in 1955, he was eager to see the famous kite festival in Ahmedabad, with hundreds of people flying kites from the roofs of the city's buildings.

II

The boy who returned with his parents and sister from California was a smiling Buddha—cheerful, self-assured, enigmatic. Although Sandy excelled in his academic studies, he had little aptitude for the sports that generally promoted popularity in school. He was always disappearing into his basement workshop to make something or other. He was probably happiest when he was off by himself, although he certainly enjoyed the attention his creations received. His bedroom was outfitted with "a maze of strings" that, as his sister described it, "pulled up shades and lowered them, pulled the casement windows closed, turned the lights on and off." Nanette gave him a mahogany highboy, painted blue, in which to store his treasures. These included wire gathered from here and there, rocks, pieces of wood, and his tools. "On Thursday, cleaning day," Peggy recalled, "a stormy scene always followed Sandy's return from school—a crucial bit of string had been removed from his doorknob, or wire from the chair. Mother sympathized, but felt obliged to maintain a minimum of domestic order."[7]

Reminiscing about his adolescent years in the *Autobiography*, and the parallel tracks of his father's and his own creative endeavors, Calder at one point announced, with what was probably a comically rueful shrug, "Well, once more father had the skylight and I the workshop in the cellar."[8] While one wouldn't want to make too much of this passing suggestion of some Oedipal conflict, there was surely an undercurrent of father-and-son drama in the six years between the Calder family's return east in 1909 and Calder's departure for college in 1915. These were the years when his father's career took off like a rocket. Stirling turned forty in 1910. Returning not only to the East but also from a close brush with death, he plunged into what turned out to be twenty years of widespread success and professional fulfillment. He reconnected with old friends who had already made names for themselves in New York; he took on major commissions not only in New York but in San Francisco, Oakland, Philadelphia, Miami, and other places as well; and he became a significant voice in ongoing debates about the place of public sculpture in a democratic society. Stirling was a man in command of his destiny.

How attentive Sandy was to his father's work is not entirely clear. In a brief reminiscence, composed in 1955 for the "150th Anniversary Exhibition

of the Pennsylvania Academy of the Fine Arts," Calder described himself as not especially aware of what his father was up to. "When I was young I used occasionally to pose for my father and, at other times, for my mother. This gave me some acquaintance with their work." Once he went off to college and turned to engineering, he was, he went on to say, "indifferent to my father's problems, although I had acquired a smattering of the technique. Thus I can think of him chiefly as a person." But, of course, his father was a person who was immersed in his work. "He loved to be alone and at work," Calder observed, "and resented intrusions. In his own words he wanted to 'fill the world with beautiful things.' Of course that is a very problematic point—to decide what is, or is not, beautiful."[9] There is a diffidence, maybe even a reticence, maybe even some competitiveness in these recollections, in which the son cannot resist offering a gentle critique of his father's search for beauty. Was Calder suggesting that in the end he was the one who really understood the nature of beauty?

A reader of Calder's *Autobiography* may suspect that he was more attentive to his father's struggles and triumphs (and shortcomings) than he cared to let on. His imagination might well have been piqued by a project Stirling undertook for a Mrs. Harriman shortly after returning to New York, a mantelpiece on the theme of Jack and the Beanstalk; but it was Peggy, not Sandy, who mentioned that child-friendly assignment in her memoir. Sandy could probably see, from an early age, that his mother's feelings about his father were complicated, her admiration for Stirling leavened by a certain skepticism or frustration when it came to the contemplative or even saturnine side of his personality. Sandy may have embraced that element of skepticism, as a way of grappling with whatever mixed emotions he had about his increasingly famous and perhaps increasingly aloof father.

Near the beginning of the *Autobiography*, Calder offered a rather revealing critique of the studio his father rented at 51 West Tenth Street in 1912 and occupied for eight years. It was, Calder recalled, "the main studio of a very old building, with a flat skylight in the middle of it. It was terrible, because the top of everything bleached with the light while the vertical surfaces were in shadow. I did not like it at all, but I suppose he finally got used to it, though I don't quite see how he could work there."[10] Of course, Calder may have been remembering the studio as it struck him in his early twenties rather than during his teenage years. But it is interesting that he chose to give a bad review to the studio where Stirling worked during one of the most successful stretches of his career. In later years, Calder's feelings for his father would be cordial, respectful, somewhat distant, the sobriety warmed by a humorously ironic affection for Stirling's elegant self-regard.

III

Sandy went to the Croton public school with the children of working people. He was quickly advanced from fifth to sixth grade and remembered there a teacher, Miss Cahill, who was "full of pizazz."[11] The Calders hired a cook by the name of Anna Tuceling, who was very much a part of the family, at ease with the more hilarious goings-on when friends came to visit. Sandy remembered her teaching him and his sister "to waltz round and round the dining table to 'The Pink Lady,' played in Beethoven cadences."[12] He sometimes played with the Stevensons' son, Harvey, an athletic fellow who went to a private school—Peggy said it was a boarding school—and whom Sandy and Peggy, behind his back, called "The Squire." Harvey wanted to play ball with Sandy, who did so reluctantly, always looking for opportunities to sit down in the shade of a tree.[13] For some years, Sandy remained in touch with Harvey Stevenson, who went to Yale and became an architect.

Although Sandy and Peggy's childhood was far too orderly to be characterized as bohemian, they always knew that their father's career set them apart from other children. As teenagers, they found that when friends came to visit, they were startled to see drawings of nudes by Robert Henri and Everett Shinn hanging on the walls. The Calder children had thought nothing of these drawings, having grown up with them, but Peggy wasn't consoled by her mother's explanation that if a drawing of a nude was a work of art, it deserved to be displayed in the living room. Sandy and Peggy soon learned to hide the offending pictures behind the piano when friends appeared.[14] Not surprisingly, they felt a special affinity with children whose families were also artistic. Peggy, attending high school in Ossining, became friendly with two sisters, Eleanor and Marjorie Acker, who were nieces of the well-known painter Gifford Beal. Marjorie became a painter and married Duncan Phillips and was involved with him in the development of the Phillips Collection in Washington, D.C., one of America's great small museums and the first dedicated to modern art.

Whatever suspicions passed through the minds of Peggy's and Sandy's friends when they saw the nudes hanging in the Calder home, the truth was that Stirling and Nanette were anything but flamboyant. When the children met a cousin of Nanette's, the actress Margaret Dale—she was from the Philadelphia branch of the family—they were shocked to find that she wore lipstick, "accustomed to thinking of lipstick as something used only by harlots." Their father, although in many respects a romantic spirit, was physically fastidious and, Peggy remarked, "very modest about his person, as was Mother."[15] Peggy said that his "Scotch Presbyterian distaste" pre-

vented Nanette from having dancing parties at home. There may have been a physical ease about Nanette with which her husband was somewhat uncomfortable—an ease that her son definitely inherited.[16] For years after his battle with tuberculosis, Stirling slept alone, in an empty room with the windows open or on a porch. Nanette had come through the births of her two children with gynecological problems. The house in Croton-on-Hudson had one wing with bedrooms for Nanette and Peggy and another with bedrooms for Stirling and Sandy. To the children, their parents' marriage might have looked chaste, as perhaps it was. But Nanette, at least to her daughter, never seemed cold. Peggy, in her memoir, commented that her mother "was utterly open about bathroom matters, and I now realize unusually frank with me for her time about sex and other sensitive aspects of adult life. Her richness, warmth, and strength were vital to us all."[17]

Among Nanette's papers is a folder marked "Betrayal Letter," containing Stirling's apologies in the wake of an affair. He wrote a poem to Nanette in the manner of Shakespeare's sonnets. He begged forgiveness of "thou dear staunch soul whom my offence hath wounded." He wondered how he could "make amends for duty strayed / How purge the air of vagary expired." When all of this happened is by no means clear. Nor is it clear if the children knew anything about it while Stirling was alive. Seven years after his death in 1945, when Nanette was deep in her eighties and finding it difficult to paint much anymore, she wrote a note to herself: "I miss the companionship of Calder very much. Though after 7 years of reflection I pronounce him selfish to a great degree."[18] Whatever the facts, Peggy and Sandy grew up with the sense that their parents' marriage was solid—perhaps at first a great love affair, perhaps later an enduring friendship.

IV

Three of Stirling's brothers were living in New York, and from time to time they came up to Croton-on-Hudson with friends for grand feasts, bringing large boxes of chocolates. Nanette made elaborate desserts, including a trifle that, heaped high on a platter, had the look of a miniature Fujiyama, the mountain beloved by the Japanese woodblock artists.[19] For the children, the brothers had all the charm and enigma of bachelor relatives who had somehow eluded the conventions of family life. Norman, always a rather elusive figure, was a sometime painter. Ron, the brother whose imposing muscled physique Stirling saluted in several sculptures, especially the bare-chested *Miner,* was the head of the gym at the parish house of St. Thomas Church in

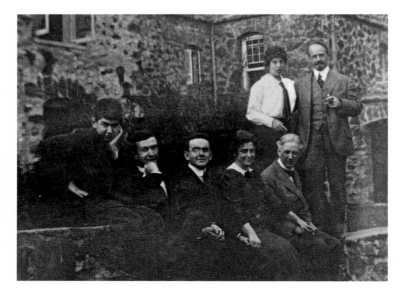

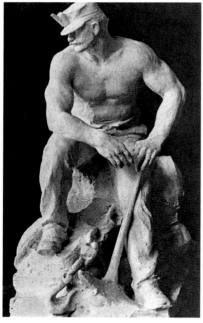

Manhattan and ran a summer program for boys at Greenport, on the east end of Long Island. Sandy attended the program twice. A prize was given to the boy who consistently had the most neatly made bed; Calder won it both times.[20] Ron was the family athlete. He was also clever with his hands. When he visited the family in Pasadena, he took a store-bought wagon and, by attaching a steering wheel, turned it into a coaster that Sandy could ride along the Pasadena sidewalks. Once the family was back east, he gave Sandy advice about coping with teasing from bullies at school, telling him, "Pick the biggest and go after him."[21] Nanette's response was to find Sandy a boxing teacher, who gave him lessons in self-defense.

It was Ralph—the youngest of Stirling's five brothers and, as Peggy pointed out in her memoir, only thirteen years older than her—who seemed closest to Stirling in his interests and, maybe, his sensibility. Ralph was dandyish and suave. He had what Peggy remembered as "a wonderfully accurate flute-like whistle"; he used it to perform bits of opera. Like Stirling, he had followed in their father's footsteps, building something of a reputation designing the decorative plasterwork known as sgraffito, based on Renaissance models, for important architectural firms, including Carrère and Hastings and Warren and Wetmore. Arriving in Croton-on-Hudson, he must have brought a whiff of urbane aestheticism. Somebody who worked with Ralph Calder a little later in an architectural office in Philadelphia recalled how he flouted the rules. He arrived after everybody else, an unflappable figure with a soft felt hat and a sweet, cherubic smile. He smoked where it wasn't permitted. He entertained his fellow workers by whistling coloratura arias and dropping the names of prominent New Yorkers. He gave the impression that he'd been inside the finest homes in New York, and spoke with great enthusiasm of the Maxfield Parrish murals in the King Cole Bar at the St. Regis Hotel.[22] In later years,

the Calders fell out of touch with the Philadelphia uncles, but after Stirling's death Calder reconnected with Ron and Ralph, who never married and were living together in Philadelphia. They were close to destitute, and Calder helped them financially. Writing to Calder after Stirling's death in 1945, Ralph said it was "swell too to know of your successes—and that you are carrying on the tradition of Art." Ralph went on to speak of the arts as the most universal of languages—as the most ethical and spiritual and soulful of languages—in terms that echoed the fervor and sincerity of Calder's father.[23]

Stirling's brothers were not the only adults who made a big impression. The Calder family spent at least one summer week on vacation with John Sloan and Everett Shinn and their wives, perhaps giving Peggy and Sandy a glimpse of the artistic brotherhood that had flourished in Philadelphia twenty years earlier. That week was, Peggy recalled, "a riotous occasion," with everybody taking part in theatrical experiments masterminded by Shinn, "a gifted actor, wondrous to behold in the process of evolving a play." For Stirling, these casual performances had to have brought back memories of their days in Philadelphia, when such events were a staple in the circle he frequented, with Sloan and Robert Henri and Charles Grafly and others. Peggy recalled two plays by Shinn—*Hazel Weston, or More Sinned Against Than Usual* and *Lucy Moore, or The Prune Hater's Daughter. The Prune Hater's Daughter,* apparently a memorable bit of fun, was also mentioned by Van Wyck Brooks in his biography of Sloan. Shinn, Peggy recalled, "would leap from one spot to another, playing all the roles, changing voices to suit the character, grabbing up anything handy for a prop in a frenzy of composition. His wife Flossie, Florence Scovel Shinn, an artist in her own right, assisted and abetted him."[24] Shinn was so addicted to the theater that he built, behind his studio on Waverly Place in Greenwich Village, a little auditorium, dubbed the "Waverly Place Players." Peggy and Sandy never saw a full performance; the nighttime events were off-limits on account of the children's bedtimes in Croton-on-Hudson. But they eagerly awaited full reports from their parents.

Shinn, with his playful and boyish personality, formed a special bond with Sandy. Van Wyck Brooks recalled that Shinn "was always thinking of gadgets, a windshield-wiper for eye-glasses, a contraption to remove lead from paper and restore it to the pencil; another was a trellis that rolled up at night, folding the flowering vines in a box in which an insecticide sprayed the blossoms until morning."[25] Shinn worked with Sandy on his model trains, helping him construct a gravity system down the yard wall, with the trains on wooden rails held by spikes and a piece of iron adding weight to the train so

OPPOSITE, TOP *The Calders and Stirling's brothers in Croton-on-Hudson, c. 1910. Probably Ralph Calder seated at center and Ron Calder standing next to Peggy.*

OPPOSITE, BOTTOM *A. Stirling Calder. The Miner, 1898. The model was Stirling's brother Ron.*

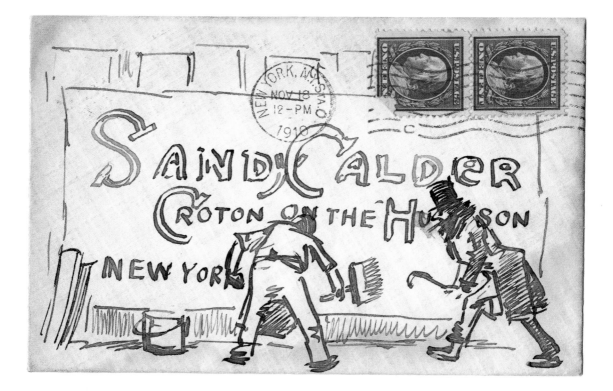

Everett Shinn's illustrated envelope, for a letter he sent to Calder in 1910.

the cars moved faster. They even installed candles in some of the cars, creating a thrilling nocturnal effect. In his *Autobiography,* Calder proudly reproduced a letter Shinn had sent to "My Dear Sandy" in Croton-on-Hudson in 1910. Inside was a drawing Shinn had done of a face-off between two cowboys. The pièce de résistance was the envelope itself, the address—"Sandy Calder / Croton on the Hudson / New York"—inscribed as the message on a poster being pasted by a workman on a wall, while a man in a big black top hat carrying a cane stalks down the street. It's a vignette of modern life, turned into an envelope; it has all the charm of an illustration by one of the great nineteenth-century comic illustrators, a George Cruikshank or a Thomas Rowlandson. Years later, Shinn did a richly phantasmagorical series of illustrations for *Rip Van Winkle.* Was it any wonder that Sandy was enthralled by this man? Decades later, Calder would send letters to his friends in his own wittily decorated envelopes.

When the Shinns divorced, Peggy and Sandy were thunderstruck. They couldn't see, Peggy recalled, "how either could function without the other or bear to leave the perpetual circus they created for themselves." On reflection, their own parents, "who sometimes seemed so lacking in glamour alongside this lively couple, appeared in much better light."[26] The stability of Stir-

ling and Nanette's marriage—including what Sandy and Peggy might have seen as its dullness—shaped their young days and provided a much-needed anchor, given their father's up-and-down career.

V

By the time the Calders settled in Croton-on-Hudson in 1910, Shinn and Sloan and other friends from Philadelphia, such as Robert Henri and William Glackens, were recognized as American art's new radicals. Henri, who was a little older than many of the others and had been embraced as a leader from their younger days, remained friends with Calder in New York, taking a small sculpture by Stirling in exchange for an oil portrait of a Spanish child, Dolores; it hung in the Calder house for decades, until, after Stirling's death, Nanette was forced to sell it. While living in France, Henri had absorbed the lessons of Manet and the Impressionists; he believed that modern experience demanded modern techniques. In 1907, when he found himself on the jury selecting the annual exhibition for the National Academy of Design, he was shocked at the refusal of his fellow academicians to embrace the work of his students and his friends, including Sloan and Shinn, who were painting the life around them with a vibrancy new to American art. Henri's frustration with the National Academy—his own work was sidelined as well—led to a search for fresh opportunities for exhibitions. One result was a show at the Macbeth Gallery in February 1908 of paintings by eight artists. Arthur B. Davies, Ernest Lawson, and Maurice Prendergast joined Stirling's friends Glackens, Henri, Luks, Shinn, and Sloan. They created a sensation. They were nicknamed "The Eight" and many of them eventually came to be known, on account of their sometimes down-and-dirty subject matter, as the Ashcan school.

Although the Macbeth Gallery exhibition contained landscapes and portraits and European scenes, what captured the imagination of the large number of visitors to 450 Fifth Avenue was the vitality with which contemporary New York was represented, its shop windows, theaters, parks, and variegated entertainments summoned up with quickening brushwork and rich, hectic color combinations. Stirling's old friends were rhapsodizing the city in a new, frank, astonishing way. Their experience as newspaper illustrators and their feeling for the painterly brushstroke—which they understood, looking back through the Impressionists and Manet, as coming from Velázquez and Rembrandt—created imperishable impressions of the delicious turmoil of the city, with its elevated trains, its cozy restaurants, its ceaseless parade.

When Sloan and Shinn visited the Calders in Croton-on-Hudson, what most impressed Sloan in Stirling's studio were small works with an immediacy not unlike that of the paintings he and his friends were doing. Sloan described in his diary "a woman's figure, lying on back with one knee up, stockings, a very real human thing, small; also a small figurine of Mrs. C[alder] in a robe, fine, modern in the spirit of the Tanagrines."[27] Those ancient Greek Tanagra figures, generally representing beautiful women, were much esteemed around the turn of the century by avant-garde artists, including Bonnard, Aristide Maillol, and Édouard Vuillard. Stirling was at his most expansively experimental in his smaller works. Like many traditionally trained artists of the late nineteenth century, he reined in his less predictable impulses and ideas when he was vying for the official commissions that were his bread and butter.

Sloan, along with his wife, Dolly, was a committed socialist; his views of the city's poorest sections were meant to strike with a power that went beyond the picturesque. He was at that time much involved with the socialist magazine *The Masses,* and Peggy remembered years later his arguments with her father, whom she described as "a philosophical anarchist, looking toward the day 'when all men's good shall be each man's rule.' "[28] While Sandy rejected his father's romantic vision of the brotherhood of man, he shared Stirling's skepticism about social engineering. Sandy lived through the 1930s without ever feeling the pull of Marxism or communism, which were embraced to one degree or another by many artists and intellectuals, including some of his closest friends. Calder might not have disagreed with his father, who according to Peggy believed that "governments . . . inevitably become corrupt; the fewer laws and regulations, therefore, the better. For men to become decent and responsible they had to become aware of their relations to other men."[29] To Sloan that would have seemed a utopian vision—as, perhaps, it was. Shinn, one gathers, was also skeptical of Sloan's faith in socialism—a skepticism that some saw reflected in the lighter aspects of Shinn's work. He explored the quotidian life of the city, with its hard-luck neighborhoods and its nightlife full of singers, dancers, and trapeze artists. But he also had a gift for fantastical rococo decoration, and created elaborate harlequinades as décor for the homes of the wealthy and for some of the city's theaters. Van Wyck Brooks recalled that Sloan found Shinn's cleverness "demonic," the way he could move from his pastels of closely observed city streets to his "big Watteau-like tapestry painting."[30]

So far as Stirling Calder's friends were concerned, everything in American art was changing, and changing for the better. What they didn't realize was that the changes they were embracing were taking on a life of their

own. It was the revolt against the old fogies at the National Academy of Design, spearheaded by Stirling's friend Robert Henri, that led to the founding of the Association of American Painters and Sculptors and then, in 1913, to the huge display of contemporary art that came to be known as the Armory Show. Although Alfred Stieglitz had opened his first gallery in New York in 1908 and had already been making the case for Picasso and Matisse, Henri and his cohort had a good deal to do with bringing the most controversial European developments to the attention of New Yorkers. The Armory Show opened in New York and toured Chicago and Boston, bringing to America the news of Postimpressionism, Fauvism, Cubism, and the wild Futurist vision of Duchamp's *Nude Descending a Staircase*. Some of Henri's friends liked some of what they saw. John Sloan later said that "when the work of the ultra-modern artists was brought to this country by Alfred Stieglitz and the Armory Show, I consciously began to be aware of the technique of art: the use of graphic devices to represent plastic forms."[31] Henri, who was represented in the Armory Show, was said to have known, as he went through the enormous exhibition before its opening, that he and his friends had been "dethroned."[32] Abstraction of one sort or another had trumped representation.

William Carlos Williams, who at the time of the Armory Show was still a young poet, never forgot his first reaction to what quickly became the most notorious painting in the show, Duchamp's shattered rendering of a figure in motion, *Nude Descending a Staircase*. "I burst out laughing from the relief it brought me! I felt as if an enormous weight had been lifted from my spirit."[33] The Armory Show helped lift the spirits of an entire generation. As to what Stirling and Nanette Calder thought of the Armory Show, which they almost certainly saw, we have no record, although Stirling's great friend Charles Grafly found it "stimulating," according to his daughter. "To his surprise," Dorothy Grafly Drummond wrote in a memoir, "he discovered in an egg-shaped marble portrait of a lady by Brancusi, vindication of his own theory of head structure."[34] I suspect that Stirling and Nanette had somewhat similar reactions. They couldn't have helped wondering if they were now the rear guard. They certainly disliked much of what they saw. But they were also perfectly capable of taking the measure of the revolutions that were transforming the visual arts.

The importance of all this in the life of their son isn't hard to grasp, because the closer you look at the world in which Alexander Calder came of age, the less need there is to establish some precise point at which he was exposed to modern art or the ambitions of the avant-garde. The avant-garde was always a part of Calder's world, even if his parents frequently perceived

it as an irritant or a threat. Duchamp would never have become Duchamp had it not been for the appearance of his *Nude Descending a Staircase* at the Armory Show in 1913. And it would be Duchamp, less than twenty years later, who visited Sandy Calder's studio in Paris and suggested that he call his kinetic objects *mobiles*.

VI

By 1912, Stirling was feeling confident enough about his health to rent a studio in Greenwich Village, the one at 51 West Tenth Street with the immense skylight about which his son later complained. In order to spare Stirling the long commute from Croton-on-Hudson, the family moved closer to the city, to Spuyten Duyvil; Sandy was delighted in his *Autobiography* to comment that the Dutch name meant "in spite of the devil" or "spitting devil." Peggy and Sandy went to Yonkers High School. The home the family rented in Spuyten Duyvil, the bottom two stories of a house owned by an old Scottish spinster, was less impressive than the Croton-on-Hudson place. But Sandy was quite taken with a separate outdoor staircase that went to the third floor. This was made of quartered oak, sawed in such a way as to show off the grain and create an elaborate decorative effect. Again Sandy had a workshop in the basement. He began to find that, as he later recalled, he "was respected by my playmates for what I could make out of wood and leather with my tools and hands. One time I even made an electric light plug out of a cork, a nail, and a piece of copper wire. But after drawing an enormous spark from this apparatus, I quit bothering electricity."[35]

The Calders' dog, Ursa Minor, came back from Philadelphia. Sandy played second base for the Spuyten Duyvil Boy Scouts. Peggy was beginning to excel at tennis. She was also taking an interest in boys. She remembered how difficult it was "to concentrate on the square of the hypotenuse while an engaging male beat out 'He's a Devil in His Own Home Town' on the back of my seat. It was one of these youths, however, rather than the teacher, who gave me my first inkling that physics could make sense."[36] Despite their growing contact with their peers, Sandy and Peggy remained to a certain extent outliers as teenagers, their assumptions and expectations much closer to those of their artistic parents than they sometimes imagined. A decade later, Calder was astonished to discover that a fellow student at the Art Students League had never been to a play in a legitimate theater, although he had lived in New Rochelle, very near New York, for fifteen years. For Sandy and Peggy, who grew up with a father who was eager to

share a lifelong obsession with the stage, it was hard to imagine that a young man had been so deprived.[37]

In her memoir, Peggy commented that after they had left Yonkers High for the next stop on the Calder family's adventures, she and her brother received a copy of the school yearbook and were surprised to discover that there had been "fraternities, sororities, clubs, and other sorts of activities going on all around them."[38] They hadn't had a clue. They were unusual children living an unusual life. How many teenagers would have thought to give their mother a book about the English Pre-Raphaelite painter Edward Burne-Jones for her birthday, as Peggy and Sandy did on August 4, 1910?

THE PANAMA-PACIFIC INTERNATIONAL EXPOSITION

I

From the nineteenth century deep into the twentieth, international expositions were among the engines of human progress, showcasing advances in science, technology, and the arts even as they brought together the achievements of disparate cultures. As a teenager, Calder had a front-row seat at the 1915 Panama-Pacific International Exposition, where his father, the acting chief of sculpture, orchestrated a vast array of projects. "Art," Stirling announced at the time, "is neither democratic nor aristocratic. It knows no class—it is concerned with life at large—elemental life. *Art is praise and all things in life are its subjects.*"[1]

When plans for the Panama-Pacific International Exposition, to be held in San Francisco, were coming into focus, the National Sculpture Society was asked by the organizers to recommend a director for sculpture projects and unanimously settled on Karl Bitter. Three years older than Stirling and an 1889 émigré from Austria, Bitter had scored great successes at the 1893 World's Columbian Exposition in Chicago and the 1901 Pan-American Exposition in Buffalo. Already overburdened with commissions, he was reluctant to take on what was going to be an enormous challenge. He eventually agreed, with the proviso that he wouldn't move to San Francisco and that the day-to-day operations would be left to a second-in-command, his friend Stirling Calder. Bitter and Stirling made trips to San Francisco in August and December 1912. Bitter died only a few days after the Panama-Pacific Exposition opened in 1915, struck by a car as he came out of the Metropolitan Opera House. For Stirling, who admired what he referred to as Bitter's "fiery initiative and amazing grasp of detail," as well as his "tenacity and generosity," the Panama-Pacific Exposition was a life changer that catapulted him into a decade of extraordinary success.[2]

Both Peggy and Sandy recalled their mother's horror, back in Oracle, on hearing of the San Francisco earthquake and fire in 1906. Three years later, before the family's departure from Pasadena, Nanette had taken the children to see San Francisco. She couldn't have imagined that they would be returning to California anytime soon. They had all been shocked by the ruinous state of the city, which had not yet recovered from the earthquake. They wondered at the heaps of brick and rubble everywhere and the naked fireplaces and chimneys; "twisted pipes and bathtubs," Peggy recalled, "sat forlornly on top of broken beams." Chinatown, however, was an amazing, exotic experience, "full of strange and often not altogether pleasant smells and of many enchanting sights." They had too little money to indulge themselves to the full, but Nanette bought Peggy a little articulated fish made of gold-colored metal, which she wore for many years on a black velvet ribbon.[3] Twenty years later, Calder made an extraordinary fish with a brass wire body for his father as a Christmas present.

The Panama-Pacific International Exposition was a celebration of the opening of the Panama Canal, which transformed San Francisco's relationship with the rest of the country. It was also a celebration of the city's reemergence from the horrors of 1906. The exposition, which rose on land-fill at the edge of the bay, offered spectacular views of the Golden Gate and the East Bay. Here was a vision of an idealized San Francisco, with build-ings, colonnades, courtyards, statues, and fountains arranged for an inte-

The 1915 Panama-Pacific International Exposition illuminated at night.

grated effect. The fine arts were represented with unprecedented breadth and depth, including significant exhibits from France and a couple of other European countries, which had arrived in San Francisco despite all the challenges presented by the war.[4] Writing in *The Craftsman*, one of Stirling's colleagues at the fair, the muralist Jules Guérin—he supervised plans for color and decoration at the exposition—wondered, "What would be better fitting to a country of such Latin temperament than these vivid gardens, stately palaces and circling courts, their Oriental colors splashed through the day with sunshine or gleaming at night with a thousand golden eyes?"[5]

Under Guérin's direction, the temporary buildings made of plaster were given a coat of color so as to simulate the look of travertine; the vast exhibition grounds took on a romantic, rose-tinted glow. Guérin predicted that the exposition would "accomplish something that no modern nation has ever wholly achieved, namely, the wedding of three great arts—Building, Sculpture and Painting—into one perfect and inevitable trinity—a trinity based on harmony of texture, color and design. Heretofore, the work of architect, sculptor and mural decorator has been separately conceived and wrought."[6] The talent came from far and wide, including the architectural firms Carrère and Hastings and McKim, Mead & White from New York. Among the muralists was the Englishman Frank Brangwyn. Camille Saint-Saëns composed a symphony especially for the exposition. The horticulturalist John McLaren, celebrated for his work on San Francisco's Golden Gate Park, featured native plants, including thirty thousand trees. At night everything was drenched in colored lights, the most elaborate and impressive display anybody had ever seen, developed by Walter D'Arcy Ryan, who was already well known for his work on the illumination of Niagara Falls in 1907 and the Hudson-Fulton Celebration in New York in 1909. His use of cut glass in coordination with light, so that the buildings shimmered like jewels, was much admired.[7]

II

The Calders moved to San Francisco in the summer of 1913. Stirling plunged into an enormously demanding job. Aside from completing his own formidable contributions to the exposition—which included the *Fountain of Energy*, the design for a *Star Maiden* to be repeated around the Court of the Universe, and two monumental sculptural groups, *The Nations of the West* and *The Nations of the East*—he was responsible for realizing at full scale maquettes sent to San Francisco by forty-four sculptors. A good deal of the sculpture for earlier fairs had been constructed in New York, with the

finished work shipped to the sites. It was the high cost and risk involved in transporting so much material cross-country that had led to the decision to set up a huge sculpture workshop on the exposition grounds.

Stirling was in charge of a shop that the San Franciscan John D. Barry, in his book *The City of Domes*, described as "a hive of industry, with sculptors, students of sculpture from the art schools, pointers, and a multitude of other white-clad workers bending all their energies toward the completion on time of their colossal task."[8] This has to have been quite a challenge for a man who was sometimes described as retiring. There were in all seventy-eight separate works, including a number of multi-figure compositions. The sculpture workshop was also responsible for producing multiple copies of architectural ornaments.[9] In his introduction to *The Sculpture and Mural Decorations of the Exposition*—one of a number of elegant volumes published by San Francisco's own Paul Elder & Co. to celebrate the fair—Stirling argued that events such as

The Palace of Fine Arts, designed by Bernard Maybeck, at the 1915 Panama-Pacific International Exposition.

the Panama-Pacific Exposition afforded "chances for experiment, invention, and originality only limited by the necessary formal settings of the architecture." Stirling believed that there were two kinds of artists: "the Imitators and the Innovators."[10] Among the innovators was Bernard Maybeck, an American who had studied at the École des Beaux-Arts in Paris and settled in San Francisco in 1890. Maybeck's circular Palace of Fine Arts, with its gargantuan columns, reimagined the Greco-Roman tradition with a brusque monumentality that suggested California's redwood forests. The Palace of Fine Arts still stands, an enduring souvenir of the exposition. Asked to comment on the influence that Michelangelo's St. Peter's Basilica in Rome had on his design for the Palace of Fine Arts, Maybeck explained that it was "all right to copy Michelangelo as long as it comes from here"—and he pointed to his heart. "But beware of those who copy him only from here"—and he pointed to his head.[11]

The Panama-Pacific Exposition unleashed something in Stirling—a wit, a derring-do. His *Fountain of Energy* was an allegorical lollapalooza. From a basin loaded with cavorting mermaids and mermen, representing the four great oceans of the world, emerged an immense globe surmounted by an

A. Stirling Calder's Fountain of Energy *at the 1915 Panama-Pacific International Exposition.*

equally enormous horse carrying a broad-shouldered, athletic rider. He was the apotheosis of Energy, the Lord of the Isthmian Way, riding across the earth. The fountain, one guide to the exposition explained, represented "Energy, the Power of the Future, the Superman." The rider carried on his muscular shoulders two smaller winged figures, Fame and Glory.[12] Some have seen in Alexander Calder's 1929 *The Brass Family* an echo of the *Fountain of Energy*, with the enormous, athletic figure carrying aloft six smaller figures. That may be so. But what hasn't been sufficiently appreciated is that Stirling was himself in 1915 an artist of wild, daring ambition—a man in search of the shape of the new. Whatever the influences on the *Fountain of Energy*—and Stirling may have been as indebted to Bernini's *Fountain of the Four Rivers* in Rome's Piazza Navona as Maybeck was to Michelangelo's St. Peter's Basilica—Stirling was also, like Maybeck, working with his heart, not his head, or at least as much with his heart as with his head.

What set the *Fountain of Energy* apart from so much of Stirling's work was precisely his fearlessness—his willingness to dispense with good taste, to go for broke. John D. Barry—who composed articles about the exposition for the San Francisco *Bulletin* in the form of conversations with an architect friend—observed, "The *Fountain of Energy* almost hits you in the face, doesn't it?" To which his friend responded, "Of course. That's exactly what Calder meant to do. In a way he was right. He wanted to express in sculpture the idea of tremendous force." Then the architect went on to worry that the *Fountain of Energy* "suggests too much energy, too much effort, not only of the subject, but of the sculptor." The architect was disturbed by the fountain. He spoke of "a nervous liveliness, characteristically American, not altogether healthy."[13] It was precisely this extraordinary force, energy, and liveliness that Alexander Calder most admired in his father's work. "I have always felt," he wrote on the occasion of the "150th Anniversary Exhibition of the Pennsylvania Academy" in 1955, "that such fantastic and flam-

boyant things as the *Fountain of Energy* and the *Star [Maiden]* at the Panama-Pacific International Exposition . . . represent his best work." Certainly Stirling believed he had done some very good work for the Panama-Pacific International Exposition. He wrote that the *Star Maiden* was "a new type of repeated architectural finial—a human figure conventionalized to become architecturally static—yet not so devitalized as to be inert."[14] This slim figure, her arms held above her head so as to frame her star headdress, must have had a certain magic, silhouetted against the San Francisco sky by day, and with the jewels on the headdress picked out by the exposition lights at night.

In the years immediately after completing his work at the exposition, Stirling fulfilled a major commission for the Oakland Civic Auditorium, designed the sculpture of George Washington the statesman for the arch in Washington Square Park, and created the sculpture for a fantastical stone boat that functioned as a mooring for Vizcaya, the elaborate Florida estate of James Deering, whose family had made a fortune in the farm machinery business. Vizcaya, with its opulent Italianate gardens and elaborate interiors, is a monument of early-twentieth-century aestheticism. Deering was a Francophile, an art collector, and good friends with John Singer Sargent; Sargent did a series of watercolors of Vizcaya, one of which includes the scaffolding set up for Stirling's work. The Vizcaya commission proved controversial when Stirling's female figures were deemed excessively erotic. Stirling, whatever his natural reticence, didn't exactly avoid the limelight. After the family's return to New York, he found himself engaged in heated public discussions about the development of a proper memorial to the World War I dead. He was pushing for designs that felt contemporary. He complained that the proposed *Victory Arch* failed to "express the distinctive character in structure of the period in which the World War was waged, and the ideals of Democracy and Justice which made Victory inevitable."[15]

Stirling saw to completion the Depew Memorial Fountain in Indianapolis, a project Karl Bitter had left unfinished at his death. For Indianapolis, Stirling created a circle of dancing figures. He announced that "we all work too much and play too little, and we do not play joyously enough." He imagined what wonders artists might create if "our spirits and minds and bodies were free." "Through his art," Stirling explained, "a man tells the world what he has seen, and his art changes and develops as his vision of truth grows greater. That is why I am opposed to organization. You cannot organize

A. Stirling Calder. Star Maiden, *1915. Ninety casts of the* Star Maiden *formed a repeating motif, silhouetted against the sky in the Court of the Universe at the 1915 Panama-Pacific International Exposition.*

a vision, and no one can make another man see clearly."[16] His son would certainly have agreed. The Stirling Calder of the Panama-Pacific Exposition and the decade that followed was a powerhouse, very different from the worn-out and dispirited figure some people encountered years later. The Depression and changes in fashion left him with very few commissions. Even when opportunity came his way, he sometimes seemed unable to rise to the occasion. Writing to her son at the very end of the 1930s, Nanette complained that Stirling risked losing a commission for a sundial because "he is so slow + nothing has happened but his making sketches."[17]

III

When Alexander Calder came to write about the Panama-Pacific International Exposition in his *Autobiography*, he lavished a good deal of attention on the pointing machine in the sculpture workshop, which was used to enlarge models into monumental statues. This had been designed by one Robert Paine; it had already been used at the World's Columbian Exposition in Chicago in 1893. Apparently Calder wasn't the only person who was fascinated by this elaborate contraption. John Barry, in *The City of Domes*, commented that "it was interesting to see it at work, under the guidance of careful and patient operators, tracing mechanically the outlines and reproducing them on a magnified scale."[18] Calder went into considerably more detail. "This," he explained, "consisted of two parallel needles, one longer than the other, according to the enlargement. It worked with a parallelogram. The small sculpture and the framework for the large sculpture were placed on two turntables which turned together through sprockets and a bicycle chain. The sculptor would put a cross on the small plaster figure and drive a nail into the wood framework where the other needle came. Rotating all about the high and the low spots, these would be represented by nailheads in the enlarged structure. The gaps between nails would be filled in according to the taste of the sculptor at work. I'd be particularly fascinated by the mechanics, the rotating motions and the parallel needles of the process."[19]

By the time Calder described the pointing machine in his *Autobiography* in 1966, he himself was immersed in the creation of monumental sculptures—and thus in dramatic experiments with size and scale. Both Stirling and his son began their large public works by developing ideas in small models known as maquettes. The challenges involved in transforming maquettes into monuments preoccupied the son as they had preoccupied the father. (They had preoccupied Calder's grandfather as well.) The Calder clan's

continuing involvement with large-scale public sculpture was certainly discussed in Alexander Calder's later years, when the son's work for Expo 67 in Montreal and for the 1968 Olympics in Mexico City seemed to echo the efforts of his father half a century earlier at the Panama-Pacific Exposition. Much as Stirling had to set up a workshop with trained specialists in San Francisco, Sandy found himself training craftsmen in Connecticut and France. Although Calder didn't use a mechanism like the pointing machine, he was definitely involved with the mechanics of scaling up works—as well as all the technical and engineering problems involved in producing durable structures on a large scale. The Biémont Iron Works in Tours carried out wind tunnel tests to ensure that Calder's largest works could withstand any meteorological challenge.

Calder's keen appreciation of the pointing machine has many implications. It marks the beginning of a lifelong fascination with relatedness—with the extent to which an object X and an object Y can be simultaneously similar and dissimilar. In the mobiles of his maturity, Calder often used a series of forms that were radically different in size but closely related in shape. Such arrangements suggest an evolution or devolution—from the smaller to the larger or the larger to the smaller—that has biological, zoological, or cosmological resonances. Calder was able to move from the miniature to the monumental and back with as much easygoing genius as any sculptor who has ever lived. He created tiny tabletop standing mobiles with the spiderweb strength and delicacy of an Emily Dickinson poem. And he produced stabiles seventy or one hundred feet high that have the colossal impact of Melville's *Moby-Dick*. The pointing machine was quite literally a mechanism designed to turn small things into colossal things.

IV

Peggy recalled that her brother was a constant visitor to his father's workshops between the time the family arrived in San Francisco, in the summer of 1913, and the official opening of the Panama-Pacific International Exposition, on February 20, 1915.[20] Once the exposition had opened to the public, Peggy and Sandy were confronted with a bewildering assortment of sights and spectacles. They spent as much time as they could at the fairgrounds.[21] Some have wondered how attentive they were to a group of Futurist paintings in the Italian section, which had been organized by the movement's ringleader, Filippo Tommaso Marinetti. Those works were by many standards the most radical creations in the exposition, and Peggy did

TOP *The conveyor system in the Machinery Hall at the 1915 Panama-Pacific International Exposition.*

ABOVE *Street scene in the Zone at the 1915 Panama-Pacific International Exposition.*

remember wandering with her brother and their friends amid the galleries and colonnades of Maybeck's Palace of Fine Arts, where the Futurist works were on display. They would also have had an opportunity to see an impressive gathering of French artworks—sculptures by Rodin and paintings by Courbet, Manet, Puvis de Chavannes, Monet, Pissarro, Degas, Cézanne, and Gauguin. All in all, this was one of the most expansive exhibitions of French painting in America at the time. There was an equal, if not stronger, showing of American art. We don't know what, if anything, particularly struck the adolescent Calder's fancy. We can be sure that as he dashed around the exposition, he was aware of his parents' interest in this splendid display of modern art.

Paintings and sculptures may well have been the least of what the exposition had to offer to a teenager with Sandy's mechanical bent. The Haye Machinery Hall presented a fantastic display of a conveyor system, transporting boxes on a sort of rising and falling, carnivalesque journey. The Palace of Liberal Arts held a vast telescope. There was the Palace of Transportation, with magnificent offerings of bicycles, cars, and trains. There were biplane demonstrations; Peggy remembered their watching "Beachey's stunt-flying exhibitions in that new-fangled device, the airplane, but happily they were not present when he fell to his death."[22] Loie Fuller performed at the exposition; she was already a favorite of the Parisian avant-garde with the butterfly dance she did in a filmy costume illuminated by colored lights. The fair was chockablock with the sort of fantastical popular imagery that a few years later would enrapture the Surrealists. In the Palace of Liberal Arts stood a gigantic version of an Underwood typewriter, 1,728 times larger than the Underwood Standard; it weighed fourteen tons. There was an enormous telephone on display in the Palace of Manufacturers, designed to call attention to the recent development of transcontinental phone connections. We

know that the Calders spent time with this display, as Peggy remembered their waiting for their first coast-to-coast telephone call to be put through.[23]

A particular magnet for teenagers like Sandy and Peggy was the Zone, the section of amusements and concessions at the eastern side of the grounds; it provided some of the background for *The Boy Scouts at the Panama-Pacific Exposition,* a suspense novel that was one of a number of books for young adults to come out of the exposition. "I understand there are dozens and dozens of eating places to be found in the Zone," one of the Boy Scouts observes. "If you want you can have an Arab dinner, a Chinese chop suey, a French meal *à la carte,* a German one, anything your taste calls for." Another boy explains, "After I once get inside the Zone, Rob, nothing can drag me out again for the whole afternoon." He urges his friend to accompany him "in roaming around among all the queer sights."[24] Peggy and Sandy must have loved the Zone, with its array of foods and amusements and gatherings of peoples from around the world, who offered performances of native dances, demonstrations of jewelry making, and much more. "So they sat there for a long time"—this is again from *The Boy Scouts at the Panama-Pacific Exposition*—"while the procession of Head Hunters from Borneo, natives of the island of Ceylon, South American *vaqueros* in their picturesque attire, pigmies from the heart of Africa, Mexican bull-fighters, Moros from our island possessions in the Orient, Chinese, Japanese, Servians, Tyrolese mountain climbers and yodlers, and a multitude of others continued to pass, many of them coming from the villages and side shows of the great amusement park."[25]

What aspects of the exposition, beyond the pointing machine, stuck in Calder's mind? Did he notice the Futurist paintings, as some have speculated? Did he stop and look at Frank Brangwyn's allegorical murals representing earth, fire, water, and air, paying particular attention to the representation of air, complete with windmill, rain clouds, arrows, and a flock of birds? Or did Calder let it all wash over him—Brangwyn's murals, his father's *Fountain of Energy,* a fourteen-ton typewriter—excited by the freedom with which artworks and machines and exotic sights, sounds, and tastes were mixed together in this great secular spectacle?

V

The couple of years in San Francisco were by any measure a very happy time for the Calder family. Nanette and Stirling, who had always been Francophiles, surely responded to the city's well-earned reputation as the Paris

Calder with his parents, c. 1914.

of America—to the many French restaurants, the Parisian feeling for erotic freedom, and the Parisian sense of Sunday as a day devoted not to God but to promenades, picnics, and sundry pleasures.[26] As was so often the case when Stirling was contentedly immersed in his work and money was coming in, Nanette felt freer, able to hire help to run the house and perhaps not so often called upon to minister to her husband's darker moods. Forty years later, she would recall in a letter the pleasure of being in San Francisco, where she "had a studio and did a lot of painting—large canvasses of portraits."[27] Meanwhile, the family's nomadic life continued. In San Francisco, they first lived in a house that had been rented for them on Broderick Street, within walking distance of the exposition's sculpture workshops. Six months later, they moved to what Calder remembered as "a very pretty house" on the corner of Taylor and Green, high up on Russian Hill, the only one in the area to have survived the earthquake and fire, a place on three levels with spectacular views across the bay to Berkeley.[28] Later still, after Stirling's obligations were fulfilled at the exposition and he had taken on a commission to produce decorations for the Oakland Civic Auditorium, they moved to Berkeley, where they lived at the bottom of Strawberry Canyon.

Peggy and Sandy, now deep in their teens, were beginning to set their sights beyond the family circle. Sandy was enrolled in San Francisco's Lowell High School, which was for students with especially strong academic abilities. Looking back on those days in her memoir, Peggy speculated that for the first time since the family had left Pasadena, Sandy found himself included in what she called "the friendly whirl of after-school activities."[29] Although he was already well aware that he was anything but an athlete, he wasn't averse to plunging into the give-and-take of adolescent sports; his fundamentally imperturbable personality seems to have armored him against disappointment. He went out for rugby and enjoyed the practice in Golden Gate Park, although he didn't make the team—a fact about which he was somewhat more circumspect in his *Autobiography* than Peggy was in her memoir. When his parents moved across the bay, Sandy remained in San Francisco to finish high school, staying with the architect Walter Bliss and his wife, friends of the Calders' who had no children of their own.

Bliss's partner, W. B. Faville, had made the initial suggestion for what became a much-discussed feature of the exposition, a great fence made of boxes filled with earth and South African dew plants; when the boxes were piled up, the effect was of a massive hedge.[30] Sandy remembered coming to the aid of Bliss, an ardent gardener who was battling slugs, by fashioning "a two-pronged fork out of wire with a trigger ejector with which he could demolish the slugs at his ease." This was yet another one of Sandy's youthful inventions. Bliss's house, which he had designed himself, was elegant, with a gold-walled dining room and windows through which they watched the fireworks at the exposition. Sandy rode the cable car to school, and in his *Autobiography* he recalled being fascinated, as so many others have been, by the operation of the cars and the turntables where their direction was reversed. "The machinery and the movement interested me and the spasmodic yanking was rather reposeful," he thought, adding that he liked the look of some of the cars, "gaily painted, basically white with gold trickles and spots of color like a circus wagon."[31]

Peggy enrolled at the University of California at Berkeley, with the intention of becoming a social worker; she had been inspired by Jane Addams's *The Spirit of Youth and the City Streets*. She worked with Jessica Peixotto, the second woman to receive a PhD at the university; one of her brothers was the artist and author Ernest Clifford Peixotto, who celebrated the natural beauties of California. Sandy was fascinated by the freedom his sister experienced at a big coeducational university. On weekends, she came back home with her laundry; the siblings spent as much time together as they could. Sandy got to know all his sister's Berkeley friends. The university also brought a new man into the Calder family, Kenneth Aurand Hayes. In Peggy's memoir, she introduced Ken through Sandy's eyes. The siblings were watching a rugby game that pitted the California team against the All Blacks from New Zealand. "As the game progressed," Peggy remembered, "it soon became obvious that Cal's valiant amateurs were outclassed. At one point in the game, the ball went sailing downfield into the arms of a Cal man who signaled for a fair catch. The New Zealand forward, racing after the ball with every intention of committing murder, had to swerve at the last second because of the fair-catch signal. It was a tense moment as he stood glowering over the youthful Cal player with impotent rage. The Cal man reached up and tickled him under the chin. The tension dissipated in the ensuing roar of laughter and applause."[32] Sandy immediately wanted to know who the audacious Cal student was. Peggy was able to reply that his name was Kenneth Hayes, that she had met him a few weeks earlier at a dance, and that "He's fun!"

Ken Hayes was from a prominent Washington State family with interests in timber and banking. His father, Harry Hayes, had died of typhoid fever in 1904. His mother, Frank Baker Hayes, was now married to a sportsman by the name of W. J. Patterson. She was living in Berkeley with Ken and his sister, Jean. Mrs. Hayes was an ardent supporter of the suffrage movement; women already had the vote in Washington State. Ken was handsome, athletic, and genial. To the Calder kids, he must have seemed the prototypical college man. But Ken and Jean had their own offbeat side. They had been performing a song-and-dance routine, as an accompaniment to the suffrage speeches their mother gave here and there. Peggy remembered exactly how the song went:

> Reuben, Reuben, I've been thinking
> What a fine world this would be
> If they'd give the vote to women
> All along the western sea.[33]

The Hayeses were a pleasure-loving family. In the summer of 1915, the Calders were joined for a vacation at the Blisses' house on Lake Tahoe by Ken, his sister, his mother, and his sister's fiancé. On the way to Tahoe, with the Hayeses' Packard stowed on the steamer that took them up the Sacramento River, a Dixieland jazz band played on the deck. Although Stirling, after a few steps, was reluctant to participate any further, Ken, Peggy, Sandy, and Nanette danced up a storm, doing the kitchen sink, which was then the rage, with four or five stiff-legged waltz whirls counterclockwise, followed by a quick bend and dip in the opposite direction.[34] Nanette, forty-eight at the time, threw herself into the fun, although she later complained of a bad back.

In the last year or so in California, Sandy became close to Ken. As part of his preparations for college, he took a chemistry course at Berkeley. He and Ken spent long afternoons together in the university pool in Strawberry Canyon, where Sandy learned to swim under the tutelage of an old Norwegian lifeguard. Stirling and Nanette, confronted with Peggy's intention of marrying Ken, insisted that she return east with them in the fall of 1915 and finish college at Barnard. They hoped that their daughter would have not only a husband but also a career. Peggy and Ken were married in June 1916 in New York. Theirs would be an enduring union. After some time in Washington State, they settled back in Berkeley. Peggy taught children's art classes for many years, worked to preserve the ecology of the San Francisco Bay, and became involved with U.C. Berkeley, especially the development of

the art museum. In the 1930s, Ken founded the Puro Water Filter Company, which installed filters on faucets to provide clean water straight from the tap. Although he never formally graduated from Berkeley, he remained devoted to the university where he and Peggy had met. He died of a heart attack while addressing the Golden Anniversary Class of 1916. In a little memorial pamphlet published after his death, his wife, referred to as "gallant Peg, his wife for fifty years," said that "there was something tremendous in going out in full sail, flags flying in the service of something he felt so keenly about and a place he loved so."[35]

VI

In the spring of 1915, Calder was finishing his last semester of high school. In this serious and striving family, there cannot have been any doubt that he would go to college. But what he would study was by no means clear. Calder was doing very well in challenging high school classes. And he was a whiz with his wires and pliers. But he was unwilling or at least reluctant to soberly face the future. In the *Autobiography*, Calder recalled his father asking, "What do you want to study?" Which set Sandy—who described himself as a bit nonplussed by the question—to thinking about one of his schoolmates. Hyde Lewis, Calder explained in the *Autobiography*, "was going to be a mechanical engineer. I was not very sure what this term meant, but I thought I'd better adopt it."[36] In the autobiographical notes written a decade earlier, Calder made the decision sound even more casual. He observed, "I 'just naturally' wanted to go to college—having seen the fun Peg was having." There may have been an edge of mockery—maybe self-mockery—in the "just naturally" and the argument that you go to college because it's going to be "fun." As for the decision to be an engineer, Calder wrote, "I guess [engineer] was the only profession I had ever heard of, except for 'artist'— and I did like mechanics."[37] It strains credulity to believe that Sandy Calder knew of no other professions that might interest him. We need go no further than Mr. Bliss, who was an architect and in whose house Sandy was living at the time.

The sixteen-year-old Sandy Calder was probably no more uncertain about his future than many a young man or woman is at that age. When, decades later, he contemplated his younger self, he may have been both charmed and bemused by the contrast between the ordinarily confused or ambivalent adolescent he had been and the preternaturally alert, creative spirit he became little more than a decade later. Over the years, a legend developed that

Calder's parents pushed him into engineering—even though, by his own testimony, he didn't seem able to think of anything else he wanted to do. It does appear to be the case that once Sandy said something about mechanics or mechanical engineering, Stirling turned for advice to the chief engineer of the exposition, who suggested that the boy apply to the Stevens Institute of Technology, in Hoboken, New Jersey. That was exactly what Sandy proceeded to do. There can be no question that Stirling and Nanette were anxious about what the future would hold for their immensely talented and perhaps, to their eyes, overly carefree son. What parent wouldn't sympathize with their wanting to give him a little shove?

Many years later, when it was suggested to Nanette that she and Stirling had initially pressured or at least encouraged their son to reject the life of the artist, Nanette would have none of it. "Nobody not even Louisa," she responded, "could make Sandy do what he doesn't want to."[38] There was certainly some truth to that, perhaps all the more so when Calder was in the throes of adolescence. In any event, somehow, together with his parents, Sandy settled not only on the study of engineering but on what was by many measures the best place at the time to study it. The Stevens Institute of Technology, anything but a trade school, was guaranteed to provide a rich, full, and rounded experience, with an integrated single curriculum that emphasized mastery of language skills and the humanities along with the sciences. Stirling, feeling financially flush after his work in San Francisco and Oakland, was more than glad to pay for this serious, solid education.[39] Engineers were in demand; according to one observer, there were "several times as many positions open as there were graduates."[40] Fifteen years later, well after Calder had once and for all rejected the life of the engineer, his education at Stevens at the very least strengthened his hand as he took on the challenges of a radically new sculptural form.

Perhaps something of the easy, optimistic spirit of San Francisco, risen phoenixlike from the horrors of the earthquake and the fire of 1906, remained with Calder for the rest of his life. Peggy, with whom Sandy would never again spend so much concentrated time as he did in the Bay Area, remembered one night during their months in San Francisco when she was returning from the exposition to Berkeley. Although Calder was probably not among the cohort that evening, like them he knew the happiness of those days and nights. "We sat in the stern as the ferry pulled out," Peggy reminisced, "listening to the mellow tones of the carillon in the Exposition's Tower of Jewels and watching the lights go out at the Fair. Singing was spontaneous. One moonlight night, Elizabeth Witter, a handsome, big girl with luxuriant sunkist hair and a lovely contralto voice, started 'Sumer is

Icumen In,' the song she had sung in the Parthenia, the Women's Spring Festival. As we all joined in and the lights went out, the water seemed black and mysterious. Stars appeared overhead as the ferry churned along, carrying us back to reality."[41] For Sandy Calder, the Stevens Institute of Technology in Hoboken, New Jersey, would be the next reality.

THE STEVENS INSTITUTE OF TECHNOLOGY

I

"The first day in college felt like racing cars starting from a standstill," Calder recalled in his *Autobiography*. There was certainly no time for reflection during those early weeks at Stevens.[1] Like his sister before him, Calder plunged eagerly into the hurly-burly of college life. He may have breathed a sigh of relief. He was loosening the bonds that bound him to his unconventional, artistic family—and catching at least the tail end of a more predictable sort of American coming of age. Amid all the excitement, Calder made a bad deal on a set of drafting instruments, buying for what he thought was a good price a set that wasn't very good and whose purchase he would regret for the four years he used them. He would, however, keep those instruments for the rest of his life. Many years after his death, and after his younger daughter, Mary, died, they turned up in her house in New York's Greenwich Village, his name etched in the metal, a souvenir of those first hours at Stevens.

When he entered his freshman year at Stevens, Calder had only recently turned seventeen. That was the youngest age for admission to the college, the average in the past couple of years having been nineteen. Younger students were advised to make sure they were well prepared, or else wait a year or two before enrolling.[2] Much as he had found strength in being the littlest one at home, being one of the youngest students at Stevens may have been a situation that Sandy sensed he could use to his advantage. He would remain the brilliant boy. His youth was underscored by his physique, for amid the scores of students taking on the lean, muscular look so natural in early manhood, Sandy, with his comically round face, only seemed to be gaining baby fat as the years went by. In 1918 in the Stevens yearbook, the *Link*, the young man with the brown hair and hazel (or, to some, blue) eyes was saluted as "Sandy-child," his face "always wrapped up in that same mischievous, juve-

nile grin."[3] More than thirty years later, Calder's wife commented to their friend Bill Rogers that Sandy "always looks like a baby."[4]

Calder was certainly academically prepared. In an uncharacteristically sober passage in his *Autobiography*, he recalled that in San Francisco he "had been trained to be studious, working every night at home, seldom going out. On top of it all, I liked mathematics."[5] If Calder's parents were aware of how young he was to be entering college, his father, who had been sixteen when he entered the Pennsylvania Academy, may have felt that there was no harm in starting early. At Stevens, Sandy wasn't far from home, just a ferry ride across the Hudson River from his family; they were living on the Upper West Side, on Claremont Avenue, right around the corner from Barnard, where Peggy was completing her studies, and a few steps away from Columbia University. Stirling had his studio downtown. At least at the outset, Calder returned home on weekends. Although nobody has ever said that any engineering program other than the one at Stevens Institute was considered, it may be that the reason Calder didn't end up at Cornell—which also had an excellent engineering program—or some other place was that the family didn't feel that their baby boy could or should be entirely on his own. Perhaps Calder didn't feel ready, either.

Founded in 1870 on a Hoboken bluff high above the Hudson River, the Stevens Institute of Technology was spectacularly sited, with wonderful views of the river and New York City. A few years later, when he had decided to become an artist, Calder painted a number of views of the Hudson, paying particular attention to the variety of boats plying the waterway. There was exhilaration in those first days at Stevens that September, not the least because Calder took an immediate shine to the room he shared with two other students, a third-floor space in what was known as Castle Stevens, the elegant summer home of the school's founding family and a building that had only a few years earlier become part of the campus. Calder, who even as a boy was acutely sensitive to the quality of living spaces and would forever fondly remember the barnlike house in the Arroyo Seco in Pasadena and the stone house in Croton-on-Hudson, loved his beautiful room in a square tower. "Really a wonderful room," he remembered, "with windows looking up and down the river and across—it was all windows."[6] Calder must have felt the poetic force of that tower room, an airy perch from which to regard the world. In the poetry of Yeats and Rilke and some other creative spirits whom Calder would soon join in the great modern adventure, the tower was the ivory tower, the place where the artist stood apart, floating above the fray, forging new forms out of life's passing parade. In his *Autobiography*, Calder mentioned that room not once but twice, recalling how he

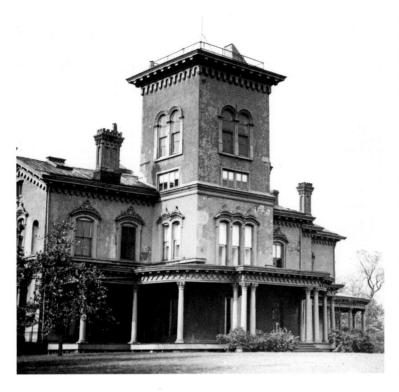

The Castle at the Stevens Institute of Technology, Hoboken, New Jersey, c. 1915. During his freshman year at Stevens, Calder lived on the third floor of the Castle.

regretted leaving it at the end of freshman year, "sacrificing the tower room with the beautiful light and views on the river—this meant a lot to me."[7]

II

The Stevens curriculum was demanding. The admission exams, which Calder had taken the previous June, had been tough, covering algebra, geometry, biology, trigonometry, physics, chemistry, English, and Latin. Calder remembered that only a quarter of the entering class managed to graduate, and although that might be something of an exaggeration—and service in World War I certainly affected the numbers, with some young men taking more than four years to finish—the thirty-five students with whom Calder received his degree in 1919 undoubtedly represented only a fraction of his freshman year cohort. Among Sandy's fondly remembered freshman friends who dropped out before too long were a Chinese fellow, Chor Hing Ou; a Cuban by the name of Mariano Juncadella; and Rube Ford, a terrific athlete with a nifty little automobile and a knack for impressing a local Hoboken cop, who kept enthusing about what a "swell guy" Rube was.[8]

The struggles some of Sandy's friends had with the curriculum may not have seemed real to him. Although Sandy Calder was never one to show off his scholarly prowess, he easily penetrated the mysteries of college math and science. Sitting in Professor Edwin R. Knapp's descriptive geometry course in his sophomore year—he received a 97 in the second term—Calder came up with answers to difficult problems effortlessly, as students around him struggled. His friend Bill Drew remembered him as "never a 'grind' because he didn't have to be."[9] Years later, the director of admissions at Stevens, Nichol Memory, looked up Calder's grade in descriptive geometry and, as he wrote in a letter to the artist, "discovered to my amazement that, so far as I know, you are the only student at Stevens who ever got a grade

of 100 percent."[10] Calder's engineering notebooks were for years preserved in his old fraternity, as a model for future students.[11] Exams were on the honor system at Stevens. Calder served on the honor board at one point, and during his term, ten students were accused of cheating. The student honor board ruled strictly, arguing that the offenders should be expelled. They were surprised to find their ruling then reversed by the institute's president, Alexander Humphreys. "He was a good man; his idea was to educate people, not expel them," Calder recalled. "He too was doing his duty."[12]

Calder (front row, second from right) with the Stevens Institute of Technology lacrosse team, c. 1918.

Calder's academic gifts were of no use when it came to college sports, and yet even here he approached each and every challenge with a mysterious, cheerful aplomb. The portrait of Calder in the Stevens yearbook was accompanied by a little proverb: "A blithe heart makes a blooming visage." It was Scottish in origin, so possibly something that came from the family. In any event, it suggested the high spirits that endeared Sandy to his contemporaries even when he might be less than graceful on the athletic field. He was just two inches under six feet, with an ungainly gait and a backside that he was all too aware was a source of comic fun. He later recalled that he had to become "quite impervious to jests about my rear." Nevertheless, he threw himself into college sports. He played football so badly that he was never actually in a game. He did a little better at what was the admittedly less competitive game of lacrosse, where in his junior and senior years he was on the varsity team.[13] In spite of his enthusiasm for lacrosse, he was, by his own admission, "not very agile."

When Stirling came to watch a game, he was dismayed to overhear some boys warning his son, who had managed to get the ball on his stick, "Go it, Sandy, don't fall down now."[14] In his unpublished autobiographical notes, Calder recalled Billy Hills, a quarterback on the football team, "warming his hands on my ass."[15] As much as possible, Calder took all this in stride. He embraced as best he could the role of the team mascot, the bright, childish kid whom everybody ribbed but also protected. A writer in the Stevens

yearbook offered an impression of the determined young man at play: "It is a rare afternoon when Sandy's bulky form is not seen lumbering over the soil."[16] Years later, Sandy's good friend Bill Drew recalled him as "powerful but not agile, fat but not tubby."[17] Despite his mathematical prowess, he had trouble understanding the lacrosse plays, perhaps too nervous to take in a series of numbers. "I was often still figuring it out," he recalled, "when the play came through where I was standing." And yet he persisted. He valued the comradeship, and maybe even more than that, he craved the physical exercise. He figured that it did him a world of good. "It was about all the concentrated exercise I've ever had."[18] His efforts didn't end at Stevens. Several years later, when he briefly studied boxing in New York, his instructor, Danny Hickey, commented, "You're like an old whore at a wedding."[19] In letters from Stevens to his sister, by then back on the West Coast, he wrote of dances and roughhousing with other boys, and of sledding and ice skating. Skating was a passion, the arabesque movements across the ice prefiguring the movements of his mobiles decades later. Dancing was another passion, though there was no particular partner on whom he focused his attentions.[20]

A few comments Calder heard during his college years stuck with him. He remembered Coach Rogers saying, "Make up your mind what you're going to do, and then see what the other fellow is going to do."[21] To President Humphreys's "good enough is best," Calder responded in his *Autobiography* that although that might hold for engineers, it wasn't true for artists.[22] A couple of remarks by a fellow student, Louie Martin, came to have particular significance for a man involved with the mysteries of abstract art: "If <u>one</u> guy says a thing is ambiguous—it's ambiguous." And: "A dispute over something is (usually) a matter of definition."[23]

III

Looking back from the later decades of Calder's career, when he was manipulating metal elements to create a radical kinetic art, it is obvious that Stevens, where he studied physics and mechanics and became acquainted with the properties of all manner of metals, is an essential part of the story. Writing in the *Magazine of Art* in 1944, Calder's friend James Johnson Sweeney observed that "Calder grew up in an age in the United States when the frontier of science, mechanics and engineering had replaced the national frontier in the popular imagination."[24] There was certainly a sense of adventure at the Stevens Institute of Technology in the decades after it was founded as the first college in the country dedicated to training young men to be mechani-

cal engineers. Thomas Edison, who held America in thrall with an endless stream of inventions, was already hiring Stevens graduates in the late 1870s; they worked on the development of the incandescent lightbulb and the illumination of lower Manhattan.[25]

But the Stevens Institute of Technology, by the time Calder was studying there, was committed to the systemization and rationalization of what had initially been a discipline based on apprenticeship and improvisation. Stevens, like other serious engineering programs in the United States, was working to bridge the gap between the old world of shop culture and the new, industrialized America, where engineers would be executives, directing a fleet of workers. There was a good deal of debate, all through the late nineteenth and early twentieth centuries, concerning the importance of shop work in the training of a mechanical engineer. Some argued that the schools might be better off focusing on the serious study of mathematics or physics—and most important of all, on the development of strong managerial skills.[26] Among the early graduates of Stevens was Frederick Taylor, who came to be known as the father of scientific management; the goal of the Taylor method was to put the work in a machine shop on a more tightly organized and therefore supposedly more smoothly running basis. The typical Stevens student, from a well-to-do family with a father in a substantial profession, aimed to become a highly paid professional. The program threatened what an engineer by the name of John T. Hawkins referred to in 1906 as the "old-time conscientious, faithful, intelligent, finger and brain wise mechanic."[27]

Calder never had the temperament for the kind of managerial role in engineering that so many Stevens graduates pursued. But he had all the makings of a finger-and-brain-wise mechanic, and he couldn't help but be excited by the old-fashioned fundamentals of the curriculum. The hours he had spent in his boyhood workshops were the best imaginable preparation for the freshman course in shop practice taught by Alfred S. Kinsey (whose son, also named Alfred, spent two years at Stevens and later became famous for his studies of the sexual habits of Americans). Kinsey senior had started working at Stevens as a machinist's helper in 1886, when he was fifteen.[28] His freshman students learned to cut steel, tin, nickel, zinc, copper, brass, bronze, cast iron, and aluminum, and how to drill and punch holes and join metals by brazing, soft soldering, hard soldering, riveting, and fusion welding.[29] The textbook Kinsey prepared for his students was loaded with the kind of nitty-gritty thinking about materials that would preoccupy Calder later on, when his fingers, at the bidding of his brain, were developing new sculptural forms. Kinsey discussed the relative malleability, ductility, and weldability of

Students working in the machine shop at the Stevens Institute of Technology, c. 1920.

steel and a range of other metals.[30] This primer in techniques may well have been as important for the sculptor Calder became as the fifteenth-century artist Cennino Cennini's *Treatise of Painting* was for the artists of the Renaissance.

The classes at Stevens left Calder with a heightened awareness of the physical principles that shaped the visual world; he studied physics, mathematics, chemistry, descriptive geometry, mechanics, hydraulics, thermodynamics, and electrical and structural engineering. Professor Knapp's course on descriptive geometry and mechanical drawing, as described in the *Annual Catalog, 1915–16,* covered the "solution of problems consisting of relations of points, lines, and planes to developable single-curved surfaces, and to double-curved surfaces of revolution. Intersections and developments. Practice in transferring to graphical diagrams, conceptions of determining representations on reference planes, of geometrical magnitudes and their relations in space."[31] Calder, who had been fascinated by the pointing machine at the Panama-Pacific International Exposition, was interested in anything that had to do with questions of shape, size, and scale. He may well have found Professor Knapp's lectures as stimulating as avant-garde artists, a decade later, found Kandinsky's book *Point and Line to Plane*. He was certainly excited by the imaginative dimension of mathematical thinking. In Professor Knapp's freshman-year class, Calder received among his highest grades of the year, a 90 the first semester and an 85 the second. He finished his freshman year with a 91 in mathematics.

Senior year brought Applied Kinetics, a course in which students explored the range of mechanical movements. The young man who would a little over a decade later invent the mobile learned about—I quote from Geoffrey W. Clark's *History of Stevens Institute of Technology*—"instantaneous motion, motion in a given time, acceleration, velocities, and the effects of friction and resistance." In the course catalog, the class was said to cover "discussion of the laws governing the plane motion of rigid bodies with applications to machines, compound and torsion pendulums, translating and

rotational bodies, discussion of work and energy, with simple application in machines."[32] It's difficult to imagine a college course that could have shaped Calder's later artistic concerns more profoundly.

IV

Two or three of Calder's contemporaries at Stevens remained true friends. When Calder first went to Europe in 1926, Robert Trube was working in London. Calder stayed with him for a few days, and Bob put him in touch with his parents and his sister, who were living in France at the time, where Bob's father's career had taken him. The Trubes helped ease Calder into Paris, although he rapidly embraced a bohemian lifestyle alien to them. Another Stevens classmate, Jimmy Horn, helped out with the mechanisms for the motor-driven sculptures Calder made in the 1930s and knew some of Calder's avant-garde friends in Paris. He drew up the plans for the studio Calder built on his Connecticut property in 1938.

Calder with his classmates Bob Trube (center) and Bill Drew at the Stevens Institute of Technology, c. 1919.

The collegial bond that remained strongest was with William F. B. Drew. He came from a solid working-class Irish Catholic family in Germantown, on Manhattan's Upper East Side. He was the first in a long series of able, pragmatic, highly successful men who were drawn to the brilliant complexities that Calder sometimes chose to hide behind a bold, benign façade. While many of the students at Stevens were the sons of well-heeled professionals, Bill Drew's father was a highly skilled cabinetmaker who, according to family tradition, made display cases for department stores as well as for the Metropolitan Museum of Art. Drew may have been especially attuned to the as yet inchoate artistic gifts of his bright, funny Stevens friend. The Drew siblings, eight in all, were a hard-driving lot. Among Bill Drew's brothers, one became a lawyer, one a doctor, and one a priest; a sister was an administrator at the distinguished girls' school Hunter College High. Drew, after graduating from Stevens, went to work for an uncle, J. L. Murphy, in the plumbing and heating business. He had an extraordinarily successful career, ultimately overseeing heating and cooling systems for premier Manhattan sites, including the Waldorf-Astoria hotel. Drew married a woman whom his daughter

describes as having a European background. He was a bon vivant, known in Manhattan's finest restaurants, but he stood a bit apart from the social whirl, preferring a weekend house in Westhampton to the more obviously fashionable Southampton or East Hampton.[33]

Drew, a star athlete, helped Calder feel more at ease with the collegiate life. And Calder helped Drew with the dicier aspects of mathematics. It was Drew who made it possible for Calder to become a member of a fraternity, Delta Tau Delta, which, Calder recalled, had "twenty to twenty-five" members, "chiefly athletes—and the sons of well-to-do-businessmen or engineers."[34] Bob Trube was also a member. "Kind of knock you dead, being pledged Delta Tau Delta?" Calder wrote to Peggy in February 1918. "It seems quite funny to me too and tickles my sense of humor immensely."[35] Calder would always take a certain pride in having managed to become a member of Delta Tau Delta. Nearly sixty years later, when he discovered that a young artist working as a gallery assistant was a member of the same fraternity, Calder delightedly shared the secret handshake. At Delta Tau Delta, Calder rubbed shoulders with the big men on campus. He was beginning to make his way among people whose backgrounds and values were rather different from his. He had inherited his parents' sense of themselves as creative spirits and, therefore, natural aristocrats.

It was Bill Drew, according to the Stevens yearbook, who "stepped in as self-appointed Professor of 'Ways and Means in Public'" and helped "Sandy-child" become "quite sophisticated." But when Drew revisited that comment sixty years later, for the collector and curator Jean Lipman's book *Calder's Universe*, he wondered who had been lending sophistication to whom. He suspected that "we were mutually attracted because we had various interests in common."[36] In the 1918 yearbook, Drew himself was remembered as having been, when he first entered Stevens, "most modest." He was characterized as "a flower in the bud." Perhaps he was worried that his working-class background put him at a disadvantage. Eventually he "shed this cloak of modesty"—as, indeed, Calder did. There was also, apparently, a whimsical side to Drew, who was part of some sort of two-man vaudeville team known as "Deghuée and Drew, Inc."[37]

Remembering his old friend Sandy as he was as a young man, Drew evoked an almost saintlike figure. "I never heard him say an unkind or derogatory word about anyone. I don't know if it ever occurred to him that people did those things." There was more. Drew said that his friend had "the clearest mind it has been my pleasure to know." He added, "What struck one at the very start was a very quiet, warm person, physically solid and ready to roughhouse at any moment just for fun. He also played football and lacrosse

just for sheer physical pleasure; and as for dancing, nobody whirled the girls more rapidly. Puns, puns, puns by the ton. He loved them and always accompanied them by that amusing giggle." Calder had lost none of the playful ingenuity that had charmed his sister when he was a boy. "His direct approach to problems was refreshing," Drew recalled. "If anyone lacked studs for a formal affair's stiff white shirt, Sandy suggested brass fasteners that we used to clip the lab reports together. If a visible hole appeared in a black sock for some formal affair, Sandy used black India ink to cover the flesh."[38]

Bill Drew and Sandy Calder were lifelong friends. Drew owned three of the paintings Calder did early in his career, among them one commemorating an outing to play golf with Drew and other friends in 1925. In 1928, Calder spent time at a farm in upstate New York owned by a relative of Drew's and worked on an important series of wood carvings. Drew was the best man at Calder's wedding in 1931 and a couple of years later helped the Calders with the down payment on their Roxbury house. He and his wife attended the memorial service after Calder's death. When Drew's widow died, ten works by Calder went to auction, ranging from an important early painting of a tennis match at Forest Hills Stadium to abstract drawings from 1933 and a brass-and-lead mobile, with fish and flowers, done in honor of the birth of the Drews' daughter, Rosario.

V

Calder's college years were not deeply affected by the war in Europe, although a handful of students from his class withdrew to serve. In the end, twenty-three Stevens students died in the war, most of them with the army on the Western Front.[39] Back in the summer of 1916, Calder had already spent five weeks at the Plattsburg Citizens' Military Training Camp, as he recalled, "quite enjoyably pretending to be a soldier."[40] The Plattsburg program, which ran during the summers of 1915 and 1916, was voluntary, developed by well-to-do Americans with an Anglophile slant who believed the United States would eventually be drawn into the war. (The program was set up near Plattsburgh, New York—which was spelled without the *h* at the time.) Stirling, with his cosmopolitan outlook, may well have thought that the United States ought to enter the war. There may also have been some thought that the rigors of military life would be good for the sometimes lackadaisical Sandy. For the young Calder, the Plattsburg training camp was yet another dramatic departure from the bohemian individualism of his

Calder at the Plattsburg Citizens' Military Training Camp, New York, 1916.

childhood, a plunge into a world of barracks and regimentation. A series of photographs survives of his weeks there, ranging from his neat-as-a-pin bed and cubby to the young Calder flat on the ground, engaged in rifle practice.

When the United States declared war against Germany in 1917, and military training was mandated for all Stevens undergraduates, Calder's Plattsburg experience earned him the post of guide of the battalion; at least that is how he later described it, adding, "That's the guy who walks out front." His new role created more problems. "As I had a way of arching my back," he recalled, "throwing my chest and belly forward, I soon got nicknamed 'the man of 400 degrees.' This embarrassed me quite a bit. So I used to take home my breeches on Sunday and try to sew in the seat of the pants on mother's sewing machine. It was good sewing training for later achievements, but it did not work. I simply had to become hardened to the compliments of my onlookers."[41] By the final months of the war, all undergraduates had to serve in a Student Army Training Corps. This was no small matter, for it involved severely condensing the time allotted for the regular course of study. Calder and Drew were in the naval division. Military life at Stevens, so far as Calder experienced it, consisted mainly of lining up, counting off, and marching on the athletic field. Apparently he continued to function as some sort of guard of the battalion, which suggests that however ambivalent he was, he wasn't incompetent. Always alert to the comedy in a situation, he was amused by the many dogs who drilled with the students and seemed to grasp all the maneuvers. Calder recalled that as he gave orders, he "learned to talk out of the side of my mouth and have never been quite able to correct it since." That was yet another variation on the slurred speech that had already trou-

bled his parents when he was six or so, and that in later decades would be interpreted by some friends as his way of avoiding directly answering an uninvited question.

The war was on everybody's mind, and students could hardly ignore a conflict in which so many men their own age were dying. Hoboken had become the primary gathering point for soldiers going overseas. In March 1918, a United States Navy Steam Engineering School, open to graduates of an engineering school or comparable program, was inaugurated at Stevens. Calder remained insulated from the European nightmare. Perhaps he was too young to think much about death. He would always be good at dismissing dark thoughts. Even late in life, when his health became a challenge, he remained buoyant. When his optimism failed, his pragmatism kicked in. When his pragmatism failed, his optimism kicked in. Over the years, this led some, in my view unjustly, to think him unfeeling. In any event, the best thing about the Student Army Training Corps, so Calder remembered, was that all the military canteens around the city were open to the students. Sandy and his cohort found especially enticing the Brooklyn canteen, where the girls were charming and great fun on the dance floor. Thereafter, he recalled, "we spent most of our time organizing our weekends, and it was rather a disappointment to have our corps disbanded at the end of the war."[42] Such was Sandy Calder's World War I.

VI

Calder, like every other senior, was required to write a paper on some particular problem in engineering. It would seem that students chose their own topics, probably with some guidance from the faculty. When Calder graduated, in the spring of 1919, the topics ranged widely: the design of concrete roads; ways to prevent concrete from freezing; the development of the automobile self-starter; optical properties of single lenses; wage systems in operation in the United States; mine timbering; development of the centrifugal pump; electric light and power for country homes. The point of the papers was to push students to explore some practical problem. Such a study, based on research undertaken beyond the walls of Stevens, may have been designed to prepare graduates for their work as engineers in the wider world. Calder's paper was titled "Stationary Steam Turbines." Given his later fascination with the power of wind to propel the metal shapes in his mobiles, it does seem fortuitous that he wrote about the power of steam under pressure to propel the rotations of the turbine. But whatever the attraction of

An effigy of Calculus, before being set on fire at the Cremation of Calculus, a spring ritual at the Stevens Institute of Technology. Calder preserved this snapshot from the 1919 Cremation.

the topic, Calder didn't seem to put very much effort into the paper. Of the fifteen pages, fully the last eight consisted of nothing but quotations from several books. Calder fulfilled the assignment in the most perfunctory manner. Compared with the papers handed in by many in his cohort, Calder's was rather thin. If the report was in fact meant as a prologue to the work one would do as a professional engineer, perhaps the explanation for Calder's mediocre performance was that he was already beginning to suspect that engineering wasn't for him.

The dizzying challenges of a Stevens education inspired a regular spring ritual, Cremation of Calculus. Although Calder never wrote about it—and, with his mathematical prowess, would not have feared calculus as so many did—the cremation was certainly in line with his taste for theatrical hilarity. Among his papers he kept two snapshots of the stuffed effigy personifying the spirit of mathematics, which was burned along with a calculus text on Castle Point Field after a riotous mock trial. In the snapshots, the dummy, unceremoniously dumped on the ground, has a freakish fascination. You could imagine it attracting the attention of a Surrealist photographer like Umbo or Hans Bellmer or Dora Maar—all artists who would, fifteen years later, be moving in circles that overlapped with Calder's circles. The snapshots Calder kept date from the Cremation of Calculus in 1919, his senior year, but he probably also attended as a junior on June 14, 1918, when the Class of 1920's brief against Cusppydoor Calculus was heard.[43]

Cusppydoor Calculus was charged with plotting the downfall of many worthy members of the student body; he forced them to cast pleasure and revelry aside. In defense of Calculus, it was pointed out that he had not caused "an excess of petroleum distillate to become horribly oxidized." One of the witnesses against Calculus was Cokey Day, who claimed that Calculus had hounded him "like a Bulgarian rat hound stalks a wounded cockroach." Dyspeptic Geometry was called to the stand, one Edward Krapp, his name surely a play on that of Professor Edwin Knapp, who had taught Calder's freshman mechanical drawing class. He was a lecturer and an inven-

tor. "I once invented a synchronized parabolic fly trap," he explained, "but I thought it would be too cruel so I never had it patented." And so on and on, until the judge ruled: "The prisoner shall be burned alive at the stake until he is dead, dead! Dead!!!" After that, the enraged students dragged Calculus to his fiery death. A photograph of the fire was included in the *Link*, so as to corroborate the written reports of Calculus's demise.[44]

During his junior year, Sandy had written to Peggy, "Nothing seems to worry me much. I seem to have a happy, optimistic frame of mind."[45] And in the years immediately after graduation, whenever he was in New York he gravitated to Stevens events. He felt the pull of the football games and fraternity parties. He wanted, as the Stevens song went, to

> . . . drink Hoboken beer;
> Like every honest fellow
> I take my whiskey clear;
> I'm a rambling wreck from Stevens Tech,
> A mechanical engineer.[46]

But the situation wasn't quite so simple. Less than twenty years later, when Calder composed a short essay, "Mobiles," for an English anthology, *The Painter's Object*, he recalled that "I began by studying engineering. But after four years I decided that engineering did not allow enough play of ingenuity on my part."[47] When he graduated in June 1919, he didn't really know what career would allow "enough play of ingenuity." He pursued the possibility of a career—or at least a job—in engineering for the next few years. But his heart wasn't in it, as his exceedingly sketchy senior paper, "Stationary Steam Turbines," already seemed to suggest.

Calder's feelings about Stevens became increasingly unsettled as time went on. In his autobiographical notes, he mused that the "reason I don't care about Stevens is that Pr[esident] Davis never acknowledged my letter after his visit (which I missed) to my show in '34."[48] And in a letter to a Stevens alumnus written in the early 1950s, he complained that President Davis had "thought I was a 'crank'—and thus I would like to remain."[49] It seems a little odd that it still gnawed on Calder, twenty years after the fact, that President Davis, who apparently actually did visit his first exhibition at the Pierre Matisse Gallery in New York, hadn't followed up with a note or a call. Calder, after all, wasn't one to hold a grudge. Perhaps what really bothered him, as he also confessed in the notes he wrote in the 1950s, was that at Stevens he had "seemed to be considered foolish + frivolous."[50] There was no reason for him to wax nostalgic about that!

The archives at Stevens contain some striking early-twentieth-century

photographs of young men working with their hands. Calder would work with his hands for the rest of his life. But the truth was that in the years when Calder was at Stevens, the men who ran the school were less interested in training engineers with a feeling for the magic of materials and the play of the imagination than in producing corporate executives who just happened to have some grounding in the basics of mechanical engineering. In 1953, when Harold R. Fee, the executive secretary of the Stevens Alumni Association, first asked Calder if he would donate a mobile to the college, his refusal was rather violent. He complained to Fee that President Davis had in some statement "claimed 'Calder + his mobiles' for Stevens. Well, you can claim me all you want—but I knew how to bend wire before I came to Stevens, and certainly there was no aesthetic feature in the course." Calder wouldn't even leave it at that. "You see," he proceeded, "I feel you don't ask for advice on aesthetics, or suggestions for bettering working conditions—you merely ask for a bit of the 'publicity' I may have acquired."[51]

How could Calder ever forgive Stevens for the part it had played in creating an America he despised—the depersonalized corporate America that William H. Whyte described in his 1956 best seller, *The Organization Man*? In the 1960s, when Calder was one of the most famous artists in the world, a group of prominent Stevens alumni—including, from Calder's year, Eugene McDermott, who had become the chairman of the executive committee of Texas Instruments—again pressed Calder to give a major work to the college. This time he did. By then he could afford to be magnanimous. Calder had outrun all the guys who had mocked him as he galumphed across the athletic fields at Stevens. And they knew it.

CHAPTER 8

ENGINEERING

I

In an essay about Aubrey Beardsley—who died of tuberculosis at the age of twenty-five in 1898, which, as it happens, was the year Calder was born—Max Beerbohm made an observation about the youth of great artists that may help us understand Calder's first few years after college. Beerbohm wrote that Beardsley worked "with a kind of desperate courage, and with a degree of force and enthusiasm that is given only to the doomed man. He knew that he had no time to lose. At an age when normal genius is still groping for its method, he was the unerring master of his method."[1]

The phrase "normal genius" may sound like an oxymoron; no doubt that was how Beerbohm meant it. This brings to mind Calder's remark that he "just naturally" wanted to go to college.[2] "Normal genius," Beerbohm concluded, "is in no hurry."[3] Calder, by Beerbohm's lights, would have to be described as a "normal genius" in the years immediately following his graduation from Stevens, when he was an ordinarily confused young man, going through something like fifteen jobs in four years. In the *Autobiography*, he described his assorted hirings, firings, and resignations as if they were scenes in a slapstick comedy. After Calder's death, one of his great friends, the writer Malcolm Cowley, no doubt having heard all the stories, characterized him as "a late bloomer."[4] Of course, he wasn't all that late a bloomer, considering that by the age of thirty he was producing work of enduring value. But it seemed late to Cowley, who was editing *Broom*, a legendary avant-garde magazine, at an age when Calder had not yet figured out what he wanted to do with his life.

These were Calder's wandering years. Although he later insisted that he had always had "a big advantage" because he was "inclined to be happy by nature," there is little doubt that during the four years following his graduation he was unhappy as often as he was happy.[5] Considering the iron resolve

with which he embraced his first formal art studies at the Art Students League, beginning in the fall of 1923, it's impossible to imagine that Calder's creative energies weren't simmering all through what amounted to his years of indecision. It must have been a strange and disquieting time for a young man who was still a couple of months shy of his twenty-first birthday when he received his diploma. He was forced to mediate, and mediate with little success, between his racing energies and his uncertain objectives. When his family gathered in Washington State, where Peggy was living with Ken and their two young boys, Calder composed a series of comic jingles, place cards for a party. When it came to describing himself, he dreamed up an altogether unflattering self-portrait:

> This is our silly old simpering Sandy
> Likes music dancing girls & candy
> He's a foolish fickle funny old slob
> For he cant make up his mind what he wants for a job.[6]

Who can doubt that this snippet of poetic fun was also a cry for help? The comedian was weighed down by his own feelings of sloth and self-indulgence; he was familiar, if not with despair, then certainly with depression. He was much too young to be such a funny old slob. He wanted to break out of his funk. He wanted to find—he may have worried that he would never find—the right job, the right career, the life that was meant to be his.

II

A year and a half or two years after leaving Stevens, Calder grew a mustache, which he kept in one form or another for eight years. This was the tallish, softish young man's attempt to achieve some gravitas—the look, he recalled later, of "a seasoned engineer."[7] At first, the mustache was small, contained, a little accent above his upper lip. The photographs taken in those years reveal a different person from the one you find in photographs taken either before or after. His brow is furrowed, the muscles in his face are tense, he's frozen in a look of stylized adulthood—an impersonation of a grown-up. He meets the camera with a wariness that you wouldn't have expected from this person who, even as a little boy, welcomed the camera's eye. What's missing, at least in most of the photographs that have survived, is the expansive spirit that was there when he was a boy and there in even larger doses later on, when he was photographed in his studio, the master

in his domain. The Calder of the years right after college looks a little like an actor trying out for a role, and not doing all that well.

Calder attempted to make a go at engineering. Right out of Stevens, he worked in Rutherford, New Jersey, for an automotive engineer. He embarked on what sounds like an accounting course at New York City's Pace Institute. Friends from Stevens, especially from the fraternity, came up with leads. So, apparently, did his father. He worked for a hydraulics engineer who had designed a water-supply project for Bridgeport, Connecticut. He worked for an insurance company, investigating possible arson; this was a job he found particularly disturbing, as he was asked to doubt people's motives. Then there was his time in West Virginia, demonstrating a motorized garden cultivator, when, as he confessed, "I . . . merely succeeded in ripping up a perfect row of cucumbers that I had singled out inadvertently."[8] One of Calder's longer stints was as a draftsman at the New York Edison Company, a job he found through an old Scottish mining engineer who was a friend of Stirling's. He enjoyed some excursions to power plants, where he was interested in the big generators.[9] But he felt underoccupied at Edison, where on many afternoons the men in his office had nothing to do and ended up playing chess. Chess was never Calder's game, although later on, when he moved in the circles of the Surrealists, where it was a source of endless fascination, he produced a few chess sets. (He would also produce a series of drawings for a book project, a collaboration with Marcel Duchamp, in which he brought the king, queen, knights, and sundry other players to hilarious, ribald life.)

Calder, 1920.

At times, Calder found himself struggling with the kind of managerial role in a booming industry that Stevens had prepared him to embrace but that he knew in his heart of hearts wasn't for him. In his *Autobiography,* he described himself in a suit and a bowler hat, stopwatch in hand, working at the Abraham & Straus department store in Brooklyn; he was supposed to

figure out the most efficient way for the store to process customers' payments. In Youngstown, Ohio—at the Truscon Steel Company, which made window sashes—one of the bosses, he recalled, "showed me how to eat a piece of pie in four bites: that was efficiency."[10] Not too long after that, he was fired by the plant's efficiency engineer because he wasn't being efficient enough. For one job—working for a firm by the name of Miller, Franklyn, Bassett—Calder was required to read a book on the subject of efficiency by Mr. Bassett. There he learned that if you had a nightclub that was doing well, you didn't enlarge it, "because people like to bump their rumps."[11] That story appealed to Calder's sense of the absurd, demonstrating that inefficiency could sometimes be a form of efficiency.

A fraternity brother, Frederick Murray, invited Calder to come out to St. Louis and work on a magazine called *Lumber,* one of a number of publications around the country devoted to the exploding building-materials industry. Murray was the director of the magazine's mechanical engineering department. The lumber industry offered all sorts of opportunities for an engineer. Considering that Ken Hayes's family had significant interests in the timber industry in Washington State, it may be that Sandy saw the job at *Lumber* as a stepping-stone to a career out west. In his *Autobiography,* Calder claimed that he found the job uninspiring. The only helpful advice he remembered giving was that the information about particular logging sites could be glued onto the back of photographs of those locations. It's clear from a letter he sent to his parents from St. Louis that he was taking the work quite seriously. He spoke of there being "Plenty of work in the office. . . . So I have to step along with it. . . . The answers we receive to the letter I sent out to the truck manufacturers are mostly an awful mess and hardly worth the trouble to read over. We asked for lists of the users of the various makes and hardly one in ten answered that query altho they sent us all sorts of literature that has no real meaning—the usual type of advertising."[12] Calder was offended when his friend Murray felt he deserved a raise and the boss, a Mr. Howe, turned him down. Calder returned to New York.

What Calder neglected to mention in the *Autobiography* was that his months in St. Louis had already been interrupted by a trip back to New York. Late in 1920—after he had been in St. Louis perhaps three months—he came down with what initially looked to be a very dangerous illness. Peggy, living out west, was told by her enormously anxious mother that the doctor in St. Louis had diagnosed "stoppages."[13] Nanette insisted that Calder come home. It is difficult to tell what the trouble was, at least from the lone letter about the illness that survives, one Calder wrote to his sister in January when he was nearly back to himself. In St. Louis there had seemed to be something

terribly wrong with Calder's kidneys. His eyesight, too, was giving him serious trouble. Writing on his father's Century Association stationery—from the Edgehill Inn in Spuyten Duyvil, where Nanette and Stirling were living at the time—Calder informed Peggy that he was "feeling very hexametrish," as *King Lear* had been read to him the day before.

"I am determined a more able bodied gent," Calder wrote, and proceeded to discuss his situation in faux Shakespearean terms. "The which hath 2 eyes, 2 ears, 1 mouth, etc.; the only difference being that my system hath; with such poor food as moves not of itself; become clogg'd. And thereupon; mine eyes did get them out of whack; but now again are in much better shape, at present writing and are like to continue so."[14] Nanette added a note to Calder's letter, observing that there were now "no albumen nor casts" to be found in Calder's system, and that the New York doctors didn't understand how the midwestern doctor had so totally misdiagnosed the case. Apparently a diet of milk, cereals, and toast was all that had been needed to cure him. Of course, there might have been something psychological about what happened to Calder in St. Louis. We don't know. He was far away from his family. And when a man who is headed for a career as an artist begins to imagine that he's losing his sight—a loss that turns out to be illusory—one does wonder what other anxieties are involved.

Not surprisingly, Calder didn't forget his fear of going blind. It's also not surprising that he eventually turned that fear into yet another picaresque adventure. Thirty years later, the young musician and composer David Amram found himself sitting at the Deux Magots in Paris with Calder, his wife, Louisa, and their older daughter, Sandra. Although Amram, when he described the encounter in his memoir, *Vibrations,* didn't make it clear how the matter had come up, for some reason Calder explained to him that his fear of damaging his eyes had led to his resignation from his first job after college. Whether this was an entirely different experience or one Calder somehow conflated with his eye trouble in St. Louis isn't clear. It's also possible that Amram somewhat garbled the story in the retelling. Drinking a few Pernods and listening to Calder's stories amid all the comings and goings in the famous Parisian café, Amram was laughing so hard that he began to worry that some stitches he'd had in the back of his mouth not too long before were going to burst. Calder said of this first job of his that "he had complained to the foreman when he was working that the light about forty feet above his head was too dim and was going to hurt his eyes. Because the company refused to change the light bulb, he left the job and began to pursue his dreams."[15] So here was Calder telling a young man that it was the threat of hurting his eyes that had opened his eyes to the artist's life.[16]

III

You can feel Calder's ebullient graphic impulses percolating in a couple of scraps that survive from the years just before and after his graduation from Stevens, although they hardly count as works of art in any ordinary sense. In his junior year at Stevens, he sent a letter to his sister in an envelope to which he gave a wonderful decorative flourish. Beneath the three-cent stamp with George Washington's head in profile, he added a figure in profile, using the head on the stamp as the man's head. Calder placed a sword in Washington's left hand; his right hand reaches to the left, the index finger pointing toward the name "Mrs. K. A. Hayes." He might have meant his envelope as a comic riposte to the statue of George Washington the statesman that his father had recently produced for Washington Square Park. Another early graphic escapade was a diagrammatic drawing attached to an anniversary greeting he sent to his parents in the fall of 1920, when he'd been out of college for a little over a year. Here he presented, in the middle of the typed letter, a series of stick figures illustrating the gradual growth of the Calder clan, from Nanette and Stirling to the smaller-sized Peggy and Kenneth, with a plus sign between them, followed by an arrow, a baby, and a question mark. Below Peggy was Sandy, followed by a plus sign and a question mark but nothing else. The stick figures were realized with elegant deliberation. In the playful combination of symbolic elements—larger and smaller men and women; the large man and woman versus the two smaller men and one woman; the baby that is unlike all the rest—there is a foreshadowing of the interactions of families of forms in the mobiles of Calder's maturity.

Stirling Calder, while dismayed at Sandy's unwillingness to double down on some entry-level job as an engineer, was aware of his son's strong albeit still somewhat inchoate artistic impulses. By Calder's own testimony, it was his father who encouraged him to study figure drawing in 1922. Stirling felt that Sandy, living at home for a spell, was underoccupied. He thought that some evening drawing classes might be just the thing. As for Calder, he said his willingness to consider a drawing class was fueled, as much as anything else, by a desire to get out of the house and away from his parents. The teacher, however, was a friend of his parents' from Pasadena, the Englishman Clinton Balmer, who had been involved in musical evenings at the Calder home. Balmer was teaching drawing classes at night in a public school on East Forty-second Street. The work he had been doing when the Calders first knew him recalled the Pre-Raphaelites, some of whose paintings Nanette admired. Calder may well have known the dreamy, phantasmagorical illustrations Balmer had done in 1904 for a book of poems by one Gordon

OPPOSITE, TOP *Calder. Illustrated envelope sent to Calder's sister, Peggy, 1918.*

OPPOSITE, BOTTOM *Calder. Illustrated letter to Stirling and Nanette for their anniversary, 1920.*

Bottomley, *The Gate of Smaragdus*, which had been elegantly published by Elkin Matthews in London. Calder told Bill Rogers that Balmer painted "vestal virgins or people holding their nipples"—apparently Calder demonstrated by pinching his own—"or a naked lady surrounded with bunches of grapes."[17]

While understandably skeptical about Balmer's swooning maidens—for all their graphic impact, they seem a little curdled—Calder found the Englishman a likable, low-key instructor. "I became very enthusiastic," he recalled in the *Autobiography*, a rather strong statement given his distaste for hyperbole.[18] Balmer taught his students to draw the model in charcoal. Although charcoal wasn't a medium that became a mainstay of Calder's career, he much later remarked that he still practiced at least a bit of what Balmer had preached. "I

remember that when you wanted to draw a new line, he asked you to draw a shadow over the old line—we crosshatched it. I still do that now when working on a stabile or other model."[19] This may have intrigued Calder because it was an addition to the drawing that simultaneously functioned as a subtraction, not unlike the crossing out of a word (which nonetheless remains visible). Balmer's way of crosshatching a line in order to eradicate it turned the line into an abstraction of a line—a material fact that was simultaneously being dematerialized. The students in Balmer's class were a sophisticated bunch. The artist Ben Shahn later thought that he and Calder had been in the same class, although Calder wasn't so sure. "It was a real pleasure," Calder reminisced, "for me to find myself in a group that shared the same interest."[20]

As Calder backed his way into his parents' line of work, he was backing his way out of the fraternity parties and dances that he had continued to attend in the first year or two after college. Apparently the brothers had gotten wind of his growing interest in the visual arts. One evening at the Delta Tau Delta house, he was greeted by a brother who eventually held an important position in chemical engineering. "Sandy," he asked, "have you been painting any naked women lately?" Although Calder was comfortable with ironic banter, he took what was probably nothing more than a conversation starter as a challenge to his integrity and resolved never again to return to the fraternity house—at least that was how he remembered it later.[21] What probably disturbed him was not so much the brother's flippant comment but the growing gap between his enthusiasms and those of his college chums. Calder didn't, however, leave all his Stevens activities behind. In 1924, a year after he had finally dedicated himself to the life of art, he was still closely following the lacrosse team at Stevens, reporting to Peggy that they had a terrific new coach and had beaten Penn, Lehigh, and Swarthmore.[22] But the sense of not quite fitting in—a feeling Calder had tried to take cheerfully in stride at Stevens—was more difficult to accept with each passing year.

IV

In June 1922, still uncertain of his direction, Calder left New York for the West Coast. He had joined the merchant marine and found a job in the boiler room of a steamship, the *H. F. Alexander,* which was scheduled to sail to San Francisco, then Hawaii, and then back to San Francisco. At Stevens, Calder had sometimes been called "California," because, so he said, he had tried to play rugby in San Francisco.[23] Could his classmates have sensed something

of California's nonconformist spirit in Sandy's unconventional behavior? Could Calder have hankered, in the midst of a crisis of confidence about his future as an engineer, for the freedom from convention that the West Coast represented?

Peggy and Ken, well aware of how difficult a time Sandy had been having since college, had urged him to try the Pacific Northwest. Ken's stepfather, W. J. Patterson, a banker in Aberdeen, Washington, had made the connection with the shipping company that arranged for Calder's passage. The *H. F. Alexander* was a big ship, carrying more than seven hundred passengers in elegant accommodations, along with a crew of some three hundred, including the waiters. Calder worked in the boiler room as what was called a fireman; each four-hour shift was followed by eight hours of rest. He didn't exactly fit in with his fellow firemen, a rough-and-tumble bunch of Irish and Italian guys. But he was intrepid. He knew how to showcase his abilities. He went into the ship's workshop and made some sort of scraper to clean out the filter that had been clogged by the sawdust in the cheap Cuban oil that fueled the ship. The trip left Calder with some imperishable memories. He savored the sights of Havana Harbor, where boats came alongside the ship, selling fruits and drinks to the passengers and sailors. In Panama, he took a cab into the city late at night and admired the tropical architecture. The buildings didn't have conventional façades; in place of walls there were curtains suspended between pillars. Decades later, heading to South America with his wife, Calder insisted on making a quick detour so she could experience Panama City.

Of all Calder's experiences during the voyage of the *H. F. Alexander*, the one he returned to throughout his life occurred on the morning of June 9, 1922. He had taken to sleeping on the deck of the ship, on a coil of rope, so as to avoid the stifling heat belowdecks. On that particular morning, Calder awoke to what he would forever remember as an astonishing sight. "I saw the beginning of a fiery red sunrise on one side and the moon looking like a silver coin on the other," he wrote in the *Autobiography*. "Of the whole trip this impressed me most of all; it left me with a lasting sensation of the solar system."[24] Here were the sun and the moon joined together in a single visual field. This was a natural occurrence, but to Calder it was much more than that. The sun was rising and the moon was fading and the two developments were absolutely interrelated, just as everything in the solar system was somehow related. Forty-six years later, Calder mounted *Work in Progress* at the Rome Opera House, a theatrical extravaganza that the artist told a friend ought to have been called *My Life in Nineteen Minutes*. Near the beginning he presented, as part of what amounted to a genesis story, a gradually

RIGHT *Woodcut of the sun and the moon from a late-fifteenth-century edition of* The Dialoges of Creatures Moralysed.

BELOW *Film still from Calder's* Work in Progress, *mounted at the Rome Opera House in 1968.*

lightening sky on which were projected white and red disks referring to the sun and moon over Guatemala. The genesis story was the genesis of his own art. His was an art not of isolated or singular objects but of a dialogue between objects—of disparate but linked elements and forces.

Calder, like all the great modern artists, was involved in a search for the new that reaffirmed old verities. In the 1930s and 1940s, Calder's friends among the Surrealists were drawn to a power in his work that was not unlike the power of the fabulists and mythologizers of earlier epochs, who enlarged natural phenomena by giving them allegorical or emblematic implications—a more than naturalistic power. A woodcut illustration for a late-fifteenth-century book, *The Dialoges of Creatures Moralysed*, shows the sun and the moon in a confrontation that could as easily illustrate the encounter of the sun and moon Calder discovered off the coast of Guatemala. The anthropomorphization in this wonderful woodcut, with the sun represented as a face wreathed by rays, is a distant ancestor of Calder's sun with a human face in *Work in Progress* and many other works. The dialogue that this image was designed to accompany—exploring the jealousies and rivalries between the sun and the moon—suggests the interest in symmetries and asymmetries and parity and disparity that would shape Calder's kinetic vision. In *The Dialoges of Creatures Moralysed*, the sun urges the moon to accept what seems to be the natural balance of powers, "for as I shyne in the day tyme and bere than the rule, so thou without impediment occupyest all the nyght at thyne owne plesure. Let us therefore mekely obey unto our maker, and exalte nat thy selfe by pryde, but suffer me paciently to do as I am ordeyned and do thou thy dutye."[25] What Calder ultimately discovered was a poetics not so much of nature but of the forces that shape the natural world.

V

By the time the *H. F. Alexander* arrived in San Francisco, Calder had had more than enough of his buddies in the boiler room and decided that rather than make the trip to Hawaii, he would proceed north and hook up with his sister and brother-in-law in Washington State. He spent a few days in San Francisco with Walter Bliss and his wife, with whom he had lived during his later years in high school in San Francisco. They all went to the Shriners Parade, though Calder was so exhausted from his trip that he slept through the festivities. Forty years later, he still regretted missing what he imagined had been a "human mobile." The Shriners, so he understood, "march this way, they meet, they march that way; then they separate, and repeat the

motions."[26] He found passage on an empty lumber schooner returning to Willapa Harbor in Washington State. And from Willapa Harbor he continued by bus to Aberdeen and then to American Lake, where Peggy and Ken and their two boys were vacationing.

Aberdeen, where the Hayes family had its base, was growing fast. The lumber industry had been pushing westward, as forests in the Northeast and then the Midwest were stripped bare by a national building boom. Aberdeen, on Grays Harbor, was a shipping hub. Calder had already visited with his parents in the summer of 1917. The Hayes family had an enormous and luxurious home; it occupied an entire block, with tennis courts and gardens. They were aristocracy, what with the Hayes and Hayes Bank and their involvement in the timber industry. But there was nothing fussy or particularly formal about the Aberdeen aristocracy. Stirling worried that Aberdeen was too much of a man's town for his daughter. And Peggy, who had been inspired by Jane Addams's work with the poor in Chicago and had studied to be a social worker, hankered to return to the more intellectual and liberal ambience of the San Francisco Bay Area.

Ken's stepfather, W. J. Patterson, who was Scottish-Canadian, struck Stirling as a caricature of the swaggering western businessman, with his yacht and his gambling. At the Elks Club, where Stirling ate with Patterson, he met an ex-saloonkeeper who, as his daughter later reported, "told him among other surprising things that the winter before had been so severe that his wife slipped on their steps and fell down prostitute."[27] The family went to a performance of *The Emperor Jones*, starring Paul Robeson, at Aberdeen's shabby Grand Theater. Stirling was amused by a stage curtain illustrated with a Nubian slave fanning a lady with a leopard at her feet, which he told Peggy amounted to a sort of folk art, "so awful, it's funny."[28] His son would inherit his eye for what we would call kitsch or camp. At the end of Robeson's performance, Stirling, the theater aficionado, leapt to his feet shouting, "Bravo! Bravo! Bravo!" He was followed by the rest of his party and then the rest of the audience, who felt that if this was what the Pattersons' New York relatives thought of the performance, it had to be the truth.

For a time, Calder's brother-in-law worked in a factory that produced shingles. Calder was interested in that job, but he ended up as the timekeeper in a Hayes and Hayes logging camp in Independence, about fifty miles from Aberdeen. In Independence, Calder worked for Cranky Jack Moore; his wife, Bertha, was the cook. Calder made out the paychecks, sorted the mail, and sold sundries to the workers. The Hayes family was amused and maybe even a little amazed that Calder got on fairly well with Jack. But it wasn't all smooth sailing. Calder felt that Jack gave him an especially hard

time because he was a kid with a college education who had gotten the job because he was related to the boss. Of course, that was true.[29] Eventually, relations with Cranky Jack became untenable and Calder took a job in another camp nearby. There he was actually able to use some of his engineering know-how. He helped work out the grading and what were called the cuts and fills for the railroad that brought the logs down from the moun-

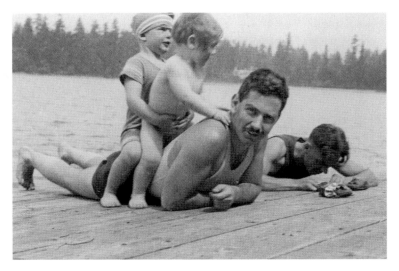

Calder with nephews Kenneth and Calder Hayes in Washington State, c. 1922.

tains. Whatever the demands of Calder's jobs, there were still many opportunities to play with his nephews, Kenneth Jr. and Calder, both at American Lake and back in Aberdeen. Sandy demonstrated his customary ingenuity, creating mechanical toys of all kinds, and indulged his nephews' infatuation with King Arthur and the Round Table, which must have reminded him of his own boyish tastes back in Pasadena. When Peggy, frustrated with the local pedagogy, decided to start a progressive school on the family property, Calder was at her side. He built swings and slides, installed blackboards, and designed some toys, including a kangaroo, a rabbit, and a duck with movable parts.

For Calder, there was magic in the northwestern landscape, where the area's extraordinary natural beauty was juxtaposed with the striking industrial structures that were the products of an economic boom. In Aberdeen, he was enchanted by all the machinery connected with the sawmills. The trains bringing lumber from the camps and the ponds full of logs had a rough, practical beauty. He savored the burners in the mills, metal silos with gauze tops. The burners ran twenty-four hours a day and gave off a dramatic glow at night. In the camps, he must have been fascinated by the shacks in which the workers lived, which were built on flatcars so they could be moved easily from one logging site to another.[30] In his *Autobiography,* Calder lovingly described the challenges involved in taking down trees; his descriptions have an analytical intricacy. This was a choreography of weights and counterweights and cables and pulleys, not entirely unlike the choreography of the mobiles he would be developing a few years later. The lucidity of Calder's descriptive prose brings Hemingway to mind: "There was a very special

man called the high-climber. He'd climb up a tall tree as it stood, and cut off the top. With a belt and a rope, an ax and a saw, he would climb up there. When he got through, the tree would be guyed with six or eight cables, and an enormous block pulley on top, weighing about two hundred pounds, with a cable running through it would drag the logs, with the help of a donkey steam-engine, to the foot of the tree or its vicinity."[31]

To Bill Rogers, writing in the 1950s in the biographical manuscript that Calder ultimately deemed unfit for publication, all this seemed to prefigure Calder's art. Rogers had a point. Taking down a tree, Rogers observed, involved "a 'plastic operation,' comprising length, breadth and thickness, plus those extra dimensions added exclusively by our century: movement and time."[32] The work was also very dangerous. A logger died in an accident in one of the camps while Calder was there, his teeth bizarrely left stuck in a hunk of wood.

VI

Calder spent eighteen months in Washington State. It was there, at the greatest imaginable remove from the centers of the American art world, that he finally decided to become an artist, or at least try. Bill Rogers, working on his biography of Calder in the 1950s, asked a number of people, including Bill Drew, how they thought this had come about. "Drew believes," Rogers wrote, "that, out in the dark forests where no one ever mentioned art, Sandy suffered the basic, unendurable deprivation which banished his doubts. The one thing denied him at last appeared to him unmistakably as the one thing he must have." Rogers also spoke to Calder's sister. Extrapolating from her testimony, Rogers wrote about "how often and how gladly [Calder] deserted his job to visit Aberdeen. He went not only for the sake of Margaret as a person, but for the sake of Margaret as a symbol. She linked him to the now distant studio life, she spoke the language he so longed to hear." The provincialism of Washington State, Rogers argued, sent Calder "flying into the arms of the Muses."[33]

In the midst of the ruggedness of Washington State, where books and pictures were virtually unknown, Calder found himself, for a dollar a shot, drawing quick portraits of the men and the few women who worked in and around the lumber camps. He was good at it. One survives of Cranky Jack Moore, with his protuberant lower lip and bumpy nose, done in rapid-fire calligraphic strokes that prefigure the wire portraits Calder would be doing a few years later. In the summers of 1922 and 1923, Calder's mother was in Aberdeen, and she did some painting while she was there. Perhaps her efforts

were a provocation for her son. In any event, when Calder's urge to paint became too strong to resist, it was to his mother, back in New York, that he wrote asking for paints.[34] A first painting, now lost, represented three great mountains: Rainier, Hood, and Adams. Calder said that his mother had thought so little of that painting that she put it under a goldfish bowl, where it was eventually destroyed. But the truth was that his parents were supportive as he turned his sights to a life in art. To Rogers, Calder would later complain that the main thing his mother taught him about painting "was to cut paint rags instead of tear them." As Rogers pointed out,

it was a little odd for Calder to gripe about this practical lesson, considering how much he appreciated the nuts and bolts of any art form.

Calder. Untitled (Cranky Jack Moore), 1922. Ink on paper.

However Calder might have struggled with the feeling that he was being "framed" by his parents, he was also turning to them for counsel—or at least considering the counsel that they gave. When he asked his mother for advice, she said that if he wanted to paint, he should, and damn the risks of a career in the arts.[35] But that was not quite the end of it. Calder wasn't going to allow his parents to have the last word. Somebody who hadn't been involved in the original frame-up was going to have to intervene. Interestingly, that person has forever remained nameless, as if he were not so much a flesh-and-blood adviser as a mythical character, a sort of demigod or prophet whom Calder discovered in the northwestern forests, and who vanished as soon as his message was conveyed. According to Calder's father, the man was a Canadian engineer of his acquaintance. Rogers said he was a waterworks superintendent.[36] In any event, Calder went up to Vancouver to consult with this man, who had told Stirling that if Calder came to Canada he would be able to help him find a job. But that's not what happened. Instead, the two men fell into a long conversation, "quite a talk about what career I should follow," Calder reported in the *Autobiography*.[37] Apparently, the engineer had really wanted to be an architect and had always regretted that he had settled for engineer-

Calder. Logging Scene,
1922. Oil on canvas board,
7 3/16 x 13 15/16 in.

ing. His advice to Calder was to do what he truly wanted to do. Which was, of course, what his parents had done. "So," Calder recalled in the *Autobiography,* "I decided to become a painter."[38] A painter. Not a sculptor. Calder was still backing his way into his true vocation.

One striking painting, a clear-eyed exploration of a landscape ravaged by the logging industry, survives from Calder's last months in Washington State. The frontier has been gutted. The picturesque has given way to the anti-picturesque. The blackened tree trunks in the muted landscape are a melancholy sight. Calder's subject matter is very much his own. His tree trunks foreshadow the parallel black elements in some of his most striking mobiles, where the proliferation of abstracted spines, stalks, or stems has a percussive impact. Although Calder's fleet brushwork suggests a certain lightness and delicacy, the painting has a muted, uneasy power; leadenness might be said to be its subject. Of course, Calder is painting what he's seeing, a natural world wrecked by modern technology, a bleak, barren place that nevertheless has its own kind of visual fascination. But is there a psychological element at work here as well? Is Calder himself feeling a little bleak? Is he feeling that he's hit bottom after attempting with next to no success to make something of himself as an engineer? We can't really say. One thing stands out: the young man who's putting brush to canvas to create this somber vista is a natural when it comes to the art of painting.

THE ART STUDENTS LEAGUE

I

Alexander Calder was a month past his twenty-fifth birthday in the fall of 1923 when he began attending classes at the Art Students League, in the school's Neo-Renaissance building at 215 West Fifty-seventh Street, near Seventh Avenue. The rather tall, mustached young man made the regular trip uptown from Greenwich Village, where he was living with his parents. Although art school was a new experience for Calder, much of what he encountered at the League was familiar: the tools and supplies at the ready; the models taking their poses; the language of the critique; even some of the teachers who posed the models and ran the critiques. Among the instructors were a number of artists, including John Sloan, who were friends of Stirling and Nanette's. Stirling himself taught at the League for a number of years. Before heading out west to spend time with Peggy and Ken, Sandy had already been friendly with at least one student of his father's from the League, Jane Davenport. In August 1921, there was talk of Calder and his father going out to spend a weekend with Jane and her parents in Cold Spring Harbor, Long Island, where her father was a geneticist. "I am not much of a swimmer," Stirling wrote to Jane, "but he is very fond of it, and I think can come."[1] Sandy and Jane became close lifelong friends; she married twice, becoming first Jane Harris and then Jane de Tomasi.

Calder moved rapidly through the League; all in all he was there maybe

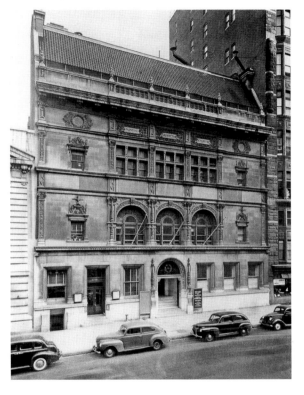

The Art Students League on West Fifty-seventh Street in New York City, c. 1935.

Calder. Self-Portrait, *c. 1924. Oil on canvas, 20 x 16 in.*

sixteen months, and during that time he did many other things. The League, although nearly fifty years old, was still the place to go to study art in New York if you were in search of the new. The new was certainly what Calder was after. His instructors, a well-known group of artists, included, in addition to Sloan, Guy Pène du Bois, Kenneth Hayes Miller, George Luks, and Boardman Robinson. They were, in their various ways, all energized by the drama and romance of the city, but Calder, while he shared their appetite for the highs and lows of modern life, didn't necessarily feel that he needed their instruction. He wasn't inclined to sit at their feet and hang on their every word. He'd already had a bellyful of other artists' opinions, after the years he'd spent listening to the dictates of the two highly opinionated artists who just happened to be his parents. "This is a very critical time for Sandy too," his mother wrote to Peggy something like a year after he had started. "I wonder often what will happen." She commented that for all its enthusiasm, his work suffered from some lack of fundamental artistic knowledge. She also admitted that she might not be entirely sympathetic to the direction he was taking, as she didn't "fall in readily with very modern ugliness. . . . We must be patient," she concluded.[2]

As for Calder, he was impatient, a neophyte in many respects, but with an already highly developed sense of his own potential. The self-doubts of the previous four years were swept aside. Although he still had everything to prove, Sandy was energized by his own resolve, and contemplated the capacities (or maybe it was the incapacities) of many of his fellow students with an equanimity that some might have mistaken for arrogance. It was Bill Rogers's impression that, compared with most of his cohort, Calder was "stronger willed, more mature, more determined to succeed."[3] Rogers stated that Calder was "surprised, and a little incredulous" when some teachers and students failed "to discern a budding talent with the brush" and that "fellow pupils puzzled him when, during a comparison of class works, they did not prefer his."[4] In his autobiographical notes, written some thirty years later,

Calder recalled that "When I went to the Art Students League I was too old + formed in way of thinking to be trapped by any system of 'art' proposed to me, unless I really found it good." Then he added, "Of course I wasn't aware of this—but it seems clear now."[5] Perhaps from the start he was more self-consciously self-assured than he later chose to admit. Calder's instinctive geniality was now reinforced by an unassailable sense of mission.

II

When Calder came into Sloan's class that October, he seemed to the quiet though charismatic instructor a little like a member of the family. Which probably left Calder feeling all the more on his guard. Sloan had known Sandy and his sister as children. When visiting the Calders in 1904 in a cottage they had rented in Seaside Park, New Jersey, he exclaimed in a letter to Robert Henri, "The Calder juniors are magnificent works. I never was more impressed with children."[6] Nineteen years later, Calder was stung when Sloan criticized him for using a lot of black to model a girl's neck, arguing that he had given her "a dirty neck."[7] One wonders if Calder was being overly sensitive, considering that some thirty years later, when Sloan talked with the writer Van Wyck Brooks about Sandy Calder's first appearance at the League, he was anything but critical. He heaped praise on his old friend Stirling's son, remembering Sandy "as studying in his own independent way, appearing with an enormous piece of architect's draughting-paper and setting this up at the rear of the class-room." Calder produced, Sloan told Brooks, "great imaginative line drawings in charcoal that filled the whole space." Sloan went on to say that they were "very remarkable in quality from the first."[8]

It may be that Sloan, in retrospect, thought more highly of his friend's son than he had at the time. Sloan spoke to Brooks about his admiration for Calder's first wire sculptures—the ones he did five or six years later—with their "ingenious manipulation of a continuous thread of wire." He praised Calder's interest "in the travels of the line, activating it, later abstracting it" and recalled that the critic Walter Pach had written Sloan from Paris in 1932 that Calder "was already well spoken of by some of the good artists he knew there." The expressive power of line was much discussed at the League when Calder was there. Sloan quite naturally saw in Calder's brilliant manipulation of "a continuous thread of wire" an affirmation of the League's focus on graphic energy. "The only really abstract art-element is line," Sloan once observed, and went on to argue that "the most purely inventive portion of

technique is the use of the line."[9] Calder told Bill Rogers that Boardman Robinson—an instructor Calder regarded with real warmth, "a real person, a big red-headed guy with a beard"[10]—had shown him how to draw "without lifting pen from paper, with one continuous uninterrupted line, like an endless wire stamped flat on the page."[11] And in his *Autobiography*, Calder ascribed a similar lesson to John Graham, the monitor in Sloan's class and an artist who became a good friend. Graham, Calder recalled, had a way of "drawing a nude with two pencils, one red and one black, and starting with the feet and running right up."[12] At the League, the bold graphic stroke was regarded as the quintessential avant-garde gesture.

Whatever Calder's discomfort with Sloan's criticism, a few months after beginning to study with him he was at a dinner for Sloan and his wife at an Indian restaurant on Forty-fourth Street. Sloan, Calder wrote to his sister, "sang all the songs he could think of."[13] A few years after that, during one or another return to New York from Paris, Calder was observed in Sloan's drawing class at the League; at least that was what Helen Farr, who would become Sloan's second wife, remembered years later.[14] There was much about Sloan's approach to art and life that resonated with Calder. Sloan was definitely in sync with the Art Students League's historic rejection of conventional academic standards. Sloan fervently believed that there was no one right way to do things. He told students, "Get out of the art school and studio. Go out into the streets and look at life. Fill your notebooks with drawings of people in subways and at lunch counters." Which is exactly what Calder did. Sloan commented that "a sense of humor is not incompatible with being earnest. It gets you over that dull, serious feeling."[15] In his book *The Gist of Art*, published in the late 1930s and destined to become something of a classic, Sloan wrote, "A student at the League can choose his art studies much as he can choose food at an automat." The automat was a cafeteria where each item—a sandwich, a piece of pie—was displayed behind its own glass door. You decided what you wanted, dropped a coin in the slot, and the door opened and you removed your selection. An artist, Sloan argued, "may shop around and even provide himself with materials for indigestion. But it is this very feature that is one of the most important in his progress, providing he keeps his mind open."[16]

Was Sandy Calder open-minded? He was and he wasn't. At times he even appeared close-minded. He was determined to chart his own course. If that meant refusing to look to the left or to the right, so be it. He was by turns skeptical, inscrutable, good-humored, pigheaded, contrarian, and just plain goofy. None of it was bad. Somehow, it turned out to be his way of embracing all the revelations of modernity while remaining absolutely himself.

III

Calder couldn't help but take note of the larger-than-life personalities, both teachers and students, who dominated the League. He was impressed by George Luks, whose unabashed theatricality he found more readily appealing than Sloan's "careful, frugal" demeanor—which was maybe uncomfortably close to his father's style. Calder commented that Sloan had once sold twenty pictures for twenty thousand dollars, which would, he observed, "keep him going a long time. Luks would have blown this in a few months."[17] Nanette had initially suggested that Sandy study with Luks, who had only recently started teaching at the League. Luks apparently felt it was fair game to rib Calder, comparing him unflatteringly with his father. "Here is the son of a great artist," he mockingly announced, "and yet he paints like this!" When Sandy made no response, Luks pushed on: "What does your father think of your working in my class?" To which Sandy drawled, "Oh, he says that's my hard luck."[18] Calder, however intent on keeping his own counsel, was interested by Luks's hot personality. He was a painter who disdained conventional methods and techniques. "Art my slats!" he told a newspaper reporter. "I can paint with a shoestring dipped in pitch and lard. . . . Who taught Shakespeare technique? Guts! Life! That's my technique!"[19] Nanette may have calculated that this guerrilla approach would appeal to her son. She was right.

Like so many of the Calders' friends, Luks had begun as a newspaper illustrator. His paintings offered a rough-hewn, openhearted response to the American experience. Luks's 1919 painting of two guides in a small boat on Lake Rossignol in Nova Scotia, their long oars bright graphic shots in the dark composition, was the sort of thing Calder had been aiming for when he'd begun to put paint to canvas in the Pacific Northwest. Luks, as described by the critic James Huneker in his book *Bedouins*, suggested the sort of man Calder would become. Could it be that Luks was inclined to give Calder a hard time because the young man reminded him of his younger self? According to Huneker, Luks was "Puck. He is Caliban. He is Falstaff. He is a tornado. He is sentimental. He can sigh like a lover; curse like a trooper. Sometimes you wonder over his versatility; a character actor, a low comedian, even song-and-dance man, a poet, a profound sympathizer with human misery, and a human orchestra."[20] Whatever contretemps they may have had, Calder obviously liked Luks. He recalled in his *Autobiography* that Luks "came in quite high sometimes and we used to have a rather good time in his class."[21] In his autobiographical notes, he put it more bluntly: "Got into Luks—stayed 2 or 3 mos. He was funny, and often drunk."[22]

Calder. John Graham,
*c. 1931. Wire, 10½ x 8½ x
10½ in.*

Calder's time at the League sharpened what was already a taste for extravagant personalities. There was probably nobody at the League who was as intellectually and temperamentally extravagant as John Graham, an émigré with a complicated Russian-Polish background. Graham, who was twelve years older than Calder, was the monitor in Sloan's class when Calder studied there; Calder referred to him as his "best friend" in the class.[23] Graham was still then going by some version of his father's name, Dombrowski. He had been a cavalry officer in the czar's army and had arrived in New York in 1920. He was a striking presence, a worldly bohemian—a type that would always appeal to Calder. He was very attractive to women, already headed into his third marriage when Calder was getting to know him. Like Calder, Graham took pride in his grasp of subjects well beyond the visual arts. In a 1937 curriculum vitae, he claimed—and *claimed* was the operative word, because he was a notorious fabulist—that he had studied and passed examinations in geometry, trigonometry, and physics, among other subjects.[24] Within a decade, Graham would establish himself as one of the most cosmopolitan figures in the arts in avant-garde New York. He had a great influence on younger artist friends, including Stuart Davis, Willem de Kooning, Lee Krasner, Jackson Pollock, and David Smith. He advised Frank Crowninshield of *Vanity Fair* on his collection of African art and produced a fabled book in 1937, *System and Dialectics of Art,* still much admired for its idiosyncratic intellectual dazzle.

Another one of Calder's cohort at the League, a Californian by the name of Clay Spohn whom Calder kept up with during his early years in Paris, remembered Sandy at the League as "a wit, you know, a great wit."[25] Calder, who had the wit to see the wit in others, was invariably attracted to artists who confronted every challenge with a certain ironic independence. He believed that an element of humor was always important, as a brake on the pieties that can turn even heartfelt seriousness into numbing sententiousness. My guess is that John Graham was the first in a group of magisterial ironists who over the years became Calder's friends; that group ultimately included Joan Miró, Marcel Duchamp, and Saul Steinberg. At the time Calder met him,

Graham's most remarkable work was still in the future. Some might argue that there is nothing of the comic or ironic spirit in Graham's mature paintings and drawings, most of which are imaginary portraits of men and women festooned with a bizarre array of magical and mathematical signs and symbols. But it's precisely the element of wit, comedy, or irony that frees Graham's mannerist fantasies from the trap of academicism. Graham may already, by the time he was getting to know Calder, have been taking an interest in folk art and primitive art, forms of expression that appealed to un- or even anti-academic sensibilities, and to which Calder would also be strongly attracted.[26] In 1931 or thereabouts, Calder made a wire portrait of Graham. Such portraits were often created as salutes to significant friendships. Graham later gave the wire portrait to the sculptor David Smith, who hung it in the living room of his home in upstate New York.

John Graham. Venere Lucifera, *c. 1951.*

Although neither Graham nor Calder spent all that much time at the League, while they were there they certainly made an impression. Clay Spohn remembered Calder as a striking presence. He was always having fun. "He'd make cartoons and he'd show them to people," Spohn recalled. "People would be sitting there very seriously and he'd come around and show them his cartoons and make them laugh. He'd spend a lot of time in the cafeteria. The playboys would spend a lot of time in the cafeteria. I took him seriously."[27] Thirty years later, Calder still recalled the names of at least a couple of the women who were studying at the League: Peggy Thayer and Eleanor Ingersoll.[28] Spohn recalled a girl who had known Calder's family and whom Spohn met in Paris, who said that "his father was sort of ashamed of him"—though worried about him might have been closer to the truth. "He was so darn likable, friendly and all," Spohn concluded. "But he was just having a good time." To which Paul Cummings, the curator and art historian who interviewed Spohn in 1976, added, "He still does."[29] Spohn's remark about Calder being one of the "playboys" who hung out in the cafeteria at the Art Students League bears some further comment. In the 1920s *playboy* did not necessarily have the same associations it would have fifty years later. In the 1950s, in an interview with the writer Selden Rodman,

Ilonka Karasz. Cover for Playboy: A Portfolio of Art and Satire, *No. 9, 1924.*

Calder used that same word to describe himself, sardonically remarking, "They call me a 'playboy,' you know."[30]

In the bohemian circles where Calder started out, a playboy could be a wit and an ironist, a puckish figure with the charms of an ebullient harlequin, rather than a practiced lady's man. This view of the playboy shaped a celebrated little magazine, *Playboy: A Portfolio of Art and Satire*, published by Egmont Arens in Greenwich Village between 1919 and 1924. Some of the most important progressive writers and artists of the day contributed to *Playboy*. These included Calder's teacher John Sloan, Stirling and Nanette's friends the artists Marguerite and William Zorach, a painter and friend of Calder's by the name of Alexander Brook, as well as E. E. Cummings, Georgia O'Keeffe, and numerous other figures in the bohemia of the day. Carl Zigrosser, who would be Calder's first dealer in New York, was on the advisory board.

In the first issue, the editors announced that *Playboy* had nothing to do with sin but instead "sprang without pain from the womb of JOY." They advocated "YOUTH and JOCUNDITY," declaring, "The time has come for smiles."[31] Among the magazine's illustrations were a good many linoleum cuts—a few years later, Calder would use that technique to announce his circus performances—including one of trapeze artists at a circus. The cover of issue 9 was a striking image by Ilonka Karasz of a tightrope walker, a subject dear to Calder's heart. Calder was shaping up to be exactly the kind of artist *Playboy* celebrated: a creator of joyous, comic, at times even ironic gestures, which in his case within a few years became the gestures of a genius.

IV

Although Calder produced still lifes, portraits, and self-portraits during those years in New York, his first big blast of energy went into a series of paintings of the city. Working with quick, fluid brushstrokes—they suggest a Jazz Age riff on some of his teachers' (and some of his mother's) painterly gifts—Calder responded to the spectacle of Manhattan in all its loose, easy,

quotidian theatricality. Nanette had once observed that "the Arts are too educated. One does not feel the living pulse of mere life."[32] Her son was pursuing that living pulse. He was hardly alone in his upbeat approach to urban life. Sloan, Guy Pène du Bois, Kenneth Hayes Miller, and other friends of the Calders', such as Everett Shinn and William Glackens, had been painting the city, and although their work had elements of social critique, there was also, as the writer Leslie Katz has observed about Glackens, a sense of being "haunted by the spectre of happiness, obsessed with the contemplation of joy"—precisely the spirit to which the avant-garde magazine *Playboy* was dedicated.[33] Calder went on painting expeditions around the city with a friend, Robert Chadeayne, a year older than he was; Chadeayne had, Calder recalled, "quite a fancy manner for doing landscapes."[34] Clay Spohn described the way Calder "would take a canvas and go out on the street some place, he'd take a set of pliers, wire, hammer, nails, tubes of paints in his pocket, brushes, everything he needed; and if the wind was blowing he would nail up the canvas to a telephone pole and wire it up so the wind wouldn't blow it and with a big crowd around he would happily paint."[35]

Sometimes Calder's vantage point was high up, from a rooftop or an apartment window—perhaps an apartment he had for a time on Fourteenth Street, west of Seventh Avenue. At other times he seemed to be working in the middle of the sidewalk. He was fascinated by both the elaborate cast iron or steel structures of the elevated subways and the netherworld of the city under construction. He set up his easel on the platform of the elevated subway line station on Cherry Street, opposite the offices of *The National Police Gazette*, an outfit, as we will discuss a little later, that employed him as an illustrator between 1924 and 1926; the building had cast iron images of boxers and athletes on the fire escapes. In Bryant Park, behind the Forty-second Street library, he painted the excavation for the IND subway, with the machinery and heaped lumber creating a drama of diagonal thrusts and counterthrusts that had an abstract dynamic power, with lines of force bending and buckling the space. He painted a parade along Fifth Avenue and, looking north up Fifth Avenue, the Tiffany Building. He painted the structures in which the police took their positions to operate what were the first traffic lights, beginning around 1922.[36] In one canvas—perhaps the first work Calder ever exhibited in public, at the "Ninth Annual Exhibition of the Society of Independent Artists" at the Waldorf-Astoria in March 1925—he painted a celebrated total eclipse of the sun on January 24, 1925. He set up his easel on the snow-covered grounds of the campus of Columbia University, where he recorded the excited crowd standing in the dusky, eerie morning light. Like the simultaneous appearance of the sun and the moon in the

*Calder. Untitled
(Excavation), c. 1924. Oil
on canvas, 36 x 29⅞ in.*

early morning off the coast of Guatemala, the solar eclipse was the universe working its own kind of magic. The dynamics of stars, planets, and other astral bodies moving through time and space would always fascinate Calder.

Like some of the Ashcan painters who were his parents' friends, Calder embraced the thrilling spectacle of the city illuminated at night. There may have been practical reasons for painting in the evening. There was a lot to occupy Calder during the days, at first his studies at the League and later his exploits as an illustrator for newspapers and magazines. It's also worth pointing out that for much of his time in New York, he didn't have a studio of his own, so he turned to the city streets for a place to paint. Whatever

the reasons, it's unquestionable that Calder saw a prototypical modern spectacle in the city at all times of day and especially after dark. He painted the brightly lit windows of the St. Regis Restaurant and people looking into the window of what appears to have been a haberdasher's. He turned his attention to the electrified marquee on what was probably a burlesque theater. He painted one of the city's excavation sites at night, this one an entire block, perhaps on the West Side, with men working under strong lights; apparently the city was expanding so rapidly that all the work couldn't be completed during the day. He painted the bunting decorating the Democratic National Convention at the old Madison Square Garden, with a great beacon illuminating the night sky, which he captured with strokes of violet, green, and pinkish-orange paint. Peggy's mother-in-law, on a visit to New York, marveled at the result. She com-

John Sloan. Picture Shop Window, *1907.*

mented that it was "a very difficult thing to attack as you can imagine with all those moving masses and brilliantly lighted colors."[37] That Democratic convention has gone down in the history books. There was such disagreement about who should be the presidential nominee and whether the Ku Klux Klan had any place in the party that the delegates went through 103 ballots, eventually rejecting the more plausible candidates in favor of John Davis, a former West Virginian congressman who went on to lose to Calvin Coolidge in a landslide. Calder's night city, whatever its forthright documentary power, also had a quickening, fairy-tale opulence.

Everything that was in motion delighted Sandy Calder. He painted a ballet school, with the central dancer in black shorts and a sleeveless top. There is a painting of a prizefight—done in 1924 and, as he recalled, "swapped for a year's tuition in boxing"—with the heads of spectators in the foreground and a practice area at the back, so that we feel we are looking down, up, around.[38] He painted the circus, with the flying trapeze, the great nets, the artists, and the spectators looking up as the painter looks down from his lofty perch. There's a scene of what seems to have been an indoor swimming pool with a tentlike roof, and a woman climbing up a diving tower while another woman is in the midst of a dive. There are several paintings

Calder. St. Regis Restaurant, *1925. Oil on canvas, 25¼ x 30 in.*

of tennis matches at Forest Hills. In one, Calder focused on the spectators in the stands, creating what amounts to a portrait of the audience. He was obviously interested in the repeating image of straw hats with dark bands. Working with brushy dots and dashes of paint, he caught all the animation of the crowd. When Calder took as his subject a six-day bike race, he captured that, too, at night, with the floodlit stands full of people represented by lighter dots on a dark ground, and the cyclists at rest. These jam-packed, exuberant scenes of modern life were the work of an artist with unabashedly big ambitions.

As Calder set up his canvases in the midst of Manhattan, he was aligning himself with a swaggering modern optimism. However much that optimism had been shaken by World War I, it would only finally be extinguished by the Depression, the rise of fascism, and the coming of World War II. Although Calder never seems to have known the writer Edmund Wilson, who gradu-

Calder. Old Madison Square Garden and Democrats, *1924. Oil on canvas, 30 x 36¼ in.*

ated from Princeton three years before Calder graduated from Stevens, they certainly walked the same New York streets; Wilson, after serving in the war, was an editor at *Vanity Fair*. Both men were fascinated by the circus, by Greenwich Village, by the excavation sites—by the spectacle of New York. Wilson, in his journals, wrote about the same Democratic National Convention that Calder painted. It somehow reminded Wilson of "a Princeton commencement—the same sultry sticky weather, the same influx of visitors, the same messy festival streets, the garlands of lights along Fifth Avenue like the Japanese lanterns strung among the trees in front of Old North." Calder, who was not far from his Stevens Institute experiences, could have sensed similar collegiate analogies. Wilson described "the motors roaring and speeding all night back and forth through Washington Square just as they used to do through the campus—plunging, whirring like dynamos,

Calder. Untitled (Forest Hills Tennis Stadium, Stands), 1925. Oil on canvas, 36 x 36 in.

through the stuffy night, spluttering as they got underway or hurtling noisily through the night."[39]

New York was simultaneously maddening and beguiling. In the 1920s, John Dos Passos—another friend of Wilson's, one whom Calder knew a little, later on—not only published the novel *Manhattan Transfer,* in which the life of the city was a reeling, careening carousel, but also attempted paintings on urban themes. Dos Passos explained to Zelda Fitzgerald that he found an "infantile excitement" in trying to paint "carnivals, amusement parks, the

flash of colored lights on faces in the dark, the view over misty suburbs twinkling with lights."[40] This was the same modern world—plunging, whirring, spluttering, noisy—that Calder was capturing as he painted the nighttime city with its gray-violet air.

V

Calder's strongest paintings suggest a journalist's attentiveness to the moment-by-moment shifts in city life. Whatever his powers of perception had been when he arrived at the Art Students League, they were certainly sharpened by the mass of drawings he was doing for *The National Police Gazette* and, eventually, a number of other periodicals. Some of the paintings, such as those of the circus and the ballet school, were obviously related to drawings done on assignment for the *Gazette*. How exactly Calder received his first assignments at the *Gazette* isn't clear. Nearly all of Stirling's old Philadelphia artist friends had worked as newspaper illustrators in their early years. And Calder proceeded to do the same kind of work in 1924 and 1925. Boardman Robinson's instruction, Calder recalled, "helped me a bit more than that of others to get my first job as an artist with the *National Police Gazette*."[41] He probably meant that Robinson acquainted him with a style that was congenial to journalistic work. But it's also possible that some of his instructors gave him introductions to editors at the magazines. It's not unreasonable to imagine that Sloan had something to do with Calder's appearing in the *New Masses*, as he was involved with the left-wing magazine, which began publishing in 1926; it was a revival of the old *Masses*, with which Sloan had also been involved.

Calder. Untitled (cover drawing for New Masses*), 1925. Ink and pencil on card stock, with crayon on tracing paper overlay, 14¼ x 22½ in.*

For Calder, who was pleased to have returned from Washington State with a thousand dollars or so saved up to support himself as he studied at the Art Students League, magazine work had the attractions of a paying job. He made twenty dollars for one of the half-page layouts he produced for *The National Police Gazette*, which wasn't an insignificant sum at the time.[42] Once he got going, he was extraordinarily enterprising. Having grown up in a family where money was sometimes scarce, Calder was well aware that artis-

Calder. "Seeing the Circus with 'Sandy' Calder," The National Police Gazette, May 23, 1925.

tic pursuits often yielded scant financial rewards. For the next quarter century, even amid his growing fame, he would struggle to make ends meet. At the Calder Foundation headquarters, there is still a portfolio he got together for his rounds of the newspapers and magazines. It's a homemade job, the covers recycled from an album of photographs of old French interiors that probably belonged to Stirling. "Return to A. Calder / 11 E. 14 St," Calder wrote inside; the portfolio evidently went with him to Paris, for there's also a later address, 22 rue Daguerre. Some of the designs for *The National Police Gazette* are in there, as well as some illustrations for the *New Masses* and a silkscreen poster for a 1925 production of Ferenc Molnár's *The Glass Slipper* at the Guild Theater on Fifty-second Street. By the middle of 1925, Calder was also doing some work, often little vignettes of figures in action, for *The Morning Telegraph*, *New York Herald Tribune*, *The New York Times*, and *The New Yorker*, which had begun publication only that February. The *New Masses*—which used several of his illustrations for its covers—wasn't the

Calder. "On a Sketching Stroll Through New York's Central Park," The National Police Gazette, October 17, 1925.

only left-leaning magazine he worked for; there was also *Survey*, for which he made pithy little sketches for an article about the Chinatowns in Vancouver and San Francisco, though one wonders if the drawings weren't done in New York's Chinatown.

The National Police Gazette, for which Calder worked most consistently, billed itself as "The Leading Illustrated Sporting Journal in the World." The cover of each issue featured a photograph of a revealingly clad young woman, no doubt intended to give a boost to newsstand sales. Calder produced well over a dozen layouts for the *Gazette* from the middle of 1924 until the end of 1925, with a few more in 1926. He covered a wide variety of subjects. The half-page spreads he designed generally consisted of one large scene surrounded by a series of vignettes. He visited sporting and entertainment events and devoted spreads to boxing, bike racing, tennis, ice skating, track, Spanish dance, polo, crew, football, and horse racing. There were also studies of the circus and of Central Park. Calder was interested in the sports-

men and the athletes, whether professional or amateur, and also in the audiences and their responses. The style evolved from a rather angular sort of Art Deco line in the works done in 1924 to a more open and informal graphic style in 1925, one that feels truer to Calder himself and sometimes suggests Japanese brush painting. Perhaps the editors gave him freer rein as he went on. Perhaps he simply felt more at ease. The pages have a playful, expansive, fleet-on-one's-feet feeling; the world is in perpetual motion, with the vignettes that surround the central scene suggesting multiple, multiplying viewpoints.

By early in 1925, Calder was being identified as the protagonist in these pictorial adventures. Scenes of the ice-skating rink were described as "impressionistic 'lines in action' by 'Sandy' Calder." Studies of Coney Island were accompanied by the observation that "artist 'Sandy' Calder has got some of this hurly-burly into his sketch, showing the sideshows, the 'hot-dog' stands, the merry-go-rounds, games of chance and the tin-type galleries." Of his studies of Trini, a Spanish Dancer, it was said that "Calder, who is essentially a 'modern' in his work, has caught the wild Andalusian grace of the dancing figures in a few strikingly expressive lines." Calder drew Miss Leitzel, the aerialist who performed with the Ringling Bros. and Barnum & Bailey Circus; she impressed him with her "100 dizzy twists at a dizzy height."[43] Miss Leitzel was also a favorite of Edmund Wilson's, who in *Vanity Fair* described her as "the freest, least self-conscious of performers, and the performer most distinguished by style."[44] The little captions on the *National Police Gazette* drawings were quite obviously, at least some of them, written by Calder, for they showcased what was already his flair for ridiculously bad puns. In the spread about the circus, a sketch of three seals was accompanied by the comment "The jury brings in a sealed verdict (write us and we'll let you in on the secret)." At the center of the Central Park spread was a couple seated on a hill, looking toward big buildings in the distance, and captioned "Centrally Parked."

VI

Done on the fly, the deadline always close, Calder's *National Police Gazette* drawings have an informality that shouldn't be overanalyzed. More than anything else, they endure as magnificent jeux d'esprit. But whatever the immediate concerns that pushed Calder to produce this raft of commercial graphic work—he wanted to earn some money; he was eager to put his name before the public—he was also driven by deeper instincts and inclina-

tions. Here we first see Calder's sardonic, ironic, and comic spirit, perhaps grounded in a happy-go-lucky son's responses to a rather saturnine, self-absorbed, and self-conscious father. Caricature of one sort or another would be an element in Calder's art over the years, certainly in the portrait heads done in wire in the years around 1930, and even much later, in the vehement comedy of the figures he made in the 1970s and entitled *Critters*. Those *Critters* are unclassifiable characters, half human and half monster, with their masked heads and triple legs sporting elegant high heels.

The language of caricature was second nature to Calder. Among the books he might have perused during his Art Students League years—they are still in the Calder house in Roxbury, some with his father's name on the flyleaf—are a little volume titled *The Eighteenth Century in English Caricature*, featuring James Gillray, William Hogarth, and Thomas Rowlandson; an edition of Max Beerbohm's *Seven Men* including his comic portraits; and a nineteenth-century Japanese woodblock book full of Hokusai's studies of strange, bizarre, and grotesque figures. For artists of Stirling's generation, caricature was not so much a particular journalistic technique as it was a method for exploring human expression, with the gross physical facts sometimes marshaled rather subtly, for deep psychological effect. In *The Gist of Art*, Sloan remarked that "to have something humorous to say is a good reason for drawing." Sloan hated the cruelty of caricature, which he saw as a kind of propaganda. So, come to think of it, did Calder, who more often than not avoided cruelty in his work. Sloan admired what he called "fine caricature," which had a "delicacy and grandeur," whether in Rowlandson or Rembrandt. He approved of distortion but rejected exaggeration. He wanted the artist to turn "the prose of nature into poetic images."[45] He spoke with enthusiasm of the French graphic artists of the nineteenth century who had immersed themselves in the life around them, mentioning Toulouse-Lautrec, Jean-Louis Forain, and Théophile-Alexandre Steinlen. Calder's parents concurred. During a 1924 trip to Europe, Nanette wrote that she was sending Calder "a Steinlen poster your father bought + thought good—so it is."[46]

The name Sloan invoked that seems most immediately relevant to Calder's art is Constantin Guys. Guys was the nineteenth-century draftsman whose fluid renderings of fashionable men and women and the hubbub of sophisticated Paris inspired Baudelaire to write his essay "The Painter of Modern Life." There Baudelaire argued that beauty depends less on the artist's feeling for eternal values than on the artist's ability to capture life's flux. Did Calder know of Guys in 1924? Did he know of Baudelaire and his cult of the flaneur, the outsider who savors the spectacle of urban life? My

Constantin Guys. Two Women, *c. 1860s.*

guess is that he did. Calder could have read about Guys in James Huneker's well-known 1910 book, *Promenades of an Impressionist.* (It was Huneker who had written so wisely about Luks.) "The street or the battle-field was [Guys's] atelier," Huneker announced. "Speed and grace and fidelity his chief claims to fame. He never practised his art within the walls of academies; the material he so vividly dealt with was the stuff of life." Guys, Huneker continued, was "in love with movement, with picturesque massing, and broad simple colour schemes."[47] So was Calder, as he drew and painted life in New York.

While nobody ought to underestimate Calder's immediate engagement with the spectacle of modern life, it's also important to point out that larger questions about the nature of art were coming into focus as he painted the city and filed his pictorial essays with *The National Police Gazette.* Calder was beginning to focus not on fixed compositions but on moment-by-moment experiences, not on stasis but on flux. It was Baudelaire who had first described this new kind of kinetic experience in the arts. "Thus the lover of universal life enters into the crowd as though it were an immense reservoir of electrical energy," he wrote in "The Painter of Modern Life." "Or we might liken him to a mirror as vast as the crowd itself; or to a kaleidoscope gifted with consciousness, responding to each one of its movements and reproducing the multiplicity of life and the flickering grace of all the elements in life."[48] Even if Calder hadn't read Baudelaire's essay, he could have gleaned some of Baudelaire's ideas from Élie Faure's *History of Art,* at least parts of which he read with considerable enthusiasm. Although little appreciated today, the impact of Faure's richly plotted, strikingly lyrical history on younger artists in the first part of the twentieth century can hardly be exaggerated.

Calder wrote enthusiastically to his sister about the first volume of Faure's four-volume work, which dealt with ancient art.[49] I think it's likely that he also found his way to the final volume of Faure's history, which opens with a quotation from Baudelaire: "The marvelous envelops us and we breathe it

like the atmosphere; but we do not see it."[50] In Faure's extraordinary prose, reality is abstracted, reimagined as a play of dynamic possibilities. His symphonic account of the history of art culminates, at the end of the fourth volume, with a vision of a coming revolution in the arts. He argues that up until now painting has embraced space as its domain. But that is about to change. "The gradually increasing importance which we give to time has stealthily introduced itself into our former idea of space. The cinematograph causes it to be born and to die there, to be reborn and to die again under our eyes, precipitating into the counterpoint of universal and continuous movement that which painting, in former times, fixed upon canvas: volumes, passages, values, associations, oppositions, and contrasts—which modify one another, reply to one another, interpenetrate, and become entangled, ceaselessly and in all the dimensions. And now, everywhere and all the time, evolving and vague relationships of an irresistible accent are being established."[51] All of which—how can one avoid it?—prefigures Calder's own conquest of time in the mobiles he would begin to create less than a decade later.

ANIMAL SKETCHING

I

In the summer of 1924, with the season at the Art Students League under his belt, Calder was for the first time a young artist on his own in the city. Stirling and Nanette had left in May to spend the summer in Europe. They gave up their apartment at 111 East Tenth Street, where Calder had been living with them, and he moved into his father's studio at 11 East Fourteenth Street. Writing to Peggy and Ken from Rome, Nanette observed that it was good that Sandy now had a place to work indoors. "He seems to enjoy painting in the streets of New York. I am anxious to see what he will develop whilst we are away—because when one works out of doors—one really needs a place where you can work at once when coming in from the street—pulling things together, etc. And he has that now."[1]

Calder was occupying his father's studio—a real artist's studio!—after all the years he had looked longingly at Stirling's impressive digs. "Am really enjoying this studio life," Calder wrote to his sister and her family a few days after his parents had left New York. "Don't make the bed, seldom eat (I weight 160, str.), have 2 easels, 3 stands, 2 tables, + the floor just littered with junk—and mother gave me all her paint, tho I am still using my own."[2] A few weeks later, he was telling Peggy about a gathering he'd put together for her mother-in-law, whom the family referred to as Nana Frank. Among the guests were his League friend John Graham, the singer and family friend Frances Gould, the painter Marjorie Acker, whom Peggy knew from high school, and a few others. Gould had come over early as Sandy was going to paint her, he told Peggy, "but we started decorating the food, and had a swell time, and never had a chance to paint."[3] The supper was a great success. Peggy's mother-in-law enthusiastically described the scene in Stirling's "fine big studio," with Sandy's work standing all around, the "dozens of big can-

vases" representing "street scenes, fighting bouts, some faces and figures," as well as "lots and lots of sketches, clever caricatures—constant experimenting that shows [Calder's] love of the thing he has found."[4] Calder was certainly getting the hang of entertaining, as Nana Frank told Peggy. "He used the model stand for his table and had one of your mother's handsome big platters for big pink slices of roast beef with whole bunches of radishes for decorations." There was tea in tiny Chinese cups. Afterward, Calder and Graham accompanied her back to her hotel.[5]

Despite the partying, Calder was living simply, without any apparent money worries. Perhaps he still had some of his savings from his logging jobs; there were the first couple of jobs in May for *The National Police Gazette;* and there was an inheritance from his grandfather Milne, who had died the summer before, some five hundred dollars, which, Calder later recalled, he lived on that summer. He was contemplating a summer excursion of his own, considering a trip to South America in June; after that plan was abandoned, he headed north to Montreal in July. We know nothing about that trip to Canada other than a comment in one of Nanette's letters, in response to an account in a letter of Sandy's now lost: "I hope you are having a bully good time on your trip to Montreal. For that is what your letter leads me to believe you are doing."[6]

Calder wrote to Peggy's mother-in-law, who was herself something of a free spirit, about the dances he'd been to and enjoyed in New York. The only problem was that "people seem to object to my paucity of costume + abundance of jumps + leaps. However, I can charleston with any of them—so that's an offset."[7] The gaiety, the parties, the drink, the love of theatrical events high and low and any and all forms of experimentation in the arts—for Calder all this began in Greenwich Village in the 1920s and lasted a lifetime. Calder's League friend Clay Spohn later spoke of the books he was reading in that period: Havelock Ellis's *The Dance of Life,* Clive Bell's essays about "significant form," and Lewis Mumford's book about the arrival of the modern spirit in America, *Sticks and Stones.* Spohn also recalled seeing Picassos in New York, perhaps at the Knoedler gallery.[8] Within a decade, Calder would begin a lifelong involvement with the art of the dance, create abstract sculpture that radically expanded the possibilities of significant form, find none other than Picasso visiting two of his exhibitions in Paris, and read a searching review of his work by Lewis Mumford in *The New Yorker.*

II

During the summer of 1924, Calder wrote a good many letters to his sister, apparently more letters than he sent to her in the months before or after that—although, of course, letters may be lost. Could it be that he was feeling the absence of the day-to-day conversation with his parents, especially his mother, and so he turned to his sister? It was a summer for letters, with Nanette and even Stirling keeping Sandy and Peggy apprised of their progress across Europe. Theirs was by no means an easy trip, for the usual challenges of travel were exacerbated by the uncomfortably hot weather, which left Stirling more often than not in a less than perfect mood. Calder, sometimes referred to by his mother affectionately as Sandow, was the summer he turned twenty-six still very much caught up in his parents' affairs. Stirling had left his son with some matters involving a sculpture commission to attend to, and he sent a few hasty letters back to New York, checking that everything was getting resolved. Sandy was also supposed to be looking out for an apartment for the three of them to share once Stirling and Nanette returned to New York.

Nanette worried about how Sandy's money was holding out. She wrote half-jokingly, a few weeks before his birthday, that she was "willing to be a pauper" so that he could be comfortable.[9] There was some back-and-forth about whether Marie Sterner—an art dealer friend of Stirling and Nanette's who was married to the painter Albert Sterner—had in fact taken a painting of Sandy's to a show she was mounting in Paris and whether it might have sold. By the time the Calders were in London in September—on the verge of heading back to New York—Nanette was writing to Sandy that "we think her Paris affair was a failure financially as there is none taking place in London." And then, after some allusions to problems in the Sterner family, Nanette commented with a bit of the sharpness of a mother addressing an overly eager and perhaps gullible son, "though I do think she has not done the right thing with your canvas I could say—I told you so—but I won't. You wanted experience—now, you have it."[10] Sandy remained friends with the Sterners.

The letters Calder sent his sister included an account in September, just before his parents' return, of their uncle Ron's failed attempt to marry a woman by the name of Alice Smith. Apparently she lived in New York and Calder knew her to some degree. If Stirling was the best-looking of the brothers—in a letter to Sandy from Greece, Nanette commented that "everyone admires your father even the men pay him compliments"—Ron was the one with the extraordinary physique, captured by Stirling in his

study of Ron as a bare-chested miner.[11] He was also the brother Sandy and Peggy liked the best, remembering how he had played with them when he visited Pasadena. Ron had come out to San Francisco to work with Stirling at the Panama-Pacific International Exposition and had ended up in Oregon. He was somehow a hapless fellow, prone to disappointment, as indeed it seemed were all of Stirling's younger brothers, each of whom lacked Stirling's extraordinary drive. Ron had become a Christian Scientist and then, according to Peggy, had his faith shattered along with a badly broken kneecap, which the power of prayer failed to heal.

Alice Smith was a childhood sweetheart of Ron's. They had been in communication for several years, with the assumption, at least on Ron's side, that they would eventually marry. When Ron received his inheritance after Milne's death in 1923, he decided to come east and make his move. But when they met, Alice told Ron she didn't want to go through with it. As all this was unfolding, the twenty-six-year-old Calder found himself acting as Alice's confidant. Then it seems that three of Calder's uncles—Charlie, Ralph, and Norman—decided that Calder was too mixed up in Ron's business, a naïve mama's boy involved in something that was way over his head. At any rate, Ralph and Norman appeared in New York with some stern warnings. Calder was eager to report everything to Peggy. He wrote to his sister that Ralph and Norman told him that he "had better not tell mother that I had been alone with [Alice] in the studio, as she mightn't like it." They seem to have assumed that Sandy was still a big baby, gabbing to his mother.

Calder continued to Peggy: "Nor[man] added that mother and I had always been very close, but that she was the only woman I really knew— and said something about these married women who go into studios. I felt amused, but wish I had slapped his face. But then they would have thought I had done something wrong (for which I should worry). To sum up, they advised me very seriously not to have anything more to do with Alice—and hinted that she might sue me thru father, or father thru me, or some very complicated sort of legal affair. It was excruciating. But I didn't say a word. After they had gone I called Alice up and saw her that evening. She said that she just hadn't felt wildly in love with Ron, when she finally saw him, and she didn't feel like marrying him + going off to live in the country (as he wanted), on such a basis. It seemed quite reasonable, but all balled up." And so there was Calder, probably feeling old beyond his years, as this woman explained to him why she didn't want to marry his uncle. Calder concluded his letter to Peggy: "But imagine those 2 telling me not to tell mother! They are alarmists, if nothing else."[12] He probably said nothing to his mother. But he wrote immediately to his sister—who was a sort of surrogate mother.

Calder. To My Valentine, *1925. Wire.*

Was Calder a mama's boy? Was the elaborate wire valentine Sandy gave his mother in February 1925 not only a foreshadowing of the wire sculptures he would do a little later but also some sort of joking confession that she was the woman in his life? A few years before, Nanette had apparently let Sandy know that she thought he described any girl he spun around the dance floor as "a peach."[13] She may have been suggesting that his feelings were a little distant and maybe stylized—that he wasn't really ready to commit to a serious relationship. She may have had a point. While Calder's return to New York had to some extent, whether he liked it or not, pushed him back into the parental nest, his mother's love, however suffocating at times, wasn't something he rejected out of hand. Certainly Nanette felt immensely close to her son—at times maybe closer than she did to her husband. Stirling and Nanette's marriage, which had begun as a love affair sanctified by their shared passion for the arts, was by no means always easy. And it certainly wasn't easy in Europe in the summer of 1924, when Stirling was all too often in a foul mood.

As Sandy embraced the artist's life, Nanette may have experienced or at least hoped to experience with him some of the artistic intimacy she had once felt with her husband. However close she was to Peggy, she couldn't help confessing in a letter to Sandy early that summer that "unlike the Hayeses—I think we understand each other without speaking the exact alphabet."[14] Writing from Venice, she confessed to her Sandow that "I often enjoy thinking how you would see things 'funny' and I imagine you laughing." Describing her reactions to Tintoretto, she concluded, "There will be so much to talk about—I hope we have the time and leisure. . . . My dear boy I hope all's well with you and work developing—I often wish you were with us but your Dad thinks it would upset you."[15] It seems that Stirling thought

Nanette was smothering their son. Or perhaps he was jealous of their close-
ness. Or perhaps both. As for Calder, for the time being he may not have
been averse to occasionally feeling a little smothered even as, step by step, he
moved beyond the family circle.

Was Calder actually in love with anybody before he met Louisa James,
the woman who would become his wife, in 1929? There is no way to know.
Which is how Calder and his wife wanted it. Although a famously sociable
couple, they were decidedly private when it came to the bedroom. Peggy
recalled her mother, in 1925 or thereabouts, telling her that Calder was "pay-
ing court to a tall, handsome girl. Her father, a hard-boiled, self-made busi-
nessman, took a dim view of his suit. The penury and insecurity of most
artists' lives was not what he wanted for his daughter."[16] In his mid-twenties,
Calder may have had his own reasons for avoiding a deepening involvement
with some particular woman. Perhaps the family was still too comfortable
a haven for him to consider shifting his allegiances elsewhere. His friends
tended to become family friends. As much as he was moving away from the
family, Calder was simultaneously pulling many of the people he met into
the family circle. It was Bill Drew who volunteered to meet Stirling and
Nanette upon their return from Europe, and make sure that they weren't
stuck in customs the whole day. Margaret Dale, the well-known actress who
was a cousin of Nanette's and whom they'd seen in *Disraeli* in San Francisco,
was painted by Calder in New York. Both Sandy and Peggy, in their mem-
oirs, recalled the strong impression that Dale's lavishly made-up face and
form-fitting clothes had made on them when they were adolescents. Paint-
ing Margaret Dale could have been a sexually charged situation for Sandy,
with the glamorous actress who was already in her forties submitting to the
lingering gaze of the energetic young artist she'd known since he was a boy.

Although in Calder's day many educated middle-class young men had
had a good deal of sexual experience by the time they were twenty-six, oth-
ers surely hadn't. In the next year or so, before he left for Paris around the
time he turned twenty-eight, Calder found himself happily up to his ears
in Greenwich Village's bohemian circles, where sexual escapades were the
order of the day. There is every reason to imagine that both in New York
and then in his first couple of years in Paris, Calder passed some nights—and
some afternoons—in bed with one or another of the women whose names
appear in letters and memoirs. But whatever romancing he did and however
smitten he might have been, my feeling is that only once did Cupid's arrow
make a direct hit on Calder's heart, and that was when he met Louisa James
in 1929. Perhaps the best way to describe Calder's connections with women
both in New York and then in his first couple of years in Paris would be as

erotically charged friendships or comradeships. They were bohemian pals getting together to kick up their heels and maybe tear off their clothes.

III

Actors, actresses, the theater, and theatricality were all in Calder's blood, a lifelong passion of his father's that became the son's passion, too. Sometime after returning to New York, Calder worked as a stagehand at the Provincetown Playhouse, among the most important experimental theatrical operations in New York at the time. He wrote to Peggy—exactly when isn't clear—about "my venture into the theatrical business. I guess mother told you that last week I worked everynight down at the Provincetown Playhouse shifting scenery. It was rather fun."[17] Calder described the place to his sister as "a very tiny theater, a converted barn," and reminded her that the family had seen the Provincetown Players perform *The Emperor Jones* in Aberdeen—a production of Eugene O'Neill's play, with Paul Robeson in the starring role.[18] The man Calder was working for was the stage designer Cleon Throckmorton. Calder almost certainly saw the production that October of a play by Edmund Wilson, *The Crime in the Whistler Room*, with Wilson's then wife Mary Blair in a starring role and sets by Throckmorton. The playhouse was planning to revive *The Emperor Jones* in December. For now, Calder was hauling scenery for *S.S. Glencairn*, also by O'Neill, which had opened on November 3; this was a series of *Four Episodes of the Sea*, with music arranged by Norma Millay, the poet Edna St. Vincent Millay's sister, and sets by Throckmorton.

Throckmorton's name appears only fleetingly in Calder's letters to his sister, and not at all in the *Autobiography* or in the autobiographical notes. Nevertheless, there is little question that the man and his work—he was Calder's age although much further along in his career—made an impression. At some point Calder gave Throckmorton some sketches for proposed designs for a revival of *The Emperor Jones*. This may suggest a certain lack of politesse on Calder's part, considering that Throckmorton had designed the original production, which one assumes Calder knew; or perhaps Throckmorton had encouraged Calder to make a proposal. Calder was anxious to find some work in the theater. In his autobiographical notes, he recalled doing stage designs for a couple of productions at the Hudson Guild Theatre, yet another one of New York's experimental outfits, this one run by Adele Nathan. Calder remembered her as a "stager of spectacles."[19] Nathan, who apparently knew Gertrude Stein a little, had a long and interesting

career in theater and film; she was involved with the Federal Theatre Project in the 1930s as well as the 1939 New York World's Fair.

Throck, as people called him, had a degree in engineering and, like Calder, a flair for gadgets. When Calder worked with him at the Provincetown Playhouse, Throckmorton's association with the theater was fairly new. He had been brought in initially to design sets for *The Emperor Jones*, after which he became the theater's first permanent technical director.[20] Edmund Wilson, recalling

Cleon Throckmorton's set for The Emperor Jones *by Eugene O'Neill, first staged by the Provincetown Players in 1920. The photograph is by Francis Bruguière.*

in his journal a drunken party at Throckmorton and his wife's apartment in 1926, noted that the music was provided by a radio that Throckmorton "had built himself"; Throck explained to Wilson that "the best radio features had all been patented by different companies, so that there wasn't a single radio on the market which was as good as possible, and it was only the government or a private individual, making his own, who could have one."[21] That kind of ingenuity would certainly have appealed to Calder. The man also had a sense of humor. There is a photograph, from a couple of years earlier, of Throck on the terrace of a Greenwich Village hangout known as the Krazy Kat, painting a young woman seated on a chair atop a table; the entire scene has the allure of a loving parody of the artist's life. Throckmorton ran a business supplying stage-set equipment in the 1930s, and later was the first art director for CBS. Calder wasn't the only well-known artist who worked for him at one time or another; Franz Kline assisted him in 1939.

In the mid-1920s, Throckmorton was making quite a name for himself with his starkly lit productions of Eugene O'Neill's plays. He had a way of transforming the actors into sharp, provocative silhouettes, with the entire stage becoming a single graphic image, as if a black-and-white woodcut or linoleum cut had been brought to life. Throckmorton opted for a highly simplified and abstracted stage picture, the lives of the seamen on the SS *Glencairn* evoked suggestively, symbolically. The dramatic power of Throckmorton's black-and-white shadows and silhouettes may have impressed Calder, who would himself cultivate a drama of black-and-white silhouettes and shadows in some of his greatest mobiles of the 1940s and 1950s. There is at least one

documented occasion, at an exhibition in London in 1938, of Calder's using a flashlight to project shadows on the walls. Throckmorton's achievement was part of a modern tradition that had begun at the end of the nineteenth century with Adolphe Appia, who aimed to create a stage picture so powerfully anti-naturalistic that it became a protagonist in the drama. Edward Gordon Craig, picking up on Appia's ideas, had dared to dream of a theater without live actors, writing, "We must translate Movement through the medium of inanimate forms and thereby produce once more an Impersonal Art."[22] Which brings us to Calder's dramatic animation of inanimate objects in his mobiles as well as in the experiments involving a ballet without dancers that preoccupied him off and on from the mid-1930s to the late 1960s.

IV

Although Calder's opportunities to take part in what amounted to a theatrical revolution remained frustratingly few in the 1920s, he would have had a chance to study at first hand some of its finest achievements if he'd visited the "International Theatre Exposition," mounted at the Steinway Building on West Fifty-seventh Street early in 1926. We will most likely never know whether Calder did or didn't visit. Throckmorton was among the hundreds of artists whose work was exhibited in what has come to be regarded as a landmark event. Given Calder's general interest in the theater and his previous connection with the Provincetown Playhouse, which was one of the sponsors of this important show, I suspect that he did pay a visit. That the

show was organized by the Viennese-trained architect Frederick Kiesler is nothing if not intriguing; Calder probably didn't yet know Kiesler, but he would become an important friend a few years later, when he invited a who's who of the Parisian avant-garde to a couple of performances of the *Cirque Calder*. The Steinway exhibition included Picasso's rattan stage props for *Mercure*, the ballet he created in Paris in 1924 in collaboration with Erik Satie and Léonide Massine; those props have been suggested as an inspiration for Calder's early wire sculptures.[23] According to the catalog for the "International Theatre Exposition," practically the entire production of *Mercure* was represented in the show, including not only stage props but also costumes and a series of photographs.

My guess is that Calder not only saw the exhibition but also took a close look at the catalog, which included texts by key members of the European avant-garde and discussions of both the Ballets Russes and the Swedish Ballet. In one catalog essay, Kiesler launched an attack on the conventional proscenium stage, arguing that "the new spirit bursts the stage, resolving it into space to meet the demands of the action. It invents the space-stage, which is not merely *a priori* space, but also *appears as space*." Kiesler envisioned a new form of theater—the exhibition included his own model of a spherical theater—where "the movement is carried from one element to another. The movements begin abruptly; accelerated and retarded, they continue without interruption until the play is ended."[24] In another catalog essay, Adolf Loos, an Austrian architect, spoke of the importance of the circus as a model for this new kind of theater. "The circus is the thing," he proclaimed. "It matters not whether the circus has a round arena or a set stage. What does matter is that it provides such a succession of nervous impressions as will prepare the ground for the growth of the roots of creative mind."[25] Four years later, Kiesler would be bringing his friends to see the *Cirque Calder* in Paris. Kiesler must have reckoned that Calder was responding, after his own fashion, to the call for new forms of theater—a theater released from both the conventions of the old-fashioned actor and the constraints of the old-fashioned cubic proscenium space.

Throckmorton and Kiesler were not the only theatrical designers who helped shape Calder's interest in the avant-garde stage. He was friends with another major stage designer, Lee Simonson, beginning sometime in the 1920s, although exactly when isn't clear. It's true that Calder never spoke of the impact of Simonson's—or Throckmorton's or Kiesler's—art and ideas. But his silence on such matters was often strategic, grounded in a refusal to lock his work into some particular historical narrative. A genius, in any event, turns influences into inspirations. Once the deed is done, there is little

to be gained by acknowledging the influence. It may even be that the inspiration annihilates the influence, at least in the artist's own mind. Calder's friend Lee Simonson was not only a designer but also a major critical voice on behalf of new currents in stage design; he wrote for *The New Republic*, was the coeditor of the book *Settings & Costumes of the Modern Stage* in 1933, and organized the important "Theatre Art: International Exhibition" at the Museum of Modern Art in 1934. In the catalog of that show, Simonson wrote that while "the actor in motion [is] the basis of the total stage picture," one couldn't deny the importance of "the design, a space composition that can enhance the total pattern of movement and heighten its emotional intensity."[26] These were the sorts of ideas Calder would have been hearing from stage design friends in New York, beginning with Throckmorton in 1924.[27]

In 1933, when Simonson wrote an essay for *Settings & Costumes of the Modern Stage*, he worried that a great, radical period in American stage design was coming to a close. "The theatre of ideas," he wrote, "for the time being seems either chaotic or quiescent." That was the theater Throckmorton had embraced at the Provincetown Playhouse. In the theater that Simonson most admired, "we became architects of a third dimension rather than painters, projectors of a plastic stage picture to which light added not only form but dramatic emphasis."[28] Calder was on his way to becoming an architect of the third dimension.

V

By the beginning of 1925, after less than eighteen months back in New York, Calder had pretty much given up his formal studies at the Art Students League. He was making new artist friends, among the most important being Alexander Brook, who was also an Art Students League veteran. Although exactly the same age as Calder, Brook had gotten an earlier start, studying at the League from 1914 to 1918. In 1920, he'd married Peggy Bacon, who by the time Calder knew them was already well known for her satirical drawings, prints, and illustrations; she published a collection of pictures and poems, *Funeralities*, in 1925. Calder rented a room for a time in Alexander and Peggy's apartment at 142 West Tenth Street. He forged a bond with their two young children. A lithograph of a bohemian party that Calder made around this time may well have been set in their apartment. Along with the artist himself, the figures in this convivial scene include Alexander Brook and Peggy Bacon, the gallerist Carl Zigrosser, who would show Calder's

work a few years later, and Zigrosser's first wife, Florence King, who is doing a Charleston in the middle of the room.

Nanette couldn't help feeling that her son was a little too impressed with Alexander Brook and Peggy Bacon. Writing to her daughter Peggy after Sandu (another one of her affectionate names for her son) had brought them over for dinner, she commented that "Sandy is quite enamoured of the whole lot and only comes home to feed—dinner and leaves almost at once—Whitney Club—drawings to do—etc." Nanette wasn't impressed by Peggy Bacon, perhaps seeing her as a rival for her son's affections, perhaps worrying about his fascination with a woman who was married to someone else and therefore unavailable. Nanette found her "a mousy sort of person—very cunning and knowing—Sandy likes her immensely and gets a great joy from the children." Nanette knew she was being judgmental, and yet she couldn't help herself. "It is not fair to judge too hastily," she admitted, "but both he and she are close in the eyes—a sign of craftiness."[29] Of course, what Nanette criticized as "craftiness" other people might have interpreted as nothing more than an ability to get along in the world.

Calder. Untitled, 1926. Lithograph, 9⅛ x 12⅛ in. Calder stands all the way to the left; Peggy Bacon is seated all the way to the right; Carl Zigrosser (Calder's first New York dealer) sits on the floor with his back to the fireplace while his first wife, Florence King, dances up a storm.

Alexander Brook and his connections certainly had more than a little to do with Calder's rapidly expanding horizons. Brook was the assistant director of the Whitney Studio Club on Eighth Street, which eventually became the Whitney Museum of American Art. Although his own work was rather academic, he was extraordinarily sophisticated when it came to contemporary art. In February 1924, he helped organize an exhibition at the Whitney Studio Club of work by Duchamp, Picasso, Braque, and the caricaturist Marius de Zayas that included Duchamp's *Nude Descending a Staircase*. Brook was one of the artists with whom Calder exhibited at the Artists' Gallery on East Sixty-first Street at the end of 1925. That was Calder's second opportunity to exhibit work in public, following the appearance of his painting of the solar eclipse at the Society of Independent Artists at the Waldorf-Astoria. The Artists' Gallery occasioned the first mention of Calder's work in print. "These minor canvases," Murdock Pemberton wrote in *The New Yorker* about the variegated works in this group exhibition, "can be had for little money and your grandchildren can then sell them for much." Pemberton cited works by Charles Couchman, Niles Spencer, Jan Matulka, and Alexander Brook as "all safe investments, we should think." And then he closed his little paragraph by observing, "A Calder, too, we think is a good bet."[30]

Brook almost certainly had something to do with Calder's becoming a member of the Whitney Studio Club, and thus being included in the club's "Eleventh Annual Exhibition of Paintings and Sculptures," held at the Anderson Galleries. Simultaneously, he was in the "Tenth Annual Exhibition of the Society of Independent Artists," with a painting of a dissection called *The Stiff*. He described the exhibitions in a letter to Peggy's mother-in-law, observing of the Whitney painting that it "was favorably commented on, but *not* bought" and of the one at the Waldorf of "medical students cutting up a stiff" that "it was amusing how it startled people + the cub reporters on some of the papers."[31] It was definitely Alexander Brook who brought Calder along to a celebration in February in honor of Constantin Brancusi, already widely recognized as the first great modern sculptor. Brancusi was having an exhibition at the Wildenstein Galleries. Calder commemorated the evening in a painting—*Firemen's Dinner for Brancusi* (1926)—but Brancusi, for reasons unclear, doesn't make an appearance in the painting, although he was in New York at the time and, one assumes, attended the banquet. Perhaps this was some sort of joke on Calder's part—the idea of having the honoree missing in action. The painting is a salmagundi of dancing, conversing, gesticulating men, the bodies fitting almost like puzzle pieces into the pattern of zigzagging tables that fill the composition. Organized by artists, the celebration was referred to as the Firemen's Dinner because it was

Calder. Firemen's Dinner for Brancusi, *1926. Oil on canvas, 36 x 42⅛ in.*

held in support of the Union Square Volunteer Fire Brigade at the Tip Toe Inn on East Fourteenth Street.

Calder was becoming an artist among artists, at ease with the movers and shakers and hangers-on of bohemian New York. He never actually said whether he attended Brancusi's exhibition at the Wildenstein Galleries, although my guess is that he did. Calder sometimes gave the impression that he knew little or nothing about abstract art until several years after his arrival in France in 1926. Perhaps he wanted to prove, at least to his own satisfaction, that he was the most independent of *all* abstract artists—"warbling his woodnotes wild," as Milton said of Shakespeare. Or perhaps it was sheer perversity, the sly trickster in Sandy Calder throwing critics and historians off the trail. The truth was that Calder was backing his way into modernism,

much as he had backed his way into engineering and then backed his way into painting. I find it hard to believe that he didn't know a good deal about modernist painting and sculpture by the time he painted *Firemen's Dinner for Brancusi* in 1926. Calder would always be adept at using what appeared to others as his obliviousness to his own advantage. Late in life, he often gave the impression that he'd fallen asleep at the lunch or dinner table, only to suddenly interject a remark that made it clear that he hadn't missed a thing. If in 1926 he seemed to some to be unaware of Brancusi and Cubism and abstract art, the truth was probably that he was absorbing those achievements in his own particular way at his own particular pace. When he "awoke" with his first exhibition of abstract sculptures in 1931, it was clear to one and all that he hadn't missed a thing.

It was in the spring of 1926 that Calder first spent time in the corner of western Connecticut that a few years later would become his home. He had gotten to know Betty Salemme; at the time she was married to a sculptor, Antonio Salemme, whose best-known work was a portrait of Paul Robeson, done after he'd seen the actor in *The Emperor Jones* at the Provincetown Playhouse. Salemme's half brother was the painter Attilio Salemme, with whom Calder would be friends some years later. In his autobiographical notes, Calder said, rather ambiguously, that he was introduced to Betty because "I told such long, interminable, salacious stories—often without point."[32] They must have met in the circles around the Provincetown Playhouse. In any event, in the spring of 1926 Calder went with Betty and Tony Salemme and another sculptor, Oscar Davisson, to a house that Betty had rented near Sherman, Connecticut. They all felt very much at ease in a part of Connecticut that was already beginning to attract the Greenwich Village crowd. That very June the writer Malcolm Cowley, whom Calder may not have known at the time but who would become one of his closest Connecticut friends, was living nearby, praising the country to Harriet Monroe, the editor of *Poetry,* as "a magnificent country, full of deer, trout, granite and poison ivy."[33] Then or soon after, the area and its cheap rents attracted the writers Hart Crane, Allen Tate, and William Slater Brown (a great friend of E. E. Cummings's and, later, Calder's brother-in-law), as well as the painter Peter Blume (who would become a close friend of Calder's in the 1930s).

Joining the party with Calder, Betty and Tony Salemme, and Oscar Davisson, at least briefly on her way to Provincetown, was Romany Marie, the restaurateur who was a sort of queen of Greenwich Village bohemia. Davisson has been remembered by Cowley's son as "a sculptor of uncertain talent. His real talent was for finding, and marrying, rich women. He spent a lot of time in Taos, and looked like the Marlboro Man, mustache and all.

He always affected a cowboy Stetson."[34] The Salemmes, according to the writer Glenway Wescott in a journal entry many decades later, were sexually adventurous. Betty, a beautiful woman, had had a brief affair with Paul Robeson. And Tony, while working in 1924 on a sculpture of Wescott in the nude, had gone to bed with him, though not, so Wescott recalled, very successfully.[35] As warm weather came to western Connecticut, the atmosphere among Calder and his friends, or at least between Calder and Betty, was at the very least playfully erotic. Calder took to swimming in the nude. Once he was so fascinated by a black snake with a butterfish in its mouth that he followed them onto the shore—whether naked or not isn't entirely clear—and watched as the snake dropped the fish and the fish flipped itself back into the water. For their swims, Betty wore what Calder remembered as men's underwear—known in the slang of the day as a "union suit," dubbed by Betty her "Helen Westley." "Men's such clothing," Calder observed years later, "was called his 'Calvin Coolidge.' Both could be found in the 'Pornographic Section' of the Sears Roebuck Catalogue."[36]

One day, Betty and Sandy were spied by a man with binoculars, some sort of official, who told them it was against the law to go swimming in the outfits they had adopted, though he wasn't averse to getting a good look at Betty in the meantime.[37] Sandy and Betty were certainly doing some flirting. She would sometimes take Sandy into the bathroom to tell some story or other. And Sandy, with his passion for puns, dubbed their little tête-à-têtes "the privy council."[38]

VI

The black snake and the butterfish up in Sherman were only two among a host of animals, both real and imagined, that caught Calder's attention in the last six months or year he spent in the States before embarking on his first European sojourn. If Calder enjoyed going native in Sherman, he also enjoyed studying the natural world, although his studies were as often as not carried out in a zoo or the pages of an art book. In his *Autobiography*, Calder recalled his father's annoyance at all the time he spent on the floor wrestling with his mother's "carroty cat." "Get a book," Stirling growled.[39] It was Stirling who gave his son, in 1924, a copy of a German book by Reinhard Piper, *Das Tier in der Kunst*, published two or three years earlier, which included 240 illustrations of animals as they were represented in the visual arts in all periods and cultures. Stirling included the tenderest of inscriptions: "To the Man Cub Still." *Man Cub*, of course, was the statue Stirling had done of his

Calder. Rooster Sundial, *1965. Ink on paper, 9 x 8 in. This drawing of the wire sundial that Calder made for his apartment in New York in 1926 was illustrated in the* Autobiography with Pictures *in 1966.*

son when he was three or four years old. Apparently Stirling still thought of his chubby son as a bear cub. Years later, Sandy would also associate one of his children—his older daughter, Sandra—with an animal. He nicknamed her Camel when she was around twelve, because she had the habit of holding her head very high and looking down her nose when she didn't like someone.[40]

Calder was beginning to produce animals galore, with ink on paper, paint on canvas, as well as in wood and in wire. When Peggy visited New York—in either 1925 or 1926—Calder was sharing a studio on Bleecker Street with Charles Howard, a Californian from an artistic family. Howard, who was a year younger than Calder, eventually made a name for himself with intricate, surreal abstract paintings and lived a good deal in England and Italy. Peggy was impressed by her brother's India-ink drawings of animals, which he was studying at the Central Park and Bronx Zoos. In May 1926, Calder's painting of a show of prize horses was included in an exhibition at the Anderson Galleries devoted to the horse in history; it included a Tang dynasty horse, an ancient Greek work, a fifteenth-century Tibetan processional banner, a Ming painting on silk, and a Gothic sculpture. Around the same time, living in Sherman in close proximity with two sculptors, Betty's husband and Oscar Davisson, Calder made a sculpture of a cat, the body flattened and elongated to fit into the format enforced by the oak fence post from which it was carved. And last but not least, he produced out of a single length of wire a rooster at the top of a vertical stretch of wire; the vertical wire created a shadow that aligned with pencil demarcations on the wooden base. This was designed as a sundial for the little apartment he had on Fourteenth Street west of Seventh Avenue, a room that lacked a clock but had a southern exposure; it was, he announced in the *Autobiography,* "my first effort to represent an animal in wire."[41] The rooster sundial was long gone by the time Calder wrote about it, so he made a drawing as a commemoration.

Calder found something fascinating—and funny and enchanting—in the fluidity with which animals moved from action to repose and playfulness to watchfulness. He was not alone. Beginning with the Romantic generation of Eugène Delacroix, Théodore Géricault, and Antoine-Louis Barye, artists impatient with the increasing rationalization of modern life had been

attracted by what they saw as the greater naturalness of the animal kingdom. Calder took little interest in the intricacies and exigencies of human psychology and had an instinctive distaste for the messy melodrama that even the most thoughtful people could make of life's ups and downs. While he could be an extraordinary portraitist when the subjects were his friends and a great student of human form and feeling in his wire sculptures of athletes, acrobats, and celebrities, he obviously felt a particular sympathy for the directness with which animals, at least so far as a person could see, telegraphed actions and feelings. Perhaps some such sympathy ran in the family, although without the ribald, scatological edge that would push Calder to include a spiral of dung as an accompaniment to a wire sculpture of a cow. Sandy's grandfather had doted on his birds and the animals he carved for City Hall, and Stirling had recently included wonderful frogs and turtles among the carousing figures on his Swann Memorial Fountain in Philadelphia, and sculpted one of his heroes, the free-spirited Walt Whitman, as an animal lover.

There may also have been, in the years when Calder was first finding his way as an artist, some sense that the direct, instinctual, unmediated nature of an animal's behavior could provoke equally powerful responses in an artist. Calder had certainly read the opening chapter of Élie Faure's *History of Art*, with its thrilling description of prehistoric paintings and carvings of animals and what Faure described as their unsurpassed "direct force of expression"

Rooster weather vane, c. 1800. This weather vane was acquired by the sculptor Elie Nadelman from a 1928 sale at the Anderson Galleries in New York. Calder could have seen this weather vane or ones like it at the Anderson Galleries, where he was included in a group show two years earlier.

and "definite, epitomized, purposeful drawing, through subtle modeling that undulates like watered silk."[42] In the United States, there was a growing interest in folk art, with its frequent focus on the elemental power of animals, an interest reflected in the work not only of Calder but of the sculptors Hunt Diederich, John Flannagan, William Zorach, and Elie Nadelman. Calder's rooster sundial had connections with the weather vanes produced by folk artists. In the 1920s, a number of rooster weather vanes were sold by the Anderson Galleries, and considering that Calder exhibited a bit there, it's not inconceivable that he saw some of them. Working on the *Very Flat Cat* in Sherman around the time his painting of the horse show was up at the Anderson Galleries, Calder may well have had a number of aspects of Faure's history in mind. Writing about the earliest impulse to make a work of art, Faure remarked that the hunter, returning from the hunt, "picks up a piece of wood to give it the appearance of an animal, a bit of clay to press it into a figurine, a flat bone on which to engrave a silhouette"—the idea being that the image is somehow implicit in the material.[43] Could it be that in picking up an oak fence post and carving it into a cat, Calder was echoing Faure's description of the first artist's ability to animate the inanimate by releasing the image that was locked in the wood, clay, or bone?

In making the *Very Flat Cat*, Calder may have had in mind a photograph of a bronze by Barye of a jaguar devouring a hare that appeared in the final volume of Faure's history, *Modern Art*. Barye, the Romantic poet of bronze animals, was an artist Faure

ranked very high. Calder could well have been captivated by his description of Barye's power: "He conceives form in the ensemble, as an architect does, builds organically, spreads and distributes movement through the muscles and the skeleton, accumulates it in jaws and paws, and, under the vibrating planes, keeps his wealth of energy at high tension." Faure spoke of Barye as bringing together "all the scattered, hidden, or quivering sources of power in the world, to concentrate them into the active or reposeful mass, beating with palpitations and traversed by waves of force."[44]

VII

Calder's visits to the zoos—Central Park was only a couple of blocks from the League—combined his desire to get out of the studio and into the city with subjects that had the kinetic excitement he would always crave. For a man who, even though he was anything but an athlete, had always been fascinated by athletes and athleticism, the animal was the essential athlete—the original athlete.[45] Calder did hundreds of drawings of animals of all kinds, his paper, ink, and assorted supplies at the ready in a contraption he specially designed for trips to the zoo. He worked with brush and ink in a quicksilver style that brings to mind Japanese ink drawings; it has been suggested that Calder learned Asian brush-and-ink technique from one or another of the Japanese students attending the League at the time.[46] It is also possible that Calder knew Pierre Bonnard's remarkable illustrations for Jules Renard's *Histoires naturelles*, originally produced in 1904 and available in an inexpensive new edition in 1922, which could have been on sale in New York—and found its way into Calder's hands. Bonnard's ink drawings of barn fowl, monkeys, goats, and birds have a calligraphic panache that certainly foreshadows Calder's work twenty years later. While there isn't necessarily any direct influence, there are surely parallel inclinations and ambitions—as indeed there seem to be when one looks back to Toulouse-Lautrec's earlier series of illustrations for Renard's book, published in 1899.[47]

Whether or not Calder had some larger project in mind when he began to make his ink drawings, soon enough he decided to turn them into a book. Actually, he was involved with two books of drawings of animals around this time. One is rather mysterious. *The P-culiar Dog, or The Piddling Pup* is a comic poem about a country dog by the name of Runt, who can urinate with more force, frequency, and deadly accurate aim than any of the dogs he encounters in the city. Calder's ribald, frenzied drawings, accompanying a series of verses by one Elmer E. Scott, were laid out and apparently ready

ABOVE, LEFT *Calder. Untitled (Rooster), c. 1925. Ink on paper, 3¼ x 2¾ in.*

ABOVE, RIGHT *Pierre Bonnard. Illustration for Jules Renard's* Histoires naturelles, *1904.*

to be sent to the printer in 1925. (They remained in that form for seventy-six years, until the Calder Foundation published a small edition in letterpress in 2001.) Nothing is known of Elmer E. Scott, and although the contemporary manuscript that survives is in a handwriting utterly unlike Calder's, it doesn't seem beyond possibility that Calder wrote the verses himself; he had shown a talent for amusing doggerel a couple of years earlier when making poetic place cards for a family gathering in Washington State. Runt can inscribe the words "Noblesse Oblige" in the air with his stream of urine; the drawings of this stunt prefigure a drawing Calder made of Jean-Paul Sartre many years later, in which the philosopher's stream of cigarette smoke forms the letters of his name. Runt outdoes all the city's "champion piddlers," although they're definitely skillful when it comes to hitting various targets.

> They gave a piddling show
> They rang in ringers on him
> To take away his crown
> But Runt just smiled and calmly peed
> The whole caboodle down[48]

The P-culiar Dog, whoever its author may be, is zany fun.

While *The P-culiar Dog* didn't see the light of day, Calder's other book project, *Animal Sketching,* became quite a success. Calder and his friend Charles Howard were determined to publish artist's manuals, Calder's

about how to draw animals and Howard's a book on principles of design. Calder may have been inspired by nineteenth-century Japanese woodblock collections of drawings, some of which functioned as manuals of one sort or another; a volume of Hokusai's sketchbooks that belonged to Calder's parents is still preserved in the Calders' Roxbury home.[49] It may seem a little surprising that Calder was embracing a pedagogical role in 1926. Neither in his twenties nor later in life did he express any interest in teaching; in the 1930s, when James Johnson Sweeney encouraged him to get involved with an American revival in Chicago of the Bauhaus, the great school closed by Hitler, he demurred. But in the general scramble to establish himself, the idea of selling a book would surely have been attractive, and perhaps even teaching wasn't yet entirely out of the question. Calder had, around this time, asked his sister to send him

Calder. "While he was wetting merrily . . . ," *for* The P-culiar Dog, or The Piddling Pup, *created in 1925 but not published until 2001.*

a copy of a book by Albert Abendschein, *The Secret of the Old Masters,* with hints about how the canvases of Titian and Rubens and other painters had been created; apparently he wasn't indifferent to the fascination of a sophisticated how-to book.[50] In Paris, he did give drawing lessons to James Joyce's daughter, Lucia, for a brief time; but what may have mostly been on his mind was the opportunity to meet the writer.

Animal Sketching, by Alexander Calder, appeared under the imprint of Bridgman Publishers in the spring of 1926, along with Charles Howard's *Design.* Bridgman had not been Calder's first choice of a publisher. He had approached Alfred A. Knopf, where, although he was turned down, he met Robert Josephy, a book designer and later a pomologist, who became a life-long friend. Bridgman put the book through a number of editions, and it has turned out to be something of a classic. It's still in print. Students of Calder's art and life have quite naturally turned to the text for insights into his early thinking. Calder commented in a brief introduction—perhaps echoing Faure—that "the earliest men of which we have any record, thousands of centuries ago, expressed their sense of beauty by leaving pictures drawn on their cave dwellings. These pictures are for the most part of animals—of deer, mastodons and wild horses." And he followed this up with a brief sec-

THE DEER FAMILY

Probably of all animal families that of the deer family is the most interesting. There is a certain beauty not only of body, but of poise and femininity that appeals strongly to the subconscious protective instinct of mankind. The deer appears to be totally inadequate as far as self protection is concerned. Nature, however, has been generous to the extent of coloring and speed of hoof. Alertness and grace are probably the noticeable traits to portray in rendering when sketching the deer family.

[31]

Calder. Illustrations for Animal Sketching, *published in 1926.*

tion headed "Action." "Animals—Action," he wrote. "These two words go hand in hand in art." The lives of animals "are of necessity active and their activities are reflected in an alert grace of line even when they are in repose or asleep."[51] Such comments, with their emphasis on line as the essence of action, quite naturally seem to set the stage for a new kind of kinetic art. But one must tread carefully in quoting from *Animal Sketching*. In a letter written to his mother the year after it was published, Calder complained bitterly about the publisher and said that at least some of the text wasn't by him. "I couldn't 'blurb' enough," he wrote, "so they got some ass to write a lot of nonsense to fill in, which in turn makes me feel very foolish when I think about it."[52]

The book was certainly a deft move on the part of a very young artist, designed as it was to appeal to a relatively wide audience of artists and amateurs. But one cannot leave it at that. *Animal Sketching* was also a turning point in Calder's art. He was reaching back to his preoccupations as a child making *Dog* and *Duck* even as he was considering the place of the animal in the history of art and suggesting directions his own work might take

in the future. The book, though inexpensively produced, has a beautiful, easy quality. Small blocks of text are juxtaposed with sketches of all sorts of animals in a succession of striking double-page spreads. In the brief texts, Calder advocates much of what his teachers at the League were preaching: the coordination of eye, mind, and hand, working together as a record and expression of experience. He emphasizes the search for characteristic features and the use of caricature, without allowing caricature to "gain control of all your drawings." He argues that action doesn't necessarily mean physical action, pointing out that "a cat asleep has intense action."[53] In his *Autobiography*, Calder said nothing about *Animal Sketching*, which perhaps reflects some of the disgruntlement he had expressed to his mother. He had thought Bridgman "a damned crook," probably because a book that sold very well had been produced for a flat fee, without any royalties. But Calder also admitted to his mother, "The book under my name isn't insincere, as far as I'm concerned, so it doesn't bother me so much."[54]

The modern imagination was drawn to the naturalness of animals. Colette, Maurice Ravel, George Balanchine, Toulouse-Lautrec, Bonnard, Picasso, and Balthus were only a few of the many creative spirits who were fascinated by their instinctive grace. The actions and reactions of animals can be beautifully direct—and in that sense quintessentially modern. "So there is always a feeling of perpetual motion about animals," Calder wrote in *Animal Sketching*, "and to draw them successfully this must be borne in mind."[55] With his first sculptures of a rooster and a cat, Calder animated inanimate metal and wood. As for perpetual motion—that was still a few years in Calder's future.

VIII

Although in later years Calder sometimes said that he had had to persuade "'the old man' to let him go to Paris," the truth was that Stirling and Nanette were supportive of Calder's decision to travel to France in the summer of 1926, not long after *Animal Sketching* had been published.[56] They provided him with seventy-five dollars a month so that he could pursue his studies. Perhaps they thought the time had come for him to leave the nest. Perhaps Calder himself regarded his next move with more trepidation than he was willing to admit. Early in 1926, some six months before leaving for Paris, he had produced a lithograph, a scene of New York City, that may give us some insight into the torn emotions of the seemingly blithe twenty-seven-year-old. That somber, allegorical lithograph is certainly unlike anything

ABOVE, LEFT *Calder. Untitled (Washington Square Park), 1926. Lithograph, 12 x 9⅝ in.*

ABOVE, RIGHT *A. Stirling Calder. George Washington as a Statesman on Washington Square Arch in New York City, 1918. The photograph—with Nanette Calder standing in front of the arch with Calder's older daughter, Sandra—dates from around 1940.*

else Calder made at the time—and perhaps unlike anything else he ever dreamed up.

A number of lithographs survive from Calder's years in New York; he had taken a lithography class at the League with Charles Locke, an artist admired for his highly refined compositional sense. These lithographs include the bohemian party scene we have already encountered, as well as a study of Central Park. The print that concerns us now is set in Washington Square Park and dominated by the triumphal arch. The drawing is blockish and blunt. The city looks austere, emptied out, like a somewhat threatening dreamscape, reminiscent of certain paintings by Giorgio de Chirico, with a huge cylinder, perhaps a trash can, in the foreground, its dark innards suggesting the abyss. The arch dominates—the arch for which Stirling had created less than a decade earlier what would be his most enduring monument in New York City, his impressive statue of George Washington the statesman. Standing at the base of the arch in Calder's lithograph are three figures, a man and a woman and a child, surely a mother and a father with their little

one. The man, a hat pulled down over his brow, his face in profile, may be speaking with the mother, who is seen from behind. The child holds the mother's hand but also seems to be pulling away.

It's impossible not to see here Sandy, Stirling, and Nanette. Sandy is the boy who has been living on and off at home, in the shadow of his father's achievements, and is now hanging on but also pulling away. The lithograph is like some dark early morning dream full of foreboding, which one barely wants to acknowledge upon awakening. The push and pull between Calder and his parents had been going on for a long time and would go on and on. That wasn't surprising. Those who saw the parents as disapproving of their son, with his easy smiles and happy-go-lucky manner, were certainly picking up on some of the older generation's concerns. The parents and the child bantered, back and forth. Calder ironically observed that "father always seemed to regret not being English—years ago I used to kid him, calling him 'Sir Stirling.' "[57] On more than one occasion in the years between Calder's graduation from Stevens and the beginnings of his success as an artist, the normally sedate Stirling lost his temper at what he regarded as his son's errant ways. If only Sandy had stuck to engineering, his father announced, he would by now be on his way to a successful career. But beneath the annoyance and the frustration—and the fear of their boy's embracing such a risky career—there was a deep faith. When Calder's thoughts became focused on Paris, it was an old friend of his parents' from Pasadena, the artist Clinton Balmer, who arranged for a job on a ship that would take Calder across the ocean.[58] On July 2, 1926, Calder set out for Paris—where everyone he knew, so it seemed, had already been or was right now or was soon to be.

CHAPTER 11

PARIS

Calder's carte d'identité,
issued on August 3, 1926.

I

No more than a dozen weeks after the publication in New York of *Animal Sketching*, Calder was in Paris, where the crowds on the café terraces along the boulevard du Montparnasse, all the artists and writers and hangers-on at the Café du Dôme and Le Select, were turning out to be a spectacle infinitely more diverting than the birds and beasts he had been studying back home. Calder, in the weeks after his arrival in Paris on July 24, would himself be singled out as a gent with some pretty eccentric plumage by denizens of the Dôme and the Select. In New York, he had had a suit made of some yards of orange tweed with a yellow stripe and had bought a straw hat to which he'd attached a fraternity ribbon. A young woman, a fellow student from the Art Students League now married to the English artist Stanley William Hayter, spied him on the sidewalk from their perch at the Select.[1]

Half a century later, Bill Hayter recalled seeing Calder. He was "walking between the tramlines." He looked "like a stoutish baby staggering with no seeming trust in the security of biped progress. This bearlike figure sported a bright mustard suit lively enough to scare the horses (still used for working purposes) and a walrus moustache." Hayter's wife called Sandy over, he sat down for a drink, and a lifelong friendship began.[2] Stanley William Hayter would in the next decade found a printmaking workshop known as Atelier 17. He began it in Paris, moved it to New York during World War II, and

after the war brought it back to Paris. On both sides of the Atlantic, Hayter became a charismatic figure as a printmaker, painter, and proselytizer; he encouraged artists including Calder, Joan Miró, Mark Rothko, and Jackson Pollock to experiment with intaglio techniques. But in 1926 Hayter was only starting out. It was right around the same time that another friend from the League, Clay Spohn, sitting across the street at the Dôme, saw Sandy in the same suit, but this time perched on the back of a bench on the sidewalk, sketch pad in one hand and a pencil in the other. He was taking advantage of his elevated vantage point to do rapid drawings of the people on the café terrace, much as he had sketched New Yorkers at work and at play for *The National Police Gazette*.[3]

Those first, wonderful glimpses of Calder in his bright orange suit on the boulevard du Montparnasse announced the arrival of a new character in the glorious theater that was Paris in the 1920s. Spohn remembered the stripes as light brown and "almost one inch wide" and recalled that the outfit was further accessorized with a cane. Although it would be a year or two before Calder began to be recognized as a somebody, more than a mere member of the supporting cast, nobody sipping an aperitif on a summer afternoon at the Dôme or the Select would have been surprised to learn that the "large and stout" man with the "long, sandy colored mustaches and beady blue eyes" would turn out to be a genius.[4] After all, wouldn't Robert McAlmon, who was sitting in those same cafés in those same years, entitle his memoirs *Being Geniuses Together*? The novelist Anthony Powell, in his autobiography *To Keep the Ball Rolling*, referred to the conviction of one's own genius as "that virus of the Twenties."[5] Everybody went to the cafés to see who was doing what and what was being said about what they were doing. John Glassco, a young Canadian who arrived maybe sixteen months after Calder, recalled in his *Memoirs of Montparnasse* meeting the American artist Adolf Dehn at the Select and saying, "Mr. Dehn, my friend and I have just arrived in Paris, and we know no one but yourself by sight. We are going to the Dôme, and won't you have a drink with us there?"[6] Conviviality was the order of the day.

Standing on the sidewalks of Montparnasse, Calder must have felt some-what shy; he didn't know the language, and his only friends were from back home. But he was armored in his orange suit—and his natural bravado. When Calder, in an early letter from Paris, included a little diagrammatic map of where a friend lived, Nanette, who was sending Calder's letters on to his sister in California, annotated the map of the area around the Luxembourg Gardens with notes pointing out where she and Stirling had once lived and where Peggy had been born.[7] Calder hadn't been born in Paris, but he may have nonetheless believed that the city was his birthright. In Paris there

were artists and writers who worked as hard as they partied, and that would suit Calder to a T. "There were models," Ernest Hemingway recalled in his memoir, *A Moveable Feast*, "who had worked and there were painters who had worked until the light was gone and there were writers who had finished a day's work for better or for worse, and there were drinkers and characters, some of whom I knew and some that were only decoration."[8]

Hemingway—with whom Calder certainly crossed paths in Paris—entitled one chapter of *A Moveable Feast*, "With Pascin at the Dôme." He described the very drunk Jules Pascin—a gifted, ebullient artist—waving him over to the table where he was sitting with two young, pretty models. Pascin, who knew Stirling Calder, would not too much later be a friend of Calder's and write the introduction for the brochure of his first exhibition in Paris. There was much chitchat at Pascin's table. The two models—one light and one dark, "the good and the bad sisters," Pascin called them—were hungry. As Pascin took them off to eat at a restaurant called Les Vikings, he bade Hemingway, "Good night, *jeune homme*. Sleep well." Closing his little recollection of Pascin with the sad thought of the painter's suicide, Hemingway said he preferred to remember him at the Dôme. He mused about Pascin's humor—in a comment that might hold true of the utterly unsuicidal Calder as well—that "it always seemed to me that in those who make jokes in life the seeds are covered with better soil and with a higher grade of manure."[9]

Three years after Calder arrived in Paris, Hemingway composed an introduction for the memoirs of Kiki de Montparnasse, the dark-haired model immortalized by Man Ray and others, including Calder, who ultimately made three studies of her, including an abstract wire portrait, *Féminité*, in 1929. Hemingway spoke of the theatricality of Montparnasse, "the cafés and the restaurants where people are seen in public." He mused on the meaning of the word *era*. He hoped that "no one will be rude enough at this point to consult a dictionary and find out what an Era really and exactly is." Writing in 1929, he speculated that "an Era is easy to start in the newspapers; editorial writers start them regularly, but people forget all about them and they have nothing to do with real Eras."[10] Calder's friend Malcolm Cowley, writing his own salute to that era in the book he memorably entitled *Exile's Return: A Literary Odyssey of the 1920s*, praised "its high spirits, its industriousness, its candor and its reckless freedom."[11] Calder, in his first three years in Paris, made his own stab at defining not only himself but also that era through the work he did. What the young man in the bright orange tweed suit created in Paris in the waning years of the 1920s by now defines that time and place as irrevocably as Man Ray's photographs and Hemingway's and Fitzgerald's fiction and memoirs.

II

Calder had made the journey from New York to Paris as a member of the crew of a run-down British ship, the *Galileo*. In his *Autobiography*, he commented, "Much later, I heard vaguely that the *Galileo* had been scuttled in New York Harbor when she caught fire while carrying explosives."[12] He had gotten the job in New York because there had been a sailor lacking from the quota, and he had agreed to sign on for five pounds instead of the customary nine (the equivalent of about twenty-five dollars at the time, or a little more than he had been getting for a half-page layout in *The National Police Gazette*). It was seventeen days to Hull. From there, Calder was planning to continue on to Paris by train and boat.

Calder was the odd man out on the crew, much as he had been four years earlier when he worked in the boiler room on the *H. F. Alexander*. The difference was that he was now a young man beginning a career as an artist, rather than a young man trying to figure out what to do with an engineering degree. Calder showed what drawings he had with him to "the mate," he remembered in his *Autobiography*, "who of course confided to me that he detested the captain. All the stories of Conrad were borne out in this instance"—a remark rather revealing of the extent to which Calder, the educated middle-class young man, couldn't help but see his adventure through a literary lens.[13] Writing to his parents at the time, he described the joy of a bath on deck in the bow, all the hot water and soap and "finally you lift the bucket and pour all the rest of the water over yourself," after which you "stand in the breeziest part of the deck and dry off." All of this, Calder related to his artist parents, made "you feel like a Rockwell Kent drawing"—Kent being the artist whose prints and drawings were full of muscular young Americans experiencing the pleasures of the outdoors.[14]

The crew of the *Galileo* was mostly from Yorkshire, mostly around Calder's age, with accents that were often nearly indecipherable. As he wrote to his parents, the sailors were "very decent and genial," although "the poor devils don't seem to know much in any direction, and even tho they make very positive statements and back them up with round oaths, they are never positive about anything." His job was painting the boat so that the rust on the decrepit vessel wouldn't be evident when they arrived at Hull. Calder told his parents that it "was pretty good fun up in the air, scrubbing + painting." His ingenuity didn't fail him. For a few nights he managed to tolerate sleep in the stifling berths belowdecks by fashioning what he called a " 'windchute' from a tin can." But after a couple of nights of comfortable sleep, "the wind shifted and the chute would no longer operate and they insisted that all

the ports be closed." So Calder decided to sleep on the wheelhouse, with his body tethered to the base of the extra steering wheels.[15]

Calder was off duty on Saturday afternoons and Sundays. With the help of a dictionary, he read a contemporary play, *Maternité*, by Eugène Brieux, a writer who had stirred controversy in France and England with his forthright presentation of the social and sexual hypocrisies of the day. Calder had already gone through the play back in New York with his father, who may well have been drawn to Brieux because he was a hero of Stirling's hero George Bernard Shaw—who had written an enormous preface to a 1911 edition of a couple of Brieux's plays, comparing his impact to that of Ibsen and Zola. In the Calder house in Roxbury, there is still a copy of an English translation of Brieux's play *Artists' Families* that must have belonged to Stirling; it was published in 1918. Here the Symbolist movement is parodied as Tri-unionism, with an experimental painting referred to as "a great sunlight picture—in the fields—nothing—light—that's it!" One of the characters wonders, "Is purely verbal expression adequate for the tone-colour and vibrations of atmospheric atoms?"[16] If Calder had looked into *Artists' Families*, he would have discovered an author who was as impatient with the highfalutin conversations of fin de siècle artists as he and Peggy were with their parents' repartee.

III

However laconic Calder liked to be, he couldn't hide his enthusiasm at his first glimpse of Europe. The sight of the lighthouse, the Bishop Rock, and Land's End he described to his parents as "rather spectacular"—high praise coming from him. And when he awoke at four in the morning, there were, he wrote, "the famous white chalk cliffs at Dover, of which you read to me at Linda Vista, when I had poison oak." Linda Vista was the street where they had lived on the Arroyo Seco in Pasadena. "The sun was just coming up, and at one level it made the palisades glisten. I don't wonder that the people on the continent tried so often to conquer the island. Dover + Epson looked quite interesting from the water."[17] Could it be that conquest was on Calder's mind?

He described the excitement of docking at Hull in a letter a few days later, displaying all his customary affection for the intricacies of winches, steel cables, ropes, and locks. He was all eyes in Hull—the first town he saw— although a few weeks later, already in Paris by then, he told his parents that it probably wasn't really much more than "a quainter, more mediaeval form

of Yonkers. The old moat within the city has been widened into a canal, +
there is also some muddy stream, more like a slough, which rises + falls with
the tide."[18] In Hull, there was a telegram from his Stevens buddy Bob Trube,
who was working in London and invited Calder to spend a few days. On the
train to London, he found the landscape somewhat flat but appreciated the
smell of new-mown hay. Bob Trube had been one of Calder's close friends
at Stevens, maybe the closest after Bill Drew. All three were in Delta Tau
Delta. Trube had grown up in France, where his father, who had also gone
to Stevens, worked as an engineer. Calder joked that Trube "came from a
family of people who had not much chin, so he used to walk between classes
with his chin high up in the air."[19]

Trube was probably one of the few students at Stevens who actually
spoke French. After Stevens, he worked for a time in Europe, before return-
ing to the United States and taking a job with Solvay chemicals in Syracuse.[20]
Calder spent three days with Bob in London, staying at what must have been
his rooming house. He enjoyed driving around in Bob's Dodge, which had
"a swell English body," he told his parents. Bob, apparently a bit lonely in
London, seemed glad for Calder's companionship. They went to the St.
Martin's Theatre and saw Arnold Ridley's hit play *The Ghost Train*, about
a group of travelers stranded in a remote railway station. Calder found it
"light, but very amusing." He commented ironically to his parents that "Bob
pounded my knee all evening, to call my attention to the humour and then
next morning told our co-inhabitants that it 'wasn't so much.'" Bob was
apparently afraid of his own simple reactions, and Calder asked his parents
to "show this part [of the letter] to Bill, please"—meaning Bill Drew, who
was perhaps straightforward about his feelings in a way that Calder was and
Bob was not. Perhaps Bob didn't know quite what to make of his old frater-
nity brother's embrace of the visual arts. Calder told his parents that when he
started to sketch somewhere in London, Bob was "rather embarrassed"—so
Sandy "desisted."[21]

During the days in London, while Bob was at work, Calder made the
rounds of the museums and monuments. In later years, Calder was some-
times said to have little or no interest in entering a museum unless it was for
an exhibition of his own work or the work of a friend. There is a story of
the Calder family being somewhere in Europe with his friend Sweeney and
Sweeney's wife and daughter, and Sweeney taking the various children into
a museum while Calder waited elsewhere, probably having a drink in a café.
But at least on this first trip to Europe, Calder was an avid student of muse-
ums and monuments—knowledgeable, curious, opinionated. He visited the
National Gallery and the Tate and reported all his impressions in letters to his

Jacob Epstein. W. H. Hudson Memorial *in Hyde Park in London, 1925.*

parents. At the National Gallery, he was very taken with the Rembrandts. He commented that El Greco, with his "mustard green yellow" and "crimson" was "really the boy!" Goya interested him. Augustus John seemed merely clever. At the Tate, Calder was struck by the work of William Blake, that master of the fantastical, found the Hogarths "amusing," but seemed most interested in the modern French works, singling out Seurat's *Bathers at Asnières* and *The Balcony* by Baudelaire's beloved Manet. His tastes were those of a modernist, attuned to the values of simplification and stylization—to boldness in the maneuvering of materials, to the autobiographical impression and the fantastical gesture. As for what he referred to as "the English stuff," most of it seemed "of a cheap, 'illustrative' nature." "Illustrative" was of course the old-fashioned Victorian value that modernists were then rejecting in favor of formal values, what Clive Bell was calling "significant form." That term had only recently been coined in the city where Calder was now visiting. He was almost certainly familiar with Bell's ideas.[22]

Westminster and the Tower of London struck Calder as pretty much spoiled, perhaps too thoroughly sunk now in the revisions of the Gothic Revival, although this artist who would spend a lifetime working with metal did admire "some handsome 15 16 + 17th century armor."[23] Calder also went to Hyde Park to see the monument to W. H. Hudson, the author of *Green Mansions*, which had only recently been completed by Jacob Epstein. Epstein, who had been born in New York, the child of Polish Jewish immigrants, had studied in Paris early in the century and was now established in London. For more than a decade already, he had been a hero among the modernists, hailed by Ezra Pound in the magazine *The New Age* in 1915 as "the first person who came talking about 'form, not the *form of anything*'"—he was, in other words, the truest and purest of formalists.[24] Epstein had carved the Oscar Wilde Memorial in Père Lachaise Cemetery in Paris. For Hyde Park he created a monument to Hudson, a broad horizontal slab on which was carved in deep, angular relief the image of Rima the Bird Girl from Hudson's *Green Mansions: A Romance of the Tropical Forest*. She was the

small dark-haired South American girl with magical powers who could talk to the birds and the animals and was finally burned alive by the Indians.

Calder and his father couldn't help but be aware of the monument, for Epstein's blunt eroticism had proved highly controversial. That would have interested Stirling. Here was a fellow sculptor who was working in the public sphere and being criticized, as A. Stirling Calder had been at Vizcaya, for what was felt to be overly sexualized imagery. Calder was clearly impressed by the monument, with its figure of the naked Rima seen from her thighs up, hair streaming, arms outstretched, enveloped by the forms of birds. It was indeed a striking image, at once serpentine and angular. Calder, even then inclined to emphasize form rather than subject matter, commented that it was "a very rich piece of relief."[25]

IV

On Saturday, July 24, Calder took the ten a.m. train from Victoria Station, headed for Newhaven, Dieppe, and Paris. He was in a coach with what seemed to him ordinary English people, including a couple from the Midlands whose speech struck him as particularly quaint. The Channel crossing was very smooth; not a single person got sick.[26] He found Dieppe amusing, as he surveyed the big hotels that dominated the little town and studied the harbor at low tide; the city had a special place in the hearts of many late-nineteenth-century artists, especially English-speaking artists, among them James Abbott McNeill Whistler, Aubrey Beardsley, and Walter Sickert.

In Paris, Calder had to wait an hour for his luggage, which he had checked through in London. But he knew exactly where he was headed, because Bob Trube had alerted his father, who, although by no stretch of the imagination a bohemian sort, was living at the Hôtel de Versailles, on the boulevard du Montparnasse, in the heart of bohemian Paris. Mr. Trube had secured a room for Calder on the seventh floor of the Hôtel de Versailles. With its upright piano, red rug, and "brown wall paper that would knock your eye out," the room as Calder described it to his parents sounded like something out of a painting by Vuillard. The man who ran the place, "a very nice American chap," quickly moved him from this room, which cost thirty-five francs a night, to one for fifteen francs a night.[27] Mr. Trube, who Calder said "claimed he had been languishing for someone to dine with," took him to a delicious dinner. In the first letter from Paris, dated July 26, Calder was already enthusing about his introduction to *fraises des bois*—"of all things whose measly looks belie their delicious taste those are it!"[28]

Calder. S.T.C.A., 1926.
Cover illustration for the
brochure of the Student
Third Cabin Association,
9 x 6 in.

Mr. Trube, whose wife and daughter, Maude, were vacationing in Switzerland, took Calder under his wing. He sneered at "all the artists who don't do any work," probably, Calder speculated, because "he'd come up the hard way as an engineer."[29] Trube might not have had much sympathy for the bohemians, but he had lived in France for years and he was comfortable with the French. He wanted to show Calder the country as he knew it. So Trube and a friend of his, a Swiss engineer, took Sandy on an all-day expedition—to visit some French friends in the country. Calder reported that they had "a charming little garden, 4 cats, a St. Bernard, rabbits, pigeons, chickens & probably a whole row of other live stock." Calder, Trube, and the Swiss engineer had a grand time that day. Calder even found himself feeling hopeful about his French.[30] Soon after, Bob came over to Paris, and there was more conviviality, Calder observing to his parents that the two of them seemed "a bit lonely" with Mrs. Trube and Bob's sister in Switzerland.[31] Mrs. Trube and Maude returned a month later. Calder and Mr. Trube were by then close enough that it was the two of them who went to meet the women's train, but they somehow managed to miss it, only to find, when they got back to the hotel, mother and daughter alighting from a cab, both tan and healthy, Calder reported to his mother. Almost immediately Calder was arranging to go swimming with Maude in one of the bathing places on the Seine near the Place de la Concorde.[32]

By the end of August, Calder had found a studio at 22 rue Daguerre. He described it to his parents, who he assumed were familiar with the neighborhood, as "near the metro station Denfert-Rocher[e]au out toward Italie from Montparnasse."[33] The hotel was a small one, run by somebody Swiss, where for 450 francs a month he had a room painted "a sort of inoffensive gray with a little balcony with a bed on it. It is almost cubical with a skylight + windows in 2 walls near the same corner (north)." It was some thirteen by fifteen feet and, as he told his parents, had "less of that cloistral effect than most places I have seen."[34] For a little more than a year, the rue Daguerre would be Calder's home base. It was modest, a bit removed from the hullaballoo of Montparnasse, but only a few minutes' walk from the grand cafés.

Like nearly all the places where Calder lived in Paris in the 1920s and 1930s, the building still stands. And it's still a hotel. The street remains a modest one, lined with shops geared to the everyday needs of the neighborhood. The filmmaker Agnès Varda, who became a friend of Calder's when she photographed him in the 1950s, has a home only a couple of blocks away.

In September, Calder made a lightning-quick round-trip excursion to New York on the SS *Volendam*. He was hired to do drawings of life on board the ship for the Student Third Cabin Association, an organization geared to the young traveler. The drawings were to be used on posters and in an advertising brochure, and Calder worked in the easygoing, lightly comic manner of his *National Police Gazette* layouts. He also did a drawing in a more abstract vein for the cover of the brochure. The trip back to France— a sea voyage where he wasn't with the crew!—inspired a witty letter about his various tablemates, who all "eat like horses (esp. one you know) and kid each other about it."[35] Aside from that rapid transatlantic jaunt, Calder would remain in France until late September 1927, when he returned to the United States for an entire year.

V

Recalling his months on the rue Daguerre in his *Autobiography*, Calder observed, "I still considered myself a painter and was happy to be in my own workroom, in Paris."[36] But in 1929, only three years after arriving in Paris, he described those first months somewhat differently, writing, "I suspended painting for quite some time and have not really gotten back to it yet."[37] The truth was that he probably didn't know what he was going to do when he got to Paris, and found himself mulling over his variegated productions during his last year in New York, which included, in addition to oil paintings and ink drawings, a wire sundial and a wooden cat. He had already, a few weeks before moving to the rue Daguerre, gone to draw at the Académie de la Grande Chaumière, the legendary unaffiliated art school where virtually every artist who came to Paris spent some time. He also told his parents that he was going to try another independent academy, Colorossi's, "as I understand there are more interesting students there."[38] Whether he went to Colorossi's and perhaps found the students no more or even less interesting is unclear; but a few weeks later, by now ready to actually paint again, he had bought at the Chaumière some brushes and paints along with a box and a palette, all for about eleven dollars.[39] Little or no painting survives from those first months in France, which suggests that Calder's attention was

indeed moving in different directions; though, of course, paintings may be lost or destroyed and things may still turn up.[40]

Although Calder had already been much on his own in Manhattan, there has to have been a new thrill in waking up early in his Paris studio, skipping breakfast, and sometimes ambling over to a café on the avenue de la Porte d'Orléans at ten or so. One workingman's morning habit of mixing red and white wine stuck with Calder. The man's explanation for this grape cocktail prefigured Calder's lifelong fascination with the juxtaposition of red and white elements, albeit in a backward sort of way. He explained to Calder that "the red wine makes you go to sleep, the white makes you jump—so this way you keep on an even keel."[41] Calder was seeing some people he had already known in the States. He was attending drawing classes in the afternoons at the Grande Chaumière. And he was trying to figure out how to make a living, which in Paris, as in New York, involved picking up assignments for graphic work here and there.[42] He even tried his hand at doing caricatures for a little money, as he had in Washington State. At least one of these survives, done of a man by the name of Georges Seldes for ten francs on October 19, 1926.

Through a new American friend, Lloyd Sloane, with whom he had taken a boat trip on the Seine, Calder met someone he remembered as "a fellow who ran a weekly called *Le Boulevardier.*"[43] This might have been Erskine Gwynne, the publisher of *The Boulevardier,* which was an English-language magazine obviously geared to visitors to the City of Light. Gwynne was just a year younger than Calder, a wealthy American in Paris. He invented a cocktail called the Boulevardier, which had a certain vogue at the time, and in 1936 published a novel, *Paris Pandemonium,* an undistinguished work about some frenetic Parisian partying. *The Boulevardier*'s artistic adviser, Marc Réal, became a good friend of Calder's. Calder did some amusing illustrations for the magazine in an Art Deco style, as well as at least one striking cover design, with horses and jockeys in black and red, the juxtaposition of those two colors marking the beginning of an abiding passion.

Calder told his parents he was working hard with a French primary grammar. By November, he was taking lessons with a Madame Le Texier, who, he reported, "is a grand old lady, and taught Mark Twain 40 years ago, and coached Whistler."[44] By the end of the year, he was proudly writing home that he had made some real progress on the language. "Your baby is beginning to talk a bit, all over again. It's swell fun, and I carried on a (somewhat choppy) conversation on the phone with a Frenchman the other day, and thought I was doing well. Pronunciation is the tough part, not in general, but the accent, and certain words."[45] Calder would live in France on and off throughout his life, but his French would always remain that of a foreigner.

"Execrable" was how I heard his French described by Paul Matisse, the son of Calder's dealer in the 1930s, Pierre Matisse, and a grandson of the artist; Paul Matisse was somewhat involved with Calder in his last years as he created a gigantic mobile for the National Gallery of Art in Washington, D.C.[46] Of course, others might call that an exaggeration. Calder was certainly always attuned to the tensions between the two languages in which he conducted his affairs. In the 1960s, he found some of the misspellings of English titles in a list typed up by a secretary at the Galerie Maeght in Paris so amusing that he decided that the misspelled titles ought to become the titles.

Calder was apparently sharing his French lessons with another American, a wealthy woman by the name of Frances Robbins. He would have known her from New York; she had bankrolled the Artists' Gallery, where Calder had exhibited at the end of 1925, and she had introduced him to Betty Salemme. Calder's American connections quite naturally led to French connections. Mrs. Robbins, who moved in bohemian circles in Paris, put him in contact with Mary Butts, an English writer still highly regarded for her atmospheric, experimental novels. By the end of the year, Butts had brought Calder into contact with Jean Cocteau and Mary Reynolds, by most accounts the great love of Marcel Duchamp's life. Of Butts, Reynolds, Duchamp, and Cocteau we will hear more. Through Bill Hayter he met the Spanish-born sculptor José de Creeft; he was a longtime resident of Paris and would a few years later move to the United States. Calder's friend James Johnson Sweeney believed that de Creeft was "a stimulant" to Calder, especially his "famous stovepipe 'Don Quixote' in the *Salon des indépendants* of 1926," a lighthearted metal concoction that might have engaged Calder at a time when he was beginning to construct figures of wire and other materials.[47] Years later, Calder remembered making a "wire dog on [de Creeft's] sink faucet which raised his hind leg when one opened the faucet."[48]

However rapidly Calder's circle was expanding, by the end of 1926 he had not yet found his way to the center of a group of artists. He told his parents that "the best people" he'd as yet met in Paris were an Englishman,

Calder. Cover design for The Boulevardier, *1926. Magazine illustration, 10¾ x 8½ in. This copy was damaged by smoke from the fire in the Calder house in Roxbury, Connecticut, in 1943.*

Calder with José de Creeft on the rue Broca in Paris, c. 1926.

George Thomson, whom he got to know while swimming, and a Romanian doctor who had lived in the States for three years and whom he had met coming back from New York on the SS *Volendam* in September.[49] Calder went with George Thomson to the Rodin Museum, a place no doubt beloved by Stirling. Although it isn't clear what he looked at there—and he later announced, as we have already seen, that Rodin's marble carvings looked like "shaving cream"—Calder might have been interested in Rodin's smaller statues of dancing figures or his fragmentary studies of hands and other body parts.

VI

Bob Trube's sister, Maude, was one of a handful of American women—some married, some not, some married but without husbands on the scene—who crop up again and again in Sandy's letters back to America. Some we will never be able to identify; others we know something about. Peggy's sister-in-law, Jean Partridge, was in France for six months. She was there to get over a failing marriage to a man remembered in the family as a very handsome philanderer, John Partridge. They were divorced and then remarried in the 1930s; he died in a plane crash during World War II. Like her brother, Jean was exceedingly good-looking; some said they could be twins. She had been in France a decade earlier with her mother and was now traveling with a young woman, a cousin of hers by the name of Cody.[50] Her son had remained in the United States. Jean and Cody were making the rounds. They were free spirits at a time when the living was easy, and they were obviously enjoying themselves. They lingered in the South of France. Jean invited Calder on a motor excursion through Brittany, but after not hearing from him soon enough, she embarked on it alone; she had, as Sandy told his mother, "a glorious time."[51] She was a speed freak when behind the wheel of a car, as a friend of Calder's commented nearly forty years later.[52] At some point, Calder was in Étretat with Jean and others. For his birthday, she gave him a set of golf clubs and a toy boat. There was

an outing to Montmartre with a bunch of people; Calder summarized it as "a very stupid evening."[53] Thirty years later, when Malcolm Cowley was going to teach at Stanford University, Calder put his writer friend in touch with Jean, who was then living out there and was, Sandy promised—no doubt still remembering the carefree young divorcée—"very gay."[54]

Another friendship that came through Peggy's Washington State connections was with Samuel and Narcissa Chamberlain. Sam Chamberlain apparently knew Ken Hayes from school in Aberdeen. Sam had served in the French ambulance corps and then in the French army and returned to the United States with a beautiful French wife, Narcissa, whom he called "Biscuit." He played the piano and collaborated with Ken on riotous jazz improvisations. Peggy remembered him as having "a ribald, easily activated sense of humor."[55] In later years, Chamberlain became known for his photographs and prints of picturesque scenery in France and New England, and for a series of cookbooks he produced with Narcissa, including *Bouquet de France*. Calder already knew them from New York, where they'd lived for a time; Narcissa had posed for him. They were in France when Nanette and Stirling visited in 1924, and when Calder arrived they were busy touring the country in an early Fiat, with Sam drawing picturesque sites and Narcissa collecting recipes and taking care of their little daughter, Narcisse.[56] Calder went with them to see a twelfth-century abbey at La Mailleraye-sur-Seine, which he found "grand, simple + open to the sky behind it . . . really stunning."[57] When it came to Sam's nitpicking draftsmanship, Calder was surely as skeptical as his mother. She had written to Sandy from France in 1924 that "Sam has been doing some rather better things right on the spot and not from photos—I wonder how he can contain himself to keep it so exact. He spent 8 hours over one—that is work and patience."[58] But whatever the quality of Sam's drawings, Sam and Narcissa were good fun to be with.

Another attractive young woman whom Calder got to know that first year in Paris was Elizabeth Hawes, known to her friends as Babe. She was at the start of a successful career as a fashion designer and was already developing a wide range of friendships in artistic, literary, and society circles on both sides of the Atlantic. She had graduated from Vassar in 1925 and headed to Paris with the laconic blessing of her mother, a woman active in public affairs in New Jersey, whose only comment was: "How long are you going to stay?"[59] In 1938, Hawes published a snappy memoir entitled *Fashion Is Spinach;* it went through a number of editions, and she followed it up with more books, including *Why Women Cry* and *Men Can Take It*. In *Fashion Is Spinach*, she related her adventures working for one of the Parisian outfits that illegally copied couture fashions. She was a skilled sketch artist who surreptitiously

Babe Hawes and Calder's wire portrait of her in a still from the film Sculptor Discards Clay to Ply His Art in Wire, *produced by the ACME Film Company, c. 1928.*

made drawings of whatever was appearing at the couture houses; the drawings were spirited off to the United States to be copied. It would seem likely that Hawes, who worked with many of the American fashion buyers in Paris, had something to do with Calder's ending up making sketches of those people for the Paris *Herald Tribune* in 1927, sketches with a caricaturist's panache that can seem to prefigure his wire portraits. Or perhaps Sandy and Babe met when he was working on that assignment.

Hawes's ingenuity, energy, and ease—the what-the-hell spirit that suffused her memoir—suggest a woman who had some of the same social skills as Calder. When you come upon Babe's remark in her memoir that "men are always very very scarce in Paris for young American girls except when June brings in the tourists," you can't help wondering if she had that kind of interest in Calder.[60] Hawes was one of those smart, self-confident, attractive women who always seemed to gravitate to Calder—and vice versa. In 1929, back in New York and already deeply involved with Louisa James, the woman he would marry, Calder gave Babe as a Christmas present a beautifully shaped body ornament that he described as a chastity belt. The sensuous metal spelled out her name and the French café slogan *"ouvert la nuit"*—which means both "open all night" and "open every night." Clearly, there was no erotic possibility that wasn't entertained in the circles in which Sandy and Babe moved—or by Sandy and Babe themselves. One wonders if the gift of the ornamental chastity belt was Sandy's playful way of announcing that whatever the two of them had been up to, with the arrival of Louisa their escapades were over.

We will probably never know if Babe Hawes and Calder were intimately involved. However sexually liberated Calder and his friends may have been in the second half of the 1920s, they weren't inclined to speak much in public about what they were doing in private—certainly not to the extent that men and women would forty years later. What we are left with are hints, hunches, and speculations about Calder's relations with women in the years before he met Louisa James. It doesn't seem beyond possibility that he was involved for a time with a painter by the name of Marion Greenwood. In later years, she was rather open about her sexual escapades, and although she didn't claim Calder among her lovers, it can't be entirely ruled out. They were definitely friends. Calder made a wire portrait of her in 1928—a portrait that he kept and gave to the Museum of Modern Art many years later—and Calder's

wire portraits very often commemorated especially important relationships. Greenwood, who is still remembered as being "spectacularly beautiful," was born in 1909; her family was artistic. She started attending classes at the Art Students League in 1924, so would have overlapped with Calder there. In 1928, she went to Paris with her mother and her sister, Grace Greenwood, who was also an artist. In the 1930s, she and her sister spent time in Mexico, attracted by the renaissance of mural painting spurred by José Clemente Orozco and Diego Rivera. Marion Greenwood was romantically involved with the sculptor Isamu Noguchi beginning at the end of the 1920s, both in Paris and in New York. This was around the time that Calder was good friends with Noguchi—a friendship we will explore later on. Noguchi made a portrait bust of Greenwood in 1929. Calder and Greenwood might have had some sort of a relationship, perhaps in 1927 or 1928, when their paths crossed in New York or Paris. If so, whatever drew them together wasn't enough to hold them together. One imagines that they would have parted good friends, eager to proceed with their lives and their careers.[61]

VII

Calder, by no means a conventionally handsome man, had ways of showing off his physical unconventionality that friends and potential lovers might regard as charmingly outrageous even as less sympathetic observers turned away in dismay. Hayter, who was with Calder in Saint-Tropez in the summer of 1927, remembered how Calder's "excessive exhibition of chest hair bursting out of a striped seaman's shirt of the type still worn in that area" inspired some reproach from "one individual [in whom] all the essence of authority in St. Tropez was concentrated."[62] And Calder himself, in his *Autobiography*, recalled how when the *Galileo* was approaching the Strait of Dover, the crew warned him that he better put his shirt on over his undershirt or he might "be arrested for 'indecency' by some police launch."[63] Between Calder's tendency to expose more of his flesh than was thought quite proper and his willingness to wear an orange tweed suit that drew attention in another way, there was surely a strong wish to be recognized and regarded physically. There was a bragadoccio about him—but a likable bragadoccio. At some point—it's not clear exactly when—Calder's friend Jane Davenport came to Paris with her husband, Reggie Harris. During the visit, when Jane was down with the flu, Sandy and Reggie decided that they were going to fulfill an old desire to see what the inside of a Parisian bordello was actually like. They found an establishment where they could watch while two girls dem-

onstrated the thirty positions of love. When the demonstration was over, however, Sandy complained, "But that was only twenty-five!"[64]

How could women not sense intriguing sexual energies and possibilities in this brilliant, unconventional fellow and his outlandish acts and off-color comments? As we have already noted, Calder briefly gave drawing lessons to James Joyce's troubled daughter, Lucia. A woman with a fantastical imagination, she ended her days in mental institutions. Her biographer, Carol Loeb Schloss, surely makes too much of the brief connection between Lucia Joyce and Alexander Calder. After all, Lucia also imagined that Samuel Beckett, then assisting her father in various ways, was in love with her, and although the extent of their relationship isn't clear, it certainly wasn't the passionate love affair that Lucia desired. But when Lucia, in an unpublished autobiographical manuscript, observed of her brief connection with Calder that "we were in love but I think he went away. Anyway he never wrote to me and I don't know what became of him," she may have been exaggerating a kernel of feeling that was really there, as the mad sometimes do.[65] To the extent that Lucia Joyce ever embraced some vocation, it was as a dancer, and she might have seen in Calder a kindred spirit—another young person who was light on his feet and wanted to catch the rhythms of the time. Surely Calder was a young man full of love—a seductive figure to those who were attuned to his quirky charms.

There is an interesting passage in a letter from October 1926, after Calder's return from his trip to New York on the SS *Volendam*. Calder wasn't feeling well. He wrote to his mother about inviting himself "to visit Frances Robbins for the day to bask in front of her fire on about 10 cushions. She has quite a grand place at 16 r. Boissonade, up high, overlooking the Observatoire. There is an old number 13 in stone over the door. Do you place it? Anyway, she seemed quite glad to have me and invited me to come again, and said if I should ever get laid up to send my landlord to her and she'd come and take care of me. So I have a nurse" (the way he wrote the word, it almost looks like "muse") "at hand—so you can rest assured of my well being."[66] A couple of months later, that first December in Paris, Frances Robbins decided to stake Calder and a few friends to a Christmas holiday skiing trip in Gstaad and Chamonix. This came off, although in the end without their patron, who found herself in the American Hospital of Paris with grippe.[67]

Robbins, some seven years older than Calder, divorced her husband, a lawyer, in 1927. She was a book reviewer and a patron of the arts, generous to the novelist Glenway Wescott, who the morning after meeting her at a party at Betty and Antonio Salemmes' in New York in 1924 received a check for $3,000 so that he would be free to work on a novel. In his jour-

nals, Wescott recalled her "great fairy-tale log cabin up steep over French-man Bay [in Maine]; the logs on the inside skinned and waxed and golden, like a violin and acoustically perfect." Wescott was visiting one summer when the Curtis String Quartet, which Robbins had supported, performed Beethoven's Opus 130 in her living room.[68] Wescott, a homosexual, clearly found Frances Robbins and the places in which she lived seductive. So, apparently, did Calder, who was entirely heterosexual. As far as Calder was concerned, there was probably nothing more to it than that. But the image of the sick young artist going off to "bask in front of her fire on about 10 cushions" clearly had the air of a seduction. One may even wonder if this is why Peggy, when she quoted from the letter in her memoir, decided not to include the part about her brother's languorously convalescing on Frances Robbins's pillows.

Whatever one makes of Calder's involvement with a number of interest-ing women in New York and Paris in the second half of the 1920s—and one must beware of making both too much and too little of these relationships—they were among many other things a way of gently beginning to separate himself from his closeness with his mother. By April 1927—he had been in France for some nine months—Nanette was complaining of the infrequency of his letters. She felt he was leaving the family behind. "I got your letter this evening," he wrote, "and it is very sweet. Believe me, truly, I do feel that I am one of the Calder family, our Calder family (immediate). I always feel that I love you 2 + Peg, and I always feel sure that I can count on you to continue to love me." Sending this on to Peggy after receiving it, Nanette couldn't help but add, "What would you think if this was written to you? It has hurt me."[69] Calder's attention was moving elsewhere—though he didn't yet know where it would alight.

CIRQUE CALDER

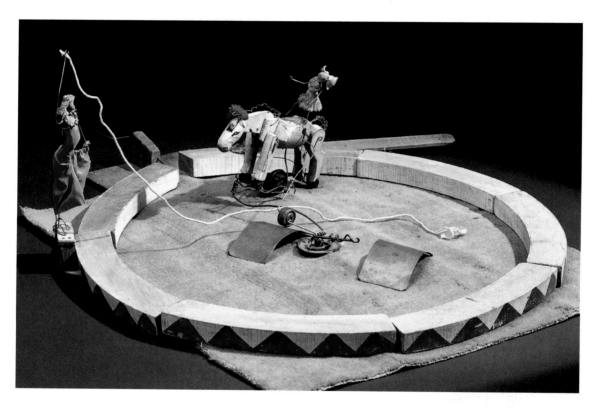

Calder. Equestrian act from
Cirque Calder, *1926–31.*

I

Calder's life as an artist in Paris began with the miniature circus he was assembling almost as soon as he arrived. The circus led to wire sculptures of figures and animals, which led to abstract sculptures dominated by arcs, circles, and spheres, which, in turn, led to sculptural constructions that circulated in space. Everything Calder ever did would be informed by the experiences of those first years in Paris, when Picasso, Brancusi, Mondrian, Miró, Joyce, Stein, Stravinsky, Ravel, and Diaghilev were all hard at work. Calder's instinctive feelings for the dramatic possibilities of play were set

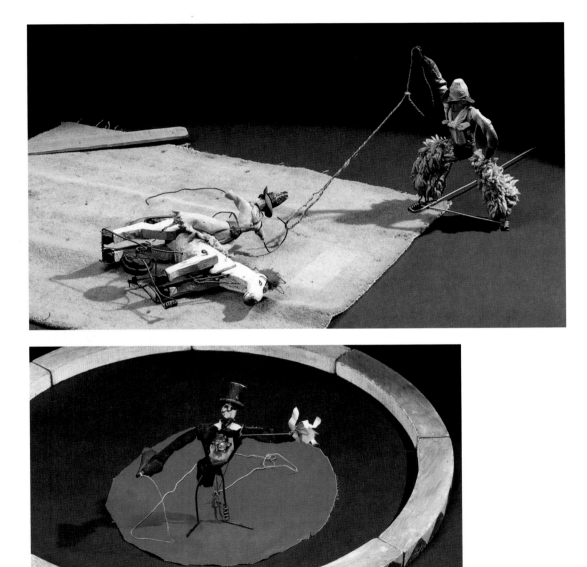

free, expressed through sculptural inventions that if at first mostly comic would soon enough turn mysterious, magical, and even austere.

The people who initially saw the *Cirque Calder*—there were probably only a few dozen in the first year he was in Paris—were invited to Calder's studio, which was nothing more than the hotel room on the rue Daguerre. As soon

TOP *Calder. Cowboy act from* Cirque Calder, *1926–31.*

ABOVE *Calder.* Monsieur Loyal *from* Cirque Calder, *1926–31.*

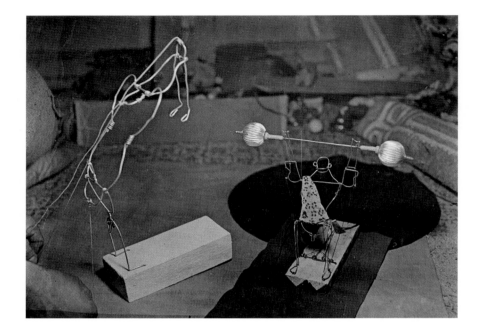

Two Acrobats and Weight Lifter *from Calder's* Cirque Calder *(1926–31), c. 1931. Photograph by Brassaï.*

as Calder had gotten settled there, he began making little figures and animals out of wire, cork, fabric, rubber, and sundry other materials. They were arranged here and there around the room—hanging from hooks, lying on a table. As Calder's visitors arrived and settled down wherever they could find a place, the big, blithe American was still moving around, gathering together his little actors and various props. This was an extremely casual affair. When Calder was ready to begin, he plopped down on the floor, leaving his visitors with the feeling that he was not so much preparing for a performance as he was getting ready to work with his creations and allowing a friend or a friend of a friend to watch as he did—to play along, if you will. Anybody could see that this was different from the puppet and marionette shows that were being presented in Parisian music halls and fairs; those were engineered as public events.

What Calder was up to was stranger and, in its Lilliputian way, wilder. The dramatis personae of Calder's circus were all something like eight inches high, their wire armatures sometimes left bare, sometimes padded with fabric to suggest the plush flesh of a belly or a thigh. What was especially fascinating was Calder's intimate relationship with his little acrobats, clowns, and animals, how they came to life through the touch of his hands. Calder, a big man, was inviting people to eavesdrop on an experiment of sorts, to focus on these pint-sized men, women, and animals with their movable parts, which he maneuvered with the intentness of a child and the confidence of an art-

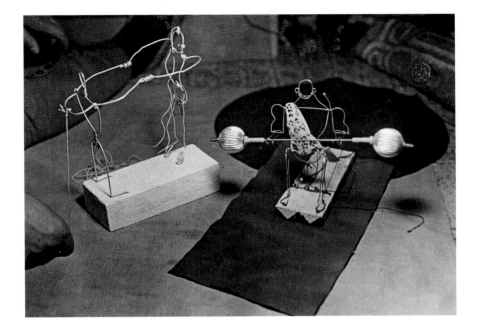

Two Acrobats *and* Weight Lifter *from Calder's* Cirque Calder *(1926–31), c. 1931. Photograph by Brassaï.*

ist. The miniature performers made the impresario look monumental. That dramatic juxtaposition has to have fascinated not only Calder's visitors but also Calder himself. Alexander Calder was at the beginning of what would turn out to be a lifelong artistic exploration of mind-expanding shifts in size and scale.

There was a tiny dog, with a coiled-wire tail and a flat-cut metal head and neck, that jumped through a paper hoop. At least, the dog tried to jump through the hoop. Sometimes he missed. Sometimes he succeeded when he tried again. Calder's intentness was part of the laid-back magic; he was willing to repeat the trick if it didn't work at first. There was a wooden horse, its legs, head, and body carved separately and joined together, finished off with a curly wire mane and tail. The horse was mounted on a little wheel, which was attached to a length of wire, which, in turn, was controlled by a crank (made with a repurposed eggbeater). As Calder turned the crank, the horse moved in a circle, around the tiny circus ring. And then, once the horse had made a couple of rounds, an equestrian acrobat with skinny wire legs, designed to fit over the flanks of the horse, was released from a catapult-like springboard. The trick was for Calder to release the acrobat into the air, using one hand, just in time for it to land on the horse, whose movement around the ring was controlled with his other hand.

And then there were the aerial acts. A solitary dancer with a tutu made of fluted candy-wrapper paper descended along a cord. Some sensational

flying duets were performed on a setup with three trapezes. The trapeze artists had cork bodies and wire arms and legs that hooked onto the trapezes and the other performers. The trapeze wires were manipulated by Calder with gentle little tugs, which somehow created the illusion that the toy figures were risking life and limb as they performed their elegant maneuvers. Within a couple of years, the circus would have a musical accompaniment, by way of a series of popular tunes played on a portable record player by one of Calder's friends or, later, by his wife. To watch Calder taking control of his curious cast of characters—with or, as probably was the case in the early months, without music—was to witness not exactly magic but something more like the genealogy of magic.

II

The first person who wrote about Calder in Paris was not an art critic but a man named André Legrand, who reported on the circus, the music hall, and other popular theatrical entertainments. It was Legrand, who published under the pen name Legrand-Chabrier, who suggested, after seeing the *Cirque Calder* on the rue Daguerre in 1927, that this young American might be a figure to be reckoned with. In his *Autobiography,* Calder adopted a characteristically casual tone about Legrand, referring to him as a "circus critic," a description that while not inaccurate certainly did scant justice to the man.[1] Legrand was a writer of no small consequence in Paris, a cultural journalist who had already published a number of books and who covered an extraordinary range of performances in music halls and circuses.

It is worth knowing a little bit about André Legrand. His pen name dated to the beginning of the century, when he had written books and articles with his close friend Marcel Chabrier, the son of the composer Emmanuel Chabrier; Marcel died in 1910 when he was in his mid-thirties. Legrand, in collaboration with Chabrier, had published a book of prose poems, *Mangwa,* as well as an account of a trip to Arles and some fiction. Both with Chabrier and, later on, by himself, Legrand wrote studies of Théophile Gautier, the nineteenth-century poet and critic who had described the romantic enchantment of dancers and clowns. Legrand and Chabrier were among the younger writers who gathered around Remy de Gourmont, the Symbolist poet and critic. And de Gourmont had collaborated at one time with that forerunner of the Dadaists Alfred Jarry, whose *Ubu Roi* could well find its way into an account of experimental theater that also included the *Cirque Calder.* Which is all to suggest that it took a man with Legrand's largeness of spirit to grasp

the idiosyncratic brilliance of Calder's still nascent gifts—to grasp them at a time when Calder himself may not have known exactly what he was up to. Legrand recognized what was to become Calder's first true subject—namely, the poetic possibilities of popular expression and the high lyric art to be extracted from quotidian themes.

It was Marc Réal, Calder's buddy from *The Boulevardier*, who brought Legrand to the rue Daguerre. Climbing the stairs to Calder's studio late in May 1927, Legrand found himself in the presence of a rather tall young American who still seemed like an overgrown boy, and who struck the French writer as immediately appealing, with his open, easy demeanor and what Legrand described as his frank blue eyes. America was the great hope for many European intellectuals in those years, and bright young Americans held a particular appeal. Calder's circus performers were unlike anything the critic had seen before; he referred to them variously as toys and as some unusual form of marionette. He described them as "stylized silhouettes."[2] When set in motion under the watchful gaze of this extraordinarily skillful young American, they achieved a mysterious reality, a kinetic power that reminded Legrand of the prehistoric cave drawings recently discovered in the South of France. (Élie Faure had written about—and Calder had read about—those prehistoric images in his *History of Art*.) What seemed especially important to Legrand was the delicacy of Calder's touch, his hands "at once powerful and caressing."[3] Calder worked his trapezists with such cunning that they seemed to replicate "the same moves as our flying trapezists in flesh and blood."[4] It was Legrand, Calder later recalled, who suggested that what was missing was a net beneath the trapeze. The net only further complicated the delicate illusion, for it suggested that Calder's aerial artists, although anything but flesh and blood, might in fact find themselves in harm's way.

What Legrand wrote about in June 1927 were a relatively small number of acts. The circus was just in its infancy. When Legrand revisited two years later, he found the circus "swarming with new artists."[5] He once again referred to them as "toys" and "stylized silhouettes," although he rejected his initial characterization of them as marionettes of some sort. The most important of the earlier photographs of the circus, by the Hungarian photographer André Kertész, dates from 1929, around when Legrand made his second visit. Calder was even then still some way from the elaborate setting, with cloth wings creating a kind of proscenium stage, that we know from films produced decades later. In the 1929 photograph, the creator is very much situated in the midst of his creations. Legrand described Calder in "his favorite position, sitting on the floor on his behind."[6] Nobody who saw the

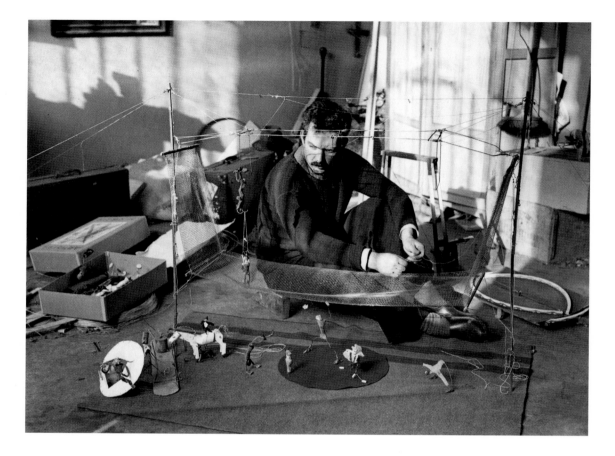

Calder with Cirque Calder *in 1929. Photograph by André Kertész.*

circus, and Legrand understood this immediately, could possibly separate Calder's creations from their creator, the dance from the choreographer who was also the dancer. Calder's often rather schematic renderings of figures and animals came alive only through the young American's intervention. If Calder's presence "on stage" with his cast of characters had any precedent in traditional puppet or marionette shows, it was in the Japanese Bunraku theater, where the puppets, a couple of feet high, were manipulated by puppeteers who were freely visible, moving around the stage as they propelled doll-like figures in a parallel theatrical universe. It was Calder's strange and marvelous spectacle—as yet rather brief, fragmentary, improvisational— that drew a number of visitors, including the poet and impresario of the arts Jean Cocteau, to the rue Daguerre only months after the American's arrival in Paris. Of Cocteau's visit there will be more to say.

III

The subject of the circus had been attracting artists for more than half a century, from Daumier and Toulouse-Lautrec to Picasso and Georges Rouault. Calder, although certainly well aware of this history, didn't need to look beyond his family's circle of friends to see that artists cared about what went on under the big tent. At the age of six or so, he had himself probably been presented as a clown in his mother's friend Charlotte Harding's 1905 illustrations for *Verses for Jock and Joan*. The Native Americans Stirling had sculpted and Nanette had painted in Pasadena had been members of a local circus. Stirling and Nanette's friend and Calder's teacher John Sloan had in 1910 painted *Old Clown Making Up* and, later on, *Traveling Carnival, Santa Fe;* Sloan once rented a clown suit for a costume ball.[7] Another family friend, Everett Shinn, painted a great many scenes of popular entertainment in various theatrical settings, including the circus.

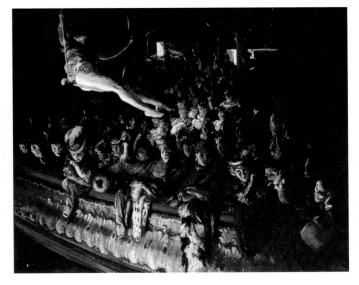

Everett Shinn. The Hippodrome, London, *1902*.

The critic Gilbert Seldes observed in 1924 in his book *The Seven Lively Arts* that "the circus can be and often is more artistic than the Metropolitan Opera House in New York."[8] While Calder was doing drawings of the Ringling Bros. and Barnum & Bailey Circus for *The National Police Gazette*, Edmund Wilson, in *Vanity Fair*, was writing about the "beautiful horses and beautiful human beings" and praising the aerialist Miss Leitzel, a favorite of Calder's, for her "bronze-brown hair" and "bacchante's violence."[9] The young poet E. E. Cummings published an essay, "The Adult, the Artist and the Circus," in *Vanity Fair* in 1925, saying, among many other things, that "a periodic and highly concentrated dose of wild animals . . . is indispensable to the happiness of all mature civilized human beings."[10] Cummings, who was a serious painter as well as a poet, illustrated the piece with his own drawings. Toward the end of 1925, Calder had gone down to Florida to sketch the circus in its winter home in Sarasota. That same year, he painted *The Flying Trapeze,* and the next year *Circus Scene,* in both instances emphasizing the vast spaces inside the tent, seen from an elevated vantage point. Years later, interviewed by the artist Cleve Gray, Calder said, "I was very fond of the spatial relations." He may have been speaking with hindsight,

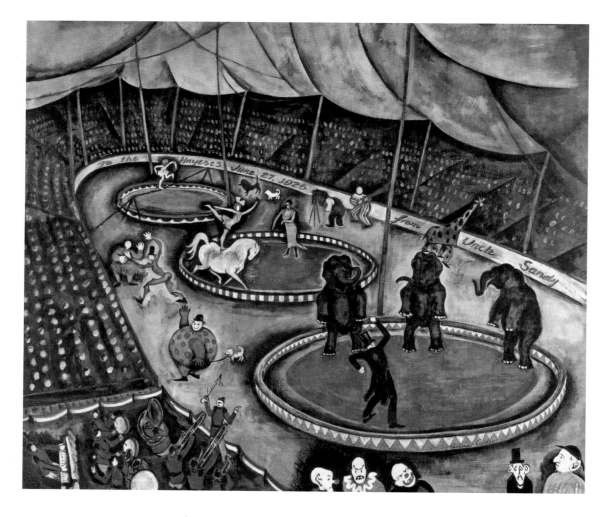

Calder. Circus Scene, *1926.*
Oil on canvas board, 69¾ x
83½ in.

now fully cognizant of the abstract forces that had attracted him well before he became an abstract artist. "I love the space of the circus. I made some drawings of nothing but the tent. The whole thing of the—the vast space— I've always loved it."[11]

In Paris, artists, writers, intellectuals, and bohemians of all sorts were even more taken with the circus than were their counterparts in New York. In the journals of Harry Crosby, the wealthy American who founded the Black Sun Press and was in Paris around the same time as Calder, there are accounts of a number of visits to the circus. In December 1927, Crosby went with his wife, Caresse; he interviewed the lion tamer, who told him that "before training lions he began at the age of eighteen to train chimpanzees." Soon after, Crosby was at the circus again, this time with Archibald MacLeish and Ernest Hemingway. "We drank beer with the Spanish Clowns

LEFT *Calder. Untitled (Nets and rigging), 1925. Pencil on paper, 8⅜ x 10⅛ in.*

BELOW *Illustration from* Le Cirque *by Ramón Gómez de la Serna, 1927, representing the author lecturing on the circus from the trapeze.*

(H[emingway] talked to them in Spanish)," he wrote, "and then Peterson took us back to see the lions (they were yawning and stretching) then more beer."[12] In the Spanish author Ramón Gómez de la Serna's *Le Cirque*—a copy of the 1927 French translation was given to Calder by a fan of his circus in 1931—the circus was said to offer a foretaste of "the universal peace of which we dream." Only cathedrals, Ramón explained in one of the book's brief, aphoristic passages, have spaces as lofty as the circus tent. And the athletes who entertain in the circus have finer muscles than the athletes commemorated in ancient Greek statues. The circus, Ramón wrote, reveals the "humorous sense of life." Eventually the whole world, he said, would become a big circus, and, like the circuses everybody was so eager to visit, the world would be simultaneously farcical and frank, true, sincere.[13]

Bohemian Paris was itself a circus where everybody was a performer of one sort or

Ramon prononçant son discours du haut du trapèze au Cirque Américain (croquis de Estalella).

another, although opinions certainly differed as to whether their farci-
cal or fantastical behavior was frank, true, and sincere. Calder, dressed in
his attention-grabbing clothes, was very much a part of a time and a place
where self-stylization and even self-caricaturization of one sort or another
were taken for granted. Some of the first visitors to the *Cirque Calder* were
known for their theatricality. Mary Butts, the experimental English novel-
ist, was an early admirer; in a draft of a letter, she said that Calder's toys
were "a marvel—there's a man with a mission."[14] An Englishman, the
writer Douglas Goldring, remembered Butts as always "a gorgeous appari-
tion at a party," with "her red-gold hair, white skin and glittering 'boot but-
ton' eyes." "All her qualities, good and bad, were exaggerated," Goldring
explained.[15] Butts was a great friend of Aleister Crowley, a master of black
magic, who when he was not visiting in Paris maintained a sort of temple
in the Sicilian town of Cefalù. He was another man with a wide theatrical
streak; as another friend of Mary Butts's, the artist Nina Hamnett, recalled
in her memoirs, he "painted the most fantastic pictures in very bright col-
ors," liked to wear elaborate costumes, and offered visitors to his room in a
hotel on the rue Vavin a cocktail laced with laudanum that he called Kubla
Khan No. 2.[16] Although Calder was far too sane and stable to ever feel the
attraction of a man such as Crowley—visitors to his temple in Cefalù tended
to come down with dangerous illnesses and not recover—Butts's taste for
the wild side would have endeared her to Calder, himself an over-the-top
personality.

Baudelaire, some seventy years earlier in his essay "On the Essence of
Laughter," had said that caricature, and the laughter it provokes, "comes
from the idea of one's *own* superiority. A Satanic idea, if there ever was
one! And what pride and delusion!"[17] But Calder in his orange suit (or Mary
Butts with her exaggerated manner) risked becoming the object of other
people's laughter, which suggests that caricature and laughter had under-
gone an evolution since Baudelaire's time. Many Parisian artists and writers
had rejected the triumphalist spirit of the old caricaturist's art, preferring to
see caricature and laughter as freed from fixed judgments—as an immersion
in the delicious, spectacular absurdities of life, a circus in which anybody
could be both artist and audience. There was a new sense of caricature as
a joyous democratic experiment, with everybody, like children, laughing at
everything. This democratic feeling for comedy became a strong undercur-
rent in Calder's mobiles, where the witty elements sometimes seem to eye
one another. In at least one instance, the great plunging black mobile *Bosquet
Is the Best Best* (1946), the head of a clown hovers among all the other ele-
ments, the comedian at the center of a comedy of movement.

IV

Apparently it was Mary Butts who brought Jean Cocteau to see the circus. Nobody was more of a self-stylizer than Cocteau. Calder took an instantaneous dislike to the whippet-thin dandy. In his autobiographical notes, Calder recalled that Cocteau came to see the circus "with about 5 little fairies"—which could lead one to assume that it was his homosexuality that turned off Calder.[18] But Calder was pretty much unfazed by other people's sexual choices and dispositions. It was Cocteau's brittle, imperious, high-bohemian manners that weren't to Calder's taste. He was not alone. The writer Matthew Josephson, a friend of Calder's a decade later, remembered Cocteau with distaste in his book *Life Among the Surrealists,* writing that "his affections of Baudelairean dandyism seemed to me forced, as his fantasies, his paradoxes, and his style generally also seemed contrived."[19] Skepticism about Cocteau ran deep. Ezra Pound, in the *Cantos,* associated him with the nineteenth-century Romantic Théophile Gautier when he wrote, "Teofile's bricabrac Cocteau's bricabrac / seadrift snowin' 'em under / every man to his junk-shop."[20] Cocteau was a connoisseur of life's flimflam and bric-a-brac. That included the circus—which was sublime flimflam.

Jean Cocteau. Baigneuse se coiffant, *1926. Pipe cleaners and mixed media. As reproduced in the catalog of his exhibition "Poésie Plastique: Objets— Dessins," at the Galerie des Quatre Chemins in December 1926.*

The appearance of one of the legendary personalities of twentieth-century Paris in Calder's rue Daguerre studio only months after the American's arrival in France might lead one to believe that Calder's conquest of Paris was lightning quick. That would be a mistake. Although Cocteau's visit was surely a sign of triumphs to come, close encounters between the well known and the virtually unknown were very much in the spirit of a time when everybody, as Robert McAlmon put it, was being geniuses together. Among Cocteau's biographers, his interest in Calder doesn't seem to merit a mention. Be that as it may, there was Cocteau, sitting in Calder's room on the rue Daguerre, this man who had for years regarded the circus as a mirror of the world. A decade earlier, Cocteau had responded to the great theatrical impresario Diaghilev's challenge to astonish him by dreaming up *Parade,* the ballet about the circus that brought Cocteau together with the composer Erik Satie, the choreographer Léonide Massine, and Picasso in an unprecedented collaboration. *Parade* mixed the boisterous simplicity

of music halls, circus sideshows, and silent movies with elaborate Cubist costumes that transformed the dancers into kinetic sculptures. Some years before seeing the *Cirque Calder*, Cocteau had described the potential of new forms of theater when he'd declared that in the hands of the young, the circus, the music hall, and the cinema could "conspire, without even knowing their effect, against the theatre which has become: an old photograph album."[21] *Parade*, Cocteau wrote at the time of the premiere, was "a work which conceals poetry beneath the coarse outer skin of slapstick."[22] Calder would have understood the impulse.

Cocteau was interested in what Calder was doing. Which is interesting, considering that whatever one might have thought about his literary achievements—and opinions certainly differed—there was no question that Cocteau was one of the most acute observers of the Parisian artistic scene. Cocteau, Calder recalled, "was going to 'undertake' me, but I came to N.Y."[23] This was confirmed by Calder's friend Babe Hawes, who wrote in the magazine *Charm* in April 1928 that "Jean Cocteau is on the look-out for his return. He wants to give a real show so that all the Parisians can get a new slant on one of their favorite pastimes—going to the circus."[24] Nothing came of Cocteau's suggestion. Calder was far too independent-minded to allow himself to be taken under anybody's wing. Was Cocteau indeed acting as a talent scout? Or was he trawling for ideas that he could claim as his own? Perhaps a bit of both. A few months after he saw the *Cirque Calder*, Cocteau had an exhibition at the Galerie des Quatre Chemins entitled "Poésie plastique"; it ran from December 10 to December 28, 1926. Considering that Cocteau had already been to Calder's studio, it isn't impossible that objects such as his *Baigneuse se coiffant*, with its bather made of pipe cleaners, whatever they owed to Picasso, might also have owed a little something to the work Cocteau had discovered that Calder was doing. Along with the figures that he conceived as parts of his circus, Calder was experimenting with a variety of pull toys and flexible dolls—and hoping that somebody might consider putting them into production.

Calder thought that Cocteau had stolen some of his ideas. He said in his autobiographical notes that Cocteau "undertook to make <u>heads of wire</u>, chenille wire, very soft (pipe cleaners)."[25] The comment about the softness of his materials was certainly meant as a dig at Cocteau! Calder must have been galled when a reviewer of the toys Calder himself exhibited the following year, at Galerie Seligmann, observed that they recalled the poetic objects in Cocteau's Galerie des Quatre Chemins show. Of course, Cocteau's exhibition might have pushed Calder to consider the as yet untapped artistic potential of his sundry toys and circus figures. And considering that

Calder would, to the very end of his life, tend to call his three-dimensional works *objects* rather than *sculptures,* it may be that Cocteau's exhibition was one among a number of occasions when the use of the word *object* caught his eye. What would become clear to Calder in 1930, when Cocteau made an openwork head of pipe cleaners as a prop for his film *Blood of a Poet,* was that some people imagined that the poet had invented the wire portrait head, whereas it was Calder who had begun making wire heads a few years earlier. So Cocteau was indeed adapting what he saw as the young American's very impressive ideas. Some would call it stealing.[26]

V

The one source of inspiration for the *Cirque Calder* that the artist himself ever mentioned was the Humpty Dumpty Circus, a toy produced by the Schoenhut Company in Philadelphia. He probably first encountered the Schoenhut circus in Maggie Shoemaker's playroom when he was seven years old. Some fifteen years later, when he lived for a time in Alexander and Peggy Brook's apartment in New York, Calder discovered that their young children, too, had a Schoenhut circus. In the *Autobiography,* he recalled that he embellished the circus for the Brook kids, customizing an elephant and a mule and rigging up a clown so that it ended up on the back of an elephant.[27]

The Schoenhut Company had begun producing the Humpty Dumpty Circus in 1903. Albert Schoenhut came from a family of German woodcarvers and toymakers, and the figures, something like a foot high, had a startling vitality. When the clowns and jugglers were arranged one on top of another in pyramidal constructions, they had a dramatic presence that one can easily see Calder admiring.[28] By the time it was taken off the market in the 1930s, the Schoenhut circus had gone through dozens of versions and included hundreds of different animals and figures, all characterized by their extraordinary flexibility. Arms, legs, and heads could be moved into dramatically different positions, by means of the ball-jointed technology for which the company had received numerous patents. Whatever pieces the Brook kids had, Calder may also have been familiar, through advertisements and brochures, with the full panoply of Schoenhut's circus, which had as many animals, circus performers, and miscellaneous props as Calder would accumulate in the five suitcases that eventually held his own circus. In a book geared to collectors of the Humpty Dumpty Circus, Evelyn Ackerman describes these now highly prized antique toys in terms that could almost be used to describe the *Cirque Calder,* commenting on the "stylization of the

Acrobats from the Humpty Dumpty Circus, produced by the Schoenhut Company in Philadelphia for about thirty years, beginning in 1903.

forms" and the "immediacy of the visual expression."[29]

In his own circus, Calder came closest to the doll-like character of some of the Schoenhut figures with his *Japanese Wrestlers*, a pair of athletes with porcelain heads. But if Calder's debt to the Schoenhut circus becomes clearer the more of the Humpty Dumpty Circus you see, it also becomes clear how he broke with the Philadelphia manufacturer's generic clowns, acrobats, and animals. Calder enjoyed introducing faux-naïf naturalistic grace notes into some of his figures: a cartoonish face on a piece of cork or a costume encrusted with rhinestones. And he often had well-known performers in the French and American circus in mind when he made his figures. Calder's bareback rider, with a big bow in her hair, was a dead ringer for Miss May Wirth, who worked with Barnum and Bailey. His Pegasus float, with dogs racing around the wheels, was closely modeled on Madame Bradma's Pegasus, another Barnum and Bailey attraction.[30] And Calder's smoking clown had the hairy legs of the legendary Parisian clown Albert Fratellini. Calder seized on these signature elements or attributes with the avidity of a natural-born caricaturist. It was the caricaturist's determination to summarize, simplify, and crystallize experience that gave the *Cirque Calder* its sting.

The *Cirque Calder* was not about fixed forms but dynamic possibilities. Calder brought his actors to life. The trapeze artist's wire-hook limbs were merely functional until the leap from the trapeze gave them poetic point. The little clown with a balloon in his mouth came alive only when Calder blew air into the balloon through a tube, and the balloon expanded until it knocked over the Bearded Lady and then burst. Another clown, at first appearing in a long dark coat, began to attract attention as Calder removed layer upon layer of clothing, until he was revealed as a comic scarecrow in skinny checked overalls. Calder's animals may have initially looked rather clunky, but once Calder set them in motion they became kinetic wonders, the particular way they were constructed precipitating particular kinds of

movement. It is important to remember that the circus wasn't exhibited as a static display in a museum until the 1960s. Before that, the only way anybody saw the men, women, and animals that made up the circus was when Calder set them in motion in a performance. At rest, they were visual ideas, nothing more. Set in motion by their oversized inventor they became a mobile calligraphy with all the heart, soul, and spirit of an old-fashioned circus.

VI

The circus was not the only popular entertainment attracting a serious audience among artists, intellectuals, and the avant-garde in the early twentieth century. Puppet and marionette shows had had a considerable appeal since the late nineteenth century, and the first admirers of the *Cirque Calder* understood that it was part of that tradition.[31] In early accounts of the circus, the little figures were very often described as puppets or marionettes—in other words, as variations on an established theatrical form. (In the early twentieth century, *puppet* and *marionette* could be fluid, almost interchangeable terms.) As late as 1943, in his catalog for Calder's retrospective at the Museum of Modern Art, James Johnson Sweeney was still writing that "for the most part these toys were of a simplified marionette character."[32] Calder and his parents shared an interest in puppet and marionette shows. Calder's mother, in Rome in 1924, saw a marionette show where the marionettes were, as she wrote to her son-in-law, "very curiously done—done from below. The marionettes as I know them are done from above."[33] In New York a few years later, Nanette wrote to her daughter about visiting an Italian marionette show with Calder and his friend Jane Harris and her husband and some others and how "we went back stage and that was the most interesting to see the works."[34] Calder himself, in January 1927, wrote to his parents about seeing in Paris a puppet show for adults, " 'an Enchanted Evening' a ballet of toy dolls, with scenery, and music by Chopin which was great fun."[35] Sometime later he bought a figure from the traditional Punch and Judy show at one of the Parisian flea markets for Babe Hawes, by then back in New York and running her own couture house. In a letter from February 1929, Calder wrote of going to see the Italian marionettes for a second time and finding them "gorgeous."[36]

Stirling may actually have had something to do, at least indirectly, with his son's turning his attention to puppets and marionettes. When Calder was living in Washington State, Stirling sent him a copy of a new book, *The Tony Sarg Marionette Book*, telling Nanette, who was also out visiting Peggy and

THE TONY SARG
MARIONETTE BOOK

Illustrated by TONY SARG

Text by
F. J. McISAAC

*With Two Plays
for Home-made Marionettes by*
ANNE STODDARD

NEW YORK
B. W. HUEBSCH, Inc.
MCMXXI

Frontispiece and title page from The Tony Sarg Marionette Book, *published in 1921.*

her family, that "maybe he will care to do something with it to amuse."[37] Born in Guatemala, Tony Sarg had lived in Germany and England before bringing what he called his "artistic marionettes" to the United States. It is quite possible that the Calders visited Sarg in his studio and workshop on West Ninth Street, where he had on display a huge collection of toys from many periods and places. If they did meet, Sandy could have been interested in this man who once said, "I have a mechanical eye." In addition to being a puppeteer, Sarg was an illustrator and a cartoonist, and sometimes, by his own testimony, he made "a mechanical drawing of a new invention in the way of a toy or a marionette."[38] Although Calder never seems to have mentioned Sarg, there are a couple of illustrations in *The Tony Sarg Marionette Book* that will pique the curiosity of any student of the *Cirque Calder*. The book's frontispiece, a drawing by Sarg, has the artist in a hat and overcoat holding a bag full of marionettes, while right next to him is a trunk bursting with more of his puppets. That brings to mind the suitcases in which Calder carried his circus from place to place. And there is a drawing of a pipe-smoking marionette, the smoke rings created by a puppeteer who blows through a tube running through the marionette's body, that strongly suggests an inspiration for Calder's balloon-blowing clown, the air for the balloon supplied by Calder himself, blowing into a tube that runs through the clown's body.

Living in Greenwich Village in the years before he went to Paris, Calder would almost certainly have been familiar with the work of Alfred Kreymborg, a poet, playwright, and editor who was associated with the Provincetown Players and whose puppet theater for adults had toured the United States a few years before. "People," Kreymborg wrote in *Troubadour*, the autobiography he published in 1925, "see and guess a great deal more than puppets are able to; otherwise, they are equally helpless, and out of this mutual helplessness comes that curious bond that lifts a man into an actor or a doll into an animated reproduction."[39] Wasn't the *Cirque Calder* all about the bonds between men and dolls? And then Kreymborg added—in words

that make one think of Calder quietly wrapping one of his figures in a cloth after the act is over—that puppets "were never a tedious people. When one was through with them, one put them away, and took them out only when one needed them again."[40] Kreymborg mused at one point, "Where were the humans who would lower themselves to the level of puppetry and maintain a relationship to each other so harmonious as to admit no personal whim into the performance?"[41]

Illustration by Tony Sarg from The Tony Sarg Marionette Book, *published in 1921.*

The abstractness of puppets and marionettes appealed to theater people who were looking for a way beyond what they saw as the suffocating literalism or realism of so much theater. Puppets and marionettes, free as they were of the quirks, insecurities, and prejudices of mere mortals, could achieve a heightened existence, an individuality that trumped everyday individuality. Given his interest in the avant-garde theater, Calder must have known about Edward Gordon Craig, the legendary stage designer who had published a magazine called *The Marionette* in 1918 in Florence. Craig praised the marionette as the only actor "who has the soul of the dramatic poet," and he floated the concept of the "Über-marionette," a marionette that was somehow more than a marionette, its movements "measured, rhythmic, planned."[42] An extraordinary number of avant-garde artists took an interest in puppets and marionettes, über or otherwise. Sophie Taeuber-Arp created a series of puppets for a production of Carlo Gozzi's 1918 play *King Stag*.

Calder. Little Clown, the Trumpeteer *from* Cirque Calder, *1926–31. These are stills from the film* Le Grand Cirque Calder *1927, directed by Jean Painlevé in 1955.*

Paul Klee produced something like fifty hand puppets for his son Felix, who performed shows with them at the Bauhaus around 1920. And in 1926, the year Calder began his circus, Alexandra Exter created a series of marionettes to be used for a movie by the Danish film director Urban Gad. Several of Exter's marionettes were exhibited in the "International Theatre Exposition" at the Steinway Building in New York early in 1926, which Calder may have seen.[43]

By the time he had begun mounting his circus on the rue Daguerre, Calder was probably convinced that it would fit right in with what Helen Haiman Joseph described in *A Book of Marionettes* as a vogue for "literary puppets" of "every type," which were seen in "artistic salons or in semi-public productions throughout Paris."[44] Many writers responded. Rilke published an essay on puppets in 1914, confessing that "a poet can fall under the spell of a marionette."[45] Anatole France wrote about the marionette shows of one Monsieur Signoret, who mounted plays based on the works of Cervantes and Aristophanes; France said that "a truly artistic idea, an elegant and noble thought, should enter into the wooden head of the marionette more easily than into the brain of a fashionable actress."[46] And George Bernard Shaw, that idol of Calder's father's, took a great interest in the subject, echoing Gordon Craig's ideas about the Über-marionette.[47] Seeing a marionette performance, Shaw suggested, would show drama students "that very important part of the art of acting which consists of not acting: that is, allowing the imagination of the spectator to do its lion's share of the work."[48] Elsewhere, Shaw observed of the puppet that "its symbolic costume, from which all realistic and historically correct impertinences are banished, its unchanging stare, petrified (or rather lignified) in a grimace expressive to the highest degree attainable by the carver's art, the mimicry by which it suggests human gesture in unearthly caricature—these give to its performances an intensity to which few actors can pretend."[49]

VII

Is all this too much of a burden to place on the *Cirque Calder*? Weren't Calder's intentions much lighter? Didn't he simply aim to amuse? Calder abhorred heavy-handedness, in philosophizing as in everything else. He was not one to indulge in metaphysical speculations, having had a bellyful as he'd listened to his father. Along with many others who had admired Charlie Chaplin's early films, Calder bemoaned the sentimentality of *City Lights*, writing to his sister in 1931 that "it wasn't just the good simple fun of the old days—with the really clever wise cracks—he tried to do something 'different,' and missed his step."[50] Calder liked comedy to be pure, direct, even a little coarse. Perhaps this is why despite his lifelong fascination with the circus and circus performers of all kinds, he steered clear of the commedia dell'arte, with its immortal protagonists Harlequin and Pierrot. My guess is that he found their antics already overburdened with layers of nostalgia and solemnity, courtesy of creative spirits ranging from Watteau in the eighteenth century to Verlaine and Picasso in more recent times.

Alexandra Exter. L'homme sandwich, 1926. Marionette designed for the "International Theatre Exposition" at the Steinway Building in New York in 1926.

But Calder's distaste for solemnity—or what he regarded as false solemnity—shouldn't blind us to the heartfelt and, dare I say, serious nature of his intentions. Early visitors to the *Cirque Calder* recognized a gravitas in the performance; something more than mere entertainment was at stake. The sculptor Isamu Noguchi, a friend of Calder's in the years around 1930 who assisted with at least a few performances, much later recalled that "with Sandy the circus was always a very humorous but also sad experience and this combination of sadness and humor pervaded each performance."[51] Noguchi's remarks were solicited by the curator and collector Jean Lipman for *Calder's Universe*, a book published to accompany Calder's 1976 retrospective at the Whitney Museum of American Art. But Lipman chose not to include Noguchi's observation about the sadness of the *Cirque Calder* in the published text. This leads me to believe that there was in 1976 (and still is today) an aspect of the circus with which Calder's admirers haven't come to terms. The sadness had everything to do with a visitor's sense that

Calder with Josephine Baker IV *(c. 1928), during the filming of a Pathé newsreel in Paris in 1929.*

Calder's actors were both more and less than human—and in that sense not entirely unlike Edward Gordon Craig's Über-marionettes. The inanimate little figures that Calder animated in the *Cirque Calder* were the beginning of an animation of the inanimate that would climax some years later, with the magisterial lyricism of his greatest mobiles.

Anything we can say about the more than human power of puppets and marionettes takes us back to the essay "On the Puppet Theater" by the Ger-

Calder. Josephine Baker IV, *c. 1928. Wire, 39⅔ x 33 x 8⅓ in.*

man Romantic writer Heinrich von Kleist, published in 1811. In Kleist's extraordinary essay—it has almost the character of a short story—a dancer who has been raptly watching a primitive puppet show in a fairground declares that grace appears "most purely in that bodily form that has either no consciousness at all or an infinite one, which is to say, either the puppet or the god." Whatever Calder knew or thought of Kleist's essay (and we can't know whether Calder knew it at all), with the *Cirque Calder* he was

Calder. Personnage pour Joan Miró, *1947. Bones and wire, 11⅞ x 4 x 3⅛ in.*

on his way to creating kinetic experiences that take place in our world but are also out of this world in the sense that they originate not in nature but in the artist's imagination.[52] In his essay, Kleist made much of the central string that controlled the marionette, arguing that this string was "nothing less than the path of the dancer's soul." Although Calder only occasionally suspended one of his doll-like figures from a string—there is a photograph of him holding a wire sculpture of Josephine Baker suspended from a single wire—much of the drama of the circus depended on the careful manipulation of one or more strings, strings that controlled the movement of the trapeze artists or enabled one acrobat to execute a handstand while held aloft by his partner. Calder did, in 1947, create a curious sort of marionette that he

gave to his friend Miró. *Personnage pour Joan Miró* is a figure made of pieces of bone, the legs of pieces of jawbone that still contain teeth. It's a strange and sinister concoction, the inanimate fragments of some animal reanimated as a marionette.

There might be little point in even relating Calder's strings and wires in the circus to Kleist's essay, except that soon enough Calder was suspending all sorts of kinetic forms from a single string. Like Kleist's marionettes, Calder's mobiles are simultaneously anything but alive and absolutely alive—and when we look at the mobiles, we may feel, as the dancer in Kleist's essay felt about the puppets, that they have both no consciousness and an infinite consciousness. When Sartre, after World War II, wrote his beautiful essay about Calder's mobiles, he may have had Kleist's words in mind as he wondered whether the movement of the mobile "is the blind sequence of causes and effects or the timid, endlessly deferred, rumpled and ruffled unfolding of an Idea."[53] Whatever the meaning of the movements of Calder's mobiles—what Sartre called "these hesitations and resumptions, gropings and fumblings, sudden decisions and, most especially, marvelous swan-like nobility"—they surely had their origins somewhere in the hesitations, resumptions, gropings, fumblings, and marvelous nobility of the men, women, and animals who first appeared before the public in Calder's little studio in the hotel on the rue Daguerre in 1926 and 1927.

In Christopher Isherwood's autobiographical novel *Lions and Shadows*—first published in 1938 but looking back to the 1920s—the character based on W. H. Auden has this to say about the theater: "The whole remaining traces of theatrical art were to be found on the music-hall stage: the whole of modern realistic drama since Tchekhov had got to go; later, perhaps, something might be done with puppets."[54] Wasn't that precisely what Calder was thinking in the months after his arrival in Paris—that something might be done with puppets? What André Legrand grasped, as he put it so vividly, was "the concentrated expression of a secret and wild individualism, nothing of a puppet circus for the throngs. It exclusively comes to life under Alexander Calder's hand, at once powerful and caressing, but only if that contact is established—truly—between him and you."[55] Those were Legrand's thoughts in 1929, two years after he first saw the circus. When he was fresh from the rue Daguerre in June 1927, he worried that his readers would imagine that "this is a storybook figure; I will reveal his name, and you can verify it. He is Alexander Calder, and I think—I hope—that you will hear of his toys."[56] And so Calder's life in art had at long last really begun.

WIRE SCULPTURE

I

Was the *Cirque Calder* in part a moneymaking scheme? The answer seems to be yes, although it may not have been clear to Calder exactly how that was going to work. Within a few years, there was at least a modest stream of income generated by circus events. A small group of public performances was set up with the help of a Parisian ticket brokerage outfit. Sometimes a hat was passed during performances in Calder's studio. And in the United States, there were attempts to turn the *Cirque Calder* into a paying proposition, as an exclusive entertainment in private homes.

Only a handful of people could fit into the rue Daguerre space, and what's more, hardly anybody had as yet heard of Calder. It was a couple of years later, early in 1929, that Paul Fratellini attended a performance of the *Cirque Calder*. The three Fratellini brothers were probably the most famous clowns of the day; their high jinks were commemorated in drawings and paintings, in wax, plaster, and terra-cotta figurines, in children's books, and in the various promotional materials for a Parisian restaurant, Au Fratellini. Paul Fratellini asked of Calder and received from him a large version of one of the circus dogs, a rubber dachshund called Miss Tamara (it was also referred to as "he"). Miss Tamara ambled along behind its master, who was Paul's brother Albert, on legs engineered so as to rise and fall, suggesting an animal's bending and unbending limbs. Fratellini and Calder became friends. There is an amusing letter from the clown to the artist about the success the dog had in Germany, although "for a while he seemed to be a bit sick and stopped eating, perhaps because he knew his master was in America."[1] But as Calder would report, and not without a certain bitterness, he never received any remuneration from the Fratellinis for this extraordinary prop.

Calder certainly felt under pressure to bring in some money in those early

months and years in Paris. He was twenty-eight, and he didn't want to take money from his parents forever. Stirling and Nanette were themselves often struggling. In the summer of 1927, Nanette wrote to Peggy that she was trying to get a little business going, selling decorative paintings done on glass. She had shown them to an antiques dealer in their building who "was enthusiastic about one of them—gave me pointers about them and suggested 57th St. gift shops—she deals only in antiques."[2] The letters Calder was sending back home in the early months of 1927 were full of discussions of his determination to make a living and all the uncertainties involved. He told his mother in April that he had "made 4 frames, all for 300 francs— and that is interesting," but we don't know anything more about the nature of this assignment. He expressed considerable frustration with his situation. "Doing drawings that don't especially excite me is a bore, unless they sell. And if they don't sell one has them on his hands long enough + gets quite sick of them (without having to destroy them because they might sell)."[3]

It was not just the drawings that were getting Calder down. In part encouraged by a Parisian friend he identified only as the Serbian, he was trying to find a way to turn all the mechanical ingenuity he'd lavished on the circus into some sort of plaything for children that might be put into production. Early in 1927, Calder told his parents, "I have made a lot of swell toys and am under way to find out what to do with them. I suppose I could get more for them in America, if they would sell at all." At the same time he wondered whether their simplified geometric forms were more geared to a European taste.[4] He confessed to his mother that "the toys are beginning to annoy me, because I have shown them so much, altho I am quite certain—just as much as ever—that they are very clever."[5] He was in touch with a lawyer in New York, one Morton Adams, who was looking into possibilities for manufacturers of the toys and who pointed out the dangers and difficulties involved in patents and getting producers to market anything aggressively. By the fall, there were some nibbles, but it was a banker from Wisconsin—Calder met him through Lloyd Sloane, the American who had introduced him to Marc Réal of *The Boulevardier*—who put Calder in touch with the Gould Manufacturing Company in Oshkosh, Wisconsin.[6] Although mainly known for fabricating plywood doors, Gould Manufacturing had a division that specialized in toys for toddlers that was, according to its 1926 toy catalog, "The Most Complete Line on the Market," producing wagons, scooters, cars, baby walkers, doll cabs, nursery toys, and sleds.[7]

In November 1927, Calder, having returned to the States a few weeks previously, traveled up to Wisconsin. As he told the story forty years later, he took the scraps left over from the production of doors at the Gould com-

Calder. Action Toys designed for the Gould Manufacturing Company, Oshkosh, Wisconsin, in 1927.

pany and out of these produced mostly pull toys—a rowboat, a kangaroo, a skating bear, and some ducks. A contract was signed, toys went into production, and Calder received what he recalled as "a very modest royalty, which was augmented much later when there was a notice about me in *The New Yorker*, mentioning the Oshkosh toys."[8] For the first time in his life, Calder was working on designs that were going to go into production. He couldn't mingle wire elements with bits of cork and cloth as imaginatively as he was doing for the figures and animals of the *Cirque Calder;* the Gould toys were inevitably more regularized, a sideline rather than a fresh innovation in his art. Some of the movements he dreamed up were sly, surprising, and probably unusual in toys of the period. But their concise, often geometric shapes and bold, primary coloring and patterning weren't all that unusual. As the German critic Walter Benjamin commented in a 1928 essay, "Toys and Play," "simplicity" had become "the fashionable slogan of the industry."[9] After Calder returned to Paris in 1928, he did colored drawings for a Rocking Zebra and a Rocking Elephant, meant, no doubt, to compete with if not replace the traditional rocking horse, which Gould also produced. We don't know how much money Calder made from the toys all in all, but a letter from November 1929 that survives included a check for $94.26, his 2½ percent royalty on sales for the previous month, not a negligible amount at the time. In 1929, the American magazine *Creative Art* ran a handsome little feature on the toys, the cool, striking photographs taken by the gifted modernist Ralph Steiner.

Calder was by no means the only artist at the time who was designing toys. There were a number of efforts afoot at the Bauhaus, about which

Calder may have known little or nothing. But he could have been aware of the Uruguayan avant-garde artist Joaquín Torres-García's efforts to get his Aladdin Toy Co. off the ground in New York under the slogan "Aladdin Toys Are Artistic Toys."[10] The poster produced for Torres-García's Go-Pony in 1924, when Calder was in New York and himself looking for ways to make some money, certainly brings to mind some of the work Calder did for Gould Manufacturing a few years later. Torres-García attended a performance of the *Cirque Calder* in 1928, and in the next few years he and Calder would be crossing paths, as two leading lights in a vibrant Parisian abstract avant-garde.[11] Even if Calder had little or no awareness of Torres-García's efforts to produce toys, they were working along parallel tracks. They both understood intuitively Baudelaire's assertion in his "Philosophy of Toys"—we have encountered it before—that "the toy is the child's earliest initiation to art, or rather for him it is the first concrete example of it."[12] Both Calder and Torres-García always managed to preserve, in works created for a highly sophisticated audience, the quality of paradisaical possibility that children experience with their most beloved playthings.

Advertisement for the Go-Pony manufactured by Joaquín Torres-García's Aladdin Toy Company in New York in 1924.

II

Children do not always know where their toys will lead them. And for a time, the greatest discovery of Calder's first years in Paris, the medium that would irrevocably shape his art, was hiding in plain sight. I am speaking about wire. Wire, a material that Calder had used off and on since childhood, was becoming essential, only he didn't really know it yet. Wire—this basic, elemental material—could be cut, bent, twisted, and knotted in a great variety of ways. Calder was aware that wire was functional, adaptable. What took him some time to see was that it could also be sensual, eloquent, poetic.

Some twenty years earlier, in Pasadena, Peggy had bought Calder a pair of pliers, which he used to fit out her doll, Princess Thomasine, as she described it, "with watches, lockets made of copper-wire spirals or 22-gauge

rifle shells, combs of copper wire threaded with beads." He also fashioned "buttons for Mother and a ring with spirals at each end of the wire."[13] In New York in 1925, he had made an elaborate valentine for his mother out of wire. The following year he devised the wire sundial in the shape of a rooster for his room on Fourteenth Street. Now, in Paris, Calder was going back to the future—so much so that for a time it was probably hard for him to believe that he was actually moving forward. For his first two gallery appearances in Paris—in April 1927 as part of the Salon des Humoristes at the Galerie La Boétie and four months later at Jacques Seligmann and Co.—he presented animals and figures made with a combination of wire, cork, wood, fabric, leather, matchsticks, and sundry other materials.[14] What he was cobbling together from this variegated stuff weren't freestanding works of art but amusements, jeux d'esprit. There was a market for such things in Paris. A reviewer who called attention to Calder's animals at the Galerie La Boétie mentioned them right after dolls by a Madame Lazarski and a Madame Roucas. That might have left Calder feeling that he hadn't traveled as far as he might have wished from Princess Thomasine and his adventures with his sister in Pasadena. But in Paris, craft and creativity weren't always so sharply distinguished. In his autobiography, Man Ray, who would soon be a friend of Calder's, recalled knowing a Marie Wassilieff, a painter "who eked out a living by making leather dolls which caricatured celebrities."[15] In *Laughing Torso*, the wonderful memoir by the English painter Nina Hamnett, we learn much about Wassilieff, including that she had studied with Matisse and was somehow involved in an art academy with Fernand Léger, who would also soon be a good friend of Calder's. Calder was hardly the only sophisticated artist in Paris who was making playthings for grown-ups.

The more Calder worked with wire, the more it seemed the most natural thing in the world. Yet by his own account, it was Clay Spohn, his friend from the Art Students League, who finally said to him, thinking of his variegated creations, "Why don't you make them completely out of wire?"[16] Spohn had arrived in Paris six months before Calder, and in urging him to make something exclusively of wire he may have sensed some radical possibility that Calder himself didn't yet comprehend. Although Spohn was a painter, the work he's best remembered for today is *The Museum of Unknown and Little Known Objects*, which he mounted at the California School of Fine Arts in 1949, when he was teaching there. Spohn spoke of his objects as composed of "interesting material, material that had some aesthetic feeling to it, or something I felt I could use to make a construction." He made a series of objects using forks he found in the city dump. "I got a lot of fun out of it," he later said. "I don't know—it was just a fun thing to do. But in a certain sense it was also poetic for me, I mean."[17] Spohn's museum has come to be regarded as part of the revival of Dadaist ideas after World War II, and although we can't say that when Spohn was talking with Calder in Paris some twenty years earier he knew anything of the serious unseriousness that Dadaism embraced, it's also possible that he was already aware of such ideas. Surely when he suggested that Sandy do something completely out of wire, Spohn was pushing his friend to do something bold, daring—*advanced*. In 1970, when Spohn got back in touch with Calder after a very long gap, he thanked Calder for making sure that Spohn's involvement in the evolution of the wire sculpture had been cited in the catalog of the Museum of Modern Art's 1943 exhibition. "You were good enough—<u>most generous</u> enough—to mention my name in a wonderful and friendly manner. Bless you for that— for giving me the 'plug' or recognition which perhaps I hardly deserved."[18]

Once Spohn had made his suggestion, Calder ran with it. He had never had any trouble seeing how wire responded with thrilling rapidity to the muscular energy of his quickly moving, dancing fingers. Now he was beginning to entertain the possibility that his dancing fingers could produce works of art out of wire alone. Years later, in his autobiographical notes,

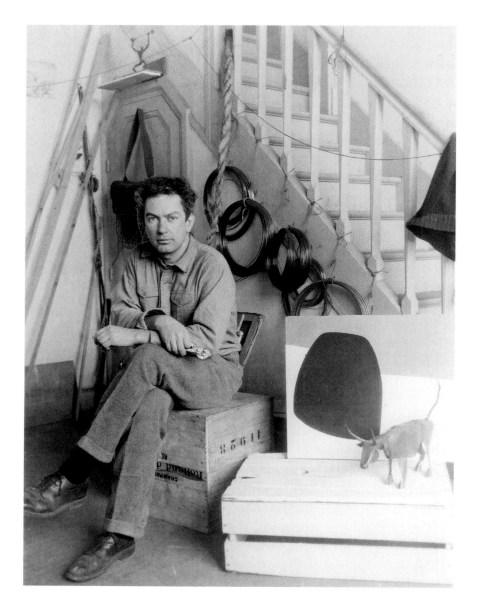

Calder in his studio at 7 Villa Brune, Paris, November 1930. Photograph by Thérèse Bonney. Calder holds the Bernard pliers in his right hand.

Calder wrote, "It must be the twitching of my fingers—even naked (without pliers) which makes me want to be plastik!" By "plastik" he meant malleable, capable of creating works of art.[19] Simple and elegant, the pliers Calder favored were developed in the late nineteenth century by a man named William Bernard, who sold his invention to the Wm. Schollhorn Co. in New Haven, Connecticut. Their key feature was a parallel grip, so they closed "like a vise," as the advertisements boasted. For Calder, it was all becoming a question of how the hand, the pliers, and the wire worked together. He

later wrote that he "avoided mechanical tools" because they "would have dictated the direction in which I was to go."[20] For Calder, the pliers were an extension of his fingers. In his autobiographical notes, written for his friend Bill Rogers, he argued for a symbiotic relationship between his hand and his pliers. "I told you, did I not, of my thoughts about attaching unlike things to each other—the balloon (?) to the basket (net) the ball to the hand (mitt) & hand + wire—(pliers) etc etc."[21] In a film clip shot in New York around this time—generally dated 1928 but perhaps from 1929—Calder, dressed in a suit and tie, works on a wire portrait of the wonderfully fresh-faced, cupid-lipped Babe Hawes; there are fascinating close-ups of his hands manipulating the Bernard pliers, with hand, pliers, and wire becoming one.

Nanette Calder once wrote to Peggy, after witnessing what she believed was a woman discouraging her daughter from using her hands, a defense of the creative spirit that had everything to do with a person's hands. "You know, Peg, I've always had such pleasure watching you and Sandy use your hands. You are both deft, unhurried and deliberate, skillful."[22] Indeed, there was a veritable cult of the hand and its powers in early-twentieth-century artistic circles. Photographers from Alfred Stieglitz to Germaine Krull did entire cycles of photographs of hands. In 1928, Hans Cürlis, who a year later would make a movie of Calder fashioning a wire figure, published an essay titled "Creative Hands." "There is a wonderful attraction in watching men at work," he wrote, "and especially in following the activity of their hands, and seeing with admiration that done which one would not be able to do oneself." Cürlis spoke of the fascination of the artist's hands at work, forming something "great, noble, and immortal."[23] In a rather carefully posed photograph by Thérèse Bonney, taken in 1930, Calder holds in his right hand the Bernard pliers, apparently the model that has a wire cutter as well as a wrench. He stares straight out at the camera, with several coils of wire hanging on the wall behind him. He's announcing that he can do anything so long as he has his pliers in his hand.

III

Two of the very first sculptural works done purely in wire survive only in photographs. They are janglingly animated studies, suggesting rapidly executed line drawings leaping into the third dimension. They represent two African-American personalities who were making an enormous stir in Paris in the months after Calder arrived, and it's easy to imagine that Calder felt some identification with these frankly ambitious expatriates. One is Josephine

Calder. Josephine Baker I,
c. 1926. Wire and wood.
Photograph by Peter A.
Juley & Son.

Calder. Struttin' His Stuff,
c. 1926. Wire and wood.
Photograph by Peter A.
Juley & Son.

Baker, the dancer who took the city by storm with her enormous, infectious smile, hilariously scanty costumes, and loose-limbed, high-flying, comically casual kinetic style. The great dance critic André Levinson spoke of her as a "sinuous idol . . . there seemed to emanate from her violently shuddering body, her bold dislocations, her springing movements, a gushing stream of rhythm."[24] The other is a work entitled *Struttin' His Stuff,* which probably represents the bantamweight boxer Panama Al Brown, a man unusually tall for his category, whose taste for elegant Parisian nightlife Calder suggests with a top hat and tails. There is a tradition—going back to Calder's 1943 retrospective at the Museum of Modern Art—that dates *Josephine Baker* (and, by extension, *Struttin' His Stuff*) to 1926, but there is no solid evidence to support this, and it makes much more sense that they were done more than five months into Calder's first Parisian sojourn, and thus sometime in 1927. Freeing himself from the juxtapositions of wood, wire, and other materials that gave much of the earliest Parisian work its funky charm, Calder for the first time here allows the lengths of brass wire to take on a life of their own. In making figures purely of wire, he may also have been remembering the metal armatures that his father, like so many traditional sculptors, used as the underlying supports for his work in clay or plaster.

Calder's long-legged figures—their hands open wide, their heads tossed dramatically back—move beyond caricature's journalistic punctiliousness, the lengths of wire now calligraphic lines of force careening through space. Baker's spiraling breasts and belly and curlicue private parts define a new kind of rococo comedy. Calder didn't immediately decide about the disposition of the figures' arms and legs. Between a photograph of the two figures together taken in Paris and photographs of them individually, set on simple wooden bases, taken later in New York, Calder made certain changes, with Baker's arms, which were one up and one down in Paris, both tossed upward for an exhilarating gesture in the later, New York version. He may have wanted to leave the arrangement of the arms permanently unresolved, an invitation to adjustments that prefigures the kinetic sculpture of a few years later. The individual photographic studies of *Josephine Baker* and *Struttin' His Stuff*—made in New York by the firm of Peter A. Juley & Son, who documented a great deal of Stirling's work—bring to these images a dash of dramatic genius. The figures are placed against very dark backgrounds, so the brass wire shimmers like lightning in the night sky.

For the rest of his life, wire would be an essential element in Calder's art. For periods of time, especially in the late 1920s and early 1930s, it would be *the* essential element. There's a painterly liquidity about wire. There's also a purity about a sculpture made of wire, because lengths of wire can be attached to one another without the addition of any other material.

The loops and knots with which Calder bound wire elements together are breathtaking grace notes in his art, structurally inevitable but also exquisitely executed and visually enchanting. Casual observers of Calder's work often assume that he was a welder. But nothing could be farther from the truth. Calder worked without the intervention of fire and heat. In response to a question as to why he didn't weld, he once said, "I always meant to learn but it never seemed convenient."[25] At Stevens, he probably did have some minimal experience with welding; it was part of the curriculum. In any event, there was nothing casual about Calder's decision to reject the welder's art. He was refusing the transformational power of fire and heat—the godlike power sometimes attributed in ancient cultures to the blacksmith who forged and welded seemingly intractable materials. Although there are a number of works of Calder's that are welded together, his deepest inclination was to avoid such irreversible joinings of one element and another. My guess is that he found something violent about the welded seam, which leaves the metal scarred. He may have seen welding as coarse and belligerent—as a violation of the purity of his materials.

Even Calder's largest stabiles were by and large composed of sections that were bolted rather than permanently welded. Over the years, he found many different ways to attach one element to another—wires to wires, wires to wood or glass or ceramic, wires to metal plates, metal plates to metal plates—without reverting to the welded seam. The blacksmith changes one thing forever into another. Calder, a poet of lightness, recoiled from the irreversibility of the welded joint. He brought elements together in such a way that although they couldn't be casually sundered, they nevertheless could be sundered. The possibility remained.

IV

Calder was back in the States in September 1927 to work out his collaboration with the Gould Manufacturing Company, but also probably to see if there were any opportunities to exhibit in New York. He had brought along some of the sculpture he'd been doing, including *Josephine Baker* and *Struttin' His Stuff.* After initially staying with his parents on Eighth Street, he rented a room for the winter not far away, at 46 Charles Street. He had brought the circus with him and gave some performances. The dramatis personae had had to be submitted to the Douane Centrale in Paris, and, as he recalled in the *Autobiography,* "All the artists were stamped with a rubber stamp on the buttocks. Some still carry traces of this branding."[26]

Sometime that fall, Calder managed to schedule what he always regarded

GREETINGS · FROM · THE · HOUSE · OF · WEYHE - 1928

Mabel Dwight. Greetings from the House of Weyhe, *1928. Erhard Weyhe stands with the bespectacled Henry McBride looking at a book, while Carl Zigrosser, with his hands on his hips, leans nonchalantly against a bookcase.*

as the first significant exhibition of his work, at the Weyhe Gallery, on Lexington Avenue; it ran from February 20 to March 2, 1928. Calder had certainly known the place—it was actually a combination bookshop and gallery—before he went to Paris. Erhard Weyhe had been an antiquarian book dealer in Germany, and eventually immigrated to the United States and opened a shop that specialized in art books. In 1919, he hired a young man by the name of Carl Zigrosser to expand the operations into art. Weyhe bought the building at 794 Lexington, between Sixty-first and Sixty-second Streets, which became a mecca for anybody interested in the modern movement. The distinctive façade included some decorative tile panels by Henry Varnum Poor, a potter who was a friend of Calder's. Weyhe made a speciality of prints by American artists, including George Bellows, Edward Hopper, John Marin, Stuart Davis, Charles Sheeler, Rockwell Kent, and John Sloan; Calder's friend Peggy Bacon also exhibited there. The gallery—intimate with print cabinets and bookcases halfway up many walls—was also the setting for exhibitions of smaller sculptures, especially the work of John Flannagan, whose studies of animals have an expressive wit that some have seen as an influence on Calder's work. Flannagan had a show at the gallery a few

weeks before Calder's opened. Calder's exhibition—actually a two-person show, with graphic work by a Weyhe regular, the painter Emil Ganso—consisted of a group of the new all-wire sculptures, plus two wooden cats, one being the *Very Flat Cat* that Calder had made out of a fence post when he was staying up in western Connecticut with Betty Salemme and her husband.

Carl Zigrosser, who sponsored Calder's exhibition, was the first of a series of cultivated and imaginative dealers who would promote Calder's work in New York in the next quarter century. Zigrosser and Calder had known each other before Calder went to Europe; he was one of the partygoers in Calder's lithographic study of a Greenwich Village gathering. Zigrosser was thirty-six when he gave Calder his first show. He was a good-looking man with blond hair and blue eyes and a relaxed, attractive manner. He had studied English literature as an undergraduate at Columbia and later recalled that his parents—his father was an engineer, born in Europe—had been "patient and decent toward my vague and errant aspirations."[27] Calder could certainly have related to that. Zigrosser and Calder never became especially good friends. But I imagine that Zigrosser, who wrote in his memories of the twenties that "above all we danced," responded immediately to the high spirits of Calder's wire figures, *Josephine Baker* and *Struttin' His Stuff*.[28] Of his first wife, Florence King, Zigrosser wrote years later that "it was exciting to be married to an athletic feminist." He and his wife shared a commitment to progressive political and social causes.[29]

Zigrosser was active among the American followers of Francisco Ferrer, a radical Spanish educator, the developer of what he called the Modern School; he was executed by the Spanish government in 1909. As the editor of *The Modern School* magazine for a time around World War I, Zigrosser published poems by Hart Crane and Wallace Stevens, two commanding figures in modern poetry in America. In a 1918 issue of the magazine dedicated to France, he included a report on Paris in wartime by Élie Faure, whose histories of art Calder had read during his time at the Art Students League.[30] By the time Zigrosser began working for Weyhe, he was as sophisticated a student of the modern movement as you could find in New York. He had taken in the revelations of the Armory Show, was a close follower of the exhibitions at Alfred Stieglitz's 291 gallery and of Stieglitz's magazine *Camera Work*, and had gotten to know Stieglitz himself quite well. In the 1920s, Zigrosser became friends with Duchamp through the critic Walter Pach. Calder was in good hands.

A lithograph made by Mabel Dwight as a Christmas card for the Weyhe Gallery in 1928 gives some sense of the convivial atmosphere in this jam-packed, exciting space. The youthful Zigrosser, hands on his hips, lounges

Calder. Jimmy Durante, *c. 1928. Wire, 12½ x 12 x 9¼ in.*

off to one side while Erhard Weyhe and the critic Henry McBride, who would soon write about Calder, together look at a book. The first exhibitions Zigrosser mounted at Weyhe's were of lithographs by Daumier and Paul Gavarni, masters of the art of caricature, to whose work Calder would literally add a new dimension with his wire portraits. Another early exhibition was of lithographs by Odilon Redon, whose fantastical visions were so important to the Surrealists. In 1925, Zigrosser collaborated on a show of drawings by Matisse with Matisse's son Pierre, who was just starting out in New York. In the mid-1930s, Pierre Matisse would become Calder's dealer.

V

Calder's mother, arriving with flowers at the Weyhe opening, declared, "Something will come out of all this, though it is not our style, something will come of it."[31] Those were indeed prophetic words. Calder's wire sculptures struck many visitors as amazements, whether his subject was a figure seated at a soda fountain, or a striding horse, or, more topically, the industrialist John D. Rockefeller playing golf or the head of President Calvin Coolidge, a Republican who the summer before had announced he would not run for a second term in the White House. In the portraits of nationally known figures there was perhaps an element of old-fashioned political editorializing, but Calder's Calvin Coolidge was too casually, insouciantly abstracted to drive any particular message home. Coolidge's poker-faced affect had become something of a joke among bohemians; E. E. Cummings published a comic text on the subject, "When Calvin Coolidge Laughed," in *Vanity Fair* in 1925, outlining the cataclysmic world events that occurred when a smile passed across the man's lips. Although one can hardly imagine Calder having any sympathy for Rockefeller the capitalist or Coolidge the

conservative, his wire impressions weren't critiques so much as they were comic transformations, turning heavyweights into lightweights. Calder was inviting his friends—and a slowly expanding following of gallerygoers—to contemplate a panoramic cast of 1920s characters. Along with the political figures, there were athletes, acrobats, artists, art dealers, and cultural impresarios, the makers and shapers of Calder's day, many of whom were becoming his friends. He was nothing if not up-to-date; Jimmy Durante had only recently become a major star when Calder made a wire portrait of him, probably in 1928.

Never again would Calder's work be so irrevocably bound up with the time in which it was created. You feel a particular kind of youthfulness in these wire sculptures: the dance-crazy, liquored-up optimism of the Roaring Twenties, with hints of the anxiety that shadowed the era's exuberance. The French called it *Les années folles.* The Weyhe show received a good deal of attention in the press. A reviewer in *The New Yorker* was reminded of the work of the cartoonist Peter Arno (who was then just beginning his career as the chronicler of Manhattan's café society), and also of Hogarth, whose pictures Calder had admired during his stopover in London on the first trip to France. There was also something disquieting about Calder's wire figures and faces, because from certain angles they dissolved into mysterious ribbons of near-abstract gesture. Calder used those enigmatic edges to add a surprising sting to his Jazz Age clownerie. A critic in *Creative Art* described the works as "the acme of elimination," in "designs that are not only humorous but telling. And that is more than a mere trickster can do."[32] One of the most striking objects the trickster had up his sleeve was hanging in the window of the gallery. It was a wire sign announcing the exhibition, with a plunging naked female figure, her wild, curly hair and open mouth sug-

Calder. Calvin Coolidge, *1927. Wire, wood, and paint, 18 x 7 x 9 in.*

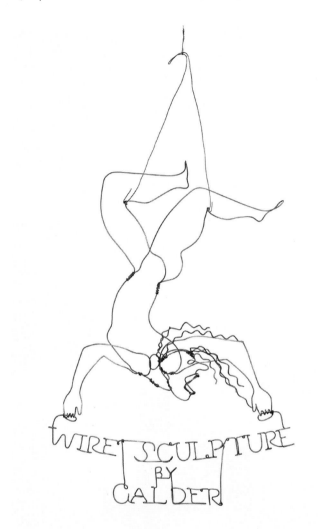

Calder. Wire Sculpture by Calder, *1928. Wire, 48¼ x 25⅞ x 4⅞ in. Calder made this sculpture to hang in the window of the Weyhe Gallery during his exhibition.*

gesting a maenad. There was something marvelous about the joyous abandon of that figure. Calder was liberating himself from the punctiliousness of the satirist's art.

Two or three things sold at Weyhe, including the sculpture of Josephine Baker, the first of five he would do of her over the next few years. Unfortunately, there wasn't much money to be made, as those works had been priced at ten or twenty dollars. By one account, Calder "loitered around the gallery in the hope of commissions for wire portraits. He also displayed trick cigarette holders which however did not sell."[33] At some point Calder commented about Zigrosser and Weyhe, "I guess they don't know much about blowing a horn."[34] There was a nice surprise from Paris, Nanette told Peggy, when a wire group of three figures—father, mother, and son—that he had sent to the Salon des Indépendants (although it arrived too late for the opening) was purchased by an Englishman.[35] One great triumph of the last months of this visit to New York was a commission for wire sculptures of athletes, designed to demonstrate the strength of a line of eyeglasses, for which Calder received the princely sum of a thousand dollars.

Calder remembered a critic writing, "Convoluting spirals and concentric entrails; the kid is clever, but what does papa think?" To this, Calder responded, "Father told me once that he was amused by the small wire things, but that my objects were too sharp to be caressed and fondled as one could do with small bronzes. However, I observed a few years later, with an object I had just painted black and placed on a mantelpiece, that somebody took the trouble to caress it and got full of paint."[36] It wasn't surprising that Calder made a bit of a joke of something his father had said. But Stirling wasn't entirely mistaken. There was something a little too sharp about some

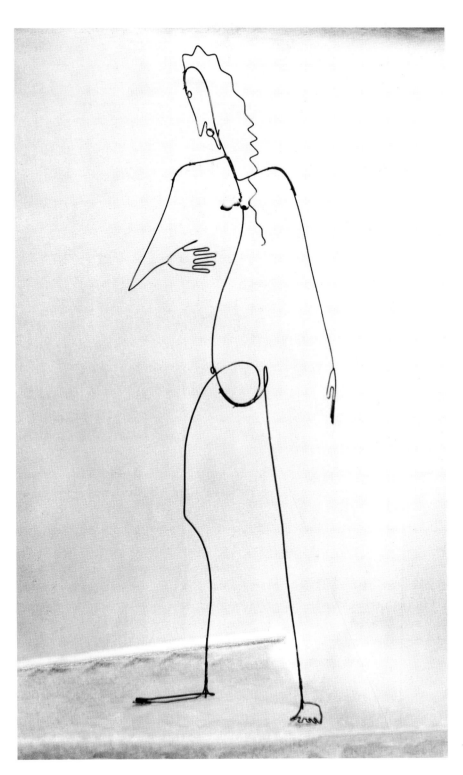

Calder. Spring, *1928.*
Wire and wood, 94½ x
36 x 19½ in. Photograph
by Peter A. Juley & Son.

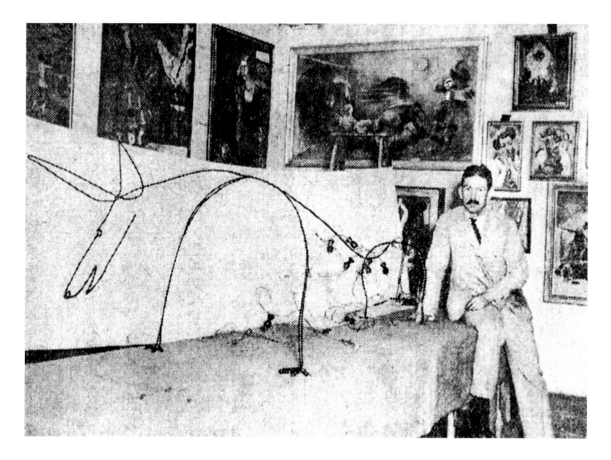

Calder with Romulus and Remus *at the "Twelfth Annual Exhibition of the Society of Independent Artists" at the Waldorf-Astoria hotel in New York, 1928.*

OPPOSITE, TOP *Calder.* Carl Zigrosser, *c. 1928. Wire, 17⅛ x 10½ x 10 in.*

OPPOSITE, BOTTOM *Calder.* Marion Greenwood, *1928. Wire, 12⅝ x 11⅛ x 11⅜ in. Photograph by Herbert Matter.*

of the earliest wire sculptures. In the next months and years, Calder's wire twists, turns, and trajectories became less abrupt. The work was increasingly sensuous—and caressable.

Only a few days after the Weyhe show closed, Calder exhibited two large mythological wire sculptures, *Spring* and *Romulus and Remus,* at the "Twelfth Annual Exhibition of the Society of Independent Artists," held at the Waldorf-Astoria. The unconventionality of Calder's wire medium was set in high relief by the size of these inventions—*Spring* was nearly eight feet tall, and *Romulus and Remus* was more than ten feet wide. *Spring,* light and fragile-seeming, sprang into life at the slightest touch of a hand; Calder was already seeing kinetic possibilities. In some brief newsreel footage that dates from this period, a wire sculpture of two acrobats shivers gently, quite obviously an effect Calder meant to provoke as the camera rolled. Calder created a bit of a sensation on Fifth Avenue when the Society of Independent Artists exhibition closed, on April Fools' Day. The *Times* reported that "women shoppers, messenger boys and other curious folks enjoyed very

much the spectacle until the owner trundled his companion"—that would have been *Romulus and Remus*—"into a taxi cab." Calder, readers were told, regarded his *Romulus and Remus* as a work of art. "I shouldn't have made her if I didn't," he was quoted as saying.[37]

When *Spring* and *Romulus and Remus* were taken out of storage after thirty-five years for a retrospective at the Guggenheim, Calder observed that "they had all the freshness of youth—of my youth."[38] Their allegorical themes must have had an urgency for Calder in the late 1920s, suggesting, as they did, glorious beginnings, the beginning of the season of growth and the beginning of a great empire. But even if he was starting to have something of a reputation as the man who worked with wire, Calder was not yet entirely convinced of the long-term possibilities of the medium, either artistically or financially.

VI

It was very much as a caricaturist working in wire that Calder made his initial appeal to the public. Around the time of the Weyhe show, Calder made wire portraits of both Erhard Weyhe and Carl Zigrosser. Weyhe, with his little mustache and high forehead, was the sober middle-aged man. Zigrosser, with his curly hair, wide fruit-slice-shaped smile, and pinpoint eyes seemed the perpetual child—in other words, a man who could see what Calder was up to. In the next months and years, Calder made heads of Frank Crowninshield, the editor of *Vanity Fair* and an impresario of the arts, of his

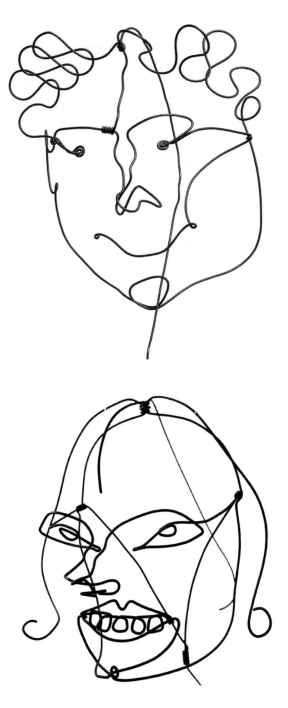

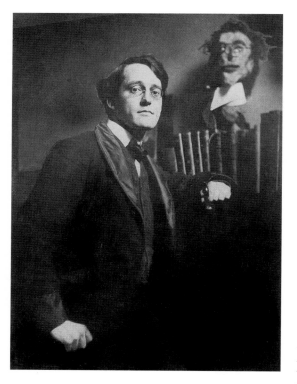

friends the painters John Graham and Fernand Léger, the composer Edgard Varèse, and Marion Greenwood, who, as I have observed, might have been romantically involved with Calder around this time. The wire portraits have some of the quality of masks, perhaps even comic masks. Such associations may not have been far from Calder's thoughts, given the thespian circles in which he and his family had moved. In a photograph of a youthful John Sloan, taken around the time he was good friends with Calder's father, there hovers in the background a sculpted head, probably a self-portrait, that may well be a mask or a theatrical prop and may be worth considering in relation to Calder's wire portraits. It's also not impossible that Calder had seen, or seen reproductions of, a portrait of Marcel Duchamp that Jean Crotti, an artist who for a time moved in avant-garde circles in New York, had made in 1915 out of wire, porcelain, and fabric.[39]

Calder had always had a flair for caricature and comedy. We've already seen how the quickening power of caricature shaped his work for *The National Police Gazette* and sharpened his sense of a world in constant motion. Now he was beginning to grasp some of the deepest powers of caricature. Caricature, while first and foremost a vehicle for comment and critique, had over the centuries doubled as a method of simplification and

intensification. Gian Lorenzo Bernini, whose genius as both a sculptor and an architect transformed seventeenth-century Rome, had virtually invented the idea of caricature, with his bracing sketches of the pope and the papal court. With a very few lines, Bernini defined a person and a personality. Bernini's summary line was a steadying force as he created the ebullient fountains, chapels, and altarpieces of Baroque Rome, a saving simplicity that informed even his most elaborate sculptural inventions. Two centuries later, the caricaturist's gift for concise visual rhetoric powered Daumier's art; the stylization of forms particularized the incendiary political cartoons while, paradoxically, idealizing the figures

in paintings of everyday life. By the later nineteenth and early twentieth centuries, in the art of Seurat and Brancusi, the spirit of caricature was more and more divorced from political or social assertion, now marshaled to transform ordinary physiognomies into hieratic or iconic images.

In James Joyce's *A Portrait of the Artist as a Young Man*, Stephen Dedalus is challenged by one of his teachers about the nature of beauty. "The object of the artist is the creation of the beautiful," he says. "What the beautiful is is another question."[40] In the early twentieth century, no creative spirit was unaware of Joyce's novel; Calder would later entitle one of his sculptures *Portrait of the Artist as a Young Man*. Certainly the nature of beauty was a question that was very much on Calder's mind in the late 1920s. He was beginning to see that the eloquence of caricature might precipitate a new kind of beauty. He could perceive something

like that happening in the paintings of Seurat. He had praised the *Bathers at Asnières* in a letter to his parents in 1926. And it's not beyond possibility that he saw Seurat's *Le Cirque*—in which comic figures became what Clive Bell would call significant forms—when it was exhibited at the Brummer Gallery in New York, early in 1926. Calder probably visited Brancusi's studio during his first year in Paris, where he could have observed the sculptor's studies of glamorous women, which suggest a purified form of caricature, with the quirks of personality granted an abstract inevitability. Writing years later of Calder's art, Sweeney recalled a conversation he'd had with Brancusi in which Brancusi had said, "To keep one's art young, one must imitate young animals. What do they do? They play."[41] To caricature was to play. And if you played it right, beauty was the result.

VII

It may have been Calder's frustration at his meager sales at the Weyhe Gallery that pushed him, in the months after the show, to turn from wire to the more conventionally salable medium of wood. Calder never believed there

Calder. Horse, *1928.*
Wood, 15½ x 34¾ x 8⅛ in.

was only one way to do things. In the next few years, he would do some works in bent metal sheeting, including an elephant, a bird, and a bull. And in keeping with his inclination never to foreclose an option, he would in 1930 in Paris make small works in plaster that were then cast in bronze; he would also return to experiments with cast forms in the 1940s.

Calder spent much of the summer of 1928 on a farm in Peekskill, New York—it belonged to Bill Drew's uncle—working in wood. José de Creeft, whom Calder had known in Paris, was carving directly in wood and stone. In New York, Calder also knew Chaim Gross, who advised him, when he asked where to buy wood, to go to Monteath's, an outfit in Brooklyn that sold tropical woods, among them rosewood, lignum vitae, and ebony; Calder, in turn, sent de Creeft there.[42] Calder's temporary move from wire to wood, whatever the practical considerations, surely also reflected a continuing unease about the ultimate authority of wire as a medium. He wasn't yet convinced that a wire sculpture could have a freestanding power. In any event, he saw no reason to foreclose other options. There was a directness about carving in wood that would always appeal to Calder. His father, in a memoir he wrote in 1939, related the growing interest in wood carving among younger sculptors to "the fashion for primitive methods," but went on to say that whether a sculptor modeled or carved the key was the same—

"mastery of form through knowledge and skill."[43]

Calder started carving with wood-carver's chisels, but he soon changed to carpenter's chisels because, as he recalled, "I could hit them harder."[44] He would almost always prefer tools produced for the skilled craftsman to those specifically designed for fine artists. This was in line with his more general desire to make the ordinary extraordinary. The subjects he chose for his wood sculpture were not very different from the subjects of the wire work, only the ethereal was now rejected in favor of the corporeal. A horse made of boxwood consists of interlocking elements, the front and back leg elements slotted into the elongated, horizontal element that runs from tail to head. For a number of animals and figures—*Nymph* is an example—he aimed to preserve the overall shape and character of the piece of wood with which he had begun. All the details are subsumed in a single form.

Calder may have imagined that Weyhe would have better luck with works in wood. That hope was at least partially fulfilled when Zigrosser managed to sell a carving of a cow for $350, from a show, primarily of the wood sculpture, he mounted the following February, after Calder was back in Paris. Nevertheless, Calder didn't feel that Zigrosser was really supporting his work. It would be more than a decade before Calder found that he and a dealer, in this case Curt Valentin, were pretty much on the same wavelength. After the second show at Weyhe closed, Calder wrote to his parents that Babe Hawes had been "quite disappointed in Zigrosser's indifferent manner toward the publicity that might be made."[45] Clearly Calder was, too.

In the fall of 1928, Calder sought a grant from the Guggenheim Foundation, which had begun operations in 1925. He was surely aware that his

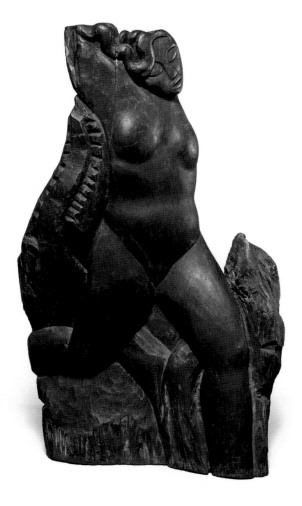

Calder. Nymph, *1928. Stained wood, 35¾ x 22¼ x 17½ in.*

friend Noguchi had received a grant from the foundation in 1927. He wrote in his application that he wanted "to invent the use of new and unusual materials and methods in sculpture." But he also worried that "the wire sculpture was 'ephemeral.'" Wanting to "search for something more lasting," he noted that he had "turned to wood-carving, and will probably have to work in all the recognized media before anything new presents itself."[46] One wonders if Calder's anxieties about wire were entirely sincere. Was he writing about a turn to wood carving because he'd been led to believe that this would appeal to the Guggenheim Foundation's relatively conservative jury? "I don't know about not being sufficiently academic for Guggenheim," he wrote to his parents, who may have raised that concern. He told Stirling and Nanette that he thought he had "a pretty fair chance," and speculated that what the foundation was mostly after was "drive and push." Whether he won the grant or not, he assured his parents that it wouldn't alter his plans. In the meanwhile, he wrote, "this rather faint possibility for receiving the scholarship is really quite amusing."[47]

Although Calder didn't receive a fellowship—and never applied again—the application is itself a fascination. The people Calder turned to for references were the artists he'd studied with a few years earlier at the Art Students League, which leads one to wonder if his teachers had in fact been a little less skeptical about his prospects than he'd sometimes made it appear. Sloan, writing to the foundation, confessed that he'd "known the applicant since his childhood." He said Calder's work "has always been remarkably original in concept and execution" and that "he has unquestioned talent genius even." Boardman Robinson praised Calder's "serious quest of new means of expression." And Samuel Chamberlain, the graphic artist Calder had known along with his wife, Narcissa, in New York and Paris—and who had already received a Guggenheim—explained, "I feel more certain about the experimental value of his project than about the high artistic standards of the work he might accomplish." He concluded that he "would look upon him as a gamble, and a rather good one." That was perhaps not the best way to recommend somebody for a grant. Then again, Sam Chamberlain may already have sensed Calder's (and Nanette's) skepticism about his own nit-picking graphic style.[48]

The chief fascination of Calder's Guggenheim application is the letter of reference written by his father. One wonders how often in the long history of the Guggenheim Foundation a father has actually recommended a son! A. Stirling Calder began by explaining that Alexander Calder was his son, and that after having "qualified and practiced as Engineer for several years, he has succumbed to the inevitable hereditary attraction, and to the art of

his Grandfather and myself." Stirling praised the range of what his son had already accomplished, noting that it covered "a wide field in study and production, in design, painting and carving." He felt that Calder's "form, while still crude, has massive sculpture quality, and his design is adventurous, and comprehensive." Stirling was beginning to see that Sandy's earlier training in engineering, far from having turned out to be a waste of time, was supporting his experiments, pushing him forward. "The breadth of science," Stirling wrote, "is being fused with the technique of line and form, and when fully assimilated will result in works of vigor and originality." The year was 1928. Most, if not all, of Stirling's greatest triumphs were behind him. And here he was, carefully but quite openly saluting his son's rising powers.[49]

CHAPTER 14

RUE CELS

I

Returning to France in October 1928, Calder decided to treat himself to what he regarded as "the luxury of taking the *De Grasse* of the French Line."[1] He was beginning the transatlantic pattern that would persist throughout his life, moving back and forth between the United States and France on boats of varying degrees of comfort and, later, on planes, and finding himself at home in both countries. In his crisscrossing of the Atlantic, he was very much a man of his day. The novelist John Dos Passos recalled of those years in his autobiography, *The Best Times*, "I lost track of the number of times

Calder working on a wire portrait of Kiki in the Pathé Cinema film Montparnasse—Where the Muses Hold Sway, *Paris, 1929.*

I crossed the Atlantic. I'd go steerage, second class, first class, according to the state of my bank account. Young women I met at cocktail parties liked to tell me I was running away from myself. . . . I was running toward something too. It was the whole wide world."[2] That must have been exactly how Calder felt.

On the *De Grasse*, Calder got to know the pianist Robert Casadesus and his daughter. Calder wrote to his parents about spending time with the musician, who was only a year younger than Calder and had already collaborated with Ravel, producing piano rolls of the composer's works.[3] Back in Paris, Calder was in many respects a changed man, his habitual boisterous confidence now steadier, at last grounded in what he recognized as some measure of achievement and recognition. In place of his room in the little hotel on the rue Daguerre, he rented a more generous space as a home and studio, in a courtyard on the rue Cels, which he later described as "rather nice, a square room with a Godin stove and walls sort of cobalt blue two-thirds of the way up and white above that."[4] The studio was owned by a friend of Calder's, Rupert Fordham, a young man from back home with considerable means who skied and boated and with whom Calder went off on adventures from time to time.[5] Calder was still in the same Montparnasse neighborhood where he had first alighted two years earlier, and over the years during which he lived on and off in Paris, he would never wander very far. One wonders if he ever took a turn around the Montparnasse Cemetery—the briefest of walks from his home—to the tomb of Baudelaire, whose great essay, "The Painter of Modern Life," had sounded so many of the themes that Calder was now echoing and enriching as he established himself in America and Europe as the Wire Sculptor of Modern Life. In the next few years, the French would begin referring to Calder as *le roi du fil de fer*—the wire king.[6]

During the little more than half a year of this sojourn in Paris, Calder plunged deep into a round of parties and studio visits, the nights of work or play sometimes extending so far that they didn't end until the next day had well begun. In his ground-floor studio on the rue Cels, he would open the window at night, and he recalled that "the postman would stick his head through in the morning and marvel at my endurance."[7] To his family he wrote about the carousing during Christmas week, when a group of friends danced all night and ended up at Les Halles at seven or eight in the morning for the market's famous onion soup. Then they slept for much of the day, after which they were at it again, with a "swell tea party + dance" on the Île Saint-Louis, with Calder supplying the music and some American friends the punch.[8] The party on the Île Saint-Louis—on the Quai de Bourbon—was

organized by two friends, Pat Morgan and Whitney Cromwell. Morgan was a painter. After returning to the United States, he became a much admired teacher at Andover, the elite boarding school, where he was involved with important exhibitions of work by Calder, Hans Hofmann, and others, and mentored a number of students who went on to successful careers, including the painter Frank Stella. For the party on the Quai de Bourbon, Calder made what he called an "Immaculate Conception Machine." "When you put a small coin on a tray it counterweighted a pan with a pink paper enfant, which was delivered by the turning of a crank." At that party there were four women wearing red, which in retrospect Calder thought might have been "when I decided for red," a red shirt becoming, in later years, his sartorial trademark.[9] He was far from being the only denizen of Montparnasse who regarded clothes as costumes, a part of the invention of a personality. The freedom of bohemian life in Paris in those years is no myth.[10]

Writing letters back to his parents in the last months of 1928 and into 1929, Calder no longer found himself apologizing for long gaps in the correspondence, because there was little to report. There was a lift to his spirits, an almost aggressive thrust to his descriptions of his plotting and planning and his increasingly frequent successes. "To begin with I am hot on the trail of a galerie—the kind I want—(in fact the director is coming to see me tomorrow)," he wrote in the last days of 1928. He spoke of the importance of an exhibition's being accompanied by "an effective advertising campaign."[11] It may be around this time that he had some interaction with Madame Zak and her Galerie Zak, which, he wrote his parents, was opposite the Church of Saint-Germain-des-Prés. He exhibited *Romulus and Remus* and *Spring* at the Salon des Indépendants in January, and one critic wrote, "At first I thought that some electricians had forgotten their electrical wire in the room."[12] Calder explained to his parents that "they were a grand success, but I wish someone had bought them, for they are the dickens to house."[13] At least one of them, *Romulus and Remus,* ended up suspended from the ceiling of his studio, a premonition of hanging sculpture to come.

Early in 1929, Calder described a ski trip to Megève, which he enjoyed, as he always enjoyed skiing, while finding some of the company dull and feeling eager to get back to Paris. "To begin with," he wrote to his parents, "I am going strong after exhibitions in London and in Berlin. And if they come off I will go to each place in turn."[14] As it turned out, the London exhibit did not become a reality and Calder would have to wait another eight years before showing his sculpture there. By April, he was writing that he was short of money and wondered if his parents could lend him $200 until the fall, adding, "It's quite an amusing life and I think I am really enjoying it."

At the end of a long letter, he reiterated that he'd "been stepping out quite a bit lately and find life quite gay."[15]

II

It was during these months that Calder became friends with the painter Joan Miró. He was five years older than Calder, had been in Paris since the beginning of the 1920s, and had already built a considerable reputation, with dreamscapes that somehow managed to be simultaneously witty and implacable. Together on the streets of Paris, Calder and Miró must have made an odd picture. The rumpled Sandy, with eyes variously described as hazel or blue and hair hardly ever combed, was a full head taller than the neat, darker-eyed Spaniard. Calder's older daughter, Sandra, who shared a birthday with Miró and in New York in 1947 exchanged a drawing of hers for a drawing of his, had occasion to watch them over several decades. They were very different people. "My father was always outgoing and very noisy," she commented, "whereas Miró was contained and quiet."[16] She also observed that "Miró was always a bit surprised by my father—by his behavior."[17] In 1961, when the Perls Galleries in New York celebrated what was then a friendship of more than thirty years, Miró saluted "this burly man with the soul of a nightingale."[18] Calder and Miró must have enjoyed their differences, a case of opposites attracting. The Yankee and the Catalonian were united in their passion for Paris, for artistic experimentation, and for the play of the independent imagination. They were lifelong friends. Miró was one of the first people Calder's wife, Louisa, wrote to after Calder's death in 1976. Miró lived to a ripe old age, dying seven years later, on Christmas 1983, at ninety. The families have remained close down to the present.

Miró had made his first trip to Paris from Spain in March 1919, when Calder was just finishing his studies at Stevens. He received a generous welcome from Picasso, his fellow Spaniard, who responded to the preternatural lucidity of the still lifes, portraits, and landscapes Miró painted early in the 1920s. By 1924, Miró found himself associated, however reluctantly, with the group of artists and writers who were banding together under the banner of Surrealism. André Breton, the poet by turns revered and excoriated as the determined and, to some, overly doctrinaire ringleader of the movement, called Miró "the most 'Surrealist' of us all." He praised Miró's pristine compositions, with their comically stylized men, women, and beasts set in equally curious landscapes and skyscapes, "as an important step in the development of Surrealist art"—an art that aimed to reveal the contours of the

Calder and Miró at the opening of the Calder retrospective at the Fondation Maeght in Saint-Paul-de-Vence in 1969.

irrational and the unconscious.[19] When Calder was first getting to know Miró, he had already produced some of the most stripped-down compositions any artist has ever done. These included a work dedicated to the Fratellini brothers, with a few lines and shapes suggesting the virtually transparent head of a clown. Did Calder know this work of Miró's? Did Calder and Miró speak about the Fratellini brothers or more generally about the circus?

It was Babe Hawes who had suggested that Calder look up Miró when he was back in Paris. He wrote to Miró early in December, not long after he was settled on the rue Cels, and in the months before Calder's return to New York in June 1929 their great friendship began. Gymnastics and, especially, boxing were interests of Miró's; he had already tried his hand at boxing with Ernest Hemingway at the American Club, though he recalled that "it was pretty funny: I came up to his bellybutton. There was a real ring, and on benches all around it a whole lot of pederasts. I did not go on with it. But I also tried indoor gymnastics and I did continue that."[20] Calder and Miró paid some visits to a gym on the rue de Richelieu. They didn't so much box as learn, Calder recollected, "to inhale and exhale with gym movements," producing in the process whistling sounds, after which they went out to dinner together.[21] Boxing and gymnastics were fashionable among the Parisian avant-garde. The Dadaists had made a cult of the boxer Arthur Craven. Hemingway had had a match at the American Club with the Canadian writer Morley Callaghan, refereed by F. Scott Fitzgerald, which Callaghan wrote about in his memoir *That Summer in Paris*. And of course Calder had created a wire sculpture, *Struttin' His Stuff*, which probably represented the African-American bantamweight boxer Panama Al Brown, who would become for a time a figure in Parisian café society under the auspices of Cocteau.

In his *Autobiography*, Calder confessed that he was "nonplussed" by the first work of Miró's he saw in his studio, but that doesn't mean that he was uninterested. A great artistic sympathy can begin with hesitation and uncertainty; that was certainly the case here. The work of Miró's that Calder recalled seeing first was "a big sheet of heavy gray cardboard with a feather, a cork, and a picture postcard glued to it. There were probably a few dotted

lines, but I have forgotten." Calder explained that this "did not look like art to me."[22] He was probably remembering a work of Miró's in a series entitled *Spanish Dancer,* one of which contains a cork and a feather; the postcard he may have been recalling from a somewhat later series of collages. The various works that Miró made in 1928 and titled *Spanish Dancer* are indeed radically simplified; any one of them would have made Calder's *Josephine Baker* look positively old-fashioned. Perhaps Calder, in saying that he felt nonplussed, was describing a moment of self-questioning, when he was taking a deep breath and trying to account for his discomfort. There is reason to believe that Calder had gotten to know Miró before he saw his work.[23] If that is the case, then his warm feelings about the man may have left him feeling initially nonplussed about the cool-as-can-be reductio ad absurdum that was Miró's *Spanish Dancer.* Jean Cocteau beautifully described the mysterious drama of Miró's stripped-down calligraphy when he wrote, around this time, that Miró "only has to draw a cross in order to crucify."[24] Perhaps what first fascinated Calder about Miró was that a man with a mild manner could have such a wild imagination.

III

Although in later years Calder tended to give the impression that when he met Miró, he was still unaware of the Dadaist and Surrealist movements, it's

Joan Miró. Painting (The Fratellini Brothers), *1927.*

a little hard to imagine that he didn't know that his new friend was a hero of the avant-garde, already celebrated for his pristine visualizations of the absurd, the irrational, and the unconscious. The Surrealists argued—so the English poet David Gascoyne wrote in *A Short Survey of Surrealism,* published in 1935—that "man's imagination should be free, yet everywhere it is in chains."[25] In the *First Surrealist Manifesto,* published in 1924, André Breton had defined Surrealism as "pure psychic automatism, by which it is intended to express, verbally, in writing, or by other means, the real process of thought. Thought's dictation, in the absence of all control exercised by the reason and outside all aesthetic or moral preoccupations." Breton went on to say that "Surrealism rests in the belief in the superior reality of certain forms of association neglected heretofore; in the omnipotence of the dream and in the disinterested play of thought."[26] What wasn't always so clear was how an artist or a writer was going to break the chains of reason that imprisoned the imagination—while still managing to shape and control a unique artistic vision.

For Calder, who had been marching to his own drummer for as long as he could remember, there has to have been something sympathetic about the Surrealists' belief in the freedom of the imagination. But Calder was far too levelheaded to ever lend himself to anything as amorphous as "pure psychic automatism." Precisely because Calder wanted to keep his own counsel without entirely ignoring the counsel of others, he found something immensely appealing about his friend Miró's ability to operate at an angle to the Surrealists. Miró managed to maintain his imperturbable composure in the face of what often seemed to be Breton's dogmatic insistence that Surrealism could be only what Breton believed it to be. Right around the time Calder and Miró were getting to know each other, Miró wrote a letter to René Gaffé, a Belgian businessman and journalist who had just bought one of his fantastical reimaginings of a seventeenth-century Dutch genre scene. Miró emphatically set himself apart from his Surrealist friends and their ringleader, referring to them as "those more or less intelligent gentlemen who brainwash us with their more or less imbecilic absurdities." As for himself, Miró said he was an artist who had to act alone, engaged in "a *struggle,* a *human* struggle,"

which involved doing "somersaults and acrobatics on a tightrope," and "not at all in a gratuitous way."[27] Calder, a great student of acrobatics and tightropes, would have known exactly what Miró was driving at.

That insistence on maintaining one's artistic individuality was the glue that bound Calder and Miró together for close to half a century. This was serious business. At the time when Calder was first coming into contact with the Surrealists, the movement was coming apart at the seams, with a good many artists and writers refusing to accept what they saw as the authoritarian leadership of Breton. Some called him the "pope of Surrealism." The painter André Masson, a friend of Miró's with whom Calder would become close in America during World War II, wrote that he and his friends weren't attracted to Surrealism as a coherent ideology but, rather, to "long-buried worlds of the outlandish or anything jarring or discordant," an attraction to

Joan Miró. Spanish Dancer, *1928. This is one of a number of works on the* Spanish Dancer *theme that Miró made at the time. None of them—at least none that exists today— precisely matches Calder's description.*

what was "marginal" or "disapproved of"—what was "against the grain." Calder might have agreed. The poet Robert Desnos, the other member of this dissident group with whom Calder was friends in 1928, had, unlike Miró, originally eagerly bowed to Breton's will. But Desnos was now on the verge of participating in the great schism. In March 1930, he wrote in what he called the *Third Manifesto of Surrealism* that Breton had turned Surrealism into a religion, "the best auxiliary for a renaissance of Catholicism and clericalism."[28] *Documents,* the magazine edited by Georges Bataille—another renegade within the movement and a friend of both Miró's and Masson's— became the literary sounding board for this apostasy against the apostasy that was Surrealism. They were, Masson would write, preparing for "a dissident future."[29] "In his early days in France," James Johnson Sweeney noted a few years later of Miró, "he frequently exhibited with Surrealists, but the individuality of his talent soon led him to a formal severance from all groups."[30] If there was ever a movement that Calder, never a joiner, was willing to join, it was the movement to sever oneself from all groups, in which Miró was a prime mover.

Calder and Miró were joined in their love of the odd, the unexpected, the unconventional. If Miró had drawn inspiration from Antoni Gaudí's blissfully idiosyncratic Art Nouveau architecture, that treasure trove of his

Calder. Aquarium, *1929.*
Wire, 16 x 19 x 11 in.

beloved Barcelona, likewise Calder had never forgotten the elegant curves and spirals of the Arts and Crafts movement, which he had encountered as a boy in Pasadena. He invoked those homegrown rococo caprices in 1929 in works such as *Aquarium* and *Goldfish Bowl,* concoctions as confidently fantastical as anything in Miró. Over the years, a great deal has been written about the impact of Miró's work on Calder's work in the 1930s. But it would be more useful to speak about a commonality of interests, which drew both of them to the pioneering abstractions done by a slightly earlier generation of artists, especially Kandinsky, Klee, and Arp. The critic Giovanni Carandente, who was friends with both Calder and Miró, believed that "their agreement on the need for organic modes of vision as expressed through abstract, biomorphic forms deepened and strengthened their friendship." He went on to argue that "very few traces of Miro's Surrealist abstraction can actually be found in Calder's sculptures and paintings." Calder's work, Carandente concluded, always embodied "a sculptor's way of seeing."[31] It is also worth noting that decades after they first met, Miró made a comment that suggests that Calder's initial bemusement with the Spaniard's work was mirrored by Miró's own bemusement with Calder's. "When I first saw Calder's art very

long ago I thought it was good, but not art. It *is* art."[32]

IV

The work Calder was now producing and exhibiting had a fresh, urgent purity—"a sculptor's way of seeing." Probably early in 1929, Calder wrote to his parents, "I think that the things I did recently, in wire were much much more sculptural than most of those things shown last year at Weyhes."[33] That word "sculptural," with its suggestion of abstract qualities, demands close consideration. In the wire work from 1929 or thereabouts there is a new kind of pressure in the shaping of space, the wire line not a calligraphic gesture

Calder. Le Lanceur de poids, *1929. Wire, 32 x 28¾ x 5 in.*

but an enveloping force—shaping the air, you might say. In *Le Lanceur de poids* the athlete becomes something of a cipher, an abstract emblem, with a head that is merely a blocky outline and all the sculpture's considerable impact centered on the reach of the arm, the tiny waist, and the shot-putter's strong legs. Here Calder reduces everything to a singular statement, as if the single-mindedness of the image were echoing the single-mindedness of the athlete. Something Joyce wrote in *A Portrait of the Artist as a Young Man* is relevant: "The esthetic image is first luminously apprehended as self-bounded and selfcontained upon the immeasurable background of space or time which is not it. You apprehend it as *one* thing. You see it as one whole. You apprehend its wholeness. This is *integritas*."[34]

There's a silken sophistication about Calder's maneuvers with the wire in *The Brass Family* and assorted studies of acrobatic duos. *The Brass Family*, with six figures balanced on the strongman's gigantic arms and shoulders, has often been compared to the pile of figures atop Stirling's *Fountain of Energy* at the Panama-Pacific International Exposition; Calder would later speak of the element of fantasy in those large public works as the finest of his father's achievements. But what holds us in *The Brass Family* isn't so much the overall composition as Calder's preternatural control of the brass

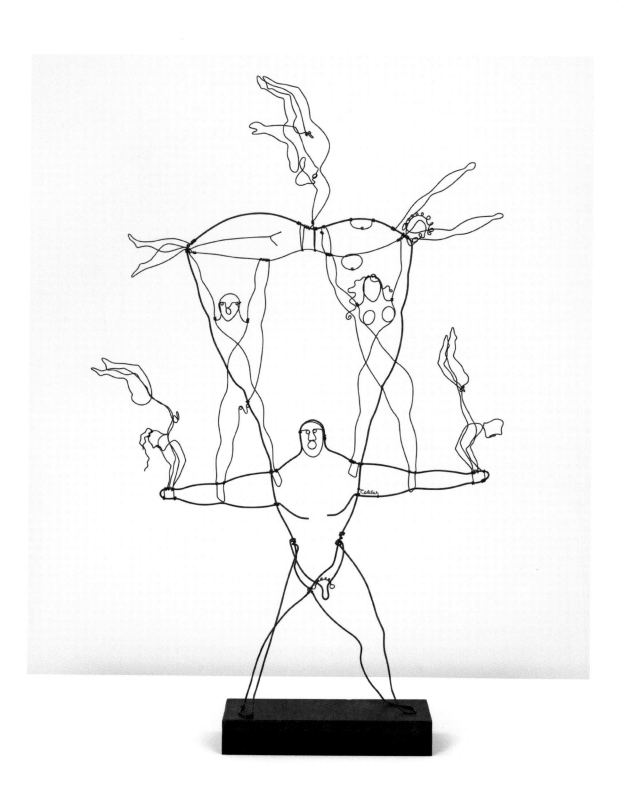

wire. We sense the movements of his hands as he manipulates the Bernard pliers to yield miracles large and small—to give the pieces of brass wire a familial relationship and bring *The Brass Family* to life. The rigor and suppleness of his technique suggest the proverbial iron fist hidden in the velvet glove. The arcs of wire, tightening and loosening their pressure, describe not only volume and void but also, perhaps most importantly, the movements of volumes through space. When we look at *The Brass Family*, we see not only the acrobats' pyrotechnics but Calder's pyrotechnics as well. Calder's twistings and knottings of brass wire contain infinities. He brings to the tiniest twist or knot of wire the exhilaration that a great keyboard artist brings to Scarlatti's trills.[35]

Hunt Diederich. Fighting Cocks Fire Screen, *c. 1925*.

In the 1920s, a number of highly skilled artists were producing decorative objects in metal. Calder was surely aware of the work of Hunt Diederich, who had exhibited with his father and whose fire screens incorporating sensuous animal forms were much admired at the time. My guess is that Calder wasn't immune to the charms of Diederich's work. Many years later, a journalist wrote of *Horse* (1928), a sheet metal sculpture he saw in Calder's Roxbury home, that it had been "much influenced by . . . Diederich"—a mention that was almost certainly based on something that Calder had said.[36] Diederich often attached pieces of metals with rivets rather than welded seams, a technique that would have interested Calder. But Diederich was a decorative artist—his objects were intended for sleek Art Deco interiors—and Calder wanted his work to have a different kind of impact, a freestanding artistic value. Calder had a problem. He was determined to reject not only the decorative assumptions of the Art Deco metalworkers but also the trappings of classical sculpture, which his father had embraced. So far so good. But then how exactly was he going to give his work a freestanding artistic value? This was the predicament in which Calder found himself in the winter of 1928–29, when it began to dawn on him that wire was a medium with a much greater artistic potential than he had imagined even after Clay Spohn had urged him to work exclusively in wire.

Calder was beginning to produce three-dimensional works in wire that rejected the traditional gravitas of sculpture but achieved their own kind of emotional gravitas. His old Art Students League buddy had been right.

OPPOSITE *Calder*. The Brass Family, *1929. Wire and wood, 67 x 41⅛ x 8⅛ in.*

In a statement prepared for a French magazine, Calder confessed that six or eight months earlier, "I did not consider [wire sculpture] to be of any signal importance in the world of art; merely a very amusing stunt cleverly executed." He went on to say that he felt a show had been justified in Paris, where "'clever stunts' are highly appreciated." But Calder's new studies in wire—so he explained, almost to his own surprise—"did not remain the simple modest things I had done in New York. They are still simple, more simple than before; and therein lies the great possibilities which I have only recently come to feel in the wire medium. Before, the wire studies were subjective, portraits, caricatures, stylized representations of beasts and humans. But these recent things have been viewed from a more objective angle."[37] He also made a connection with the overlapping of forms in Futurism, although before we associate his work too closely with that of Giacomo Balla or Umberto Boccioni it's good to remember that in the early twentieth century, the word *Futurism* was often used to suggest modernism more generally—and so could include Cubism and any number of other movements.

What may be especially telling in Calder's statement is the emphasis on objectivity. I assume that Calder was aware of a German movement that was widely discussed at the time, the Neue Sachlichkeit, or New Objectivity. Among its leaders, as it happens, were a couple of artists known for their gifts as caricaturists, namely Otto Dix and George Grosz. And among the books still to be found in the Calder house in Roxbury are a couple of Otto Dix catalogs from the mid-1920s. The Neue Sachlichkeit—a movement that included photographers as well as painters and graphic artists—sought to combat the excesses of Expressionism with a new emphasis on clarity, sobriety, and severity. Those were certainly the values Calder was going to be pursuing in the next few years.

V

One wonders if Miró saw Calder's first one-man show in Paris, at the Galerie Billiet–Pierre Vorms, on the fashionable rue La Boétie on the Right Bank. It was up in February, even as the second Weyhe show was on in New York. Calder's friend Bill Rogers would later write—perhaps echoing something Calder had said, with a note of triumph in his voice—that "for four days at the age of thirty he was exhibiting in New York and Paris simultaneously."[38] The Billiet show, including works in both wire and wood, was one that Calder paid for. That hadn't been the arrangement he'd hoped for, but as he told his mother, he sold six works, "4 to two Englishmen—who prom-

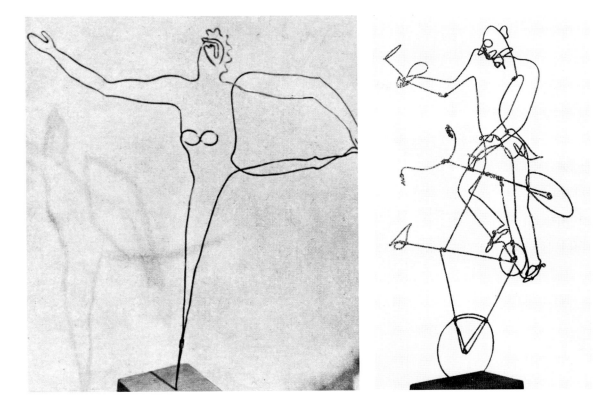

ABOVE, LEFT *Calder,
Untitled, c. 1928. Wire and
wood.*

ABOVE, RIGHT *Calder,
L'équilibriste, c. 1928.
Wire and wood.*

ised to lend me the things should I have a show in London, and the other two to Georges Bernheim (Paris dealer), for his own personal use."³⁹ Although we don't know all of what was in the exhibition, it was clear that Calder was still moving beyond the spirit of popular caricature that had shaped his impressions of Calvin Coolidge and John D. Rockefeller. A wire study of a dancer with one leg raised, reproduced on the announcement for the show, is bracingly abrupt in its distillation of complex movement, a leg turned into a narrow, precipitous V shape that resolves not into a pointed foot but a point, pure and simple. In a work entitled *L'équilibriste,* with a man balanced atop a bicycle poised on its back wheel, both the snaky figure of the rider and the geometric play of circles and triangles are shot through with Calder's carnivalesque spirit. There are places (and spaces) in these wire sculptures where we can see that Calder was well on his way to becoming an abstract artist.

Among the artists who attended the opening of the Galerie Billiet exhibition was the American painter Stuart Davis, who had been in Paris for some months, working on a series of boisterous, beguiling impressions of the city's streets. Davis was, like Calder, a friend of John Graham's. They had surely crossed paths on both sides of the Atlantic; seven years later, Calder

Jules Pascin. Visite chez Mr. Calder fils, *c. 1928.*

would become a member of the anti-fascist American Artists' Congress, of which Davis was secretary. Writing to his mother on the stationery of the Café du Dôme on the afternoon of the opening of Calder's exhibition, Davis commented, "Nobody is much interested in his work but it is an excuse for a lot of people to bump into each other. There's no use talking. Paris is the place for artists. Here an artist is accepted as a respectable member of the community whether he is good or bad."[40] Which is not to say that Davis necessarily thought Calder's work was bad. Calder's reputation, however, remained uncertain, unsettled. It would be a year or more before the Parisian public embraced Alexander Calder as more than a comedian. Considering

that Calder himself was only beginning to grasp the implications of his work with wire, the rest of the world could be forgiven for still regarding him as a lightweight when they regarded him at all.

The Galerie Billiet exhibition was accompanied by the briefest and breeziest of catalog essays, composed by the painter Jules Pascin. Pascin, whom we've already encountered in Hemingway's memoirs, was famous for his gently brushed, erotically charged studies of the female nude. Calder had met Pascin at the Dôme, through Yasuo Kuniyoshi, a painter also known for sweet portrayals of the female form (although Kuniyoshi's were more sharply focused than Pascin's). Of Kuniyoshi, Calder later remarked that he had "never liked him particularly."[41] Pascin had shown drawings at the Weyhe Gallery just before Calder's work was there. He also happened to be an old friend of Stirling's. In his unabashedly flippant introduction, jotted down on a piece of stationery at La Coupole, another one of the Montparnasse gathering places, he observed that Stirling was "the handsomest man" in their group of American artists and expressed some disappointment with the son, at least in the looks department. "Returning to Paris, I met his son SANDY CALDER, who at first sight left me quite disillusioned. He is less handsome than his Dad! Honestly!!!" After which Pascin proceeded to give the son the nod. "But in the presence of his works, I know that he will soon make his mark; and that despite his appearance, he will exhibit with spectacular success alongside his Dad and other great artists like me, PASCIN, who's talking to you . . . !"[42] Pascin's introduction, as Calder explained to his parents, was useful precisely because it was so unlike the usual prefaces, "rather lengthy treatises in a serious manner." Although Pascin had done it "facetiously . . . it was quite a success for it stood out so signally from others."[43] In any event, it was what Calder was able to elicit at the time. He was still depending on his father's cohort for support, much as he had when he applied to the Guggenheim Foundation.

Pascin did an affectionate drawing of Calder's studio, with a clutch of dignitaries surveying the scene, and Calder's works rendered in a mock Calderesque line. One night on the rue Cels, when some fifty people had shown up for what turned out to be a riotous party, many apparently invited by Pascin, Calder did a performance with a sort of marionette, fifteen inches high, made of wood, metal, and bits of chiffon. As Calder remembered, "Pascin tore up pieces of paper and made very amusing and indecent *ombres chinoises* of a man following my lady."[44] This mention, in Calder's *Autobiography*, of *ombres chinoises*—or Chinese shadows—cannot be ignored. The Chinese shadow puppets had been one of the chief attractions of Le Chat Noir and other late-nineteenth-century Parisian cabarets; such performances also took

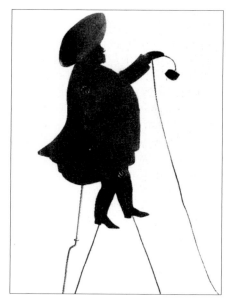

Eliseu Meifrèn. Shadow puppet, cutout black card and metal, c. 1900. This puppet was used in performances at Els Quatre Gats, the café in Barcelona that Picasso frequented as a young man.

place at Els Quatre Gats, the café in Barcelona that Picasso frequented in the years around 1900. Could it be that Calder saw in Pascin a survival of the Europe of the fin de siècle? Did Calder associate Pascin's shadow-puppet improvisations with the shadow plays that had influenced the complex, silhouetted forms in the work of Toulouse-Lautrec, Degas, Bonnard, and Vuillard? And were those silhouettes, in turn, an influence on the mobiles Calder began making a few years later, with dramatically shaped black forms transformed as they became shadows on the surrounding walls?

VI

All of Calder's new strengths were on display in an exhibition, less than two months after the Paris show closed, at the Galerie Neumann-Nierendorf in Berlin, another city at the forefront of the avant-garde. The exhibition was quite large, containing forty-eight works, mostly in wire, with an emphasis on the increasingly broad effects Calder was achieving in his portrayals of animals, nudes, dancers, acrobats, and other athletes. In one group, a standing male figure, a planar wire drawing thrust definitively into the third dimension, was juxtaposed with a reclining woman who might have been mistaken for a wire drawing inscribed on the horizontal surface, save for an elbow, a knee, and a foot that pushed away from the floor. To his parents, Calder wrote that the show was "an absolute journalistic success, for I have had wads + wads of clippings, and most people in Paris, even, seem to know I had a show in Berlin."[45] Calder later recalled that his association with the Galerie Neumann-Nierendorf had been triggered by an encounter with a photographer he met in Paris, Sasha Stone, who thought that the artist whom the French were getting around to referring to as *le roi du fil de fer* ought to be known in Germany. Stone, from a Russian Jewish family, was a significant figure in photographic circles in France and Germany at the time. He produced what has become a famous photomontage cover for Walter Benjamin's memoir *One Way Street*, and was quoted in Benjamin's 1931 essay "Little History of Photography," observing that "photograph-as-art is a very dangerous field."[46] He died in 1940 in Perpignan, one of a group trying to make their way out of Nazi-occupied France and to freedom in the Americas.[47]

It was in Berlin that Calder received his first review by a critic with a significant place in the modern movement. This was Adolf Behne, who in

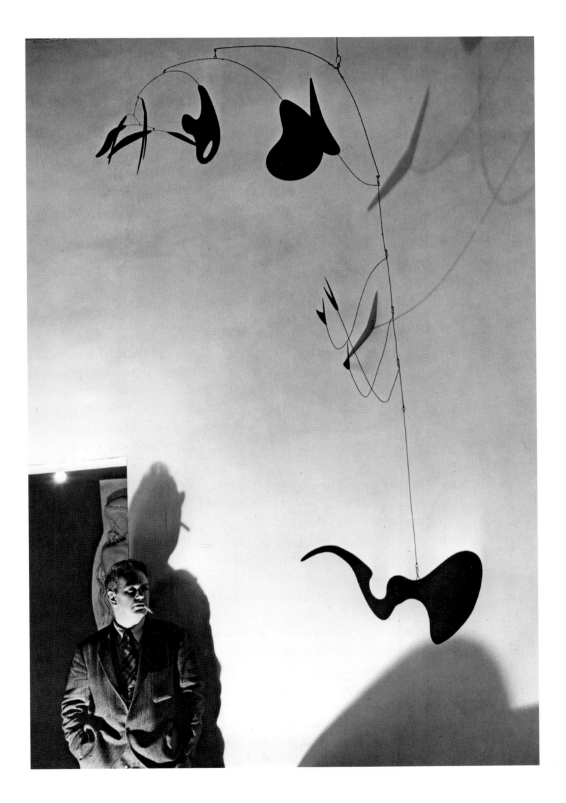

27 Elefant	38 Lebensretter	
28 Leopard	39 Trapezkünstler	
29 Regen	40 Baker, Jos. (klein)	
30 Hund	41 Maske	Weißblech
31 Ente	42 Pelikan	Holz
32 Hund	43 Mädchen	Holz
33 Ente	44 Katze	Holz
34 Hase	45 3 Akrobaten	Holz
35 Tänzerin	46 Frau	Holz
36 Spidi	47 Frau mit Regenschirm	Holz
37 Composition	48 Elefant	Holz

GALERIE NEUMANN-NIERENDORF
BERLIN W35 LÜTZOWSTR. 32

AUSSTELLUNG
ALEXANDER CALDER
SKULPTUREN AUS HOLZ UND AUS DRAHT

Photo Sasha Stone

DRUCK VON H.S. HERMANN G.M.B.H. BERLIN SW 19

Cover of the catalog of Calder's exhibition at the Galerie Neumann-Nierendorf in Berlin in 1929; the photographs are by Calder's friend Sasha Stone.

1918, along with Bruno Taut and Walter Gropius, had begun the Workers' Council for Art, a forerunner of the Bauhaus. Behne's review is among the most important early discussions—if not the most important early discussion—of Calder's works. Sasha Stone that very year produced a book of photographs of Berlin with a text by Behne, *Berlin in Bildern,* so it may be that Stone provoked Behne's interest in Calder. Behne begins by observing that Calder's work comes "not from the America of skyscrapers and billionaire kitsch" but from the America of Mark Twain and Buster Keaton. He speculates that Calder might be "the first humorist of sculpture," and goes on to comment on Calder's rejection of "what has been regarded as the alpha and omega of all sculpture since Thutmose in Egypt: mass, corporeality." Set up in the Galerie Neumann-Nierendorf, Calder's sculpture moved gently, "bobbing, springing, vibrating like soundlessly working circus performers." Behne argues that the heart of Calder's wit "is in the method, in the joyful dismantling of Michelangelo, in the (downright usurious) exploitation of air, in the bold abbreviation of the process that knows how to precisely form

space with the hint of a few pressure points. Sculpture has become . . . an aerial act." Behne relates Calder's works to the experiments of the Russian Constructivists. But he also sees what would for many observers become the key to Calder's genius—namely, his way of turning the impersonalization and mechanization of modern life into a new form of enchantment. "The conveyor belt, rationalization, the conquest of the air . . . here they are naively detoxified, humanly meaningful, have become art."[48]

On the last day of his visit to Germany, Dr. Cürlis, whose thoughts about the power of the artists' hands we have already encountered, filmed Calder as he made a wire sculpture. It must have been around the same time, if not on the very same day, that Calder made a wire portrait of the smiling, whimsically bespectacled man. Dr. Cürlis was filming a considerable number of artists at work, including Lovis Corinth, Käthe Kollwitz, Max Pechstein, George Grosz, and Georg Kolbe. He produced two or more films in the cycle *Creative Hands*, under the auspices of the Institute for Cultural Research in Berlin. This wasn't the first and certainly wouldn't be the last film to focus on Calder's working methods. Calder surely realized that film was a medium perfectly suited to catch the kinetic possibilities of his wire sculptures, which were already designed to delicately shiver and shake when they were touched. It isn't clear whether Calder was as yet aware of the avant-garde filmmakers who were experimenting with movement that was divorced from any narrative or documentary function. Calder would soon be friends with Fernand Léger, the painter who had considered becoming a filmmaker and whose short abstract film, *Ballet mécanique*, done in 1924, pursued ideas about kinetic experience that were paralleled and echoed in Calder's work of the early 1930s. Marcel Duchamp, Man Ray, and others were taking up related cinematic directions. Film was yet another theatrical discipline with which Calder would be involved, if only tangentially, in the coming years.

One memorable theatrical production that Calder encountered during his time in Berlin was *The Threepenny Opera*, which had opened the previous August and to which he was taken by Karl Nierendorf. This sensational collaboration between Bertolt Brecht and Kurt Weill, based on John Gay's eighteenth-century opera, brought a rough-textured, dark-toned lyricism to the underbelly of modern life, embracing the popular and the quotidian in ways that could not have failed to appeal to the inventor of the *Cirque Calder*. Thirty-five years later, Calder saluted *The Threepenny Opera* as "a great experience. I still remember Mackie Messer, in evening dress with white gloves, in a cage of chicken wire with his back to the audience. All of a sudden he pranced around, spread out his arms, and yelled."[49]

VII

In the months he lived on the rue Cels, from late in 1928 until his return to New York in June 1929, Calder was playing catch-up with the modern movement in his own inimitably sly, laconic way. If years later, remembering his beginnings, he sometimes failed to mention artists, works of art, or ideas that if not staring him in the face had certainly been very much in the air, it may have been because he had never entirely known what pushed him in a particular direction. The modern movement was everywhere, with innumerable signposts pointing the way to an utterly original vision.

What were the origins of Calder's originality? We know that nothing was more important to him in the early months of 1929 than his embrace of an invigorating simplicity, the realization that wire sculpture could go well beyond what he himself had referred to as "clever stunts." But the origins of Calder's simplicity aren't so simple. Artistic inspiration involves instincts, apprehensions, and revelations ranging from the subliminal to the nearly spiritual, and the zigzagging, even ricocheting connections need to be mapped in ways that defy strict rules of evidence. Let's begin with André Gide, whom so far as we know Calder never met. In a series of notes published in 1921, Gide asserted that classicism was "the art of expressing the more by saying the less."[50] This was very close to what Calder was referring to in 1929 when he wrote that the wire sculptures "are still simple, more simple than before; and therein lie the great possibilities."[51] It's also not so far from the ideas that were being embraced by the artists of the Neue Sachlichkeit in Germany. Did Calder know Gide's text? There is no reason to think he did. Gide himself, making his remarks in the *Nouvelle revue française*, was responding to a widespread interest in the merger of classicism and modernism into a new kind of simplicity, an interest that engaged not only painters and sculptors but writers and composers as well. Calder certainly saw the relationship between the simplicity of the wire sculptures and the possibilities of a resurgent classicism. The evidence for that is unquestionable, considering his turn to classical subjects with *Romulus and Remus*, *Spring*, and *Hercules and Lion*.[52]

One of the strongest supporters of this new classical simplicity was none other than an early admirer of the *Cirque Calder,* Jean Cocteau. "Simplicity," Cocteau wrote, "must not be taken to be the synonym of 'poverty,' or to mean a retrogression. Simplicity progresses in the same way as refinement."[53] A decade earlier, with *Parade*, Cocteau had brought together Picasso, Satie, and the choreographer Léonide Massine in a celebration of themes from the circus, popular music, Cubist painting, and Hollywood films, all joined to

create a new kind of theatrical experience. What kind of experience was that? It was a work of boisterous simplicity, the quotidian somehow distilled, purified, elevated. Which was more or less what Calder was after. *Cock and Harlequin,* the book in which Cocteau presented his defense of Satie, *Parade,* and the new simplicity, appeared in an English translation in 1926. We don't know if Calder knew or read *Cock and Harlequin.* What is certain is that there are passages about Satie in *Cock and Harlequin* that illuminate the movement of Calder's work from the *Cirque Calder* to *The Brass Family* and *Le Lanceur de poids* and the first abstractions of the early 1930s. Cocteau believed that Satie used the directness of popular entertainment to give art a new eloquence. He commented of Satie's interest in the café concerts, with their singers who provided subjects for Degas and Toulouse-Lautrec, that they were "OFTEN PURE," while "THE THEATRE IS ALWAYS CORRUPT."[54] It was just

Calder. Hercules and Lion, *1928. Wire, 60 x 48 x 24 in.*

such a search for the purity of the popular arts that had led Calder to the circus, the acrobats, the boxer, and Josephine Baker. As the American critic Paul Rosenfeld put it, writing in 1921, "Satie, like his brethren of the circus, is a good acrobat."[55] So was Calder, an acrobat with wire as Satie was with notes. They embraced the quotidian and carried it aloft, into the empyrean. When Cocteau wrote, "Art is science in the flesh," he might just as well have been describing Calder's gradual discovery that he could make art out of some of what he had learned at the Stevens Institute of Technology. "The musician," Cocteau wrote, "opens the cage-door to arithmetic; the draughtsman gives geometry its freedom"—as Calder would a few years later in his mobiles.[56]

For a man Calder never met—and we can be sure of that, since Satie was dead by the time Calder arrived in Paris—Satie looms large, at least in the biography of Calder's imagination. As we've already observed, some of the

wire sculptures Calder produced in the late 1920s recall a movable prop, a horse and rider made of black-painted rattan, that Picasso created for *Mercure*, a ballet with music by Satie and choreography by Massine that was mounted as part of Count Étienne de Beaumont's Soirées de Paris in 1924; although Calder couldn't have seen that production, he might have seen the sets for *Mercure* two years later, at the "International Theatre Exposition" in New York, or the year after that, when in June 1927 the Ballets Russes revived *Mercure* for three performances in Paris. The sets and costumes for *Mercure* were in a tongue-in-cheek classical manner, with Greco-Roman themes and motifs evoked wittily, casually. They were consonant with the brittle humor of Satie's music, but also with the light, ironic neoclassicism that Calder marshaled for *Spring*, *Romulus and Remus*, and *Hercules and Lion*. There's another rather intriguing affinity between *Mercure* and the *Cirque Calder*. As part of the circus, Calder created with clothespins miniature versions of the tableaux vivants that were part of the Ringling Bros. and Barnum & Bailey Circus. The Ringling Bros. acts were reimaginings of classical sculptures, including the *Three Graces*, with performers in frozen poses painted white. *Mercure* was in fact a series of tableaux vivants, including one of the *Three Graces*. In his sets for *Mercure*, Picasso had reimagined classical subject matter with materials not generally associated with the fine arts, which suggests a link between *Mercure* and the *Cirque Calder*, although it may be a link of which Calder was entirely unaware.

Thinking especially of Picasso's rendering of the *Three Graces*, Cocteau wrote, undoubtedly with a certain loving, delicious irony, that *Mercure* was a "sumptuous spectacle. There is only an oilcloth curtain, an imitation marble well-head, a sloping surface pierced with holes and, emerging from these holds, unshaven scene-shifters combing out old wigs and wearing pink tights with huge stuffed breasts. This is theatre."[57] The *Cirque Calder* had its own funny wigs, curious tights, and stuffed breasts. I am left wondering if Cocteau, on seeing the *Cirque Calder* on the rue Daguerre, had been moved to exclaim, "This is theatre!" Having dispensed with the old idea of the work of art as a window on the natural world, modern artists embraced art's limitless theatrical possibilities, nature now turned inside out, presented as if in a funhouse mirror, or rejected more or less entirely.

VIII

Among the small group that had been present while Pascin wrote his introduction to the Galerie Billiet exhibition on a piece of stationery at La Cou-

pole was Tsuguharu Foujita. He was a painter with a strong theatrical sense. He had studied dance with Isadora Duncan, and his enormous round glasses and dark hair cut in a bowl shape had earned him a place among the sights of Montparnasse. His abiding subject was the female nude, painted in such a way as to give avant-garde eroticism an informal elegance; to some he seemed a throwback, a conservative, an old-style bohemian. Calder and Foujita participated in a little film that the British company Pathé made in the spring of 1929, *Montparnasse—Where the Muses Hold Sway.* Foujita was seen standing in one of the quiet side streets of Montparnasse, and then drawing a model. Calder was identified not by name but only as "the smart art world's latest vogue" and "the telephone wire sculptor." He was filmed in the rue Cels studio, seated with Kiki, the quintessential artists' model of Montparnasse. He was making her portrait, and upon completing or nearly completing the wire head, he charmingly held it up to compare the wire nose with her famously prominent nose.

That same year, Kiki wrote about Calder in her memoirs. She praised him as an "ingenious Yankee" and commented that "while he has been nicknamed the 'Wire Man,' there is nothing wiry about his build. The artist is bulky as Jack Falstaff, larding the lean earth as he walks along, and resembles a lumberjack in his striped sweater, corduroys and heavy shoes."[58] Today Kiki is mostly remembered for the photographs taken of her by Man Ray, her American lover. Man Ray, whose eight-year relationship with Kiki ended in 1929, had, like Calder, been born in Philadelphia; he arrived in Paris in 1921. He eventually photographed everybody who was anybody, naturally including Calder. What Calder knew of Man Ray's work in 1929 we cannot say, but it's difficult to imagine he hadn't at least seen some reproductions of the rayographs. These were the abstract photographs that Man Ray created without a camera, by arranging curious combinations of objects on light-sensitive paper; their gravity-defying forms would have interested the man who would soon invent the mobile. By the time Calder knew Man Ray, he was recognized as a founding member of the Dadaist movement and an intimate of the Surrealists, though like Miró and Calder, he was adept at avoiding ideological traps. "There were rivalries and dissensions among the avant-garde group," he said, "but I was somehow never involved and remained on good terms with everyone—saw everyone and was never asked to take sides."[59]

Whatever Calder knew of the most recent developments in art and literature in Paris when he returned to New York in June 1929, he was moving among an impressive circle of Parisian friends and acquaintances. He had spent time with—or at least had as guests at his circus performances—Mary

Calder. Féminité (Kiki's Nose), *c. 1930. Wire, wood, tin, doorknobs, and paint. Photograph by Marc Vaux.*

Butts, Stuart Davis, Robert Desnos, Tsuguharu Foujita, André Kertész, Yasuo Kuniyoshi, Man Ray, Joan Miró, Isamu Noguchi, Jules Pascin, Mary Reynolds, and Kiki de Montparnasse. Not long before he left for New York there was a *Cirque Calder* performance in Foujita's studio, with Foujita providing accompaniment on the drums. Foujita was a legendary self-promoter. He had appeared in an advertisement for Lucky Strike cigarettes. "Really," he once proclaimed, "publicity is important. There's nothing that beats the combination of ability and publicity."[60] From the sound of it, Calder and Foujita didn't see much, if anything, of each other in later years. The senti-

mentality of Foujita's work couldn't have been to Calder's taste. But at the moment Calder may have found a certain fascination in Foujita's brand of outlandishness. Sandy was hungry for any publicity that came his way and on that score might have figured that Foujita had a thing or two to teach him.

In the *Autobiography,* Calder claimed to be unsure why he chose to leave Paris at that particular moment, musing, "Maybe the money was getting low." Or maybe it was just that with each fresh triumph in New York or Paris, he felt compelled to cross the Atlantic yet again, and see what the other city might yield. The Paris edition of *The New York Herald* reported, "Sandy is soon leaving us for a trip to the States; purposes: family re-union and money-making. And remember, there is a little of the Scot in Sandy."[61] The Scots were known for their frugality. Before leaving for New York, he decided to shave off his mustache. He had grown it after leaving Stevens, during the difficult years when he was trying to establish himself as an engineer, imagining or hoping that it would make him seem more mature, a more respectable member of society. That mustache had gone through a great many transformations: longer and shorter, waxed or not. Now, eight years later, having established himself as an artist to be reckoned with among those in the know, he no longer felt the need for what had perhaps always been a bit of a disguise.

LOUISA JAMES

Louisa James on the
De Grasse, *1929.*

I

Calder, still short of funds despite his successes in New York, Paris, and Berlin, had enjoyed his trip the past November from New York on the *De Grasse* too much to deny himself the pleasure again. So when he decided to return to the States, he booked himself on the same boat, departing on June 22. The *De Grasse*, which the French Line had inaugurated in 1924, was a luxurious ship with an indoor swimming pool and a spectacular dining room, although it was no longer the line's most glamorous vessel; that honor went to the *Île de France* on its maiden voyage in 1927. For Calder, who had worked his way to San Francisco and later to Europe as a crew member on a couple of rusty old boats, being a paying customer on the *De Grasse* has to have been heaven.

Calder regarded himself as a fairly experienced seaman after those earlier voyages. He believed that moving as much as possible was the best way to avoid seasickness, so he made it a habit to circulate on the deck. Early in the voyage, as he made his rounds, he came up behind a young woman, also making the rounds, with a man who was her father or at least old enough to be. Wanting to get a better look, he reversed direction, and after passing the couple and discovering that she was indeed attractive, with blue eyes and

thick, light hair, he made a point on his next pass around the deck of wishing them, "Good evening!" To this, Calder remembered years later, he heard the older man say to the young woman, "There is one of them already!"[1] Apparently Calder had been identified as a young man on the make. As for the couple Calder was making it his business to get to know, the man was Edward Holton James, and the woman was his daughter Louisa James, who would soon enough become the most important person in Calder's life. Calder would claim, in his *Autobiography*, that Louisa's father "had traveled with her to protect her" and wound up being out of the way on the *De Grasse* only because he was laid low with a bad case of asthma.[2] The truth, however, was that Louisa was already something of a free spirit. The father and daughter hadn't actually been together all that much in Europe. While her father had been in Geneva—where, as a well-to-do gentleman with progressive ideas, he took an interest in the doings of the League of Nations—Louisa had been spending time more or less unchaperoned in Paris, working on her piano playing and seeing friends from back home.

Calder, c. 1930.

We do not need to imagine what attracted Sandy when he caught sight of Louisa taking her constitutional, for there is a photograph of her sitting on the rail of the *De Grasse*. Her cloche hat, her pearl necklace, and her fur stole are sleek and elegant and wonderfully inviting, framing her bright eyes and open, smiling lips. She regards the camera with a look that's frank, maybe even fearless, and her casually crossed legs, set off by two-toned pumps and a fashionably short skirt, suggest a woman who would gladly take another turn around the dance floor. Louisa, twenty-four years old, had been born in Seattle, Washington, the youngest of three daughters. She was no stranger to transatlantic travel. When she was two, the family had spent five years in France before returning to Boston, where the family had deep roots; her parents now lived in Concord. Edward Holton James was a leftist who had taken part in a defining event in American politics two years earlier, the protests against the executions of the anarchists Sacco and Vanzetti. Although Louisa's parents weren't insisting that she find a husband in their own circles, as she and her father had discovered in Europe, it wasn't necessarily easy for a well-brought-up American girl to meet anybody in her age group beyond the staff of the hotel where she was staying. Only a few weeks earlier, when her father had urged her to come from Paris to Geneva, it was because he'd thought she might find some interesting people and maybe even a boyfriend

there. He wanted her to have some adventures. "If you had been here last week," he wrote to her from Geneva in March, "you probably could have had your pick from the League of Nations delegates."[3]

Young, beautiful, wealthy, and feeling rather independent, Louisa couldn't have helped but recognize in Paris the city that James Joyce called "a lamp lit for lovers in the wood of the world."[4] But so far as anybody has ever said, Louisa was returning to the United States without a beau. Perhaps she was in no particular hurry to settle down. Like many another young woman of her time and place, Louisa hadn't attended college, but she was very definitely a seeker, a dreamer, a woman who hoped to make something significant of her life. Among the dusty books still sitting in boxes in the attic in the Calder house in Roxbury are a few bearing her maiden name, including an Everyman's Library edition of *Socratic Discourses by Plato and Xenophon*. In 1924, when she was all of nineteen, Louisa was reading in French or at least looking into the second volume of Proust's great novel, *À la recherche du temps perdu*. *À l'ombre des jeunes filles en fleurs* had come out in 1919; the final volume of Proust's magnum opus wasn't published in France until 1927, five years after the author's death and two years before Louisa and Sandy met on the *De Grasse*. Even as a young woman, Louisa moved in a circle of young men and women who shared her artistic interests. Henry-Russell Hitchcock, who would organize the legendary international architecture show at the Museum of Modern Art with Philip Johnson and become one of America's foremost architectural historians, was already a friend of hers, or at least so Calder told Malcolm Cowley years later.[5] There are photographs of Louisa, from well before she met Calder, wearing some rather unconventional clothes, including a dress made of a boldly block-printed cotton fabric that was probably imported from India. Her older daughter has said that in her twenties Louisa considered becoming an artist.

And suddenly, on the deck of the *De Grasse*, there appeared precisely the sort of bohemian young man Louisa had contemplated from a distance in Paris, where she certainly frequented the cafés and nightspots where fashionable Americans went in the 1920s. Sandy Calder was just a few years older than Louisa. He was funny and easygoing and appealing with his now clean-shaven face. And he had evidently already had some significant measure of success in avant-garde circles in Paris. He was definitely an unusual young man, certainly compared with the fellows she was meeting in the United States and Europe, who generally came from her own upper-class circles. Sandy's unconventionality—he told her he was a "wire sculptor," which, not surprisingly, meant nothing to her—piqued the interest of this woman who herself had an unconventional streak, something she had inherited from

her father. Calder put on his tuxedo in the evenings on the *De Grasse*—he still had one—and he and Louisa danced, as he later recalled, rather violently, mostly to the tune "Chloe," a song about a young man's sentimental affection for his old mammy that Al Jolson had made famous. He was five feet, ten inches or a bit more; she was five foot five. During the days they played deck tennis and watched the flying fish from the bow. Sandy probably told Louisa that he had, packed away in two suitcases, a miniature circus that had already caused a bit of a sensation among those in the know in Paris.

There's nothing like an ocean voyage to encourage a rapidly developing relationship, and whatever exactly it was that Sandy Calder and Louisa James got up to on the *De Grasse*, we know that by the time the boat was approaching New York, they were very much a couple. Louisa's father later observed that he had seen less and less of his daughter as the voyage progressed, and that by the end "they had to scramble to get ready to go ashore."[6] The night before the *De Grasse* was to dock in New York, Louisa and Sandy quarreled, or at least Louisa quarreled with Sandy. Anxious to be fresh when he met his parents the next morning—and not wanting to spend money on the drinks involved in a last night of partying—Sandy announced that he was going to bed early. Louisa, seated opposite him at a large round table, was incensed, so incensed that she hurled a spoon in his direction. The spoon actually hit him, leaving a cut on his brow. Sandy went off to his cabin to go to sleep. But Louisa wouldn't be deterred. Along with George Parker, another artist who was one of their friends on the ship, she headed down to Sandy's cabin, where they got him out of bed and, one assumes, back on the dance floor. With the days on the Atlantic coming to an end, Louisa may well have seen Sandy's desire to go off to sleep as part of a more general desire to bring their connection to a close. She wasn't going to allow that. By hitting him above the eyes with a spoon, she committed an act that, no matter how spontaneous, had some deeper intention. Louisa was leaving her mark.

They were also left with another memorable image. Sandy was impressed by the way Louisa's fairly short, very abundant hair formed snakes when blown around by the ocean air. This led him to give her a nickname: Medusa. Soon enough, those corkscrews of light brown hair were immortalized in a wire bracelet and a wire portrait. Forever after, Sandy referred to Louisa as Medusa. It might seem a strange name for the woman with whom you were falling in love and who would become the mother of your children. In Greek mythology, Medusa was a Gorgon whose hideous face, surrounded by snakes, had the capacity to turn men to stone. Medusa was beheaded by Perseus, who eventually gave her head to Athena, who placed it on her shield. Sandy was certainly well aware of the implications of the name. Not

long after meeting Louisa, he made a drawing in which a young naked man seems to be fleeing from a snake with a Medusa's head who hovers above him, her long body wound around a tree. In the distance is another couple, the man apparently fleeing from another female figure, who pursues him like an animal, crawling on her hands and knees. The drawing is strong stuff. An art historian, Barbara Zabel, has quite accurately described Louisa as seen here as "a formidable temptress" and Calder as "an earthbound—and very naked—man, looking over his shoulder with undisguised panic as he flees his pursuer." Zabel wonders whether Calder "made the drawing to humor Louisa in the aftermath of an argument, or simply as a mock commemoration of the age-old battle of the sexes."[7] However one interprets this casual sketch, there's no question that it speaks of strong emotions.

But Sandy Calder was never one to succumb to dark feelings. And, at least in the family, Medusa became such a beloved name for this steady, cool, beautiful woman that the mythological allusions may ultimately have seemed beside the point. Sandy's father, a few years later, ever so casually addressed a letter to "Dear Sand + Medusa."[8] This was the Calders' Medusa, who was nothing like the Medusa of Greek myth. The Freudian undertones, although unavoidable, shouldn't be

pushed too far. There is reason to believe that in the years between the wars it was a compliment to refer to a woman's hair as suggesting Medusa. The English painter Nina Hamnett, who flourished in the same Parisian circles as Calder, recalled that one day Picabia, a painter Calder admired, brought to a lunch party the famous opera singer Marthe Chenal, whom Hamnett praised as "the most magnificent-looking creature, very tall, with a wonderful figure and a beautiful and very animated face, with curious purplish-red Medusa-like curls all over her head."[9] Perhaps to be a Medusa was to be a modern kind of beauty. Perhaps the point was that Louisa, Sandy's Medusa, without turning him to stone, was changing him in some fundamental, irrevocable way. Perhaps what it all came down to was that Louisa had a force field strong enough to match Sandy's own.

Calder. Medusa, *c. 1930. Wire, 12¼ x 17¼ x 9½ in.*

OPPOSITE, TOP *Calder.* Medusa, *1929. Brass wire, 1¼ x 2⅞ x 2½ in.*

OPPOSITE, BOTTOM *Calder. Untitled (Self-Portrait with Medusa), c. 1929. Ink on paper, 16⅞ x 11 in.*

II

As it turned out, Calder's parents weren't there to meet him the next morning at the dock in New York. There was a telegram waiting, informing him that they were in Pittsfield, in western Massachusetts, where they had had a summer place for several years. This was an old New England farmhouse with fifty or so acres, a barn that Stirling had converted into a studio, and a stream running down the back of the property. In his studio, Stirling was probably already working on his immense statue of Leif Eriksson, to be given by the United States to the people of Iceland and installed in Reykjavík to commemorate the thousandth anniversary of the Icelandic parliament. This would turn out to be the last major commission of Stirling's career. Calder arrived in Pittsfield with some of the pieces of brass jewelry he had begun to produce; his father found them very handsome. Calder later recalled that it was for a French painter who had appeared at the Neumann-Nierendorf show in Berlin that he had made what he surmised was "about my first jewelry," a collar with a dangling fly.[10] Peggy and her two boys were with Stirling and Nanette, visiting from California. Sandy once again entertained his young nephews, as he had in Washington State seven years earlier. They helped him mount a performance of the circus, operating the little mechanism that moved the horse around the ring. Calder's great college friend Bill Drew and his cousin Bill Murphy came to visit. They brought Calder and Peggy and the boys back to New York for a few days, where Calder took Peggy and his nephews to a game at Yankee Stadium. There they had the surprise of Al Jolson, seated in a box across from the grandstand, standing up and singing a couple of songs.[11]

Sandy and Louisa were in touch. She was staying with Mary, the middle of the three James sisters, in a cottage the family had in Eastham on Cape Cod. She invited him to come and visit. The sisters were alone on Cape Cod that August. What we know of Sandy's visit there comes from letters Louisa sent to her mother, who was now in Geneva, where her father, who had apparently made a quick return to Europe, was writing reports from the League of Nations, at least one of which had already been published in the New York *World*. There would always be a deeper bond between Louisa and Mary, who were two or three years apart, than between Louisa and her older sister, Olivia, who had opted for a more conventionally upper-class existence. Mary, deaf from the age of eight, was the most affectionate and loving of the sisters and, despite her deafness, was largely free of the Boston Brahmin remoteness that was part of the girls' inheritance from their mother, a Cushing from one of the old Massachusetts families. Mary and Louisa

always felt somewhat ambivalent about their Cushing ancestry—in certain respects proud of it, even as they struggled to shake it off.[12] Decades later, Louisa was startled to hear her own tape-recorded voice and discover that she still spoke with the plummy Boston accent she knew from her mother; she imagined she'd left it behind long ago.[13] Mary herself eventually married a creative spirit with bohemian inclinations, the writer William Slater Brown, who had lived in Paris, known Hart Crane, and been close to E. E. Cummings. Cummings immortalized his World War I adventures and misadventures with Brown in his novel *The Enormous Room.*

In Eastham, Sandy appeared in his role as the happy-go-lucky comedian. He was the perfect guest, repairing everything that needed fixing and keeping everybody "in gales of laughter all day long," as Louisa reported to her mother.[14] He seemed to get on with all their friends on the Cape. At least one night while he was there, Mary ended up staying with friends after a picnic, which probably left Sandy and Louisa completely alone. What they got up to, nobody will ever know. When Calder's birthday came around, on August 22—this was well before the birth certificate had been obtained from Philadelphia that, confusingly, placed it a month earlier—Louisa wrote to her mother that she was "going to organize a theatre party or a moving picture party to celebrate."[15] Louisa was beginning to think that she would spend the fall in New York, with or without Mary. They had been together there the previous winter in an apartment at 45 West Eleventh Street, very much the neighborhood that Calder and his parents called their own.

III

Louisa James, as Sandy no doubt quickly discovered, came from a family as artistically and intellectually distinguished as any in America. Her paternal great-grandfather, Henry James Sr., was in the mid-nineteenth century a well-known American follower of the Swedish philosopher and theologian Swedenborg, and friends with Emerson and other New England notables. Although Louisa's paternal grandfather, Robertson James, had never distinguished himself, his two oldest brothers were none other than William James, the great student of philosophy and psychology and the author of *The Varieties of Religious Experience,* and Henry James, known at the beginning of his career as Junior, before he began his ascent to near the very pinnacle of any list of novelists writing in English. Henry James, in his memoir *Notes of a Son and Brother,* had looked back on Louisa's grandfather's thwarted artistic ambitions and dreadful alcoholism and remembered "two or three

of his most saving and often so amusing sensibilities, [which] the turbid sea of his life might never quite wash away."[16] Louisa's father had inherited from his father, if not the tormented spirit, then certainly the searching soul.

A great friend of the Calders' in later years, the cartoonist Robert Osborn, had been regaled with stories of Louisa's father, Edward Holton James, that left the impression that he was a "wild-man."[17] The Calders may have been telling Osborn about the trouble he had gotten into during World War II, when he published pamphlets advocating isolationism and opposition to the draft that briefly landed him in a Massachusetts jail. Louisa's older daughter, Sandra, suspects that her mother found her father "a bit wacko."[18] He was said to be the worst violinist ever to perform on a couple of Stradivariuses, one of which he had dismembered to see how it worked. But a source of pride for the Calders, whose liberal politics would turn them into staunch opponents of the Vietnam War in the 1960s, was the story of her father's being knocked down by policemen during the Sacco and Vanzetti protests in Boston. After the Italian immigrants had been executed for treason, Louisa's father took an interest in Sacco's son Dante, and brought him on one of his trips to Geneva in the early 1930s.[19] Edward James's liberal ideals had been shaped by his father, who had given him, when he was sixteen, Henry George's *Progress and Poverty,* which set him on his path. "I was kindled by the enthusiasm of the author," Louisa's father later wrote, "that kind of enthusiasm which Tocqueville describes as lifting men out of the beaten track to accomplish a noble purpose."[20] After Edward James's mother left his alcoholic father, they ended up living in the Boston area, where Ellen Emerson, the daughter of the great philosopher who had been a friend of Henry James Sr.'s, took Louisa's father under her wing.

Edward Holton James wrote about his intellectual development in a book, *I Am a Yankee,* that he privately published in 1943 as part of his effort to distance himself from the United States' involvement in World War II. He recalled a growing friendship with Ellen Emerson, who "made me feel at home in the Emerson house. I was twelve and she was perhaps fifty, but our minds seemed to be more or less on the same level at least when it came to picnics." Ellen's brother, Edward, gave him a gun that had belonged to Thoreau. And when Edward was preparing for the entrance exams for Harvard College, Ellen invited him to stay with her. "For a week I sat in Emerson's study, and in his rocking chair, and rocked more than I studied, looking at the tiers of crumbly books in broken bindings, and trying to figure out what kind of a man Ralph Waldo Emerson really was." At Harvard, already suspicious of wealth and privilege, Edward was repelled by "a steam-bath of conformity," feeling that this "education for the gilded youth" was intended

to make "them more gilded, and to prepare them as 'men of culture' to keep the established system in place and take part in the great national game of piling up of wealth."[21] But at least he could go and talk to his uncle William James when he became inflamed with excitement about Emerson's essays, although apparently his uncle didn't exactly share his enthusiasm.

When Louisa was growing up, her family was almost as peripatetic as Calder's. An adventurous upbringing was something that Sandy and Louisa had in common. Both families had experienced life on the West Coast as well as the East Coast. And neither family felt that their horizons were limited by the Atlantic Ocean. Louisa's parents, at the time Calder was getting to know her, lived in somewhat unconventional circumstances in Concord, sharing meals while inhabiting separate but adjacent houses. This was said to be because Louisa's mother, also named Louisa, couldn't tolerate her husband's violin playing. In a curious and charming little book, *Memoirs of a Bear Hunter*, Louisa's father, who explained that he had never hunted a bear in his life, recalled watching over his daughters in their nursery in Seattle, discovering a Stradivarius while with them in an antiques store in France, and receiving a visit from his uncle, the eminent novelist, while they were living in Seattle. Henry James certainly followed his nephew's radical political views. He was so embarrassed by a pamphlet Edward Holton James published that was critical of the king of England—James became a British citizen during World War I—that he rescinded the admittedly modest amount he had originally planned to leave him in his will.

Edward Holton James's father, Robertson James, had ended up a ruined man, living apart from his wife, but she came from a wealthy Milwaukee family, and Louisa's father may have inherited some money from her. However that may be, Louisa's mother brought the more significant wealth into the family; her father had been a merchant who spent time in China. She, along with her middle daughter, Mary, was a Christian Scientist and, although not a political radical like her husband, was involved with charitable works and had set up a poorhouse in Boston. A few years later, Louisa's mother would invite Nanette to a meeting of something she referred to as the Institute of International Relations, dedicated to "an effort to prevent the on-coming world war by educating people about the underlying forces."[22] When Peggy met Mrs. James in 1933, "she had white hair and looked superb in the purple clothes she loved to wear. She kept busy doing needlepoint as a discipline for her hands, which had developed a slight tremor."[23] Louisa's parents often seemed to go their separate ways. When Sandy and Louisa got married at her parents' house in Concord, her father was off in India, doing research for a book about the injustices of British colonial rule.

IV

The fact that Louisa's family was well set financially couldn't have been a matter of indifference to Calder, whose parents had never really achieved economic security and were definitely now feeling the pinch. Early in September 1929, not long after Calder returned to New York from seeing Louisa in Eastham, Stirling wrote to Peggy, "It would be a lie to claim that we are happy, but it is only the lack of money that makes us so."[24] Life was perilous for Stirling and Nanette, as he was still living from commission to commission, and never had a regular relationship with a gallery that could sell his smaller works or the distinguished teaching career that old friends like Charles Grafly and John Sloan could count on.

Despite his brash self-confidence, Sandy Calder must sometimes have wondered how he would make ends meet. And if money and how to earn it had never been very far from Calder's thoughts, whatever worries he had must have multiplied in the wake of Black Thursday, October 24, 1929, and the gradual but inexorable unraveling of the world economy. The catastrophe was beginning to unfold just as Calder was beginning to be recognized—and recognized as an artist who caught the champagne ebullience of a period that would soon vanish. Although many people weren't affected immediately, the new reality was sinking in. Late in October, the day after he mounted a circus performance at the Lexington Avenue apartment of Mildred Harbeck, a textile designer, Calder seemed surprised, when he asked Erhard Weyhe what he thought of the event, to hear the dealer exclaim, "Mr. Kalder, yesterday I lost eight thousand dollahr." "This did not depress me," Calder observed in his *Autobiography*, perhaps with an edge of irony—the poor man refusing sympathy for the rich man.[25] There were moments when Calder's optimism could make him seem cool or even hard-hearted. His brother-in-law's family, whose banking business had apparently already begun collapsing a couple of years earlier, would lose all their money in the wake of the crash, although in its immediate aftermath Ken was assuring Peggy that they wouldn't be affected. Stirling and Nanette, who had put their savings in the Hayes family bank, were heading into a very dark decade. As for Louisa James, her family's money must have been very soundly invested, for neither then nor later was anything ever said about straitened circumstances in the James family.

By November, Louisa was living in an apartment in New York, perhaps the one she mentions she and Mary had rented the year before at 45 West Eleventh Street, in a sturdy Beaux Arts building on a block of old Greenwich Village townhouses. Although neither Sandy nor Louisa left behind much

of a record of how they were getting along in the winter of 1929–30, there was no question that they were functioning as a couple, regularly appearing together at social events. There are a few tantalizing glimpses and glances in Calder's mother's letters to Peggy, who was now back on the West Coast. Nanette could see that something was heating up. She felt some frustration that although Sandy was on their side of the Atlantic, she wasn't seeing him, or at least not having much time with him to herself. When Nanette said to her son that Louisa was his "inamorata," he blushed for a few moments, she reported to Peggy.[26] Around New Year's, she wrote to Peggy after a happy day spent with Sandy, in part visiting the animals in the Central Park Zoo. "We went on to an Italian joint. He left me after to call on ? would not disclose himself—but I know where Louisa James lives."[27] (Though Peggy corrected it in her memoir, in her letter Nanette spelled Louisa's name "Louise.") Soon after that, Nanette ran into her son on the Fifth Avenue bus. "I heard a nose blow that was just like Sandy's—I partly turned round—and the next I knew Sandy was sitting beside me. He was on his way to get Louise James and I was on my way to the Brevoort to meet your father." Later in

A. Stirling Calder. Louisa James, c. 1930. The photograph was taken in the 1950s in the Calders' home in Roxbury, where Stirling's bust of Louisa always had a place.

the same letter, Nanette commented, "He is very devoted to Louise—but it is no use supposing anything for he gathers honey everywhere."[28]

Was this just another one of the companionable flirtations Sandy Calder had been conducting since his days at Stevens, when he said every girl was a peach? Nanette couldn't really tell. As for Stirling, he immediately hit it off with Louisa. At least, he was very taken with her looks. Sometime early that year, he made a portrait bust of her in his studio, a studio Sandy was also occasionally using that winter. He emphasized her oval head and her sensitive yet sober and aristocratic features, with her simply cut hair falling to the sides. As a man who prided himself on being the good-looking one in the family—and who definitely had an eye for a good-looking lady—he surely responded to the thought that Louisa might become a close relation. Stirling may have been the first Calder sculptor to take Louisa as a subject; or if not, he was a close second after his son, whose wire portrait of Louisa, with all-seeing eyes and a couple of curling tendrils of hair, dates from around the same time. Stirling's terra-cotta portrait of Louisa always had a special place in Sandy and Louisa's home.

V

Over the winter, Louisa could see that Sandy's talent, energy, and charm were unlocking more and more doors. For a young woman who, as her older daughter would remark many years later, had "wanted something different," life with Sandy was very different—wonderfully different—from anything she'd known.[29] In the six or so months Calder spent in New York, from the fall of 1929 until his return to Paris the following March, the circus was becoming his calling card, as he built a reputation in the fashionable New York drawing rooms where people took an interest in bohemian goings-on and the most recent developments in the arts.

The first performance in New York that season, on August 28, was in the couture house of his friend Babe Hawes, announced with a striking little linoleum-cut invitation, printed in blue ink. Hawes, after returning to New York in the fall of 1928, had opened a boutique on West Fifty-sixth Street. This establishment was initially known as Hawes-Harden, Rosemary Harden being the partner whose husband's money got things rolling. It seems that Calder had been in touch with Babe while still in Paris, and had promised to mount a circus performance at her shop almost immediately after arriving in New York. When he changed his plans and hotfooted it up to Pittsfield to see his parents and then to Cape Cod to see Louisa James, Hawes was left to

complain that he was supposed to be in New York, performing on West Fifty-sixth Street. Who exactly attended the performance that finally took place late in August we don't know, but among Hawes's earliest customers was the actress Lynn Fontanne, which gives some sense of the circles in which she was moving.[30] Through the Hardens, Hawes knew Frank Crowninshield, the editor of *Vanity Fair*, who, Calder remembered, attended a different circus performance a little later, in the fall. Calder had met Crowninshield the year before, perhaps through Zigrosser and the Weyhe Gallery. Or it might somehow have been through John Graham, whom Crowninshield hired to put together a collection of African art.

Calder had done a wire portrait of Crowninshield in 1928, but it was not until early in 1930 that Crowninshield featured some of Calder's work in *Vanity Fair*. That fall and winter, Calder was popping up all over fashionable New York. In December, at a birthday celebration held for the Rus-

Calder. Calder's Circus Invitation (Chez Hawes-Harden), 1929. Linocut, 9¼ x 7 in.

sian pianist Alexander Glazunov, Calder encountered the caricaturist Aline Fruhauf, a woman with a wonderfully long neck, who promptly began to draw a sketch of Calder for her column in *Top Notes*. In response, Calder, with equal alacrity, drew a sketch of Fruhauf on a pad he pulled out of his pocket. The editor of *Top Notes* left a striking word-portrait of Calder. He was "a nice young man, quietly mirthful, distinguished from among the other white shirt–fronted gentlemen of the party by a curiously wrought ornament which seemed to be a bee or dragonfly of gold filaments, perched where a shirt-stud should be."[31] Hawes recalled, "Once a lady from *Harper's Bazaar* came into the shop and admired a wire fish bowl which Sandy Calder had given me. 'It's no wonder you get on so well,' said she, 'you have so many clever friends.'"[32] According to Calder, Hawes at some point also had in her shop a large figure made of heavy wire designed to hold yard goods.[33]

Calder. Fish, *1929. Brass wire, 5 x 15½ x 2 in.*

It may have been Babe Hawes who first encouraged Calder to consider jewelry as a moneymaking proposition. At the time, there were certainly painters and sculptors who aimed to satisfy a well-heeled, cosmopolitan public's appetite for elegant items of dress and décor. By the beginning of the 1920s, Sonia Delaunay had been producing fabrics and fashions, and by the end of the decade, Alberto Giacometti was working with the furniture designer and interior decorator Jean-Michel Frank. In a letter written to Noguchi in 1929, Calder mentioned that some of his jewelry was being shown in England, although we know nothing more about that. By 1930, Calder was in touch with Thérèse Bonney, the American photographer who with her sister had produced a book called *A Shopping Guide to Paris.* Their *Guide* catered particularly to the high-end shopper looking for unusual items. It seems reasonable to assume that the photographs Bonney took of Calder and his jewelry were part of her more general efforts to promote fine design on both sides of the Atlantic. It's likely that Hawes and Bonney knew each other. However it all started, Calder produced jewelry for sale pretty steadily through the 1930s.

Whatever the commercial motivations, Calder revealed in his jewelry a passionate exactitude, a feeling for the intimate and the luxurious that

couldn't always find an outlet in his increasingly bold wire constructions. There will be more to say about the exquisite bracelets, necklaces, pins, and hair ornaments that seemed to pour effortlessly out of his studio during the 1930s and were even the subject of a couple of shows in New York at the beginning of the 1940s. Calder's motifs ranged from spirals to butterflies and ultimately embraced a veritable encyclopedia of the animal, vegetable, and mineral worlds. Working in brass and silver, Calder pushed his virtuosity to the limit even as he reimagined the traditions of the Arts and Crafts movement that he had first encountered as a boy. This refined sense of craft wasn't restricted to jewelry but extended to a range of smaller objects, including the gifts he presented to his parents for Christmas in 1929. For his father, there was a brass wire fish, its body elegantly delineated with gentle curves to create a form with the authority of some ancient ritual object. And for Nanette, there was the outline of a goldfish bowl in wire with two fish that moved through the water when you turned a crank, a device as whimsically rococo as Stirling's fish was crisp and cool. That fish tank was kin to the one Babe Hawes displayed in her shop.

Calder. Goldfish Bowl, *1929. Wire, 16 x 15 x 6 in.*

VI

Another friend from Paris who was around New York that winter was Isamu Noguchi. He operated the record player for at least one circus performance, a responsibility that would soon become Louisa's. Along with Babe Hawes, Noguchi cropped up in one of Nanette's letters to Peggy that winter, where he was described as "a handsome little chap and a good artist" who was as "unconventional as Sandy."[34] Noguchi was six years younger than Calder. His father, the well-known Japanese poet Yone Noguchi, had more or less abandoned his mother, and Noguchi had had a difficult upbringing in the United States and Japan. As a teenager, he had been something of a prodigy. He studied with an academic sculptor in Greenwich Village, in the same building where Stirling had his studio. He and Calder probably met in Paris in 1927, where Noguchi arrived in April on his Guggenheim fellowship, for which he had been recommended by a rather astonishing group of men, including Alfred Stieglitz and the music and art critic Paul Rosenfeld. Noguchi had seen a show of Brancusi's work at the Brummer Gallery in New York the previous November; in Paris, through the writer Robert McAlmon, he received an introduction to the sculptor, and ended up working as his assistant for some months.

The friendship between Calder and Noguchi has rarely received the attention it deserves, perhaps because it eventually fizzled—an unusual dénouement, given Calder's talent for sustaining connections. Physically, Calder and Noguchi were polar opposites, the younger man small, with a beautifully lean, muscular physique and a strikingly good-looking head. They also couldn't have been more different psychologically, for Calder was as emotionally expansive as Noguchi was emotionally reticent. If indeed Calder was more than friends with Marion Greenwood, who had a love affair with Noguchi, that might need to be factored into their friendship. Years later, Noguchi complained that Calder had had a relatively easy time with his career. He remembered that in Paris Calder had been receiving some support from his parents, which Noguchi, who felt he was practically an orphan, must have resented. In the next decade and more, Calder and his work were embraced by the Museum of Modern Art with an enthusiasm that certainly eluded Noguchi. Calder, for his part, watched his attempts to collaborate with the choreographer Martha Graham fizzle, while Noguchi gained greater and greater renown for his. In the end, it may simply have been Calder's ease that unnerved Noguchi. In the 1970s, Noguchi remarked that "Sandy somehow, whether he was or wasn't rich, was able to get away with it."[35]

Whatever their differences, as the 1930s began, Calder and Noguchi were both at the beginning of extraordinary careers. They both cut a figure. They shared many friendships in New York and Paris. Their outlook was international; they saw modernism as a universal language that could be spoken with a range of accents and intonations: American, European, Asian. Both sculptors found themselves somewhere between representation and abstraction, not yet entirely sure what their direction would be. And they were each working on a series of portraits—including, as we have seen, portraits of Marion Greenwood. Noguchi's portrait busts were lucidly articulated solid forms, some with a sleekly glamorous Art Deco look. Like Calder's wire portraits, Noguchi's portrait busts saluted his friends as well as the movers and shakers in the artistic circles where these two enormously ambitious young men were rapidly becoming well known. In February 1930, Noguchi had a show of his sculpted heads at the Marie Sterner Gallery; Sterner and her husband, the painter Albert Sterner, were old friends of Calder's parents', and she had taken a bit of an interest in Sandy's painting a few years earlier. Around this time, Sterner made a fine drawing of Louisa in which she has some of the power and grace of a Pre-Raphaelite beauty. Calder would also probably have seen the exhibition that Noguchi had along with the visionary engineer Buckminster Fuller in late October at Romany Marie's Tavern in the Village, a hangout for all the artists and writers; Romany had been at Betty Salemme's place in Connecticut when Sandy was there a few years earlier.

Isamu Noguchi and Grace Greenwood, Marion Greenwood's sister, at the Maverick Festival, Woodstock, New York, 1929.

Calder did have an exhibition in New York that winter, at a place called the Fifty-sixth Street Galleries, which was affiliated with the Roman Bronze Works, where some of his father's works were cast. Although Calder, in his *Autobiography,* remembered this show as one of his less glorious moments, it did contain a range of work. There were paintings, wood and wire sculptures, toys, jewelry, and textiles—textiles were apparently yet another of Calder's moneymaking projects. On the announcement were warm words of praise from Murdock Pemberton, a critic at *The New Yorker* and a friend. "Calder is nothing for your grandmother," he wrote, "but we imagine he will be the choice of your sons. He makes a mockery of the old-fashioned

frozen-stone school of sculpture and comes nearer to life in his creations than do nine-tenths of the serious stone-cutters. Some of his wood elephants and tin animals are masterpieces of motion and balance, and his cow is a cow with all of her pathos left in."[36] The exhibition at the Fifty-sixth Street Galleries leaves one wondering whether there had been a falling-out between Calder and Weyhe or Calder and Zigrosser, perhaps precipitated by the slow sales. Of course, the space at Weyhe was highly restricted, and Calder may have wanted a bigger place so he could show more stuff. Calder may have also liked the possibility of presenting exactly what he pleased, without a highly opinionated and critical dealer to curate the selection; he said later that at the Fifty-sixth Street Galleries, he had had "a show of all my wares."[37]

More than one exhibition was presented at the same time in this gallery, which may have functioned as a sort of department store for art. While Calder's show was mounted on the third floor, there was, on the first, work by Ivan Mestrovic, a bombastic Expressionist whose figures in bronze, much celebrated at the time, would soon enough sink into oblivion. What did interest Calder at the Fifty-sixth Street Galleries was an exhibition of antique mechanical birds. He responded with his mechanical fish.

VII

Early in 1930, Calder and Noguchi became involved with an experiment in the exhibition and promotion of modern art at Harvard University, something masterminded by a Harvard undergraduate by the name of Lincoln Kirstein. This was called the Harvard Society for Contemporary Art. Kirstein was nine years younger than Calder and still practically a boy, albeit a very tall, determined, and outrageously precocious boy. Over the years he would become the greatest impresario in the history of the arts in the United States—the American Diaghilev. He provided critical support for the early career of the photographer Walker Evans; almost single-handedly rescued the achievement of the sculptor Elie Nadelman; brought George Balanchine, that supreme genius of the dance, to America and with him founded both the School of American Ballet and the New York City Ballet; and then proceeded to help establish the American Shakespeare Festival in Stratford, Connecticut. All the while, Kirstein was producing a stream of books that range from histories of dance and monographs on the visual arts to poetry, fiction, and memoir, much of it written in a wonderfully rich and idiosyncratic prose style, at once casual and grandiose, direct and baroque.

Even as a young man, Kirstein was saturnine, imposing, and irrepressible.

He appears in a portrait sculpture Noguchi did around that time with a grandly intellectual forehead and a steely, determined look far beyond what one might expect in a man still in his twenties. Kirstein was a visionary. It didn't hurt that his father was a principal in Filene's Department Store in Boston, who was able to provide seed money for many of his son's exploits. Already the year before—his sophomore year at Harvard, no less—Kirstein and another undergraduate, Varian Fry, had founded what would prove to be an extraordinarily important literary magazine, *Hound & Horn. Hound & Horn* brought Kirstein into contact with figures on the order of T. S. Eliot and Ezra Pound. They seemed perfectly happy to contribute. "I was an adventurer," Kirstein later wrote; "*Hound & Horn* was my passport."[38] Kirstein's second grand adventure as an undergraduate, coming close on the heels of *Hound & Horn* (and briefly overlapping with the magazine, which lasted until 1934), was the Harvard Society for Contemporary Art.

Among Kirstein's partners in the Society for Contemporary Art was Edward Mortimer Morris Warburg, known to all as Eddie. Although Kirstein's family had money, Eddie's had a great deal more. Already as an undergraduate, Warburg owned a Blue Period Picasso. He would go on to be a prime mover in the early years of the Museum of Modern Art and help finance the School of American Ballet. The Harvard Society for Contemporary Art has come to strike many as a brief, out-of-town prologue to the Museum of Modern Art, which opened some nine months after the Harvard experiment began. Indeed, Alfred H. Barr Jr., who would be the founding director of the Museum of Modern Art and a great supporter of Calder's, was at the time that the Society for Contemporary Art got under way involved in graduate studies at Harvard and very much interested in what Kirstein and his friends were up to. Kirstein, who was almost absurdly gifted, created for the rooms where the society held its exhibitions a rather impressive abstract mural, a meandering arrangement of gears, pipes, and assorted machine age images. Writing much later in *Mosaic,* his account of his early years, Kirstein counted the Harvard Society "a luxurious playpen or laboratory in which I could make up my heated, but as yet still smoldering, sense about the difference between 'originality,' 'personality,' and 'quality,' and whatever connected these in the present context."[39]

How Calder hooked up with Kirstein's Harvard operation isn't entirely clear. It could be that Noguchi, who exhibited together with Buckminster

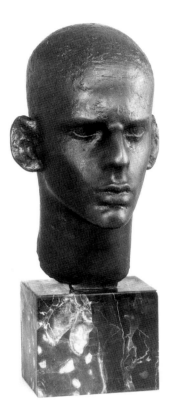

Isamu Noguchi. Portrait of Lincoln Kirstein, *1929*.

Fuller at the Harvard Society not long after Calder, was somehow involved. In the *Autobiography,* Calder enigmatically and rather grumpily explained that "somebody from Baltimore butted into my business and arranged a show in Eddie Warburg's gallery at Harvard. Warburg and Kirstein had hired a floor in an office building across the street from the college."[40] In a letter to Peggy written that January, Nanette said that Stirling had given Calder a telegram, and that "a person wished him to call up no—so + so—It was a young woman—whom he did not know asking him to supper Sunday night to meet some Harvard men one of whom had bought some of Sandy's work—(Warburg—the banker's son)—at first he said he was already engaged for Sunday evening—then he asked if he might bring a young lady. Upon a favorable response he accepted the invitation."[41] The young lady has to have been Louisa. How all of this came about is impossible to say. That Warburg—who for a time, after Harvard, taught art at Bryn Mawr—was somehow involved is supported by Kirstein, who in *Mosaic* observes that the Calder show "was intrinsically the work of Eddie Warburg."[42] Warburg, according to Kirstein, "was generous and funny, a declared comedian, close to the practiced clown. Like that of a clown, his bearing was tinged with a reverse, not exactly melancholy, but a lurking apology for jokes that would never spark laughter."[43] So it would have made sense to Kirstein that Eddie Warburg wanted to bring up to Harvard another comedian: Sandy Calder.

Although a few years later Kirstein was involved with Calder in some very preliminary discussions about at least one theatrical experiment, there was never any great affection between the two men. The famously unpredictable and impatient Kirstein ended up having no patience whatsoever with Calder or his work. One gets the impression, from Kirstein's memoirs, that Calder wasn't a figure he had studied closely or thought much about, considering that in one sentence he managed to confuse Calder's father with Calder's grandfather and identify the statue by Milne atop the Philadelphia City Hall (which he believed was by Stirling) as being of Benjamin Franklin rather than William Penn.[44] But the coolness Kirstein felt toward Calder by the time he published his memoirs in the 1990s makes the warmth with which he recalled Calder's visit to Harvard all the more striking. Apparently he rated Calder's appearance in Cambridge late that January—the show was up for a week—as among the "few golden hours" of the Harvard Society. He recalled that Warburg drove to the railroad station to pick up Calder, who arrived with no sculpture but only "three coils of heavy wire, a pair of pliers, and some wooden blocks. Back in Eddie's rooms in Holworthy Hall, Sandy took off his shoes and socks and changed into pajama bottoms. Using a big toe as anchor, he bent, turned, and twisted his seventeen prom-

ised pieces, each affixed to its wooden base. There was a quivering *Hostess* with her shaky lorgnette; a cow with four spring udders and a coil on the floor representing 'cow pie.' "[45]

For some reason, Kirstein remembered that Calder came back a year later to perform the circus, although in fact he performed it on his visit in 1930. That isn't the only confusion that persists in accounts of the exhibition. Calder told Russell Lynes, the author of what remains the definitive history of the Museum of Modern Art, that it wasn't true that he had arrived at Harvard with nothing but a coil of wire.[46] Whatever finished sculptures he had brought with him from New York, apparently in Cambridge Calder convinced his young hosts that he was some sort of wizard with wire—which of course he was—turning coils into sculptures in a matter of hours. In his memoirs, Kirstein recalled of the *Cirque Calder* how "unforgettably, before the show, with sly, self-deprecating ingenuity [Calder] padded through his audience handing out peanuts."[47] That appreciative little vignette, a salute to Calder's theatrical subtlety, is a high compliment, coming from one of the great connoisseurs of theatrical performance in twentieth-century America. As for Calder, in later years he had very little to say about Kirstein. He recalled of the Harvard show that he sold a necklace, a couple of drawings, and a wooden giraffe. And that Eddie Warburg seemed to want him to do something in a precious metal. "That never appealed to me," Calder reflected. "A wood sphere painted vermilion is much better than a gold one."[48] Warburg told Russell Lynes that Calder "also made a wire portrait of my father from a photograph and put a test tube in the lapel with a carnation in it."[49]

By the time of the Calder exhibition at Harvard, the society had already had a show of recent American art, featuring works by Marin, O'Keeffe, and Gaston Lachaise. That had been followed by a School of Paris survey with work by Braque, de Chirico, Dufy, Gris, Miró, Man Ray, Rouault, Soutine, Pascin, and Brancusi. It may be that Calder's appearance at the Harvard Society for Contemporary Art helped ease his way into the Museum of Modern Art, much as his exhibitions at the Weyhe Gallery were stepping-stones to the Julien Levy Gallery (Levy had briefly worked for Zigrosser at Weyhe) and the Pierre Matisse Gallery (Matisse had collaborated with Zigrosser on an exhibition of Henri Matisse's work). Looking back on those months and years when Calder was moving from joker and elegant entertainer to magician and essential modernist, it is fascinating to see how his cause, a cause he himself was only beginning to fully comprehend, was supported or promoted by this person and then by that person, each one of them a key figure in the mosaic of modernism in America.

VIII

What mattered most during Sandy's eight months in the United States was his deepening affair with Louisa. So far as his work went, it was not a time for leaps or revelations. The circus, however, was expanding, taking on something close to its ultimate size. Calder was living for a time on the East Side with Robert Josephy, the book designer he had met back in 1926 when Josephy was at Knopf and Calder was trying to find a publisher for *Animal Sketching*. With Josephy's help—he was a handy guy who had made "some aluminum tables with glass tops" for Babe Hawes's shop—Calder pushed the circus from the two-suitcase operation he'd brought with him on the *De Grasse* to something closer to its final five-suitcase size.[50] Josephy was a life-long friend, and his daughter, who married a doctor and lived in Europe for a time, remembers the warm friendship of Sandy and Louisa decades later. He designed at least one book for the Museum of Modern Art, *The Architecture of H. H. Richardson and His Times*, written by Louisa's old friend Henry-Russell Hitchcock. Josephy himself would leave New York and develop a great interest in apples and farming, eventually writing a book about his life as a farmer. That winter Calder added to the circus the lion cage and the lion tamer, as well as the climax of the chariot race, which drew on his memories of the Tournament of Roses that he'd seen some twenty years earlier in Pasadena. It would seem that Calder was coming to conceive of the circus less as a series of freestanding acts and more as an event with a beginning, a middle, and an end.

Certainly the *Cirque Calder* was becoming an increasingly formal affair, as Calder arrived in the living rooms of various East Side establishments to set up the show. There was a performance at the end of October in the Lexington Avenue home of Mildred Harbeck, whom Calder had met earlier in Paris, where he had shown her elements of the circus. She was a textile designer and had encouraged him to make some designs she could show to her contacts in New York; these might have been the ones that he exhibited at the Fifty-sixth Street Galleries. Harbeck was in her early thirties. She and her sister Helen had served in France with the American Red Cross during World War I, where her brother, a doctor, had been active. She had a continuing attachment to France, where she was probably doing work with the Women's Overseas Service League, a branch of the American Red Cross. She was a member of the Junior League; it may have been through her that performances of the circus began to be arranged through that organization's entertainment center at Saks Fifth Avenue. Calder remembered that the performance in the Harbecks' home attracted not only Erhard Weyhe but also

Frank Crowninshield and the photographer Edward Steichen, who worked for *Vanity Fair*. That was an impressive crowd to find gathered in the old Harbeck family brownstone in Murray Hill. Mildred Harbeck, a woman who obviously early on felt some enthusiasm for Calder and his art, came to a tragic end. Despondent about the deepening Depression, she committed suicide in 1932, discovered by her sister Helen in a room full of gas.[51]

There were several other circus performances during the winter of 1929–30, when the Depression was only beginning. One was at the home of Newbold Morris in Babylon, Long Island, where Noguchi ran the phonograph. Decades later, when Morris was the New York City parks commissioner, he and Calder found themselves at loggerheads over Morris's opposition to the installation of a work by Calder at Lincoln Center. Another *Cirque Calder* performance was at the home of Calder's friend Paul Nitze, who later made a great name for himself as a diplomat. Calder remembered meeting Nitze in Berlin in 1929, during his exhibition at the Neumann-Nierendorf Gallery; Nitze had only the year before graduated from Harvard.[52] Back in the States, he returned to Harvard for a year in graduate school and then began working in investment banking in New York. It was

Calder. Copulating Pigs, *1930. Wire, 14 x 16 x 4 in.*

Nitze who arranged for Calder to make some hilarious copulating wire pigs for the Porcellian Society at Harvard, an exclusive club originally known as the Pig Club because it was founded over a roast pig dinner in 1794. Calder gave free rein to his taste for rollicking, frolicsome physicality.

What would turn out to be the most famous circus performance of the season was held at the home of Aline Bernstein, the well-known theatrical designer. Noguchi again ran the phonograph, and among the guests Calder invited was his stage designer friend Lee Simonson. Calder later remembered Simonson—who had gone to Russia in 1926 to see the results of the revolution and had written about it for *The New Republic*—being careful to put his peanut shells in a container, so as not to mess up the blond wall-to-wall carpeting. Among Bernstein's guests was the writer Thomas Wolfe, with whom she was having an affair. At the time, Calder had no idea that Wolfe was present and had the general impression that Bernstein and her friends were pretty much nonplussed by the circus. But that wasn't the end of it. A decade later, when Wolfe's novel *You Can't Go Home Again* appeared posthumously, with its smoldering indictment of a country heedlessly careening into the Depression, it turned out that Calder's performance in Aline Bernstein's living room had been immortalized, at least after a fashion. Wolfe presented Calder, in the person of the artist Piggy Logan, as the last gasp of the decadence of the 1920s. There will be much more to say about Wolfe's novel, which was published in 1940.

There was one last commission early in 1930, a mural for a room in the apartment of William Randolph Hearst Jr. All that now exists of this project is a long description in a letter from Nanette to Peggy that March, after Calder had headed back to France. Hearst and his wife had spent time in Europe, and one wonders if Calder knew them from there. On walls that had first been gilded, Calder created a veritable African jungle, covering the entire surface, including the ceiling and doors, to create a wraparound effect. There were palm trees that climbed onto the ceiling; zebras, one in red, white, and blue, the other black and gold; two wild cats, one yellow and one black; a large deer with twisted horns; and giraffes, a hippopotamus, and an elephant. A sketch in Nanette's letter to Peggy suggested that the animals were presented in a style reminiscent of the drawings of animals that had recently been found in prehistoric caves.[53] Nanette, much impressed by a good deal of the Hearst mural, was less than enthusiastic about Calder's addition of some three-dimensional elements. She thought it was a "cheap though amusing idea" to include "a small wire holding a peanut below the elephant's trunk." And she mentioned disapprovingly the real grapefruits and oranges attached by wires at various points, though she probably meant

wax or plaster fruit. All in all, Nanette, who had gone to the Hearst apartment to pick up the palette, brushes, and paints her son had left behind, was impressed. "He has a grand funny bone," she wrote to her daughter, "+ is a devil for doing it and letting it go at that—not mincing matters." That was quite a deft analysis of Calder's quicksilver brilliance.[54] Years later, recalling the Hearst commission in his autobiographical notes, Calder couldn't resist one of his awful puns: "Painting in a Jungular vein."[55]

Calder had hoped to make $500 from the job, although Nanette thought he deserved $1,500. Hearst seemed inclined to argue about what the work was worth, so payment was delayed, although Calder received some sort of remuneration after his return to France. Soon after, the Hearsts redid the room and the mural was no more. It had been Nanette's impression during Calder's last months in New York that he was anxious to make some money, so he would have a cushion when he returned to France. She told Peggy that he seemed to have come back from Boston and his little adventure with the Harvard Society for Contemporary Art with a bit of cash. He talked about paying back the $200 he owed his parents. Nanette also thought she had overheard him on the phone telling Bill Drew that he had sold a sculpture of a camel for $500. By March, it did seem that he had made some sales, mostly of wood sculptures, and so he booked passage on a Spanish freighter, the *Motomar*, planning to head to Paris via Barcelona, where he meant to look up his new friend Miró.

In what state Sandy was leaving things with Louisa isn't clear. Was he already pressing her to marry him? Was she hesitating, enamored but unable to quite accept so dramatic a departure from the world she had grown up in, however much that world might bore her? Or was it already agreed that in the fall she was going to cross the Atlantic herself and rendezvous with him in Paris? What we do know is that when the *Motomar* left from Brooklyn on March 10, Louisa was not there to see Calder off. Nanette was there, with a crate of oranges and other fruits for her boy. And Louisa's sister Mary came to say good-bye. Actually, when Nanette and Mary arrived at the dock, the person who had still not appeared was Sandy. This gave Nanette a chance to explore the boat. His cabin, next to the officers' dining room, seemed comfortable, with two portholes, three berths, and one closet, although the bathroom, way off, Nanette reported, was a "dirty thing." Nanette met the Spanish captain, who spoke a little English and more French. She was given a glass of Malaga wine, which she enjoyed.

Finally Sandy appeared with his big load of luggage. But where, one wonders, was Louisa? Was she angry? Was she afraid that it would be not a temporary good-bye but a permanent one? We don't know. She did send

along a box full of edibles to help sustain him on the trip. It's interesting that when Calder wrote about that season in his *Autobiography,* some thirty-five years later, he remembered very clearly that Louisa hadn't been there to see him off. It would seem that matters between them had not yet been settled.

VILLA BRUNE

I

In the dozen months after the *Motomar* left New York Harbor in March 1930, Calder became an abstract artist and a married man. These were the two most important decisions he ever made, the foundations on which he would build for the rest of his life. He might flirt with an attractive woman or even pinch a bottom, but nobody ever said that he was unfaithful to Louisa. And he might draw or sculpt figures and animals, for book illustrations or the series of sculptures called *Critters* from near the end of his life, but his commitment to abstraction remained fundamental and in many respects changeless. Some will say there is finally no way to adequately explain how so much could happen in so short a span of time. Some will say it's enough to point out that Calder turned thirty-two in the summer of 1930, and that for such an enormously gifted young man it was now or never. What everybody can surely agree is that by the time Calder's first exhibition of abstract sculpture opened at the Galerie Percier in Paris in April 1931, his own artistic biography could no longer be separated from the history of the art of his time.

Calder's supremely adventurous decade began with what was by now a familiar kind of adventure, though one he still savored. He was on a ship crossing the Atlantic. On the *Motomar* he was experiencing Latin culture, if not for the first time in his life, then more intensely than he had before, while traveling with a boat full of student officers. He was somewhat confused by their speech, which didn't match the entries in the Spanish dictionary he had brought along. He wondered why they were greeting him with *"Bon día"* rather than *"Buenos días."* Although he was already friends with Miró—and had studied Spanish, at least to some extent, at Stevens—he was perhaps as yet unclear as to the existence of Catalan as a separate language.[1] Spain in general and the Catalonian culture of northern Spain more specifically

Calder. Cow, *1930. Bronze,*
5¾ x 8 x 3⅜ in.

would become serious interests of his and Louisa's in the next decade. They
traveled all over the country; he met young Spanish architects and artists
emboldened by the founding of the republic in 1931; he made a fountain for
the Spanish Pavilion at the 1937 International Exposition in Paris; and with
Francisco Franco's triumph and the end of the republic, he and Louisa pro-
vided a welcome for the film director Luis Buñuel and other exiles in New
York. It was on the *Motomar* that Calder first encountered blood oranges,
eggs fried with garlic and olive oil, and salt cod, which troubled his stomach
but which he regarded in retrospect with some nostalgia.[2]

The boat was bound for Barcelona, but during a quick stop in Málaga,
on Spain's southern coast, Calder was enchanted by the brilliant greens
and purples and the striking arrangements of the vegetables and fruits in
a shop. He had already glimpsed something of Latin culture on his brief
visit to Panama City, when he was on his way to visit Peggy and Ken in
Washington State; he never forgot what he later described as "the tropical
architecture, the buildings seeming to have no exterior walls, only supports
+ floors, and only occasional curtains or screens."[3] After arriving in Bar-
celona and getting his luggage through customs—the circus now filled five

suitcases, and the customs inspectors seemed curious about his records and phonograph—he checked into the Hotel Regina, where the simplicity of the interiors, with stark white walls and red tile floors, made quite an impression. That strong, clean look shaped Calder's ideas about interior space. A few years later, when he and Louisa bought their old farmhouse in Connecticut, he whitewashed all the walls, as he put it in the *Autobiography,* "as per the permanent teaching of the Hotel Regina in Barcelona."[4] The undiluted colors of the south—green and purple vegetables and fruits, red tiles, white stucco walls—answered a need in Calder for full-force expression, not only in Spain but later on, after the war, during trips to Brazil, Venezuela, and Mexico. Calder had hoped to make contact in Barcelona with his great new friend Miró, but he was nowhere to be found. Calder attended a bullfight and then headed straight for Paris.

Back in what was now at least as much his home as New York, Calder was emboldened by a regular monthly check of at least fifty dollars from the Gould Manufacturing Company and decided to rent a more substantial studio. He settled on one of eight studios on villa Brune, a sort of alley on the farthest edge of the Fourteenth Arrondissement. Another artist who lived there, the English painter and printmaker Julian Trevelyan, recalled it in his memoir *Indigo Days* as "a little backwater from the busy life of the quarter."[5] The studios fronted on a steep bank, below which ran the tracks of the Petite Ceinture, the circular rail line constructed in the nineteenth century just inside the old fortifications to link the city's great railway stations; the line finally closed in 1934. Trevelyan remembered the tracks as lined with acacias and recalled that behind the studios there was "some sort of home for the aged, where little black figures could be seen walking round asphalt paths amongst the strangely pollarded plane trees. Occasionally a great chimney amongst the buildings would start to belch a pall of heavy black smoke, probably at the time that some vast communal meal was being cooked, though one of my friends was convinced that the authorities periodically burnt the bodies of the excessively old inmates when they became a nuisance."[6]

Villa Brune was certainly remote from the Parisian hurly-burly, although the excitement of La Coupole, La Rotonde, and the other Montparnasse cafés was a comfortable walk or bike ride away. The Petite Ceinture gave villa Brune some of the quality of an urban industrial artifact, and that sense of a rough, picturesque nineteenth-century leftover would have appealed to Calder. At one end of the street there was a bronze-casting outfit, the Fonderie Valsuani, where Calder soon cast in bronze a series of small plaster studies of figures and animals—including a horse, a cow, a cat, and an elephant. These casually, fluidly modeled little objects marked yet another excursion

into the old world of closed sculptural form by this artist who had already begun to conquer the new world of open sculptural form. A couple of the acrobatic figures—one standing on its head and another with its feet in the air—have some of the liquidity of Stirling's smaller studies, which may, in turn, owe something to Rodin.

It's not clear exactly how Calder found his way to villa Brune and the cluster of studios mostly occupied by young, English-speaking artists. Calder commented in his *Autobiography* that next door there was an American sculptor, Adrien Alexander Voisin, who was a couple of years younger, had studied at the École des Beaux-Arts, and was already making a name for himself with rather conventional studies of wild animals and Native Americans; one imagines he took advantage of the Fonderie Valsuani. Calder wasn't pleased when the concierge, whose face he described as "like an enormous piece of chewing gum," informed him that Voisin was "really somebody." When Calder responded that he was also somebody, the imperturbable concierge announced, "Oh! Every one of us is somebody."[7] Voisin wasn't Calder's kind of artist. But the habitués of villa Brune in the year during which Calder lived there, roughly from March 1930 to April 1931, included a number of artists more to Calder's taste. The international cast of characters featured the Englishman Julian Trevelyan, the Italian painter Massimo Campigli, and two American painters, Vaclav Vytlacil and William Einstein. Another painter who was part of their group in the early 1930s was Maria Helena Vieira da Silva, a South American who was at the beginning of a highly distinguished career and would remain a friend of Calder's.

II

Calder was settling into his new studio when he received a telegram from a wealthy friend, Rupert Fordham, with whom he'd sometimes skied and who owned the studio on the rue Cels where Calder had lived before he'd sailed back to New York on the *De Grasse*. Fordham was in the Mediterranean with his thirty-five-foot sailboat, a German beauty built of teak. He planned to explore Corsica and was in need of a crew member in a hurry. Calder couldn't resist. Fordham, at least in Calder's account, sounded a bit hapless. Sandy wrote to his parents that Fordham "never can remember where he has left a thing, nor what disasters happen to books, jam, victrola records, etc, when one puts to sea without securing them."[8] And to Noguchi, who knew Fordham, Calder observed that although Fordham had owned the boat for only two months, "he had managed to get it quite dirty."[9] Fordham had already

gotten into a bit of trouble with the marine police because of his peculiar style of navigation, and then shortly after Calder's arrival he damaged his rudder on the cable of a big dredge boat. Of another well-to-do character who was somehow involved in this Mediterranean escapade, identified as Dechert, Calder complained that "he has no resources whatever—except those in the bank."[10] Such were the trials that came with having wealthy friends.

The couple of days' excursion around Corsica was a pastoral idyll, with glorious weather. They explored the northwest corner of the island, which Calder told Noguchi he found "very handsome."[11] The island, in the Ligurian Sea, closer to Italy than to the French mainland, had long been part of the Republic of Genoa, before a brief period as a republic and then conquest

Calder. Necklace, 1930. Brass wire, ceramic, and cord; loop: 15¾ in.; element: 2⅝ x 1⅜ in.

by France in 1769. When Calder visited, it was still off the beaten track, although already explored by a generation of bohemian tourists who were eager to acquaint themselves with underappreciated corners of the Mediterranean world. Corsica is mentioned in *The Rock Pool*, the young English writer Cyril Connolly's 1936 novel about foreigners rather aimlessly whiling away their time in the South of France. Naylor, the underemployed protagonist of Connolly's novel, is chatting with an attractive bohemian who turns out to be some sort of baroness. He asks her why she's drinking a particular liquor. "Oh," she responds, "I learnt to drink it in Corsica." "When were you there? I know Corsica," Naylor says. "This spring." "I was at Calvi." "Oh, yes, Calvi is very mondain."[12]

Corsica, however *mondain*, was still quite primitive. That was part of its

TOP *Antoni Gaudí's Parc Güell in Barcelona, completed in 1914 and open to the public in 1926.*

ABOVE *Calder. Ring, c. 1930. Brass wire and ceramic, 1½ x 1¼ x 1 in. Made for Joan Miró.*

appeal. Calder was delighted to come upon a farmer in the midst of harvesting the wheat, where "there was a circular space paved with big stones, on top of which the wheat was being pitched, and a horse was running around in a circle dragging a big stone. The horse's driver was himself seated whip in hand on a donkey—quite an assembly." Calder was offered a glass of wine by the farmer but felt too abashed to accept. In Calvi—the town dates back to the Middle Ages—he was fascinated by a public toilet atop the thirty-foot-high fortification wall. "Its housing and a twenty-foot beam," he recalled, "on which people sat, overhung the wall—plumb over a thicket of cacti."[13] Walking along the Corsican ramparts, Calder found broken bits of blue pottery, which he collected and later set in brass wire mounts as if they were precious gems to compose a ravishing necklace, which he gave to his mother for her sixty-fourth birthday. Looking at that necklace, one wonders if Calder, while briefly in Barcelona not too long before, had gone to see or at least seen photographs of Gaudí's Parc Güell, with its famous benches and balustrades made of mosaics of brilliantly colored broken crockery; they were much admired by Miró. Not very much later, Calder made a large ring for Miró that contained a blue porcelain fragment.

Calder's Corsican excursion with Fordham was supposed to end in Saint-Tropez. On the way back to the French coast, however, the rudder that had already been damaged ceased to respond. Calder, ever resourceful, improvised an alternative, rigging a big oar over the side with an arrangement of ropes. But because of Calder's imperfect navigation, which certainly wasn't helped by the improvised rudder, they ended up some forty-five miles northeast of Saint-Tropez, in Villefranche-sur-Mer, near Nice. Calder took a room in the Welcome Hôtel. Cocteau had made the hotel famous a few years earlier; the smell of opium was said to pervade the place. The hotel attracted bohemians, including the writer Georges Hugnet, who would become a friend of Calder's, and Neo-Romantic artists such as Leonid Berman and

Christian Bérard. When Francis Rose, a painter Gertrude Stein took under her wing, had his seventeenth birthday party at the Welcome Hôtel, Isadora Duncan arrived in her Greek tunic with her dance pupils from her studio in Nice. Glenway Wescott—who as we have seen was a friend of Frances Robbins's—recalled "impromptu dressing-up, processions, fireworks. Cocteau wore beautiful pajamas and dressing gowns."[14]

The Welcome Hôtel was right on the quay. Calder was awakened by sunlight, the voices of fishermen, and the noise of the nets being put in place at five a.m.[15] Whatever reputation for decadence the hotel had, it was its informality that appealed to Calder. Many of Sandy's friends and acquaintances, including Pascin, Man Ray, and Brancusi, had vacationed in the area. Mary Butts, who had brought Cocteau to see the circus, also spent time in Villefranche. Calder told Noguchi that he "met Mary Reynolds—Marcel Duchamp's lady—who is a swell

Calder letter on stationery of the Welcome Hôtel, Villefranche-sur-Mer, 1930.

dame, and who has a little villa"; they had already crossed paths in Paris.[16] Although Calder might still have been a little shy about accepting a glass of wine from a Corsican farmer, he certainly knew his way around bohemian France. One night he got a lift back to the Welcome in the Lancia of the New York art dealer Val Dudensing, whose shows of Picasso and Matisse and others at the Valentine Gallery were familiar to Calder. Dudensing and Calder were acquainted—the dealer had seen a performance of the circus—but as Calder recalled, "he always seemed to patronize me rather than take me on into his stable."[17] However casual his clothing and unpretentious his manners, Calder never had any trouble rubbing shoulders with the beau monde. He enjoyed stylish people and eagerly joined hands with them in life's grand game, especially if they were smart, funny, and open-minded. But the people with whom he became closest, however fun-loving they might be, were the dreamers who were also very much doers, optimistic but levelheaded, with an appetite for hard work.

III

Louisa James and Helen Coolidge in Ireland, 1930.

While Calder was exploring Corsica in the summer of 1930, Louisa was exploring another island culture, this one to the north. Whatever her understanding with Sandy had been when he left New York in March, by late July Louisa had crossed the Atlantic again and was writing to her mother from County Galway, where she was beginning a bicycle tour of Ireland with a friend, Helen Coolidge. The crossing, she reported, had been dull, "but now we are here and the excitement begins"—how much excitement, it would seem, her mother was never exactly told.[18] Louisa and Helen spent August with their bicycles, mostly in the countryside, indulging an appetite for off-the-beaten-track adventures that would certainly not betray Louisa in the years to come. "On the way over to Aran," she wrote in one letter, "the boat stopped at the smaller islands to collect the cattle for the fair and it was terribly exciting to watch them tie the bulls and the cows on the beach and then pull them through the water." Of the Galway Fair, she wrote that "the square is jammed with cows, bulls, and sheep, and such muck under foot! However it's very amusing and very smelly. . . . We hate to leave Ireland and will miss it terribly."[19] In Dublin, they spent a beautiful night sailing down the Liffey. They went to see the painter Jack Yeats, a brother of the poet and later much admired by Samuel Beckett. Both Louisa and Helen bought paintings. "They were expensive," she wrote her mother, "but I thought it would be a good way to spend my Christmas money and although I had never heard of him before he is a very well known Irish painter and his work will undoubtedly increase in value." The painting she bought was called *Jaunting Car.*[20]

Arriving in London at the end of the first week of September, Louisa and Helen went to five hotels before they found a room in a place that was "awfully nice small and attractive," just the sort of situation Louisa thought her mother would like. She and Helen were heading for Paris the next day.

To her mother, Louisa mentioned her plans to see Pauline Cauchie; she had been her governess years before and remained a friend. But she said not a word about Sandy Calder. What was clear was that Louisa was in a hurry to cross the Channel. She and Helen had decided to fly from London to Paris, still an unconventional choice in 1930. She explained to her mother that it "isn't so terribly expensive and we will be safely there by the time you get this."[21] In Paris, she put up at the Hôtel Foyot on the rue de Tournon—where Mary Butts had stayed for a time. Mere steps from Place Saint-Sulpice and the Luxembourg Gardens, the Foyot was identified in a 1929 guidebook as not one of the fanciest hotels but a very good, very comfortable Left Bank establishment, with a fashionable restaurant on the premises. It was maybe a thirty- or forty-minute walk from villa Brune. Calder met her at the hotel. And after that the record—at least the record from letters that have survived—is very thin.

Hôtel Foyot, Paris, c. 1910. Photograph by Eugène Atget.

Sandy and Louisa were now alone together in Paris. And fairly uncommunicative. Perhaps that was all anybody needed to know. The more one contemplates that silence—of course, there may have been letters home that were lost—the more it seems to reflect a degree of intimacy in the months before their marriage that they were reluctant to publicize, certainly then and probably even later. We know that Louisa spent something like six weeks in Paris. We don't know if she attended any of the circus performances Calder gave that fall. We can be sure that whatever sense she had had the winter before in New York that Calder was a rising star was confirmed by everything she saw in Paris. Whether or not she was familiar with the names of some of the avant-garde eminences—including Le Corbusier and Mondrian—who visited villa Brune that fall, she could see that something was afoot. She may have still been in Paris at the end of October, when Calder exhibited nine works at the Association Artistique les Surindépendants in the Parc des Expositions in the Porte de Versailles.

Louisa and her friend Helen were eager to plunge into Calder's bohemian world. As somebody who had spoken French from the time she was a child, Louisa didn't have the language barrier that stumped so many Americans. Although almost nothing is known about Helen Coolidge, we do know that

she made friends among the artists who lived on villa Brune. The year after the Calders married, she went with them on an excursion to Brittany, a place for which Louisa would develop a great affection. Some five years later, when William Einstein, one of Calder's neighbors on villa Brune, was back in the United States and another friend asked Calder what Einstein was up to, it turned out to be Coolidge who was in touch with him.

IV

Where exactly Louisa and Sandy were in their conversations about marriage isn't easy to say. Louisa, in a draft of a letter to her mother composed when she was back in New York in November, said that she had been "receiving letters and cables that I must come immediately"; she felt she couldn't keep him waiting any longer.[22] In his *Autobiography*, Calder did remark that after "Louisa decided to go home . . . it took a lot more correspondence before we decided to get married."[23] When Sandy wrote to Noguchi in late November—Louisa had already been back in New York for a few weeks—there was no mention of marriage. Nanette, however, on the eve of the wedding, speculated to Peggy that Louisa "would have stayed and married him then—but consideration for her mother and the promise to Mary to share the apartment [in New York that winter]—she told me she would have stayed over—before I knew of marriage."[24]

Sometime that fall, at least according to Calder's sister, there was a letter from Sandy's friend Bill Hayter in Paris; the family had apparently asked him to find out what was up between Sandy and Louisa. (It is unclear how the Calders knew Hayter; perhaps they were acquainted through his wife, with whom Calder was friends from their time together at the Art Students League.) Hayter reported that "Sandy is to be married." He also reported that when he questioned Sandy about Louisa, he remained "noncommittal." Had Hayter met Louisa in Paris? Was Calder keeping her from some of his friends during the time she was in Paris? We don't know. Perhaps Hayter had met her but hadn't had a chance to really get to know her. "Finally," Hayter explained, "I asked, 'What does she do?' 'She's a philosopher,' he replied."[25] At some point in her teens or twenties, Louisa had thought of becoming an artist. But a philosopher was what she would become. Louisa was the philosopher of Alexander Calder's creative and imaginative life, the contemplative spirit in whose profound gaze he realized himself as an artist.

The crisscrossing reports as to when Louisa and Sandy finally decided

to tie the knot are probably impossible to disentangle or decode. Sandra, Louisa's older daughter, although admittedly thinking of her mother as she knew her many years later, grew up believing that even at twenty-five Louisa James was a woman who knew her own mind. That was probably what Louisa herself was remembering when she said to some close friends—of her younger daughter Mary's marriage at the age of twenty-two—"I guess she knows what she is doing as she has been thinking about it for nearly a year now—I was twenty-six when I married and no one knew what a wire sculptor was."[26] My feeling is that it hadn't taken Louisa very much time to realize that Sandy was the man of her dreams. I suspect she'd realized *that* by the time she and Sandy disembarked from the *De Grasse* the summer before. But turning her dream into a reality took a little longer. However unconventional Louisa might have been, when confronting the question of marriage she was also very much a young woman from a fine Boston family, and aware of all the considerations that came with her place in the world. Sandy's prospects were at best uncertain. His family had no significant financial assets. And although Louisa and her parents had as little religious prejudice or anti-Semitic feeling as anybody in their social circles, it must have entered into Louisa's considerations that she would be marrying a man whose mother was Jewish. For her, that may have meant nothing more than that he was different from her. To accept all the differences took a little time.

The most we will ever know about Louisa's thinking comes from a draft of a letter to her mother that she wrote that November. We don't know if she ever sent it. Louisa had just come in from a polo game, which she had attended with "a not particularly entrancing young man"—presumably a man of her own class. She had decided that she was "sick to death of going out with one person and another that don't interest me." What followed were the most heartfelt words she would ever commit to paper about Sandy: "I am sick of it chiefly because the only person that amuses me and has amused me for the last year and a half, is Sandy. The only thing to do to my mind is to make it permanent, and get married, and the sooner the better. I can't make him wait any longer, as it's already been almost a year, and I shall not be able to accomplish anything myself until I get really settled. To me Sandy is a real person which seems to be a rare thing. He appreciates and enjoys the things in life that most people haven't the sense even to notice. He has ideals, ambition, and plenty of common sense, with great ability. He has tremendous originality, imagination and humour which appeal to me very much and which make life colorful and worthwhile. He enjoys working and works hard, and thus ends the summary of his character. However he is getting impatient and I don't see how I can keep him waiting, if I have definitely

decided to get married. Helen after seeing him a week in Paris thinks he is just the person for me and she has excellent judgment. If you want any first hand information ask her. The thing that you <u>must try and understand</u> is that it <u>can not</u> drag on."[27]

V

Even as Louisa was taking the starring role in Sandy's life, the rest of the dramatis personae were changing, too. By the time Calder had left Paris in the summer of 1929, he felt that he belonged to "quite a gang." But when he came back, he could see that the gang was different, although in his *Autobiography* he was vague about the changes. He remembered there being among his friends or at least among his newer friends a rejection of their old preferred hangout, the Café du Dôme, in favor of La Rotonde, which was right across the street.[28] The Englishman Douglas Goldring, a friend of Mary Butts's and acquainted with other people Calder knew, recalled that at the Dôme there was "a tradition of hostility against 'the place opposite' "—which would have been the Rotonde. Allegiances were always complexly intertwined and hard to parse, as the artist Julian Trevelyan, Calder's neighbor on villa Brune and a little later a figure among the English Surrealists, sagely remarked in his memoirs. Trevelyan argued that "it has never been useful to talk about new trends in Paris; there are just new individuals and occasionally new groups."[29] In the next months, Calder became involved with a great many new individuals and at least one extraordinarily important new group, Abstraction-Création.

Calder was leaving behind the picturesque bohemian world where he already felt at home. Stirling's old friend Pascin, the author of the first catalog statement about Alexander Calder, had committed suicide in June, while Calder was still in the States. This man who had once upon a time been dubbed the "prince of Montparnasse" was a victim of alcoholism and depression. Some believed that his funeral, which had reportedly been attended by hundreds if not thousands, signaled the end of an era. The bohemian circles in which Calder was now moving were shaking off the picturesque fripperies and frills of an earlier time. Before leaving Paris the previous summer, Calder had made his first profound connection with the avant-garde, when he became friends with Miró. The artists he was getting to know tended to be less self-absorbed than old-style bohemians such as Pascin and Foujita. They were determined to build a community of creative spirits who shared certain ideological and philosophical principles and artistic ideas and ideals.

They were avant-garde in the deepest sense of the word: they were looking to the future. They wanted to bring to an end five hundred years of representational painting and sculpture. Their mission, a very great one, was to totally unravel the symbiotic relationship between naturalistic appearances and artistic inventions that had shaped Western art since the Renaissance. Not long before Calder's return to Paris in March 1930, two important, albeit short-lived, organizations for the advancement of abstract art were founded in Paris, Cercle et Carré (Circle and Square) and Art Concret. Calder was soon friends with many of the artists who were involved. They included Jean Arp, Jean Hélion, Wassily Kandinsky, Piet Mondrian, Michel Seuphor, Joaquín Torres-García, Theo van Doesburg, and Georges Vantongerloo. Some were in their twenties, some considerably older. Many of them had had key roles in developing ideas about abstract art over the previous fifteen years in France, Russia, Germany, and Holland.

Although Calder didn't have an especially high opinion of some of the painters who had studios on villa Brune—and it isn't entirely clear how much their time there overlapped—my guess is that the gang on villa Brune probably shared more interests and experiences than Calder later cared to admit. Of William Einstein, known to his friends as Binks, Calder had very little to say and that by no means admiring; he dismissed Einstein's interest in Mondrian and Léger as a "smattering of knowledge" mostly picked up from books—which wasn't fair.[30] Binks was a chubby, amusing young man. He hailed from St. Louis, had some sort of a trust fund, and was a distant cousin of the photographer Alfred Stieglitz. After he and his wife returned to the United States in 1933, Einstein worked for Stieglitz in his gallery, An American Place, and helped Georgia O'Keeffe organize a show of John Marin's work at the Museum of Modern Art.[31] Binks Einstein was probably always more of a follower than a leader. That wouldn't have endeared him to Sandy, who admired independence above all else. Of Julian Trevelyan, Calder left no clear impression. Trevelyan and Vaclav Vytlacil, another American with a studio on villa Brune, may have struck Calder as being, like Einstein, all too willing to take the role of the student or the disciple, whereas Calder was already beginning to be regarded as a somebody—*le roi du fil de fer.*

But Calder had a way of absorbing everything that was going on around him. Einstein, Trevelyan, and Vytlacil may have taken the plunge into abstract art a bit before Calder or at least at the same time as him—and they may have shown him a thing or two. Both Einstein and Trevelyan (who arrived on villa Brune some months after Calder) studied at the Académie Moderne, a school whose very name probably struck Calder as an oxymoron. The painter Amédée Ozenfant, the moving force at the school, advocated

a codification of Cubist principles that many in the avant-garde, including Picasso and Braque, regarded with skepticism. Nevertheless, the Académie Moderne—where Fernand Léger, who would soon be a good friend of Calder's, also taught—had become a gathering place for artists from other parts of Europe who were embracing a radical abstract art. Among Calder's books there remains a much-thumbed copy of the 1928 edition of Ozenfant's *Foundations of Modern Art*, a sort of history-cum-manifesto in which Calder would have encountered key works by Duchamp and Picabia, two artists with whom he soon enough shared various affinities. Whether Calder's neighbors were leaders or followers, there can be no question that abstract art, in all its variety, was a rallying cry in the studios on villa Brune.[32]

There was also a great deal of fun to be had on villa Brune. If the old-style bohemia and the new-style bohemia had one thing in common, it was their fondness for partying and hilarity. One of the artists living on villa Brune for whom Calder retained the warmest feelings was Massimo Campigli, who according to Trevelyan was "a great organizer of parties"—they were often costume parties—"that generally ended in orgies." Campigli was beginning to paint what Trevelyan referred to as his "Etruscan-looking heads," the stylized and stylish impressions of women for which he became famous, at least in Europe. If some letters he wrote in the 1950s are any indication, Campigli had an easy grasp of English, which was the language in which life in the villa Brune studios was generally conducted. And what a life it was. The artists would sometimes, Trevelyan recalled, "hire a bal musette orchestra, accordion and drums, and dance until the small hours." Sandy and Louisa were certainly up for that. In later years, they would from time to time bring jazz musicians from New York up to their home in Roxbury, Connecticut, to play at dance parties. Calder was glad to later boast to a correspondent or two that some of his and Louisa's guests had gotten caught up in sexual shenanigans in the Roxbury bedrooms or pond, although Sandy and Louisa remained above the fray. In case anybody imagined that the studios on villa Brune were occupied only by men, Trevelyan remembered "a group of beautiful six-foot American girls living in the studios," one of whom was discovered one morning "asleep in the dustbin, into which one of her boyfriends had pushed her the previous night after an argument."[33]

VI

One of the very few artists Calder met around that time who could match his own discipline, drive, and esprit was the dazzlingly bright, gifted, and

ambitious Jean Hélion. Six years Calder's junior, Hélion was physically smaller than Calder, a lean fellow, but like Calder tousle-haired and casual, with the kind of easygoing and unpretentious manners that were a breath of fresh air after the affectations of much of the Parisian avant-garde. It didn't hurt that Hélion spoke English with a confidence that was unusual among the French. Hélion was born in Normandy; his father was a taxi driver. As a teenager, he studied organic chemistry and then, after arriving in Paris in 1921, had worked as an architectural apprentice. His early involvement with disciplines as rational as chemistry and architecture would have appealed to the rationalist in Calder. By the same token, Hélion would have been interested in Calder's early studies in engineering, especially at a time when Mondrian, an artist both men fervently admired, said that he envied the position of the engineer, who "devotes his life exclusively to construction, and . . . creates pure relations by sheer necessity."[34] In 1926, Hélion met Joaquín Torres-García, who

Calder and Louisa Calder in Jean Hélion's studio in Paris, 1933. Clockwise from top left: Hélion, Anatole Jakovsky, Louisa, William Einstein, and Calder. On the table is an egg-laying bird created by Calder.

was beginning to produce subtle, earthy abstractions that joined Mondrian's strict orthogonals with signs and symbols that evoked his South American roots. Torres-García—whose toys Calder may have been aware of back in New York—gave Hélion his entrée into the Parisian avant-garde.

When Hélion and Calder met, Hélion was already romantically involved with a young American woman, Jean Blair, whom he married at her family's home in Virginia in the middle of 1932; there's an uproarious letter from Hélion to Sandy and Louisa, describing the wedding and Hélion's somewhat startled encounters with his bride's distinguished Virginia clan. Like Louisa, Jean was a woman with bohemian inclinations who hailed from an old American family, though in her case Confederate rather than Yankee, and without the ameliorating eccentricities of the Jameses. Jean had a sister, Louise, who was also pursuing the bohemian life in Paris. It was at Louise's

wedding to Pierre Daura, another artist in the circle of Torres-García, that the French Jean met the American Jean. Hélion lived in the United States for periods of time in the 1930s and 1940s; he advised the important collector Albert Gallatin and had an impact on younger American abstract artists. In the 1930s, Calder and Hélion exhibited with the same groups; they helped each other ensure that their work was seen; they reported back and forth about the critical reception of the new abstract art in the United States, England, France, and the rest of Europe. Hélion's connections with young abstract artists in England eased the way for the appearance of Calder's work in London a few years later. Calder saw after the storage of some of Hélion's work in the United States. Many years later, Hélion remembered how Calder had suspended his wire portraits from the ceiling, so that they cast striking shadows as they moved—creating, one imagines, a kind of protocinema.[35]

Calder and Hélion were lifelong friends, both in France and in the United States. They met as the optimism of the pre–World War I years, only partly revived in the 1920s, was once again turning to pessimism amid the darkening perspectives of the Depression. Both men were bullish about the future, or at least about their own futures—which made for a powerful connection in a time of ever-growing doubt. Abstract art, although still fervently embraced, had lost much of its messianic glow and ideological force. No wonder both Calder and Hélion rejected the stranglehold of ideology and insisted, throughout their lives, on the freedom to cross stylistic lines. Calder bristled when his work was labeled as Surrealist. Hélion, years later, was startled and perhaps also amused to hear André Breton, the ringleader of the Surrealists, who was by all accounts opposed to the pure geometric art Calder and Hélion were doing in the early 1930s, suddenly praise the abstract movement. Breton explained that pure abstract art, when judged "amidst the disorder and smugness of the times, stood as a surrealist act."[36] If abstract art could be counted Surrealist, then anything could be anything else—which was perhaps a good thing, a sort of liberation.

Calder, whatever his allegiance to abstraction, never hesitated to draw figures, create sculptures of birds and fish, and incorporate unabashedly vegetal shapes in his mobiles. Hélion, meanwhile, made a turn toward representation in the 1940s that would forever remain controversial among many of his old friends. He emerged after the war—and a period in a German prisoner-of-war camp that he wrote about in a book, *They Shall Not Have Me*, published in English in the United States in 1943—with extraordinary street scenes and interiors, by turns lyric and perfervid. This work developed a small but fiercely loyal following among painters and writers, including the poet John Ashbery, who once remarked in the international edition

TOP *Calder.* My Shop, *1955.*
Oil on canvas, 48 x 60 in.

LEFT *Jean Hélion.* Studio,
1953.

of the *Herald Tribune*, "Hélion is not just one of the great figurative paint-
ers; he is one of the greatest painters of any kind today, in my opinion."[37]
Although Hélion's rich and variegated achievement has been the subject of
some major museum shows in Europe, he has never received the widespread
acceptance that admirers such as Ashbery wished for him. Meanwhile, of
course, Calder has become among the most widely admired artists of the
twentieth century, his name familiar to museumgoers on every continent.

But in the early 1930s, Calder's great international fame was as unimagi-
nable as the great triptychs of French street life that Hélion painted in the
1960s and 1970s. What the men shared was a joyful restlessness, two adven-
turesome spirits in turbulent times. What exactly Calder thought of Hélion's
later work, we don't know; it seems that he was skeptical. But a 1955 painting
by Calder of the interior of his studio, with canvases arrayed helter-skelter
near a brown stove, will bring to mind, at least for those who are familiar
with Hélion's later work, some of the interiors he did of his big Parisian
studio in the early 1950s—paintings that Calder may well have known. In
the decades after the war, when Calder came into Paris from his home near
Tours for appointments, he would sometimes stop for a rest or a nap at the
apartment near the Luxembourg Gardens where Hélion was living with his
third wife, Jacqueline. Returning from the bathroom one day, Calder con-
fessed with some embarrassment that he'd tugged so hard on the toilet-paper
holder that it had come out of the wall. He asked Jacqueline if there was any
wire in the house. There was. And Calder proceeded to whip up a toilet-
paper holder that is still in use, some fifty years later.[38]

MONDRIAN'S STUDIO

I

Not long after settling in on villa Brune, Calder wrote to his family that he was planning to "shut up the [circus] and am going to leave it there for a long time as it hinders my work."[1] This may come as a surprise to those who know the *Cirque Calder* from the Whitney Museum of American Art, where it has been on more or less permanent display since 1971 and has become one of the best known, if not the best known, of his works. The truth is that Calder spent much of his life trying to "shut up" the circus. In the early 1930s, his interests were moving elsewhere, and by the end of the decade, there were only occasional circus performances, generally associated with a gathering after an opening or a get-together at the Calder house in Connecticut. By the 1950s, Calder wasn't eager to submit his bulky frame to the workout required to mount a full performance.

But however much Calder might have wished to be done with the circus in 1930, it was not to be. There was, in fact, a series of performances on villa Brune—and plans for even more. The previous May, the editors of *Vogue* had come to see the show and had arranged for him to run it again at their studio and have photographs taken. Some performances in the fall, as Calder wrote to Noguchi in November, had been precipitated because "all my American debtors seemed to fail me—so I felt stumped." He ran four nights of the circus, charging twenty-five francs (or about one dollar) a head, and made one hundred dollars, with an audience of forty people twice and only seven one evening. He had "bought some large planks and with my tables + boxes + stairs was able to arrange quite a decent theatre—for 40."[2] He had help selling tickets from a broker on the Champs-Élysées. Some neighborhood concierges and others seemed annoyed about the ruckus his visitors created, so Calder was thinking about hiring a hall around Christmastime and trying another performance with the help of the broker.

In October 1930, the architect Frederick Kiesler, a man of consequence in artistic circles on both sides of the Atlantic, suggested a group of half a dozen or so people he thought might want to see the show. The result was a couple of performances that are among the most important Calder ever mounted. Suddenly Calder found himself face-to-face with the crème de la crème of the new Parisian avant-garde—which was a thoroughly international avant-garde. Kiesler's list included the painters Léger, Mondrian, and Van Doesburg, the architect Le Corbusier, and the important critic Carl Einstein. During the performances, Calder had scant time for conversation and no time for reflection, busy as he was getting the show up and running. His impression was that these formidable figures weren't having an especially warm response—or, indeed, any response at all. They certainly weren't smiling. Clearly, they were tough customers. Years later, Calder said that only Van Doesburg seemed to have a sympathetic reaction, while Léger, Mondrian, Le Corbusier, and Carl Einstein said little or nothing, at least nothing Calder remembered. Calder wouldn't have been intimidated by that; he wasn't one to be intimidated. If they struck him as stern, it was because for them, art was an altogether serious business. And Calder—who by his own testimony was eager to shut up the circus and move on—was prepared to be taken seriously.

Did Calder's new acquaintances sense the rigorous geometries and cool, elegant ironies that fueled the *Cirque Calder*? Did Mondrian, who could be rather sphinx-like and was beginning to be recognized as the supreme master of a cool, elegant, rigorous art, see the *Cirque Calder* in that light? We don't know. Calder wouldn't have known, either. He was so little aware of the various avant-garde attitudes, friendships, and feuds of the day that he inadvertently almost provoked a social disaster when he invited everybody for the same night. How on earth could he have known that Van Doesburg wasn't on speaking terms with somebody or other? Although Van Doesburg and Mondrian, pioneers of the Dutch avant-garde, had earlier fallen out over Van Doesburg's use of the diagonal in his paintings, that argument had been patched up by 1930. Such strictly artistic arguments were cooling as the rise of totalitarian regimes endangered all artistic innovation; the difference between a ninety-degree angle and a forty-five-degree angle paled when the most basic human freedoms were imperiled. Calder thought the problem was with Carl Einstein, or perhaps Léger, but it was also possible that the problem was with Le Corbusier, who in the *Europa Almanach* in 1925 had complained that Van Doesburg was "lost in fantasy and arbitrariness."[3]

Léger might have been expected to take an interest in the *Cirque Calder*. Perhaps he did and Calder didn't know it at the time. Like Calder, Léger was

physically imposing, remembered by their mutual friend John Dos Passos as "a hulk of a man, the son of a Norman butcher. He seemed to me to have a sort of butcher's approach to painting, violent, skillful, accurate. Combined with this was a surgeon's delicacy of touch that showed up in the intricate gestures of his hands."[4] Calder, of course, was also admired for the intricate gestures of his hands—which were very much on display during a performance of the circus. Léger was friends with the Fratellini brothers, the clowns for whom Calder had made the mechanical dachshund; he had done an ink drawing of the brothers in 1920 and had also designed some Cubist costumes for them.[5] Calder may have been aware that Léger had already constructed a geometric marionette representing Charlie Chaplin for his 1924 film *Ballet mécanique;* Léger's Chaplin performed a delicate dance, a movement experiment not unrelated to certain elements in the *Cirque Calder.* Whatever Léger's immediate reaction, he and Calder were soon good friends.

Perhaps Van Doesburg's enthusiasm for the circus was fueled by the same taste for absurdist amusements that had a few years earlier drawn him into the orbit of the Dadaists. In 1922, Van Doesburg had declared, "Art is play, and this game possesses its own rules. As former art generations played with nature, so new artists (for instance Dada artists) play with the machine."[6] Van Doesburg was very interested in the possibilities of movement. In a lecture published in the magazine *De Stijl* in 1922, he spoke about film as striving for "the new plastic expression . . . by means of a combination of the elements of space and time."[7] Hélion later recalled that Van Doesburg "had ideas about suggesting a fourth dimension by opposing diversely oriented cadences."[8] The connections between abstraction, movement, and the fourth dimension were much discussed in avant-garde circles. The *Cirque Calder* was a puppet show, but it was also an experiment in motion, the three dimensions of space thrust into the fourth dimension of time. That couldn't fail to interest painters, sculptors, and architects who saw the future of art as a kinetic future. But the men Kiesler urged Calder to invite to see the circus on villa Brune were battle-tested veterans of the avant-garde, and for the time being they had no reason to believe that Calder was anything more than a skirmisher in the artistic wars in which they were engaged.

Years later, Calder recalled that Binks Einstein, who ran the phonograph for the circus, "made the acquaintance of everybody during the intermission, while I was busy setting up for the next half."[9] Calder left the impression that Einstein had somehow gone behind his back, using the *Cirque Calder* performance as an opportunity to get himself invited to Mondrian's studio. But it could also be that Calder, less inclined than Einstein to look to his elders for guidance, wasn't all that eager to make what amounted to a pilgrimage.

Coming Soon
THE ART SENSATION of NEW YORK!
TO GREENWICH VILLAGE!

"QUINTESSENCE OF CINEMA"

FILMS – Distinctly Artistic
MUSIC – Ensemble a Moderne
PRESENTATIONS – Light – Color – SILENCE

THE FIRST 100%
CINEMA
– unique in design –
– radical in form –
– original in projection –
conceived – executed by
FREDERICK KIESLER

OPENING
IN
EARLY
JANUARY

FILM
GUI...

*Frederick Kiesler, in front
of the placard for the
opening of the Film Arts
Guild Cinema, New York,
c. 1929–30.*

In the *Autobiography*, Calder observed that Einstein returned from his visit to Mondrian's studio and "recounted marvels."[10] At that point, Calder's curiosity was piqued. He decided that he would go and see for himself what all the fuss was about. What he saw changed his life.

II

But before we turn to Mondrian, there is more to be said about Frederick Kiesler, who precipitated Mondrian's visit to the *Cirque Calder*. When Calder mentioned Kiesler in his *Autobiography*, published the year after Kiesler's death in 1965, it was only as a man who "was having a fling with my circus" in the fall of 1930.[11] Kiesler was far more important than that. He was offering a helping hand as Calder turned away from the old gimcrack bohemian world and looked for support among the movers and shakers of the abstract avant-garde. Kiesler was born in Romania in 1890 and studied in Vienna. He was one of those men whose very short stature only seemed to concentrate and intensify his energies. Nowadays, when Kiesler is remembered at all, it's for designing the interiors of Peggy Guggenheim's Art of This Century Gallery in New York in 1942, with its curved walls, biomorphic "Correalist" furnishings, and paintings suspended on wires or thrusting armatures so that they seemed to float in space. Twenty years later, in collaboration with Armand Bartos, he realized another highly idiosyncratic architectural vision, the Shrine of the Book in Jerusalem, which houses the Dead Sea Scrolls. Kiesler struck Calder's friend Hélion as being, along with two other barrier-breaking artists, the Hungarian László Moholy-Nagy and the Dutchman Van Doesburg, "something like engineers of vision."[12] Such a possibility would have certainly interested Calder.

Kiesler emerged in the 1920s in Berlin as one of the most important avant-garde stage designers of the day. He brought not only to theatrical design but also to exhibition design a new freedom in the way figures and objects were located in space. His "electromechanical" set for Karel Capek's play

about robots, *R.U.R.*, staged in Berlin in 1923, was the stuff of legend on account of its imaginative use of lights and moving elements. One night at the stage door of the theater, Kiesler was met by Kurt Schwitters, Hans Richter, Moholy-Nagy, and El Lissitzky, who took him off to meet the architect Mies van der Rohe. Kiesler's *Space Stage*, for the 1924 "International Exhibition of New Theater Techniques" in Vienna, was an openwork spiral structure that has come to be regarded as a significant contribution to the development of theater in the round; the curved volumes of the Shrine of the Book were a much later realization of related themes. While Kiesler may have yearned to complete more architectural commissions than he ever actually did, he did have an extraordinarily varied career. In the late 1920s, he designed the Film Arts Guild Cinema on Eighth Street in New York's Greenwich Village, in which the entire building became "a plastic medium dedicated to the Art of Light." He also published a book about contemporary design in which he spoke of a city where "we will have NO MORE WALLS" and there will be "Liberation from the ground."[13] From 1934 to 1957, he was director of scenic design at the Juilliard School of Music in New York. He designed the American premiere of Sartre's *No Exit* in 1946. And he enjoyed a growing reputation as an artist in his later years, beginning in 1952, when his sculpture was included in the Museum of Modern Art's "15 Americans" exhibition, which also featured paintings by Jackson Pollock, Clyfford Still, and Mark Rothko.

It was apparently the composer Edgard Varèse, about whom we will be hearing more, who first introduced Kiesler to Calder, although exactly when and where is unclear. Kiesler had been living mostly in the United States since 1926, so it seems likely they crossed paths in New York, perhaps when Calder was there in the fall and winter of 1929–30, if not earlier.[14] Calder might well have seen the "International Theatre Exposition," which Kiesler organized at the Steinway Building in 1926; we've considered that possibility already. What is certain is that Kiesler was moved by the kinetic elegance and wit of the *Cirque Calder*. Years before, Kiesler had run a marionette theater in his apartment in Vienna. Adolf Loos, a Viennese architect, wrote of Kiesler's experiments with a theater in the round that he had used "the circus form" to create a " 'stage space,' which carries in itself the seeds of a revolution in staging methods."[15] Kiesler himself, writing about store and window design in the late 1920s, spoke of "a dream of a kinetic window."[16] And in 1928 in the magazine *De Stijl*, he called for "a system of tension in free space" and "the detachment from the earth, the suppression of the static axis."[17] These comments suggest some of the possibilities that Kiesler saw in Calder's work in the fall of 1930. The possibilities became realities in

the abstract sculptures and mobiles Calder began producing a year or two later.

By the time Calder mentioned Kiesler in his *Autobiography,* many people no longer remembered what a force he had been. In the 1950s, Kiesler sorely tried Calder's patience with what can only be described as envious outbursts. He wrote to Calder that he was being "quite obnoxious" and that "it is about time you changed your ideas about me and my work"—a comment that he immediately hastened to modify, remarking that Sandy shouldn't "take that too seriously."[18] To this Calder responded—no doubt frustrating Kiesler all the more—that it was the architect who was being unfriendly. He offered Kiesler and his wife, Steffi, another invitation to the Calders' place in Connecticut, and wondered if Steffi had received the brooch he made for her.[19]

III

Calder would never forget his visit in October 1930 to Mondrian's studio at 16 rue du Départ, just off the boulevard du Montparnasse, a few minutes' walk from villa Brune. Over the years, he wrote repeatedly about the experience. That visit "was like the baby being slapped to make his lungs start working," Calder explained in notes written for Malcolm Cowley in the 1950s. He further commented that it "gave me the shock that converted me."[20] A decade later, in the *Autobiography,* he described it as "a bigger shock, even, than eight years earlier, when off Guatemala I saw the beginning of a fiery red sunrise on one side and the moon looking like a silver coin on the other."[21] For Calder, who hardly ever admitted to being in somebody else's debt, this salute to Mondrian stands out, all the more so considering the consistency and intensity with which he expressed his feelings.

We cannot say with any certainty what Calder knew of Mondrian's work before he visited him on the rue du Départ. Writing to the American collector Albert Gallatin four years later, Calder said that "my first impulse to work in the abstract came upon a visit to Mondrian's studio."[22] Some thirty years after that, in the *Autobiography,* he argued that before his visit to Mondrian's studio, "I did not consciously know or feel the term 'abstract.'"[23] This is a statement that bears close examination. It beggars the imagination to think that Calder was unfamiliar with abstract art—or the term *abstract*—in the fall of 1930. Only a simpleton could have spent as much time in artistic circles in New York and Paris in the 1920s and remained as unaware of abstract art as Calder sometimes suggested he was—and Calder was anything but a simpleton. I believe Calder's meaning becomes clear only

when we shift our focus from the word "know" to the word "feel." Whatever Calder may have known of abstract art or of Mondrian's art before visiting Mondrian's studio—and I think he knew a lot—he didn't have a feeling for a pure abstract art. He hadn't yet experienced abstract art viscerally, immediately, with all his heart and soul. Which brings us back to the comment he made in his notes for Malcolm Cowley, about the baby being slapped to make its lungs work. The slap doesn't give the child its lungs or the capacity to use them; the slap sets in motion a process that's inherent but not yet unleashed. Mondrian didn't make Calder a great abstract artist, but he awakened the possibility—he unleashed it.

Mondrian was two years shy of sixty when Calder met him. He'd lived on the rue du Départ before World War I; he'd gone back to Holland during the war, returned to Paris in 1919, and reclaimed his place on the rue du Départ in 1921. The entrance to his studio—it was also where he lived—was in a little courtyard on a street immediately adjacent to the Gare Montparnasse. Both the extension of the street and the structures in which Mondrian lived dated from after the expansion of the railroad in the decades around 1900. The building in which Mondrian had his studio was demolished in the late 1930s to allow for further rail expansion. Although Calder's place on villa Brune was more rural than Mondrian's on the rue du Départ, they were both situated next to rail lines. Mondrian apparently savored the rough-and-tumble environment; the Mexican painter Diego Rivera, who had a studio in the same complex, did a number of paintings that included views of the railroad tracks. Mondrian's apartment had a curious setup, with the bedroom in one structure and the studio, irregularly shaped, a few steps up in what was a different but conjoined building.

In the 1980s, a Dutch researcher by the name of Frans Postma managed to recover the floor plans of the building on the rue du Départ in the Archives de Paris. Working with those plans—as well as memoirs and photographs, many by André Kertész, who also photographed the *Cirque Calder*—Postma reconstructed the five-sided studio room, with windows on two sides. The odd shape of the studio was part of its magic, the violation of the rectangular shape one would ordinarily have expected creating surprising spatial and visual dislocations. That magic echoes again and again in letters and memories of the period. Michel Seuphor, an artist and critic and Mondrian's first biographer, recalled, like so many others, the shabbiness of the building and the shock upon coming from a dark entrance into the light-filled studio. "When you entered, it was still dark, but when you went through that second door [from the bedroom to the studio], when *that* opened, you went from hell to heaven. Beautiful! It was incredible."[24] Arthur Lehning, a left-wing

Piet Mondrian's studio,
26 rue du Départ, Paris,
1926.

Dutch political writer, also recalled the studio as "extraordinarily bright."[25] Maud van Loon, a sometime journalist, remembered that it was "marvelous . . . like stepping into paradise."[26] And another Dutch journalist called it "a geometrically perfect space, dancing with vivid colors."[27] Louise Daura, Hélion's American sister-in-law, wrote home to her family that Mondrian's studio was "as interesting as his paintings."[28]

Calder remembered that irregular space as "a very exciting room."[29] The studio enlarged—magnified—the spirit of the artist and his art. What struck Calder wasn't so much the paintings—there weren't many on display—but the light and the whiteness of the space, all the furniture painted white or black, the Victrola redone by Mondrian in red, and the broad back wall and the other walls with rectangles of various grays and colors arranged here and there. Calder wasn't looking at paintings so much as he was walking into a painting. It was, as Lehning said, "a Neo-Plastic space," meaning a

space entirely defined by Mondrian's Neo-Plastic principles. These were the principles he had developed in his painting and his writing, where all of artistic experience is distilled into images built of vertical and horizontal lines and primary colors and black and white. Standing in that astonishing studio, Calder at last understood where the increasing simplicity of his own wire sculpture had been leading him. It was much more than an understanding. It was a feeling. Calder could now see himself working in the abstract.

Mondrian's studio was animated by the power of rectangles of primary colors to convey emotions and intensify experiences; he had been thinking and writing a great deal about architecture and how painting might finally expand and almost dissolve into architecture. Louise Daura told her family that "with all of those colors at their maximum intensity, the proportion of each in reference to the whole was so perfect that it was at once gay and restful."[30] Calder called these walls of rectangles Mondrian's "experimental stunts with colored rectangles of cardboard tacked on."[31] He said, "It was hard to see the 'art' because everything partook of the art. Even the victrola had been painted so as to be in harmony. I must have missed a lot, because it was all one big decor, and the things in the foreground were lost against the things behind. But behind all was the wall running from one window to the other and at a certain spot Mondrian had tacked on it rectangles of the primary colors, and black, gray + white. In fact there were several whites, some shiny some matte."[32] Here abstract art became a visceral, wraparound experience.

Calder, imagining that there might be even more dynamic movement in the room, suggested to Mondrian "that perhaps it would be fun to make these rectangles oscillate." Calder may have been thinking of attaching the colored shapes to motors, as he himself would do in some works over the next few years. That abstract forms might be set in motion and even in rapid motion was an idea that Calder was most likely aware had been considered, if not pursued, in writings, films, and sundry experiments by Léger, Man Ray, Van Doesburg, Naum Gabo, and Moholy-Nagy. But Mondrian, with what Calder recalled as "a very serious countenance," replied, "No, it is not necessary, my painting is already very fast."[33] Mondrian was right. What Calder recalled as the "simplicity and exactitude" of Mondrian's studio was in fact the vehicle for a propulsive power, a mysterious dynamism provoked not by the obvious mechanics of motors but by rectangles thrust into visually dynamic relations within his light-filled, five-sided room.[34] This was what Mondrian, in his essay "Plastic Art and Pure Plastic Art," called "the dynamic rhythm" of "inherent relationships."[35] Calder sensed that dynamism, even if he didn't yet fully understand it.

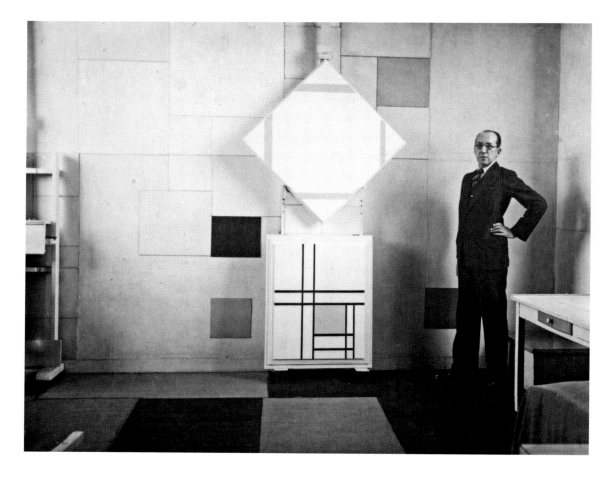

Piet Mondrian in his studio, 26 rue du Départ, Paris, 1930.

The speed Mondrian referred to was the speed with which the eye perceives counterpoised forms—the speed, for example, with which a red form and a blue form can be grasped by the eye as a dynamic relationship. Photographs of Mondrian's studio over a period of years show how the arrangements of rectangles changed. An issue of the magazine *Cercle et Carré*, published at the end of June 1930, included two photographs of the back wall of Mondrian's studio, taken in 1925 and 1930. Over a period of five years, Mondrian filled the wall with many smaller rectangles, creating a dance of forms not entirely unlike the dance of forms in the mobiles Calder produced a decade later. Calder sensed all of this, as he later explained to Edna Warner Allen, who, along with her husband, was a serious collector of Calder's work and who left a record of his table talk. "After I'd made a great many circus acts," Calder told her, "I started making simple forms instead of objects in order to capture the motion. Ha Ha! Most people don't know what it's about, but some people understand. Mondrian did, and we talked about our art. He had insight. He told me to stick to primary colors; and I needed to know that.

He told me he saw my line quiver. Mondrian loved Boogie Woogie music and he tried to put that on canvas."[36] It was these various kinds of speed—the literal speed that abstract film and some early experiments with kinetic sculpture had brought into art, as well as the implicit speed of Mondrian's stripped-down compositions—that came together in Calder's work of the next few years.

Piet Mondrian.
Composition with Red, Blue, and Yellow, *1930.*

IV

But there was something else about Calder's experience in Mondrian's studio that was important. That was Calder's sense of the uniqueness of Mondrian's position and of Mondrian himself. Thin, bespectacled, and carefully dressed, Mondrian was a paradoxical figure. He was emotionally reserved but also loved to dance. He was a loner who stood at the head of a movement. A generation later, Hélion wrote that "that lovable, gentle and

Calder. Untitled, 1930. Oil on canvas, 39¼ x 25½ in.

silent man has remained for me an example of the self-demanding artist whose devotion to his art shaped his life."[37] Hélion referred to Mondrian as "the real painter of absolute abstraction."[38] He was a revolutionary thinker who rejected the intellectual rabble-rousing and pugilism so often associated with revolutions—even revolutions in the arts.

By the late 1920s, Mondrian had reached the sparest expressions of his entire career, canvases of a strange, anti-voluptuous voluptuousness, the pure white plane interrupted by a very few vertical and horizontal black lines and a few rectangles of pure red, yellow, or blue. There were only a handful of artists in Holland, Germany, and Russia who had pursued an abstract art as irrevocably austere as Mondrian's. In Paris, he stood out as the most radical painter of them all, the purity of his art all the more striking in a Montparnasse where abstract art had never really taken hold; and, indeed, in the years after World War I, various sorts of representational painting were re-surgent. Mondrian's influence could be felt even in the work of Picasso, whose Cubism had electrified the Dutch artist a decade earlier but who now, in certain paintings of the artist in his studio, was echoing Mondrian's strict black horizontals and verticals and planes of primary color. Although opportunities to see Mondrian's work in public remained few and far between—he wouldn't have his first one-man show until he moved to New York in the 1940s—his work was reproduced in avant-garde journals, and his writings were occasionally published. In his essays he presented a thrillingly idealistic vision of what he called "pure plastic art." There was a Hegelian dialectical spiritualism about Mondrian's belief that the entire history of art was resolving into an irrevocably abstract expression. In Mondrian's magnificently

optimistic writings, the perfection of society and the perfection of art for art's sake somehow turn out to be one and the same thing.

It's fascinating that Calder, a pragmatist who never rejected natural forms, should have regarded the unabashedly idealistic Mondrian as a touchstone—perhaps *the* touchstone. In Mondrian's studio, Calder saw how the most complicated structures or forces could be generated from the simplest and most basic elements. Although Calder himself was only from time to time a pure abstract artist, he felt the power of Mondrian's purity, or perhaps what he really felt was the independence this purity represented. If Calder's first encounters with Miró, a year earlier, had suggested that an artist might delve into the world of the phantasmagorical and absurd to which the Surrealists had laid claim while

Calder. Untitled, 1930. Oil on canvas, 32 x 25½ in.

remaining entirely himself, Mondrian showed Calder how a near-total transformation of the nature of art could be mounted as a matter of personal expression, a sort of revolution of the self conducted within the self and for oneself.[39] Somewhere in the notes Nanette collected after Stirling's death, Calder's father had written that "art to be alive must be continually arriving at new forms. A new emphasis, born of a new insight into what life may be, and what we need to make it so, will open up to the future."[40] Mondrian's studio was Calder's opening to the future.

V

"So now, at thirty-two"—so Calder put it in the *Autobiography*—"I wanted to paint and work in the abstract."[41] His first attempts were paintings rather than sculptures—perhaps a bow to Mondrian, but also a return to

Calder. Untitled, 1930. Oil on canvas, 28¾ x 23¾ in.

his mother's art, which he'd embraced when he'd decided to become an artist back in Washington State, eight years earlier. Painting was once again the route into sculpture. For the rest of his life, Calder turned to painting when he wasn't intensely involved with sculpture, as a way of refreshing his imagination.

These paintings are spare and enigmatic. Most of them—there are fewer than two dozen—don't bring to mind Mondrian's canvases, in which the black lines extending from edge to edge assert the rectangle of the painting as a powerful, freestanding planar reality. Calder was already thinking about

abstract forms as they moved through a fluid three-dimensional space. If you want to find correspondences with what Calder was doing with paint and canvas in 1930, you might look to the free-floating rectangles of Kazimir Malevich, the angled forms of Van Doesburg, and the meandering landscape abstractions of Miró. There are even elements that suggest the canvases of the American abstractionist Arthur Dove, an artist much admired in the Alfred Stieglitz circle whose work Calder could have encountered in New York. In one of Calder's paintings, a small yellow disk hovers above a serpentine black line and a group of overlapping, sensuously curvilinear forms

Calder. Untitled, 1930. Oil on canvas, 36⅛ x 28¾ in.

in black, brown, gray, and white. In another, the vertical canvas is divided horizontally into two planes, one black and one white, and that's all there is, aside from a tiny white square situated deep in the black space. In a third canvas, there's a single line, which curves into the light and bends back into the shadows; in a fourth, white and black circles communicate across a diagonal arrangement of red, black, and white triangles.

You can feel in the blunt austerity of these images the thunderclap of Calder's visit to Mondrian's studio. In one canvas—with a thick black band extending from the top to the bottom of the rectangle and two shorter, narrower horizontal bars of black—Calder approached the particular discipline of Mondrian's Neo-Plasticism. But he never subscribed to Mondrian's exclusive use of black and white and the primary colors. He felt free to include in his paintings the circles, arcs, and biomorphic forms that he knew perfectly well had no place in the Neo-Plastic universe. There's something free and easy about these paintings, which are two or three feet in their longest dimension and which Calder was knocking off quickly, probably mostly in October and November. What you feel is that a lot of pent-up ideas—ideas about everything he'd been thinking about and seeing around him—were suddenly emerging on the surface of the canvas. Even before Calder headed back to New York in December, he seems to have been working out abstract ideas in wire. In his autobiographical notes, Calder observed, "It was Mondrian who made me abstract—but I tried to paint, and it was my love of making plastic things that turned me to constructions."[42] By "plastic," Calder meant what Mondrian meant. He meant *plasticity*—the way forms could be shaped and reshaped to transform the space around them. Six months later, Calder emerged in a Parisian art gallery as one of the most original sculptors of his time. *Le roi du fil de fer* was becoming an abstract artist. But first he had to go back to America and marry Louisa James.

MARRIAGE

I

Calder arrived back in New York on the *Bremen*, just three days before Christmas. He had four sculptures in an exhibition at the Museum of Modern Art, "Painting and Sculpture by Living Americans," which had opened at the beginning of December. The museum was little more than a year old. This ninth loan exhibition was an effort—as Alfred H. Barr Jr., the museum's director, explained in a foreword to the catalog—to present the

Calder. Cow, 1928. Wood, 12⅝ in. high.

work of thirty American painters and seven sculptors who hadn't been seen at the museum before. The exhibition included Stirling's old friend William Glackens; figures in the Stieglitz circle, including Arthur Dove, Marsden Hartley, and Charles Sheeler; and newer talents, including Mark Tobey and Stuart Davis, whom Calder had known in Paris.

Calder was represented by works in wood: *Cow*, *Stooping Girl*, *Man with a Hollow Chest*, and *Acrobats*. He was very nearly the youngest artist in the show. It was a significant honor. One wonders if Barr—who picked the show along with his friend Jere Abbott, the museum's associate director, and four trustees—had considered exhibiting any of Calder's wire sculptures. Perhaps they felt that the wire figures lacked gravitas. Whatever the reason, Calder was now moving beyond many of the concerns that shaped the work by which he was known in New York; *Cow*, reproduced in the catalog, had been carved in 1928. Calder may have felt that his appearance at the Museum of Modern Art, however exciting, was also something of a backward glance. Nonetheless, it was a highly auspicious debut, the beginning of what turned out to be a long and gratifying association with the museum. Six years later, Calder was commissioned to make a mobile to hang above the entrance to the museum on the occasion of Barr's epochal "Cubism and Abstract Art" show; his work was included in both that exhibition and "Fantastic Art, Dada, Surrealism," mounted the same year. Seven years later, he had a retrospective at the Modern. It hardly mattered that in 1930 the New Yorkers who had heard of Alexander Calder still regarded him as the comedian they had known a year or two earlier. Early in January, he ran five performances of the *Cirque Calder*, this time in a space on Fifty-seventh Street and Seventh Avenue, where he passed the hat to make a little money. "He is after jobs and money and his circus affairs," Nanette wrote to Peggy. "He has hopes of making a thousand in the next few weeks!!!!"[1]

Much of the James family was in New York for Christmas. The major exception was Louisa's father, who was in India working on *I Tell Everything: The Brown Man's Burden (a Book on India)*, his account of the cruelties and follies of colonial rule, the great movement for independence, and the place of Gandhi. *I Tell Everything*, with its graceful mingling of travel writing and political writing, remains an impressive achievement. Louisa's father would not be back for the wedding, and, indeed, in April 1931, a Chicago paper reported that he was involved with Indian extremists in Karachi. Writing to Peggy—who felt very much out of it in California and was desperate for some news—Nanette reported on all the goings-on with Louisa's mother and her sisters, Olivia and Mary. It was Mary, the sister with whom Louisa was always close, who had accompanied Nanette to the boat when Sandy

had left the previous March. Olivia's four-year-old son was reported to be very cute. When he referred to the toy French village Sandy had brought him for Christmas as a castle, Sandy made a drawbridge to complete the illusion. Sandy must have been reminded of his own fascination with King Arthur and the Knights of the Round Table all those years earlier in Pasadena. Nanette felt frustrated that she had no time alone with her son. Frances Gould, the singer with whom Sandy had been friends since his years at the Art Students League, had Sandy, Louisa, Nanette, Stirling, and some others over for a breakfast on Christmas Day. Nanette wore a medallion Sandy had made for her, a big circle of flattened wire with a stone in the center. Everybody seemed to be getting along famously. There were balloons, and Sandy blew up two and put them in Mary's sweater to comically enlarge her breasts. Another friend tried to make a bustle-like behind for her out of two more balloons, but one burst—"so there was only one cheek," Nanette reported.[2] For dinner, Sandy, Louisa, and Nanette went off to his old college buddy Bill Drew's; Nanette lingered after the meal, while Sandy and Louisa rushed off to her older sister's to see the tree.

Members of the James family at the home of Olivia's husband, Chanler Chapman, in Barrytown, New York, c. 1929. Olivia and Chanler are in the front; Mary is seated at the left in the second row; Louisa is behind Chanler; Edward Holton James is seated on the right.

To Peggy's most urgent questions—about Louisa, the woman her little brother was marrying—Nanette offered a detailed description. Her evaluation of the twenty-five-year-old Louisa, while somewhat restrained, was animated by a desire to think well of the woman who would soon enough be her daughter-in-law. "She is not enormous," Nanette began, "nor fat—medium I should say—athletic somewhat—fair—blue eyes—bushy brownish hair (the Drews say she looks Irish)." She commented that Stirling, who had already made a bust of Louisa, "thinks she is pretty. So she is." But perhaps it was a little hard for Nanette to admit it. "Their [Louisa's and Mary's] speech is Bostonese," she went on. "They lived in Paris seven years when they were little so their French is good. . . . They wear large felt hats like poke bonnets—very good coloring—pretty silk dresses—a little different from those I see." She commented that Louisa was taking singing lessons and had a good voice when they sang carols at Frances's. But Nanette was a bit mocking when relating that when Louisa explained that she was still learning to breathe and "can't sing yet," her "can't" came out as "kaant." She tried to get at the enigmatic quality of Louisa's personality—what Sandy had probably been referring to when he'd told Hayter she was a philosopher. "She is neither shy nor bold nor merry," Nanette observed, "but loves Sandy's jokes + Sandy's mauling—has I think a very clear head."[3] Writing to Peggy a few weeks later, just before the wedding, Stirling echoed Nanette, observing that "in character [she is] directly different from Sandy, who fascinates her, with his rough playfulness. She is rather reserved and undemonstrative—told me so when I embraced her as our new daughter. She is physically attractive and speaks very prettily, with an accent derived, she says from an early English governess. Also speaks French well enough to be able to laugh at Sandy's."[4]

Nanette felt sure that Louisa "will root for him and already has a buyer for one thing—maybe—she is self possessed having taken care of herself and gone her own way for years. Though she has not earned the money." To Peggy's questions about the right wedding gift—Nanette suggested a Chinese silk kimono, or perhaps a piece of Native American jewelry—she wondered whether Louisa would "ever fall in for the gay colors and exotic things we like." Here there was perhaps a hint of condescension, but only a hint. She told Peggy that Louisa "has nice manners and nice speech, and a good head." She was determined, Nanette added, "to have a little home that is comfortable + pleasant and expects to rent it in a quarter where the hoi polloi can't come in for a drink." Nanette, in summing up, told her daughter, "Am I happy about it—certainly and I am eager for the wedding."[5] Stirling added, in his letter to Peggy, "I think she is a very nice girl and should do your brother a lot of good."[6]

II

On the day of the wedding, January 17, 1931, Nanette and Stirling headed up to Boston on the train with Bill Drew, Sandy's best man. Stirling had been nervous about the trip, as he was deep in work on the clay model of his monumental statue of Leif Eriksson, destined for Reykjavík, and was fearful that the clay might freeze while he was away. But the trip up, in a private drawing room, which was Drew's idea, was "cosey," Nanette wrote to Peggy.[7] They were met at the Back Bay station by Sandy, who had mounted a circus performance the night before, and they drove to the Jameses' place in Concord. There they found Louisa, as Nanette recalled, "in all her glory of a new blue frock long train and tiger lilies white red spots," in the process of being photographed. Sandy, until being shooed away, was disagreeing with the photographers about precisely how Louisa should hold her head for the photographs.[8]

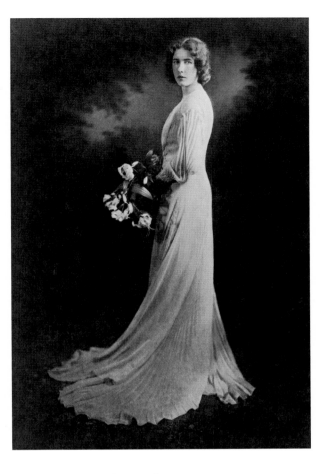

Louisa Calder on her wedding day, January 17, 1931.

Nanette was gratified by Louisa's sweet acceptance of the two gardenia blossoms she had brought her; she put them with the lilies in her wedding bouquet. Sandy had made Louisa a ring in the shape of a helix with a spiral on top; it was his first piece of gold jewelry, fabricated with the help of a jeweler in Paris by the name of Bucci. She regarded this as an engagement ring, so they had gone to Waltham and purchased a simple wedding band for two dollars. While Stirling and Nanette went off to change, Nanette into a yellow silk dress, Louisa had Sandy substitute a pair of black shoes for his brown ones, which his mother had been impressed to see he'd actually polished. To Peggy, Nanette described the wedding as attended by "forty eleven old dames"—"forty-eleven" being a comic term for a number one is not willing to determine. Helen Coolidge was Louisa's bridesmaid. Louisa's sister Olivia was present but not Mary, who was sick in bed in New York. The minister, upon asking Sandy what sort of a ceremony he wanted, had been told "anything you wish will be all right with me."[9] When the minister apologized for missing the circus performance the night

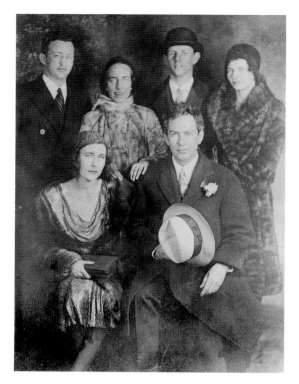

Calder and Louisa Calder with their wedding party, January 17, 1931. Bill Drew is standing to the left; Helen Coolidge is next to him.

before, Sandy replied, "But you are here for the circus, today."[10] The minister was in white. Candles were lit. And there was music on a piano, but not the traditional wedding march; this pleased Nanette. Nanette told Peggy that they "left out the blessing of the ring—but the 'I take + I will' were dutifully spoken."[11]

Afterward, there were tea sandwiches and plenty of ice cream. Then Sandy and Louisa, Bill Drew, Helen Coolidge, and two other friends of Louisa's went off together for a wedding dinner. It wasn't very good, Bill reported to Stirling and Nanette the next day on the train back to New York. It had lacked what Bill said was the most important ingredient: champagne. Meanwhile, Stirling and Nanette were left to fend for themselves with Mrs. James, who seemed to have planned nothing for dinner. She wasn't very domestic and usually depended on servants. But as she was mostly living in New York, there weren't any on hand. Perhaps the entire affair had seemed a little strange to the Calders, what with Mr. James off in India. Finally Stirling asked for some tea, and that and some bread and cheese was scrounged up. Nanette concluded that she hadn't especially liked Louisa's dresses, "though they were up to date + stylish."[12] As for her son, Nanette reported to Peggy that he had "behaved beautifully," although she worried that he hadn't given the minister more than a couple of dollars.

There was a photograph taken later the evening of the wedding, after Sandy and Louisa had had dinner with their four friends. They found a photographer's shop, and Helen offered to pay for photographs, although they didn't quite understand how expensive it was going to be. When shown one of the photographs the next day, Nanette declared it "terrible."[13] Seated in front are Sandy and Louisa. He's in an overcoat, with a flower in his buttonhole, holding his clean new hat; his face is open, youthful, frank. Louisa is seated next to him, in a print silk dress with a low scooped neck and a hat or a scarf on her head. Behind them are the four friends. Sandy and Louisa look hard into the camera. They seem affected, deeply affected, by what they've done that very day. Later that night at the James house there was a telephone call, with somebody asking for "Mrs. Calder." Louisa's mother went off to tell Nanette, not realizing it was the new Mrs. Calder who was wanted.

Sandy and Louisa spent less than two weeks more in the United States. There was a visit to Cold Spring Harbor, on Long Island, to see Jane Harris and her husband Reggie, an anthropologist; they had just returned from the Yucatán. They all went out dancing, but Jane found her husband slow on his feet, and Louisa complained to Jane that Sandy was "an exhibitionist."[14] One imagines she said it lovingly. Jane and Sandy, old friends, danced together, and Reggie danced with Louisa, and everything was all right. Reggie seemed to Nanette to have fallen a little in love with Louisa. At least that was her impression when she saw the two couples together in New York, where they all went to an Italian restaurant and an Italian marionette show. Perhaps Louisa was still easing herself into her husband's wild ways. There was no need to worry: Louisa and Sandy were going to dance their way through the next forty-five years.

III

By the last days of January, Sandy and Louisa were on the SS *American Farmer*, headed for France, less than two years after they had met on a ship headed for the States. They were roughing it, with uncomfortable bunks, but it must have hardly mattered and surely not only because, as Calder recalled years later, "there was all the ice cream you could stand."[15] Writing to her new in-laws from London—she signed herself "Louisa-Medusa"—Louisa observed that Sandy was having two to three helpings of pie at dinner and lunch and growing "visibly stouter." She had also gained some weight. They were reading *Moby-Dick* together. Sandy wrote to his parents that he liked the unpretentiousness of the boat, "especially, the simplicity of the furnishings etc.—it allows it to look really like a boat. The social hall looks like a parlour in a modest home somewhere out in New Jersey—but is comfortable + not full of rococo junk."[16] As they got near England, Calder spent several hours one night watching "the lighthouses, and the lights of other ships, and the men crawling up the ladder into the crows nest."[17] It was a smooth journey. "So far our married life has run smoothly," Louisa told her in-laws. "No storms at sea it must be a good omen."[18]

After a day or two in London, they were back in Paris, where they stayed for a couple of months in Calder's place on villa Brune. Calder's studio was downstairs; their bedroom was upstairs, right above the entrance, no doubt with a good view of the old railway line. It was fun for the newlyweds, playing house in the studio with the Campiglis, the Einsteins, Vaclav Vytlacil, and Julian Trevelyan nearby. The Campiglis, Massimo and his Romanian

wife, Magdalena, became close friends. The studio was rigged up with Sandy's contraptions for opening doors, turning on lights, and, supposedly, receiving coffee produced by the Einsteins' maid via a wire running from one window to another. One friend recalled years later that "an American flag waved every time the water closet opened and shut."[19] Trevelyan, who in his memoirs described Calder as "a big lovable American schoolboy with tousled hair who had never quite grown up," remembered the crazy contraptions in the studio, remarking that "often they failed to function, and he would have to hop out of bed to fix them. When I saw him last"—this may well have been after he and Louisa had left villa Brune—"he was making a machine for tickling his wife Louisa in the next room."[20]

Sandy and Louisa coped with bugs in a single cot bed he'd had for years. They ate at Romano, an Italian restaurant near the Comédie-Française, where they particularly liked the zabaglione, which they tried to make at home. The dish left them with quantities of egg whites, which they thought to save for some other recipe, only to find, as Sandy later recalled, "a day or two later, a hairlike mold arose over the whites—two or three inches high."[21] It was all part of the comedy of starting out on their own. Calder wrote to his parents about the cheerfulness of the entire setup. He described his "charming wife" as she was "munching a cheekful of bread, my back is leaning against the open window, and the bonne is clearing away the repas."[22] There were some Calder necklaces tacked to one of the white-painted walls, a black fireplace with some mimosa blooms on the mantel, cheerful Arabic curtains like ones Nanette had in New York, and a "gay red rug." Red would become a keynote in Calder's mobiles and stabiles. "In dining we put a large plank on 2 boxes, quite low, spread a cloth, etc. and sit on the Arab poufs right before the fire. And it really is lots of fun with all the giddy colours about."

Louisa, Calder told his parents, had even turned out to be quite a good cook. They both went to the gym three times a week. "I love it," Louisa wrote to Nanette. Their relationship was playful and physical. "I never get enough strenuous exercise," she went on to Nanette, "except when Sandy and I have tussels and he knocks me down, and I try to knock him down, which is a more difficult proposition."[23] There were a couple of circus performances in the apartment of their neighbor Binks Einstein. (In sending Sandy's letter on to Peggy, Nanette couldn't help interjecting in the margin: "Sandy in his happiness! circus.")[24] Louisa had bought a bike, and they took the train to Chantilly and biked to Senlis. There they visited Sam Chamberlain and his wife, the beautiful Narcissa. One Sunday in April, they went to see the Fratellinis' traveling show and stayed until two in the morning to watch the crew strike the tent—a deconstruction of space that excited

Calder, who later spoke of his admiration for the space inside the circus tent.[25] In 1925, while visiting Ringling Bros. and Barnum & Bailey Circus in Florida, he had made quite a few drawings of the circus tent, focusing on the structure of the tent itself. He was fascinated by the way these large spaces were enclosed, using a relatively small number of wood or metal poles and lengths of canvas that created curving, arching forms. The relationship between the poles and the canvas was dynamic—dramatic. And as the tent was taken apart, that dynamism gradually dissipated.

IV

Many expatriates were heading home, their finances already affected by the Depression. Calder found himself somewhat insulated from the unfolding economic collapse, for Louisa came not only from money but from a family whose wealth had been wisely invested. Although it's not entirely clear what Louisa's income amounted to in those years, the Calders' older daughter, Sandra, recalls a figure of $200 a month, without being sure exactly when that figure dates from.[26] Given that $200 in 1930 would be something over $2,750 today, and that a dollar would certainly go farther in France in those years, the figure makes sense. It would have allowed them, when added to whatever highly variable funds Calder was bringing in from his own work, a comfortable living. Nanette had observed to Peggy around the time of the wedding that they had received a good many checks, so they "won't starve the first year."[27] There had been talk of their buying a house, one supposes in Paris, for Louisa had received a "good sum" from her godmother, and another had been promised by her mother. Bill Drew, who was apparently already doing pretty well in the heating and cooling business, had also promised Sandy a significant sum. This was, Nanette explained, "so Sandy can hold up his end in their house purchase."[28]

In the end, they didn't buy a home. In May, back in Paris for some three months, they rented a three-story house on the rue de la Colonie; Calder converted the top floor into a studio. Louisa's old governess, Pauline Cauchie, had discovered the house back in February while looking for an apartment for herself and her husband. It was "too much for themselves," Calder recalled, "but just the right thing for Louisa and me."[29] Although the Calders' house at 14 rue de la Colonie no longer exists, much of that quiet street in the Thirteenth Arrondissement is still lined with comfortable single-family houses that suggest an early-twentieth-century bourgeois stability. It wasn't all that much farther from the hurly-burly of the Montpar-

nasse cafés than they had been on villa Brune. Writing to his sister, Calder described the house as "very nice," having "large squarish rooms with big windows; 3 stories high, the top being 2 studio + 2 small rooms, 2nd 2 large + 1 small + bath, + ground floor 2 large. And a small garden derrière."[30] There was some kerfuffle because the previous tenant hadn't paid all the rent he owed the proprietor, who was an old woman, and the Calders had mistakenly given to this tenant, who was some sort of shady character, money that ought to have gone to the proprietor. Writing to her mother on the third day of 1932, Louisa said they had gone to consult Ray Harper, apparently a family friend and a lawyer in Paris.[31]

The house, with its large windows, was wonderfully light. They painted almost everything white, with shiny black woodwork, the kitchen and bath a pale blue. There was an old yellow carpet for the runner on the stairs.[32] The look of the interiors was bright and a little stark, the sort of atmosphere that had enchanted Calder at his hotel in Barcelona and in Mondrian's studio. In his ever so casual way, Calder would always be very particular about the colors and furnishings and objects he lived with. Years later, he recalled how Louisa had bought for the rue de la Colonie house a pitcher that he found unpleasantly shaped. "Now, a *broc*," he explained to his friend the curator Jean Lipman (who also happened to be an important collector of American folk art), "is a beautiful thing of conical shape, tall and slender—and instead she had bought a pitcher, fat and dumpy. She said, 'You won't see these things anyway, because they'll be in the cook's room.' But I was furious, and took the two objects"—a pitcher and a bowl—"down to the cellar and drove a spike through each."[33] Something of the taste of the Arts and Crafts movement, which he had absorbed as a child in Pasadena, would remain with him to the end of his life, reflected in the simple wooden furniture and beautifully shaped functional objects he favored. Louisa bought a piano and, with a gift of $200 from her father, some nice rugs.[34] Calder reported to Mrs. James that Louisa was "working very seriously on the piano, and I bang away on an anvil, or any other thing of the moment, on the 3rd floor."[35] A few months later, Calder reported to his parents, "My wife is yodelling more strongly than usual. It carries all the way up to the studio."[36]

There are enchanting snapshots of the newlyweds, with their curly heads of hair, leaning out the windows of the house, which were ringed with ivy. The lovely garden, with its rosebushes, provided a playground for the animals they acquired, beginning with the little long-haired dog that they named Feathers. Feathers, Calder recalled in the *Autobiography*, "white with a gray head and two or three black spots, [was] very fluffy when dry. But when he'd been out in the garden in the rain, he shrank in size and resembled any nasty

OPPOSITE, TOP *Calder playing the harmonica in the rue de la Colonie garden, Paris, c. 1931.*

OPPOSITE, BOTTOM *Louisa Calder looking out the window, rue de la Colonie, Paris, c. 1932.*

little fox terrier."[37] They also acquired a black-and-white cat that was part Angora.[38] For a time they cared for a baby crow somebody had found. And there was a tortoise.[39] There's a photograph of Sandy sitting in the sun-dappled garden in a T-shirt, playing a harmonica. The garden became the setting for meals with a nearly endless series of friends. The Campiglis had what Calder referred to as a "stunt of cooking bullets of hashed mutton + Beef (mixed) over charcoal. We have done that twice in our garden."[40]

A Corsican maid named Madame Battini brought them breakfast in their bedroom and made lunch and then disappeared. Calder reported to his mother-in-law that Louisa was "getting every day to be handier in the kitchen. Last year it was creamed onions + Zabaglione—and now it is escalope de veau and gateau de riz."[41] Calder wrote to his mother asking for recipes for rice pudding, chocolate pudding, and *gâteau de riz,* finishing off with a "please" to rhyme with *"riz."* Sandy learned how to make polenta.[42] But he was already plagued by weight problems. "We live like rabbits," he told Mrs. James in one letter, "on lettuce + carrots," and to his parents he explained, "I am working and starving. Working in a gymnasium— and starving myself—as well as possible—at mealtimes. I have stomach trouble—(it's too big)."[43] As the years went by, Calder didn't try as hard to keep his weight down. He commented in the autobiographical notes he wrote for Bill Rogers twenty years later, "My friend Bill Drew has a covenant with 2 friends that they shall weigh-in on a certain day every year and pay forfeits to each other if they have gained. I suppose they still do this. But when I run into Bill, and he says I'm 'looking fine'—but, although I don't say it, to me he looks scrawny + pasty."[44]

Louisa's father and her sister Mary were slated to visit. When they arrived, Calder ran around with Mr. James, helping him meet people who might write reviews of his book about India. By the end of June, social life on the rue de la Colonie was in full swing. Louisa wrote home about entertaining a succession of Norwegian, Swedish, and Dutch friends or acquaintances. One

night the composer Edgard Varèse arrived, along with the opera singer Titto Buffo, and proceeded to prepare a delicious minestrone soup. Older figures in the art world came to dine, including the distinguished dealer Léonce Rosenberg. Rosenberg's Galerie de l'Effort Moderne was a major showplace for Cubist painting after World War I and in the early 1930s presented works by Picabia, an artist who interested Calder.[45] Another dealer who dined on the rue de la Colonie was John Becker, a young man with a gallery at 250 Madison Avenue in Manhattan. When the Calders weren't entertaining on the rue de la Colonie, Sandy and Louisa were entertained by the spectacle of the Parisian art world. They were at the vernissage for a Matisse exhibition in June. "It was very grand," Louisa wrote to her mother, "everyone in evening clothes and lots of amusing people to watch so that you were torn between looking at the pictures or the people."[46] Albert Barnes, the pioneering American collector of modern art, was there with, Calder told his parents, "a bunch of old Philadelphia hens."[47] So life went on for the next two years, until Sandy and Louisa returned to the United States to make a home in July 1933.

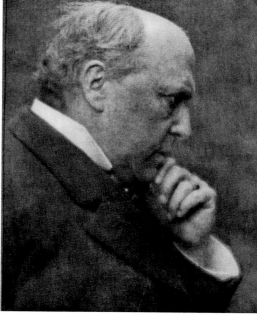

Henry James, 1906. Photograph by Alvin Langdon Coburn.

V

No history of the American artist's adventures abroad would be complete without a chapter on Alexander Calder. Of course, there were already quite a few chapters in that history by the time Calder came along, and some of the finest of them had been written by none other than Louisa's great-uncle, Henry James. Louisa herself, with her childhood years in France and months in her twenties spent searching for friendship and love in Paris, might be regarded as a latter-day Jamesian heroine. And the adventures of the man she married were every bit as much a continuation of James's transatlantic saga. This saga, which James explored in both his fiction and his nonfiction, often involved not only an American artist in Europe but, more specifically, an American sculptor in Europe.

Roderick Hudson, which James came to count as his first novel although it was actually his second, is the story of a young American sculptor who arrives in Rome and rapidly makes a reputation for himself. Roderick is

"impulsive, spontaneous, sincere" and strikes his great friend and patron, another young American, as a "rare specimen" who ought to be allowed "all possible freedom of action."[48] But the very freedom his gifts permit become Roderick's undoing, as he's unable to push forward after his first great success. He's overtaken by a strange kind of malaise. He dies, perhaps a suicide, in the Swiss Alps. Published in 1875, *Roderick Hudson* was based on James's experiences with a group of artists in Rome in the 1870s, among them the sculptor William Wetmore Story. After Story's death in 1895, James accepted a commission from his family to write a biography of his old friend. *William Wetmore Story and His Friends,* published in 1903, is composed in James's very ripest late style. Hidden amid the magnificently labyrinthine sentences of *William Wetmore Story and His Friends* is a warning about the dangers of the expatriate life—what James refers to as the "Borgia cup." "The fact that the conditions had verily," James writes, "since Claude, never, among the northern invaders, flowered into the grand style made little enough difference when they had begotten we may perhaps not say so many grand substitutes for it, but at least so many happy dreams of it, so many preparations, delusions, consolations, a sense of the sterner realities as sweetened and drugged as if, at the perpetual banquet, it had been some Borgia cup concocted for the strenuous mind."[49] By the time James was writing about his old friend, his sense of the dangers of the expatriate life had been underscored by his passionate friendship with a handsome young Norwegian-American sculptor by the name of Hendrik Christian Andersen, who was living in Rome. While James was for a time completely under the spell of Andersen's charm and dashing looks, he was far too clear-minded not to see that the young man's wildly ambitious statues were also utterly absurd.

The sculptor's struggle to extract life from inert clay or stone was something James saw as echoing his own creative struggles. James always felt a camaraderie with visual artists and sought their friendship; late in life, Stirling Calder fondly remembered a reception held in honor of James decades earlier at the Pennsylvania Academy of the Fine Arts.[50] Certainly nobody knew better than James that Europe, where the creative impulse was by many measures far more widely accepted than it was in America, could both embolden an artist and be his undoing. While for James the story of the young American artist in Europe was as often as not a story of thwarted dreams, fifteen years after his death his grandniece was marrying a sculptor who, although his art was nothing like the classical figure sculpture James's friends had done, flourished in the transatlantic world where Roderick Hudson, William Wetmore Story, and Hendrik Andersen ultimately floundered.

That such a fulfillment was possible James never doubted. In *The Ambassadors,* one of his latest and grandest novels, Lambert Strether, the American who has been sent to Paris to bring his fiancée's errant son home, has a revelation about the powers of artistic Europe that forces him to rethink his entire life. He has been taken to a reception at the home of Gloriani, a sculptor whose imposing presence James is said to have modeled on some combination of Whistler and Rodin. In Gloriani's garden, Strether experiences "the deepest intellectual sounding to which he had ever been exposed." He senses "the most special flare, unequalled, supreme, of the aesthetic torch, lighting that wondrous world for ever, or was it, above all, the long, straight shaft sunk by a personal acuteness that life had seasoned to steel?"[51] Nobody would ever describe meeting Alexander Calder in quite those terms. But in the recollections of people who visited Calder in the later decades of his life, whether in the United States or in France, there was a sense of their being wonderstruck, a sense that they were witnessing that same personal acuteness—and another supreme achievement.

That France might nourish such an achievement in ways that the United States could not was something that both Sandy and Louisa understood, although unlike many of James's protagonists, they never felt the need to ultimately choose between Europe and America. They would manage to live for decades on both sides of the Atlantic, literally American citizens but spiritually French citizens as well. Writing about Delacroix's letters, James reflected that France was "a country and a society in which an artistic career is, on the whole, held in more honor than anywhere else—in which the artistic character is more definitely recognized and more frankly adopted. In France the artist finds himself, ex officio, a member of a large and various society of fellow-workers; whatever may be his individual value, his basis or platform is a large and solid one, resting upon social position and social opinion. He has to make his work a success, but he has not, as happens in England, where the vivacity of the artistic instinct appears to have been checked in a mysterious manner by the influence of Protestantism, to justify and defend his point of view."[52] The France James wrote about was very much the same place where half a century later his grandniece and her husband found themselves happily at home in the summer of 1931. In the years and decades to come, Calder would be a commanding figure in that "large and various society of fellow-workers" of which Louisa's great-uncle had spoken with such eloquence.

VOLUMES—VECTEURS—DENSITÉS

|

The first exhibition of Calder's abstract sculpture opened at the Galerie Per-
cier, at 38 rue la Boétie on the Right Bank, on April 27, 1931, only a few days
before the Calders moved to the rue de la Colonie. The exhibition was called
"Alexandre Calder: Volumes—Vecteurs—Densités / Dessins—Portraits."

*The exterior of the Galerie
Percier, Paris, during
Calder's exhibition in 1931,
with his works displayed in
the window. Photograph by
Marc Vaux.*

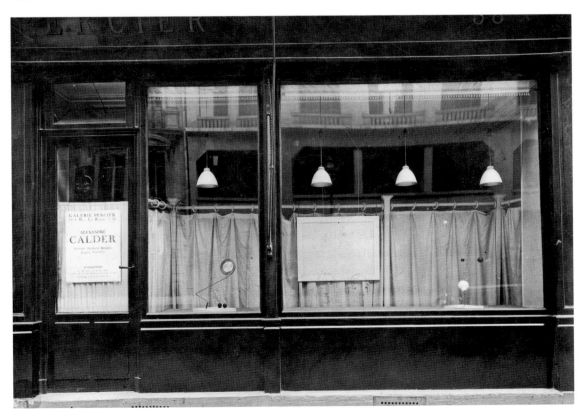

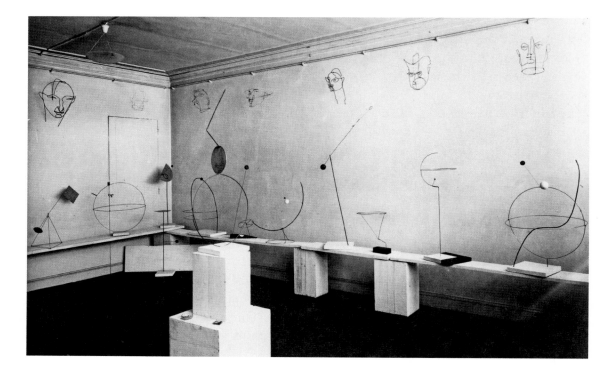

Calder's exhibition at the Galerie Percier in Paris in 1931. Photograph by Marc Vaux.

Although abstract sculpture had been shown at the Galerie Percier at least once before—in 1924 there was an exhibition by the brothers Naum Gabo and Antoine Pevsner—such work was anything but the norm in Parisian galleries or, for that matter, in galleries anywhere else in the world.

André Level, the collector and connoisseur who owned the Galerie Percier, was a figure of considerable distinction in the Parisian avant-garde. In 1904, he had organized La Peau de l'Ours, a consortium that purchased work by avant-garde artists ranging from Redon and Van Gogh to Matisse and Picasso and then auctioned it with great success at the Hôtel Drouot in 1914, sharing the profits with the artists. Level was on good terms with Picasso (who made a lithograph for the memoirs Level published in 1959); he built an important collection of Cubist paintings, wrote with distinction about African art, and was a friend and sometimes valued adviser to a wide circle of artists. In his *Autobiography*, Calder had little to say about Level, observing with some irony that the dealer had been bothered by the size of the breasts on the trapeze artist in one of Calder's line drawings. This made Level sound like a prude, although he may in fact have been objecting that trapezists were by and large flat-chested. Calder gave the impression that Level was hesitant to embrace the young American's abstractions. Apparently the gallery did insist that Calder include some wire portrait heads along with his new

abstract sculpture; the thought may have been that the portraits were more likely to sell. It's difficult not to feel that Calder was minimizing Level's role in his emergence as an abstract artist. Perhaps what irked Calder more than anything else was that he had had to pay something for the use of the gallery and for the catalog.

If visitors to the Percier exhibition lingered on the sidewalk before going in, what they saw in the window was a drawing on the theme of the circus, wire portraits of Louisa and Miró, and two abstract sculptures. Going inside, they found more wire heads high up on the walls—a rogues' gallery of Calder's bohemian world. The main event, however, comprised some twenty abstractions that Calder had produced in the months since visiting Mondrian. Nobody had seen anything like this before. And whatever Calder's dissatisfaction with André Level, the Galerie Percier was an altogether appropriate place for his barrier-breaking exhibition. The opening was a jam-packed sensation. A few days later, Louisa wrote to her mother, "The man who runs the gallery told Sandy he knew as many people as the President of France."[1] The fact that a widely respected dealer was giving the nod to Calder's first abstract works sent a powerful message to the small world of dealers in avant-garde art on both sides of the Atlantic. Calder was a figure who couldn't be ignored. Picasso, who lived down the street from the gallery, appeared even before the opening. Calder hadn't met him before. They never became friends, but their paths crossed over the years, most significantly in 1937, when Calder's *Mercury Fountain* and Picasso's *Guernica* were positioned just inside the entrance of the Spanish Pavilion at the Paris International Exposition.

Calder's presentation of his first abstract sculptures was simplicity itself, surely in part inspired by the white-painted furnishings in Mondrian's studio. Calder had brought to the gallery the long planks he used for benches for the circus performances in the studio on villa Brune. He mounted them on champagne boxes to create a low-lying platform that ran around the walls of the gallery, the entirety painted white, as were all of the wooden bases of the sculptures that weren't painted black. Each of Calder's pared-down compositions—the *volumes, vecteurs,* and *densités* of the exhibition's title—was a masterstroke. Never before had such sculptural force been expressed so concisely. The wire that had once articulated the muscular limbs and torsos of athletes was now turned to another kind of muscularity: the muscularity of vectors, volumes, and even voids. Calder had exchanged the erotic charge of a shot-putter or a gymnast, by turns cool and comic, for a cosmic eroticism. Calder's subject was nature's fundamental, animating forces. Although by many measures austere, these works were also strangely

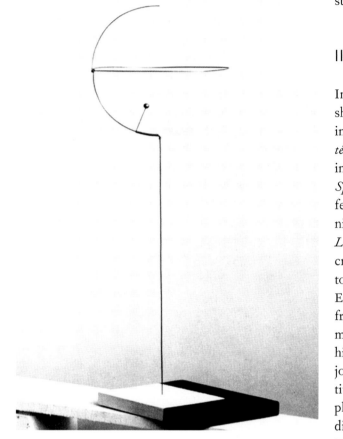

voluptuous—a voluptuous asceticism, if such a thing were possible.

II

In the catalog of the Galerie Percier show, the abstract works were gathered in groups entitled *Sphériques, Arcs, Densités,* and *Mouvements Arrêtés.* Most of the individual objects were titled *Sphérique I, Sphérique II, Arc I, Arc II,* and so forth. A few had metaphoric titles: *Féminité* (femininity), *La pomme de terre* (the potato), *La basse-cour* (the barnyard), *Croisière* (a cruise), and *Musique de Varèse* (a reference to the avant-garde music of the composer Edgard Varèse, who was becoming a good friend).[2] In later years, Calder sent some mixed messages about the importance of his titles. On one occasion, speaking to a journalist, he went so far as to assert that titles were no more important than license plate numbers—nothing but a means of distinguishing one object from another. The truth was more complicated. While

Calder. Sphérique I, *1930. Wire, brass, wood, and paint, 39⁹⁄₁₆ x 12¾ x 12½ in.*

some of Calder's titles were incidental or misleading—and not even created by the artist himself—others were highly significant. Never were Calder's titles more important than when he was first exhibiting his abstract sculpture at the Galerie Percier. The titles were keys that unlocked both the works in the exhibition and the fundamental principles of his work at the time—and the principles that guided him for the rest of his life.

When we add to the *Sphériques, Arcs, Densités,* and *Mouvements Arrêtés* of the Galerie Percier catalog the *Volumes* and *Vecteurs* of the exhibition's title, we have nothing less than a grammar of Calder's art. In his progressive simplification of the titles of the works in the show—a preliminary draft of those titles still exists—we glimpse both his largest ideas and his determination to frame them in bold but succinct terms. That probably explains why the title *Traverse en arc circulaire* was rejected; it threatened to offer a fixed interpretation of a work. Some of the discarded titles evoke travel. One of

them, *Invitation au voyage,* was an allusion to a poem by Baudelaire. Another, *The Moon and Sixpence,* referred to Somerset Maugham's novel about Gauguin, who, of course, traveled to exotic places. *The Moon and Sixpence* may also have interested Calder for another reason. Apparently Maugham borrowed the title from a reviewer of his previous novel, *Of Human Bondage,* in the *Times Literary Supplement,* who had commented that "like so many young men [the protagonist] was so busy yearning for the moon that he never saw the sixpence at his feet."[3] Calder would have been taken with that comparison between the moon and the sixpence—two shiny circular objects, the one minuscule and the other enormous, but both, seen from a certain perspective, appearing the same size.

Arranged on the long, low platform at the Galerie Percier were a group of skeletal sculptural objects that explored the nature of matter and movement, using the crisp but cryptic rhetoric of a poet rather than the cut-and-dried language of a scientist. Calder rec-

Calder. Croisière, *1931. Wire, wood, and paint, 37 x 23 x 23 in.*

ognized the beauty—a fresh, preternatural beauty—that could emerge from a focus on the fundamentals of form and space and the movement of form through space. It had been only a few months since he'd visited Mondrian, who would later write in his essay "Plastic Art and Pure Plastic Art" about *"the great hidden laws of nature which art establishes in its own fashion."*[4] Mondrian described "dynamic equilibrium," "dynamic rhythm," and the laws that informed relations of "position" and "dimension."[5] Whether or not Calder was familiar with any of Mondrian's writings by early in 1931, he was very much in sync with Mondrian's insistence that the freedom of abstract art was a freedom that obeyed certain fundamental principles or laws.

Calder was asking difficult questions and offering difficult answers. Let's begin with *Sphérique I.* Here the essential question is about the nature of density—and the difference between a volume and a void. *Sphérique I* consists of a long vertical line of wire that resolves into a wire arc, to which is attached a circle of wire and a small brass sphere. Among many other things, the sculpture is a study in the difference between volume and density—with

the extreme density of the tiny metal sphere opposed to the much larger volume of air that's defined by the encircling wire. In the works in the Galerie Percier show—and in works done around that time or a little later, such as *Object with Red Ball* and *Small Feathers*—we see volumes, vectors, and densities and how they move and interact. A vector, represented by a straight length of wire, shoots through space, only to be slowed by an abrupt shift in direction or halted entirely by the dramatic termination of the wire line in a wooden sphere.

The eloquence of Calder's first abstract sculptures was rooted in the artist's simplicity of means—in something as basic as the elegance with which wire elements were attached to one another. Consider *Croisière*, which was reproduced in the tiny catalog of the Galerie Percier show. Here we have two intersecting circles—or perhaps it's better to call these circumferences—to which Calder adds a curving length of thicker rod and two small spheres, painted in white and black. A *croisière* can be a cruise on a boat. In the preliminary list of titles, there was a slightly more elaborate version: *Croisière dans l'espace*—in other words, *Cruise Through Space*. That's precisely what this object offers: a movement through space or through several spaces. The two wire circles define a space—an enclosed space. And the thicker, meandering length of rod moves through and beyond that space, thereby defining that spherical, delimited space as existing within a larger, perhaps limitless space. As for the two solid spheres, they're attached to that more delimited space and through their density offer what might be thought of as a critique of that space even as they reach into limitless space. Readers of Pascal will be reminded that he declared, "Nature is an infinite sphere whose center is everywhere and whose circumference is nowhere."

Working as a minimalist, Calder mapped a complex, cosmological scheme. And that fundamental tension between simplicity and complexity echoes through *Croisière*'s great themes: location and dislocation; here and there; now, then, and forever. These are themes that Calder first grasped when he saw the sun and the moon in the sky early in the morning off the coast of Guatemala. To imagine the sun and the moon as seen by a man on a boat moving across the surface of the earth was to imagine all locations as fluid, set in a constantly changing dynamic. Paul Klee, a painter Calder greatly admired, imagined in his "Creative Credo," first published in Germany in 1920, a situation very close to Calder's experience off the coast of Guatemala. He described "what a modern man experiences as he walks across the deck of a steamer: 1. his own movement, 2. the movement of the ship which may be in the opposite direction, 3. the direction and velocity of the current, 4. the rotation of the earth, 5. its orbit, 6. the orbits of the moons and planets

around it. Result: an interplay of movements in the universe, at their centre the 'I' on the ship."[6] This was precisely the play of forces and counterforces that Calder set in motion in *Croisière*. (This was also something like the situation in which Calder had found himself when he'd first encountered Louisa, as she and her father walked in one direction around the deck of the *De Grasse* and he walked in the other.)

III

Calder brought a lucid, speculative spirit to his work for the Galerie Percier. Could it be that when he responded to his friend Hayter's questions about Louisa by saying that she was a philosopher, he was suggesting that she brought out a more contemplative or speculative side of his own personality? In his *Autobiography*, Calder recalled that "Louisa took all my new objects and my work without any demur. She seemed to accept them, and it did not occur to me or to her to discuss it."[7] Perhaps it was more than simple acceptance. Perhaps Louisa's philosophical turn of mind was turning her husband into something of a philosopher. To which her response would quite understandably have been a sibylline silence.

With his first group of abstract sculptures, Calder was engaged in a free-flowing philosophical investigation. Certainly no group of works created in the twentieth century more perfectly embodies Plato's thoughts about "the beauty of shapes" in the *Philebus*. In his introduction to the Museum of Modern Art's "Cubism and Abstract Art" exhibition—it was mounted five years after the Galerie Percier show and included work by Calder—Alfred Barr wrote that "defenders of abstract art during the past twenty-five years have often quoted a famous passage from the *Philebus* of Plato." Socrates, as recorded by Plato, was speaking not of "the shapes of living figures, or their imitations in paintings," but of "straight lines and curves and the shapes made from them, flat or solid, by the lathe, ruler and square, if you see what I mean. These are not beautiful for any particular reason or purpose, as other things are, but are always by their very nature beautiful, and give pleasure of their own quite free from the itch of desire."[8] Calder was exploring the nature of that beauty. At the Galerie Percier, the pleasure to be derived from the contemplation of those basic forms was a revelatory pleasure—the discovery of a new kind of nakedness, the nakedness not of human figures but of abstract forms.

The clarity of Calder's first abstract sculptures shouldn't blind us to the romantic yearning they represented—a yearning for infinities and for the

finitude that can define those infinities. I am reminded of the thoughts about cosmic forces that ran through the mind of Stephen Dedalus, the student hero of James Joyce's *A Portrait of the Artist as a Young Man*, as he lost his Catholic faith. (It's probably worth noting that it was published in 1916, the year Calder entered Stevens.) As Stephen sat in a college classroom listening to a professor who some said was "an atheist freemason," he found himself contemplating not the abstractions of religion but the abstraction of space itself—which was the subject of Calder's work at the Galerie Percier. "The formula which he wrote obediently on the sheet of paper," Joyce observed, "the coiling and uncoiling calculations of the professor, the spectrelike symbols of forms and velocity fascinated and jaded Stephen's mind." Stephen imagined how the "souls of mathematicians might wander, projecting long slender fabrics from plane to plane of ever rarer and paler twilight." Earlier, Stephen had mused, "What was after the universe? Nothing. But was there anything round the universe to show where it stopped before the nothing place began? It could not be a wall but there could be a thin thin line there all round everything. It was very big to think about everything and everywhere."[9] Joyce's descriptions of "long slender fabrics [projecting] from plane to plane" and the "thin thin line . . . round everything" could be descriptions of Calder's first abstract sculptures. Calder was defining the everything and the nothing of the world.

IV

For the first time in his life, Calder was part of a movement that was much larger than he was. This was the modern movement, which for the rest of his life provided the support of an extraordinary cohort of artists, critics, dealers, curators, and collectors. Don Brown, writing in the Paris edition of the *Chicago Tribune*, reported that visitors were pleased and refreshed by the Galerie Percier show. Brown ran into Leo Stein, one of the first to buy Picasso's paintings, a generation earlier, but more recently a critic of Picasso's work; Stein remarked that Calder's works were "more complete and satisfying in their realization than the recent abstractions of Pablo Picasso."[10] Late in May, Calder wrote to tell his sister that although he hadn't sold anything, the show "was a real success among the artists."[11]

If anybody had any doubt as to the accuracy of that statement, they had only to read the words Fernand Léger had composed for the little catalog. Léger welcomed Calder into the most exalted circles of the Parisian avant-garde. One imagines that even the preternaturally confident Calder (who not so long before had made do for a catalog introduction with Pascin's amusing

but utterly lightweight words) was a little surprised by the force of Léger's remarks. They deserve to be reproduced in their entirety.

Calder. Fernand Léger, 1930. Wire, 16 x 14 in. Photograph by Marc Vaux.

Erik Satie illustrated by Calder. Why not?

"It's serious without seeming to be."

Neoplastician from the start, he believed in the absolute of two colored rectangles . . .

His need for fantasy broke the connection; he started to "play" with his materials: wood, plaster, iron wire, especially iron wire . . . a time both picturesque and spirited . . .

A reaction; the wire stretches, becomes rigid, geometrical—pure plastic—it is the present era—an anti-Romantic impulse dominated by the problem of equilibrium.

Looking at these new works—transparent, objective, exact— I think of Satie, Mondrian, Marcel Duchamp, Brancusi, Arp—these unchallenged masters of unexpressed and silent beauty. Calder is of the same line.

He is 100 percent American.

Satie and Duchamp are 100 percent French.
And yet, we meet?[12]

It's impossible to overstate the significance of Léger's words. Léger was seventeen years older than Calder and had long been a central figure in the Parisian art world. Nanette, annotating a letter of her son's before sending it on to Peggy, explained that Léger was "one of the present big abstraction-ists . . . so severe + steely. I could not stay in the room where they were."[13] His *Contrasts of Forms* paintings, done before and at the very beginning of World War I, were at the time among the most thoroughly abstract works produced anywhere in the world; his experiments with film in the 1920s were recognized as landmarks of radical cinema; he was very much a public fig-ure, through his exhibitions, his teaching, and his writings about the new art. It was extraordinary to find Léger speaking of Calder's first abstract sculp-tures in the same breath as the work of Satie, Mondrian, Duchamp, Brancusi, and Arp. If there was some quality that united all these artists, it was their each being nonpareil—the master of an entirely unique vision. Whatever Mondrian might share with other pure abstract painters or Arp and Du-champ with other exponents of Dadaist ideas, each of these artists impressed first and last with his individuality, with a sensibility that was indissolubly his own. So it would be with Calder. In a few words, Léger described many of the dualities that fueled Calder's art for the next forty-five years: the gravitas that didn't preclude lightness; the lucid geometry wedded to a taste for the fantastical and picturesque; the blunt American spirit who was at home with French grace.

Léger refused to clutter his new friend's supremely uncluttered works with ponderous meanings or explanations. He spoke of the sculpture in terms of its basic characteristics—rigid, geometrical, transparent, objective, exact—which resulted in what he called an "unexpressed and silent beauty." That was all. That was enough. He may have been responding to Calder's own attitude toward his work. In a letter to his parents, Calder described these objects in a similarly direct, unadulterated manner, as "abstractions in wire with spheres + blocks of wood, painted in some instances." He offered no explanation as to what they might signify.[14] They signified nothing—and everything.

V

While Léger's salute to Calder described an artist in the fullness of his powers, many of the critics and historians who've reflected on the Galerie

Percier show have struggled to account for the audacity of Calder's first abstract work. They've searched for relevant ideas and inspirations both in the art and the science of Calder's own time. Commentators who knew Calder in the 1930s, most significantly James Johnson Sweeney and Alfred Barr, argued that he owed a significant debt to the work done by the Russian avant-garde in the years before and after World War I, work often characterized by the artists and their supporters as Constructivist. Rodchenko's hanging sculptures, Tatlin's *Monument to the Third International,* and works by Gabo were mentioned. Even earlier, the German critic Adolf Behne, writing about the Neumann-Nierendorf show in 1929, had related Calder's work to the experiments of the Russian Constructivists.

But there is a problem with the genealogy of Calder's first abstract works as it was articulated by Barr and Sweeney. As early as 1934, in a letter to the collector Albert Gallatin, Calder asserted that he had known nothing about any of these works or for that matter about Constructivism in general until Hélion told him about all of it in 1933.[15] Surely it was Calder's own testimony that pushed his friend Sweeney, in 1938, to observe that although Calder's work was "built on a Constructivist foundation," the artist "nevertheless had no connection with Russian Constructivism except in the fundamentals of its structure"—a statement that, to say the very least, is hard to parse.[16] To the end of his life, Calder insisted that he had known nothing about the Constructivists in 1931. Sometime in the 1960s or 1970s, in a letter to a young art historian, Nanette Sexton (who also happened to be his grandniece), Calder observed that "crabby guys before this have said that I must have known about the Russian Constructivists—but it's quite untrue, i.e. I knew nothing about them till after having made some of my first mobiles."[17] It is no wonder that the art historian Arnauld Pierre, writing about all of this with great sensitivity a generation after Calder's death, dubbed it "The Constructivist Hypothesis."

What is one to make of a hypothesis that the artist rejects? Pierre's solution was to describe a range of beliefs and ideas—ideas of Mondrian's, Gabo's, Moholy-Nagy's, and others'—that he saw Calder as "instinctively" embracing.[18] Of course, Calder had visited Mondrian's studio. But had he read Mondrian's writings? Calder's involvement with the abstract avant-garde was only beginning when his show opened at the Galerie Percier, so it's not clear that he was familiar with the sorts of ideas first floated in Gabo and Pevsner's 1920 *Realistic Manifesto,* a founding text of Constructivism, in which they rejected "mass as a sculptural element," spoke of "bring[ing] back to sculpture the line as a direction," and argued for "kinetic rhythms as the basic forms of our perception of real time."[19] One wonders if Calder knew that the exhibition Gabo and Pevsner had had seven years earlier at

Naum Gabo and Anton Pevsner's set for La chatte, *the ballet choreographed by George Balanchine, 1927.*

the Galerie Percier had been called "Constructivistes russes."[20] It's possible that Calder had seen photographs of the Constructivist stage sets done in Paris in 1927 and 1928 for Diaghilev's Ballets Russes, not only the transparent sets for *La chatte* by Gabo and Pevsner but also the sets by Georgi Yakoulov for *Le pas d'acier*. Even if his familiarity with Constructivist sculpture was hazy, Calder might have come across a reproduction in 1929 in *Cahiers d'art* of a work that had surely been influenced by the Constructivists, namely Picasso's welded-metal maquette for his *Monument to Apollinaire*, which Picasso had executed with the assistance of the sculptor Julio González.

Did Calder need the Constructivists to tell him that sculpture could be a matter of lines rather than planes and voids rather than volumes? That's the essential question. In 1929, two years before he had made an abstract sculpture, a number of critics, including Paul Fierens and Edouard Ramond, described Calder's work as "drawing in space"—using a phrase that would eventually be associated with Picasso and Constructivism but, in fact, appears to have first been associated with Calder's wire figures.[21] And why not? Wasn't Léger suggesting that his friend was some sort of strange genius? And how does genius operate, if not by intuitions, leaps, thunderbolts? Calder's wire sculpture would have been unimaginable without the revolution that Braque and Picasso had begun with Cubism, but the work of Kandinsky, Mondrian, and the Constructivists would have been equally unimaginable without the Cubist revolt against reality. Calder's friend the Italian critic Giovanni Carandente once mused that it wasn't strange that a genius would see his development "as a sort of spontaneous flux, as if it all sprang from the chance happenings of daily life: meetings, events, works and exhibitions."[22] Calder's wire figures and portraits had pushed him into a simplification and even an abstraction of volume. After which, the slap of the visit to Mondrian's studio might have been enough to convince him to create volumes ex nihilo.

Calder's own father had written, "Sculpture must proceed with invention—not with imitation."[23] And in his book *The Gist of Art*, Calder's old teacher John Sloan had dreamed of equipping an art school "with hun-

dreds, no, thousands, of the simple solids, in different sizes, covered with all sorts of materials including cloths of all textures and surfaces, metals of all hues, wood of all kinds, rough, smooth, polished. And the students would draw and paint these for a couple of years with figure drawing on the side for dessert."[24] Calder's sculpture had for so long been so unlike other sculpture that the unlikeliness of abstract sculpture made mainly of wire may have seemed, if not the most natural thing in the world, then not all that unnatural. The possibility of an imaginative geometry had been planted long ago.

VI

Calder knew exactly what he was doing when he gave most of the works in the Galerie Percier show titles that evoked grand principles rather than particular situations. He wanted to distance himself from the charms of the local and the anecdotal that had fueled so much of his wire sculpture. We do Calder a disservice if we try to localize what he wanted to generalize. But just as some of the thrilling purity of Mondrian's implacable verticals and horizontals emerged from his studies of the structures of trees and the way piers extended into the ocean, so Calder's pristine abstractions were fortified by a wide range of associations and allusions.

Long after the Galerie Percier show, Calder related his move into kinetic art to his interest in the mechanics of the solar system and described visiting a planetarium in Paris and seeing eighteenth-century models of the solar system in a museum.[25] The art historian Joan Marter has pointed out that there was much discussion of the planets in the press after the discovery of Pluto, early in 1930.[26] Much later, Calder told a reporter from *Life* magazine, "The first inspiration I ever had was the cosmos, the planetary system. My mother used to say to me, 'But you don't know anything about the stars.' I'd say, 'No, I don't, but you can have an idea what they're like without knowing all about them and shaking hands with them.'"[27] In some drawings done around the time of the Percier show, there are suggestions of the dynamics of the cosmos, with a few circles and parts of circles inscribed on mostly empty sheets of paper to evoke infinities. They are among the most original works of those years. At the same time, the simplicity of the black lines calls to mind the spare cosmologies of John Flaxman's neoclassical illustrations of Dante's *Divine Comedy,* done more than a hundred years earlier. Perhaps with the works exhibited at Galerie Percier Calder was creating his own kind of divine comedy.

The European avant-garde, having pretty much rejected the old verities

and mysteries of religious experience, sought its own verities and mysteries, and often found them in the study of nature, including the immensities of the solar system and the universe. Picasso was interested in celestial maps, which may have influenced the drawings he did in the early 1920s of networks of lines connected by small dots. In 1931, the painter Torres-García, who was good friends with Hélion and crossed paths with Calder in various Parisian circles, penned a little booklet entitled *Père Soleil,* in which he wrote of "Uni/versus," "Équilibre," "Unité," "Système Planétaire," and "Kosmos"—all terms familiar to admirers of Calder's art. In one drawing in *Père Soleil,* Torres-García juxtaposed the sun and the moon in a single image—very much the juxtaposition that fascinated Calder in the sky over Guatemala. What Calder always regarded as his first wire sculpture, done when he still lived in New York, was a sundial with a rooster at the top of a long wire stem—a static work that harnessed the kinetic power of the earth as it circulated around the sun. For some artists and writers in Paris in the

1920s and 1930s, a fascination with astronomy couldn't necessarily be detached from a fascination with astrology. The wealthy American expatriate publisher Harry Crosby, whose enthusiasm for the circus we have already observed, was obsessed with the sun and its powers. He wrote in his journals that "in solar symbolism there are rules which connect the Sun with gold, with heliotrope, with the cock which heralds the day, with magnanimous animals such as the lion and the bull, that 92,930,000 miles is the Sun's distance from the Earth."[28] Calder wasn't the sort to indulge in such obsessive thinking. But

Joaquín Torres-García. Two pages from Père Soleil, *a book made in 1931 but not published until 1974.*

the sun would be an essential image in Calder's work over the years.

Perhaps the answer to Léger's question about where the 100 percent French and the 100 percent American might meet was in Calder's ability to give European metaphysics and dreaming a pristine clarity. In an essay entitled "Parade and Palingenesis," the French critic and curator Jean Clair says something interesting about the connections between the circus and the cosmos. While Clair's language is speculative and philosophical in ways that one imagines would have set Calder's teeth on edge, there may be no passage that comes closer to describing the turn in Calder's work at the very beginning of the 1930s, when seemingly out of nowhere he became one of the most self-confident abstract artists in the world: "The arena of the bullring and the arena of the fairground circus, simply in the way they look, both have commerce with the sphere of the gods. The circus, the *circulus* that designated the planetary orbits, is that magic space in which bodies escape gravity. Under the sky of the big top, bodies describe precise arcs, sketch out figures that, being akin to those of the zodiac, hint at fate."[29]

VII

When comedians stop telling jokes—and that, for the moment, seemed to be what Calder was doing—nobody can be blamed for wondering why. It wasn't surprising that some reviewers of the Galerie Percier show, particularly those who had already been following the work of Calder the comedian for a few years, were dismayed by where the American seemed to be headed. A decade later, Sweeney recalled that "those who had enjoyed what he had previously done so well were left completely at a loss." Some, according to Sweeney, suspected that the work "was merely some elaborate joke."[30] Short reviews of the show tended to be illustrated with a wire head rather than an abstraction. That was the familiar Calder at least some of the press preferred. In *Beaux-Arts,* a critic complained that the only really acceptable works in the show were the wire portraits. Otherwise, Calder had lost "much of his humor." "You will regret," the critic reported, "to see, moreover, the

artist evolving a grandiloquent and esoteric formula for constructing *volumes, values, densities* (?), and *arrested movements* (??).”[31] The accusation of pretentiousness was not one that had been made against Calder before; if he had been accused of anything, it was of being insufficiently serious. Perhaps for this man who had more often than not kept his own counsel, becoming what some now regarded as an obscurantist was no more trying than having been what others had earlier regarded as a goofball. What Calder had never been willing to be was a conformist.

The dramatic shift in Calder’s work has inspired a number of explanations. In her memoir, Calder’s sister, Peggy, speculated that “Louisa’s inheritance, along with wedding checks from friends and relatives, now made it possible for Sandy to experiment freely, without regard to what would sell, to follow his imagination wherever it might lead.”[32] Joan Marter, in her study of the artist, theorized that “Calder’s commitment to Louisa—and soon after, the prospect of a family—must have been among the motivating forces to his finding a clear direction for his work, a personal statement beyond the *Circus*.”[33] Was there a connection between Calder’s marriage and Calder’s abstractions? I have already suggested that something in Louisa’s philosophical temperament may have affected Calder’s thinking. It may also have been that Calder, who was now in his thirties, was feeling even more self-confident than he had before, and therefore eager to embrace fresh, challenging experiences, whether with Mondrian and his studio or with the woman he almost immediately named Medusa. Of course, there’s a sense in which a great work of art needs no explanation because it’s its own explanation. But I believe we do Calder a disservice if we fail to recognize that his first abstractions were among many other things a heartfelt response to the challenging times in which he and Louisa found themselves.

Both Calder’s marriage and Calder’s turn to abstraction occurred amid the cataclysmic transformations in Europe and America brought about by the Crash and the beginnings of the Great Depression. I believe that these developments in the larger society registered in Calder’s art without in any way upsetting its formal perfection. The Paris to which he and Louisa returned early in 1931 was very different from the Paris Calder had found when he’d first arrived in 1926. The composer Virgil Thomson, whom Calder probably already knew and with whom he would collaborate on a great production of Erik Satie’s *Socrate* in 1936, wrote with extraordinary sensitivity about Paris in the early years of the Depression. He observed that “those vowed to preserving the gay twenties [were] first to leave, since it was clear by the end of 1929 that the postwar time was over.” Those who remained were a different breed—and this was the breed of which Calder

was a part. "We had long since lost taste for its bar-stool discussions of courage," Thomson wrote, "its pride in banal misbehaviors, and had moved into a range of sentiment that seemed to us far fresher. Our new romanticism was no nostalgia for the warmths of World War I or for the gone-forever prewar youth of Stravinsky and Picasso, but an immersion complete in what any day might bring. *Mystère* was our word, tenderness our way, unreasoning compassion our aim."[34]

The connection between Calder's changing art and the changing world in which he lived has rarely been discussed, in large measure because however the wide world might shape and reshape his vision, Calder never lost his sure sense that a work of art must have a freestanding power. But the resoluteness with which he remained absolutely himself ought not blind us to his seismographic sensitivity to the world in which he lived. If Calder's wire sculptures of dancers, acrobats, and circus animals were one of the last, great expressions of the 1920s, with its brittle but exultant spirits and its promise of a never-ending champagne high, the abstract sculptures of the early 1930s struck an entirely different note, a note in which wit was not entirely absent but was now more astringent, ambiguous, even severe, mingled with a larger speculative spirit, an austere idealism. Who can doubt that the Crash and the deepening realities of the Depression played a part? *Les années folles* were over. Reality was turning out to be hard to bear. So Calder the pragmatist became something of an idealist, maybe even a Platonist.

VIII

That Calder was, at the time of the Crash, perceived at least in some circles as a giddy troubadour of the Roaring Twenties, and for that reason not to be taken entirely or even at all seriously, is by no means pure speculation. In *You Can't Go Home Again,* a novel that surveys American and European society moving from the wild optimism of the 1920s into the Depression and the rise of Hitler, Thomas Wolfe presented Calder, in the person of Piggy Logan, the ringmaster of a miniature circus, as epitomizing much that was trite, crude, and foolhardy in the cultural life of the decade that had concluded with the Crash.

Wolfe, who died in 1938, was only two years younger than Calder. *You Can't Go Home Again,* which appeared posthumously in 1940, was carved out of a vast, chaotic manuscript by Edward Aswell, his editor at Harper & Row. (Maxwell Perkins, his previous editor at Scribner's, was widely acknowledged as having shaped his earlier books.) As we have already seen, the

chapter called "Piggy Logan's Circus" was based on a performance Calder gave on Christmas Day 1929, mere weeks after the Crash, in the home of Aline Bernstein, a well-known theatrical designer who, though married to a wealthy man, was also Thomas Wolfe's lover. Apparently Bernstein crossed paths with Calder at his exhibition at the Fifty-sixth Street Galleries. When Calder told her he would like her to see his circus but didn't have a place large enough to mount a performance, she offered her apartment, saying, "Have it at my house. It's often a circus there, anyway."[35] Bernstein was the model for Esther Jack, the lover of the novelist George Webber in *You Can't Go Home Again*. In his *Autobiography*, Calder recalled the evening at Bernstein's quite clearly, but commented, "I was never aware that the great Wolfe—that is, Thomas Wolfe, the writer—was present at my circus performance. He did not have the good sense to present himself and I only heard from him much later—some nasty remarks on my performance, included in a long-winded book."[36] ("Long-winded" was an understatement.)

The book, not surprisingly, is still regarded with considerable distaste in the Calder family, although a reader does have to admit that Wolfe was by no means unaware of Calder's artistry. He wrote about the attentiveness Mr. Logan brought to his actors, "taking each wire figure in his thick hand and walking it around the ring and then solemnly out again"; he noted the net strung for the trapeze artists with "punctilious fidelity to reality"; and he described how, when the aerial artists missed their appointed connections, "Mr. Logan settled the whole matter himself by taking one little figure firmly between two fat fingers, conveying it to the other, and carefully hooking it onto the other's arms."[37] Wolfe presented Piggy Logan as both a bull in a china shop, heedlessly rearranging Mrs. Jack's elegant living room, and a high society flibbertigibbet, bringing along with him a pack of young, elegant, silly boys and girls, who rolled into the Jacks' apartment unperturbed by the fact that they hadn't exactly been invited. When Logan arrived at the sword-swallowing act, Wolfe saw a sort of allegory of the "life and customs in this golden age," as if Piggy Logan were expressing the cruelty of opulent Manhattan as he worked a hairpin into his little sword swallower until "suddenly the side of the bulging doll was torn open and some of the stuffing began to ooze out."

One partygoer watched "with an expression of undisguised horror and, as the doll began to lose its entrails, she pressed one hand against her stomach in a gesture of nausea, said 'Ugh!'—and made a hasty exit. Others followed her."[38] Wolfe, whether inadvertently or otherwise, ignored the fact that at least some of Calder's gang were serious artists. As we've already noted, his friend Lee Simonson, the important modernist stage designer who wrote

about the arts for *The New Republic*, was at Bernstein's that evening. It was Noguchi who assisted with the performance, an exceedingly hardworking fellow with no money whatsoever. He was transformed, in Wolfe's account, into Hen Walters, an elegant gadabout who spoke with "ecstatic jubilation."[39] It was one of the ironies of the evening that Calder, in remembering it, also found the crowd somewhat trite. According to him, Bernstein's only comment was "It's a lot of work."[40] And her sister, who worked at Bergdorf Goodman, seemed perturbed when she noticed that he had, among the boxes used to pack up the circus, one from Bergdorf Goodman.

Wolfe's indictment wasn't aimed at Calder so much as at his lover's Upper East Side values—of which Piggy Logan's circus somehow became a symbol. When Esther Jack, at the end of the performance, asked an attorney, Roderick Hale, what he thought about Piggy's circus, Hale announced—in words that one feels expressed Wolfe's own feelings—"It's like some puny form of decadence."[41] For Thomas Wolfe, who composed novels on an operatic, if not an oceanic, scale, "puny" may well have been a more damning word than "decadence." And if the decadence of Piggy Logan's circus wasn't enough, the evening at the Jacks' elegant apartment culminated with a fire in the vast apartment building that sent all the guests out onto the street and took the life of an elevator operator, who perished while trying to save the inhabitants. The literary critic Alfred Kazin, writing about the novel two years after it appeared, in his study of modern American literature *On Native Grounds,* called the evening in Esther Jack's apartment "a bacchanal disturbed by Wagnerian fire," and saw it, coming in the autumn of the Crash, as among the keys to a vision of a world "of decline and fall, of emptiness and dissolution."[42]

For Wolfe, the world's poverty and suffering were somehow reflected in his own poverty and suffering—and vice versa. Wolfe, as Kazin wrote, could be "a prophetic voice who brought the same shattering intensity to his studies of contemporary demoralization, the climate of fascism in Europe and America, the confusion and rout of the masses, that he did to his self-torment and yearning for personal freedom and redemption."[43] For Wolfe, the only artistic response to the world's troubles—and to his own troubles—was a hyperbolic naturalism; the compositional process had to be drawn out, expanded, inflated into manuscripts that took a master editor to disentangle. Art as a distillation of life or a principled retreat from life was anathema to Wolfe. In a passage in *You Can't Go Home Again*, he ribbed one character, named Haythorpe, as "an aesthete of the primitives," and then an "aesthete of the nigger cults," and "still later, aesthete of the comics—of cartoons, Chaplin, and the Brothers Marx," and even later an aesthete "of Expression-

ism; then of the Mass; then of Russia and the Revolution; at length, aesthete of homo-sexuality; and finally, death's aesthete—suicide in a graveyard in Connecticut."[44] That sardonic catalog, although hardly describing Calder, touched on some aspects of the artistic repertory that interested Calder, especially the possibilities comedy held for artistic expression.

How could an artist like Wolfe have possibly understood Alexander Calder, who wasn't a tormented personality and who was by nature skeptical of the prophetic voice? What Wolfe missed completely in Calder was his gift for speaking to the world even as he stood somewhat apart from it. Calder was creating a parallel universe with its own laws and logic, but one that enlarged the possibilities of the world he was living in. Wolfe's response to the catastrophic turn from the 1920s to the 1930s was an art of unabashed engagement and rhetorical hyperbole—raging against the rich, against capitalism, against injustice. Calder's response to those same events was an art of cool, idealistic possibility—an art of movements and suspended movements, of circulating points, lines, planes, and spheres.

IX

Calder was beginning to express profound emotions through enigmatic emblems. The emblem is an abstraction of images and ideas, a compression of vast experiences into a succinct form. Calder was one of a number of modern artists who found in such distillations an escape from the excesses of Expressionism, much as T. S. Eliot and other modern poets found in the work of the Metaphysical poets an escape from the excesses of Romanticism. Although there is no reason to think that Calder knew the illustrations that the English artist E. McKnight Kauffer made for a beautiful 1925 edition of Burton's *The Anatomy of Melancholy*, I find in their skeletal, compressed impressions of geometrical and astonomical forms some affinity with Calder's infinitely more ambitious early abstract objects. For Calder, who was so fond of the telegraphic power of jokes and wordplay, the emblem or heraldic device had a comparable appeal. It was a way of expressing a great deal with the simplest of means. In 1960, Calder made a lithograph of a knight in armor, carrying a spear from which hangs a little mobile. This was an emblem of war and aggression turned to peace and play, his own version of swords into plowshares: swords into mobiles.

At the same time that Calder was shaping his response to some grand philosophic questions out of a few twists of wire, he was also working on illustrations that have an emblematic power for *Fables of Aesop*, with texts

drawn from a late-seventeenth-century retelling of the tales by Sir Roger L'Estrange. The commission came through Monroe Wheeler, the partner of the novelist Glenway Wescott. By the end of the 1930s, Wheeler would be deeply involved with the organization of exhibitions and publications at the Museum of Modern Art, where he helped pave the way for Calder's 1943 retrospective. Wheeler and Wescott were friends with Frances Robbins, on whose cushions Calder had convalesced early in his stay in France. Wheeler and Wescott knew Butts, knew Cocteau, and had spent time at the Welcome Hôtel in Villefranche. They were part of what Cyril Connolly, in his novel *The Rock Pool* in the 1930s, regarded as the "charmingly dated Paris of the Select and the Bal-Musette, and parties on the Ile Saint-Louis."[45] It may have been through Wescott and Wheeler that Calder met Gertrude Stein and Alice B. Toklas, although we don't know if his note to them in March 1932, thanking them for the meeting and hoping they might come and look at some of his work, had the desired effect.[46]

The *Aesop*, beautifully designed by Wheeler, was published in a limited edition by Harrison of Paris, the press Wheeler ran with Barbara Harrison, who married Glenway Wescott's brother Lloyd. Katherine Anne Porter's *Ship of Fools*, the novel on which she labored for twenty years and published in 1961, was dedicated to Barbara Wescott. In *Ship of Fools*, a pair of unhappy lovers, both of them artists, are on a boat traveling from the New World to the Old World not too many months after Sandy and Louisa had

joyfully discovered each other on a boat crossing the Atlantic in the opposite direction. Emblems and allegories were apparently an interest of Wheeler's. Around the same time that Harrison of Paris published Calder's *Aesop*, the press published Wescott's *A Calendar of Saints for Unbelievers*, with illustrations of the signs of the zodiac by Pavel Tchelitchew, a Neo-Romantic painter with whom Calder would cross paths a number of times over the years. Calder's *Aesop* is an elegant *livre d'artiste*, treasured by collectors of beautiful and rare books. Although Sweeney called it "a masterpiece of American book illustration," it has not received much attention from students of Calder's art, who perhaps don't know quite what to make of his immersion in these allegories of the lives of animals at the very moment when he was first embracing pure abstract art.[47] Which was precisely the point, because even as Calder was becoming something of an idealist,

FABLES OF ÆSOP
ACCORDING TO SIR ROGER L'ESTRANGE

WITH FIFTY DRAWINGS BY
ALEXANDER CALDER

A CAT AND A COCK

IT was the hard fortune once of a cock, to fall into the clutches of a cat. Puss had a months mind to be upon the bones of him, but was not willing to pick a quarrel however, without some plausible color for't. Sirrah (says she) what do you keep such a bawling, and screaming a nights for, that no body can sleep near you? Alas, says the cock, I never wake any body, but when 'tis time for people to rise, and go about their business. Nay, says the cat, and then there never was such an incestuous rascal : why, you make no more conscience of lying with your own mother, and your sisters — In truth, says the cock again, that's only to provide eggs for my master and mistress. Come,

37

A FROG AND A MOUSE

THERE fell out a bloody quarrel once betwixt the frogs and the mice about the sovereignty of the fenns; and whilst two of their champions were disputing it at swords point, down comes a kite powdering upon them in the interim, and gobbles up both together, to part the fray.

A LION AND A BEAR

THERE was a lion and a bear had gotten a fawn betwixt them, and there were they at it tooth and nail, which of the two should carry't off. They fought it out, till they were e'en glad to lie down, and take breath. In which instant, a fox passing that way, and finding how the case stood with the two combatants, seiz'd upon the fawn for his own use, and so very fairly scamper'd away with him. The lion and the bear saw the whole action, but not being in condition to rise and hinder it, they pass'd this reflexion upon the whole matter; here have we been worrying one another, who should have the booty, 'till this cursed fox has bobb'd us both on't.

THE MORAL OF THE TWO FABLES ABOVE

'Tis the fate of all Gotham-quarrels, when fools go together by the ears, to have knaves run away with the stakes.

29

A FOX AND A CARV'D HEAD

A S a fox was rummidging among a great many carv'd figures, there was one very extraordinary piece among the rest. He took it up, and when he had consider'd it a while, well, (says he) what pity 'tis, that so exquisite an outside of a head should not have one grain of sense in't.

THE MORAL

'Tis not the barber or the taylor that makes the man; and 'tis no new thing to see a fine wrought head without so much as one grain of salt in't.

7

Calder. "A Fox and a Carv'd Head" *from* Fables of Aesop, According to Sir Roger L'Estrange.

he was also refusing to give up his love of the piquant and the particular.

Calder found, in the *Aesop* illustrations, an opportunity to deal with questions of conflict and cruelty that were increasingly evident in the world but had no place in the sculpture he was producing at the time. Calder's *Aesop* is a dog-eat-dog world, perhaps not exactly tragic but certainly tragicomic. For all their linear charm, Calder's drawings of a cat tearing apart a cock or of a sword fight between a frog and a mouse (both of whom lose their lives) are also striking emblems of a world where cruelty and violence are always present, sometimes contained, all too often unleashed. In one illustration, for the fable "A Fox and a Carv'd Head," Calder reflects on the ironies of a representational art, for the fox discovers that the inside of an "exquisite" head is empty—with not "one grain of sense."[48] That empty head may also suggest the ever-growing vacuum in leadership around the world—all the empty-headed heads of state. With the *Aesop*—and some circus drawings exhibited at the Galerie Percier—Calder was perfecting a quick-witted linear style, the drawn line a two-dimensional reconstruction of the wire as acted on by his pliers. There's a beautiful, muscular inscrutability about Calder's line, which can be turned to tasks both grave and gay. For the cover of Louisa's father's book *Jews for Jesus*, Calder produced a drawing of a Jew being devoured by a lion in an arena—the Colosseum, which prefigured the circus that had been Calder's amusing calling card in the 1920s, a bloody emblem of man's darkest impulses.

Calder explained to his parents in the middle of February that he was illustrating *Aesop,* so we can assume that the drawings were done at precisely the same time as the sculptures for the Galerie Percier.[49] Reading L'Estrange's little tales—some a few sentences, rarely more than a medium-sized paragraph—Calder was challenged to find the telling image, much as he was trying to compress large ideas about volumes, vectors, densities, movement, and stillness in sculptures such as *Croisière* and *Sphérique I.* Behind the many sculptures at the Galerie Percier that included two spheres—one black, one white—there was always the story of the morning on the Pacific off Guatemala, when he'd seen the sun and the moon simulta-

Calder. El Sol Rojo, *1968.*
Sheet metal, bolts, and
paint, 84 ft. high.

neously. The narrative had become an emblem. When André Legrand, that first commentator on Calder's work, wrote about the American artist again in 1932, he was reminded by the first mobiles of the illustrations in Renaissance treatises—in other words, of those emblematic images that compress large stories and ideas.[50] Calder was becoming a master of the emblematic image—a gift that he would carry with him throughout his life and that would culminate in his immense stabile *El Sol Rojo*, mounted in front of the Aztec Stadium in Mexico City for the 1968 Olympics.

MOBILES

I

It was in the fall of 1931, in the third-floor studio of Sandy and Louisa's comfortable house on the rue de la Colonie, that Marcel Duchamp took a liking to one of Sandy's motorized works. Only a few months had passed since the Galerie Percier show, with its vectors, arcs, and spheres, and now

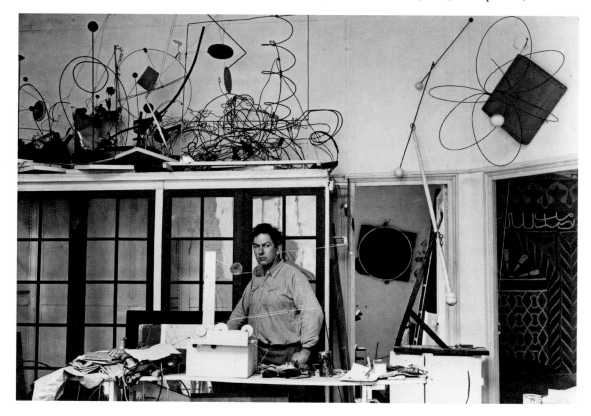

Calder was trading the evocation of movement for movement itself. Although the paint wasn't quite dry, Duchamp asked if he could touch this kinetic object with its three solid shapes—two spheres and one elongated, cigar-like form. Duchamp had been a close student of the mysteries of movement even before his *Nude Descending a Staircase* became the sensation of the Armory Show in 1913. Calder asked Duchamp what he thought he should call these peculiar new sculptural objects, which included mobile elements, some propelled manually, some by means of a motor.[1] With the seasoned chess player's gift for contemplative silences and quick, dramatic gestures, Duchamp responded that they should be called mobiles.[2] And so they were. Not too long after, another artist friend, Jean Arp, announced, perhaps with a flicker of irony, that the works that didn't move should now be referred to as stabiles. And that became their name. It was the growing popularity of Calder's mobiles in the next couple of decades—among artists, hobbyists, manufacturers, and the public at large—that led to the term's eventual embrace by Merriam-Webster's dictionary.

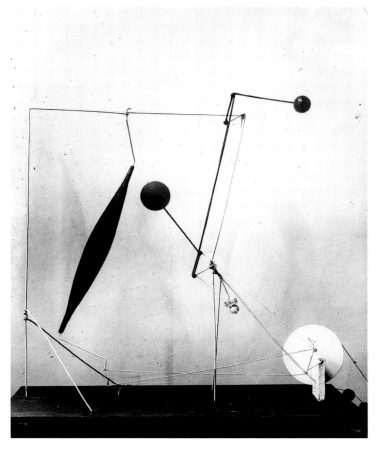

Calder. Untitled (The motorized mobile that Duchamp liked), 1931. Wire and wood, with motor, 36 x 36 x 12 in. Photograph by Marc Vaux.

Duchamp had come into Sandy and Louisa's life some months earlier, introduced to them by his lover, Mary Reynolds. Calder had known Mary since shortly after he arrived in Paris and had perhaps gotten to know her a bit better in the summer of 1930, when he came off Fordham's yacht and spent some time in Villefranche, where Reynolds had a home. There was something brittle and complex about the relationship between Reynolds and Duchamp, with the generous-hearted and gentle Mary never quite at peace with Marcel, who, for all he felt for her (and he did), still demanded the freedom to pursue other erotic adventures. Sandy and Louisa, every bit the ardent newlyweds and never inclined toward the sort of sexual games Mar-

Mary Reynolds and Marcel Duchamp, photographed in London in 1937. The photograph, although sometimes credited to Man Ray, is by the English photographer Costa Achilopulo. Some have suggested that the tape measure in this amusing Surrealist double portrait is a reference to Duchamp's Three Standard Stoppages *(1913–14).*

cel played with Mary, nevertheless made a real connection with the older couple. Sandy and Louisa liked devoted duos, no matter the complexities of the match, and after their own fashion, Marcel and Mary were devoted. Calder, who always admired refinement in craftsmanship, would surely have responded to the seriousness with which Reynolds had begun an apprenticeship with the famous bookbinder Pierre Legrain in 1929. In the 1930s and 1940s, she produced a series of unique, luxurious book bindings that used the traditional paper and leather elements of that art in imaginative and unexpected ways. For Paul Éluard and Man Ray's *Les mains libres,* for instance—working with a design by Duchamp—she attached kid gloves to the tan morocco binding, creating a classic of modern decorative art.[3]

Mary Reynolds was a beautiful, elegant American woman, seven years older than Calder. She had grown up in the Midwest, lost her first husband in the war, and come to live in Paris to pursue the bohemian adventures on which she and her husband had already embarked in Greenwich Village. She is a radiant figure in memoirs of the period. Virgil Thomson, a good friend,

referred to her as "the queen of American Montparnasse," and went on to describe her as "straight, well-dressed, and clearly a lady (though she did love roistering and bars)." Of the many women who adored Marcel, she was "his most adoring," Thomson wrote; at least this was true during the years he knew them in Paris.[4] Robert McAlmon, in his *Being Geniuses Together*, remembered their mutual friend Mary Butts calling Mary "the world's most charming woman." And McAlmon went on: "She was, indeed, too charming, and that is dangerous when accompanied by a striking head set magnificently on a fine neck above as fine a pair of shoulders and as beautiful a back as Aphrodite. She drank with, and was friends with, all of the better people of each type, artist, gigolo, drunk, scrubwoman, *poule*, or parasite, and generally she paid the bills of them all."[5]

Mary had an income sufficient to let her live comfortably in a house on the rue Hallé. There what had been through much of the 1920s a secret romance with Marcel had turned into something quite open and secure, with Duchamp, who kept a small separate apartment, spending most of his time at Mary's. Mary's close friend Peggy Guggenheim, who had met her husband Laurence Vail through Mary (people had thought Vail and Mary would get married), wrote in her memoirs, "Every time Mary was asked why she didn't marry Marcel, she would say Marcel didn't want to. Every time Marcel was asked, he would say Mary didn't want to."[6] Mary's house, where Brancusi, Joyce, Breton, and Cocteau were frequent guests, was striking, light-filled, with a décor in which Duchamp had taken a hand, the walls covered with maps and a famous collection of earrings that piqued the interest of Anaïs Nin. In the 1940s, Calder added to Mary's collection a pair with a design based on her initials. Janet Flanner, the writer who for decades published her celebrated "Letter from Paris" in *The New Yorker*, commented on "how intimate she was with the artery-stream of Paris, in the pulse of its creators, major and minor. There was something *immediate* in her sense of appreciation, she seemed to be right at the side of writers and artists as they became themselves, so she was a continuous witness"—and indeed there she was, as Calder became the maker of mobiles.[7]

Duchamp, the man who was now casting his famously discerning eye on Calder's mechanized objects, has to have struck Sandy as something of a bohemian monument. When Calder was still in his teens, Duchamp had already shaken New York with his *Nude Descending a Staircase*. But Calder was never one to be daunted—except, perhaps just a little bit, by Mondrian. Although they were in some respects polar opposites, the dashing, laconic Frenchman—"slender, erect, red-haired," in Virgil Thomson's recollection—and the ebullient, easygoing American had no trouble becom-

ing friends.[8] A few years after Duchamp's death in 1968, Calder jokingly reminisced that "he was very clever at keeping his weight down, which I admire but do not emulate."[9] Duchamp, who so far as the world was aware in the early 1930s had more or less given up art for chess, was among other things one of the great connoisseurs and talent scouts of the century. He had a decisive role in establishing Brancusi's reputation in the United States; he guided the collection of Walter and Louise Arensberg, whose salon had been a gathering place for New York's nascent avant-garde; and he joined forces with Katherine Dreier and Man Ray to develop the Société Anonyme in New York, which sponsored exhibitions in the 1920s that were among the first of modern European art in New York. Now Duchamp was giving Calder some help. Both Calder and Duchamp had done comic illustrations for the periodical press at the beginning of their careers; their willingness to see just about anything in a comic light was a gift they would always share. They both had a taste for wordplay and puns—as, indeed, did Mary Reynolds.

BALLETS RUSSES

1928

Pavel Tchelitchew. Cover of a program for the Ballets Russes, 1928.

II

It was Duchamp who spoke with the dealer Marie Cuttoli about exhibiting Calder's recent work in her Galerie Vignon on the rue Vignon on the Right Bank. Calder's work first appeared there in a group show of drawings in January 1932, his study of elephants hung alongside works by Neo-Romantic artists, among them Eugène Berman, Leonide, Kristians Tonny, and Gertrude Stein's friends Francis Rose and Pavel Tchelitchew. The work of the Neo-Romantics, with its pale echoes of Picasso's Rose Period and the dreamscapes of the Surrealists, hasn't worn very well. But they were a force to be reckoned with in the years leading up to and even just after World War II. Although the formal power of Calder's work put him in an altogether different league, they shared with Calder, as Calder did with the Surrealists, a sense that there were aspects of time and space—something mysterious and bewitching about the possibilities of the fourth dimension—that modern art had not yet adequately explored.[10] For Tchelitchew, perhaps the most interesting of the Neo-Romantics, that exploration involved a study of not only astronomy but also astrology.

Tchelitchew admired Calder's work. In 1937, he wrote to Lincoln Kirstein—whom Calder originally knew from the Harvard Society for Contemporary Art—that "there are more fakes in art now than ever and as far as I am concerned, there are only three people of my generation—Yves Tanguy, Joan Miró and Alexander Calder; the rest are either too old (Romantic), or too young (Esteban Francés)." He went on to comment on "how wonderful Plato is—what a relief for my poor brain." Could he have had the Platonic eloquence of Calder's sculpture in mind?[11] For the next decade or so, Calder's social circles and those of the Neo-Romantics overlapped. Monroe Wheeler, who published Calder's *Aesop*, took Kirstein to Tchelitchew's studio in Paris in July 1933. Of his designs for the 1928 ballet *Ode*, with choreography by Léonide Massine, Tchelitchew commented, "The moon will sail past; all creation will explode before your eyes; flowers, fruit, essential geometry; thunder, lightning. Cosmic phenomena."[12] In the single 1933 issue of a Parisian magazine called *Mouvement*, there was both an illustration of an early Calder moving work, blurred in action, and a brief notice of the company Les Ballets 1933 and its dazzling young choreographer, George Balanchine, who was referred to as the "apostle of dynamism." Balanchine's move to the United States was of course masterminded by Kirstein.[13] Calder was another apostle of dynamism. Tchelitchew's designs for George Balanchine's 1933 ballet *L'Errante*, with their radical use of light effects and transparency, might have piqued Calder's interest, at least in passing, considering his own involvement with shadows and transparencies. Like the magic of Balanchine's ballets, in which a new dynamism upended the fixed poses of an earlier generation of dancers, the magic of Calder's mobiles was precipitated by a break with the gravitational orientation of earlier generations of sculptors. For Calder, the Neo-Romantics might have been just a few more voices in the great modern conversation, to be listened to with half an ear as he went merrily on his way.

Sculpture mouvante de Calder.

Calder. Untitled, c. 1932. Marble, wood, and motor. This photograph, by Marc Vaux, was illustrated in the single issue of the magazine Mouvement *in 1933.*

Marie Cuttoli, too, moved between the world of the Neo-Romantics and the circles of the Cubists and the Surrealists; she mounted an exhibition of Man Ray's photographs at the Galerie Vignon in December 1932, some ten months after showing Calder's mobiles. When her own collection was exhibited at the Beyeler Gallery in Basel in 1970, it was dominated by an

extraordinary group of early works by Miró, as well as an important 1946 Calder mobile titled *Whose Breast Have You Hooked Onto?* and a great cache of Picassos, including rare early *papiers collés*. Cuttoli was good friends with Picasso, and after World War II, when Picasso was staying at her villa near Antibes, she was involved with the creation of the Musée Picasso there. Cuttoli is nowadays best remembered for working to revive the French tapestry industry, beginning in the late 1920s, when she commissioned designs from Braque, Léger, Picasso, Dufy, Matisse, Rouault, and Miró. Short, solid, and always very elegantly turned out, Cuttoli and her partner, the United Nations diplomat and human rights advocate Henri Laugier, were legendary for the entertainments in their immense apartment at 55 rue de Babylone, a residence later owned by Yves Saint Laurent. In the early 1950s, when Sandy and Louisa's older daughter, Sandra, was in her late teens and starting a life in France, Madame Cuttoli gave her the keys to a tiny maid's room way up in the building on the rue de Babylone. Sandra lived there for some two years, part of the time sharing the little space with her friend Aube Breton, the daughter of André Breton.[14] Calder always felt great affection for Marie Cuttoli.[15] He and Louisa visited her in Morocco in 1964, and he designed two rugs, which she produced.

III

Duchamp once remarked, of his own *Nude Descending a Staircase*, that in the early years of the new century, "the whole idea of movement, of speed, was in the air."[16] In January 1917, in an avant-garde magazine by the name of *The Soil* that was published in New York and that Calder might have happened upon then or a little later, a group of photographs of industrial machinery was gathered under the title "Moving Sculpture Series." But it was a long way from the sort of Dadaist joke about the artistic potential of heavy machinery that Robert J. Coady, the editor of *The Soil*, offered with his "Moving Sculpture Series" to the mobiles that Calder produced a generation later. Calder, in 1959, offered a nuanced and I think realistic view of the situation in the 1930s and the years just before and after, observing that "when I began making mobiles, everyone was talking about movement in painting and sculpture. In fact, there wasn't much of it." For Calder, the move into movement was neither entirely obvious nor entirely easy. "The idea of making mobiles," Calder reflected, "came to me gradually."[17]

Calder had always been fascinated by kinetic phenomena of all kinds. On the face of it, there was nothing out of the ordinary about that. Many boys

Umberto Boccioni.
Dynamism of a Cyclist,
1913.

have been interested in toy trains, and some high school and college students have been interested in the fundamentals of physics. A great many young men have, like Calder, loved dancing, bicycling, and sports of all kinds. Only in retrospect can we see that there was something a little unusual about Calder's hunger for movement, reflected as it was in his enthusiastic but embarrassingly mediocre and possibly headstrong performances on the athletic field in high school and college, as well as in his shenanigans on the dance floor, where his style was wildly improvisational. Even as a grown woman, Calder's older daughter couldn't forget her mortification as she'd watched her father improvise his way around a high school dance, a lone adult making a spectacle of himself at the Putney School in Vermont, where she was a student. At least in the late 1920s, Calder also earned a certain celebrity in Montparnasse as an inveterate cyclist, his bulky body quite a sight as he whizzed along the streets. Noguchi later reminisced that Calder was always on his bicycle, riding around the city, and there was even a report in the press about the artist returning "from Berlin on his pet bicycle, adorned in the habitual sailor trousers and orange socks, loaded down with his wire horses and wooden cows."[18] This is a charming image. It's much more than that as well.

The bicycle we are familiar with—the two-wheel safety bicycle—was invented in the 1880s. By the beginning of the twentieth century, the bicy-

Marcel Duchamp. Bicycle Wheel, *1916–17.*

cle rider was a figure very much associated with avant-garde ideas about the possibilities of movement and speed. Boccioni's *Dynamism of a Cyclist* (1913) was one of a number of works that made the connection. Duchamp's first readymade was a bicycle wheel. He later remarked of it: "To see that wheel turning was very soothing, very comforting. . . . I enjoyed looking at it, just as I enjoy looking at the flames dancing in a fireplace."[19] Calder, in New York in the mid-1920s, painted an all-night bicycle race. In his 1897 novel, *Days and Nights,* Alfred Jarry, one of the great eccentrics of modern literature and a hero of the Dadaists, presented his protagonist Sengle on his bicycle, rushing off to a tryst. Riding his bicycle was Sengle's way of seeing the world. "He should use this machine with gears," Jarry wrote of Sengle, "to whisk up forms and colors as fast as possible with a rapid suction as he whirls along roads and bicycle tracks." In the wake of this experience, Jarry speculated, "the mind can far more easily recreate its own forms and colors." Jarry described Sengle on his bicycle as "a skeleton exterior to himself" and spoke of "the mineral prolongation of his bone structure, and almost infinitely perfectible because based on geometrical principles."[20]

Was Calder, on his bicycle, feeling the possibilities that would soon enough produce the skeletal dramas of the mobile? He was, after all, taking off through the air. Cycling involved a defiance of gravity, with the movement of the bicycle keeping the rider aloft. On his bicycle, Calder must have felt a bit like the trapeze artists who played such an important role in his art, providing key moments in the *Cirque Calder.* Movement presented dangers—the danger of the cyclist falling off the bicycle or the acrobat falling from the high wire—but it also signified liberation. There is no question that Calder felt that his bike riding was important. In

1968, when he created *Work in Progress* for the Rome Opera House—he also referred to it as *My Life in Nineteen Minutes*—he included a scene with actual cyclists in brilliantly colored costumes making figure eights around the stage.[21] That same year, Calder made a free reconstruction of an early motorized mobile for the exhibition "The Machine as Seen at the End of the Mechanical Age," which his friend the curator Pontus Hultén mounted at the Museum of Modern Art in New York. Calder entitled this work *The Bicycle (Free reconstruction of "The motorized mobile that Duchamp liked")*.

Calder. Six Day Bike Race, *1924. Oil on canvas, 30 x 36¼ in.*

IV

In the half dozen years leading up to the first mobiles Calder exhibited at the Galerie Vignon, his work was crowded with prefigurings and foreshadowings. The dramatis personae of the *Cirque Calder*, whether regarded as puppets or marionettes or some utterly new theatrical form, were objects set in motion, shapes that shifted in space as Calder pushed, wheeled, catapulted, balanced, or otherwise manipulated them. Mobility of one sort or another was more of a factor in the early wire sculpture than is evident when they

Film still from Calder's Work in Progress, *mounted at the Rome Opera House in 1968.*

are seen nowadays in the static spaces of museums. Calder's wire study of the golfing plutocrat, *John D. Rockefeller*, done around 1927, had a long golf club that would swing when it was wound up. *Hercules and Lion* and some of the wire heads were meant to be suspended from strings, thus by their very nature mobile. The wire portraits, likewise, shivered when gently touched. And it was no coincidence that the seven-and-a-half-foot-high *Spring* (*Printemps*) sprang to life when given a tug. One observer reported that visitors to the 1929 Salon des Indépendants were "pulling 'Printemps' way over to one side + letting her go."[22] In the 1929 film of Calder and other denizens of Montparnasse prepared by the British outfit Pathé, *Spring* was anything but static; it quivered with life.

The wire sculpture of Josephine Baker that Calder held aloft in the Pathé film was a sort of marionette. In accounts published in relation to the Pathé film, reviewers spoke about a wire woman "on flexible enough legs that she balances in the air with the slightest breeze" and of comic wood and wire toys that "strutted in the glare of the Klieg lights."[23] The 1929 *Goldfish Bowl*, a gift for Calder's mother, had a crank that when turned sent the two fish into fluid motion. This had apparently been inspired by a group of eighteenth-century caged mechanical birds that had been displayed at the Fifty-sixth Street Galleries at the time of Calder's exhibition there. Sweeney, a few years later, wrote about *Goldfish Bowl* with great enthusiasm, describing it as "a sort of music-box with visual rhythms."[24] Although the Galerie Percier show included neither cranks nor motors, there were, as Calder later recalled, "two slightly articulated objects that swayed in the breeze."[25] That was how he described them in his *Autobiography*, but elsewhere he said that they had "a slight articulation . . . because I felt that perhaps I wasn't the final person to decide which was the absolute best position."[26] Mere months after the Galerie Percier show, with *Two Spheres Within a Sphere*, the sort of crank mechanism that Calder had used in *Goldfish Bowl* was being used to create an abstract kinetic object.

For Calder, movement was becoming not so much a quality inherent in certain figures and objects as it was an entirely new realm of poetic enchantment. Fixities were becoming fluidities, shapes and the relationships between shapes were constantly shifting, and new dynamics of time and space were gradually, and then sometimes even suddenly, being revealed. In his essay "Einstein and Cubism," the art historian Meyer Schapiro argues that for

nineteenth-century thinkers as diverse as Hegel, Darwin, and Marx, there was an increased emphasis on "the historical sense of nature as changing, as becoming." For these theorists, "time assumed prestige as the dimension of growth, change, fulfillment, and hope, as opposed to the older view of time as an eroding, destructive force, pertaining to the ruination of things and death. Modernity saw a new awareness of the time of the art, of the timeliness of one's present historical moment."[27] Calder was looking for a way to capture that timeliness. He was going to conquer time.

V

Paris was cold when the Galerie Vignon show opened on February 12, 1932. Duchamp—who throughout his career designed or provoked the designs of a steady stream of announcements, magazines, books, and posters—had urged Calder to emblazon the invitation card with the words "CALDER SES MOBILES" and a schematic drawing of the motorized object that the older artist had liked. It's a striking announcement. Some of the objects in the Galerie Vignon show were motorized and others

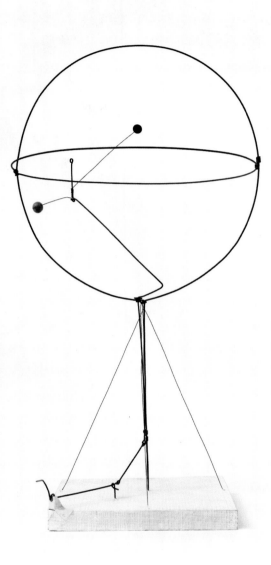

Calder. Two Spheres Within a Sphere, *1931. Wire, wood, and paint, 31½ x 17 x 17 in.*

had moving parts of one sort or another. Unfortunately, nothing close to a complete list of the works in the exhibition has been preserved. What we do know is that the opening was a triumph. Waverley Lewis Root, the reporter for the Paris edition of the *Chicago Tribune*, said that "Montparnasse trooped across an all but frozen river. . . . It was worth the trip."[28]

 Calder had constructed the motorized elements with the help of Jimmy Horn, who, he told one dealer, "did all my wiring for me."[29] Horn was a New York boy who had graduated from Stevens with Calder in 1919; he'd

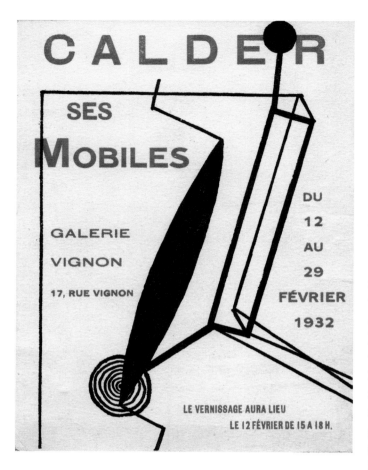

Announcement for "Calder: ses mobiles," at the Galerie Vignon in Paris in 1932.

played lacrosse and been the editor of the student yearbook. He seems to have gotten to know some of Calder's bohemian crowd in Paris. Later in the 1930s, he helped draw up the plans for the studio Calder built on the foundation of an old barn in Roxbury, Connecticut.[30] The motorized objects were certainly high-maintenance, and Calder didn't have an easy time installing the show. It was difficult to get all his objects to "work properly—when desired." That was how he explained it to his mother-in-law a few weeks before the opening, thanking her for a ten-dollar check, which "has come in very handy for mechanical equipment for the things I am working on now."[31] Remembering the vernissage, Calder remarked that "as I made most of the reduction gears myself, there was a good deal of greasing necessary. I spent most of the day of the opening leaning over my gearing, greasing and adjusting my babies. Louisa went home and got a clean shirt for me, but I had quite a beard by the end of the afternoon."[32]

Gabrielle Buffet—the painter Francis Picabia's first wife, and a friend of the Calders' who'd been introduced to them by Mary Reynolds—referred in the avant-garde magazine *Vertigral* to the show as a *"Chambre des Machines Inutiles"*—a room of useless machines. Another critic, not unflatteringly, described the gallery as a laboratory.[33] The motors, gears, and belt drives with which Calder was now working gave many of the objects at the Galerie Vignon a new kind of visual complexity. If the abstractions at Galerie Percier had been crisp and classical, the works at Galerie Vignon had a mannerist intricacy. In *Pantograph* (1931), the black box of the base nearly overwhelmed the delicate wires and metal disks in red and black that performed their elegant dance. Calder's new objects, however much they depended on their mechanical parts, had nothing to do with the cult of the machine as a sleek, indomitable power, an idea that Art Deco designers had embraced.

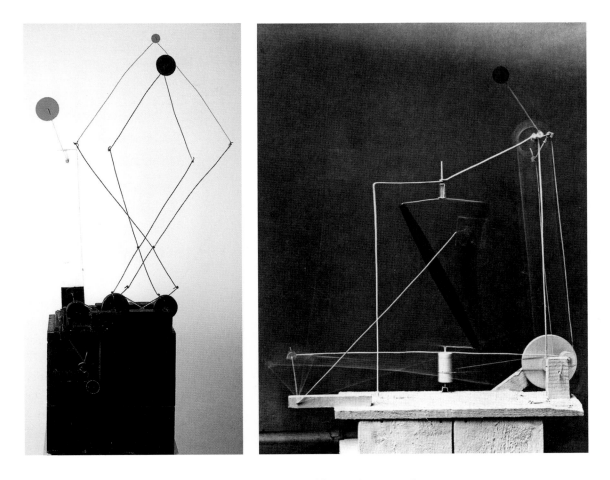

There was a delicacy and a gentle wit about Calder's objects—almost a mockery of the utility of the machine. The homegrown quality of some of Calder's mechanisms was part of the sculptures' off-beat poetry. Calder wasn't the engineer in the factory but the artist in his atelier (even if he insisted on calling his studio a workshop).[34]

Calder's subject was still the arcs, spheres, densities, vectors, movements, and arrested movements of the Galerie Percier—only taken several steps further. Klee, Kandinsky, and Miró had already made masterpieces out of arcs, spheres, densities, and vectors, but in their paintings the movement was implicit, kinetic experience reconstructed in stillness—through what Klee described in his *Pedagogical Sketch Book*, first published in 1925, as "symbols of movement," such as the spinning top, the pendulum, the circle, the spiral, and the arrow.[35] Calder's revolutionary mission was to trade the implicit for the explicit. At the Galerie Percier, he had moved arcs and vectors into the third dimension. At the Galerie Vignon, he upped the ante, taking his arcs

Calder. Object with Red Discs, *1931. Sheet metal, wood, wire, rod, and paint, 88½ x 33 x 47½ in. Photograph by Marc Vaux.*

and vectors into the fourth dimension, that of time. Gallerygoers could now watch as the journey of a line or a sphere unfolded in actual time and space. A few artists (Hans Richter, Moholy-Nagy, Duchamp) had made attempts in this direction. But each of them had pulled back. It was Calder who finally embraced all the kinetic possibilities.

In an account of his artistic evolution published five years later, Calder wrote, "I had the idea of making one or two objects at a time find actual relationships in space."[36] He was aiming for something dramatic—for an art that wasn't so much about being as about coming into being or being in time. In a statement published only months after the show closed, Calder described what he was after: "Nothing at all of this is fixed. Each element is

able to move, to stir, to oscillate, to come and go in its relationships with the other elements in its universe."[37] Years later, Duchamp commented of the chess game to which he had devoted so much of his energy that although the chess pieces were not "pretty in themselves . . . what is pretty—if the word 'pretty' can be used—is the movement." He went on to compare this to Calder's mobiles, the sense of there being "some extremely beautiful things in the domain of movement, but not in the visual domain. It's the imagining of the movement or of the gesture that makes the beauty, in this case."[38]

The Galerie Vignon was the beginning of a one-man artistic revolution. Like all true artistic revolutions, it was also a reaffirmation of the essential nature of the work of art—its freestanding value. Calder's objects moved through time and space—but not the same time and space in which visitors to the Galerie Vignon lived their lives. The relationship between the visitors to the Galerie Vignon and Calder's mobile objects was very much like the relationship between the visitors to a theater and the performers on the stage. The elements that moved, stirred, and oscillated in Calder's mobiles, like the performers on the stage, existed in a parallel time and space—one with its own laws, possibilities, and revelations. Often the movements in Calder's objects were startlingly slow—a break with what gallerygoers imagined to be the normal flow of time, which forced them to slow down and pay very close attention. Gabrielle Buffet described two little spheres, one black and

Calder. Chess set, c. 1944. Wood and paint; board: 18 x 18 in.

Calder. Cadre rouge, *1932.*
Wood, sheet metal, wire,
and paint, with motor,
78¾ x 98⅜ in.

one red, taking their different journeys, and the infinite precision with which their relationship had been established, an extraordinary subtlety in the way they moved. André Legrand found a mysteriousness that bore comparison with certain antique astronomical models, something he may have known interested Calder. Legrand spoke of a "cinematic geometry." He liked the way the balls, spirals, straight lines, diagonals, and circles were all gathered together in "a gentle sequence of logical movements, which are, strictly speaking, poetic." Buffet saw analogies to counterpoint in music, and some of the quality of architecture in the movement of the lines. Legrand, writing in *Art et Décoration*, predicted that these mobiles would be an especially fine accompaniment to the simple forms of modern architecture. He thought that they might be used to create an atmosphere, much as one might put a record on the phonograph.[39]

The performer on the stage, and more specifically the dancer on the stage, was an image that was very much on Calder's mind around the time of the Galerie Vignon show—and, indeed, all through the 1930s. *Cadre rouge (Red Frame)* is one of a series of works he began around that time in which mobile elements are set either within a rectangular frame or in front of a colored rectangular plane. These works suggest both a proscenium stage and a three-dimensional, animated painting. In *Cadre rouge*, the frame is red, and

the elements—including a black disk pendulum, two spheres, a sheet metal rectangle, and a wire helix—each move in a different way. In a description accompanying a reproduction of *Cadre rouge* a year after it was exhibited at the Galerie Vignon, Calder made it clear how important these distinctive movements are. The two white balls rotate at high speed, the black helix at a lower speed, and another element even more slowly.[40] The drama depends on the juxtaposition—and, ultimately, the unity—of different elements moving in different ways. Calder described this as "not a simple translatory or rotary motion but several motions of different types, speeds and amplitudes composing to make a resultant whole."[41] The relationship of the parts to the whole—that most ancient of artistic concerns—remained Calder's concern, only now with time and space united in a radically new way. In his seminal book *Space, Time, and Architecture*, the architectural historian Sigfried Giedion—who became a friend and admirer of Calder's a few years later—quoted a man by the name of Hermann Minkowski in 1908: "Henceforth space by itself, and time by itself, are doomed to fade away into mere shadows, and only a union of the two will preserve an independent reality."[42] That independent reality was the new reality of Calder's mobiles.

VI

In a letter to Frederick Kiesler, Calder said the Vignon show "has been very well received, but has not been all bought up as yet. I still hope to sell one or 2 things as a result." He also reported that artists who visited were "enthusiastic."[43] Among the enthusiasts he listed Léger, Picasso, Duchamp, Cocteau, Arp, Taeuber-Arp, and William Einstein, as well as the critic Carl Einstein and the dealers Jeanne Bucher and Pierre Loeb. Calder sent pretty much the same message to a young man in New York by the name of Julien Levy. Levy had just opened a gallery and Calder was trying to arrange a show. About Levy, his gallery, and Calder's exhibition at Levy's gallery there will be much to say.

The reporting in the Paris press made it clear that Calder was by now a known quantity. Journalists described his weight, his height, his disorderly hair, and repeatedly commented on his by now established reputation as a creator of comic wire figures as well as his evolution, announced in the Galerie Percier show a year earlier, toward an austere abstract style.[44] Georges Maratier, who ran the Galerie Vignon for Marie Cuttoli, recalled years later that the show was controversial with the press. Calder echoed that in his *Autobiography*, recalling a story describing his work as *"l'art automobile."*

"The journalists," Calder asserted, "did not seem to understand anything I was driving at. . . . They just did not, or would not, understand."[45] But the clippings don't exactly bear that out. Although there were only a few sales, Maratier gave the impression that this didn't matter to Madame Cuttoli, who had done the show as "a friendly gesture purely out of admiration for the artist and his earnest art of fantasy." Maratier particularly remembered a grocer's boy, a "wide-eyed youngster [who] sneaked in every morning before the regular patrons were admitted and begged to have the motors plugged in so he could watch the movements."[46]

Calder told Kiesler that among the prominent figures in the avant-garde who visited, there was only one dissenter: Mondrian. When Calder had first visited Mondrian's rue du Départ studio in the fall of 1930, he had commented to Mondrian that he ought to make the rectangles of color pinned to his wall oscillate. To this Mondrian had responded that his paintings were already fast enough. When Mondrian arrived at the Galerie Vignon, he announced to Calder—this was how Calder related it to Kiesler a few weeks later—that his works "weren't fast enough." The fact was that the movements of Calder's motorized objects were rather slow. Gallerygoers were invited to stand still and patiently watch Calder's objects—to contemplate them over a period of time. As Calder recounted the exchange with Mondrian to Kiesler, the two artists appeared to be locked in a comic debate. "When I stepped on the gas," Calder wrote, "he said they still weren't fast enough, so I said I'd make one especially fast, to please him, and then he said that that wouldn't be fast enough—because the whole thing ought to be still."[47] One can imagine the scene, with Calder speeding up the motor on one of the mobiles, and Mondrian complaining that it still wasn't fast enough—and then announcing that it ought not to move at all. The art historian Arnauld Pierre deduced from this amusing encounter some fundamental disagreement between Mondrian and Calder as to what art ought to do, with Mondrian aiming for an absolute fixity and Calder for the exact opposite.[48] But that seems to me to misunderstand the extraordinary interest of Calder's contretemps with the great Dutch painter.

When Mondrian told Calder, a year and a half earlier, that his paintings were fast enough, he was defining the underlying compositional principle of his work. It was the implicit diagonals in his work—the thrilling juxtapositions of variously sized and differently colored rectangles and perpendicular black lines—that created a sensation of speed, of action, of a world that was alive. In 1920, Mondrian published a pamphlet entitled *Le Néo-Plasticisme* under the imprint of Léonce Rosenberg's gallery; in it, he spoke of the dynamic power of his art. "Our whole being is both one and

the other," he wrote, "the unconscious and the conscious, the immutable and the mutable, emerging and changing shape under their reciprocal action."[49] In a later essay, he wrote, "Whether obscured or clarified, rhythm expresses dynamic movement through the continual oppositions of the elements in the composition. By this means, plastic art expresses *action*."[50] When Mondrian, at the Galerie Vignon, told Calder that his mechanized mobiles could never be fast enough, he was saying that their literal motion could never achieve a poetry of motion—which had to be very fast and very slow, at once quick and still, like the sense of movement in a classical landscape painting that is immobile but full of movement. Calder answered Mondrian's objections with the objects he began creating in the next few years, which are generally wind-powered rather than motorized. Their movements are infinitely variable—with potential movement almost imperceptibly becoming actual movement, with the mobile and the immobile and the fast and the slow forever wedded to each other.

VII

When Duchamp had suggested that Calder call his new objects "mobiles," both he and Calder were aware of the double meaning *mobile* has in French. As Calder later explained to Malcolm Cowley, Duchamp "gave me the term he used for his own moving constructions—'mobile.' This, in French, means not only 'movable'—but also a 'motive' 'a reason for an act' so I found it a very good word."[51] There had to be not only movement but a reason for the movement. The literary theorist Roman Jakobson, recalling his early days among the Futurists right after World War I, once wrote that "the overcoming of *statics*, the discarding of the absolute, is the main thrust of modern times, the order of the day."[52] For many early-twentieth-century artists, intellectuals, and scientists, that longing to overcome statics and discard the absolute involved the search for some dimension or dimensions beyond the three in which we all live—a desire to break through the finite, into the infinite. Duchamp perhaps stated this most succinctly in an interview in the 1960s when he remarked, "I'd say I liked the fourth dimension as one more dimension in our lives. . . . Now, you know, I live in three dimensions. It was mostly talk with us, but it did add an extra-pictorial attraction."[53]

Movement and, especially, some movement beyond the third dimension had preoccupied Duchamp for many years before his visit to Calder's studio on the rue de la Colonie. His *Nude Descending a Staircase* was by no means the most significant product of this preoccupation with time, which

some regarded as the fourth dimension. In 1920, Duchamp had created a large motorized optical device with rotating glass plates, which Man Ray photographed in motion. There was another large motorized optical device, the *Rotary Demisphere*, created five years later. Another year after that, Duchamp, in collaboration with Man Ray, created his *Anémic Cinéma*, with patterns of overlapping circles arranged for rhythmic effect. A number of Duchamp's early readymades—the snow shovel and the wooden coatrack—were suspended from the ceiling, so that they rotated to some degree, not unlike Calder's wind-driven mobiles. We also know that Duchamp took an interest in the shadows that the coatrack cast on a wall; some have seen the two-dimensional shadows of a three-dimensional object as suggesting the possible relationship between a three-dimensional object and its extension into the fourth dimension. The fourth dimension may well have been on Duchamp's mind when he examined Calder's kinetic works on the rue de la Colonie. The notes Duchamp had been making for twenty years—many concerned his work on *The Large Glass*—reflected a search for a fourth dimension. He suggested that an infinite expansion of aspects of the third dimension might take us to the fourth. "A 4-dim'l figure is perceived (?) through an ∞ of 3-dim'l sides which are the section of this 4-dim'l figure," he wrote.[54] Certainly the forms on Duchamp's *The Large Glass*—fictive three-dimensional figures inscribed on a transparent surface and thus thrust into the actual space of the room in which *The Large Glass* was displayed—could be argued to prefigure Calder's mobiles.[55]

Thirty years later, Giovanni Carandente, an Italian critic Calder liked and respected, began a little book about the artist by observing that Calder's great achievement was to be "the first sculptor in all the long history of the art to impose a fourth dimension: *time*, as motion in space."[56] It may be that Calder never consciously thought about his mobiles in terms of the fourth dimension. Then again, it may have been Calder who spoke to Carandente about the fourth dimension, and in any event, Calder could hardly have been entirely immune to all the discussion about the fourth dimension in Paris in the 1930s. Was the fourth dimension actually time? Was the fourth dimension another dimension of space? Was it possible to argue that if a shadow was a two-dimensional distillation of a three-dimensional world, then the three-dimensional world was a distillation of a four-dimensional world? (And might this help us understand Calder's interest in shadow play?) Such questions, debated at the time, were part of the background of the mobile. As early as 1910, the painter Max Weber had written in Alfred Stieglitz's *Camera Work* that the fourth dimension was "the consciousness of a great and overwhelming sense of space-magnitude in all directions at one time,

and is brought into existence through the three known measurements. It is not a physical entity or a mathematical hypothesis, nor an optical illusion. It is real, and can be perceived and felt. . . . It arouses imagination and stirs emotion. It is the immensity of all things."[57]

Anybody who, like Calder, listened to the conversations in the Parisian cafés and studios would have heard a good deal about the fourth dimension. Mary Butts kept a diary that gives us some sense of how ideas about the occult and especially the ideas of the Russian mystic Peter Demianovich Ouspensky overlapped with quasi-scientific and entirely serious mathematical questions about the relationships between form, time, space, and the fourth dimension. In 1926, Butts wrote of "4th dimension space [as] the separating of a group of solids, binding them also together into a whole we cannot see."[58] The next year she was reading Alfred North Whitehead and wrote down in her journal this passage of his that might prefigure the mobile: "The question now arises whether all enduring objects discover the same principle of differentiation of space from time; or even whether at different stages of its own life-history one object may not vary in its spatio-temporal discriminations."[59] Did Calder discuss any of this with Mary Butts? Probably not. But that's hardly the point. Calder was beginning to feel the power of his genius, and genius, a matter of intuitions that short-circuit normal matters of influence and assimilation, would be attuned to the implications of the occult, of Ouspensky, of Whitehead.

VIII

Whatever sympathy Calder had for such thinking might well have been reinforced by the friendship he was developing around this time with the composer Edgard Varèse, who was fifteen years his senior. While nowadays most immediately associated with the brazen sonic affront of putting sirens and other anti-classical sounds on the orchestra stage, Varèse was also fascinated by the mystical and the occult, although he may have been moving away from those interests in the early 1930s, when he and Calder were becoming close. Born in Paris, Varèse was a rising star of the European musical world before World War I. He had studied with and been befriended by a glittering succession of musical and literary figures, including Vincent d'Indy, Gabriel Fauré, Jules Massenet, Richard Strauss, Ferruccio Busoni, Romain Rolland, Max Reinhardt, and Hugo von Hofmannsthal. In the middle of the war, Varèse arrived in the United States and almost immediately created a sensation with a performance of Berlioz's monumental *Requiem;* Berlioz was

Calder. Edgard Varèse, *c. 1930. Wire, 13¾ x 11⅝ x 14½ in.*

a composer Calder had written about admiringly to his parents early in his time in Paris. It would seem that Calder met Varèse in New York; according to Sweeney, it was Varèse who initially brought Kiesler to see the circus. By the time they were becoming friends, Varèse was already a considerable figure in modern music. Chou Wen-chung, a composer who was close to Varèse and was also a friend of Calder's, noted that Varèse "disapproves of all 'isms'; denies the existence of schools; recognizes only the individual."[60] Varèse himself said, in an interview in 1926, "Anyone who does not make his own rules is an ass."[61] These were definitely attitudes with which Calder would have concurred. It might even be that the older Varèse emboldened him.

Writing to Peggy in April 1934, Nanette told of going to a performance of *Ionisation,* one of Varèse's most startlingly percussive compositions. "Sandy," as his mother put it, "had tickets for us for a most unusual performance of music last night." She was glad she hadn't ended up sitting next to her friend Catherine White, as she was "most conventionally conservative and it was plus ultra modern music—Sandy's friend Varèse had the most noisy one with 2 sirens (auto) to make noises too—It was like living at the corner of 44th + Broadway forever." Afterward, "Sandy brought me home at midnight with Varèse a wee man who was South American—Mr. + Mrs. Salzedo—the harpist + the 2 sirens in the back seat—They went on to a party at Varèse—but I decided that was not for me. . . . Wish you had been there to hear the din— I was amused at Sandy who said the sirens were the best notes in Varèse music. I am glad V— did not hear him. He has rhythm because he dances but otherwise so far I think music is not in him."[62] That Calder and Varèse

had become quite close by the early 1930s is clear in a letter written by Louisa to her mother-in-law in March 1931, when she and Sandy were living in the studio on villa Brune. Louisa explained that Sandy was spending time with Varèse: "Sandy is working downstairs, and talking to Varèse, the composer, whose music corresponds to Sandy's wire abstractions, so he likes to watch him work."[63]

But in what way did Varèse's music correspond to Calder's new abstract wire sculptures? Varèse had given up melody, harmony, and what Virgil Thomson, years later, in a review of a concert featuring a piece by Varèse, would call "deliberate pathos," much as Calder had given up the traditional stable arrangement of elements and any obvious appeal to what one might regard as the more somber emotions.[64] Varèse's music employed pure sounds in

Calder. Musique de Varèse, *1931. Wire, sheet metal, wood, and paint, 32 x 27 x 27 in. Photograph by Marc Vaux.*

surprising juxtaposition, much as Calder employed pure shapes in unexpected relations. In lectures given in the 1930s and later, Varèse spoke of "the movement of sound-masses, of shifting planes" and how "when these sound-masses collide the phenomena of penetration or repulsion will seem to occur. Certain transmutations taking place on certain planes will seem to be projected onto other planes, moving at different speeds and at different angles." He spoke of "groups of sound constantly changing in shape, direction, and speed, attracted and repulsed by various forces." And of music "as spatial—as bodies of intelligent sounds moving freely in space."[65] All of these concepts can of course seem very close to Calder's thinking, as he began to make objects move at different speeds and shift directions, planes and forms advancing through space, colliding or nearly colliding, their relations and juxtapositions ever changing.

Calder. Untitled, *1932.*
Ink on paper, 30¾ x 23 in.

What is less clear but I think equally important is that Varèse and Calder shared an interest in planets, the solar system, the universe, and the cosmos; the spiral and the helix were forms dear to both men, with their corkscrew movements that might suggest movements beyond the familiar dimensions of our world. In the early years of their friendship, Varèse was struggling with a vast, ultimately unfinished operatic work that has come to be known by various titles, including *L'astronome* and *Espace* (among his literary collaborators on this work was Robert Desnos, with whom Calder was friends).[66] In a scenario for *L'astronome*, Varèse wrote of images and themes that surely engaged Calder as well. He described how "all the constellations will grow pale as Sirius grows more and more intense. Milky Ways." A voice in the scenario cries out, "The point, the point, it's getting bigger." And Varèse wrote that he wanted to evoke "Equator, light of a world" and "Dizzying space."[67] Of the inspiration for *Arcana,* Varèse had earlier written to his wife about a dream he had, in which "I was on a boat that was turning around and around—in the middle of the ocean—spinning around in great circles. In the distance I could see a lighthouse, very high—and on the top an angel—and the angel was you—a trumpet in each hand."[68] The stars, the constellations, the dizzying spaces, the circles, the spinning were all very much concerns of Calder's. As for what Varèse referred to as the hidden secrets in sounds and in noises—wasn't Calder's work in the early 1930s becoming among the greatest of all artistic studies of the hidden secrets of space?

IX

It was precisely this expansion of awareness, this sense of a space that breaks out of the clearly defined space of the classical painting or sculpture that Calder was after as he began incorporating movement into his objects. In a group of elaborately finished drawings made with ink, gouache, and watercolor in 1932, the year of the Galerie Vignon show, he explored the many dimensions that might be discovered beyond the three dimensions in which we normally live our lives. Calder pursued a startling range of shifting relationships and jumps in scale as he gathered together solid and semi-solid forms and allowed them to rise, fall, and float through an indeterminate space. Cordlike forms expand and contract; seemingly heavy forms float free; elements turn in on themselves. In the brilliant *Movement in Space* (1932), an enormous spiraling coil moves from up close to very far away. The spiral—a shape that had interested Calder since, as a boy in Pasadena, he had encountered it among the works of Native Americans and the Arts

Calder. Movement in Space, *1932. Ink and gouache on paper, 22¾ x 30⅛ in.*

and Crafts movement—held a privileged place in the iconography of the fourth dimension. The closed circle was a phenomenon of the Euclidean world. But the spiral was a circle that opened up into other dimensions and perhaps other times and spaces. It was a form that was of great interest to Duchamp—and to Varèse as well.

P. D. Ouspensky, in a visionary treatise much admired in the 1930s, *A New Model of the Universe*, explained, "If we represent time by line, then the only line which will satisfy all the demands of time will be a *spiral*. A spiral is a 'three-dimensional line,' so to speak." It was the spiral that carried Ouspensky ever deeper into his spatial researches, indeed from the fifth dimension into the sixth, which "is the way out of the circle. If we imagine that one end of the curve rises from the surface, we visualize the third dimension of time—the sixth dimension of space. The line of time becomes a spiral." That might very well be the endless spiral in Calder's *Movement in Space*. Later on, Ouspensky spoke of the "emptiness" of "celestial space"—not unlike the emptiness of Calder's white paper—which becomes filled with "luminous points [that] have turned into worlds moving in space. The universe of flying globes has come into being." He added, "If we wish to represent graphically the paths of this motion, we shall represent the path of the sun as a line, the path of the earth as a spiral winding round this line, and the path of the moon as a spiral winding round the spiral of the earth."[69] Whether or not Calder was aware of these passages—Ouspensky's book was published in English in 1931—they certainly suggest the kind of thinking that animated his art.

Calder's last one-man show in Paris, just before he and Louisa returned to the States in the summer of 1933, was at the Galerie Pierre Colle. The critic Paul Recht, in the single issue of the magazine *Mouvement*, wrote about Calder's new work with great enthusiasm, seeing "celestial conjunctions, where the eye attentive to the intervals of the cycles is continuously in the presence of other coincidences."[70] Much of Calder's work was still propelled by motors or cranks, but the wind-driven mobile, which would finally take his art into new lyric territory, was coming to the fore. Recht described an early version of the work entitled *Small Sphere and Heavy Sphere* (1932/33), which evinced what he described as a "disconcerting freedom." He wrote about it in some detail: "You see two balls, one large and one small, attached respectively to wires of unequal lengths, which are in turn attached to the extreme ends of an arm—like the arm of a scale which hangs from the ceiling. Animated by a pendular and a rotary movement, the large ball drives the small ball, which describes the most unexpected scrolls in the air as it strikes the surrounding objects. Using means like gravity and centrifugal

force, Calder has produced the most extraordinary visual variations on the theme of fatality."[71] Although the work that was exhibited at the Galerie Pierre Colle has not survived, a version done shortly afterward still exists. This second version wasn't shown in public during Calder's lifetime.[72] It was regarded as so daringly experimental that Sweeney refused to include it in Calder's 1943 retrospective at the Museum of Modern Art.

Small Sphere and Heavy Sphere was Calder's first hanging mobile. Here the action of the two elements—the larger one red, the smaller one white— precipitates a series of aural effects as the small sphere strikes a group of

Calder. Small Sphere and Heavy Sphere, *1932/33. Iron, rod, wire, wood, cord, thread, paint, and impedimenta, 125 in. high; dimensions variable.*

objects arranged here and there, however one wants, including a wooden box, some bottles, a tin can, and a sort of gong mounted on an iron stand. The three dimensions of space are united not only with the fourth dimension of time but with what might be thought of as the fifth dimension of sound. Was Calder thinking not only about the movement of the spheres but also the music of the spheres? And was the heterogeneous group of found objects that surrounded the mobile elements a nod to Kurt Schwitters and the Dadaists and their interest in the found object? Sweeney, writing years later, suggested that the aural element Calder sometimes added to his objects might have at least in part been inspired by the "Chinese wind bells, with which Calder had become familiar in his youth in San Francisco, [which] were made by a gust of air to please the ear with their tinkling tunes."[73] Of course, the sounds made by *Small Sphere and Heavy Sphere* weren't tinkles but an assortment of more or less resonant knocks, bangs, clinks, and clunks. Calder may have seen the possibility of linking up with his friend Varèse and his idea of "voices in the sky, filling all space, crisscrossing, overlapping, penetrating each other, splitting up, superimposing, repulsing each other, colliding, crashing together."[74]

In his biographical manuscript, Bill Rogers wrote that the Galerie Percier show had left Calder feeling "that perhaps I was too much the perfectionist. Who was I, in other words, to decide an object must be just this way or just that?"[75] This passage was based on a comment in the autobiographical notes that Calder had prepared for Rogers. There Calder put it this way: "When I was making the objects Arp later called 'stabiles' I felt that perhaps I was exactly a perfectionist: i.e. that who was I to decide that a thing should be just this way, or just that way—so I made one or 2 objects articulated, so that they could be in a number of positions. It was this idea that led to the motion, and only a little later that I went after it for the motion itself."[76] So at least in this series of observations, Calder was arguing that movement was a rejection of perfection. But a rejection in favor of what? That was the question. In his 1931 *Object with Red Ball,* Calder created a composition that could be rearranged by the spectator, who was free to readjust the two objects that hung from a horizontal rod and realign that rod in relation to a large circle of wire. The result was an object that might be said to encourage spectators to discover their own idea of perfection. As for *Small Sphere and Heavy Sphere,* there perfection was exchanged for a new kind of freedom—a controlled freedom. With both *Object with Red Ball* and *Small Sphere and Heavy Sphere,* Calder determined the elements that made up the composition but defined their relationships only up to a point. He was leaving it to the audience to arrive at a conjoining of forms and forces that felt especially engaging or

exciting. He was also pushing beyond the formal restraint of the works at the Galerie Percier to a more variegated and heterogeneous formal language— a language that would give voice to all the twists and turns of his own highly variegated and excitable imagination. It would take another half dozen years before Calder exchanged his skepticism about perfection—what the great poet Guillaume Apollinaire had described as the long struggle between freedom and order—for the more perfect union of freedom and order that he achieved with masterworks such as *Eucalyptus* and *Vertical Foliage*.

RUE DE LA COLONIE

Cover of Abstraction-Création: Art non figuratif, *no. 1, 1932.*

I

In the fourteen months before Sandy and Louisa returned to America to settle down in July 1933, Calder became a comanding figure in an international effort to dramatically expand the understanding, appreciation, and acceptance of abstract art. On the cover of the first issue of the yearbook of Abstraction-Création, the confederation of painters and sculptors that was founded in Paris in February 1931, Calder's name appeared in the extraordinary lineup, which included Robert Delaunay, Sonia Delaunay, Jean Arp, Sophie Taeuber-Arp, Naum Gabo, László Moholy-Nagy, Piet Mondrian, Antoine Pevsner, Theo van Doesburg, and Georges Vantongerloo. In the first weeks of 1932, Calder exhibited with many of the Abstraction-Création artists, including Mondrian, Taeuber-Arp, and Vantongerloo, at the Parc des Expositions at the Porte de Versailles. There was another group show early in 1933. A great deal was going on. Early in 1932, Calder wrote to his mother-in-law that he and Louisa "tore around from one vernissage to another."[1] His arrival in this auspicious avant-garde company—he became a member of Abstraction-Création four months after it was founded—has often been told as the story of an American in Paris. But that story was part of a much larger story, for Paris was the international capital where a loose-knit, often fractious community of abstract artists was now banding together. Until the very end of his life, Calder remained an essential part of a free-spirited and serious alliance of men and women who believed that just as abstract art transcended

appearances, so their artistic and social affinities transcended national borders. "Our dear old international Sandy" was how Calder was referred to in a letter Hélion wrote a few years later to their mutual friend Sweeney.[2]

The international outlook came naturally to Sandy and Louisa; they had acquired it from parents who had a taste for travel, were curious about the world, and felt connected to institutions far beyond their native shores, whether the art schools of Paris in Calder's parents' case or the League of Nations in Geneva in the case of Louisa's father. Abstraction-Création was another league or brotherhood (with some sisters as well). The members cheered each other on. Calder later recalled, "I guess all the members . . . came to see my show," referring to the exhibition at the Galerie Percier.[3] They came to the rue de la Colonie as well. Sandy and Louisa's house was becoming a gathering place for artists, some of whom were living on a shoestring and appreciated the food and drink the Calders could provide, thanks to Louisa's regular check from back home. From time to time, Calder mounted performances of the circus, sometimes for close to a hundred people. A great-aunt of Louisa's, Mrs. Alice Cuyler, who lived on the rue Picot, never missed a performance, her place reserved in the front row. Early on, Calder told his parents that he was thinking of using one of the front rooms on the second floor "as a gallery, for my stuff, and for some 7 or 8 others who paint or work in the same direction"—that would be the abstract direction—"as there is no place where they can be seen collectively."[4] Mondrian was a visitor to the rue de la Colonie. Calder remembered that he would "listen to records and say very seriously, with a shake of the head: '*Ça, c'est bon. Ça, c'est pas bon.*'" Calder was amazed one day to hear Mondrian announce, "At Le Boeuf sur le Toit, they painted the walls blue—like Miró." He hadn't realized that Mondrian frequented a nightclub with which Cocteau was involved—or that he was familiar with Miró's work.[5] Mondrian could be a surprise, his single-mindedness in no way irreconcilable with a wide-ranging curiosity.

It was on the rue de la Colonie that Sandy and Louisa came into their own as hosts, with the winning combination of easiness and seriousness that would in the years to come enchant so many people. The conviviality continued in various New York apartments, in the Calders' farmhouse in western Connecticut, and in their first and second homes in the little French village of Saché, not far from Tours. The Calders were by turns high-spirited and high-minded, equally open to a wild night of dancing and a somber political conversation around the dinner table. Many friends who knew them over the years—friends like the artist Saul Steinberg and the playwright Arthur Miller—had no trouble navigating Sandy's complicated combina-

tion of easygoingness and iron will. But for others, beginning on the rue de la Colonie, there seemed to be something suspect or at least challenging about Calder's personality. Michel Seuphor, the young artist and writer who would later publish the first major book about Mondrian, clearly felt this way. Seuphor was described by Torres-García as "a youngish man of keen intelligence and agile, poised, alert and of high spiritual vibration."[6] In the 1940s, he presented an account of a *Cirque Calder* performance on the rue de la Colonie in a novel entitled *Douce Province*. The house was packed with an extraordinary assortment of avant-garde luminaries, including Varèse, Arp, Tristan Tzara, Amédée Ozenfant, André Salmon, and Robert and Sonia Delaunay. Seuphor described Sonia Delaunay as "beautiful, taciturn, with the smile of the Mona Lisa." As for the man who had somehow brought all of these people together on a hot night on the rue de la Colonie, Calder, in Seuphor's portrayal, was a "tough, sporty, rich American" who disguised his extremely poor grasp of the French language with a series of exclamations and mutterings. Seuphor referred to him ironically as "Yankee Doodle: a man of action."[7]

Variations on this portrait of Calder as a sly opportunist reappeared throughout his life, from Thomas Wolfe's depiction of Piggy Logan to later remarks by Noguchi. The accusations were unfounded. Calder worked hard. He wasn't daunted by setbacks. He kept his eye on the prize. He wasn't to blame when his imperturbability caused discomfort. Although he was a man of deep thoughts and deep feelings, he was constitutionally optimistic. Calder couldn't help it if his upbeat attitude sometimes raised suspicions.

II

Abstraction-Création was only one of a number of groups organized in the years between the two world wars to bring together abstract artists in the name of shared ideas and ideals. What abstractionists, those inveterate individualists, might actually share remained a subject of considerable controversy, and groups broke up as easily as they came together. In the first months and years after the Bolshevik revolution, some artists had hoped that the new art might triumph along with a new progressive social order. But Lenin's USSR had rejected avant-garde art in favor of a conservative social realism. With capitalism greatly weakened and reactionary forces on the rise, it was beginning to seem that the best thing for abstract artists to do was cultivate their own gardens. This, in part, accounted for the fascination, for Calder and Hélion and so many others, of Mondrian, who seemed quietistic, a sage dreaming his dreams on the rue du Départ. When Hélion, years later,

Jean Hélion. Composition, *1934.*

wrote about his friendship with Mondrian, he saw him much as Calder must have seen him: not as the proponent of the totalizing theory that the Dutch artist called "pure plastic art" but as a solitary genius who had "something of the classical painter in him," not "merely" interested in "projecting with force what he had conceived" but concerned with "adjusting proportions and colours with infinite hesitation and sensitiveness."[8]

For Calder, who was by nature immune to the appeal of a messianic or totalizing vision in abstract art or, for that matter, in anything else, the growing sense among many of his friends that any abstract style was a personal style made perfect sense. Calder was very much his father's son in his aversion to hard-edged polemic and ideological purity; he would have reacted to the Communist sympathies of some of his Parisian cohort much as his father had reacted to John Sloan's hard-edged leftism, understanding the impulse but remaining immune. Julien Levy, the dealer who mounted the first exhibition of Calder's abstract work in New York in 1932, recalled him as having "no overt politics or prejudices that I know of, if not those of Jeffersonian democracy."[9] That was exactly right, for both Sandy and Louisa were in every way liberal spirits. When they did become politically active in the United States in the 1960s, it was as lifelong progressive Democrats who felt that Lyndon Johnson's escalation of the war in Vietnam was a betrayal of those principles. Hélion and Binks Einstein visited Russia in 1931, eager to see firsthand what was happening to art in the Soviet Union. But Hélion, himself always instinctively liberal, later reported in the left-

ist but anti-Soviet pages of the American magazine *Partisan Review* that he had been "unable to find the men who were working freely," if indeed they existed, and that he had observed that "painting or sculpture did not seem to play much part in anything but propaganda."[10] There seemed no public for abstract art—perhaps not in Western Europe, but certainly not in Russia.

However great might be the appeal of ideological purity in the 1930s, there were liberals and pluralists with whom Calder could make common cause. When Theo Van Doesburg, who had joined forces with Mondrian almost fifteen years earlier to proselytize for a pure abstract art in the Dutch De Stijl movement, attended the *Cirque Calder* at the villa Brune in October 1930, he responded with particular enthusiasm. Although Calder knew too little about Van Doesburg to understand what it was that moved him, the fact was that Van Doesburg, whatever the purity of some of his work, was a pluralist when it came to artistic possibilities. Over the years, he had embraced both Dadaism and Constructivism. In 1923, as the Bolsheviks had been turning against abstract art, Van Doesburg had dismissed the very idea of a proletarian art—an art geared to what some assumed were the tastes of the working people. He'd argued that "the artist is neither proletarian nor bourgeois, and his creations belong neither to the proletarian class nor to the bourgeoisie. They belong to everybody." Art, Van Doesburg asserted in words that would have appealed to Calder, "is an activity of the human spirit and is dedicated to the aim of liberating man from the chaos of life, from tragedy."[11]

Van Doesburg, who was fifteen years older than Calder, died suddenly of a heart attack in March 1931—so Calder barely got to know him, though he and Louisa remained close to Nelly, his widow, who was a year younger than Calder. Hélion, however, had known Van Doesburg quite well. He remembered Van Doesburg as "ardent and querulous, impatient to act and to speak before being swallowed up by silence."[12] In Hélion, Calder found a friend who embodied some of Van Doesburg's complex vision—a mind Hélion recalled as "fertile, free, adventurous, capable of contradicting itself." Calder, who was an exacting but idiosyncratic thinker, clearly liked having a seat at the table when a man like Van Doesburg or Hélion was formulating ideas in public.[13]

III

For the first of the Abstraction-Création yearbooks, published in 1932, Calder included photographs of *Croisière* and another sculpture from the

Galerie Percier show and produced one of his most striking statements, a brief for a new abstract art written in prose that was spare and succinct, minimalist but also oracular. He spoke of his desire to make art "out of volumes, motion, spaces bounded by the great space, the universe." He insisted that his works were "not extractions, but abstractions. Abstractions that are like nothing in life except in their manner of reacting."[14] Calder's aesthetic would never be more pared down, more a matter of fundamentals than in this statement, written in the wake of the preternatural eloquence of the Galerie Percier compositions. For Calder, at least as he wrote in the first Abstraction-Création yearbook, abstraction was a distillation not of the appearances of the world but of the forces that moved the world. Movement was taking the decisive role in his art.

The artists of Abstraction-Création were quick to embrace Calder's work at the Galerie Percier. But austerity was by no means the only value they embraced. The painters and sculptors who had come together in Abstraction-Création valued freedom, fertility, adventure; they were not only capable of contradicting one another, they expected to do so. Hélion referred to the first of their yearbooks as "a dictionary of artists, all sincere and interesting, but very different in their aesthetic."[15] In an unsigned introduction to *Abstraction-Création: Art non figuratif 1932*, he explained that while "abstraction" referred to artists who "arrived at their conception of non-figuration through a progressive abstraction of natural forms," "creation" referred to those artists who were involved with "a conception of pure geometric order."[16] Abstraction-Création was a group that refused to make judgments about the relative value of the works its members were creating. There was a feeling that there had already been too much infighting among the members of what was in fact a small, fragile, embattled community. The pluralism that Abstraction-Création celebrated was very much in sync with the development of Calder's art in the next decade, when both geometric absolutes and naturalistic derivations played their part, as indeed they would to the very end of his life.

Calder's work was, among many other things, a response to the unpredictability of the world in which he came of age. At a time when so much was so uncertain, there could be no single ideal position or possibility. The German critic Carl Einstein was at the time writing about what he referred to as nomadism, an art that emerged from an unstable world. Einstein had been at one of the performances of the *Cirque Calder* at the villa Brune in October 1930; he knew Miró from the renegade Surrealists around the journal *Documents;* and he was a friend of Braque's and the author of a book that emphasized Braque's mystical side. Einstein was interested in the arts as they

had been practiced before humankind settled in cities—in what he called "the life of the nomad, of the restless hunter and shepherd." He argued that "the logically conceivable or fixed moments are merely points of rest, reflections on the surface of the stream which carries us along in a mysterious manner." He worried that there were too many periods in the history of art when man "defends himself against the manifold diversity and confusion of experience." Einstein was interested in Kandinsky and Klee, and one of his most famous essays was produced for a show of ancient bronze statuettes at the Stora Gallery in New York in 1933. He cited as a prime example of nomadism the art of the Etruscans, who embraced "a great spirituality which flourished before classic art became academic." "Space," he wrote, "gains form and meaning through the expression of human energy."[17]

The idea of nomadism, an art whose formal freedom arose out of geographic and social mobility, made perfect sense in the early 1930s. Many artists, writers, and intellectuals were on the move, a long way from home and searching for freedom—or, at least, for some relatively hospitable environment in which to do their work. Many were not as lucky as Sandy and Louisa, who would always have a homeland to go back to. Mobiles, which were before anything else celebrations of mobility, were, among many other things, Calder's instinctive response to the shifting social and political forces of the early 1930s. Calder believed that it was time to repeal the old certainties of the immobile statue in the city square—of his father's George Washington on the arch in Washington Square Park.

IV

In April 1932, after more than a year of married life in Paris, Sandy and Louisa returned to the States for the summer. Before they left Paris, they had a big party on the rue de la Colonie. Mary Reynolds brought Gabrielle Buffet, who had written about the show at the Galerie Vignon and would end up using the Calders' house while they were away.[18] They traveled from Antwerp on a Belgian freighter. Calder told his parents there were ten staterooms and the price of passage was ninety dollars.[19] The Calders passed a carefree summer in the States. They spent time with both sets of parents and "barnstormed" around, as Calder put it, to see friends in an old Dodge that Bob Josephy had sold Calder the year before and that had been left with Stirling and Nanette.[20] Their dog, Feathers, was a great hit with everybody, and learned to swim in the pond near Sandy's parents' house in western Massachusetts. In the middle of July, Calder performed the circus on a Saturday

evening at Stirling and Nanette's place; some fifty people were there, including Bob Josephy and his wife, who had arrived the night before. Writing to her daughter the following Monday, Nanette described Sandy, "big and husky" in a pink shirt and trousers, giving "a fine performance of his circus in two acts. In the entr'acte, the people strolled outside where there was a table full of doughnuts and lemonade. Inside were two baskets of peanuts." Louisa ran the phonograph, "with appropriate music for the circus and is very sedate about it and very observant of people." Louisa, Nanette explained, was knitting and crocheting and had already done a swanky pair of gloves for her mother-in-law. "She is a sweet nice person," she continued, "+ she + Sandy are cosey together." She struck Nanette as being "rather a tomboy and likes to be going about." Nanette wondered "into what she will develop with Sandy as a companion."[21]

Calder was hoping to find a gallery in New York that would mount an exhibition of his new work. The people who had already lent their support on both sides of the Atlantic were an impressive lot. Now Calder set his sights on a show with Julien Levy, who, although still in his mid-twenties, was becoming a force in the international avant-garde. The previous fall, Levy had opened a gallery in New York and had mounted an exhibition of paintings by the Calders' friend Campigli, as well as one of drawings and paintings by Eugène Berman, with whom Calder had shown at Cuttoli's Galerie Vignon. Levy had also presented a pathbreaking exhibition entitled "Surréalisme," including works by Picasso, Ernst, Dalí, Duchamp, Man Ray, Cocteau, and Joseph Cornell. A particular focus at the Julien Levy Gallery in its early seasons was photography, a subject hardly even beginning to be embraced by art galleries—and, indeed, an unusual subject in galleries for the next thirty or forty years. Even as the Calders were making their way back across the Atlantic, Levy was presenting a show of photographs by Man Ray.

Levy's father was in the real estate business, with apartment buildings on Park Avenue. His mother had gone to Radcliffe. Julien entered Harvard in 1923, where he studied art history with Paul Sachs, the visionary instructor in the curatorial arts who made a deep impression on Barr, Kirstein, and A. Everett Austin, who was known to one and all as Chick. Austin, one of Levy's tutors at Harvard, went on to become the director of the Wadsworth Atheneum in Hartford. At Harvard, Levy was already collecting on a small scale, with prints by Klee and Chagall and a drawing by Egon Schiele in his room, "all little treasures I managed to afford while on a hiking trip in Germany."[22] All of twenty-one at the time, he persuaded his father to buy a Brancusi *Bird in Space* from a show at the Brummer Gallery in 1927.

Isamu Noguchi. Julien
Levy, *1929.*

Duchamp, who was much involved with that show, was so impressed by the son's powers of persuasion that the young Levy found himself befriended by the legendary Dadaist. On the day they met, Duchamp struck Levy as a "volatile and impish impresario."[23] They became fast friends. Levy was lean and elegant. In his memoirs, he characterized himself as having a natural affinity with the sort of artists who were "high-strung," aloof, princely, artists such as Balthus, Cocteau, Tchelitchew, and Duchamp. When Julien left Harvard a semester short of graduating, his father wasn't pleased, but he nevertheless gave his approval for a trip to Paris. Levy traveled with his great new friend Duchamp. The expatriate writer Robert McAlmon, the author of *Being Geniuses Together,* was on the same boat. The first night in Paris, Levy found himself at a party at Peggy Guggenheim's. In Paris in 1927, Levy was arguably better connected than Calder was at that point. He knew all the people that Calder would eventually know—and then some. He frequented the Stein salon, met Joyce and Hemingway.

If Levy thought of himself as one of the "high-strung" aesthetes, he reckoned that Calder, whom he would meet soon enough, was a very different type of man, what he called *costaud,* not unlike Picasso or Léger, "full, rugged peasant faces, large, strong hands, indefatigable force."[24] Before opening his own gallery, Levy worked briefly at the Weyhe Gallery, assisting Carl Zigrosser, who had of course shown Calder's work. While at Weyhe, he met the photographer Berenice Abbott. She was attempting to rescue the work of Eugène Atget, who had been virtually unknown at the time of his death in 1927 but would eventually be recognized as the greatest of all photographic chroniclers of early-twentieth-century Paris. Levy offered the necessary assistance; he came up with the money to buy the contents of Atget's workroom and mounted exhibitions of his work. In his memoirs, Levy remembered telling Calder a bizarre story about a workman losing the tip of his finger at Weyhe, which Levy discovered while he was with a client and hid behind a bookcase, whence it never emerged. In Paris in 1933, it was Levy who took Kirstein to Brancusi's studio, where he was impressed by "the all-but-finished 'portrait' of Mrs. Eugene Meyer, magnificently monolithic in the hardest of black diorite."[25]

Levy had seen some of Calder's mechanized sculptures on the rue de la

Colonie; he also remembered some toys, "waddling ducks, head-and-tail-wagging dogs," the sort of thing Calder had done for the Gould Manufacturing Company.[26] Monroe Wheeler, who published Calder's edition of *Aesop,* apparently told Levy about the success of the Galerie Vignon show. In March 1932, Calder wrote to Levy that he and Louisa were "coming over to spend the summer anyway, and intend spending the month of May with Mrs. James in Concord, but of course don't have to spend all the time there, or can come a bit earlier."[27] Levy responded that he might be interested in giving Calder a show, "though my schedule is already pretty full and I cannot now say at exactly what part of the season."[28] The arrangements were rather casual. Levy said that he was sailing for Paris in mid-April and hoped they wouldn't "pass each other on ships in the night. If so arrangements can be made here at the Gallery with Joella who will be in charge."[29] Joella was Levy's wife. Calder, just before leaving Europe, explained that "we will pass on the ocean, anyway, we will wave to you." He still wasn't sure there was a show. He wrote that he would bring seven or eight things that were transportable, adding, "If you have an open moment in May you might save it for me. Anyway I'll hot foot it around to the gallery to see you, and learn what's up."[30]

Massimo Campigli. Joella Levy, *1931.*

V

Joella, who married Julien in 1927, was the daughter of Mina Loy, a poet and legendary bohemian who had grown up in London and established herself in Greenwich Village in the circles around the Provincetown Players during the World War I years. Levy recalled that Joella "adored Sandy and everything he did." Calder had that effect on many independent-minded, free-spirited women. And so although Levy was in Europe when Calder arrived in New York, Joella leapt into action on Sandy's behalf. She arranged for him to mount a show in the gallery, scheduled to begin on May 12, with Calder paying for the announcements, which wasn't an unusual arrangement.[31] Calder had brought with him from Paris what he described as a bale of sculptures, a three-foot cube; by the time the work arrived in New York, it was somewhat the worse for wear, as it had been strapped to the top of a cab in Antwerp and gotten rained on during the Atlantic crossing.[32] Man Ray's exhibition had already been taken down, and while Calder's work was being arranged on a number of pedestals, on the gallery walls was a show of photographs of New York by New York photographers, including Walker

Calder. Two Spheres, *1931.*
Wood, wire, and paint,
with motor, 21½ x 11 in.

Evans, George Platt Lynes, Berenice Abbott, and Ralph Steiner. Calder presented only a couple of mechanized works, for which, as he had already warned Levy, his old Stevens friend Jimmy Horn had done all the wiring.[33] Calder was exhibiting at the close of the first season of a gallery that would throughout the 1930s and 1940s be one of the most adventurous in New York.

Calder's opening, Joella reported to Julien in Europe, was "quite a good one. . . . People have been piling in for Sandy's show."[34] "Though Calder," a press release explained, "has been variously described as a bright young blade who has a lot of fun with wire and one of this country's geniuses, [his sculpture was] not taken as a joke in Europe."[35] As proof of this, there was a quotation from the introduction to the Galerie Percier show by Léger, an artist already well known in the United States. Frank Crowninshield, the editor of *Vanity Fair,* who had been following Calder's work for some years (he had seen the circus and was the subject of a wire portrait), came to the show and told Joella to call whenever there was something the gallery wanted him to do for them. There was a good deal of press, with a reporter from the *New York World-Telegram* meeting the artist at the gallery, where Calder struck the writer as "a middle-aged man, who wears shapeless tweeds and sandals. His hair is graying and his mouth is usually half-open in a guileless, sleepy smile. The lashes of the right eye are black, the left gray."[36] When told that a vertically moving ball—in *Two Spheres* (1931)—seemed like something in a shooting gallery, Calder responded, "The balls in a shooting gallery move for a utilitarian purpose. This has no utility and no meaning. It is simply beautiful. It has a great emotional effect if you understand it. Of course if it meant anything it would be easier to understand, but it would not be worthwhile."

This was the language of modernism, what the English critics Roger Fry and Clive Bell called "significant form." Nearly two decades after the Armory Show, some of the press was still inclined to kid around about modern art and treat criticism as a sort of comic performance. But there were exceptions. The extraordinarily sophisticated critic Henry McBride, writing in the *Sun* under the heading "The Franco-American," suggested that only in Paris could Calder's delicate meditations on mechanical movements have been born. A pattern was developing in Calder's career, whereby in France he would be judged 100 percent American, while observers in the States saw something French about his work. McBride observed that New Yorkers, living as they were in the midst of the Depression, "have no energy left for chimeras. Not even for chimeras that resemble instruments of precision in a laboratory built for Prof. Einstein." McBride described the "cute little motors that run these discs and wires and small planets," and said that Calder's "Saturns and Jupiters, if that is what they are, move so lazily on their orbits, that, too, is fun." McBride was reminded of something by Stravinsky: played pianissimo, "it could scarcely be heard, yet, for all that, with a recognizable purpose that finally breathed out its design." He mentioned a fish in deep water and "the ardent but noiseless activity of a spider."[37]

Calder. Double Arc and Sphere, *c. 1932. Wood, wire, rod, string, and paint, with motor, 32½ x 11½ x 11¼ in. Photograph by Marc Vaux.*

Calder's father was at the Levy opening. He told his son that he "could not dissociate himself from a screw eye and a pulley which drove one object around; he said he could see nothing but a man on a motorcycle making laps." To which Calder added that "he was at least puzzled by what I made." Puzzled and interested and sympathetic—as Stirling would be about his son's work until his death thirteen years later.[38] Edward Alden Jewell reviewed

Calder. Small Feathers,
*1931. Wire, wood, lead,
and paint, 38½ x 32 x 16 in.*

the show in *The New York Times* and found it at first bizarre but also a fascination. Jewell reported a comment of Calder's father's, who struck Jewell as "manifestly proud." "Well," Stirling said, "we should all keep moving in a world so full of wonders."[39] Stirling knew that modern artists sometimes approached their work in a scientific spirit. A couple of years later, he wrote to his daughter in Berkeley, who was beginning to teach art, about Cézanne, who he said "was a searching scientific painter working quite like a scientist alone in his laboratory with a problem that he alone saw clearly and to which he devoted a life, that at the time was thought a failure."[40] And then Stirling added that Peggy ought to read Zola's novel *L'oeuvre,* in which the protagonist is a painter based on Zola's childhood friend Cézanne.

Levy was not entirely reliable when he wrote about Calder in his memoirs toward the end of his life. He imagined that the performance of the *Cirque Calder* that Thomas Wolfe fictionalized was somehow connected with the Calder show at the Julien Levy Gallery in 1932, when, in fact, Wolfe had written about a performance in December 1929. In the important volume he published about Surrealism in 1936, Levy described Calder as an artist who didn't know his own mind. "Alexander Calder," he wrote, "is sometimes surrealist and sometimes abstractionist. It is to be hoped that he may soon choose in which direction he will throw the weight of his talents."[41] In retrospect, Levy may have regretted or resented that he never really became Calder's dealer. There was clearly some push and pull between the slender aesthete and the sturdy artist as they crossed paths over the years. In his *Autobiography,* Calder recalled that after the premiere of Virgil Thomson's *Four Saints in Three Acts* in Hartford in 1934, at a party at Chick Austin's, "Julien Levy got rather tight and blocked

the passage. Whereupon, Louisa suggested that Jim Soby and I put him to bed, which we did." We have already encountered the collector and curator James Thrall Soby—Calder made metal birds for his Victorian birdcage—and there will be more to say about him. Levy, Calder continued, "came down shortly after, very indignant that we should have called attention to his inebriety, and remained in that state of indignation for about twenty years, first blaming me and later Louisa. However, we have become good friends again—and I hope this account does not make him angry once more!"[42]

In his memoirs, Levy recalled being "furious" in the wake of Calder's exhibition because "his electric motors blew fuses in the gallery, and worse, holes had to be dug in the pristine walls for new outlets."[43] Levy also argued that he had been an early advocate of Calder's move from motor-driven to wind-driven mobiles. "I felt strongly," Levy wrote, that a simplicity not unlike the simplicity of the movement of the toys "would be more pure and interesting art than the elaborate patterns made by motors"—which Levy said he found ultimately "predictable and monotonous." He claimed that he had suggested to Sandy that he let elements "drift and turn without motors."[44] Perhaps some of these thoughts occurred to Levy only many years later, when he came to write his memoirs. Then again, it was Levy, according to Calder, who dubbed a 1931 abstract work *Feathers*—an allusion to the Calders' furry little dog. This object, which is now known as *Small Feathers*, was one of the earliest with nonmotorized mobile elements, and Levy's giving it a name that alluded to a living, breathing animal suggests that he was indeed attuned to Calder's growing interest in naturalistic echoes and allusions.[45]

VI

When Sandy and Louisa left New York for Barcelona toward the end of August, they both had touches of poison ivy on their faces.[46] They were seen off at the boat by Jane Harris and her husband Reggie, the same friends with whom they had spent time in the days after their wedding, just over a year and a half earlier. They had decided to stop in Spain on their way back to Paris and see Miró. Sandy and Louisa visited him at his farm in Montroig, southwest of Barcelona. This farm was the subject of a painting that Hemingway had purchased and of which he wrote, "It has in it all that you feel about Spain when you are there and all that you feel when you are away and cannot go there."[47]

To visit Miró in Montroig was to experience the old, imperishable Catalonia—the austere, magical landscape that had nourished this most

ABOVE *Jane and Reggie Harris seeing off Calder and Louisa Calder, as they leave New York on the* Cabo Tortosa *for Barcelona in late August 1932.*

RIGHT *Joan Miró.* The Farm, *1921–22.*

sophisticated and cosmopolitan of artists. Calder mounted a performance of the circus for the farmers and other workers around Montroig. Years later, Miró recalled how "everyone was transfixed and totally overwhelmed by it"—a response he couldn't help but contrast with the "bored, emotionless" reactions of the audience watching a filmed performance of the *Cirque Calder* in a Montparnasse movie house in the 1960s.[48] One day the Calders and Miró went to the seashore at Cambrils and watched fishermen bringing in their catch and transferring it to large, flat baskets, the fish stacked in a spiral. The arrangements and the baskets were "very pretty," Calder remembered. Then the fishermen "picked up the baskets [by handles at the sides] in a queue and proceeded into the square. There, the first man turned in a circle until the others followed up around

him in a spiral." Sandy and Louisa bought one of the baskets. Such woven things would be a lifelong enthusiasm, especially when they lived in the Touraine, where baskets were made from the rushes grown in the Indre River.[49]

It was an extraordinarily exciting time in Miró's homeland, with the military dictatorship overthrown in January 1930 and a transition from monarchy completed with the founding of the Second Spanish Republic on April 14, 1931, a little over a year before the Calders arrived. For a Catalonian like Miró, who saw the region's history and culture as distinct from the rest of Spain's, it was especially gratifying that the new constitution gave Catalonia a degree of autonomy. Spain was a ray of hope for progressives in Europe and the United States as they surveyed the political and social turmoil in Europe in the wake of the Crash. Like Calder, Miró was always

Calder. À bas la Méditerranée, *c. 1937. Silver wire, 3½ x 2⅞ in. each.*

suspicious of political extremes, and in its first months and couple of years the republic seemed animated by a fundamentally pluralistic and moderate spirit. Responding earlier to Breton's sympathy for communism and the Surrealists' interest in group endeavors, Miró had registered his own skepticism, commenting that individuals with "strong or excessive" personalities— the artistic personality, in other words—"will never be able to give in to the military-like discipline that communal action necessarily demands."[50] Calder was very much in sympathy with a comment Miró made about it being best to let all ideas sink to the bottom of the Mediterranean. He went so far as to emblazon it on a pair of earrings that he made around 1937: *"À bas la Méditerranée."*

The promise of a democratic Spain was matched by fresh efforts on the part of Miró and other artists and architects to band together in loose-knit confederations, with the idea of supporting a new openness and freedom in the arts. Josep Lluís Sert was among the young architects involved in GATE-PAC (Association of Spanish Architects and Technicians for Progress in Contemporary Architecture), which was organized to press the case for a modernist architecture in Spain some nine months after the founding of the republic. Sert had already worked with Le Corbusier in Paris and would be one of the architects of the Spanish Pavilion at the 1937 International Expo-

Calder. Mobile with Hats,
*1957. Wire and paint,
29 x 40 in. Calder made
this mobile for his friend
Joan Prats for the window
of his hat shop in
Barcelona.*

sition in Paris. Calder and Sert, who immigrated to the United States in the wake of the Spanish Civil War and later had a career at Harvard, were lifelong friends. When the *Cirque Calder* was performed in Barcelona, it was in the hall of GATEPAC, the event sponsored by ADLAN (Friends of the New Art), a brand-new organization with which Miró was deeply involved.[51] Sert was another founding member, as was Joan Prats, the Barcelona haberdasher, art collector, and publisher for whom Calder would later make a mobile consisting of wire hats. For some years, Calder treasured a hat Prats had given him. He worried about its whereabouts after forgetting it at a friend's place in New York in 1936. "I hope you found my hat," he wrote, "it had 'AC' cut with scissors in the band—and was from Prats Barcelona. I seldom wear it, but have a great affection for it— probably because Prats gave it to me, and I'm fond of Spain."[52] In the 1950s and 1960s, Joan Prats published a series of beautiful, square-shaped books, including volumes on Gaudí's architecture, Barcelona's Art Nouveau, and Miró's art, as well as one about Calder.[53]

In a manifesto, the members of ADLAN said that their goal was to be "receptive to the latest manifestations in all of the arts" and "maintain an open mind in the face of dogma and accepted values."[54] In addition to Calder's circus, an early event was a reading from Federico García Lorca's *Poet in New York*. When, the following February, the Calders returned to Spain for a month, there was a gallery show and a performance of the *Cirque Calder* in Madrid and an exhibition under the auspices of ADLAN at the Galería Syra in Barcelona; Calder also visited the Prado, although Hieronymus Bosch's *The Garden of Earthly Delights*, which had a profound impact on his work a decade later, had not yet been moved there from the Escorial. Calder's association with the Spanish republic has invariably been linked

with the *Mercury Fountain*, which he made for the 1937 International Exposition in Paris, but his involvement with the liberating dreams of the republic began much earlier, not long after its founding, when Miró, Prats, and Sert sponsored the *Cirque Calder* and the exhibition of Calder's drawings and a few sculptures in Barcelona. Calder also mounted two performances of the *Cirque Calder* during their February visit for paying audiences, according to Louisa, with the "hope to make some money."[55]

Sometime in the last year or so in Paris, Calder crossed paths with another Spaniard who has forever been associated with the history of modern painting: Salvador Dalí. He remembered going to visit Dalí, who "had many lewd (?) postcards and was pasting them in books."[56] Offered the opportunity to examine a scenario that Dalí had written for a movie, *Babaouo,* Calder commented that there were "too many restless inner tubes, pumping up and down." Dalí took offense. That was the beginning of what Calder referred to as a "coolness [that] has existed between us ever since."[57] That coolness, whatever its origins, only intensified when Dalí became a supporter of Franco and the fascist triumph in Spain. By the end of the 1930s, Breton, at one time a strong supporter of Dalí's, had dismissed him with the anagram "Avida Dollars."

VII

The last year or so in Paris was punctuated by travels, and not only to Spain. There had been a visit to Brittany with Louisa's friend Helen Coolidge in 1931, and in 1932 Sandy and Louisa were back there. The Atlantic coast held a particular appeal for Louisa, perhaps reminding her of earlier summers on Cape Cod; in the 1950s, the Calders bought a vacation house in Brittany. Sandy wrote to his parents from Port Blanc that they were there with the young filmmaker Jean Painlevé and were joined by Edgard Varèse and his wife Louise, who were friends of Painlevé's as well as of the Calders'.[58] Painlevé was the son of Paul Painlevé, who had been a prime minister of France and was also a renowned mathematician. Painlevé fils had been involved with the Surrealists in the 1920s—he appeared in Buñuel's *Un chien andalou*—and by the early 1930s was becoming well known for his films of underwater life. These interested Picasso; they may well have also stirred Calder's interest, with their focus on the forms and movements of the underwater world. In 1953, Painlevé made a film of the *Cirque Calder*. In Brittany, the Calders spent time with one of Painlevé's collaborators, Geneviève Hamon, and her family; her father, Augustin Hamon, a socialist and writer,

had with his wife produced French translations of Stirling's beloved George Bernard Shaw.[59] Family was knit deep into the Calders' life. Louisa's father had passed through Paris for a couple of days in January 1932 with Dante Sacco, a son of the Italian executed for treason. Dante Sacco was acting as Edward James's chauffeur. Mrs. James had also come to visit, later that winter or spring.[60] On the way back from Spain the following February, the Calders visited Louisa's godmother, Tante Bullard, in Rome.[61]

During Sandy and Louisa's last six or so months in Paris, Miró stayed with them a couple of times on the rue de la Colonie. He had an exhibition at the Galerie Pierre Colle in December, and the following June he was in a show with Calder and Hélion and some others at another gallery, Pierre Loeb's Galerie Pierre, and was simultaneously in a Surrealist exhibition at Pierre Colle's.[62] Calder had had a show at Pierre Colle's the month before, in May. These final exhibitions of Calder's before the return to New York probably owed something to his friendship with Miró, who had been exhibiting regularly with Pierre Loeb since 1924. Calder and Miró were by now very close; they were even talking about collaborating on some sort of object, although this never came to pass.[63] The exhibition at Galerie Pierre included six artists, Calder along with Arp, Miró, Pevsner, Kurt Seligmann, and Hélion. With the exception of Miró, all the artists in this stylistically heterogeneous exhibition were members of Abstraction-Création. Although Calder didn't care for the texts, which were written by Anatole Jakovski, the small, elegant catalog, which Hélion organized and the artists pitched in to pay for, remains a striking souvenir of the variegated strands of the abstract avant-garde. Calder's art was certainly moving in fresh, unforeseen directions. One of the last works he made in France, the mobile *Cône d'ébène*, juxtaposes three highly variegated wood forms—one cone-shaped, one spherical, one suggesting a medieval helmet or an exotic bird—in a whirling dance.

The times were tumultuous, with the darkening shadows of the Depression and the increasingly frightening news from Germany. Nevertheless, the Calders had reason to feel optimistic. Sandy's star was rising on both sides of the Atlantic. And either toward the end of their stay in the United States or after their arrival in Spain, Louisa discovered that she was pregnant. They were expecting to have a child in Paris—much as Calder's mother had had her first there in 1896. But sometime in the spring Louisa miscarried, with Calder rushing her to a clinic in the middle of the night. The next morning, when Calder explained to their housekeeper what had happened, the housekeeper responded, "My mother, she has had many miscarriages." In his *Autobiography*, after relating that the housekeeper, when asked how many children her mother had had, said, "Ten, that makes fifteen with the mis-

OPPOSITE *Calder.* Cône d'ébène, *1933. Wood, wire, rod, and paint, 106 x 55 x 24 in. Photograph by Marc Vaux.*

carriages," Calder abruptly shifted direction and commented on the many frightening articles in the European press about the possibility of war. He remarked that "we thought we had better head for home. Louisa hoped to have a baby in tranquillity and Europe did not seem tranquil at the time."[64]

We know no more details about Louisa's miscarriage. But with the pregnancy so abruptly and tragically ended, the adventure of having a child in a foreign country no longer seemed so appealing. Calder would have remembered the stories about his older sister's birth in Paris, a terrifyingly long labor with a deeply unsympathetic doctor. He may have felt that whatever the fascinations of Paris, it was better to start a family in the States. It's perhaps worth noting that although the Calders lived more in France than the United States in the 1960s and 1970s and remained ardent Francophiles to the end of their lives, they almost invariably found their primary doctors in the United States. When it came to the medical profession, they may have believed that Old World traditions were no match for American know-how.

The years on the rue de la Colonie were an extended honeymoon in Paris, the city that Joyce had said was a lamp lit for lovers. As a going-away present, Miró gave them an imposing painting, its surface saturated with a deep, striking blue. Although Sandy and Louisa later lived in France for many years, they never really lived in Paris again. But there was no sense of retreat in their move back to the United States. The New York to which they were returning was a city with a growing awareness of the new abstract art—and Calder was beginning to be recognized as one of the leaders of the movement. Hélion was on the boat with them back to the States, where he was going to marry Jean Blair. He was continuing his work with the collector Albert Gallatin on his important collection, initially displayed as the Gallery of Living Art at New York University. In April 1933, the Bauhaus had finally been closed by the Nazis. That marked the end of a generation of avant-garde experimentation in Europe. At least a few people were beginning to suspect that the future of modern art—and of the serious study of modern art—was going to be in the United States.

Alfred Barr, who had been enormously excited by his visit to the Bauhaus a few years before, was determined to bear witness to what the European avant-garde had already achieved. As part of that effort, Louisa's old friend Henry-Russell Hitchcock had already collaborated with the young architect Philip Johnson on an epochal exhibition of contemporary architecture, what they referred to as the International Style, at the Museum of Modern Art. Hans Hofmann, a painter and teacher whose international reputation had earlier brought some American artists to study at his school in Munich—including Calder's friend Vaclav Vytlacil from villa Brune—had recently

arrived in the States, where beginning in 1933 he ran a school in New York that helped shape the ethos of Abstract Expressionism. Erwin Panofsky, a towering figure in German art history, was living in the United States; he was one of the scholars Barr and Meyer Schapiro wanted to bring together with Sweeney and others for what Schapiro described as "a group for the discussion of modern, and especially contemporary, art."[65] Surely there was a growing feeling that modernism could be reimagined in Manhattan. What nobody could as yet imagine was how many of the creative spirits with whom Calder had been associated in Montparnasse would be forced in the next few years, at least temporarily, to reinvent themselves in New York.

CHAPTER 22

PAINTER HILL ROAD

Saul Steinberg. Calder and His Daughter Mary in the LaSalle, *c. 1948. Saul Steinberg became friends with the Calders soon after he immigrated to the United States in 1942.*

I

The first thing the Calders did on their return to the United States was to visit their parents in Massachusetts—Louisa's in Concord and Sandy's in Pittsfield. The old Dodge Calder had bought from Bob Josephy a couple of summers before was replaced by an immense 1930 LaSalle touring car, a luxurious but old-fashioned vehicle with a canvas top and seating for up to nine people. Calder probably bought it fairly inexpensively, perhaps because such an extravagant vehicle had become a white elephant in the midst of the deepening Depression. Calder kept that car running for seventeen years, a boat of an automobile that may at first have been a badge of idiosyncratic bohemian luxury but would eventually become a badge of plain old bohemian eccentricity. Years later, it was the subject of a comic drawing by Saul Steinberg and a nostalgic recollection of its dashboard by the playwright Arthur Miller, who described how the original dials had been replaced by a strange assortment of wires. How could Calder not have appreciated this big, bold piece of machinery? A student of automotive design might note that the LaSalle was at least in part modeled on the design of a famous European luxury car, the Hispano-Suiza. And a student of automotive design who was also a student of modern art might point out that Picasso was the proud possessor of a 1930 Hispano-Suiza, which he treasured deep into the 1950s, when Calder had at last had enough

of the LaSalle and given it to his mechanic. We know that Picasso owned his Hispano-Suiza at least as early as 1932, the year before Calder returned to the United States.[1] Was Calder aware of Picasso's car? We don't know. But who can wonder that these modern masters loved their modern machines?

It was in the LaSalle that the Calders set out to find a house in the country, a place where they could begin to establish roots as a married couple in their native land. Their plan all along was probably to rent an apartment in New York City during the winters but to have a country home as a base of operations. Although they looked a bit along the Housatonic River in Massachusetts, where Calder's parents' summer place was, and where Calder had helped his parents house hunt not that long before, Sandy and Louisa's most assiduous investigations were carried out within a couple of hours of New York. On Long Island, they went all the way out to Yaphank with Jane Harris. Up the Hudson, they looked around in Tarrytown and New City. And in Connecticut, they first went to Westport, on Long Island Sound, where Bob Josephy was now living a sort of rural life. Then they looked farther inland, in Sandy Hook and Danbury. In Danbury, with gas money borrowed from Josephy, they went off with a real estate agent to see a place in Roxbury. Forever after, Sandy and Louisa disputed which one of them, on spying a run-down eighteenth-century house over the brow of a hill, had been the first to exclaim, "That's it!"[2]

The house at 314 Painter Hill Road was a two-story colonial with an attic and a central chimney. The bones of the house dated to sometime between 1750 and 1790, while the Greek Revival–style doorway and the windows in the gabled peaks were nineteenth-century additions. Known as the Jehiel Hurd House, it was on eighteen acres, part of the estate of one Charles R. Hurd, being sold by a relative who lived nearby. The price was $3,500, with 10 percent down, which Calder's old college buddy, the ever-loyal Bill Drew, wired to the real estate agent's office. Calder borrowed $1,100 on a life insurance policy, and for the rest there was a mortgage, which was paid off five years later. The deed was signed on September 1, with Calder using his parents' address in Pittsfield, Massachusetts. Stirling and Nanette had been invited for a picnic to look over the place, along with Calder's sister, Peggy, who was visiting back east at the time. Years later, Peggy recollected that the house was in pretty sad condition when they first saw it. A brief bit of film footage, taken when Calder's parents were inspecting the house with Sandy and Louisa, leaves no doubt that Peggy was telling the truth. "The well-proportioned old farmhouse," Peggy recalled, "looked forlorn that day, with windows broken and paint peeling. Father walked all around, inspecting the adzed floor and roof beams, and pronounced the basic structure sound and

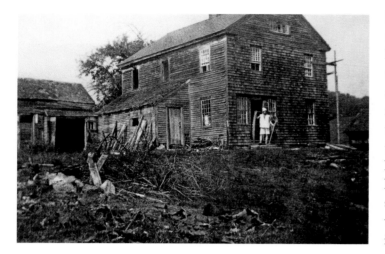

*Calder in front of the
Roxbury house in September
1933, as the repairs and
renovations were beginning.*

handsome. Mother, appalled at the
clean-up job ahead, was won over
by the forsythia and lilacs that
screened the house from the road,
and by the apple orchard, which
needed only pruning."[3] Sandy,
true to form, didn't allow himself
to be discouraged, and remem-
bered only that his parents had
been very taken with the land, the
sense of the house on a gentle rise,
with pastures and vistas unfolding
in various directions.

The place needed everything—
plumbing, heating, electricity, the works. In the fall, Sandy and Louisa
stayed with a Parisian friend, the sculptor José de Creeft, who had relocated
to the States and was living with some other people in New Milford. Calder
got together what he later recalled as "a strange crew of carpenters, painters,
and even a plumber who used to study *Popular Mechanics* and undertook to
put all the plumbing and heating in the house for $1100."[4] That fall, Louisa
had an account set up in the First National Bank in New Milford; $1,000 was
deposited in September.[5] It would be a number of years before the house on
Painter Hill Road was really a comfortable place to live. Sandy and Louisa
did spend much of the winter of 1933–34 trying to get their new home in
order. Calder found the weather that first winter in the country severe and
also somehow exciting. The Calders didn't wind up regularly living there
year-round until sometime in the 1940s. Sandy might be imperturbable in
the face of all the challenges involved in renovating a dilapidated old house,
but when he plunged into a similarly challenging renovation in France in the
1950s, albeit with a good deal of help, Louisa's initial reaction was to try to
head him off, perhaps remembering all too well what they had gone through
during those first years in Roxbury.

The dairy barn near the house had burned down a couple of years earlier.
But there was an old icehouse just behind the house, which Calder converted
into a rudimentary studio with a dirt floor, installing some recycled win-
dows on an easterly wall. He would work there until he constructed a new
studio on the foundation of the old barn in 1938. Downstairs in the house
proper, they combined two rooms into a living room of some twelve by
twenty-five feet; eventually the kitchen, in the northwest corner at the front
of the house, facing the road, was joined with a small dining room to create

a single larger kitchen. Upstairs there were three bedrooms and a bathroom, the rooms running one into the other. All the walls were whitewashed to give the clean-lined effect that had first struck Calder at the Hotel Regina in Barcelona. Out of the packing cases in which their belongings arrived from France, Calder made a corner cupboard for the kitchen and painted it barn red. They began with a coal-burning furnace that Calder found a trial to deal with. "Many times," he recalled, "I ran down cellar . . . naked, to shovel ashes on the bed of coals and keep the steam down."[6] There weren't many trees around the house when they bought it. Like much of that part of the world, it had been turned into hardscrabble farmland and would become truly bucolic only when city dwellers took up the challenge. They patched

Calder in the icehouse studio in Roxbury, 1936. Photograph by James Thrall Soby.

up the old apple trees, and Henry Karrmann, the farmer next door, from whose mother they had bought the house, dug an ash and a maple out of the woods. These eventually flourished, along with a dogwood from their friend the potter Henry Varnum Poor, who lived in New City.[7]

II

For Louisa, whose accent and aristocratic bearing would always mark her as a Boston Brahmin with roots going back to the American Revolution, Roxbury, first settled in 1713 and incorporated as a separate township in 1796, was not entirely unfamiliar terrain. Arthur Miller, who became friends with the Calders after he bought a place close to them in the late 1940s, wrote in his autobiography about the Calders and the group that would become their first Connecticut friends, especially the artist Peter Blume and the literary critic Malcolm Cowley. They had "come up here," he said, "when small, bony farms still covered the landscape." He sensed that although "the farms were dying off," the Calders and some of these other artistic and literary pioneers responded to an area that "still wore its pleasing air of relaxed rural decay." Even when Miller moved up, some fifteen years later, "I still had in my barn the gig in which the farmer who sold me my place had driven to church."[8] What endeared Sandy and Louisa and then Arthur Miller to the area was the mingling of an old Yankee forthrightness with the altogether different demeanor, in its own way also forthright, of the creative spirits who found their way to the inexpensive houses in the area. When Peggy wrote her book, *Three Alexander Calders*, after her brother's death, she pretty much ended the story with his return to the United States in 1933 and the purchase of the Roxbury house, as if by then he had become the man and the artist he would always be. Perhaps that wasn't far from the truth.

In his *Autobiography*, Calder left the impression that he and Louisa landed in Roxbury almost by accident. Their decision was less random than Calder chose to let on. The inventor of the mobile was often glad to let life look more serendipitous than it actually was. In the spring of 1926, Calder had already spent time very near Roxbury, when he was with his Greenwich Village friends Betty and Tony Salemme and their friend Oscar Davisson, in a house near Sherman. When Sandy and Louisa bought the Roxbury house, they may have already known that José de Creeft was living in New Milford, and they were surely aware that writers and artists had been taking up residence in the area, at least during the summers, since the mid-1920s. Malcolm Cowley, who moved his family to the area in 1936 and became one of Sandy

and Louisa's closest friends, described in his classic account of the expatriate experience of the 1920s, *Exile's Return,* how "about the year 1924 there began a great exodus toward Connecticut, the Catskills, northern New Jersey, and Bucks County, Pennsylvania. Many of the former expatriates took part in it; and soon the long process of exile-and-return was resumed almost in the form of a mass migration."[9]

Cowley had been part of a group that congregated across the state border, in Tory Hill, New York, beginning in 1923. This included, in addition to Cowley, the poet Hart Crane, the writers Matthew Josephson, Allen and Carolyn Tate, Robert Coates, Nathan Asch, and Jack Wheelwright, as well as Peter Blume.[10] Even before Calder visited with the Salemmes, a boardinghouse run by one Addie Turner had become the setting for some of Cowley's most resonant memories of Crane, who although homosexual had an explosive affair with Cowley's then wife, Peggy. You would hear Crane in his room in the boardinghouse, Cowley recalled, "the phonograph playing a Cuban rumba, the typewriter clacking simultaneously; then the phonograph would run down and the typewriter stop while Hart changed the record, perhaps to a torch song, perhaps to Ravel's *Bolero.*" Cowley remembered how one afternoon he arrived "to find Peter Blume sitting on Hart's chest and Bill Brown sitting on his feet; he had been smashing the furniture and throwing his books out the window and there was no other way to stop him."[11] The Calders never knew Crane, but Cowley and Blume would be very close friends, Coates (the art critic at *The New Yorker* for some years) a friend to some degree, and William Slater Brown was the friend of E. E. Cummings's who would later marry Louisa's sister Mary. In 1942, Brown published a novel, *The Burning Wheel,* about an advertising copywriter who decides to take up life in the country.[12] Peter Blume and his wife, Ebie, had a house in the area a couple of years before the Calders arrived.

Many of the creative people who were already feeling the pull of western Connecticut when the Calders arrived in 1933 shared Sandy and Louisa's deep attachment to French life and culture. Cowley, Brown, and Matthew Josephson had spent extended amounts of time in Paris some years before Calder. The French speakers in western Connecticut—including Cowley, Josephson, and Sandy and Louisa—would make the area especially attractive to the European artists and intellectuals who began to arrive in the United States at the end of the 1930s. Roxbury was also not very far from Hartford and the Wadsworth Atheneum, an old museum that was being dramatically transformed by its young director, Chick Austin. Even before Calder had his show with Julien Levy, Levy was helping Austin put together what was the first museum exhibition dedicated to Surrealism in the United States,

Four Saints in Three
Acts *was first mounted at
the Wadsworth Atheneum
in 1934; the libretto was
by Gertrude Stein, music
by Virgil Thomson,
choreography by Frederick
Ashton, and sets by Florine
Stettheimer.*

"The Newer Super-Realism." Calder may also have already been aware of
another Hartford resident, James Thrall Soby, who, after graduating from
Williams in 1926, had been in Paris acquiring modern paintings. Since 1928,
Soby had been working with Austin, helping him transform the Atheneum
into a center for the study of contemporary art. Soby became a strong sup-
porter of Calder's work in the next few years.

When *Four Saints in Three Acts,* the opera with words by Gertrude Stein,
music by Virgil Thomson, choreography by Frederick Ashton, and sets by
Florine Stettheimer, opened at the Wadsworth Atheneum on February 7,
1934, Sandy and Louisa were there, having driven over from Roxbury in the
LaSalle. Calder, wearing a yellow fisherman's shirt he had bought in Barce-
lona, was seated amid a sea of tuxedos, near luminaries including Mr. and
Mrs. John D. Rockefeller Jr. and the art dealer Paul Rosenberg. Buckmin-
ster Fuller was there, as was Calder's friend Noguchi, who had driven up
from New York in Fuller's Dymaxion car.[13] Katherine Dreier, a collector
and patron of Duchamp's, was also in attendance; she had already been in
touch with Calder in Paris.[14] For Louisa and Sandy, it must have seemed
as if the world they had known in Paris had reassembled, not all that far
from their ramshackle farmhouse in Roxbury. It was at the dinner after the
premiere at Chick Austin's house, a striking, highly theatrical reimagining
of a Palladian villa, that Calder and Soby found themselves depositing the
impossibly inebriated Julien Levy in a bedroom to calm down.

III

The experience of country life had a profound effect on Calder's art. Until he and Louisa put down roots in Connecticut, Calder's imagination was essentially urban. His first sophisticated works had been paintings of the Manhattan streets. He studied the crowded sidewalks, the elevated trains, the construction sites, the brash signage, and the night sky artificially illuminated. Of course, he drew and sculpted animals and even wild animals, but they were almost invariably creatures at home in the circus or the zoo, their forms and movements more often than not observed beneath the big top or through the bars of a cage. Calder's people, the athletes, friends, and celebrities of his wire works, were all performers of one sort or another. He portrayed them in the context of big-city sociability, whether the acrobat in the circus, Josephine Baker in a nightclub, or the face of an artist such as Léger as Calder would have seen him at openings and parties. When Calder turned to abstraction, his geometric forms remained city forms, suggesting the intellectual pursuits of a sophisticated urban culture, with its mathematicians and physicists, its laboratories and planetariums—the nature of matter and the universe not experienced directly but speculatively, theoretically.

In Connecticut, Calder experienced nature more directly. He was affected by the leafing out of trees in spring, the air currents moving the clouds, the dance of snowflakes in the midst of a storm, the actuality of bodies, including the body of the artist himself, moving through space and time. Less than a year after buying the house on Painter Hill Road, Calder was designing large mobiles that were meant to stand out-of-doors, their movements a response to the wind currents that animated the Calders' eighteen acres. "I have made a number of things for the open air," he wrote a few years later. "All of them react to the wind, and are like a sailing vessel in that they react best to one kind of breeze."[15] In the years to come, he would also continue what had already been an interest in working in wood, sometimes polishing pieces to highlight their natural color and grain, at other times showcasing the curious shape of a limb or a root. Calder's work had already been changing during his last months in Paris, a case in point being *Cône d'ébène*, with its dissonant, dancing ebony elements. Calder's visual vocabulary, in the past couple of years largely restricted to the circle and sphere and straight or angled line, more and more sprang from nature's variety, at one time or another suggesting seeds, fruits, vegetables, leaves, and petals. In the Abstraction-Création yearbook, Hélion had distinguished between artists who begin with a pure geometric order and artists who begin by abstracting from nature. Calder was becoming more and more the latter kind of artist, although the natural world would almost invariably be sifted through a powerfully conceptual-

izing imagination, and to the end of his life he remained sympathetic to the geometric authority of the circle and the polygon.

The Brazilian critic Mário Pedrosa, who became a lifelong friend of Calder's in the 1940s, commented that although "no other artist of our time has had such a natural and spontaneous relationship with the machine and everything mechanical," at the same time "his fascination for organic forms has persisted. These two passions are inextricably linked in his imagination."[16] Such a dual loyalty to the natural and the mechanical was by no means a simple thing. In *Exile's Return*, Cowley recounted a heated discussion with William Slater Brown back in the 1920s, when Brown was spending the winter in a cottage in Woodstock, New York. "Bill," Cowley recalled, "was bent on expounding a theory of aesthetics that he had derived from staring at a pine tree outside his studio window. Art, he said, should resemble a tree rather than a machine. The perfect machine is one to which any added part is useless and from which no part can be subtracted without impairing its efficiency. Trees, on the other hand, have any number of excess branches; and art should resemble them, should have a higher factor of safety than the machine. Art is the superfluous." Cowley did not agree. "I disagreed with him so vehemently," he recalled, "that I slipped and plunged head foremost into a snowbank."[17] For Calder, there was never some definitive choice that needed to be made between trees and machines. He was at ease with both.

The first summer in Roxbury, the summer of 1934, Calder produced a standing mobile some ten feet high that he called *Steel Fish*. It's a big, broad invention, with a straight-up rod supporting a horizontal rod from which a number of forms are suspended, with a large red semicircle and a black tear shape on one side balanced against three small disks on the other. In addition, there's a small black sphere on one side and a small white sphere on the other. The forms are not that different—and perhaps no different—from those in works done in the hothouse of Montparnasse, and yet in Connecticut they possess a different temper and tempo. In photographs taken at the time, *Steel Fish* stands on top of what Calder referred to as the "great rocky mound on top of a gentle hill" that had struck him and Louisa when they first saw the house. *Steel Fish* is silhouetted against the wide New England sky. Sandy stands nearby, almost dwarfed by his curious, expansive creation, which has some of the quality of an idiosyncratic and utterly impractical weather vane.[18] The two great shapes, one red, one black, seem positively hungering to catch the wind, so that they'll be spun around. Calder's forms are no longer so tightly wound, no longer working together with that particularly Parisian elegance. There's something rawboned, loose-limbed, frank, and unrestrained about *Steel Fish*. The gallery in Paris has been traded

for a hill in Connecticut. Calder's forms have relinquished a certain self-consciousness. *Steel Fish* is waiting for a windstorm, so that the shapes can careen.

In the next few years, Calder produced a couple of private commissions for standing mobiles to be placed outdoors. One was for James Thrall Soby, for his house in Farmington, Connecticut. The other was for a Mrs. Charlotte Whitney Allen, for her garden in Rochester, New York. Like *Steel Fish*, they were large—Allen's was almost nine feet high and Soby's was twenty-two feet high—with a weight and a heft that set them apart from the delicacy of the Parisian abstractions. Although intimate by the standards of much later public sculpture, they marked the beginning of an interest in monumentality

Calder. Steel Fish, *1934. Sheet metal, rod, wire, lead, and paint, 115 x 137 x 120 in.*

Calder's Well Sweep *installed at Soby's home in Farmington, Connecticut, 1936. Photograph by James Thrall Soby.*

that would become central to Calder's work. Soby's object, mounted behind his modernist house on the top of an old well in 1936, was called *Well Sweep*. Calder had always taken an interest in mechanical devices of all kinds, and in the years to come he would sometimes echo or reimagine those traditional mechanisms in his sculptural objects. *Well Sweep* was among many other things a functional object, with a bucket to collect water. Calder's circles, no longer objects of pure contemplation, were now designed to react to the force of the wind or the shove of a hand.

Abstract sculpture in the out-of-doors has by now become so familiar that we hardly recognize what pioneers collectors like Soby and Charlotte Whitney Allen really were. Soby was a force to be reckoned with in modern art

in America. In 1934 he published, under his own auspices, *Photographs by Man Ray: Paris, 1920–1934*, a volume with lush gravure plates. Long recognized as a classic, it contains a portrait of the photographer by Picasso and texts by Breton, Duchamp, Éluard, and Tzara. The next year Soby brought out *After Picasso*, a pioneering study of the Surrealists and Neo-Romantics. Soby was a significant curatorial figure at both the Wadsworth Atheneum and the Museum of Modern Art, where he organized exhibitions devoted to the early de Chirico, Miró, Dalí, and Balthus. All the while, he collected in a serious way, and he eventually donated much of what he had acquired to the Museum of Modern Art. He was also a gifted amateur photographer who produced glorious photographs of Calder in his first icehouse studio in Roxbury in the mid-1930s, as well as hilarious studies of his friends cavorting around his Farmington home; we see Louisa playing her accordion, and Sandy palling around with the painter Eugène Berman. Soby's *Contemporary Painters*, published by the Museum of Modern Art, contains a section titled "Three Humorists: Klee, Miró, Calder." Calder produced a set of andirons with a spiral design for the fireplace in Soby's living room.

Calder and Margaret French dancing while Louisa plays the accordion at Soby's house in Farmington, Connecticut, 1936. Photograph by James Thrall Soby.

Charlotte Whitney Allen has nowhere near so significant a place in the history of modern art as Soby, but she was without a doubt a woman of some daring. She and her husband, Atkinson Allen, had hired Fletcher Steele to design their small garden in Rochester, New York, some ninety by two hundred feet. Steele, remembered as a key figure in modern landscape design, had already published a book called *Design in the Little Garden* in 1924. A Francophile who had felt the impact of the great decorative arts exhibition in Paris in 1925, he had arranged for Gaston Lachaise to design a sculpture of a female nude for the Allen garden in 1926. A year or so before Calder returned to the States, Steele had discovered his early abstract work in France; the two men had talked about collaborating. With his customary fearlessness, Calder,

Calder. Untitled, 1935. Sheet metal and paint, 105½ x 72 x 41 in. The sculpture Calder made for Mrs. Charlotte Whitney Allen is shown in her garden, but not in the hidden spot for which it was apparently originally designed.

back in America, pushed Mrs. Whitney Allen to agree to a hand-driven or wind-driven sculpture for a corner of her garden. In April 1935, he wrote to her, suggesting that Steele thought "I ought to make you an object (not water-impelled) that one might displace, and then watch it seek to regain its original calm, equilibrium, and peace of mind. I think so too."[19] Calder made the sculpture the following fall, working with a blacksmith in Rochester. Designed for a hidden spot, it must have been a wonderfully startling geometric vision, with its triangular base, angled metal rods, and yellow, red, black, and white disks to be discovered amid the tight-packed garden, a dramatic stylistic contrast with Lachaise's standing female nude. Mrs. Whitney Allen, who had received a Mexican divorce in 1934, was a sympathetic figure; Sandy told Peggy he and Louisa had "spent a very gay week" with her while he was putting the mobile together.[20] She owned another major work by Calder, an eight-foot-high composition entitled *Vertical White Frame.* Calder said that it had been a "spring cleaning gift," acquired by Mrs. Whitney Allen after she sold some furniture belonging to her mother and, presumably, had more room for contemporary art.[21]

IV

The first opportunity Calder had to exhibit on his return to the States was in a show entitled "Modern Painting and Sculpture," held that August at

the Berkshire Museum in Pittsfield, a small but ambitious regional institution near his parents' summer place. Six years before, Stirling had received a commission to create a fountain for a room in the museum; one wonders if it was through his father that Calder came to their attention. Four years after the "Modern Painting and Sculpture" exhibition, Calder fils created a permanent installation for the museum. He marshaled winding, snaking mobile elements to transform two air vent grilles in the auditorium into enchanted topologies.

Each of the four artists included in "Modern Painting and Sculpture" had some association with western Massachusetts; the most prominent, along with Calder, was the abstract painter George L. K. Morris. Calder wrote a brief statement for the catalog. Never before had he related his own work to that of his contemporaries in such straightforward terms. He may have felt that the New England audience needed some background if they were going to come to grips with the motor-driven mobiles he was presenting at the Berkshire Museum. He mentioned the

Calder. Air Vent Mobile, *1937. Sheet metal, rod, wire, and paint, 57 x 34 x 6 in. This is one of two works that Calder made to be installed in the auditorium of the Berkshire Museum in Pittsfield, Massachusetts.*

painting of the Futurists; he described his friend Duchamp's *Nude Descending a Staircase*, with its elimination of "representative form" so as to emphasize "the sense of movement"; and he discussed his friend Léger's film *Ballet mécanique*, "the result," Calder wrote, "of the desire for a picture in motion." After which he raised the question that he would spend the rest of his life answering: "Why not plastic forms in motion?"[22] Of course, by "plastic forms" he meant forms that had a visual power, not forms made of some synthetic material. Calder tended to recoil from anything synthetic. A year later, writing to the English artist Ben Nicholson about the use of the word *synthesis* in the prospectus for a new magazine entitled *Axis*, Calder wor-

Balthus. Pierre Matisse, *1938*.

ried that "synthesis itself, connotes too many (not so good) commercial processes + products—above all, synthetic manure—which is, beyond a doubt, much inferior to the old-fashioned hand-made variety."[23] The Berkshire show had a sweet epilogue a generation later, when Sandy and Louisa got to know the poet Elizabeth Bishop, who remembered seeing his work in Pittsfield all those years earlier.

Calder wasn't one to pass up a chance to show his work, and in the early 1930s, when opportunities to present an art as radical as Calder's were few and far between, a place in an exhibition at the Berkshire Museum was cause for at least a small celebration. But Calder was hankering for more—a lot more. He wanted to find a dealer who would exhibit his work in New York on a regular basis—and, he hoped, manage to sell a few things. Whatever the foot traffic and reviews that Calder's show with Julien Levy had received the year before, the relationship between the two of them was never easy. Calder must have sensed that he didn't have a future with Julien Levy, well before the dramatic evening in Hartford when he helped carry the drunken Julien up to bed. There were a number of distinguished New York galleries—including Wildenstein, Rosenberg, and Valentine—that exhibited works by Picasso, Braque, Matisse, Bonnard, and other members of the earlier generations of the School of Paris. But there were hardly any dealers with significant ties to emerging collectors and curators who took an interest in abstract artists of Calder's generation. It may not be too much of an exaggeration to say that there was really only one dealer in New York who would have been able to even begin to satisfy an artist as ambitious as Alexander Calder.

Pierre Matisse was the man Calder imagined might solve some of his problems. The Pierre Matisse Gallery was in the Fuller Building, on the northeast corner of Madison Avenue and East Fifty-seventh Street; the gallery remained in that spot for more than fifty years. It was a beautiful Art Deco building, its entrance topped by a clock in a frame designed by the sculptor Elie Nadelman, who would become a great favorite of Kirstein's. Two years younger than Calder, Matisse had already been working in New York for nearly a decade to establish himself as a salesman for the finest work produced by the modern movement in Paris. It didn't hurt that his father

was by many reckonings the great-
est painter of the twentieth century.
After first making his mark in New
York selling works by his father and
his father's generation, Matisse had
begun representing Miró, whose
paintings had been shown to him by
Miró's Parisian dealer, Pierre Loeb.
Physically smaller than Calder, with
a concentrated energy, Pierre was
determined, careful, and deliber-
ate, undeterred by the disappoint-
ments of the moment, intent on
playing a long game. He had some
of his father's passion, and some of
his father's steeliness. Calder had
already met Pierre in Paris the year
before; he had visited the rue de la
Colonie at least once.[24]

As soon as Calder was more
or less established in Roxbury, he
launched a campaign to persuade
Matisse to show his work. Calder
was very much the suitor. Matisse
had not taken on an American art-
ist and would essentially remain

*Calder. A Universe,
1934. Iron pipe, wire,
wood, string, and paint,
with motor, 40½ x 30 x
29 in. Alfred H. Barr Jr.
traded the work he initially
purchased for the Museum
of Modern Art at the "First
Municipal Art Exhibition"
for this work, which was
subsequently included in
the Modern's exhibition
"Cubism and Abstract Art"
in 1936.*

committed to European artists during his long career. (The painter Loren
MacIver was the only other American Pierre Matisse exhibited over an
extended period of time.) Matisse was certainly aware of Calder's growing
reputation in France as well as his close friendship with Miró. As Cowley
wrote years later, Calder was "the only American to be accepted as an equal,
and as a boon companion, by the whole Paris group of innovators: Léger,
Arp, Miró, Pascin, Mondrian, Masson, Tanguy, and the others."[25] Perhaps
that's how Matisse regarded him, too. Although Matisse wasn't a man to be
pushed into a situation he didn't want to be in, it certainly didn't hurt that
Calder was leaning on him. Calder enlisted the help of Miró, who, in a let-
ter dated February 7, 1934, urged Matisse to take a serious look at Calder's
work. Following up on a visit Matisse made to the Calder place in Roxbury at
more or less the same time, Calder wrote to Matisse, "I would like very much
to arrange for a little show somewhere. Do you think it would be at all fea-

sible at your Gallery? I realize that you didn't see very much to enthuse over when you were here—but I have completed about 10 objects in all so far—and am working hard."[26] From Matisse's response, it sounds as if Calder already had some works at the gallery, because he spoke about taking the responsibility for sending them to a show, the "First Municipal Art Exhibition" at Radio City in March, from which Alfred Barr bought a standing mobile for the Museum of Modern Art. (Stirling was also in the "Municipal Art Exhibition," with his three works listed right after his son's three works in the catalog.)

"I would like very much to have an exhibition of your objects," Matisse wrote to Calder in the middle of February. But he immediately added, "Unfortunately I have so far specialized in the paintings and sculptures of artists from the so-called 'school of Paris.' I have refrained often with regret from showing works of American Artists that I like for that reason."[27] Was Matisse rejecting Calder's advances? That's one interpretation. But that's not how Calder saw the situation. In responding, he stayed focused on Matisse's interest in giving him an exhibition—and pretty much set aside the dealer's qualms. We can see what an advantage Calder's imperturbability was in a situation like this. He wasn't going to linger on Matisse's comments about specializing in European artists—which some American artists might have seen as a brush-off. Perhaps there was an element of obliviousness in Calder's psychological makeup that worked to his advantage. Since he never doubted his own motives, he felt no reason to worry about other people's. "Your note is slightly ambiguous," he wrote back to Matisse, "tho I don't suppose you thought it so. I trust you mean you are willing to show my things and that you can arrange them on your schedule."[28] Calder and Matisse were two wily egotists engaged in a genial battle, which was precisely how they would remain for the decade during which they worked together. Calder was the bull in the china shop. But it was Matisse's shop, and Calder was there only so long as Matisse tolerated him. In the autobiographical notes Calder composed in the 1950s, he dropped in without further explanation a line he must have heard more than once from Pierre Matisse: "Oh Sandy you should never say such things."[29]

Whatever the crossed signals may have been, by the third week in March 1934, Matisse was writing to Calder in Roxbury about what a good time he and his wife, Teeny, had had with him and Louisa; they were becoming friends.[30] He wanted to make sure the gallery was getting photographs of the works to be displayed, and he wanted to work out plans for when to bring the work to New York and install the show, which was to run from April 6 to April 28. Calder and Matisse had become partners, but they were sparring partners

as well, as the letters they produced in the coming years make clear—and, not infrequently, comically clear. There was some rather amusing back-and-forth about the installation, with Calder announcing that he and Louisa were going to a party in Rockland County, about thirty miles north of midtown, on Friday evening, March 30. Calder mentioned that maybe he would appear and install the show late one night that weekend. This was a maneuver that, he said, "will look funny"; he suggested that Pierre bring his camera to record it.[31] Matisse, having none of it, instructed Calder to come on Sunday morning. Calder seemed to enjoy using his French in letters to his new French dealer. Matisse rebuffed his advances; he probably dismissed Calder's fairly amateurish French as an all too obvious attempt to butter him up.

The following month, after the show had closed, when Calder wrote to Matisse about how sales were going of what he referred to as *"des objects Calderien,"* Matisse shot back in English, urging Calder to pick up his work before it got caught up in some summer renovations in the Fuller Building. He used Calder's French ironically, observing in English that "you better come quick to get your 'objects Calderiens' if you don't want to find just a bundle of wire mixed up with some plaster blocks!!!" When Calder asked, *"Si tu viens peux tu m'apporter un marteau et un pince que je pense d'avoir laisses à la galerie,"* Matisse responded, "I have been looking all around the gallery for your hammer and 'pince' without being able to see them. But I have discovered that a number of hammers and 'pince' have disappeared. Have you seen by any chance, among your 'outillage' any of these that look like a Matisse hammer and a Matisse 'pince?'"[32] Calder later found his own tools at home, "under a bit of cloth that I had thought to be the bottom of the box."[33] And when Calder asked for lists of *"fausses-clients"* friends had supplied, Matisse responded that they were still going through the lists, looking for *"vrais clients."*[34]

V

Of the three shows Calder had with Matisse in the next four years, we know the least about the first. The objects in the exhibition—as revealed in a surviving photograph—were skeletal, airy, and austere, very much in the spirit of the work Parisians had begun to get to know at the Galerie Percier and the Galerie Vignon. On the afternoon preceding the opening, Nanette went up to the Fuller Building to see how things were going, and wrote to Peggy that "the gallery is too small + the background not good but the work is most entertaining." A man who appeared in the gallery—she recalled the

name as Mr. Goetz—"said they always had more fun at Sandy's exhibitions in Paris than any others—with the machinery going people were <u>amused</u> + friendly." Nanette went on to observe that "his ideas—the proportions forms + colors ought to do something for him somewhere."[35] Nothing was purchased immediately, but five works were sold the following year. The Wadsworth Atheneum purchased a mobile, and another work was bought for Smith College by Jere Abbott, a curator who had been close to Barr in the early days at the Museum of Modern Art.[36] The show may well have been timed to run concurrently with "Machine Art," an exhibition a few blocks away, at the Museum of Modern Art. This had been organized by Philip Johnson—who, like Levy, Kirstein, Barr, and Austin, had gone to Harvard. "Machine Art" showcased some of the most beautiful machine-made objects of the day: an outboard propeller, a ball bearing, a compass, a microscope, pots and pans. The connection between the Calder show and the "Machine Art" show was certainly made by the critics. In the *Brooklyn Eagle,* Anita Brenner—best remembered for her celebration of Mexican culture in her book *Idols Behind Altars*—suggested that this was "a season whose major events have concerned themselves with questions of the machine age, whether in the realm of social and economic ethics or in art."[37]

The most important review of Calder's first exhibition with Pierre Matisse was written by Lewis Mumford in *The New Yorker,* where he was then the art critic. Mumford, who zeroed in on Calder's unusual relationship with the machine age, was at the beginning of a commanding career as a writer on architecture and society; in the decades after World War II, he launched a powerful critique of what he saw as an increasingly mechanized, rationalized, and routinized world. Although not, early or late, a great enthusiast of Calder's work, Mumford shared a number of friends with Sandy and Louisa; like the Calders, Mumford would be an outspoken opponent of the war in Vietnam. Mumford was perfectly capable of seeing what Calder was up to, even if he didn't entirely go along with it. In the 1930s—and, indeed, well into the 1960s—gallerygoers and museumgoers were generally welcome to interact with Calder's objects; the hands-off policies of more recent times weren't yet in place. Mumford was definitely attuned to the kinetic charms of the work. "In one," he wrote of an object at Pierre Matisse, "he balances the moving parts on a pivot against a heavy-weight arm, and by giving the weight a push one imparts motion to the free-hanging parts, and they continue in motion for a long time." He could see that Calder was moving between a language of "straight lines, helices, red and black circles" and a language of forms "sometimes wiry and wavy, like the magnified feelers of gargantuan insects."[38]

OPPOSITE *Calder's first exhibition at the Pierre Matisse Gallery in New York in 1934.*

Calder. Untitled, *c. 1934.*
Pipe, rod, wood, wire,
paint, and string, 45½ x
38⅛ x 12¼ in.

Mumford, who had already published a brilliant celebration of late-nineteenth-century American art and culture entitled *The Brown Decades*, didn't necessarily accept the argument that "the static sculpture of the past no longer expresses our age." Reviewing the Modern's "Machine Art" exhibition only a few weeks before he turned his attention to Calder, Mumford had been rather ironic. He'd confessed that as a boy he had loved all sorts of gadgets, and he admitted that at the Modern's show, he had "wandered in a delighted daze through the fairyland of mechanics that enveloped my adolescence." But he wondered where the modern artist's fascination with machines was leading. "If you like ball bearings and springs," he wrote, "you are prepared for Brancusi, Moholy-Nagy, Jacques Villon, and Kandin-

sky; or, if you like these artists, you are prepared for Machine Art."[39] What the art said about the machines or the machines about the art wasn't entirely clear. Mumford, who although still shy of forty was very much an old soul, was skeptical about the significance of this newfangled exhibition.

As for what Mumford thought about Calder, it would seem that he was sympathetic to what he correctly perceived to be the artist's anti-ideological stance. "His talents," Mumford wrote, "have always been ingenious and playful. His wire figures and animals of the static period did not require any elaborate philosophical justification before one could enjoy them; they were just amusing. That is equally true of the sort of purist mechanical toyshop he erected at the Matisse Gallery. If this were really a mighty intellectual

Calder. Red, White, Black and Brass, *1934. Sheet metal, rod, wire, brass, lead, and paint, 113 x 68 x 53 in.*

attempt to abstract and formalize the spatial relations or the mechanical concepts of a world that has become vaguely emotional over the more incomprehensible parts of Einstein, if these mobiles were to be taken *au grand sérieux*, one would have to quarrel with their happy amateurishness. To tell the truth, they lack mechanical rigor and perfection. But the fact is that Calder is a sort of abstractionist Joe Cook, and he preaches a lesson unlike the scientific philosopher's—not the importance of being earnest, but the blessedness of remaining young."[40]

There was a sense of damning with faint praise about Mumford's review; the accusation of "happy amateurishness" would certainly not have been appreciated. And yet Mumford had gotten halfway toward defining the particular character of Calder's art. He had spotted the rejection of what he called *"au grand sérieux,"* Calder's refusal to regard art as an occasion for theoretical posturing. What Mumford had missed was the deeper seriousness of Calder's art, the willingness to take the supreme intellectual risk of turning ideas into images, which is what all the great artist-philosophers have done.

VI

The little brochure for Calder's show at the Pierre Matisse Gallery marked the first of the many times that the remarkable James Johnson Sweeney, whom Calder had first heard about from Léger, acted as an advocate for his work. Sweeney would not only be a staunch supporter through his work as a critic and a curator; he would also be a friend with whom Sandy bonded amid the transatlantic excitements of modernism in the 1930s. They would remain close to the end of Calder's life. Nobody else—certainly nobody else in the United States—was as attuned to the transatlantic nature of Calder's achievement.

Sweeney was the sort of aesthete Calder always liked best—a levelheaded aesthete, fully engaged in the ordinary matters of life. Sweeney was a big, bold, high-spirited man—a can-do personality. He had been born in Brooklyn two years after Calder. Sweeney's family had emigrated from Ireland; they owned a prosperous business, Sweeney and Johnson (Johnson was his mother's maiden name), importing lace and textiles; his mother was an amateur painter. Sweeney had played guard on the football team at Georgetown University, where he'd received his BA, and then rugby at Cambridge in England, where he'd done some graduate work in literature. In Paris, he had met Miró as early as 1927, was involved with the avant-garde magazine *Tran-*

sition, and knew Mondrian, Hélion, and Léger.[41] He spent time in the circle around James Joyce, and figures in Richard Ellmann's classic biography of the writer. Sweeney worked with Joyce in the summer of 1938, as *Finnegans Wake* was nearing completion. He was proud to have been able to reply, when Joyce asked him if he understood the phrase "Clontarf one love one fear," that those were "the last two numbers of the date of the Battle of Clontarf."[42] At the end of the 1930s, when Joyce was living in Switzerland and having trouble receiving funds from his American publisher, Sweeney's intervention was key to his receiving what was owed him.[43]

Sweeney was proudly Irish. That was part of the key to his closeness with Joyce, with whose family the Sweeney family remains involved to this day. Sweeney much later wrote a little book about Irish illuminated manuscripts, especially the Book of Kells and the Book of Durrow, with their animals that sometimes suggest the animals Calder dreamed up for his jewelry. Of the snakes on the cross that Stirling had made to mark his father's grave, Swee-

Calder. James Johnson Sweeney, *1964. Ink on paper, 43 x 29¼ in.*

ney apparently commented that he thought them more Irish than Scottish, perhaps a humorous way of suggesting that at least in spirit the Sweeneys and the Calders were fellow countrymen. Jim and his wife, Laura, free-spirited but churchgoing Catholics, had five children. Their elegant apartment on the Upper East Side was the site of memorable gatherings around an enormous punch bowl. It was also the setting for a terrific art collection. This included a Calder with a cascade of small red disks, *Object with Red Discs* (1931), which had been shown at Pierre Matisse and came in the family to be known as the "Calderberry Bush"; it was originally given that nickname by a brother of Jim's, John Lincoln Sweeney, known as Uncle Jack. Sweeney also owned a 1938 diamond-shaped painting by Mondrian, *Composition in a Square with Red Corner,* which he had first seen in an early charcoal version in Mondrian's Paris studio in 1936 and bought from the artist two years later.[44] A painter by the name of Dick Wray observed that artists "thought that Sweeney was another artist."[45] Sandy and Jim had their ups and downs. In some notes, Calder alluded to "all the rows," certain jealousies and angers, and blamed some of it on Laura Sweeney. But of all the critics and curators who wrote about his work, Sweeney would always be the one Calder

admired the most, and the only one he could be said to have admired almost unreservedly.[46]

Sweeney's personal wealth gave him a certain independence from the vagaries of a conventional museum career; he was actually managing the family business while he was involved with various curatorial duties at the Museum of Modern Art in the early 1940s. He was the first director of the Guggenheim Museum in New York as it moved into Frank Lloyd Wright's building at the end of the 1950s. And later, in the 1960s, he became head of the Museum of Fine Arts in Houston, where he remained for seven years. When Calder was just getting to know him in 1934, Sweeney was among the younger Americans establishing the study of modern art as a serious discipline. Beginning in 1934, he taught a course called "Tendencies in Modern Art" at New York University's Institute of Fine Arts. He was also already mounting exhibitions at the Renaissance Society at the University of Chicago, an organization that proselytized for modern art in the Midwest. An exhibition there in the summer of 1934 included Calder's *Object with Red Discs*. Also in 1934, Sweeney published, under the auspices of the Renaissance Society, a book called *Plastic Redirections in 20th Century Painting*, which covered some of the same ground that the Museum of Modern Art covered in its "Cubism and Abstract Art" show two years later. None other than Erwin Panofsky praised *Plastic Redirections* in the Museum of Modern Art *Bulletin*. Writing to Sweeney that September, Calder said he had read the essays in the book and thought "them very tersely and well stated."[47] Calder would always like the straightforwardness of Sweeney's writing, the absence of unnecessary rhetorical flourishes.

For the Pierre Matisse show, Sweeney composed a mere nine lines of text. He observed that Calder's work "leans on the shapes of the natural world only as a source from which to abstract the elements of form" and praised Calder for "a lyricism entirely his own—a freshness, gaiety and charm."[48] Over the years, nobody wrote with more sensitivity than Sweeney about the complex role of play and humor in Calder's art. Speaking about modern sculpture at the Byrdcliffe Colony in Woodstock, New York, in 1939, Sweeney emphasized the "modernization" by Stirling's beloved Rodin "of the Baroque's emphasis on the internal movements of the composition." Turning to Calder, Sweeney said that the "use of movement as an element of expression probably reaches its boldest development in the work of the American Alexander Calder. In Calder's work we find an interest in mobility not only related to the Constructivist's effort toward a new freedom in the definition of space, but also colored by an illogicality that goes even a step further than that of the Surrealists. For in Calder's work illogicality is car-

ried beyond representation into the field of technic, where it translates itself into modes of humour based primarily upon the element of surprise."[49]

VII

It was Sweeney, in the months after the first Pierre Matisse show, who brought Calder's work to Chicago, where nearly forty years later a matchless public space would be created through the juxtaposition of Calder's monumental red *Flamingo* with the obsidian blackness of Mies van der Rohe's triumvirate of buildings known as the Federal Center. In January 1935, Sweeney helped mount a show of works by Calder at the Renaissance Society; it was remounted the following month, relatively unchanged, at another venue in that city, the Arts Club of Chicago. Sweeney's text for these shows expanded on what he had written for Matisse. He was beginning to consider the origins of Calder's genius—and where that genius might lead. He saw "an interesting parallel with that of the fountain sculptors, of the fifteenth and sixteenth centuries in Rome and Florence. Just as out of their playing with water and their free and often fanciful solutions of technical problems, grew what we recognize today as some of the earliest hints of the baroque style in sculpture; so Calder's realizations, vividly vernacular to the present age as they are, offer, at the same time, more probabilities of relationship with the plastic expression of the next, than does the work of any other American sculptor today."[50]

Calder's Chicago exhibitions gave him some early visibility in a city that would soon provide a home for the New Bauhaus, with which Sweeney was involved and, indeed, sought Calder's involvement. The president of the Renaissance Society, the woman with whom Sweeney had been working for at least the past year, was none other than Eva Watson-Schütze, the old friend of Nanette's who had taken the series of photographs of the baby Sandy and his sister and their mother, photographs bathed in a tender romanticism. It seems impossible that Watson-Schütze, although very ill at the time, wouldn't have seen the connection. Surely Calder's mother did. And yet it went unmentioned, at least in the letters that survive. Nevertheless, we can see here a passing of the torch. The avant-garde generation of the 1890s, of which Nanette and Stirling and Eva Watson-Schütze had been part, could see that the sacred flame was now held aloft by another avant-garde generation, in which Nanette and Stirling's son was emerging as a heroic figure.[51]

Sweeney was a close observer of Calder's work as the geometric elegance of his first Parisian abstractions gave way to something stranger, wilder,

maybe less expected. A decade later, when he organized the Calder retrospective at the Museum of Modern Art, Sweeney wrote with great feeling about this time when "the richness of natural forms" was overtaking Calder's "late severely geometric forms." "Little by little," Sweeney observed, "calculated forms gave way to forms suggested by the material—a lump of wood, a piece of bone—till finally the materials employed seemed scarcely touched by tools. At the same time, chance rhythms had come to supplant patterned rhythms." Sweeney believed that by 1934 "the geometrical cycle opened by the shock of Mondrian's studio was completed. The organic cycle was now beginning; and with it a search for new suggestions from new materials for both static and mobile sculpture, and for a new sculpture in space."[52] Sweeney would be there to the very end of Calder's life, following every twist and turn in his career. He spoke with rare eloquence at Calder's memorial service at the Whitney Museum of American Art more than forty years later.

FROM SANDRA TO *SOCRATE*

I

In the summer of 1934, the first summer they were settled in Roxbury, Louisa was pregnant again. The house on Painter Hill Road was already beginning to acquire those touches of Calder's genius that over the years made so many nooks and crannies memorable: the wire grilles and utensils hanging on a rack in the kitchen; the ebony toilet-paper holder in the shape of a hand in the upstairs bathroom; the wire replacement handles for broken drawer pulls; the metal spiral inserted as a strainer for hair in the sink

Rack in the Roxbury kitchen with grilles and utensils that Calder made in the late 1930s and 1940s. The photograph, by Herbert Matter, was taken in 1950.

drain; the soap dish with its curves and curls of wire on the edge of the bathtub; the milk skimmer with a spiderweb design in silver. Each of these was a small poetic achievement, crafted with the same authority that Calder brought to the work he exhibited at the Pierre Matisse Gallery and, eventually, in galleries and museums around the world.

Sandy and Louisa were beginning to see the outlines of a community and a life in Connecticut. They may not have known when they bought their place that the painter Peter Blume and his wife, Ebie, were living nearby, but the Blumes were probably the first people in the area with whom Sandy and Louisa became close friends. Calder already knew Blume, a good-looking guy with a thick head of curly hair, from their Art Students League days. Born in 1906, Blume had been part of bohemian Greenwich Village in the late 1920s. His wife, Ebie, became a great pal of Louisa's. Around the time they were all

becoming friends, Blume was turning his highly polished fantastical style to a composition entitled *The Eternal City*, on which he would labor steadily for several years. This painting is a surreal Roman dreamscape, a nightmarish vision of an Italy overtaken by fascism, with Mussolini as an enormous, bizarre, green jack-in-the-box presiding over the ruins of a civilization. Julien Levy exhibited *The Eternal City* in New York in 1937, and in the 1940s it became a much discussed and highly admired work in the collection of the Museum of Modern Art. In the catalog for "Fantastic Art, Dada, Surrealism," the exhibition that opened at the Museum of Modern Art in December 1936, Calder's and Blume's radically different visions were both included among the group of artists said to be in some way "akin to, if not actually allied with, the Dada-Surrealist tradition."[1] Their work was as different as night and day—and Blume was as slow a worker as Calder was fast—but they shared an impregnable self-confidence, a determination to go their own ways. In 1952, Blume painted in his meticulous representational style a study of his own bedroom, called the *Italian Straw Hat*, on account of the straw headgear hanging on the wall; suspended from the ceiling was a 1942 Calder mobile that contained, among other elements, the perforated top of an Old Dutch Cleanser can.

Roxbury was still roughing it, and as Louisa's pregnancy progressed into the early fall, shadowed by the memories of the miscarriage in Paris not too long before, she decided to go up to Concord to stay with her parents until the baby was born. Calder shuttled back and forth among New York, Connecticut, and Massachusetts. In New York, he probably stayed with his parents, as he and Louisa didn't have an apartment there until sometime in the fall or early winter of 1935.[2] One weekend in the fall, the Sweeneys, who were also on their way to Boston, came through Roxbury, where Jim helped Sandy bring in the end of Louisa's tomato crop before they headed up to Concord together. In Concord, Sandy had gotten used to Louisa's

parents' rather unusual living arrangement. Mrs. James lived in a house in the middle of their four-acre plot, while Mr. James, who, Calder recalled, "wanted to be a bit aloof, had built himself a house in the corner of the lot, straddling a little brook." This was a sort of studio, with great big windows, which were thought to ease his asthma. Downstairs there was a study and a living room; above was his bedroom and two guest rooms, one of which the Calders used. Sandy liked the room, with its bands of red and green and gold around the top of the walls, the doors of natural varnished wood, the ceiling low.[3]

Sandy presented his wife with many gifts of flowers, while Mrs. James, who worried that he was draining her daughter's trust, made him promise to be a good businessman. Although Calder was never an extravagant spender, it was understandable that Mrs. James was concerned about her son-in-law's finances. No matter how industrious he might be, he wasn't bringing in very much money. But for the time being, Calder's eagerness to press forward with his career and, hopefully, boost his earnings was taking a backseat to his concerns about his wife's health and well-being. A few weeks before Louisa was due, Pierre Matisse wrote to Calder, wondering if he would like to have an exhibition a month later. Matisse had a few demands: Calder would pick up some of the cost of catalogs or announcements; if possible, he would mount a performance of the circus; and, Pierre concluded, "there won't be any wall cracking or floor nailing, or ceiling bursting and I have to be sure that my carpet is not going to be eated up by your wild menagerie."[4] Calder, quite understandably, was unwilling to

TOP *Peter and Ebie Blume in 1931, the year they were married.*

ABOVE *Peter Blume.* Italian Straw Hat, *1952.*

consider an exhibition so close to the birth. He didn't even want to commit to a date later in the spring. This man who rarely if ever turned down an opportunity to show made his position very clear. "It will be impossible for me to do anything about a show at this moment," he wrote to Matisse, "as I am standing by Louisa to see how things come out. And they, or at least IT, should come out about May 1st. And after that, for quite a time there will be a lot of cooing, etc; little white squares to be washed; and other stinks to be cleaned up, and I'll have to do a lot of work arranging the house at Roxbury."[5] The next exhibition with Pierre Matisse would have to wait.

II

Sometime during her pregnancy, Louisa, perhaps under the influence of their great new friend Duchamp, had decided to take up chess. It was one evening while she was playing a game with Sandy, struggling with some knight's move, that she announced, "Let's go to the hospital." So they went off in the LaSalle. It was a beautiful April evening. They arrived at the hospital around nine. Sandy, after getting Louisa settled, went back to the car to take a nap.[6] He woke up around one in the morning—at least, that is what he remembered years later. First he was told by a nurse that all was well. Then he was told by a Dr. Johnston that although the baby was fine, Louisa was bleeding. Johnston was seeking the help of another physician. Writing to Nanette the very next day, Louisa's mother reported that the labor had been fairly easy, without too much pain, and that around three in the morning a big, healthy baby girl had been born, weighing eight pounds. But then Louisa began to hemorrhage badly. Around four a.m., a Dr. Gustafson was called in from Boston. He arrived an hour later. After blood donors were tested, transfusions began. The first transfusion didn't do much, but the second one seemed to help, and a third, although lined up, proved unnecessary. When Louisa's father arrived at the hospital early in the morning to see how she was doing, although he was told she was now out of danger, the realization of how profusely she had bled led him to collapse on the lawn. "A brave man," as Calder recalled, "but did not like the thought of blood"—or of his daughter in danger.[7] Although the immediate peril had passed, there was still considerable worry about an infection developing.

Louisa's womb, Mrs. James reported to Sandy's parents, "had more or less collapsed and had to be replaced I mean put in place again. It was packed with gauze and now the only really important thing is that there shall be no infection, this will be determined within two days." Mrs. James couldn't

Calder and Louisa Calder with Sandra, c. 1937.

believe that all this had happened in the past twenty-four hours; it seemed like a month, with all the waiting and worrying. Sandy, after sleeping in the LaSalle at the hospital the first night, was back in their house the next day, rushed to the hospital early in the morning, raced home for a quick breakfast, then returned to the hospital again.[8] By the time Calder himself wrote to his parents, he was able to say that Louisa was doing very well. As he described it, "the uterus collapsed and turned partially inside out." When they removed the packing from the uterus, "there was no bleeding, so it was not necessary to put any back in. So 3 days from yesterday (after all possibility of infection is passed) it will be clear sailing." He sent much love. And he added, "Thank you for your prayers." Those were telling words, coming from the casually agnostic or perhaps even atheistic Alexander Calder. Sandy was not one to talk much, if indeed at all, about prayer. But it was a time for prayers. Although he wouldn't have been the sort to come right out and say it, he must have been more worried than ever before. His Medusa, the love of his life, had been hovering between life and death.[9]

Louisa remained in the hospital for more than two weeks, with day and night nurses. Mrs. James was embarrassed that as the days passed, the baby had still not been given a name by her bohemian parents; her proper Boston friends, quite understandably, wanted to know what the new arrival was

going to be called. In addition, the hospital needed a name before the baby would be allowed to leave. The Calders had been given a book about how to choose a name by a theatrical producer whose own name Sandy later couldn't recall. Calder liked Rana, which in one of the Scandinavian languages, he had learned, meant "goddess" and in Spanish, "frog." But in the end they settled on something closer to home and perhaps pleasingly inevitable, which was Sandra. "I suppose," Calder recalled years later, "it was after me—Alexander, Alexandra, etc.—though we had started out to call her after no one."[10] Before they headed back to Roxbury, they found a nurse who could help out with the baby. This was Dorothy Proctor; she didn't stay with the Calders all that long but was always remembered with great fondness. With all the upheaval, Louisa never began to nurse, so Sandra was fed Carnation milk right from the start. They returned to Roxbury for the summer with Sandra, the nurse, and Feathers in tow.

Sandy and Louisa would never be very far from their children and grandchildren for long. Asked once, years later, why he didn't like Picasso, Calder responded that he wasn't a good father.[11] Calder wasn't always the easiest man to have as your Pop, which was what he was called by his daughters and sometimes by his wife. But there was never any question about his devotion to Sandra, to the sister who arrived four years later, or to the men they married and the grandchildren they produced. For Calder, who had grown up believing that art was a family affair, it was the most natural thing in the world to watch his family grow along with his art.

III

If Calder was reluctant to commit to a show with Matisse in the first months of Sandra's life, he was nevertheless hankering to take on new challenges. In the next year or so, he collaborated with the choreographer Martha Graham and the composer Virgil Thomson, expanding an interest in the theatrical arts that could be traced back to the *Cirque Calder*, to his brief time working at the Provincetown Playhouse, and to his father's thespian enthusiasms. As Sweeney put it some years later, "Calder's love of the spectacular had always been keen."[12]

By the time Calder was exhibiting with Pierre Matisse in the 1930s, he was grappling with what since ancient times has been one of the essential questions in the arts—namely, the relationship and relative value of painting, sculpture, poetry, music, dance, and other theatrical and narrative forms. First trained as a painter, Calder had shifted his attention to sculpture, gained

his first notoriety with miniature theatrical performances, and then begun to introduce elements of kinetic and aural experience into sculpture. Beginning with *Cadre rouge* (*Red Frame*), made in France in 1932, and continuing with *Black Frame* and *The White Frame* in the 1934 show at the Pierre Matisse Gallery and with works produced in the next couple of years, Calder created what amounted to three-dimensional kinetic paintings, with elements either mechanical or wind-driven set within a wood frame or in front of a sheet of plywood. He later recalled that George L. K. Morris—the pioneering abstract painter who exhibited with Calder at the Berkshire Museum and contributed to *Partisan Review*—had written "an article about painters who were sculptors, sculptors who were painters, painters who were painters, and sculptors who were sculptors. I was #1, Mondrian #2, Picasso #3 + #4."[13]

This was no joking matter. In the first half of the twentieth century, modernists were pretty much split as to whether the future of the arts involved

Calder. Black Frame, *1934. Wood, sheet metal, tubing, rod, wire, and paint, with motor, 37 x 37 x 24 in.*

Calder's July 19, 1934, letter to James Johnson Sweeney, with a drawing of A Merry Can Ballet.

a purification of each individual art or a union of all the arts. Matisse was all for purification. In his most radical works, he communicated complex emotions using a very small number of colors and lines. The English critics Roger Fry and Clive Bell saw this process of purification as a search for what they referred to as "significant form." A few decades later, the American Clement Greenberg, an admirer of Matisse, Fry, and Bell, argued that "the unique and proper area of competence of each art coincided with all that was unique in the nature of its medium."[14] Those who were seeking a union of all the arts were inspired by a very different principle, by what Wagner had called the *Gesamtkunstwerk*—the total work of art that rejected the traditional divisions between the arts in favor of new meldings and minglings. The collaborative efforts of the Ballets Russes and the Bauhaus represented various moves in this direction. What could be confusing about Calder was that he seemed to be moving in *both* directions. The austere objects he exhibited at the Galerie Percier announced a taste for the most gnomic of modern utterances—they were as pure as pure can be. But a kinetic three-dimensional painting such as *Black Frame* suggested a very different direction—a taste for narrative and poetic complication that was equally characteristic of Calder. There would be critics, including Clement Greenberg, who mistook Calder's hard-fought complexity for a trivializing prolixity.

The idea of a theater of abstract forces, in which the sets and props might have as much kinetic impact as the dancers themselves, didn't begin with Calder. Such ideas had been explored by Constructivists in Russia and Germany and by Oskar Schlemmer at the Bauhaus. However much Calder knew about those experiments—my guess is that he knew more than a little—he had been pressing forward with his own version of a theater of abstract forces in his studio on the rue de la Colonie in his last year or so in Paris. He combined abstract elements in a sort of puppet or marionette theater that

could be manipulated by strings. This he humorously called *A Merry Can Ballet*. In some notes, he referred to it as "an abstract ballet using a frame with rings in the 2 top corners through which strings passed from the hands to the objects—springs, discs, a weight with a little pennant." There were cans below, which made the music; to these apparently Varèse, although he otherwise liked the concept, took exception.[15] In an account of his development published in 1937 in an English anthology, *The Painter's Object*, Calder

Calder's studio on the rue de Colonie in Paris in 1933. Calder's A Merry Can Ballet *is in the foreground. Photograph by Marc Vaux.*

wrote that "for a couple of years in Paris I had a small ballet-object, built on a table with pulleys at the top of a frame. It was possible to move colored discs across the rectangle, or fluttering pennants, or cones; to make them dance, or even have battles between them. Some of them had large, simple, majestic movements; others were small and agitated."[16]

There is a family connection between these "ballet-objects" and a somewhat later work such as *Black Frame,* shown at Pierre Matisse early in 1934. One can consider *Black Frame* as a sort of theatrical maquette—and also, of course, as a three-dimensional painting. The overlapping dark forms are almost like the rocky backdrop of a Romantic stage. They become the setting for a motor-driven dance. The dancers are a disk that is yellow on one side and white on the other, a smaller red sphere, and a white conical helix. Each moves in its own fashion and speed, three personalities in otherworldly communion. Their interactions aren't always smooth; the red sphere moves abruptly, with a bounce. A dance, then, of abstract forces—the dance in some way divorced from the dancer, a new answer to or at least a new approach to Yeats's question in "Among School Children," "How can we know the dancer from the dance?"

IV

We do not know how much Calder saw in Paris of the Ballets Russes and sundry other dance companies that flourished both before and after the death of the company's great director, Sergei Diaghilev, in 1929. But it was a time when ballet was so pervasive that "everybody felt called upon to become ballet dancers," as Robert McAlmon only half-jokingly recalled in his memoir, *Being Geniuses Together.* He hastened to add, "I was fancying myself as Nijinsky, demonstrating what long, flying jumps I could take."[17] Although Calder never owned up to seeing a single performance, in his diaries Lincoln Kirstein reported talking with Calder and Noguchi during intermission at a performance by the Ballet Russe de Monte Carlo in June 1933, shortly before Calder's return to the United States. This was a company that had been formed in the wake of Diaghilev's death, and the ballet Calder was obviously there to see was *Jeux d'enfants,* with sets by Miró and choreography by Léonide Massine.[18] My guess is that Calder saw a good deal more. He rarely spoke about performances he had been to; even his presence at the concert that included a major piece by Varèse in New York in 1934, an event that had to have meant something, we know about only from one of his mother's letters to his sister.

Joan Miró. Set and costumes for the 1932 ballet Jeux d'enfants, *with music by Georges Bizet and choreography by Léonide Massine.*

The Paris Calder knew was saturated by the collaborative, cross-disciplinary spirit of the Ballets Russes. Virgil Thomson, the composer with whom Calder would soon join forces on a great production of *Socrate*, Erik Satie's composition for voice and chamber orchestra, later recalled how essential the Ballets Russes had been in shaping the Paris where they came of age. "It was the choreographic stage that made the epoch shine," Thomson announced. He wondered if it was really not so much the Crash as Diaghilev's death in Venice in August 1929 that marked the end of the 1920s as an era in the arts.[19] The year before Calder had come to Paris, Thomson had been in discussions with none other than James Joyce about "a ballet, to be based on the children's games chapter of *Finnegans Wake*. He gave me a hand-printed edition of that chapter, with an initial designed by his daughter Lucia"—whom Calder knew, having briefly given her drawing lessons.[20] In 1929, Robert McAlmon published an essay about Joyce's as yet untitled *Finnegans Wake* called "Mr. Joyce Directs an Irish Word Ballet." Ballet, in the years when Calder was in Paris, was a metaphor for a new kind of freedom in the arts—and McAlmon went to the heart of that in his essay. "Music and the ballet," he wrote, "are less inhibited by the demands of *meaning* than literature has been. Audiences do not insist upon a story or a situation to appreciate the movements of a dance or the strains of music. Critics allow that there can be a pure art in these mediums; they have sometimes come to permit [the same] with painting, sculpturing and architecture." He observed—in words that might evoke Calder's comic sense—that

"good comedy, clowning, pantomime, nonsense, slapstick, drollery, does not appeal to the sense of humour by explanation, but by gesture."[21]

Calder had almost certainly read one of his father's favorite books, *The Dance of Life*, by Havelock Ellis; a copy of the 1926 edition is still in a box in the attic in the Calder house in Roxbury. Although practically forgotten today, *The Dance of Life* was widely admired at the time, and its argument about the kinetic power of the dance as a metaphor for what might be called the life force must have set off responsive chords in the man who would develop the greatest kinetic sculpture of his time. "To dance," Ellis wrote, "is to take part in the cosmic control of the world." He argued that "dancing and building are the two primary and essential arts" and, further, that "the art of dancing stands at the source of all the arts that express themselves first in the human person. The art of building, or architecture, is the beginning of all the arts that lie outside the person; and in the end they unite." Dancing, in the widest sense, is "simply an intimate concrete appeal of a general rhythm, that general rhythm which marks, not life only, but the universe, if one may still be allowed so to name the sum of the cosmic influences that reach us."[22] Some of Calder's mobiles of the 1940s and 1950s fulfill Havelock Ellis's vision of a cosmic dance.

V

It was in the midst of his experimentation with works that were somewhere between painting, sculpture, and theatrical maquette or abstract marionette performance that Calder began reaching out to Léonide Massine, who, after Diaghilev's death, aimed to continue the impresario's work, at that time with the Ballet Russe de Monte Carlo. Massine had had his greatest impact during the Diaghilev years as a character dancer of singular vibrancy. In *La boutique fantasque*, a ballet with choreography by Massine and brilliant sets by André Derain, he and Alexandra Danilova danced a cancan that nobody who ever saw it forgot—an imperishable vision of Victorian foolishness, with the handsome Massine wearing a comically absurd mustache.

In the 1930s, Massine's own choreographic thinking was moving away from character and narrative, toward an increasingly symphonic vision, the dancer perhaps seen as an abstract force moving to the music. Something like a year before the Calders left Europe, Calder had been eager for Miró to put him in touch with Massine. Calder wrote to his parents that he "knows my stuff, so I wrote him, and sent him photos and perhaps I will be able to arrange for myself to do a ballet next year. The Russian who used to do

them, Daglieff (?), died 2 years ago, but one of the McCormacks has put up some money for their continuance."[23] In the spring of 1933, Massine visited the rue de la Colonie, where he saw Calder's various experiments, including, no doubt, *A Merry Can Ballet*. Years later, Calder told the Italian art critic Giovanni Carandente that he had been unable to persuade Massine to allow him to create a ballet without dancers, but even Calder, as he confessed to Sweeney early in their friendship, was concerned with how his ideas might be realized on a full theatrical scale.[24] It remained a yearning. In 1937, a *Time* magazine reporter said that Calder wanted "to make enormous enlargements of his bobbling Mobiles to be the background for a modern ballet."[25]

The evening Kirstein ran into Noguchi and Calder at the ballet, Calder told Kirstein he was going to be doing something with Massine.[26] For a year or so after the Calders' return to the States, the possibility remained alive. The Ballet Russe de Monte Carlo had a season in New York, at the St. James Theatre, beginning a few days before Christmas in 1933. Among the works performed were Massine's collaborations with not only Miró but also André Masson; Calder and Masson would be close friends a few years later. The company's presence in New York must have been tantalizing for Calder. He may well have seen some performances. Perhaps he met with Massine. Threaded through Calder's correspondence in the months after his return from Paris—and straight through Louisa's pregnancy—is a series of references to a project in Monte Carlo with Massine. In the weeks before his first show at Matisse, Calder commented that he might be going to Monte Carlo. Laura Bragg, the director of the Berkshire Museum, told him that she hoped the Monte Carlo project worked out.

In two letters to a new English friend, the painter Ben Nicholson, Calder first commented that he might be going to London to meet with Massine (although Massine was not paying Calder's way). Then he said there was talk of his going to Monte Carlo to work on a production already being developed. Calder told Nicholson, though, that he was hesitant about this, and would prefer to start something different from scratch.[27] On the day of the opening of the Pierre Matisse show in April, Nanette wrote to Peggy, "I think the Monte Carlo trip is off—no doubt no money."[28] But Massine may not have entirely abandoned Calder's vision of abstract colors and shapes as dynamic forces on the theatrical stage. Beginning in 1937, not too long after his contacts with Calder had ended, Massine was in conversation with Henri Matisse about a new ballet. Together they created *Rouge et noir;* the music was Shostakovich's First Symphony. Matisse referred to the dancers in their variously colored costumes as creating a "vast mural in motion," with the stage dominated by five colors—white, yellow, blue, red, and black—to

which Massine ascribed allegorical meanings.[29] All of this doesn't sound entirely unlike something that would have been dreamed up in Calder's studio. Perhaps Massine's conversations with Calder had some part in shaping the work he did a few years later with Matisse.

Calder's missed connections with Massine remain tantalizing. The same can be said about the few encounters he had with George Balanchine, by most estimates the greatest inventor of ballets in the twentieth century. Lincoln Kirstein, who had admired the performance of the *Cirque Calder* at Harvard a few years earlier, brought Balanchine to Calder's first show at Pierre Matisse in 1934. He recorded in his diary that "Balanchine thought he might make fine décor for ballet. Great big toys."[30] The following October, Kirstein reached out to Calder about making a proposal. In his diary, Kirstein noted, "Sandy Calder into the School with designs for a ballet on a pad of paper. A great red heart-like shape, and his mobiles shooting around. I thought it might be nice but Balanchine said it was too close to Miro's *Jeux d'Enfants*. I'm always too enthusiastic about possible collaborations and I'd superficially thought Sandy with his pure color would be good for Bach."[31]

That would not quite be the end of the interactions between Calder and Kirstein that had begun at the Harvard Society for Contemporary Art. In his autobiographical notes, Calder recalled that Kirstein came to talk with him about doing sets for a ballet in 1946 or 1947; this would be around the time Kirstein was organizing Ballet Society, the little company that was the prelude to the New York City Ballet, where for decades Balanchine's unstoppable imagination produced masterworks ranging from *Agon* and *The Nutcracker* to *Kammermusik No. 2* and *Vienna Waltzes*. Kirstein also reached out to Noguchi to do something for Ballet Society; Noguchi's work for Ballet Society, his designs for *Orpheus,* have proved an enduring element in a legendary collaboration between Balanchine and Stravinsky. In order to work with Ballet Society, Calder was going to have to join the Scenic Designers Union; he was even going to have to take the organization's exam. He considered it. As he recalled later, "I was going to do it, but at the last moment said 'Oh shit, I'll end up by telling them to go to hell, anyway' (I had already seen those bastards in 1925)."[32] The mention of some sort of run-in with the Scenic Designers Union in 1925 is interesting, because that would be around the time that Calder had been working with the Provincetown Players and the Hudson Guild Theatre.

Despite their common interests, Calder, Kirstein, and Balanchine never worked together on a theatrical project. It couldn't have helped matters that by the 1940s, Kirstein was a sworn enemy of abstract art. Balanchine, however, may have never entirely dismissed the possibility. In the early 1970s, a

French friend of Sandy's found Balanchine and Calder meeting together at the Perls Galleries on Madison Avenue, which then represented his work.[33] Perhaps Balanchine and Calder both recognized that there was still an opportunity for a collaboration—but it would, in the end, remain one of modernism's missed connections.

VI

Even as his prospects with the Ballet Russe de Monte Carlo were receding, Calder was beginning to work with the most admired American modern dancer and choreographer of her generation. In the early 1930s, Martha Graham was developing a radically austere dance language, the body achieving an Expressionist power as it was bent and stretched into unexpected geometries. Is it any wonder that Graham was excited by the kinetic and geometric possibilities of Calder's art? Calder and Graham were probably aware of each other as early as 1929, when Calder was close to Noguchi and Noguchi was commissioned by Graham to do two portrait busts. In the summer of 1934, when Graham was turning forty and had already been a figure in the New York dance world for much of a decade, she began a series of workshops and performances at Bennington College in Vermont. She was looking for artists who might make contributions. Noguchi did his first set for Graham in 1935, for the solo dance *Frontier*. They proceeded to forge one of the most fruitful collaborations in the history of the theater, with his distinctive

Martha Graham in Frontier, *set by Noguchi, 1935. Photograph by Barbara Morgan.*

severe biomorphic forms becoming part of the bewitching atmosphere in dances from *Appalachian Spring* and *Errand into the Maze* in the 1940s, to *Clytemnestra* at the end of the 1950s, and even beyond. As for Calder and Graham, his significant involvement with the choreographer ended early in 1936.

Sometime during the summer of 1934, Calder drove down from Roxbury to Highridge, Connecticut, just north of Stamford, to work on some ideas with Graham and her dancers. Along with a small group of dancers and a close friend, the composer

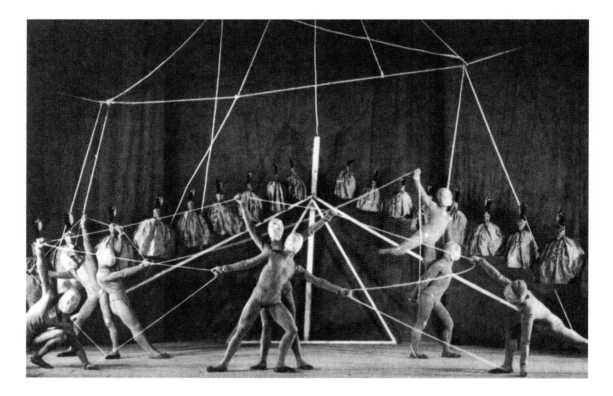

Pavel Tchelitchew. Set and costumes for the 1928 ballet Ode, *with music by Nicolas Nabokov and choreography by Léonide Massine.*

and choreographer Louis Horst, Graham was spending time at a property known as Snake Hill Barn, rented by Edith Isaacs, the editor of *Theatre Arts Monthly,* and meant for relaxation and experimentation among her cohort. Calder's idea—an idea with which Graham was apparently entirely prepared to work—was that the sets and props on the stage should themselves be mobile, dancing elements. One wonders if he was familiar with the sets Tchelitchew had done for Massine's ballet *Ode* in 1928, which involved a sort of spider's web of ropes that the dancers manipulated as they moved. Calder's idea was to design objects that would be maneuvered by the dancers, stage props becoming elements that danced as part of the dance. At Snake Hill Barn, two of Graham's dancers, Bonnie Bird and Dorothy Bird (who weren't related), worked in the woods with Calder, mounting pulleys in the trees and running ropes through the pulleys. They attached each of the mobiles Calder had brought from Roxbury to one end of the rope, while the other end was attached to the dancer. By varying their own movements, the dancers could vary the movements of the mobile, the dancer animating the inanimate in a process that naturally delighted Calder.[34] These experiments in the summer of 1934 were a prelude to Graham's large-scale work *Panorama,* which she was planning for the following summer in Bennington.

Calder, Graham recalled in her memoirs, arrived in Bennington the following summer in the LaSalle, with Feathers in tow. Louisa was presumably back in Roxbury with the infant Sandra. According to what Graham referred to as "Bennington lore," Calder appeared wearing "nothing but his undershorts" and "was taken immediately to a rather conservative men's shop in town to be outfitted. 'I need some pants,' Calder said to the salesman." To which the reply was: "You most certainly do."[35] Graham may have been unconventional, but Calder's brash physicality inspired comment even among his fellow bohemians. There were thirty-six dancers in *Panorama*, and new music by Norman Lloyd. Graham wanted to produce a history of the American consciousness in three parts, ranging from the Puritan fathers, through the South and slavery, to a new spirit of social awareness. There was to be a stage set and lighting by Arch Lauterer, a frequent collaborator of Graham's. Lauterer expanded the small old stage in the Vermont State Armory with a three-level arrangement. How Lauterer and Calder were meant to work together is not entirely clear. It would seem that in the end they didn't do so very well.

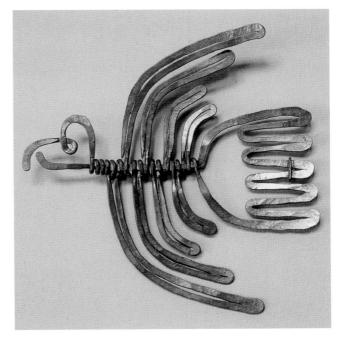

Calder. Bird brooch, 1935. Brass and steel wire, 5¼ x 5½ in. This brooch was given to Bonnie Bird.

Recollections of the run-up to the premiere suggest a chaotic situation. Graham was constantly changing the choreography, which was especially challenging for the two dozen student dancers participating in Bennington's summer program. Calder's mobile objects were hung on ropes over the rafters. The girls who were assigned to manipulate them nicknamed themselves the "Three Fates," because they were going to determine how the shapes moved. It was not easy to control these movements. And it didn't help that, apparently on the spot, Calder had developed another element, "a huge, jointed, scissor-like 'lightning' device," which was mounted along a balcony. Bonnie Bird was supposed to operate it by stepping on a lever, but in rehearsal the force was so great that she was practically thrown off the balcony—so it was abandoned.[36] Grateful for all the work the "Three Fates" had done, Calder awarded them each with a piece of jewelry. Bonnie Bird inevitably received a pin in the shape of a bird.

Panorama was among Graham's first attempts at a dramatic presentation of the spirit of America. As for the mobiles, she was frustrated that they couldn't be fully controlled. They moved when they weren't meant to move, and went places they weren't meant to go. It's difficult to know exactly what the audience saw—or experienced. A reviewer in the *New York Herald Tribune* said that while Lauterer's décor, with its blocks of black and silver, "was appropriate and telling," Calder's "disks of white and red with white stripes, suspended on ropes arbitrarily propelled, kite-fashion through the air, recalled the days of Dadaism."[37] That wasn't a good thing. Dadaism was unwelcome in the sober atmosphere of the 1930s. John Martin, in *The New York Times*, wrote that "the use of 'mobiles,' that is, pieces of movable décor, designed by Alexander Calder, had to be largely abandoned on account of mechanical difficulties."[38] Which didn't mean that Graham was ready to give up on Calder's theatrical vision.

Graham's second outing with Calder was *Horizons*, which was mounted in February 1936 in New York. Now the mobiles were conceived as a separate part of the performance. A program note explained that "the 'mobiles' designed by Alexander Calder are a new conscious use of space. They are employed in *Horizons* as visual preludes to the dances in this suite. The dances do not interpret the 'mobiles' nor do the 'mobiles' interpret the dances. They are employed to enlarge the sense of horizon."[39] In her memoirs, Graham recalled that the mobiles were manipulated by two dancers standing in the wings. The four dances in Graham's suite were named "Migration," "Dominion," "Building Motif," and "Dance of Rejoicing." The reviewers, by and large disposed to embrace Graham's new art, were generally less welcoming of Calder's contributions. In the *New York Telegraph*, Calder's mobiles were ribbed as "a series of floating balloons, ropes wriggling like sleepy snakes, and something that resembled a huge turnip."[40] In the *Times*, John Martin seemed to be warming to what he saw here. He described the "disks, spirals, globes and one or two less easily classifiable shapes which turned by mechanical means before a white curtain on an otherwise empty stage." The *New York Herald Tribune* reported that Calder's décor "aroused much discussion as well as applause interlarded by hissing and booing."[41]

Although the applause may have been overtaken by the hisses and boos, some part of the avant-garde audience was eager for Calder's revolution in stage design. Another modern dancer, Ruth Page, approached Calder, interested in a collaboration that would involve a mobile and perhaps music by Calder's friend Varèse. But even the avant-garde, caught up as it was in the social concerns of the 1930s, might be forgiven for wondering if Calder's abstraction wasn't a throwback to an earlier, more playful time. The

reviewer of Graham's *Horizons* in the generally sympathetic *Dance Observer* commented of Calder's décor that it was as if a work by "Paul Klee had projected itself out of its canvas and put itself under the . . . footlights"— apparently with no purpose other than creating a hubbub that distracted from the dance.[42] Whatever Graham's enthusiasm for Calder's theatrical experiments, apparently more than a few of her admirers were worried that Calder was creating confusion, his kinetic objects a distraction from her deepening meditations on the American experience. Calder and Graham would remain lifelong friends. But it was Calder's friend Noguchi who became Graham's most consistent and devoted theatrical collaborator. His pared-down sets and props, striking modernist inventions that were immobile, in the customary theatrical tradition, didn't compete with Graham and her dancers. The work Graham and Noguchi did together has endured, a landmark in twentieth-century theatrical collaboration.

VII

Even before Calder headed up to Bennington for *Panorama,* he was working toward what would be his great theatrical achievement of the 1930s, the staging at the Wadsworth Atheneum of Erik Satie's *Socrate,* a composition lasting some forty minutes. The commission came from Virgil Thomson, whom Calder had already known in Paris. Thomson arranged Satie's *Socrate,* which was based on a French translation of passages from Plato's dialogues, for two singers rather than the one who usually performed it at that time, accompanied by a small orchestra. *Socrate* was to be part of what Thomson recalled as the "ultrastylish" Hartford Festival of the Arts, which he organized with Chick Austin for the Wadsworth Atheneum.[43] Although Thomson and Calder were perhaps more acquaintances than friends, they had some good friends in common: Duchamp, Mary Reynolds, and Henry-Russell Hitchcock. If their paths didn't cross more often than they did, it may have been a question of sexual orientation, for although there was not a bit of prejudice on either side, Thomson moved in a world that was as predominantly homosexual as Sandy and Louisa's was predominantly heterosexual.

The Calders had attended the premiere at the Wadsworth Atheneum of *Four Saints in Three Acts,* with a libretto by Gertrude Stein and music by Virgil Thomson. For Sandy and Louisa, the glitter and glamour of that evening must have been as close as they had ever come to experiencing the merger of high society, high bohemia, and high art that had characterized Diaghilev and the Ballets Russes in London and Paris in the 1910s and 1920s. Chick Austin

Virgil Thomson, 1936.
Photograph by George
Platt Lynes.

was determined to resurrect that kind of excitement at the Atheneum in Hartford. Louisa's old friend Henry-Russell Hitchcock observed that Chick "had charisma. He bubbled over with ideas, and they were so stimulating that everyone was willing to work with him and for him."[44] Sandy and Louisa, whatever their allegiance to a more sober bohemian atmosphere, were never afraid to kick up their heels. They weren't immune to the high spirits of an era that they had largely missed, but which Thomson had known firsthand and commemorated so beautifully in his memoirs. It had been a time, he recalled, "when money, caviar, and diamonds; intelligence, amiability, and good looks; talent, imagination, and wit; ambition, success, and charm were available everywhere." On the stage there were, as Thomson recalled, "certain theater spectacles still unmatched," the "glory of the time's finest artwork," while out in the audience there was "a mundane firmament, a dynamo-audience generating its own light from the magnetic proximities of talent, vast worldly experience, known sexual prowess, and beauty aflame."[45] With *Socrate*, Calder had his Diaghilevian moment. He gladly threw himself into the spirit of the Hartford Festival—which included film, music, and dance.

The climactic celebration was to be the Paper Ball, an elaborate costume party redolent of what was by now the old modern Parisian glamour, with its aristocratic-bohemian entertainments and regular Bal des Quat'z'rts, where groups of revelers came in thematically coordinated costumes. Tchelitchew, a master of stagecraft, hung the balconies of the museum's spanking-new Avery Pavilion with a ton of humble newsprint, shredded and painted to resemble baroque columns and swags; it was an effect of magical theatrical opulence forgotten by nobody in attendance. Tchelitchew also designed costumes for many of the partygoers, as well as for Austin, who came dressed as the master of ceremonies. Hitchcock, an architectural historian, Tchelitchew outfitted as an architectural ornament. A week before the event, Calder was commandeered to dress one group of partygoers, including Pierre Matisse. He cut witty masks and costumes out of paper to create a

carnival of animals—tigers, elephants, and sundry other beasts—who marched into the ball together. One bit of film footage of Calder's sartorial escapades remains, a souvenir of an evening that was the last hurrah of high bohemian life between the wars, an American ball perhaps unmatched until Truman Capote's Black and White Ball some thirty years later.

As for the more serious business of the festival, there had been preliminary discussions about Calder's involvement with *Socrate* certainly by late in 1934. We know that because a couple of days after Christmas, Calder wrote to Thomson, mentioning that he hoped to hear the music when he was in New York just after the New Year.[46] In late February, Calder again wrote to Thomson, worrying that he had been told by Eleanor Howland at the Atheneum—she married James Thrall Soby in 1938—that things were at a standstill for lack of funds. Of this Sandy observed to Virgil, "I told her that that couldn't be the thing I was to do—because there never had been any funds!"[47]

Pavel Tchelitchew's decoration for the Paper Ball at the Wadsworth Atheneum in Hartford in 1936.

Even as late as the end of November 1935, some ten weeks before the festival was to open, Calder was writing to the museum asking for the dimensions of the stage and wondering if there was going to be a piano onstage, no doubt having heard the keyboard version of *Socrate* and perhaps not aware that an instrumental version was being performed.[48]

It is not clear if or when Calder was apprised of the full extent of the Hartford Festival, or that *Socrate* was to be part of a theatrical triptych. First on the evening was a revival of Stravinsky's *Les noces,* the music presented without Bronislava Nijinska's legendary Ballets Russes choreography, but with the singers surrounded by a reconstruction of the original décor by Natalia Goncharova. Second on the program was a new composition by Balanchine, a little ballet called *Serenata: "Magic,"* to music by Mozart, though exactly which music is not now known. Although Balanchine had only recently turned down Calder's suggestions for a ballet décor, at the Wadsworth Atheneum, Sandy found his work juxtaposed not only with Balanchine's but also with that of a group of artists who were involved with both the recent past and the near future of the art of the dance. The décor for *Serenata* was by Tchelitchew, who collaborated with both Massine and Balanchine. The ballerina was Felia Doubrovska, a Ballets Russes star near

the end of her career. She was accompanied by five women and Lew Christensen, a beautiful young American dancer who would go on to be a famous Apollo in Balanchine's *Apollo.*

Although Thomson certainly knew Tchelitchew far better than he knew Calder, he has to have realized that Tchelitchew's rococo imagination would hardly make sense as an accompaniment to Satie's somber vision of the death of Socrates. Austin had also made it clear that he particularly wanted to involve American artists in what he hoped would be a celebration of American prowess in the arts. One wonders if Thomson realized that Calder had already, at the time of his first show of abstract sculpture at the Galerie Percier, been linked with Satie. Did it occur to either Thomson or Calder that the sort of geometric sculpture Calder was doing in the early 1930s was often described in terms of Plato's famous words in the *Philebus* about the beauty of "straight lines and curves and the shapes made from them"?[49] No matter what the answers to these questions, one cannot underestimate Thomson's perspicacity in commissioning a décor for this most somber and sobering of musical works from an artist who had a reputation as a comic, a charmer, and a concocter of amusements. In *Socrate,* Calder's sobriety, another fundamental aspect of his art, was fully on display.

VIII

There were few pieces of music that Thomson admired more than *Socrate.* He once praised Satie's works as being "as simple, as straightforward, as devastating as the remarks of a child. To the uninitiated they sound trifling. To those who love them they are fresh and beautiful and firmly right."[50] Satie composed *Socrate* in the last years of World War I. It was commissioned by the Princesse de Polignac, an American with a famous musical salon in Paris. While Satie's other major composition of the war years, *Parade,* looked back to the giddiness of the prewar times, with *Socrate* he confronted the defeat of reason by the forces of unreason, a theme on most thinking people's minds by the end of World War I.

Speaking to students in Los Angeles in the 1960s, Thomson said he regarded *Socrate* as one of the greatest musical settings of words in European music, its only parallel being certain works by Bach. Thomson had known Satie slightly when he was first in Paris, and he said of the composer that he was "reticent about his personal sentiments" and that "direct emotional expression would have seemed to him bad manners"—observations that could also have been made about Calder. Confronting the accusation that Satie's music was simple, using too many common tunes and effects,

Thomson pointed out that "the common-place is not the banal." He went on to argue that "the commonplaces of language and of life are what we all live on: how do you do, I'm sorry to hear that, ever sincerely yours, even deepest sympathy." He spoke of Satie's use of "neutral materials, musical abstractions, used as blocks in an architecture that houses and protects a vocal line so sensitive to the sound and meaning of text."[51] Less than a decade after collaborating with Calder, Thomson spent a weekend with the young composer John Cage, singing and playing the score of *Socrate*. In a letter to the dancer Merce Cunningham, his partner in art and life, Cage, who a few years later composed music for a movie about Calder's work, wrote enthusiastically of the Satie he'd just heard. *Socrate*, he said, is "an incredibly beautiful work. There is no expression in the music or in the words and the result is that it is overpoweringly expressive."[52]

Pablo Picasso. Erik Satie, *1920.*

Describing his work on *Socrate* a year after the Hartford production—*Socrate* would be staged again the following summer, in a festival in Colorado at which Martha Graham also performed—Calder said that "the whole thing was very gentle, and subservient to the music and the words."[53] The small orchestra was in the pit. On either side of the stage, which was twelve feet by thirty, stood the singers, Eva Gauthier, a soprano, and Colin O'More, a tenor, each before a lyre-shaped music stand. They shared between them the passages from Plato that relate a banquet, a walk by the Ilissos River, and the death of Socrates. For the three sections—nine, nine, and then eighteen minutes in length—Calder placed on the stage three elements: a red disk, thirty inches in diameter, left of center; a sphere made of two seven-foot metal hoops, to the right; and a vertical form, three feet wide and ten feet high, white when the audience first saw it, all the way to the left. During the comic description of Socrates at the banquet, the red disk moved across the stage. During the walk by the river, the sphere rotated toward and away from the audience. And during the long death scene, the white form slowly dropped onto its side, turned flat on the floor, and then returned to a standing position, but now revealing its other side, which was black.

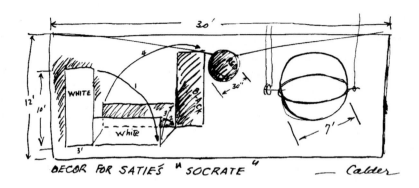

Calder. Drawing of the décor for Erik Satie's Socrate, *performed at the Hartford Festival at the Wadsworth Atheneum in Hartford in 1936.*

Calder never hazarded a meaning for what he had made. But Thomson, although himself emotionally reticent, remembered that the setting, even if "simple to the eye and restrained in movement, was so sweetly in accord with the meaning of the work that it has long remained in my memory as a stage achievement."[54] In several accounts, Thomson remembered *Socrate* somewhat differently from how Calder described it, and his recollections, even thirty years later, give us some sense of the full emotional force of the work. He recalled nothing moving during the first section, when Alcibiades praises Socrates. He described the sphere revolving "sedately" as Socrates and Phaedrus walked along the Ilissos. And he wrote of the red disk being in motion during the death scene, "the sunlike disk . . . descending diagonally across the sky." Most revealing, he referred to what Calder called the vertical form, which turns from white to black, as "stele-like," the black vertical suggesting a tombstone, a memorial, much as the sphere suggested the world, the universe, human possibilities. Certainly never before and perhaps never after were the essentials of Calder's art—the pull of gravity, the flux of movement, the rising and falling of forms—so deeply rooted in questions of life and death, the connection unspoken even as the words were spoken. Both Thomson and Calder, like Satie before them, were far too thoroughly immersed in their craft to want to make obvious allusions or associations. But who could doubt that *Socrate*, a work about the death of the Greek philosopher, had a particular resonance in 1936, when the Europe of creative, exploratory thought was already dead in Germany and imperiled everywhere else?

"Attention to words and music had not been troubled," Thomson wrote thirty years later of Calder's setting, "so majestic was the slowness of the moving, so simple were the forms, so plain their meaning."[55] Amid the glitter and glamour of the Hartford Festival, *Socrate* was an extraordinary

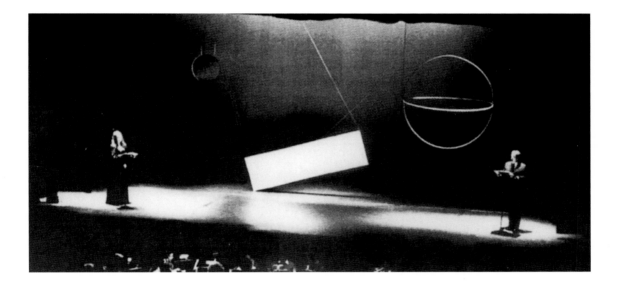

tonic—somber, restrained, without the slightest touch of irony. This muted gravitas, a side of Calder first revealed at the Galerie Percier five years earlier, was the ballast that would forever ground his champagne wit. This was a recognition of life's saturnine side, which Calder was far too deep a spirit ever to deny, despite his indefatigable high spirits. Summing up his response to this great work, Thomson wrote that Calder's set "is so plain to look at and yet so delicately complex in its movements (for it does move and without injury to musical effect), so intensely in accord with the meaning of the musical work and yet so rigidly aloof from any over-obvious illustrating of it, that it remains in memory as one of our century's major achievements in stage investiture."[56]

Reconstruction of Calder's décor for Erik Satie's Socrate, *mounted at the Beacon Theatre in New York in 1977.*

A VERY GOOD YEAR

Interior of the apartment on New York's Upper East Side where the Calders lived c. 1935; on the mantelpiece is Calder's 6 Woods (1935).

I

The twelve months that began with the premiere of *Socrate* in Hartford marked a very good year for Alexander Calder. His standing in the international avant-garde was solidified with one-man shows and appearances in major museum surveys in the United States as well as significant exposure in Europe. Sandy and Louisa were living in New York much of the time, in the first of a couple of apartments on the Upper East Side, this one at 244 East Eighty-sixth Street.[1] Calder improvised inexpensive storefront studios in the same neighborhood. "We rather expect to pass several months in New York," he wrote to Pierre Matisse in July 1935, commenting that Alfred Barr, at the Museum of Modern Art, seemed "to be arranging a show of abstract art (historically represented) for this winter."[2] Calder was also interested in keeping abreast of the work of a younger generation of creative spirits. Sometime early in 1937, he was at a gathering at the loft shared by the poet and dance critic Edwin Denby and the artist Rudy Burckhardt, to see the first of Burckhardt's experimental films, *145 West 21* (the address of the loft). Denby and Burckhardt were close

to Willem de Kooning, and would be important figures in avant-garde circles after World War II. Also in attendance were Kirstein, Carl Van Vechten, Joseph Cornell, and Jane Auer (who would soon marry Paul Bowles).[3]

For Calder, who had grown up in a family where frequent changes of address were taken in stride, Roxbury was beginning to signify rootedness, the place one could really call one's own. But at least in those first years, it was inhospitable in the winter, especially with a young child. Sandy and Louisa would keep an apartment in New York at least off and on well into the 1950s, when they had a place at 20 Great Jones Street. The Upper East Side neighborhood the Calders settled on in the 1930s and 1940s, without ever establishing anything like a permanent address, was what was known then as Germantown, an area filling up with German-speaking immigrants in the 1930s, drawn by the cheap rents, which also attracted the Calders. Calder may have felt that Greenwich Village, the bohemian precinct where he had started out and his parents still lived, was too much a part of his past. Sandy and Louisa may also have wanted to set some boundaries between themselves and his parents. Nanette was certainly a loving presence for Sandra, her only granddaughter and her only grandchild on the East Coast. In the years to come, it was Nanette who took Sandra to concerts and plays, insisting on the cultural education that she had given to Peggy and Sandy when they were children and that her son by now took so much for granted that he hardly realized it needed to be cultivated.

In the first two years of his daughter's life, Calder had two more shows with Pierre Matisse, in February 1936 and February 1937. His work was also included in three exhibitions at the Museum of Modern Art: "Modern Artists as Illustrators," organized by Monroe Wheeler, who had published Calder's *Aesop* in Paris; and "Cubism and Abstract Art" and "Fantastic Art, Dada, Surrealism," two epochal survey exhibitions organized by Barr, one at the beginning and the other at the very end of 1936. There was more. Calder had a one-man show at Vassar College in May. He had a show in Los Angeles. He was included in "Art of the Machine Age" at the Worcester Art Museum over the summer. He was represented in exhibitions of Surrealist art in London and Paris, as well as in an important show of Constructivist art in Basel.

II

In the second half of the 1930s, Calder was fortunate to find a photographer whose exploratory spirit matched the spirit of his work. This was

Herbert Matter with Calder's Tripod *(1939) in the Sculpture Garden of the Museum of Modern Art in New York during Calder's 1943 retrospective.*

Herbert Matter, a Swiss whiz kid who immigrated to the United States in 1936. He was one of a number of photographers who seemed to be taking a particular interest in sculpture in those years. Their achievements include Charles Sheeler's and Walker Evans's documentation of African carvings, Paul Strand's interpretations of the statues of Christ in old Mexican churches, Brassaï's studies of Picasso's busts and figures of Marie-Thérèse Walter, and Horacio Coppola's studies of Mesopotamian sculpture, for *L'art de la Mesopotamie,* published in 1935 by Christian Zervos, a friend of Calder's and the editor of the important magazine *Cahiers d'art.* These photographers wanted to free sculpture from the enforced passivity of the pedestal and the niche. They wanted to give sculptural form a more than formal power—a kinetic power. The lighting in their photographs can be ravishing, with shapes sometimes emerging from inky darkness and at other times granted a startling clarity. Matter, who created an extraordinarily moving record of Calder's work between 1936 and 1943, explored similar themes in his studies of Alberto Giacometti's sculpture in the 1950s and 1960s, a project that was initiated by Pierre Matisse.

We don't know exactly how Matter and Calder met, but it was soon after Matter came to the United States, and it's possible that they had already crossed paths in Paris. Although Matter was nine years younger than Calder, they counted some of the same Parisians as friends and acquaintances. It could be that they first met through Léger. They might also have met through Sweeney. Matter had already built a major reputation in Zurich, designing posters, many for the Swiss tourist industry, that combined bold, modernist typography with striking photomontage elements. In New York, he was embraced by the most progressive figures in graphic design. He worked with Alexey Brodovitch, the art director at *Harper's Bazaar,* who influenced a generation of photographers, including Richard Avedon and Irving Penn. Matter played a role in the design of the Swiss Pavilion for the 1939 New York World's Fair. For a time, he designed all the catalogs and posters for the Guggenheim Museum, including a memorable cover for the catalog of Calder's 1964 retrospective.

Matter was a rather glamorous figure—tall, lean, and handsome. A couple

of years after he arrived in New York, he met a gifted and beautiful painter by the name of Mercedes Carles, who was a student and close friend of Hans Hofmann's. The brilliantly accomplished and wonderful-looking couple were married in 1941, by which time Herbert was as much a part of New York's downtown artistic world as of the city's uptown magazine and advertising circles. Along with their little boy, Alex, who was named after Calder, Herbert and Mercedes were always welcome visitors in Roxbury. Mercedes's father was the pioneering American abstract painter Arthur B. Carles. Her mother, Mercedes de Cordoba, was the subject of famous photographs by Edward Steichen. In

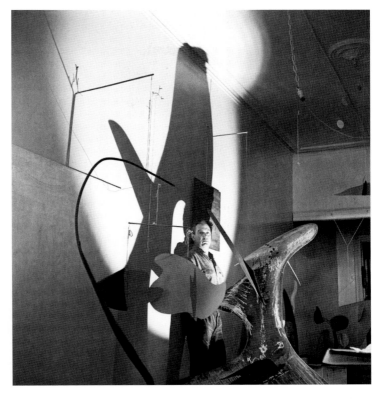

Calder with White Panel *(1936) and* Devil Fish *(1937, before completion), in his storefront studio in New York in 1936. Photograph by Herbert Matter.*

the 1960s, Mercedes Matter was the moving force behind the founding of the New York Studio School of Drawing, Painting and Sculpture in Greenwich Village, which aimed to merge modernist pictorial principles with the old atelier system. The Studio School ran a summer program in Paris, which would from time to time send busloads of students to visit the Calders in their home in the Touraine.

Matter's work with Calder began late in 1936, when he went to Calder's studio in a storefront on the Upper East Side to photograph both the artist and his work, in preparation for Calder's third exhibition at the Pierre Matisse Gallery the following February. Matter also photographed the work when it was installed in the gallery. Calder would have found Herbert's technical competence and ingenuity appealing. Matter's focus on the nuts and bolts of the creative process never stood in the way of his pursuit of lyric beauty. Sweeney later observed of Matter that "for him there are no technical taboos."[4] It was surely this rejection of all taboos, whether technical or artistic, that joined Matter with Calder in what might be described less as a collaboration than a meeting of minds—with Matter intuitively understanding that Calder regarded his plunging, careening forms with a lovingly human

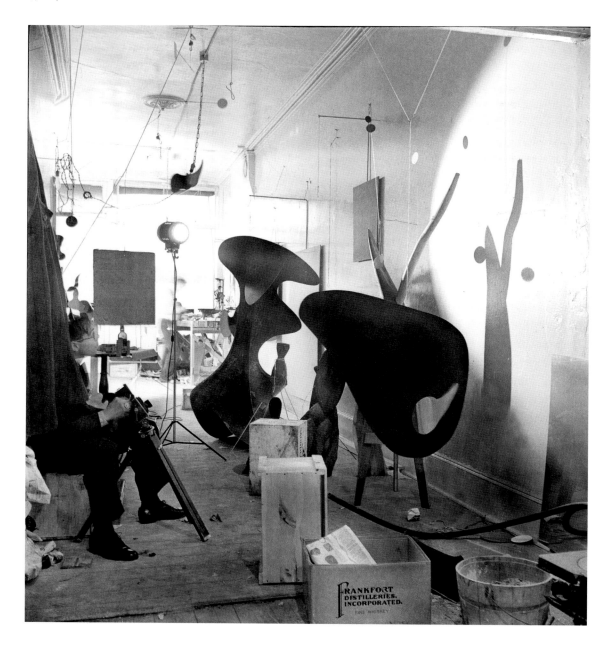

Calder's Devil Fish
(1937, before completion),
Tightrope *(1936), and*
Elephant *(1936) in his*
storefront studio in New
York in 1936. Photograph
by Herbert Matter.

eye and gave even abstract objects a caricatural edge. They were certainly in sync in the first series of photographs Matter made of Calder's work, in the storefront studio on the Upper East Side, a relatively narrow and deep space, painted white.

There is in Matter's photographs a feeling for the work of art as it comes into being, the fantastical freedom of forms emerging from the cramped old

space. Matter was attuned to all the quirks and particularities of the awkward room. He allowed his camera to linger on old-fashioned woodwork and on buckets, cartons, bottles, and boxes. His photographs moved between the formal and the informal, the planned and the accidental. Among Calder's new works were a group that extended ideas he had originally been developing in *Cadre rouge*, *The White Frame*, and *Black Frame*, but now with the motors and cranks pretty much completely abandoned. He was arranging biomorphic forms in front of flat planes painted in red, white, yellow, orange, green, or blue, to create what were in essence mobile paintings, with the three-dimensional shapes casting shadows on the flat backdrops

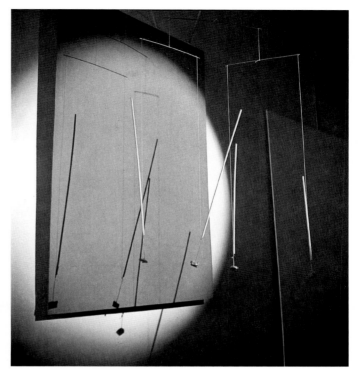

Calder's Swizzle Sticks *(1936) in his storefront studio in New York in 1936. Photograph by Herbert Matter.*

that defined the space. Matter worked almost like a jazz musician, riffing on the curved and angled shapes of wall-hung works such as *Swizzle Sticks* and *White Panel*, as well as of freestanding works such as the imposing (and not yet quite finished) *Devil Fish*. He created a dance of shadows along the walls that splendidly doubled or paralleled the shadow play in Calder's work. Both Calder and Matter could have seen here affinities with the shadow plays of nineteenth-century avant-garde cabarets such as Le Chat Noir, which as we have already seen influenced the art of Toulouse-Lautrec, Degas, Bonnard, and Picasso.

Calder's work brought out Matter's loosest, most easygoing instincts. This photographer, who in the late 1940s captured in singular images the multiplying movements of an Indian dancer, Pravina Vashi, recognized the revolution that Calder was bringing about in sculpture. By setting inanimate objects in motion, Calder turned the work of art into the protagonist in a dramatic narrative. With his passion for all things kinetic, Matter responded instinctively to a Calder such as *Swizzle Sticks*, which he photographed in 1936 as an abstract dance event. Using stroboscopic techniques, Matter set *White Frame* and *Dancers and Sphere* in motion, so that the elements unfurled in a visual echo chamber. In a series of photographs done before Calder's

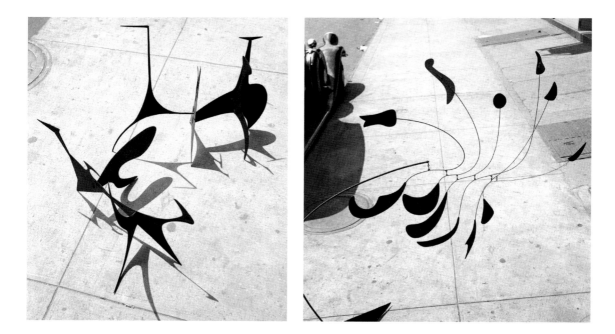

ABOVE, LEFT *Calder's Untitled (maquette, 1939) and* Spiny *(maquette, 1939) outside his storefront studio in New York in 1940. Photograph by Herbert Matter.*

ABOVE, RIGHT *Calder's Untitled (1939) outside his storefront studio in New York in 1940. Photograph by Herbert Matter.*

OPPOSITE *Calder's* Dancers and Sphere *(maquette for the 1939 New York World's Fair) set in motion in his storefront studio in New York in 1938. Photograph by Herbert Matter.*

1940 show at Pierre Matisse, eight stabiles and standing mobiles were carried out of the storefront studio and photographed on the sidewalk. There's a sneaky wit about these photographs, a sense that the sculptures, having been born in the studio, were now taking their first steps out in the world.

III

Calder's work of the later 1930s suggested not only the biomorphic but also the anthropomorphic, the zoomorphic. He was creating an entire taxonomy of curious creatures, some with heavy bodies set on tripod legs. At the Pierre Matisse Gallery, the works seemed to meander through the gallery, almost as if they were animals in some new sort of zoo. In a number of Matter's photographs, we see, arranged beneath the spindly supporting legs of the enormous *Big Bird* (1937), a gaggle of smaller but related sculptures. The smaller works, studies for larger ones to come, are a flock of chicks protected by their mother's imposing form. Calder was hoping that Matisse might find some collectors who wanted these maquettes transformed into large-scale objects for their gardens, but at least for the time being no commissions were forthcoming.

There was a shaggy-dog-story quality about some of the work of those years, beginning with a sculpture made by balancing one piece of found

Calder's exhibition at the Pierre Matisse Gallery in New York in 1937. Photograph by Herbert Matter.

wood atop another and titling it *Requin et baleine* (*Shark and Whale*). "I get ideas for [my works] everywhere," Calder told a reporter for *Time* magazine during his show at Pierre Matisse early in 1937, "except when driving a car. I try and think of something slithering around and the next thing I know I'm in the ditch."[5] That was an offhand joke, but also the observation of a highly sophisticated artist. The delight Calder took in thinking about different sorts of movement—the slithering of a snake, the car running off the road— revealed an artist who was always examining the kinetic possibilities. Calder was creating an abstract menagerie, an array of unexpected forms, many

of them sent into confounding, fascinating motion—motions galumphing, jagged, swishy, swirly. When a reporter from the *New York Post,* looking at the show at Pierre Matisse early in 1936, aimed to describe the varieties of movement, he said that the sculptures were "oscillating, dangling, whirling, vibrating, springing and shuddering"—quite literally as if they were alive, a springing mountain lion, a dangling monkey. The reporter, one Bill Holman, spoke of "gangling contraptions with strangely shaped blades joined by wiry members," as if the subject were some peculiar exotic bird.[6]

Perhaps the strangest work in the 1937 show was *Tightrope,* with two tri-

pods made of metal rods and ebony wood set some ten feet apart and four enigmatic abstract personages made of wire suspended in between. Here Calder's earlier immersion in the world of acrobats and other athletes was cross-fertilized with his more recent preoccupation with the signs and symbols of abstract art—and neither the naturalistic nor the anti-naturalistic impulse was allowed to quite win the day. If a gallerygoer plucked the wire on which Calder's spectral performers were perched, they were immediately set in quivering life, each vibrating in its own way. When Matter photographed *Tightrope* a few years later, he set it in a darkened space, as if to suggest a group of actors illuminated on a stage. The tripods and the quizzical, calligraphic forms suspended on the tightrope are treated as theatrical presences, inanimate forms animated through the hyperbolic presentation. The sharp light transfigures the ordinary materials, and Calder's bent and twisted lengths of wire achieve a thrilling immateriality. Calder's abstract acrobats become the protagonists in an archaic drama.

We don't know if Calder was familiar with Nietzsche's words about the tightrope and the tightrope walker in *Thus Spake Zarathustra*. But it's not impossible, considering all the interest artists and intellectuals took in Nietzsche in the early twentieth century. Even if he didn't know Nietzsche's writings, they help us grasp the meaning of a work of Calder's that's as grave as his setting for *Socrate*. This is what Zarathustra said: "Man is a rope stretched between the animal and the Superman—a rope over an abyss. A dangerous crossing, a dangerous wayfaring, a dangerous looking-back, a dangerous trembling and halting. What is great in man is that he is a bridge and not a goal: what is lovable in man is that he is an *over-going* and a *down-going*."[7]

IV

"Calder takes a lively enjoyment in *grotesqueries*," Robert Frankel remarked of the 1937 show in *Art News*.[8] The grotesque can be either tragic or comic, or even a combination of the two. Frankel was also reminded of the riotously absurd drawings the nineteenth-century English artist and writer Edward Lear produced to accompany his limericks. He may have found himself thinking about Lear because Barr had included some of his work in the 1936 survey "Fantastic Art, Dada, Surrealism" at the Museum of Modern Art—an exhibition in which Calder was also represented. Lear drew flowers with petals in the shapes of babies or lobsters or forks, as well as noses so long that they resembled the branches of trees. Frankel's term *"gro-*

tesqueries" was just right for the bulbous and bizarre forms Calder was coming up with in the later 1930s, when he wanted to see how far he could move from the geometric restraint of his Galerie Percier moment.

There were always competing forces at work in Calder's art. He wanted to be clear and unfussy, to get straight to the point. At the same time, he liked to linger over life's oddities and obscurities. He embraced this dialectical play. In many works, Calder consciously mingled the totally abstract and the more or less anthropomorphic. In some sketches and smaller sculptures, he made a joke of what some people regarded as his eclecticism. On the envelope of a letter he sent to James Thrall Soby in 1943, he turned the initial *T* into a monumental abstract sculpture with a single ball hanging from one arm of its top, while the letter's base resolved into two perfectly human feet.[9] Sweeney, writing a decade later, observed that "humor took the place of subject matter with Calder, just as a less innocent type of humor was that of the dadaists."[10] Humor, then, not as a subject but as an attitude, a view of the world, although I'm not sure that Calder's humor was more innocent than that of the Dadaists. Calder's humor was more relaxed. In the 1930s, Calder traded the essentially adolescent jokes of the Dadaists for the dry wit of a middle-aged man of the world.

Calder's comedy was at least in part a physical comedy; he made animate forms move in unexpected ways. As Calder more and more emphasized kinetic sculptures driven by a breeze or by the push of a person's hand, the movements became increasingly unpredictable, with almost continuous shifts in speed, rhythm, and direction. Calder's humor in the mid- to late 1930s was not entirely unrelated to what the poet W. H. Auden, in his "Notes on the Comic," published in 1952, saw as the comic surprise of an umbrella blown inside out by a gust of wind while a man is carrying it—or of a film running backward. Auden found what he referred to as "comic contradiction" in "the operation of physical laws upon inorganic objects associated with a person in such a way that it is they who appear to be acting from personal volition and he who is or appears to be the helpless thing."[11] Of course, the person viewing one of Calder's mobiles wasn't forced to act in some unusual or unexpected way. But the surprise of discovering forms in motion in a gallery or museum, which had heretofore been a place where

Manypeeplia Upsidownia.

Edward Lear. Manypeeplia Upsidownia, *1871. This was reproduced in the catalog of the 1936 Museum of Modern Art exhibition "Fantastic Art, Dada, Surrealism," which also included work by Calder.*

Calder. Apple Monster, *1938. Wood, wire, and paint, 66 x 55½ x 32½ in.*

objects remained at rest, certainly transformed the relationship between art and audience. It was part of Calder's genius that he made all of this feel self-evident, inviting, sometimes amusing—whereas the relatively small amount of kinetic art that had already been produced by Richter, Moholy-Nagy, and a few others tended to be cold and clinical, with no kidding around allowed.

Comedy and humor had been central to Calder's art, beginning with the wire figure sculptures of the late 1920s. In the 1930s, he was often linked with other abstracts artists who had a sense of humor, especially Miró and Klee.[12] Robert Frankel, writing in *Art News,* observed that "a relationship to Miró is evident in these works, though less neurotic and more humorous than the Spaniard."[13] Soby, a decade later, in an essay entitled "Three Humorists: Klee, Miró, Calder," argued that Calder's work had a plainspoken quality

that seemed particularly American. Soby also believed that Calder's humor—as well as Miró's—was earthier than Klee's, "less mediated" and "narrower in emotional scope." He quoted from Klee's diaries these lines by Gogol: "There is a laughter which is to be put on the same dignified level as higher lyrical emotions, and which is as distant as heaven from the convulsions of a vulgar clown."[14] This was of course meant to suggest something philosophical in Klee's comic sense. Soby was implying that Calder's humor lacked that lofty lyric quality. But wasn't that precisely the impact of *Tightrope*, right along with the humor?

V

Calder's association with the Pierre Matisse Gallery, which almost exclusively represented European artists, may have fostered among some American critics and gallerygoers a sense that this native son was working in the shadow of Europeans such as Miró, Klee, and Arp. But the fact that Calder was expressing himself through a language of geometric and biomorphic forms that was also employed by many European artists—among them Kandinsky, Klee, Miró, Arp, Taeuber-Arp, and Giacometti—was a problem only so long as one focused on the visual language rather than the imaginative use of that language. Calder was certainly not the first artist to use geometric and biomorphic forms. But being the first isn't the end-all and be-all. We don't underestimate Raphael and Michelangelo because their figures move through space with a fluidity that was first given visual expression by Leonardo. Nor do we hold it against Titian that late in life he adopted specific forms and figures from Michelangelo's work. We believe that each artist has discovered a particular, individual vision within the communal vision. Why do some deny that same freedom to Calder?

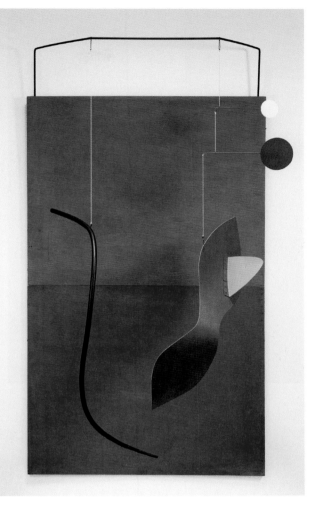

Calder. Red Panel, *1936. Plywood, sheet metal, tubing, rod, wood, wire, string, and paint, 108 x 60 x 44 in.*

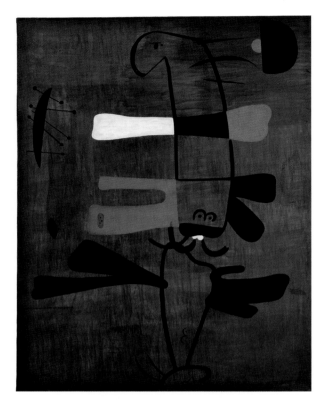

Joan Miró. Untitled, 1933.
Miró gave this painting
to Calder and Louisa as a
going-away present when
they returned to the United
States in 1933.

There is also a much bigger question that must be raised about the relationship between Calder's art and that of Miró—and Klee and others. This is the question of the relationship between the art of sculpture and the art of painting. We must understand Calder's achievement in terms of the art of sculpture—and the kinetic revolution he brought about in sculpture. Kandinsky, Klee, and Miró were picture makers and storytellers. The rectangular plane of the canvas was the stable field on which their stories unfolded or unfurled. Years later, Miró observed of his own forms that they were "both immobile and mobile. They are immobile because the canvas is an immobile support. They are immobile because of the clarity of their edges and the framing to which they are sometimes subjected. But precisely because they are immobile, they suggest movement."[15] Whatever family resemblance some of Calder's forms had with some of his friend Miró's, the difference was that Calder embraced actual, literal movement. Calder made objects move. And that made all the difference in the world.

For two thousand years, European sculptors had aimed to reimagine the human figure, an essentially kinetic form, as a static form. It isn't insignificant, I believe, that Calder often referred to his works not as sculptures but as objects. He wanted to distinguish his three-dimensional work, which so often animated the inanimate, from traditional sculpture, which stilled the moving figure. The Surrealists saw a talismanic or fetishistic power, a mysterious life force, in certain objects, often the curiosities they found in the flea market. In 1936, Calder contributed a mobile made of broken bits of glass to an important international exhibition entitled "The Surrealist Exhibition of Objects" at the Galerie Charles Ratton in Paris. While Calder recoiled from the hard-edged Freudian meanings that the Surrealists often ascribed to their talismans and fetishes, he was definitely determined to trade the old reliable magic of mimesis for a celebration of the unpredictable and the uncanny. The unabashed oddity or eccentricity of some of Calder's mobiles and stabiles did give them a talismanic or fetishistic quality, a mysterious life

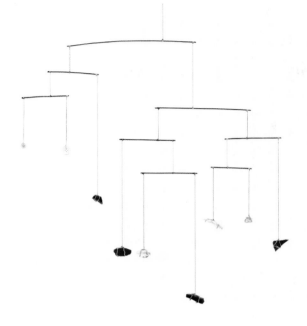

force, although without any of the primitivist or folkloric frills that gave all too many Surrealist objects the sentimentality of knickknacks. If there was another artist who was pursuing a path parallel with Calder's in the 1930s, it was Giacometti, with a construction such as *Hour of the Traces*, made of plaster, wood, and steel, with a pendulum-like ball and another form canti-levered off a wire.

Calder. Untitled, 1936. Brass wire, glass, buttons, and string, 20 x 18 x 18 in. This work was exhibited at "The Surrealist Exhibition of Objects" at the Galerie Charles Ratton, Paris, 1936.

"Just as one can compose colors, or forms," Calder wrote in 1933, "so one can compose motions."[16] Calder would have been sympathetic to something Miró said three years later, in a letter to Pierre Matisse, about a few sculptural objects he made. "I feel myself attracted by a *magnetic* force toward an object, and then I feel myself being drawn toward another object which is added to the first, and their combination creates a poetic shock."[17] But with his mobiles, Calder pushed the relationship between object and object— sometimes found objects, but more frequently objects made by the artist himself—into poetic regions that nobody else explored, certainly not Miró. Calder took the idea of a magnetic force literally. He forced objects to actu-ally move in relation to one another. If some of the visual vocabulary he was using in the 1930s was familiar, there was no question that his theater, his drama, and his activation of the object were entirely his own. The worlds wrought by Klee and Miró were imaginary worlds that remained on the two-dimensional pictorial surface. And Miró's sculptural objects remained static.

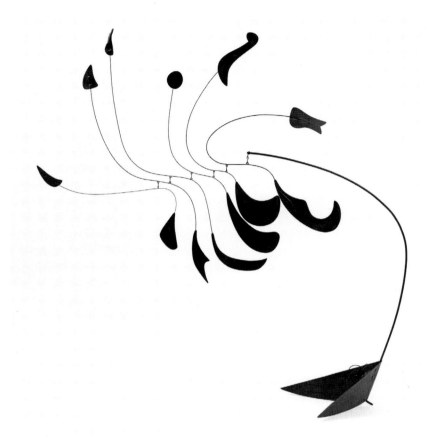

Calder. Untitled, 1939.
Sheet metal, rod, wire, and
paint. 55½ x 64½ in.

They were conceptualizations rather than actualizations of a magnetic force. The worlds wrought by Calder were imaginary worlds reimagined—no: realized!—in the very midst of the three-dimensional reality in which we live our lives. The result, only beginning to come into focus in the exhibitions at Pierre Matisse in 1936 and 1937, was a new relationship between the imaginary and the real.

VI

Although Calder was one of the most widely respected abstract artists working and exhibiting in New York in 1936, abstract art still wasn't receiving anything like the consideration—much less the respect—that its strongest supporters believed it deserved. The Museum of Modern Art, which opened its doors in 1929, had initially emphasized the work of the Post-

impressionists, and was only really joining the fight for the acceptance of abstract art with the opening on March 2, 1936, of "Cubism and Abstract Art." This epochal exhibition filled all four floors of the museum with paintings and sculptures as well as photography, architecture, furniture, graphic design, and film. Calder, represented by a couple of mobiles, was one of the very few Americans in the show; another was Man Ray. To be included in "Cubism and Abstract Art" was an extraordinary honor. And if that weren't enough, Calder had been commissioned by Barr to create an imposing mobile for above the entrance to the museum, which at the time was located in a townhouse at 11 West Fifty-third Street; it was three years later that the museum opened its very own modernist building on the same block. Calder's mobile, with its juxtaposition of geometric and biomorphic forms, suggested the variety of works presented in the exhibition.

Alfred H. Barr Jr., c. 1930.

For the Museum of Modern Art, where 1935 had concluded with a wildly popular Van Gogh retrospective, "Cubism and Abstract Art" was a much tougher sell. In *The New York Times*, Edward Alden Jewell, who had already written about Calder, called it "the most bewildering exhibition arranged thus far in the career of the Museum of Modern Art." Jewell referred to the show as a "maze" and a "journey through strange worlds" but also as "brilliant" in its reach and range. There was much discussion in the press about the fact that United States Customs officials had held up the opening of the exhibition, because they had been reluctant to accept that some of the sculptures that arrived in New York were in fact works of art. Works by Giacometti, Henri Laurens, Vantongerloo, Duchamp-Villon, Boccioni, Arp, Moore, González, Nicholson, and Miró had, according to the customs people, required a 40 percent duty, as they failed to fit a description of sculpture as "imitations of natural objects, chiefly of the human form." In some ways, it seemed that little had changed since the Armory Show in 1913. The press was still willing to argue that abstract art was some sort of a hoax—as the Associated Press put it, "the Museum of Modern Art's latest successful bid for crowded galleries." But in comparison with the Van Gogh show, which had pulled in something like 125,000 visitors, "Cubism and Abstract Art" drew only 30,000. Henry McBride, the most astute critic writing for a New

Cover for the catalog of the Museum of Modern Art's 1936 exhibition "Cubism and Abstract Art," designed by Alfred H. Barr Jr.

OPPOSITE *Calder.* The Praying Mantis, *1936. Wood, rod, wire, string, and paint, 78 x 51 x 40 in.*

York newspaper, urged his readers to see in the new abstract art a reflection of society. What was discomfiting in the work of these artists echoed what was discomfiting about the times, "as though the poor artists could help being like the times they live in! Why blame the artists for that!"[18] McBride was trying a bit of gentle persuasion to ease his readers over their initial discomfort with this challenging show.

The catalog of the exhibition—which friends of Barr's remember emerging from the almost unimaginably feverish efforts of the curator and his wife, Marga—was the most ambitious yet devoted to the subject and remains a landmark achievement more than three-quarters of a century later. For the dust jacket, Barr designed a chart tracing the evolution from Postimpressionism in the 1890s to the abstract art of the 1930s, with dozens of arrows in red and black angled and curved and sometimes even crisscrossed down the page. All of this climaxed in what Barr saw as two divergent strains of abstract art, which, in his customary dry manner, he referred to as "geometrical" and "non-geometrical." In his comments about Calder, Barr remarked that he saw him moving between the two strains and observed that "recently Calder has deserted geometrical shapes for irregular quasi-organic forms." He noted that it had been "under the joint influence of Mondrian and Gabo" that Calder had "turned his back on the popular success of his wire portraits to experiment with mobile constructions built of wire, iron pipe and metal." Calder would probably have disagreed about Gabo's significance. But he certainly would have agreed with Barr when he commented that Calder's mobiles "display an ingenuity and visual humor quite different from the kinetic constructions which Gabo designed as early as 1922 or Rodchenko's hanging constructions of 1920."

The two mobiles included in "Cubism and Abstract Art" emphasized the range of Calder's art. The earlier work, which is now known as *A Universe* (1934), reflected the pure geometry of the Galerie Percier moment. The 1936 work, which was simply entitled *Mobile,* suggested any number of associations: the movement of water, something birdlike, an African mask. Some months later, when Barr again included Calder's work in the equally ambitious exhibition "Fantastic Art, Dada, Surrealism," one of the two

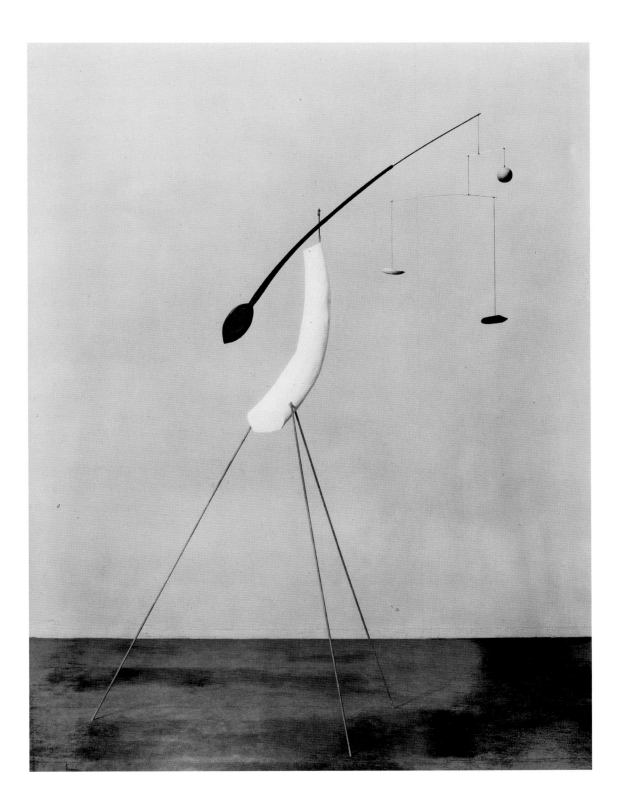

Calder. Untitled (1935) hanging at the entrance to the Museum of Modern Art's 1936 exhibition "Cubism and Abstract Art," for which Calder was commissioned to make this sculpture.

works was *The Praying Mantis* (1936), a three-legged abstract critter that was unabashedly zoomorphic. Calder's inclusion in both "Cubism and Abstract Art" and "Fantastic Art, Dada, Surrealism," while a testament to the reach and range of his art, was also perhaps the beginning of a problem that would haunt all those who aimed to categorize his art in the future. Those who defined Calder as an abstractionist couldn't account, even in his most purely nonfigurative work, for the empirical wit and naturalistic play of his responses to air currents and gravity's pull. And those who classed him as a Surrealist of sorts couldn't account for the levelheadedness and purity of his art. Of course, this was just fine with Calder, who aimed to elude all the labels.

The struggle to elude all the labels was itself a privilege, available only to an artist who was well enough known to be labeled in the first place. Barr was anxious to establish his museum as an international center for the study of modern art, and there was no question that he wanted Calder to be a part of the story. In the catalog of "Cubism and Abstract Art," Calder was the sole American among what Barr referred to as "The Younger Generation." Also included were Calder's good friend Jean Hélion, as well as Alberto Giacometti, whom Calder had probably already known a little in Paris, and two Englishmen he would get to know quite well in the next year, Ben Nicholson and Henry Moore. They were all, Barr wrote, "mature masters." He believed that their work illustrated "the remarkable renaissance of interest in abstract art among the younger artists who not only have strengthened recent developments but have actually resurrected problems which excited the vanguard of twenty years before. Most of these younger men were members of the Abstraction-Création group which flourished in Paris during the early '30s."[19]

MERCURY FOUNTAIN

I

Whatever satisfactions and triumphs New York offered in the way of work and play, Paris was never far from Sandy's and Louisa's thoughts. Across the hallway from them on East Eighty-sixth Street they had found a place for some Parisian friends, the architect Paul Nelson and his wife, Francine. They'd gotten to know the Nelsons during their last year or so in Paris; the architect Josep Lluís Sert remembered being with the Calders at the Nelsons' Paris apartment in 1933.[1] Paul was an American who had fought in France in World War I and then remained abroad, studying architecture and painting, and marrying Francine, who was French. Although his career as an architect never really took off, at least not to the extent he might have hoped, Paul had a gift for friendship and for bringing people together. He had become quite close to Braque when still a student, and had helped Braque design a country place at Varengeville-sur-Mer, on the Normandy coast, where Paul and Francine also had a home. Now the Nelsons were returning to France and, as Calder recalled in the *Autobiography,* "made us promise to come and visit them."[2]

It had been four years since Sandy and Louisa had left the rue de la Colonie. For Calder, that was the longest gap since he had started going to Paris, a decade earlier. Time was passing. Calder's 1937 U.S. passport was the first on which he described his hair as gray, rather than dark brown. Surely the Calders were hankering to see all their European friends. A return engagement was in order. Sandra was a toddler, which seemed as good a time as any to take her on her first transatlantic journey. The Roxbury house was well enough established that they could feel confident in leaving it for a number of months. And with the political situation in Europe worsening with each passing day, Sandy and Louisa must have reckoned that if they didn't return

to France now, there was no way of knowing when they would have another opportunity. Already when Sweeney had returned from Paris two years earlier, he'd written to Calder, "Paris was not a very gay spot. Everyone was hoping to find a way to leave it."[3] That was an understatement.

What Calder didn't let on in the *Autobiography* was that there were opportunities for exhibitions in both London and Paris. Much as he had finally managed to secure a show at the Julien Levy Gallery by more or less appearing on Joella Levy's doorstep, he probably figured that his prospects in London and Paris would be improved if he weren't an ocean away. Back in 1933, just before leaving Paris, Calder had written to a young Englishman, Douglas Cooper, who had become a partner in the Mayor Gallery, in London, and planned to devote his energies to contemporary art. Cooper, still in his twenties, was at the beginning of a long and distinguished career. As a dealer, he fought against what he saw as the insularity of English taste. After the war, he moved to the South of France, where he established a reputation as an extraordinarily discerning collector and historian of Cubism; for a time, he was quite friendly with Picasso, who designed a cover especially for Cooper's book *Picasso Theatre*, still the definitive work on the subject. In 1937, it had already been four years since Calder first asked Cooper to give him an exhibition. Miró had had a show with the Mayor Gallery in July 1933, and at the time Calder had pressed Cooper for an exhibition, making his case in much the same cheerfully forceful manner as he had with Levy and Matisse.[4] Now, after his New York successes, Calder's London show seemed to be becoming a reality. And if there was indeed to be a show organized by Cooper at the Mayor Gallery—or, for that matter, at Cahiers d'Art in Paris, the operation run by Christian Zervos and his wife, Yvonne, where Calder also had hopes—he wanted to be in Europe to make some of the work; that would be easier than shipping all the objects from New York.

Sandy, Louisa, and Sandra left New York in April 1937 on the *Lafayette*, one of the great transatlantic ocean liners of the 1930s, famous for its Art Deco interiors. The crossing was uneventful, very smooth, but there wasn't a lot of sun, so they didn't spend much time sitting out on the deck. Although the food and quarters were fine, the relatively few fellow passengers seemed, as Calder wrote to his parents shortly after they arrived, "a bit dull, so we lapsed into that condition, too." The brightest spot was Sandra, who turned two just after they arrived in France, and who liked to march up and down the ship's endless flights of stairs. She seemed to be getting toilet trained, announcing one night that she wanted her potty. "She has also gotten into a habit," Calder reported to the grandparents, "of shrieking + wailing, and crying out 'Money' (wishing to delve into someone[']s purse)."[5] Along on

Louisa Calder and Sandra in Paris in 1937 with Pierre Matisse's wife, Teeny.

the trip to help out with Sandra was a young woman, Dorothy Sibley. Dorothy, who was in the tenth grade at the time, was from Eastham, on Cape Cod. Louisa's family had a house there—Sandy had visited Louisa there shortly after meeting her on the *De Grasse*—and the Calders had rented a cottage from the Sibley family for a couple of summers. Decades later, Dorothy's younger brother still remembered the letters she sent back from France that summer, full of reports of the Calders' packed social life. A pin in the shape of a fish that Calder made for her was a treasured possession.

Paul and Francine Nelson met the Calders when they landed at Le Havre on April 15. To what Calder described as Paul's "disgust"—bemusement was probably the operative emotion—they sailed through customs with ease, the inspector unperturbed by their twenty-seven pieces of luggage, which included two accordions, a baby's bed, and the *Cirque Calder* packed in five bags.[6] There was little doubt that the Calders were planning to stay for a while. Along with their own car, the Nelsons had brought along the village butcher's truck, into which they piled the luggage. They set out for the Nelsons' place in Varengeville, sixty miles away. It was springtime, and the French countryside was at its most beautiful, the fields a lush green and the flowers in bloom. They spent three days at Varengeville, punctuated by a visit by Miró and his wife, Pilar, neither of whom Sandy and Louisa had seen since they were last in Europe. They walked on the chalk cliffs and got a taste of the coastal town where they were planning to spend the sum-

mer, but the more immediate plan was to go to Paris and reconnect with life there.[7] Over the next months, the friendship with Nelson that had taken off the previous winter in apartments across the hall on East Eighty-sixth Street proved invaluable. Without Nelson, the summer at Varengeville-sur-Mer would have been unimaginable. And Nelson helped them find a wonderful place to stay in Paris.

In 1929, Nelson had designed a house at 80 boulevard Arago in Montparnasse for an American writer, Alden Brooks. Brooks, who was moving back to the United States, had the use of his house until the new owners took possession, in three months' time, and made it available to the Calders. Calder and Brooks knew each other already. Nobody could have been surprised that these two lively, adventuresome men got on well. They remained friends; in 1956, when the artist Saul Steinberg and his wife were headed to California, where Brooks and his wife were then living, Calder supplied Steinberg with Alden's address and phone number.[8] Brooks had been born in Cleveland, gone to Andover and Harvard, and had, like Nelson, fought in World War I, only in his case in the French army. He had written about his war experiences on several occasions, including in a series of short stories about the war, *The Fighting Men*, published in 1917; one of the stories was included in Hemingway's anthology *Men at War*. Like many people, Brooks was of the opinion that Shakespeare had not been sophisticated enough to have written Shakespeare's plays, and when the Calders were with him in Paris, he was deep in his researches about an English courtier named Edward Dyer, who, Brooks would argue in his 1943 book, *Will Shakespeare and the Dyer's Hand*, was the real Bard.

What became the Calders' temporary digs that spring was an impressively elegant home in an advanced style, a "swell" place, as Calder wrote to Sweeney; the house still stands.[9] The street façade was dominated by a grid of reinforced concrete filled with brickwork, the windows in horizontal bands, the overall effect reminiscent of the work of Auguste Perret, in whose atelier Nelson had worked. Although undoubtedly imposing for a single-family dwelling, it was a serene, disciplined, and entirely unshowy piece of architecture. There wasn't much furniture, but the generous spaces were inviting. On the street level, the façade of the house was punctuated by a large door so that a car could be driven straight through the house to the garage in the back, which Calder used as a studio. There was even a turntable in this modernist garage, something Nelson had dreamed up, so that a car would not have to be backed all the way into the street. Though Calder never saw anybody use this mechanism for its intended purpose, one evening when a lot of people were visiting, they "stood on the turntable and rode around in

gay rotation," he later recalled.[10] Calder did indeed acquire a car that spring, a used Ford, but perhaps he didn't attempt to park it in the bowels of his home.

On the boulevard Arago, not that far from the rue de la Colonie, which they had left four years earlier, Sandy and Louisa plunged back into the rounds of entertainment that had always characterized their life in Paris. When Alden Brooks and his wife were leaving for the United States, there was a big party at

Calder's postcard to James Thrall Soby, announcing Cirque Calder *performances in Paris in June 1937, both at the boulevard Arago house and at the home of the painter Filippo de Pisis.*

Jamet's, a restaurant down the street, with the Mirós, the Nelsons, and others.[11] In the hallway of 80 boulevard Arago—it was a big house, so it must have been a big hallway—the Calders improvised a banquet table, beginning with the kitchen table and adding planks and some miscellaneous chairs. One night early in June, Duchamp and Mary Reynolds came to dinner, joined later in the evening by Pierre and Teeny Matisse, and James Thrall Soby and his wife, who were also traveling in Europe.[12] The next afternoon there was a performance of the *Cirque Calder* at the home of the painter Filippo de Pisis, an Italian Calder had known in the old days. Nelson recalled many presentations of the circus in those months.[13] Among Soby's papers is a postcard announcing a performance, the relevant facts boldly written out by Calder himself, with details of a second show added on the side. Sandy and Louisa were again happily up to their ears in the life of Paris.

The souvenirs still preserved in Roxbury from those months in Europe include an elaborate playbill for a performance of two works by Alfred Jarry, *Ubu enchaîné* and *L'objet aimé*. Jarry, who was still in his thirties when he died in 1907, was a master of the eccentric gesture and was revered by the Dadaists and Surrealists; we've already encountered his interest in the hallucinatory experiences of the bicycle rider, as described in his novel *Days and Nights*. It would seem that Calder attended the Jarry evening mounted at the Comédie des Champs-Élysées in September 1937. *Ubu enchaîné* was one of the notoriously obscene plays that Jarry had based on the character of a schoolteacher he despised; he turned that physics professor into a monstrously absurd combination of villain and hero. Jarry's vision of a world run amok was just the right entertainment as a quartet of sadists—Hitler,

Mussolini, Stalin, and Franco—was taking over Europe. Jarry had foreseen a world where everything was turned upside down and inside out. The second work on this double bill, *L'objet aimé,* has been described by the critic Roger Shattuck, in his book *The Banquet Years,* as a "verse libretto" that "laughs at love as no different from other human delusions and pretenses."[14] The Europe they all cherished was looking like one more human delusion. The décor and costumes at the Comédie des Champs-Élysées were by Max Ernst, and the playbill included drawings by Picasso, Miró, and Yves Tanguy, who would soon move to the States and become a friend of the Calders' in Connecticut.[15]

II

The Spanish Pavilion at the 1937 International Exposition in Paris, designed by Luis Lacasa and Josep Lluís Sert.

When the Calders arrived in Paris in April, the city was awash in plans for the opening of the 1937 International Exposition of Art and Technology in Modern Life, which had originally been scheduled for May 1 but was now delayed. The enterprise was vast, with a site extending across the Seine, from the Eiffel Tower on the Left Bank to the Trocadéro on the Right Bank, with events and buildings set all along the Seine to the Grand Palais. The exposition grounds covered some 250 acres. "In Paris disorder reigns," Douglas Cooper wrote at the beginning of May to Pierre Matisse, who was then still in New York. "Everywhere there are skeletons of buildings, strikes, preparations, parades." He added, ironically, "It is only the Belgians, of course, who are ready to open."[16] Calder could not but be fascinated by the preparations. As a teenager, he had watched his father oversee the sculpture projects at the Panama-Pacific International Exposition in San Francisco, and he would never forget the exhilaration he and his sister had felt at having ringside seats as that enormous endeavor unfolded. Now, twenty

years later, many of the hopes for artistic and technological progress that such world's fairs had embodied since the mid-nineteenth century were centered on the preparations for the Paris exposition. Calder's old friend Léger was working on a number of murals, some incorporating photomontage, for the Ministry of Agriculture, and Miró, along with Picasso and a number of other Spanish artists, had been commissioned by the Spanish government to contribute work to the national pavilion, which in late April was wildly behind schedule.

One Sunday not long after Calder had arrived in Paris, he went with Miró to visit the site of the Spanish Pavilion, where they were met by Sert, who was designing the pavilion along with Luis Lacasa; Calder already knew Sert fairly well. There wasn't much to see at that point, only some girders and columns suggesting where the walls would be. A winding ramp was in place; it would eventually lead to the exhibition halls. And there was a flight of stairs. After getting a sense of what the spaces were going to look like, Calder proposed to Sert that he do a mobile for the Spanish Pavilion. In Calder's autobiographical notes, he recalled that he had "begged to be allowed to do something"—strong words indeed.[17] But no amount of persuasion seemed to work. Sert turned him down. The artists who were contributing—Miró, Picasso, the sculptor González, and others—were, quite naturally, all Spaniards. There could be no place for an American. At least that was how things looked until a few weeks later, when Sert spoke to Miró, who told Calder, "Sert wants to see you."[18]

Sert, it turned out, had a problem. One of the natural resources the organizers of the Spanish Pavilion wanted to showcase was the mercury that came from the mines in Almadén, halfway between Madrid and Seville. Mercury was essential to the war effort, used in making heavy artillery. In order to save money for the cash-strapped pavilion, the plan had been to reuse a mercury fountain designed for the Exposición Ibero-Americana in Seville in 1929. But when Sert finally saw photographs, he knew that its conventional design, much like any old fountain in a Spanish square, would be out of keeping with the modernist style of the pavilion, where the fountain was to be one of the first things a visitor saw, just a few feet from Picasso's mural.[19] Calder's recollection was that it looked like a drinking fountain—"making mercurial pipi in all directions."[20] Sert wanted to know if Calder would be willing to design, very quickly, an entirely new fountain, although using the pumping mechanism already being put in place. Naturally, Calder's answer was yes. He had done at least one public project already, the mobile that had hung outside the Museum of Modern Art's "Cubism and Abstract Art" exhibition the year before. Now he was linking hands with his father and his

grandfather, who had dedicated most of their energies to large public works. Although public sculpture would never be more than a part of what Alexander Calder did, it was a new challenge, and Calder embraced it.

III

A number of months before the Calders arrived in Paris, Miró wrote to Pierre Matisse, "We are living through a terrible drama, everything happening in Spain is terrifying in a way you could never imagine." He predicted that it would "leave dark marks in our mind."[21] For artists and intellectuals on the left, the Spanish Civil War was the great cause of those years, the battle of a democratically elected government against the forces of fascism, already on the march across Europe. Miró had an apartment that spring in Paris in the same building where Paul Nelson lived, and it was there that, in May, he finished his *Still Life with Old Shoe*, with its battered shoe, withered apple, half loaf of bread, and bottle of gin. This "melancholy protest . . . against Spain's poverty and suffering," as Soby, who was in Paris that summer, called it, is one of the great allegorical still lifes of the twentieth century, with each object painted as if it were a burning ember: charred, deformed, yet still illuminated.[22] Miró was also

Joan Miró. Still Life with Old Shoe, 1937.

working on a postage stamp in support of the Spanish cause, the design depicting a Catalan peasant with a raised fist. Although the stamp was never issued, the image was used for a poster sold at the Spanish Pavilion.

Under the leadership of General Franco, the fascists were making tremendous strides in Spain, their ever-growing victories dependent on the iron-fisted support of Hitler and Mussolini. For the Spanish republic, hard-pressed by General Franco's advancing forces, a presence at the International Exposition was a critical move. England and France had remained neutral in the war, and the Spanish Pavilion was seen as a last-ditch attempt to garner some desperately needed international attention and support. It was Germany's aerial bombardment of the Basque town of Guernica on

April 26—only days after the Calders had arrived in France—with civilian casualties widely reported in the European press, that plunged Picasso into work on his mural for the Spanish Pavilion, a project that until then Spanish officials had feared he might never actually complete. Artists were seen as among Spain's most important ambassadors to the world. Picasso had been declared the honorary director of the Prado. Calder's friend Christian Zervos had traveled in Spain with a group that included a friend of Julian Trevelyan's, the young poet David Gascoyne, who later recalled the revelation of Romanesque and medieval art "in the houses of exiled, executed Fascists, now requisitioned by the Government and also in churches, cathedrals etc." In Gerona, Gascoyne wrote, "some wonderful old tapestries of the Apocalypse had been discovered, which had not been seen by anyone from outside for centuries."[23] In March, major Catalan art, removed from Barcelona for safekeeping, was the subject of a show at the Jeu de Paume, with Picasso and the great cellist Pablo Casals lending their names to the organizing committee.

For supporters of the republic, who had initially welcomed the Soviet Union as an ally, the situation was becoming increasingly frightening and ambiguous. Although the chaos of a country torn apart by civil war made it difficult to know exactly who was doing what to whom, more than a few supporters of the republic were beginning to realize that the Stalinists had as little interest in a democratic Spain as the fascists. In 1938, George Orwell published his account of his disillusionment with both the Communists and the anarchists in Spain, *Homage to Catalonia*. Although the book received little attention at the time, it has come to be recognized as a model of liberal clearheadedness in a world increasingly torn between the draconian forces of the Left and the Right. Some cracks were beginning to develop in the Left's long-running love affair with the Soviet Union. Nevertheless, André Gide's *Return from the U.S.S.R.*, a lucid, prophetic account of the troubled society he encountered when he visited the Soviet Union, made Gide persona non grata among nearly everybody on the left when the book was published in Paris in 1937.

That the Spanish Pavilion was going up at all in the spring of 1937 must have seemed something of a miracle, given the darkening situation on the Iberian Peninsula. For Sandy and Louisa, the calamity in Spain couldn't be separated from their close friendship with Miró, whom they had visited in his homeland, and who was so profoundly affected by the rapidly deteriorating situation. They had spent time in Spain a few years earlier, in the exhilarating early months of the new republic. And now this victory for democracy that had lifted the hopes of all their Spanish friends was seriously threatened and

by some reckonings near extinction. Many years later, in a letter to Willem Sandberg—he was a friend of Sandy's, the director of the Stedelijk Museum in Amsterdam, one of the great graphic designers of the twentieth century, and a hero of the Dutch Resistance—Calder somewhat downplayed his feelings about the fate of the Spanish republic at the time he was working for the Spanish Pavilion. "Actually," Calder wrote to Sandberg, "I did the Mercury Fountain for the fun of doing it, and it was only subsequently that I became fond of the Spaniards as a nation. Of course I knew Miro + Sert before that, but my affection was personal."[24] One wonders if Calder, writing to Sandberg at the height of the red-baiting of the Cold War, was trying to minimize what some could have described, albeit entirely inaccurately, as pro-Communist sympathies.

The fact was that for the Calders, their personal connections with Spain had only made the larger conflict, which was a conflict between democracy and totalitarianism, all the more real. Looking back on that tumultuous period, the English sculptor Henry Moore, whom Calder became friends with later that year, recalled that there had been a plan for a group of artists and writers, including W. H. Auden, Stephen Spender, Moore, Calder, and some others, to go to Spain during the Civil War, "but we weren't allowed to, at the last moment."[25] On a bookshelf in the living room in Roxbury there is an immense chronicle of that war, published by the Ediciones de la Alianza de Intelectuales Antifascistas in Madrid in 1937. Inside is a piece of paper on which Sandy and his young daughter both drew pictures. This is certainly a book the Calders brought home from Europe—a souvenir of a calamitous time.

IV

With the Republican government back in Spain overwhelmed by the war effort, planning for the pavilion pretty much devolved on people in Paris, spearheaded by Luis Araquistáin, the new ambassador, who had brought together a cosmopolitan group of Spaniards to work on the pavilion, many with deep ties to the avant-garde.[26] Of the two architects involved, Sert had worked with Le Corbusier, and Luis Lacasa, although more conservatively disposed, had studied modernist architecture in Germany in the 1920s.[27] Along with Miró, Picasso, and González, who had worked with Picasso on his first welded-iron sculpture, the pavilion attracted the energies of Josep Renau, an innovator in photomontage; the Surrealist filmmaker Luis Buñuel; and the sculptor Alberto Sánchez, who created a tall, slender, allegorical con-

crete structure for the entrance to the pavilion. Sánchez became a visitor to the house on the boulevard Arago over the summer. He had a fine singing voice, vividly remembered years later by the Calders. In the wake of the defeat of the Spanish republic, Sánchez sought asylum in the Soviet Union and then more or less vanished, never again allowed to work as an artist.

The 1937 International Exposition in Paris; the German Pavilion is at the left.

Many observers—among them the architect Robert Mallet-Stevens—felt that the exposition, including most of the projects for which the French government was responsible, was nowhere near as artistically innovative as it ought to have been. There seemed to be too little development beyond the Art Deco taste, with its streamlined neoclassical forms, that had dominated the International Exposition of Modern Decorative and Industrial Arts, back in 1925. Much as Germany and Russia now dominated the course of the Spanish Civil War, so their paired pavilions dominated the Paris exposition. These two buildings were in a bombastic neoclassical style, two immense and imposing structures, tall and rocklike in appearance, the German one designed by Albert Speer, the Soviet one by Konstantin Melnikov. Not surprisingly, a modernized classicism, with its adamantine authority, was the style now embraced by totalitarian regimes, whether of the Left or the Right. Poised on the bank of the Seine, the two buildings were locked in what looked like a terrifying face-off, at least as visitors saw it, with the Nazi eagle atop the German Pavilion glowering at the sculptural group of a vigorous young man and woman brandishing a hammer and a sickle, an allegory of industry and agriculture that Vera Mukhina had designed for the top of the Soviet Pavilion.

Calder. Alvar Aalto, 1937.
Strainer and wire, 12¼ x
11¾ x 2⅜ in.

Léon Blum's Popular Front government—which collapsed in June, right after the opening of the exposition—had belatedly supported one of the more innovative contributions to the exposition, Le Corbusier's Pavilion of Modern Times. Robert Delaunay, who had been one of Calder's cohort in Abstraction-Création, was supervising murals for the Railway Pavilion. Junzo Sakakura's Japanese Pavilion, its Asian influences reimagined in the light of Le Corbusier (with whom Sakakura had worked), was a favorite among those looking for progressive design. But perhaps the most original among the foreign contributions was Alvar Aalto's Finnish Pavilion, a striking modernist creation that even while acknowledging the lessons of the Bauhaus and Le Corbusier pointed the way beyond the purism of white walls and right angles and shimmering metal to a fresh, naturalistic modernism. The free-spiritedness of Aalto's Finnish Pavilion must have appealed to Calder.

Aalto and his wife, Aino, and Sandy and Louisa became friends, an affectionate attachment inaugurated that summer by a whimsical portrait Calder made of the architect. Here Aalto's wire-mesh face suggests a modernist window, both utilitarian and poetic, that links the inner and the outer man. Aalto was certainly an artist after Calder's own heart—liberal-spirited, open-minded, pressing forward with his architectural vision. He was also very much a ladies' man. One woman told his biographer, Göran Schildt, "He was a lady's man right down to the fingertips all right. He always tried with everybody. But his flirting was always so humorous and innocent that nobody could possibly be angry with him."[28] And Schildt, himself a lifelong friend, reported that Aalto "rarely engaged in serious argument; he preferred to make irreverent fun of things. That is why the professed Communist Hans Schmidt could think he had found a fellow traveler in Aalto, while the liberal Socialists Markelius, Gropius and Giedion also always found him to be on their own wavelength."[29] The ability to pursue an altogether original artistic vision while getting on with just about everybody—industrialists, Communist Party leaders, even church "potentates," so Schildt explained—was something Sandy certainly admired.

Arriving in Paris with Aalto was Maire Gullichsen, the wife of a Finnish industrialist, who had recently embarked with Aalto and his wife on Artek,

the company that would produce and distribute internationally the Aaltos' furniture and glassware. For the Gullichsens, Aalto produced a factory, workers' housing, and one of his greatest houses, the Villa Mairea. Maire, in turn, became friends with Sandy and Louisa. She hosted them when they visited Finland after the war, and she collected some of Calder's work along with a great deal of his jewelry. Years later, she recalled that spring in Paris, when the furnishings and glassware by Artek were exhibited in the Finnish Pavilion. "I was just a country lass," she joked, "and all Alvar said was 'Now we'll go and see the Zervoses,' and Madame Zervos was an utterly wonderful person. They had started publishing *Cahiers d'Art,* and Alvar and I met

The Finnish Pavilion at the 1937 International Exposition in Paris, designed by Alvar Aalto.

Picasso at their place. Then we started going around with the whole gang, such fun it was." She recalled their "sitting at various bars and Alvar told me about his mother, how lovely she was. She had had such and such embroidered knickers, and it was from them—Mama's underwear—that Alvar had got the inspiration for his vases and lamps. Of course we worked hard at the pavilion, but somehow we always ended up at some bar or dance floor and had a marvelous time. Moholy[-Nagy] was also in Paris. He was a rather charming fellow and I liked to promenade with him. In the Spanish pavilion he said: 'Here's Calder's fountain and this is Picasso's *Guernica*.' Yes, it was wonderful, that quicksilver fountain."[30]

V

The Spanish Pavilion—with its light, open construction and outer walls framed in a steel structure of large, bold rectangles—was one of the more invitingly improvisational buildings to emerge on the exposition grounds. It was true that the murals by Picasso and Miró were easily dwarfed, at least in terms of size, by many other works on display at the exposition. And as sheer spectacle, Calder's *Mercury Fountain* certainly couldn't compete with the acres of fountains, illuminated with colored lights at night, that were one of the chief attractions of the summer, reproduced in countless magazines, newspapers, and souvenir books. But the works created by Picasso, Miró, and Calder for the Spanish Pavilion are without a doubt among the crowning artistic achievements of the 1937 International Exposition.

The style of the Spanish Pavilion—although to some extent born of necessity, because the Spaniards had had to build in the cheapest, fastest way imaginable—made an invigorating contrast with the aggressively elaborate structures ubiquitous at the exposition. The building was essentially a rectangular box, three stories high, with the main floor—which housed Calder's *Mercury Fountain* and Picasso's *Guernica*, the first things visitors would see—giving onto a tentlike space with a retractable roof, where performances of one kind or another took place. There was a counter where Spanish books and publications were sold, as well as a bar serving Spanish drinks and food. From the ground floor, visitors took a ramp up to the third, where there were exhibitions of native crafts and paintings and drawings by Spanish artists. From there, they descended a staircase dominated by Miró's mural *The Reaper* to the second floor, where Josep Renau's photomurals illustrated the accomplishments and struggles of the Spanish people. The elegantly restrained geometry of the structure was a perfect foil for everything on dis-

play, whether murals packed with information about the Spanish republic, or Iberian ceramics, or Picasso's massive busts of Marie-Thérèse Walter, which he had allowed the organizers to bring from his country house at Boisgeloup.

Calder's sensibility was very much in sync with the evolving spirit of the pavilion. He had been inventing his own brand of light, open structures all through the 1930s. Only an artist who was as confident a problem solver as Calder—who thrived on projects that challenged his engineering know-how—could have moved so quickly, happily, and successfully through the design and execution of the *Mercury Fountain,* which was created in a matter of weeks, mostly, it seems, in June, leading up to the pavilion's opening on July 12. As mercury was highly cor-

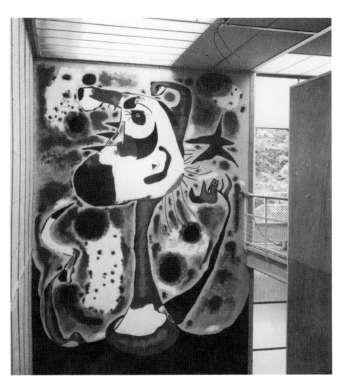

Joan Miró. The Reaper *in the Spanish Pavilion at the 1937 International Exposition in Paris.*

rosive, there were few materials with which Calder could work—basically only glass and polished steel, he was initially told. The height from which the mercury could drop also had to be restricted to three or so inches, to avoid having their limited supply of the element lost as it splashed onto the floor—or onto visitors. Taking all this into consideration, Calder made a model in sheet aluminum, using a handful of ball bearings to simulate the movements of the mercury. Sert obtained approval for Calder to go ahead with the fountain. The model turned out to be such a delight that Calder began to use it for mini performances, as if it were a new twist on the circus. One evening that spring, Sert came upon a crowd of people outside the Café Select on the boulevard du Montparnasse; they were all watching Calder, kneeling on the sidewalk before one of his earliest Parisian haunts, delightedly demonstrating how the ball bearings spilled over the surfaces of his miniature fountain.[31]

Like the mobiles that had been preoccupying Calder for the past few years, the *Mercury Fountain* was an experiment in the artistic reshaping of natural movement, only now the kinetic element involved the gravitational pull of this peculiarly heavy liquid. Calder found himself conceiving a fountain in which the emphasis was on the downward progress of the liquid, and

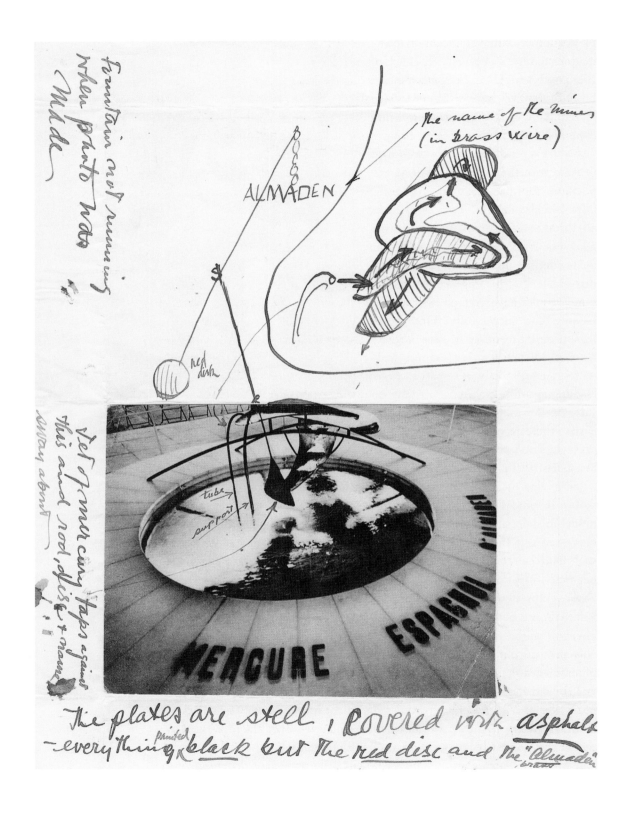

Fountain not running
when photo was
made

the name of the mines
(in brass wire)

ALMADEN

red
dish

Let Amercury taps against
this and not disc + mann
away about

tube

support

MERCURE

ESPAGNOL D'ALMADEN

The plates are stell, Covered with asphalt
— every thing printed black but the red disc and the "Almaden"
 brass

the wonderful patternings and poolings it made as it slid toward the basin from which the fountain rose. Working in the garage of the house on the boulevard Arago, Calder conceived a structure made of horizontal plates, cantilevered over the basin with slender metal supports. When he discovered that black pitch was being used to line the fountain's basin because it was impervious to mercury's corrosive power, he resolved to cover his metal plates in black pitch. This provided the perfect backdrop for the meandering progress of the mercury, which was the true subject of Calder's fountain. Basically, the fountain was composed of three unpredictably shaped metal dishes—"dynamic" shapes, as Calder described them in a little article the next year for *Stevens Indicator*, the magazine published by his alma mater. The mercury pooled, wiggled, dropped, and splattered from plate to plate.[32]

The initial plan for the fountain contained no movable metal parts; this was to be a stabile, with the mercury providing the mobile element. But at some point Calder, feeling that a stronger vertical vector was needed in this essentially low-lying, horizontal structure, concocted a sort of eight-foot-high antenna, made of two metal rods, accompanied by a red circle and the word ALMADEN, calligraphed in Calder's brass wire. The paddle-shaped bottom end of this antenna was arranged so as to be struck by the mercury as it descended into the basin. And this pressure of liquid metal against solid metal sent the antenna into an agitated figure-eight movement, so that the name of the mine that supplied the mercury bobbed up and down, six or seven feet in the air, a constant reminder of the natural resources of the Spanish earth.

VI

For visitors to the Spanish Pavilion, after its much-delayed opening in the middle of July, the defining experience was probably their first glimpse, on entering the main floor, of Picasso's *Guernica*, that terrifying, shattered universe in black, white, and gray, with the *Mercury Fountain* nearby. Certainly *Guernica* was like no mural anybody had ever seen. But then the *Mercury Fountain* was like nothing anybody had seen, either. Arrestingly and idiosyncratically shaped, it was—as the critic André Beucler explained in the luxurious magazine *Arts et métiers graphiques*—"graceful and precise like a great insect." The fountain did not bear Calder's name, and Beucler didn't tell his readers—and perhaps didn't himself know—that it had been conceived and created by an American artist. Having credited this remarkable invention to the architects Sert and Lacasa, Beucler went on to write enthusi-

OPPOSITE *Drawing of* Mercury Fountain *in Calder's letter to James Johnson Sweeney, 1937.*

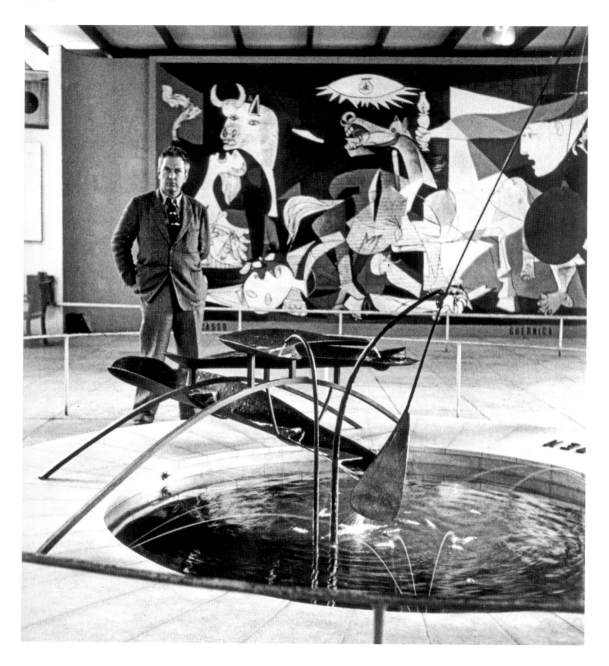

Calder in the Spanish Pavilion with the Mercury Fountain *in front of him and Picasso's* Guernica *behind him, 1937.*

astically about how the fountain "allowed the mercury to flow slowly, to collect itself into a mass, to scatter, to roll from time to time in melting pearls, to play perpetually by itself, to the delight of the public which was present for the first time at the delicate spectacle of mercury moving in a fountain."[33] The public that began arriving in July was smitten by the fountain. People

took to tossing coins into the basin, fascinated at how they floated on the heavy liquid. Collected each day, the money was used for the aid of Spanish children caught in the maelstrom of the Civil War.

"In the old days you were Wire King," Léger told Calder at the opening, "now you are Father Mercury."[34] Léger saw something grandly allegorical in this fearlessly modern fountain by an artist whom an American journalist nicknamed "Calderon de la Fuente."[35] *Fuente* means *fountain*, *spring*, or *source* in Spanish; the name may also be a reference to the seventeenth-century Spanish playwright Pedro Calderón de la Barca. Calder recognized the power a fountain has to focus the beauties of the natural world, even as nature is reshaped to suit man's purposes. He would have remembered his father's work, at the Panama-Pacific International Exposition, on the *Fountain of Energy*, a vast allegorical invention with a basin populated by figures representing the great oceans of the world. Like the fountains the popes commissioned from Bernini and other artists, Calder's *Mercury Fountain* was at once an object of delight and a celebration of political clout, in this case of the Spanish republic's continuing control of a precious natural resource, the mercury from Almadén. The happiness so many visitors to the exposition found in watching the mercury take its meandering course across Calder's fantastical structure wasn't so different from the pleasure Bernini's fountains had been inspiring in Romans for centuries; there is a famous story about Pope Innocent X's enthusiastic response when Bernini first turned on the water on the *Fountain of the Four Rivers* in the Piazza Navona. The *Mercury Fountain* was also by no means the first fountain to spout something other than water; in the town of Marino, near Rome, the fountains produce wine on the day of the patron saint's festival.

Nobody who had watched the development of Calder's art through the 1930s would have predicted that in 1937 he would be producing a fountain with political ramifications. But then nobody would have predicted that Miró and Picasso would have been responding so directly to political developments, either. Indeed, at the outset of the Spanish Civil War, questions had been raised as to where Picasso's sympathies might lie. Picasso, Miró, and Calder were products of the great flowering of art for art's sake in the years just before and after the turn of the century. They aimed to give private feelings a formal presence, a form so compelling that it couldn't be ignored. The Depression, the threat of fascism, and the promise of socialism had led some to believe that art for art's sake was an idea whose time had passed. Although Calder, like Picasso and Miró, aimed to steer clear of these debates, he was well aware of them and even engaging with them in the months leading up to his involvement with the Spanish Pavilion. It was, of course, precisely

these arguments about the relationship between art and politics that had led Thomas Wolfe, who died in 1938, to inveigh against aestheticism and Alexander Calder himself in *You Can't Go Home Again.*

VII

Even before going to Europe, Calder had signed the call for membership in the First American Artists' Congress, to be held in New York in February 1936. Although the preponderance of the artists and writers involved were associated with the Communist Party in one way or another, there were also some who were not, among them Calder, the designer Norman Bel Geddes, Calder's friend James Johnson Sweeney, and the critic Lewis Mumford, who had written with such subtlety about Calder's work and actually presented the opening address at the congress.[36] Others were ready to reject art for art's sake entirely. Louis Lozowick offered a rose-tinted report on the situation in the USSR, where, so he explained, "speculative manipulation of market values in art has been eliminated together with the institution so popular among the well-fed—the starving artist."[37] That the Russian artist, starving or otherwise, might no longer be able to paint what he wanted—and certainly not an abstract painting—was something that Lozowick didn't care to mention. But the thrust of the congress was not so much pro-Soviet as anti-fascist. Peter Blume, by now a good friend of Calder's, gave a talk entitled "The Artist Must Choose." Blume suggested that modernist art reflected the values of a now defunct "leisure-class culture" and said that "the typically Fascist idea of a large subject class dominated by a highly civilized minority was enormously popular with the esthetes of the late 'Twenties."[38] That Blume himself was a sort of aesthete—as, indeed, was his friend Sandy Calder, who had emerged in the late 1920s—was an uncomfortable truth that at least for the moment Blume may have found it possible to set aside.

Early in 1937, while Calder was still in New York, the pages of *Art Front,* a casually printed, vibrant little magazine published by the socialist Artists Union, had been full of heated discussions about the relationship between art and social change. Calder's friend Sweeney had done the translation of Louis Aragon's "Painting and Reality," an essay in which abstract art was totally rejected and the French poet declared that painting "will either be a socialistic realism or painting will cease to exist, that is, will cease to exist on a level of dignity." The next month, *Art Front* had carried a resounding rejection of Aragon's position by Calder's friend Léger. Léger's view was that the public shouldn't be denied the essential discoveries of modern art

and what he and many others called "the new realism." "It would require," he wrote, "no great effort for the masses to be brought to feel and to understand the new realism, which has its origins in modern life itself, the continuing phenomena of life, under the influence of manufactured and geometrical objects, transposed to a realm where the imagination and the real meet and interlace, a realm from which all literary and descriptive sentimentality has been banished." After all, Léger pointed out, "hanging on the wall in the popular bals-musettes, you will find *aeroplane propellers*. They strike everyone as being objects of beauty, and they are very close to certain modern sculptures."[39] Calder certainly endorsed Léger's belief that the public, if given half a chance, could respond to modern art, even to abstract art. By the end of his life, Calder had proved it, with the enormous sculptural objects that he designed for cities around the world.

Because of the unique set of conditions under which the Spanish Pavilion was created, with no strict ideological guidance from the central government and no mere bureaucrat dictating what could and couldn't be displayed, the artists involved were free to create as they wished. For Calder, Miró, and Picasso, at this terrible moment in the history of Spain, current events were stirring their imaginations to a degree that only their most private feelings had in the past. Later that year, the English writer Myfanwy Evans discussed *Guernica* in her anthology *The Painter's Object;* the book also contained a text by Calder. (Myfanwy Evans became Myfanwy Piper after marrying the painter John Piper in 1937. She would later write some important librettos for Benjamin Britten under that name, but her critical contributions to the visual arts were made under her maiden name.) *Guernica*, Evans wrote, was anything but "a 'Red Government' poster screaming horrors to a panic-stricken intelligentsia. It is a passionate recognition of the facts, so purged as to become almost detached statement, and ultimately so unrealistic as to be almost as abstract as [Picasso's] most abstract painting. Yet only a Spaniard could have done it because only a Spaniard could have exploited in just that way the present events in Spain."[40] Calder's *Mercury Fountain* was utterly abstract, a work in a very different mode from either *Guernica* or Miró's *The Reaper*. But the letters boldly displayed in brass wire at the very top of the fountain—ALMADEN—gave Calder's creation a powerfully polemical presence. It was apparently Calder himself who had chosen to inscribe the fountain in this way. In 1937, Calder shared with Picasso and Miró the sense of the artistic act as a political act that was simultaneously a personal avowal.

Even before the Spanish Pavilion had opened, however, there were those who were dismayed at the extent to which the artists working on it diverged from any clear political program. *Guernica*, today almost universally ad-

mired as the twentieth century's definitive vision of the horrors of war, raised hackles among some of the Communists involved in the pavilion, who objected to Picasso's highly individualistic style and believed that visitors would have been better served by an unabashedly naturalistic treatment of current events, the sort of thing Louis Aragon had advocated in his essay "Painting and Reality." Ilya Ehrenburg, the Soviet author who acted as a goodwill ambassador to intellectuals in the West, was of the opinion that if the pavilion was reopened in 1938—this was discussed for a time—*Guernica* ought to be replaced. But it was not only leftists who had problems with the way artists were responding to the Spanish Civil War. Although Sweeney was not in Paris that summer, four years later, when he organized a retrospective of Miró's work at the Museum of Modern Art, he expressed reservations about the realism of Miró's *Still Life with Old Shoe*, worrying that the artist had not been acting freely, because he had been "hedged in on all sides by discussions of Marxian philosophy and class injustice." For Sweeney, *The Reaper* was preferable, but only because it reflected "a return to the more fantastic spirit that had characterized his earlier work as a whole."[41] Two years later, when Sweeney came to write about the *Mercury Fountain* in the catalog for Calder's retrospective at the Modern, his high praise reflected his feeling that this was an achievement in which "all the important threads of his work up to this point were drawn together": the "spirit of play," the "movement and the changing relations of form in space," the "new effects through new materials," the "outdoor scale." Sweeney seemed unwilling or unable to discuss the *Mercury Fountain* as a response to the Spanish Civil War.[42]

Perhaps Sweeney, for all his appreciation of the *Mercury Fountain* as pure invention, missed the extent to which both Calder's and Miró's creations were shaped by events, by a sense of the horror of what was going on in Spain, however "abstracted" those responses might be. In 1959, when Soby organized the Museum of Modern Art's next Miró retrospective, he took issue with Sweeney's formalist response to *The Reaper*. These two curators were friends and were arguing about the work of an artist friend. Soby, who had been in Paris in the summer of 1937, pointed out that he had seen Miró's mural "on many occasions." And he believed that the "ferocious and tormented central figure of a reaper with sickle was intended to have a symbolic as opposed to a decorative meaning." Some, Soby continued, thought this bust of a peasant with a sickle in his right hand derived from a passage in the Apocalypse, "in which a reaper with sickle gathered grapevines and cast them into 'the great winepress of the wrath of God.'" Others, he continued, saw *The Reaper* as referring to a Catalan song of liberation, "Els Segadors."[43]

Whatever the iconographic significance of the image, an exclusively formalist reading wouldn't do. Perhaps an entirely formalist reading of the *Mercury Fountain* wouldn't suffice, either. Calder had marshaled his abstract play of forms in the service of the Spanish republic at a time when its very existence hung in the balance. What had been the workings of the private imagination had become—naturally, inevitably—the workings of a public imagination. For the first time in his life, Calder found himself speaking to the wide world.

VIII

Although one wouldn't want to entirely discount Calder's comments to Willem Sandberg in the 1950s, when he downplayed his interest in Spanish politics in 1937, the human cost of the Spanish Civil War was something he and Louisa found themselves thinking about for the rest of their lives. When Sweeney was organizing Calder's retrospective at the Museum of Modern Art in 1943, he quite naturally included a model of the *Mercury Fountain*, which was at that time still Calder's most important public commission. Writing to Sweeney that August, Calder was anxious that both in the exhibition and in the catalog the caption for the *Mercury Fountain* mention "the Spanish Republic, and Sert + Lacasa, the Architects of the Pavilion—and hope you will agree that it is fitting—something like this."[44] The *Mercury Fountain* was a work of art created for a particular place and a particular purpose. It was part of a much larger endeavor—a great human struggle, the struggle of the Spanish people to preserve their republic.

The republic went down to defeat. Sandy and Louisa did everything in their power to help the victims of the war and its unimaginably cruel aftermath, as Franco jailed, murdered, and forced into exile those who had opposed him. When Luis Buñuel arrived in the United States with his family, Calder "immediately took us into his home," as his son Juan later recalled, and Buñuel asked Sandy to write in support of his and his wife's applications for immigration visas.[45] Sert, who eventually became dean of the Harvard Graduate School of Design, remained a lifelong friend. The Calders' involvement with the Spanish cause went well beyond personal connections. When Nancy Macdonald, the wife of the literary and social critic Dwight Macdonald, founded Spanish Refugee Aid in 1953, along with Pablo Casals, Mary McCarthy, Arthur Schlesinger Jr., and Norman Thomas, the Calders were immediately supportive. Over the years, their support only grew. In 1965, Calder wrote to Nancy, suggesting that "I could do 5 or 6 lithos for you, 100 prints of each, signed (by me). And I think you could sell them

for $60 or $75." That summer, Nancy visited the Calders in France, where Louisa, as Nancy recalled, "was there to carry on the practical world of her dreamy husband, and we had a rather heated argument with her about Communism."[46] The nature of that argument remains unclear, though perhaps Louisa responded to the firmly anti-Communist Macdonald with some show of sympathy for what must have been their many Communist friends among the French intelligentsia. But the argument might have been different, for the Calders were certainly anti-Communist.

Beginning in the mid-1960s, until close to his death a decade later, Calder produced something like 2,705 original signed lithographs to be sold for the benefit of Spanish Refugee Aid. By Nancy Macdonald's reckoning, this netted the organization something like a half a million dollars—quite a sum at the time. It was no wonder Calder was eventually named honorary chair of the organization, along with Casals's widow, Marta Casals Istomin. In a memoir she published some years later, Nancy Macdonald permitted herself what some might have regarded as an unnecessary airing of an old grudge, observing that "in contrast to our dealings with Pablo Casals, the 'shrewd peasant,' those with Sandy were always open and direct." Nancy Macdonald was a formidable woman who embraced a great cause, and Sandy must have liked and admired her as she liked and admired him. When Calder died in 1976, Louisa sent the organization $2,000 at Christmas. Calder's involvement with the hopes, fears, and tragedies of the Spanish republic, which had begun with his and Louisa's visit to Miró in Spain in 1932, outlasted his own life.

A LONDON SEASON

I

Once the Spanish Pavilion was open, the Calders gravitated to Varengeville-sur-Mer, the little resort town a few miles from Dieppe; they arrived by late July and remained until early October in what Calder remembered as "a sort of chalet, tall and shallow, facing the sun."[1] Everybody the Calders knew in Varengeville was talking about the Paris exposition, the Spanish Pavilion, *Guernica,* and the *Mercury Fountain,* and some of the visitors, among them Miró and Léger, had been actively involved in the exposition. The coastline around Dieppe was a terrific place to reminisce, relax, and refuel—and to contemplate the upcoming season in London, where Calder now had a

Joan Miró and Calder in Varengeville-sur-Mer, 1937. Photograph by Paul Nelson.

Barbara Hepworth. Cup and Ball, *1935. Hepworth sent this photograph of the sculpture to Calder in 1937.*

December 1 opening scheduled for the Mayor Gallery show, the second major event in what was turning out to be a triumphant year in Europe. There would also be trips back to Paris from Varengeville, including probably for a performance of Jarry's *Ubu enchaîné* in September.

Englishmen had been coming to Dieppe since the early nineteenth century, and the city had something of a reputation for encouraging cross-pollination between French and English artists and writers. Calder, with his Scottish ancestry and strong Francophile instincts, couldn't have been immune to the city's interesting past. Varengeville, set high on chalk cliffs, with dramatic walks down to the beach where they swam, had its own distinguished history of artistic and literary activity. Monet had painted there, in a studio that Paul Nelson now used. Proust had admired the little Church of Saint-Valéry and its *cimetière marin*, writing to his friend Marie Nordlinger of "the relative silence that gives more depth to the regular and repeated coming of the waves, so far below."[2] In 1927, it was just outside of Varengeville, at the sixteenth-century Manoir d'Ango, converted to an inn, that André Breton wrote *Nadja*, his novel about a love affair with a mysterious Parisian, half elegant siren, half waif. *Nadja* has come to be recognized as one of the key literary monuments of Surrealism.[3]

Varengeville is "quite densely populated by Montparnos," Calder wrote to Sweeney in September. For Sandy and Louisa, separated from their old friends in Montparnasse by an ocean for the past four years, this was a time for wonderful, leisurely reunions. With the rapidly darkening situation in Spain and across Europe, there must have been a sense of a summer respite, a late gathering of friends from less troubled times. Georges Braque and his wife, Marcelle, had been spending half the year in Varengeville since the end of the 1920s, initially introduced to the spot by Nelson, who had made sure that at one time or another virtually every member of the Parisian avant-garde spent at least a bit of time in the seaside town. Marcelle became part of the easy back-and-forth between the mostly younger residents and visitors that summer. One day, while Calder was sitting outside his house writing a letter to Sweeney, she appeared at the garden gate. When Sandy got up to let her in, the ink pot tipped over, leaving a great black blot on one page. "Excuse

all the ink," he wrote when he sat back down again, "but I got up to let Mme Braque in the front gate and the wind did the rest."[4] When Mary, the Calders' second daughter, was born in 1939, the congratulatory postcard from the Nelsons was also signed by Marcelle. As for Braque, he had always played the accordion— there are photographs of him from the early Cubist days with Picasso with an accordion in his hands—and at times during the summer he joined Louisa in a duet.

"It's been rather like living on an island," Calder wrote of the group of friends who were gathered together.[5] Miró's dealer, Pierre Loeb, a great expert on primitive art and a supporter of the Surrealists who had included Calder in an important group show just before the Calders left for the United States, rented a house. So did Pierre and Teeny Matisse. Georges Duthuit, a critic, and his wife, Pierre's sister, Marguerite, had a place nearby. The Mirós spent a month visiting with one or

Ben Nicholson, c. 1934.

another person, and would end up spending much of 1938 in Varengeville. Léger visited with his wife, Jeanne. And the Calders invited some of the English artists Sandy had probably first heard about through Hélion and with whom Sandy had been corresponding in recent years. Ben Nicholson and Barbara Hepworth, painter and sculptor, came to visit. They were a striking couple, Nicholson with a jaunty style and a lean, muscular build, and Hepworth, an English beauty with a full, sensuous face set off by dark hair and eyes. Nicholson had known Dieppe since he was a boy, visiting with his father, the painter William Nicholson, and he and Hepworth had already been to Varengeville in 1933 to see Braque; they were good friends. Nicholson counted a visit to Braque's studio in Paris as a formative event. He was emboldened by some reliefs the Cubist had done in plaster, and returned to London, where he began his own reliefs, stark white-on-white constructions with astringent arrangements of circles and rectangles. Another visitor to Varengeville was the critic Herbert Read, a tall, gentle spirit who had already included Calder in his important book *Art Now*. The painter John Piper and his wife, the writer Myfanwy Evans, also came; Myfanwy was soft and gentle, with sly eyes and still something of a childlike quality, John

perhaps more severe, at least so he seemed, with his prominent forehead and strongly shaped nose.

There were excursions in the Calders' Ford sedan, "which rather screeches along at 50 km per hour," Sandy reported. Everybody went to Dieppe, "a wonderful little port to hang around if you like the sea and the smells that go with it." Calder loved the easy conviviality. The swimming was terrific, and there was some tennis, too. "It has been," he told Sweeney, "like a dude ranch—for someone of the community will find a rugged bit of wearing apparel—for sailors usually—in Dieppe . . . and the next day everyone rushes to equip himself—with big shirts, or purple sox, or a red kerchief at the neck."[6] All this must have delighted Sandy, who had been known for his outlandish outfits since he'd first appeared on the sidewalks of Montparnasse in his orange striped tweed suit. Wasn't he the one who had worn a yellow fisherman's shirt from Barcelona to the black-tie opening of *Four Saints in Three Acts*? There were jazz records and dance parties. It was a little town full of big personalities, Calder among them. Later that fall, in response to some remark Pierre Matisse had made in a letter about "the enfant terrible," Douglas Cooper shot back, "L'enfant terrible: est-ce Georges [Duthuit], est-ce Sandy?"[7] From a later letter, it appears that Matisse had been referring to Duthuit, whose marriage to Pierre's sister, Marguerite, wasn't going well. But Sandy, an extraordinarily self-confident and from time to time startlingly brash personality, could be a handful. Pierre Matisse knew that as well as anybody.

Georges Braque, 1931.

II

Braque, one of the founding fathers of the modern movement, was fifty-five years old that summer, and when he was not playing his accordion he may have been a somewhat weighty presence amid the vacation pleasures of Varengeville. After buying land in the town in 1930, he had commissioned Nelson to design a house and studio, but what was eventually built, an elegant version of a Norman peasant's home, was more to Braque's specifications than in line with Nelson's original ideas. Nelson had met Braque at the École des Beaux-Arts, where Braque had looked through the young American's sketchbooks and urged him, "Take your faults and turn them into advantages

that is into forms of expression." This advice struck Nelson like a thunder-bolt. He remembered how when Braque left, "I jumped, I shouted, I almost cried, I knew from that moment that I could be Nelson and Nelson could be myself, a creator, a distinct creator."[8]

For Braque, there was surely something attractive about this young Amer-ican, with his gift for bringing people together. Braque, like his old friend Picasso, took a particular interest in Americans, who came from a world that was unfinished, full of possibilities. Could it be that Braque liked the fact that Nelson had served in the American air force in World War I? Both Braque and Picasso had been fascinated by early aviation, and Picasso, iden-tifying Braque with Wilbur Wright, had nicknamed him Wilbourg.[9] Calder, the American artist who had originally studied to be an engineer, may have also been of more than passing interest to Braque. Braque had experimented with ideas of flight in some constructions in 1911, and although they've been lost, it's said that they resembled model airplanes. Calder's mobiles could have given him a certain sense of déjà vu. That summer, Calder presented Braque with a curious wire object, some two feet wide, a wire circle criss-crossed with spiderweb-like patterns and meant to hang from the ceiling. It's an enigmatic work, with skeletal forms and figural, geological, and cosmo-

logical allusions. This topological fantasy brings to mind the bold patterning and intricate overlapping in Braque's still lifes of the late 1930s. That Calder took a much more than passing interest in Braque is suggested by his recollecting a generation later, when he came to compose the *Autobiography*, an encounter they had that summer.

One morning Braque stopped by the garage overlooking a vegetable garden that Calder was using as a studio. Braque was disgruntled. An American had appeared before breakfast, a representative from the Carnegie Museum of Art in Pittsburgh. The man had been determined—at that ungodly hour—to bestow upon Braque the Carnegie Prize, for his painting *The Yellow Cloth*, since the artist hadn't traveled to Pittsburgh to receive it. A conversation ensued in Calder's studio, and Braque remarked that "when there are people around and you are working, and you prefer to stop working for a moment and think of something by yourself, then the people who surround you wonder what in the world you are doing and why the hell you don't get busy."[10] In part, Braque may have been regaling one American with a story of the gaucherie of another American. But what seems to have stayed with Calder was the sense of Braque as an outsider, as a man who went his own way, wryly observing the follies of officialdom and the incomprehension of the public. Calder might not have shared Braque's contemplative disposition, but he did have his own inner compass. Amid all the discussions about the rival claims of Surrealism and abstraction, he steered his own course. He never felt himself to be a warrior in a battle being waged for one particular kind of art. "When an artist explains what he is doing," Calder wrote at the time, "he usually has to do one of two things: either scrap what he has explained, or make his subsequent work fit in with the explanation. Theories may be all very well for the artist himself, but they shouldn't be broadcast to other people."[11] Braque might have agreed.

The controversies about the rival claims of Surrealism and abstraction simmered even in Varengeville, for some of Calder's English friends were already at cross-purposes as to what direction the avant-garde ought to take. The Pipers and Nicholson and Hepworth had to be invited to Varengeville "separately, of course," as Calder later recalled; it was a delicate business, because though they had been involved together in the ongoing struggles to establish abstract art in England, the couples were no longer on good terms.[12] Nicholson and Hepworth were pushing for a pure abstract art, what Myfanwy later called their "adamant abstract position," while the Pipers supported a more pluralistic view of the possibilities of nonrepresentational art and took an interest in Surrealism and even welcomed a return to representation.[13] Around this time, Ben Nicholson was collaborating with Naum Gabo, who

was living in England, on an anthology called *Circle: International Survey of Constructive Art*, in which Calder was included, although Gabo complained to Nicholson about Calder's "vacillating character which has always been questionable because of his frequent appearance among the Surrealists."[14] At more or less the same time, in *The Painter's Object*—another English anthology, this one edited by Myfanwy Evans and also including Calder—Henry Moore observed that "the violent quarrel between the abstractionists and the surrealists seems to me quite unnecessary. All good art has contained both abstract and surrealist elements, just as it has contained both classical and romantic elements."[15] Calder surely would have agreed.

It could be these controversies Cooper was referring to when he wrote to Pierre Matisse later that year that "the Varengeville period must have been complicated. I'm so good—I don't get mixed up in such idiocy."[16] It may have also been that Cooper was referring to more strictly personal matters, perhaps the tensions in the relationship between Marguerite Matisse and her husband, Georges Duthuit.

III

Although Calder had not met Nicholson or Hepworth—or, for that matter, John Piper and Myfanwy Evans—before leaving France in 1933, Hélion had put him in touch with them, and his work had begun to be known in England. So there was a backstory to Calder's involvement with English artists that began in the summer in Varengeville and grew during the autumn and winter in London. Along with the young critic Herbert Read, these young artists had been hoping to bring to England some of the excitement about abstract art that had animated the Abstraction-Création group in Paris. Calder was, quite naturally, interested in what was going on in England. After Herbert Read included Calder in *Art Now*, Calder told Nicholson in a letter of July 28, 1934, how happy he was; then, turning to the situation in the United States, he remarked that "real interest in things of our sort here (in New York, at any rate) seems to be about nil. But now and then there is a faint gesture."[17] Calder was hoping that the American collector Albert Gallatin would "screw up enough courage to have something of mine in his museum," the Gallery of Living Art, which had opened at New York University, on Washington Square.[18] Hélion was doing what he could to help Gallatin shape his collection, although Gallatin was very definitely a man with ideas of his own and tended to be tight with the purse strings. That same year, when Myfanwy, not yet married to Piper, went to Paris, Piper urged her to visit Hélion and "eat

Early Winter, 1937

AXIS

A QUARTERLY REVIEW OF CONTEMPORARY
ABSTRACT PAINTING & SCULPTURE
Editor : Myfanwy Evans

2 Reproductions in colour
25 in black and white

Artists

Paul Nash
Joan Miró
Alexander Calder
Fernand Léger
Barbara Hepworth
Ceri Richards, etc.

Writers

Myfanwy Evans
Anthony West
Robert Medley
Kenneth R. Walsh
John Piper, etc.

two shillings and sixpence

Cover of Axis: A Quarterly Review of Contemporary Abstract Painting & Sculpture, *edited by Myfanwy Evans, 1937.*

lots of [Hélion's] American wife's waffles and see his pictures and Alexander Calder's wire cow that drops a cow pat, and if you do you'll come away having found out all the pictures in obscure places that are worth seeing."[19]

Myfanwy returned to England and, with Hélion's encouragement, founded *Axis*, a journal in which Calder was featured. A brief, elegant text by Sweeney in the Summer 1935 issue declared him a master of a "gay asceticism."[20] Around the same time, Nicholson became an informal agent for Calder's work in England. Calder had given Nicholson and Hepworth a mobile, and there were others in his keeping. A Calder mobile hung in Read's home for a time, and the painter Paul Nash bought one in 1936. Meanwhile, Nicholson sent one of his plaster reliefs to the Calders at the end of 1936, and Calder wrote back that "Louisa + I are both <u>very</u> much pleased with it. . . . Candidly, I don't think photographs do you any credit, for I find this much finer than the sensation any photograph has ever given me of your things."[21] This austere, monochromatic relief, with its few circular and rectangular forms, has remained in the Calder family, a work that shares with Calder's Galerie Percier abstractions an invigorating restraint.

Calder was included, along with Mondrian, Arp, and others, in the important exhibition "Abstract and Concrete," which traveled to Oxford, Cambridge, Liverpool, and London in 1936 and has come to be regarded as a milestone in the reception of nonobjective art in England. Of "Abstract and Concrete," Hepworth wrote to Calder, "it is going to awaken a lot of interest, as people in this country are really only acquainted with abstract work through photos."[22] When the show reached London, she had a "great feeling of activity." She told Calder that people "had enjoyed your big mobile . . . very much." And there were "5 Mondrians on show in London at the moment. Very beautiful ones—it is an event in itself."[23] Like Calder, Nicholson counted a visit to Mondrian's Paris studio as among the turning points in his life. In the letters Calder and Nicholson and Hepworth exchanged, there was a sense of young artists in far-flung places who saw

themselves fighting parallel battles. In an installation photograph from the "Abstract and Concrete" show that Hepworth chose to include many years later in her autobiography, one of her own bold, firm, round sculptures is set beside works by Nicholson and Calder on a tabletop, and they create a wonderfully harmonious whole. The three artists are perfectly in sync, with the heft of Hepworth's carved stone set off by the openness of Calder's standing mobile, both of which are, in turn, juxtaposed with the lucid planarity of Nicholson's relief, with its right angles and incised circles.

The Calders and their new English friends were all around the same age. That summer in Varengeville, Sandy and Louisa were thirty-nine and thirty-two, John Piper and Myfanwy Evans, who married that year, were thirty-four and twenty-six, and Nicholson and Hepworth were forty-three and thirty-four. Nicholson and Hepworth had already had children together—triplets, in fact—and would marry the following year, after the finalization of Nicholson's divorce from Winifred, a painter who lived in Paris and was close to many of the artists Nicholson also knew. They were joined by their youth—and by the sense of the challenges involved in taking on the world. Myfanwy, writing years later about her encounters with the older avant-garde in Paris in 1934, Mondrian and Arp and Taeuber-Arp and Brancusi, described artists who had the "quality of private, active intensity in the midst

Installation view of "Abstract and Concrete: An Exhibition of Abstract Painting and Sculpture Today," at the Lefevre Gallery in London in April 1936. Calder's sculpture T and Swallow *(1936) is on the left.*

of an indifferent world—a world that, all the same, like a selfish parent, had produced the very life that it rejected or was bored by."[24] It was the battles against that indifference that animated the younger generation.

IV

The fall of 1937 was a fast-moving, extraordinarily promising period for avant-garde art in England. Myfanwy found Sandy and Louisa a one-room flat in Belsize Park, and Sandy rented a studio not far away, in Camden Town. The Calders, always easy travelers, fell right into the rhythms of life in northwest London. Sandra went to school for the first time, appearing at the end of her first day with one word on her lips: "Boy." Clearly she was in her element, abroad in a country where people spoke her native language. Sandra would not really learn French until, in her late adolescence, she moved to France herself. When she was growing up, her parents often spoke in French when they didn't want her or her younger sister to know what they were saying.

Living in northwest London, the Calders were at the edge of Hampstead, which was bookish and artistic, strongly leftist, and still somewhat rural in feeling. Calder was a hit with London's bohemians. A woman by the name of Margaret Gardiner described him as "a great, burly, rather rough-shod man who contrasted oddly with the delicacy of his early mobiles." Gardiner was a close friend of Hepworth's who, along with her partner, the scientist Desmond Bernal, loomed large among London's leftist intelligentsia. Gardiner frequently visited Hepworth and Nicholson in Hampstead's Mall Studios, which had a pleasant garden where the painter Cecil Stephenson set up an elaborate model train engine—something that must have appealed to Calder. Not surprisingly, Stephenson, a grown-up who enjoyed playing with toys, offered his own space in the Mall Studios for a performance of the *Cirque Calder.* Gardiner remembered that "the 'ring,' strewn with sawdust,

looked most authentic; there was a barrel of beer and we all sat, mugs in hand, on the floor, while Sandy manipulated his marvelous little creatures made of wire, wood and rag. They seemed incredibly alive as they pranced, pirouetted and clowned, more real than the real tinsel thing. It was enchanting."[25] Gardiner asked Calder to make her some jewelry, and watched him "as he hammered brass into flat spirals to make a splendid necklace for me. He made me a pair of earrings to match—but I kept on losing one or other of them and asking him to replace it until I hadn't the nerve to ask him yet once again and so I banged a pair out for myself on the kitchen floor."[26]

Hampstead was filling up with refugees. Marcel Breuer, Walter Gropius, and Gabo were each in Hampstead for a time. Working with Gabo on *Circle*, Nicholson and Martin were attempting to revive on English soil the kind of visionary modern polemic that could no longer find much support on the Continent—certainly not in Hitler's Germany. Breuer and Gropius became involved with Isokon, an English firm developing modern furnishings and architectural designs, which managed to build some adventuresome structures in and around Hampstead.[27] Soon enough, however, Breuer and Gropius left for the United States, where they believed they would find more opportunities, and indeed, Gropius was almost immediately hired by Harvard. Moholy-Nagy, a pioneer in kinetic sculpture, was also living in the city, involved in a variety of work, taking photographs for books about London street markets and the greatest of the public schools, Eton, and designing shop windows in a new, dramatic style. He, too, would leave London for the United States, where he would become involved with the founding of the Chicago Bauhaus, in which Sweeney had hoped Calder would take a role.[28] Mondrian arrived in Hampstead in 1938, and stayed for a few years, before proceeding to New York. There's a beautiful photograph of him standing among the flickering greenery in the garden of the Mall Studios, where Calder had performed the circus. A few members of the English avant-garde bought small paintings from Mondrian, and hung them in the austere, white-painted cottages that were bohemian refuges in those troubled times.

For English modernists like Herbert Read, who had celebrated the radical transformation of twentieth-century design in his 1934 book *Art and Industry*, there was reason to believe that the modern movement was at last reaching critical mass in England. Some of England's best artists would never improve on the work they were doing in the second half of the 1930s, whether Moore's recumbent figures with their fluid yet massive forms, or Nicholson's startlingly severe white-on-white reliefs, or Hepworth's sensuous marble volumes with their ultimate distillation of classical form. Responding to some of these developments, Calder's friend Alfred Barr, in

the catalog of "Cubism and Abstract Art," observed that "perhaps the most surprising resurgence of abstract art has occurred in England."[29] In London in 1937, as in Paris earlier in the decade, Calder added the special spark of his American ingenuity to the European adventure. He brought an element of New World glamour to the Old World avant-garde. Even some gallerygoers who didn't know Calder's work from the various group shows in England he had been in would have visited the International Exposition in Paris over the summer and seen the *Mercury Fountain*, which was mentioned in many accounts of Calder's Mayor Gallery show.

V

Douglas Cooper, although convinced that the English were philistines, still hoped that the Mayor Gallery might find an audience for avant-garde art in the elegant precincts of central London, where the whole world had been coming to buy luxury goods for more than a century. This was the London show Calder had been dreaming about for several years.[30] It cannot have hurt that Cooper was doing some business with Pierre Matisse. Indeed, right around the time the Calders were leaving for Europe, Cooper was in New York. It's reasonable to imagine that the plans for the Mayor show were set in motion then, even if a definite date hadn't been set.

Near the Mayor Gallery on Cork Street was the enormously adventuresome London Gallery, which had opened in 1936; Calder was included in the show "Constructive Art" there in July. When Peggy Guggenheim, who had already been living in England for a few years, opened her Guggenheim Jeune Gallery early in 1938 on Cork Street, she wore earrings by Calder to go with the Calder in the show. Back in 1936, when he was on a trip to New York, the Calders had met Kenneth Clark and his wife, Jane, and, as Sandy wrote to Nicholson, sold them "a lot of jewellery <u>and</u> an <u>object</u>."[31] Clark was the young, handsome, brilliant, and wealthy director of England's National Gallery; he was definitely a good man to know in London. No less an authority than Roger Fry, the great formalist critic of the previous generation, had declared Clark the only man who could carry on his work. When the Calders got to London, it was the American couple who introduced John and Myfanwy to Kenneth and Jane Clark. Myfanwy wound up arguing with Clark about abstract art; he had mixed feelings about the subject, although he was already a great admirer of Moore's. But they found themselves united in their admiration of Constable. In the next few years, as John Piper turned to paintings of the English landscape, Clark became a strong supporter.

Years later, Kenneth Clark remembered the 1930s as the time of the "Great Clark Boom."[32] He and Jane were the glamorous young couple everybody wanted to know. A little of that magic may have rubbed off on the Calders while they were in London. Perhaps it didn't hurt that Louisa was related to Henry James, another American who had conquered London society; in one newspaper account, Louisa was mistakenly said to be the daughter of the famous bachelor. In any event, she looked grand in a long white dress she had bought from Francine Nelson. Calder, perhaps in response to the elegant crowd in which they were suddenly moving, made Louisa her first gold necklace during the London stay. For a month or so, Sandy and Louisa, the easygoing Americans, were the toast of London. In December, *Vogue* let readers "into a jewel secret. Calder, young American abstract sculptor, whose show is now running at the Mayor Gallery, occasionally makes jewellery of great charm and originality."[33] Among the people who bought jewelry were the wives of the actor Charles Laughton and the architect Serge Chermayeff.

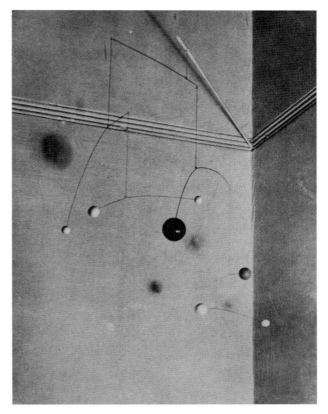

Calder's Untitled (c. 1935) as illustrated in The Painter's Object, *the anthology edited by Myfanwy Evans in 1937.*

Accounts in the society columns of the opening of the Mayor show, attended by Sacheverell Sitwell, Clive Bell, Iris Tree, and Lady Bonham Carter, noted that it had included a showing of the circus, but this time without the mugs of beer that had been passed around in Stephenson's Mall Studios workspace. "Mr. Calder himself worked the circus," one column reported, "with the aid of various members of the audience, and did the patter of a French clown, gave the orders of the ring-master and managed affairs generally."[34] Fashionable London, which had welcomed Diaghilev and the Ballets Russes two and a half decades earlier, hadn't lost its appetite for the theatrical experiments of creative foreigners. Accounts emphasized that many visitors were wearing Calder's jewelry, with Jane Clark at the head of the list. And it was widely reported that Kenneth Clark had bought one of Calder's constructions. Clark was having a tough time in the press just then, having pushed the National Gallery to spend a great deal of money

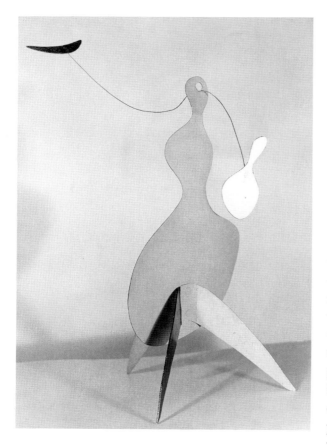

Calder. Lady Clark with
Sir Kenneth in Her Arm,
*1937. Sheet metal, wire,
and paint, 17 x 9 in.*

on some panels that he had believed were by Giorgione but were now generally agreed not to be. "Perhaps as an antidote to Giorgione," *The Daily Telegraph* speculated, he had bought from Calder "a sort of three-storey Chinese pagoda, which swings and wobbles."[35]

There is little precise information about the works exhibited in the relatively small space of the Mayor Gallery. Many of the gallery's records were lost in the Blitz, and the only photographs of the show that exist are a few of Calder posing with one or another object. Some of the work had been shipped from New York, while other pieces had been made in England, either in London or at the Pipers' Fawley Bottom farmhouse, near Oxfordshire. What dominated the room was a stabile, well over six feet high, with a few great metal planes intersecting, their curving edges suggesting something whale-like or seal-like. This work was designed to be pounded with one's hand at various places, yielding a range of sonorous clangs and bangs. We know of several standing mobiles in the show. There was the one Clark bought, with its pile of pagoda shapes. And there was another, an exercise in asymmetry, with spheres of different colors and sizes hanging on wire arcs. Near the walls, Calder had arranged what amounted to wire drawings, bonelike or torso-like forms filled with crisscrossed and zigzagging lines, related to the construction he had given to Braque over the summer. These works created interesting shadows on the walls, which Calder sometimes chose to underscore or emphasize with the help of a flashlight. He was pursuing his interest in shadow play—something like the *ombres chinoises* that Pascin had contrived at a riotous party in Calder's rue Cels studio some years earlier, although in Calder's case the shadows were abstract rather than obscene. A critic in *The New Statesman and Nation* was reminded of "certain abstract drawings by Picasso." He thought these constructions of Calder's "might be used to explain the structure of some aberrated atom, only instead of one drawing you have an infinite number as they turn about on their strings."[36]

The Mayor Gallery exhibition was part kinetic art, part light show, part sonic experiment. The critic in *The Listener* wrote that "the mobiles transcend our notion of the work of art as something fixed and static—they move, generally on wires and strings, sometimes more mechanically, and to be appreciated must be realised as the trajectories of related bodies: arbitrary planetary systems, microcosmic worlds of colour following their restricted courses, weaving a free pattern in a finite space."[37] In *The Architects' Journal*, Calder's works were seen as having "almost unlimited possibilities as an art form. And may not this preoccupation with the abstract movements of a mechanical ballet, or something very like it, together with Moholy-Nagy's theories of light, and Auden's experiments with sound, one day revolutionize the cinema and raise it to its place as one of the arts?"[38] There was no doubt that the reviewer was seeing a sketch for a *Gesamtkunstwerk*—the dream of a work of art, inaugurated by Wagner, that would merge all the possibilities of art.

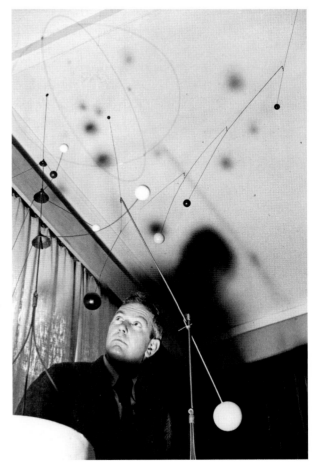

Calder with three untitled works at the Mayor Gallery exhibition in London in 1937. On the left is the "pagoda" bought by Kenneth Clark.

VI

The London the Calders came to know was going to change all too soon, with the beginning of the war. Hepworth later recalled how for her three children in 1937, "the red-letter days were when Gabo or Calder, and later, Mondrian, came to share nursery tea. Three pairs of eyes would watch every movement and three pairs of ears listen to every word."[39] A year after the Calders had gone back to the United States, Hepworth found herself writing to Louisa and Sandy that "Life is just <u>hell</u> here. Work goes so well + more + more people are interested + care about it; but what can one do with 'stark reality' in the shape of Hitler + A.R.P. stalking the streets? Every week more of the nice things disappear."[40] She spoke of going to America, a plan that never came to fruition. In 1941, when Nicholson published his

"Notes on Abstract Art" in *Horizon*, the wartime magazine edited by Cyril Connolly, he sent a copy to Calder, crossing out the face in a reproduction of a painting and writing below it, "tough girl redrawn by blockmaker," obviously annoyed by the distortions of the painting created by the technician who'd done the reproduction.[41] The struggles to make art and to make it right continued, whatever the situation. In the midst of the war, Nicholson and Hepworth received a letter from Calder in which he apologized for being such a poor correspondent. Although perfectly aware of the horrors they and their fellow Englishmen were living through, he remained emotionally reticent, saying little more than that "in spite of the fact that we never write to you you are often in our thoughts."[42]

Back in the States, Sandy and Louisa remembered the times they had spent at the Pipers' Fawley Bottom farmhouse. This pastoral place, which the Pipers had acquired a couple of years earlier, was simple, unpretentious, and altogether magical, a hotbed of creative activity in the gentle English countryside; it held for the London avant-garde some of the charm and fascination that the Calders' Roxbury farm held for the New York avant-garde. Kenneth Clark, who was starting to visit Fawley Bottom around this time, wrote that "to stay with the Pipers at Fawley Bottom, to poke the ashes of the dying open fire, while the children rammed one in the stomach, to sleep in a room full of dark brown books on Gothic churches, with a heavy heraldic banner on the bed; to enjoy Myfanwy's cooking, a bottle of wine and the conversation of two of the most completely humanised people I have ever known, was the perfect antidote to life in London, even though Jane did once find a mouse drowned in the glass of icy water beside her bed."[43] Moholy-Nagy, on a visit to Fawley Bottom, was fascinated by the flints (shaped, Myfanwy recalled, like "little Arps and Henry Moores") he discovered in the fields; he struck Myfanwy as a machine age man suddenly bewitched by the rural life. Léger, Myfanwy recalled, "showed his zest and pleasure in his country surroundings by sitting down and doing a watercolor, which, though black and white, red and yellow and blue with a little green—pure Léger colors—was unmistakably a field with trees. His huge form and jovial presence gamboling about with Sandy Calder's equally huge one made our meal like a Normandy wedding feast."[44]

Among the works Calder left in England was a large standing mobile that remained with the Pipers at Fawley Bottom: a three-legged thing with a few great, careening shapes in green, red, and yellow. The Calders and the Pipers always stayed friends. Piper, like Henry Moore, exhibited in New York with Curt Valentin, who would also be Calder's dealer after the war. As the decades passed, the Calders saw the Pipers in France periodically, when

they stopped off at the Calders' place in the Touraine on their way to or from Provence. For Myfanwy, years later, when she tried to disentangle the conflicts of the 1930s, as Nicholson and Hepworth were pushing into an ever more insistent purity and she and John were taking a greater interest in nineteenth-century landscape painting and medieval English sculpture, it was the freedom of the work of Calder and his friend Miró that she came back to. She recalled the designs Miró had done for the ballet *Jeux d'enfants*, which Kirstein reported that Calder and Noguchi had attended in Paris, and "the flying wires and painted planets of Calder's mobiles." Myfanwy never forgot how the Mayor Gallery show had been received. "Even the silly gossip columnists," she recalled, "the many sneerers and the solemn ones who 'suspected the validity of the modern movement' were overcome by its gaiety, a compliment, however, that in England quickly deteriorates into condemnation—Sandy Calder has never quite been forgiven by the English public for the wit and gaiety of his inventive and delicate art: 'They're just toys aren't they?' "[45] In Myfanwy's view, the English public was unable to figure out the answer. Perhaps they should have been forgiven for this confusion that was caused by their own pleasure. After all, people are still looking at Calder's work and wondering, "They're just toys aren't they?"

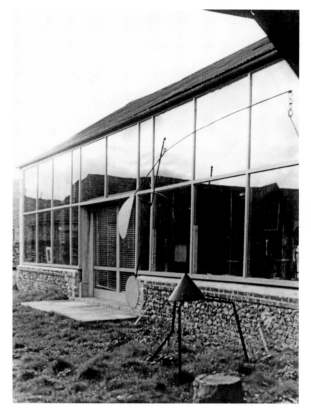

Calder. Untitled, 1937. Sheet metal, wire, and paint, 89¾ x 80 x 102¼ in. This is the standing mobile that Calder left with John and Myfanwy Piper.

TURNING FORTY

I

Calder turned forty the summer after the family returned from Europe, an event he celebrated—as he would celebrate many other birthdays—in tandem with Malcolm Cowley, who had been born on August 24, 1898. That was either two days or a month and two days after Calder's birthday, depending on whether you believed Calder's mother or the records office in Philadelphia. Of course, this was four years before the records office had been consulted, so nobody had any idea that the date of Sandy's birth might be anything other than August 22. But even in 1942, after questions had been raised in Philadelphia, Calder was determined to continue "celebrating our twin spirits," as he wrote on a postcard to Cowley, adding that "in fact it calls for 2 doubleheaders."[1]

Calder, c. 1940.

The fortieth-birthday bash was memorable, a gathering of friends at the Calders' place in Roxbury at the beginning of the decade and a half when they were as close as they would ever come to being 365-day-a-year residents of Painter Hill Road. An elaborate cake was produced by an Italian bakery in Danbury, as Calder recalled in the *Autobiography*, "built like a zoned building, stepped up twice. It was white, with lavender mocha. In mocha it said: FORTY, FIT, FAT, AND FARTY."[2] By now Calder was no longer fighting his girth with the visits to the gym or the diets he and Louisa had made part of their Parisian routine in the early 1930s. In his autobiographical notes, Calder listed with something like wry resignation the various comments that

had been made about his adipose. He recalled that his father had once or twice said he resembled Winston Churchill—who, Calder added, was at least a great hero of Stirling's. He recalled being twice likened to the mammoth Diego Rivera, an artist about whom Calder did not have good feelings. "This," he wrote, "I took as an insult—though I think that person thought well of D.R." A decade later, in some restaurant or café, Louisa heard somebody ask somebody else, "Who is that Pickwickian-looking character?" And a friend of Mary Reynolds's had apparently said to Calder's face, "You look well—you always make me think of Foxy Grandpa."[3] In the early 1940s, while Calder was searching for birthday presents for Louisa in a shop in Manhattan that specialized in Mexican arts and crafts, a woman whom Calder had danced with a little bit around the time he left Stevens came up to him and said, "Oh, I used to know your son!" Calder simply patted her shoulder and said, "Never mind!"[4]

Malcolm Cowley in his office at The New Republic, *1934. The photograph is by Cowley's friend the poet and critic Morton Dauwen Zabel.*

Jane, Calder's friend from the days before he first went to Paris, was at the fortieth-birthday celebration with her new husband, Jimmy; she had been Jane Davenport, then Jane Harris, and was now finally Jane de Tomasi. Jimmy had to hold the birthday cake in the air during the twenty-mile trip from Danbury, to protect it, and wound up, Calder recalled, "practically paralyzed for half an hour" afterward. They bought a couple of dozen pizzas and lots of cubes of meat, to be roasted, and Calder set up a bar in his studio in the old icehouse. Among the people who showed up were James Soby; Pat Mestre, the dean of Bard College, whom Soby referred to as the Bard of Dean; and a lot of friends of the Cowleys' whom Calder didn't exactly know. There was a great deal of drinking. Their maid, Adèle, carrying out the cake, slipped on a stone step so that the multitiered concoction landed upside down in the new-mown grass, adding a third color to the lavender and white—"but," Calder reported, "it was still delicious." Things just went on and on from there, so much so that people forgot about the food, leaving Louisa, at the end of the party, to hand out pizzas to the departing guests as if they were door prizes.[5] "There were individual incidents," Calder recalled, "such as attempted drowning and even rape, they claim. We did find a pair of glasses up at the pond the next day."

Lost eyeglasses seem to have been a leitmotif at Calder parties. Some years

later, Muriel, Malcolm's wife, found herself writing to the Calders about a pair of glasses that had apparently turned up after another party. "As for the glasses: I know they are not Berryman's"—one presumes that would be the poet John Berryman. "We returned to the scene of that famous party to get HIS. Remember? I remember ladies plunging into the water fully dressed; MacGregor's wife smoking a cigar in white satin bathing suit. If the glasses haven't been missed—well, I suppose you hang 'em in the downstairs' john. Let whomsoever's eye fits—wear 'em."[6] Among the books still in Roxbury is Cowley's 1929 collection of poems, *Blue Juniata,* inscribed to Sandy on his fortieth birthday, "in memory of 1 mad night."[7]

II

Whatever the liquor-fueled rustic recreations Cowley and Calder and their friends shared in the late 1930s, the artistic, intellectual, and political challenges of the time could never be forgotten for long. In a couple of memoirs that are too little admired today, *Life Among the Surrealists* and *Infidel in the Temple,* Matthew Josephson, one of the Connecticut friends, left a powerful picture of a European avant-garde that everybody, including the Calders, could see was imperiled by the rise of extremism both on the left and the right. Josephson had known the pioneering Russian abstractionist El Lissitzky in his glory days in Germany in the 1920s, before the Soviet Union declared that abstract art had no place in the new Marxist society. Visiting Russia in the winter of 1933–34, Josephson couldn't help asking his old friend how he could bear having given up painting. " 'No, the time for all that has gone by,' he said with his fine sad little smile. 'Perhaps some day, after I am gone, we will come back to it.' "[8] In Paris, Josephson was worried by what he referred to as "the laughter of indifference; even the catastrophic changes in neighboring Germany seemed 'desperate but not serious.' "[9] His old friend the poet Philippe Soupault complained that Paris, which had been "international and also pro-American" had now "gone back to her old ways, to being entirely French, entirely provincial!"[10] Was it any wonder that the Calders had gone home in 1933?

None of the Calders' friends was more deeply affected by the era's political travails than Malcolm Cowley. Cowley, who was an editor at *The New Republic* in the late 1930s, was up to his ears in the Left and its relationship with the Soviet Union and Marxism and how all of this related to the future of capitalism and culture and the growing threat of Hitler and Mussolini. At the time, Alfred Kazin was a very young writer who received book review assignments from Cowley at *The New Republic.* In his memoir *Start-*

ing Out in the Thirties, Kazin recalled Cowley "sail[ing] in after lunch with a tolerant smile on the face which so startlingly duplicated Hemingway's handsomeness, the sight of Cowley in the vivid stripes of his seersucker suit seemed to unite, through his love of good writing and his faith in revolution, the brilliant Twenties and the militant Thirties."[11] It's easy to see how that jaunty personality would have appealed to Sandy and Louisa. Cowley's face, Kazin went on, "had kept the faint smile of defiance, the swashbuckling look and military mustache of intellectual officers in the First World War, the look of gallantry in sophistication that one connected with the heroes of Hemingway . . . ; he had an *air*."[12] If Dada and Surrealism in Paris and New York were part of the background of what Cowley called "the Connecticut migration," in the foreground there was the politics of the later 1930s, in which Cowley was deeply, perilously engaged.[13] So was their friend Peter Blume, although to a less perilous degree.

The Moscow Trials and the Spanish Civil War had pushed even those who had remained Stalinists well into the 1930s to rethink their positions, but at the time of the 1938 birthday party, Cowley was still sticking with the party line (though apparently he was never a card-carrying member). A few weeks after the doubleheader of a fortieth-birthday party, Edmund Wilson wrote to Cowley, horrified that he was "circulating a letter asking endorsements of the last batch of Moscow trials" and urging him, if these were indeed his convictions, to "purge your head of politics—revolutionary and literary alike—and do the kind of valuable work of which you're capable."[14] Responding from Connecticut some days later, Cowley defended his position as "Generally pro-Russian, pro-Communist, but with important reservations." It was a long letter, and at one point he explained that he had "heard a loud barking outside the window. Rowdy the spaniel had found a cock pheasant in the alfalfa field and pheasant had flown down into the swamp. I grabbed the shotgun and went out. Pheasant had disappeared. I walked on into a weed field. There I stopped and began thinking about your letter and suddenly pheasant flew up under my feet and I was so abstracted I didn't shoot. So I'll blame you now for making me miss a pheasant. . . . Let's actually forget that political stuff, Stalin hiding under your bed and Trotsky in my hair, and talk about books for a change."[15] It would not be until sometime after the Hitler-Stalin Pact of August 1939 that Cowley moved away from his allegiance to the Communists.

Whatever might have seemed extreme or downright wrongheaded in his politics—and he himself came to regard his Stalinism as a stain perhaps never to be expunged—Malcolm Cowley's intelligence, his joie de vivre, and his dedication to the life of the mind and the life of art resonated with the Calders. And vice versa. Malcolm, Sandy, and Louisa would always share

a commitment to progressive ideas and ideals. In the 1950s, there was talk of Cowley writing a book about Calder. And when the Calders were again established in France, the Cowleys borrowed their house in the Touraine for a time. After Calder's death, when his sister published her triple portrait, *Three Alexander Calders*, Cowley composed a beautiful introduction that is one of the most sensitive things ever written about Calder. He spoke of the intense work, the pleasure in company, the devotion to family, and exclaimed, "Sandy, Sandy, with his crooked smile, his bear hugs, and those half-closed hazel eyes that missed very little. . . . There is so much I remember about him, so much that makes me feel the pain of his absence."[16] Although they hadn't lived in Paris together, the bond of Paris and its strenuous pleasures was a perfume, an air, as Kazin would have put it, that sustained them in the Connecticut countryside.

III

Calder's fortieth-birthday present to himself was the new studio that began to go up in Roxbury not long after the double birthday party, on the foundation of the burned-down barn just to the east of the house. It was finished sometime in the fall, and forever afterward Calder referred to it as his

shop—a matter-of-fact term that he preferred to the more traditional *studio,* much as he liked to refer to the three-dimensional works he produced as *objects* rather than *sculptures.* Working with his old Stevens classmate Jimmy Horn—who had been in Paris in the early 1930s, where he'd helped Calder with some of the motorized elements on the early abstract pieces—Calder came up with a design for a studio that had the satisfyingly geometrical floorplan of a double square. Calder chose a prefabricated factory sash for two walls basically entirely of glass, a thirty-foot-long wall facing to the southeast and, cattycorner to that, a fifteen-foot one. The long back wall had windows high up, while an old silo foundation was preserved as part of the building, with a semicircle of windows. The structure was some twelve feet high, the walls of humble cinder block, with two big doors, mostly glass, in the middle of the long wall of glass, making it easy to take relatively big pieces in and out. The windows could be opened by a chain that undid a bolt, the top of the window tilting inward and the bottom outward, creating what Calder described in his *Autobiography* as "a wonderful funnel for air on the hottest summer day, and I worked amid these funnels"—which no doubt also kept his mobile elements in constant motion.[17] At long last, he had a light-filled place in which to work. In his autobiographical notes, he wrote, "I prefer <u>daylight</u> in my shop because I want to see clearly what counts, and be able to eliminate in my mind what does not count."[18]

Calder's father's studios had always been quite impressive. Peggy recalled

The Roxbury studio, c. 1955.

OPPOSITE *Calder during the construction of the Roxbury studio, 1938.*

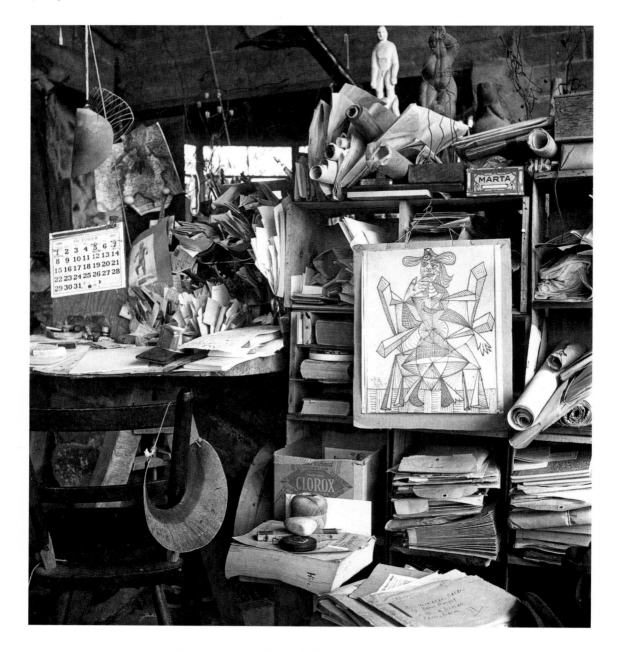

Calder's desk in the Roxbury studio, 1950. Photograph by Herbert Matter.

"a large room with skylight, the floor covered with fine powdered clay dust that stuck on one's shoes, leaving tracks behind.... He had only a few objects about: a bronze Etruscan deer, a Greek mask, a Chinese theater poster or Japanese print."[19] Stirling craved a certain kind of setting—a setting that evoked the dignity of the Beaux Arts tradition. His son had very different ideas. Over the years, Calder worked in a wide variety of situ-

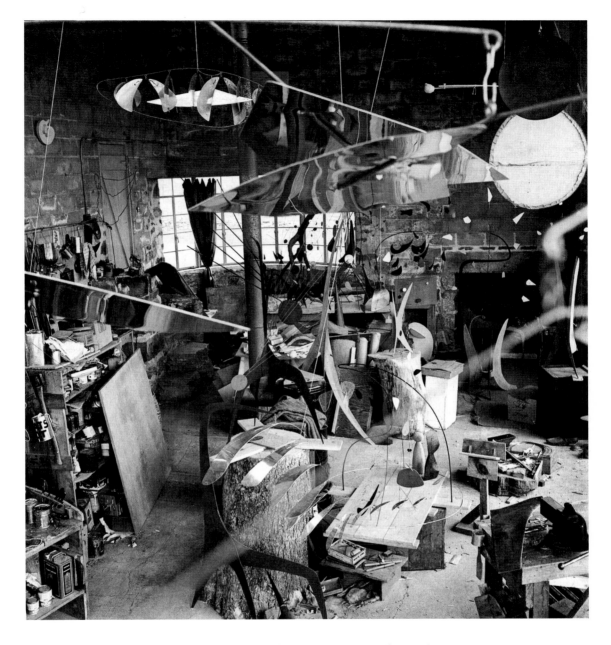

ations. These included the hotel room on the rue Daguerre, the studio in the villa Brune, the third floor on the rue de la Colonie, and more than one storefront on the Upper East Side. The first Roxbury studio, the one with a dirt floor in the old icehouse at the back of the house, was hardly calculated to grab a visitor's attention. In the photographs Soby took in the 1930s, the impression was of coziness, with low ceilings and repurposed windows

Calder's Roxbury studio, 1941. Photograph by Herbert Matter.

installed on the southeast side. The interior was fairly dark, and in several of Soby's photographs, Calder was working right at the doorway, nearly outdoors. Wherever Calder set up to work, he accumulated heaps of stuff, a visual rumpus that sharply contrasted with his father's taste for a certain austerity. Peggy recalled that their parents "never ceased being amazed that beautiful, meticulous work somehow emerged from the chaos."[20]

The big new Roxbury studio quite rapidly became the most amazing conglomeration of finished works, works in progress, materials with which to make works, plus an assortment of objects ranging from the rare to the banal. An old desk was heaped, ever higher and higher, with bills, letters, and papers of all kinds. Calder attached shaped bits of wire to his pencils, so that they wouldn't roll off the slant-topped desk. His last request of the workmen who built the studio was that they twist seven rows of screw eyes into the rafters; as he put it in the *Autobiography*, "my sky is studded with about 150 screw eyes. And when I want to put a pulley aloft with a rope through it—to suspend a mobile or some object—I have a long stick with a notch and stiff wire hook at the end, which holds another hook attached to the pulley, and I fish for the selected screw eye with this device."[21] Within a few years, the result was a wonderland, the air crowded with mobiles and pieces of mobiles, a constellation of metal shapes floating, as his sister recalled, "like trapeze artists," and the floor full of workbenches, tools, and more and more metal shapes. "To the uninitiated," Peggy wrote, "it seemed a great mess, but Sandy always knew where everything was and moved about with great efficiency. His tools were where they could most conveniently be reached. . . . Sketches were clipped to the edge of Sandy's 'desk.' Benches were strewn with tin snips and saws, rasps and files; a hand drill stood waiting." Peggy recalled, perhaps not entirely accurately, that "along the walls, old masks made of an inner tube and cans, a wire hat, and endless other relics of bygone efforts or parties, leaned or were fastened."[22]

The Roxbury workshop became the center of Calder's world. He would, in the second half of his life, work in many other places, happy to improvise, as when he visited Caracas in the 1950s and created much of an exhibition in a metal workshop at the university. During his later decades, when he and Louisa lived more and more in France, southwest of Paris in the village of Saché, not far from Tours—at the time it was something like a four-hour drive from the capital—there was a workshop not entirely unlike the Roxbury workshop, but only half its size, next to their sixteenth-century house. In Saché, there was also a cottage that Calder used for making gouaches, and, ultimately, by 1963, a vast modern workshop on a hill, in which Calder never felt entirely comfortable. For his larger works, executed from maquettes created in his own studios, he turned in the following decades to a couple

of ironworks in Connecticut and one in Tours, which he came to regard as extensions of his own studio. But in some sense, it would be the Roxbury studio that remained forever the essential Calder studio, even if in his last two decades he returned there for only a couple of months a year. It was the place where his winged vision really took flight—a light-filled double-square space deep in the hills of Yankee Connecticut.

One visitor, the critic Selden Rodman, contemplating "the air . . . busy with dangling 'contraptions,'" found himself thinking of the Wright brothers, who used to use the word *contraptions* to refer to "their experimental warped airfoils and rudimentary engines. But more significantly," Rodman remarked, "I thought, the Wrights too were in love with simplicity, with perfection of motion and economy of means."[23] In the Roxbury studio, Calder's unprecedented marriage of Yankee experimentalism and Old World aestheticism grew and deepened and yielded an extraordinary bounty.

IV

In the months when the Roxbury studio was going up, Calder was involved in plans for a first retrospective exhibition of his work, at the George Walter Vincent Smith Gallery in Springfield, Massachusetts, under the auspices of the gallery's director, Cordelia Sargent Pond. Calder had first met her at the Connecticut home of Katherine Dreier, Duchamp's great friend and collector. Duchamp, Man Ray, and Katherine Dreier had been the founders of the Société Anonyme, which, in the decade before the opening of the Museum of Modern Art, had been instrumental in sponsoring exhibitions of modern art in New York; for some years, Duchamp's *Large Glass* was one of the chief attractions of Dreier's Connecticut home. Cordelia Pond wanted to bring the news of modern art to Springfield. What better way was there to do that than with an exhibition of work by Alexander Calder? One of Pond's supporters was a man we've already encountered by the name of William Garland Rogers; he had been friends with Gertrude Stein in Paris and was now writing for *The Springfield Union* and would soon become friends with the Calders. He later published a much-admired study of the American author, *When This You See Remember Me: Gertrude Stein in Person*. As we've seen, in the 1950s Bill Rogers wrote a book about Calder, a project that the Calders initially encouraged but ultimately found too lightweight to satisfy their demanding tastes.

Cordelia Pond had written to Calder that March. By early July, the month before the big birthday bash, they had agreed on a November date for the show. Calder was going to take care of getting the work to Springfield, and

he was going to be paid $300 to rent a truck. As the November 8 opening of the show drew near, Calder found himself concerned about how he was going to fill the gallery, which was enormous—some seventy by forty feet, more than four times the square footage of the studio he was building. He wrote to Pond at the beginning of October, worrying that "your gallery seems so vast that I have a fear of being lost in it"—a rather extraordinary admission coming from the ever-confident Mr. Calder.[24] He wondered if they might arrange for Pierre Matisse to send some works by Miró and maybe by Léger to hang on the walls. Within a week or so, when it was clear that this wasn't an option, Calder wrote to Sweeney, who was composing a small text for the exhibition brochure, saying that he was now planning to include some old wire acrobats and wooden animals, works that he had apparently not initially meant to exhibit.

What Calder ultimately came up with was a wide-ranging retrospective, more than eighty works, including drawings.[25] There was a good selection of early compositions in wood and wire, including a *Josephine Baker* and *The Brass Family*. There were some thirty mobiles and some abstract wooden objects. Cordelia Pond had wondered whether Calder would exhibit some of his jewelry. He was reluctant, writing her that "ordinarily I don't like to exhibit it with the mobiles."[26] While no jewelry was listed in the brochure, he did end up supplying the museum with a considerable number of pins, rings, bracelets, and necklaces, apparently bringing them toward the end of the show. Pond suggested that she might be able to sell something for him, perhaps at a closing event. They also had an extensive correspondence as to who should be invited to the opening and a dinner the evening of the opening. Austin, Barr, Matisse, Soby, Sweeney, and Katherine Dreier were invited to the dinner. And, of course, there were the friends from around Roxbury—Cowley, Blume, Coates, and Josephson, along with James Thurber, who lived in Woodbury. Calder also wanted invitations sent to the major European architects who were now in exile in the United States, including Mies van der Rohe (who had recently moved to Chicago), Walter Gropius (who had apparently already visited the Springfield museum), and Marcel Breuer, whose domestic architectural projects in the coming years would sometimes be ornamented with Calder mobiles.

As things turned out, Barr, Matisse, Sweeney, and Soby couldn't make it to Springfield for the opening. But it must have hardly mattered to Calder, for on the train coming up from New York that afternoon were none other than Fernand Léger and Alvar Aalto and his wife, Aino. They were his fellow artists, they happened to be in New York, and they were voting with their feet, coming to the support of their American friend as he had his

first "out-of-town" retrospective—which they all probably regarded as a "tryout" for bigger New York City shows to come. Léger's work had been known in New York since the twenties, when Dreier's Société Anonyme mounted a retrospective of his work. Aalto was the subject of a show at the Museum of Modern Art that had opened the previous March and was traveling to Springfield after Calder's show closed. He and his wife had arrived in New York in October for six weeks. Aalto had a lot on his plate. He was designing the Finnish Pavilion for the 1939 New York World's Fair, and was also hoping to solidify his connections at the Museum of Modern Art and with the Rockefellers, who were deeply involved with the Modern, and with various architects. At the opening, both Aalto and Léger were called upon to make a few remarks. It was a hot, crowded evening, and Cordelia Pond somehow neglected to introduce Calder to the gathered throng—which she apologized for later. Calder was fine with that, explaining that once one is introduced, the members of the public "usually proceed to pose embarrassing questions, the answers to which are irrelevant and seldom have any bearing on the matter, but which somehow (probably as an engineer) I feel constrained to make."[27] In *The Springfield Union*, the opening was illustrated with a photograph of Calder—in a tuxedo, no less—with Aalto and Léger to one side and Katherine Dreier to the other.

Also present for the opening celebrations was Sigfried Giedion, an archi-

The opening of Calder's retrospective at the George Walter Vincent Smith Gallery in Springfield, Massachusetts, in November 1938. From the left: Louisa Calder, Aino Aalto, Cordelia Sargent Pond, Katherine Dreier, Sigfried Giedion, Alvar Aalto, Calder, and Fernand Léger.

tectural historian who had studied under Heinrich Wölfflin in Europe and had recently left Switzerland to take up a post at Harvard, where he was presenting the Norton Lectures; they were published three years later as *Space, Time and Architecture: The Growth of a New Tradition*. Giedion's wife—it's not clear if she was in Springfield with him—was Carola Giedion-Welcker, also a student of Wölfflin's and an author of important studies of modern art, who had already included Calder in a book about modern sculpture. Giedion and Aalto were friends, so for them Springfield may have been something of a reunion. Giedion stayed with Cordelia Pond and her husband for the opening. Writing to Pond on Fogg Museum stationery two days later, he was in no doubt as to the importance of the show. "I congratulate you once more," he wrote, "for your courage and your excellent catalogue. You are a real pioneer, and—pioneer names will not be forgotten. Fine Exhibition!"[28] He was right. Her bravery in mounting such a show in a middle-sized city cannot be underestimated. Writing back to Giedion a week later, she observed that the exhibition "is attracting a great deal of attention, some unfavorable but largely favorable. One man came in the second time to see 'if the show is as funny as I thought it was.' But we are especially pleased at the number of men who are coming in to see it, and young people are fascinated by it."[29]

Bill Rogers observed in *The Springfield Union* that none of the other modern sculptors whose work one might think of as extreme (not Pablo Gargallo, not Ossip Zadkine) had managed "to negotiate a break as complete as Mr. Calder's."[30] Sweeney, in his brief foreword to the exhibition brochure, argued that at a time when "a romantic adulation of the machine" had become almost a commonplace among artists, Calder, perhaps because of his engineer's education, had "avoid[ed] the dangers of a fustian seriousness where a natural dignity already existed. As a result Calder stands today as perhaps the only American artist of his generation who is internationally recognized as having made, and as still making, a creative contribution to expression in the plastic field."[31] Rogers had warned Cordelia Pond, as she confessed to Calder, that "Springfield would not like it and would make fun of it." But she went on to assure Calder that Rogers seemed to be wrong. "Many are puzzled by it and try too hard to find hidden meanings but they are fascinated, admit it, and are enjoying it thoroughly." Barr's friend Jere Abbott, a key figure in the early days of the Museum of Modern Art, came to see the exhibition and left Cordelia Pond a note saying, "The show is absolutely knockout."[32]

V

Knockout or not, there was still the matter of how to make a living. Fixing up Roxbury wasn't without its expenses, even if Calder did much of the work himself. And Louisa was pregnant again, expecting another child in the spring of 1939. Although Calder was becoming better and better known, sales of his sculptures remained few and far between. The records of the Pierre Matisse Gallery show Calder selling only one sculpture in 1939 and netting $133, three in 1940 for a total of $333, and gradually climbing to four sales in 1942, netting $583. (That $583 would be worth about $9,000 in 2017.) While the sculptures he exhibited with Matisse were the crux of Calder's creative life, he remained on the lookout for ways to make some money.

Alvar Aalto, who during his October visit to New York had arranged for the architectural firm of Wallace K. Harrison and André Fouilhoux to oversee the construction of the Finnish Pavilion at the 1939 New York World's Fair, had returned early in March to work on the project. Calder quite understandably wondered what opportunities there might be for him at the New York World's Fair. Although it's not clear how he first came into contact with Wallace Harrison, it might have been through Aalto or Léger. Harrison was related to the Rockefellers through marriage and was already, around the time Calder was getting to know him, an important adviser to Nelson Rockefeller on matters of architecture and design. Harrison and Fouilhoux were involved in a number of projects for the New York World's Fair, not only the Finnish Pavilion but also the Consolidated Edison Building, for which they had designed an imposing blue glass façade fronted by a water basin some two hundred feet long. Calder received a commission to orchestrate a series of jets of water for the Consolidated Edison Building basin, creating what was billed as a *Water Ballet*. (Calder certainly remembered that he had briefly worked for an earlier incarnation of Consolidated Edison after graduating from Stevens.)

Whatever his frustrations with Graham, Massine, and Balanchine a few years earlier, Calder hadn't given up on the idea of a ballet without dancers. More or less simultaneously with his work on the Consolidated Edison *Water Ballet*, Calder was working on a series of maquettes that he hoped somebody might adapt for a large-scale kinetic sculpture at the World's Fair. In each of these three maquettes—one was later titled *Dancers and Sphere*—four differently configured vertical forms were set on a single base and engineered so that each object moved in its own way. Everybody who knew Calder seemed to be excited by the prospect of what he might do. The

dance critic Edwin Denby offered a series of suggestions to the organizers of the World's Fair in an article in the May–June 1938 issue of the magazine *Modern Music*. He wanted "bigger marvels" than those already promised, which might include "Sandy Calder doing skywriting in colors, Aaron Copland improvising a cannon concert during a thunderstorm, Virgil Thomson lecturing on Wagner from a parachute, his voice all over the fairgrounds."[33]

We know that Calder had been working out his ideas for the Consolidated Edison *Water Ballet* since the summer before the World's Fair opened, because when Henry-Russell Hitchcock, traveling out west with Marcel Breuer, sent Calder a postcard of Sponge Geyser at Yellowstone, the note on the back exclaimed, "Such water ballets Breuer and I have seen today. Do add some steam to yours and have coloured algae around the edges of the basin."[34] Calder's Consolidated Edison plans called for a syncopated display of jets of water that, he said, were "designed to spurt, oscillate or rotate in fixed manners and at times as carefully predetermined as the movements of living dancers."[35] Although it is possible that the special nozzles Calder specified were installed and even tested, it's not clear if his original plans for the *Water Ballet* were ever realized. Even if they were briefly put into action, sustaining the five-minute "performances" that Calder hoped would occur every fifteen minutes or so throughout the fair apparently proved too difficult.[36]

The clearest indication we have of what Calder had in mind comes from an illustrated article he published in August 1939 in *Theatre Arts Monthly;* the magazine devoted its entire August issue to the theme "Theatre for a World's Fair." Calder proposed a series of "movements." He may have regarded these as similar to the movements in a classical ballet, only with jets of water taking the place of the dancers onstage. Calder's *Water Ballet* began with a first genteel movement involving two jets of water. The second movement consisted of four large detached masses of water sent high into the air ("a sort of bomb"); then there were seven slender rotating jets; then a great fan-shaped spread of water; and then a finale that brought back the seven jets and the two jets and the cannonades. All this was illustrated with a diagrammatic

A graphic diagram, by Alexander Calder, of his 'choreography' for a water ballet to play in front of the Consolidated Edison Building at the New York World's Fair (courtesy Architectural Forum).

gradually, lifting to its full height and then diminishing. It is a fan-shaped spray, originally designed to rotate, but since its installation it has been found more effective if left stationary in a plane parallel to the building, permitting it a larger size and more continuous visibility.

When the fan disappears, the 7 jets reappear, rise up to full height and stay at that point while the 2 end jets begin to play. The finale is reached with the end jets playing and cannonade.

579

drawing in *Theatre Arts Monthly*, neatly arranged in a grid of twenty squares, laying out the sequence of movements as if it were a series of storyboards for a movie.[37] Some years after World War II, a new version of the *Water Ballet* was created as part of the vast campus of the General Motors Technical Center in Warren, Michigan, not far from Detroit. Eero Saarinen began designing the center right after the war, but it was only completed in 1956. The buildings were arranged around an artificial lake; most of them were in a severe rectilinear style that echoed the work of Mies van der Rohe, but there were jolts of bright red, yellow, and blue brick walls, as well as one great domed structure. In one corner of the lake, Calder's ballet was set in motion, its sprays and volleys of water leaping and catapulting through the air.

Although the World's Fair didn't provide Calder with anything like the opportunities he'd hoped for, *Water Ballet* was not the only project that had a gratifying afterlife. In 1961, one of Calder's maquettes for a monumental sculpture with four kinetic elements was finally realized, for the exhibition "Movement in Art," organized at the Moderna Museet in Stockholm by a friend of Calder's, the curator Pontus Hultén. Back in the 1930s, Calder had frankly done these maquettes "on spec." Some thirty years later, he laughingly confessed to an interviewer that although he had made them for the World's Fair, "Nobody ever looked at them."[38] *The Four Elements*, as it came to life in 1961, is a comedy of dissonant styles or characteristics, a slapstick performance, but a slapstick closer to the gravitas of Buster Keaton than the giggles of the Marx Brothers. One element suggests an abstraction of a dancing figure, a triangular conical apparition with arms as if draped in some sort of robe. The other elements are a column composed of semicircles, a disk mounted on a striped pole, and a lozenge-like shape made of two intersecting arcs. Calder's idea was that when they were propelled by powerful motors, the four elements would be dynamically related, each moving in its own particular way at its own

Calder's Water Ballet *as permanently installed at the General Motors Technical Center in Warren, Michigan, in 1956.*

OPPOSITE *Calder's diagram of* Water Ballet *(1939) as reproduced in* Theatre Arts Monthly *in August 1939.*

Calder. Untitled (maquette for 1939 New York World's Fair), 1938. Sheet metal, wood, wire, string, and paint, 14¾ x 19¾ x 9¾ in.

particular pace, each with its inscrutable message, competitors on a playing field.

There is nothing of the hurly-burly of a world's fair about the spot where Calder's *The Four Elements* was finally realized. Set among the modestly scaled nineteenth-century architecture of Skeppsholmen, the island in Stockholm that is the home of the Moderna Museet and used to be the main base for the Swedish navy, *The Four Elements* strikes a visitor as simultaneously somber and celebratory, the geometry grave even if the colors are gay. But whether we imagine it at the 1939 New York World's Fair or see it in Stockholm today, *The Four Elements* is a dance unlike any other.

VI

Commissions of various sizes and shapes had been coming Calder's way. We have already seen the air vent covers he designed for the auditorium of the Berkshire Museum in 1936. Through his friend Paul Nelson he received a commission to design a trophy for CBS. He applied for and won a competition to design a Plexiglas sculpture, and the finished product was exhibited in

the Hall of Industrial Science during the World's Fair. He had conversations with Wallace Harrison about designing a mantelpiece for one of the Rockefeller residences, although this doesn't seem to have borne fruit. (Matisse had done an overmantel for a Rockefeller apartment the year before.) And he worked with the architect Percival Goodman, the brother of the social critic Paul Goodman, on a series of six sculptures intended to accompany Goodman's submission for a competition for the proposed Smithsonian Gallery of Art on the Mall in Washington, D.C.

Of all these commissions in the late 1930s, none matched in importance *Lobster Trap and Fish Tail* (1939), the fifteen-foot-long mobile Calder was commissioned to create for the staircase in the Museum of Modern Art's new, International Style building, designed by Philip Goodwin and Edward Durell Stone, which opened its doors on West Fifty-third Street on May 8, 1939. The inauguration was planned to be more or less simultaneous with the opening of the World's Fair on April 30; the entire museum was taken up with a show geared to fairgoers. It was called "Art in Our Time," and contained more than three hundred works, ranging from American folk art and works by Cézanne and Renoir to the achievements of contemporary artists, including two by Calder, *Steel Fish* and his mobile for the entrance to the "Cubism and Abstract Art" exhibition. On May 8, two days before

Calder's The Four Elements *(1961) as permanently installed in front of the Moderna Museet in Stockholm.*

Calder. Six maquettes for Percival Goodman's design for the Smithsonian Gallery of Art, 1939. Wood, sheet metal, wire, lead, and paint, dimensions variable.

the official opening, there was a dinner in the Trustees' Room on the penthouse floor of the new museum. Calder had designed especially for the occasion what Russell Lynes, in *Good Old Modern,* his history of the museum, described as "silver candelabra which looped their way among greens and lilies down a long table set with glasses for three wines."[39] On the night of May 10, there were forty dinner parties, arranged by trustees and committee members. Louisa borrowed an elegant dress from Joella Levy. She wore on her head a lacy concoction of brass wire, "crowned with real flowers, that Sandy had made for the occasion."[40] Alvar Aalto was at the opening in tails, Maire Gullichsen recalled. She was wearing "enormous Calder jewelry," she told Aalto's biographer, Göran Schildt, adding, "In those days 'all the right people' wore Calder jewelry."[41]

Calder's *Lobster Trap and Fish Tail,* his permanent contribution to the new museum, was a most curious construction, a joining of three apparently irreconcilable parts. At top was what I imagine to be the fish tail, a shape red on one side and yellow on the other with colored fins, suspended directly from the ceiling. Then, balanced beneath, were at one end what I imagine to be the lobster trap, an openwork sort of rib cage, and on the other end an array of nine black petal or leaf shapes, set as if on a stalk. Revolv-

ing year after year in the museum's stair-
well, which was inspired by a stairwell
that Gropius had designed at the Bauhaus
in Dessau a decade earlier, the mobile
has fascinated visitors since that opening
night in 1939 with what Sweeney called
its "inexhaustible shadow-play."[42] Its
meaning remains enigmatic. The title, as
pointed as any in Calder's work, sounds
almost like something out of the *Fables
of Aesop* that Calder had illustrated a few
years before, as if the fish tail and the
lobster trap were elements in an allegory,
competitors for some prize. I am tempted
to argue that the fish tail, a sort of spine,
is all internal, the lobster trap, a cage, all
external. Each configuration suggests
growth, whether the growth of a spine or
a rib cage or a branch of a bush or a limb
of a tree. Is the mobile somehow a medi-
tation on the animal, vegetable, and min-
eral kingdoms? Does the fish tail stand

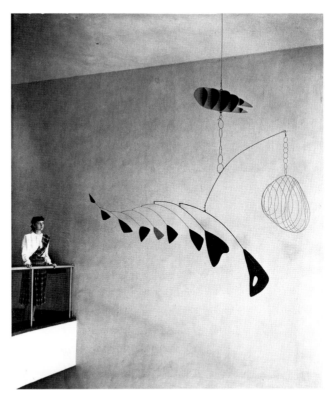

Calder. Lobster Trap and
Fish Tail, *1939. Sheet
metal, wire, and paint,
102 x 114 in. The
photograph, from 1949,
shows the mobile as
permanently installed in the
stairwell of the Museum of
Modern Art, New York, for
which it was designed.

for animal, the panoply of abstract leaves or petals for vegetable, and the
trap made of metal for mineral? Who can say?

Nanette and Stirling were at the opening of the Modern's new building.
In a letter, Nanette told Peggy that they "went early and had a look around
before the mob arrived. Many canvases we knew but many more—all very
interesting. But the mob was terrific when we were ready to leave nearly
eleven o'clock. We missed Sandy and Louisa."[43] Their son and his ele-
gantly turned-out Medusa were no doubt just then arriving from one of
those forty dinner parties. Whatever reservations Nanette and Stirling had
about the work that Sandy and his friends were making, they were also
excited about what the new generation was up to. They were glad to display
Sandy's abstract sculpture outside their house near Pittsfield, Massachusetts.
And when Sandy stored an abstract painting by his friend Jean Hélion in
Stirling's studio, Stirling hung it up so he could study it. Clearly, the old man
was taking an interest. In 1937, Nanette had written delightedly to Sandy's
sister about being at a dinner where films and photographs of the Interna-
tional Exposition in Paris were shown, and how she and Stirling had been
able to catch at least a glimpse of Sandy's *Mercury Fountain*. One man—

who, as it happened, had met their son—told Stirling and Nanette that "he admired the fountain and tried to get a photograph—but the shining mercury baffled him." Another man, who taught at Princeton, showed movies of the fountains, including "a good one of the mercury but it was passed before you could see it as you would wish." Nanette told Sandy that the Princeton professor praised the proportions of the fountain, observing that the juxtaposition of "the mercury and the dark iron" was "splendid."[44]

Nanette was perfectly at home with the Princeton professor's formal analysis of her son's *Mercury Fountain*. She was a modernist—a woman attuned to formal values. The notes she wrote in her later years were full of striking ruminations, both on art and on literature. She praised a nude by Picasso at the Museum of Modern Art, contrasting its particular values with "an Ingres perfection." She grappled with a story by Dylan Thomas, "The Orchards," her first reaction, that it was "crazy," eventually modified by her sense that there "was a natural sequence of thought reveled in by one accustomed to indulging in such thoughts. Almost like a fountain spouting." When she wrote that "black is the ultimate background of space and of consciousness," she could have been considering her son's mature work.[45] Black was Calder's favorite color—if, indeed, it can be called a color.

VII

What I take to be the abstraction of a lobster trap in *Lobster Trap and Fish Tail* might be regarded as a throwback—to the wire works of the 1920s or to an act in the *Cirque Calder*. Calder's visual and imaginative appetites would always be cyclical, a spiraling evolution of concerns, with changes and transformations in his work not infrequently bringing him back to reconsiderations of earlier images and ideas. While the gifts of the storyteller and the satirist with which he had emerged in the late 1920s would for periods of time be banished from his sculpture, they would always reemerge, whether in the illustrations for a book or the animal forms in a piece of jewelry.

Calder had begun making jewelry when he was a child, gifts for his mother and his sister. We have already seen that by the end of the 1920s, perhaps inspired by his friend the fashion designer Babe Hawes, he had begun to regard jewelry as a potential source of income. He may have had a show of some jewelry in London around 1930. And he may have had some discussions around that time with Thérèse Bonney, the photographer who took an interest in the artist and his jewelry and was acting as a go-between for well-to-do Americans and American businesses on the lookout for unusual

luxury items produced in Paris. Calder's sister had tried to sell some buttons and buckles in the Bay Area in 1935. And he told her that he had "made a lot of stuff for Dilkusha (a couturière) in Paris"—she seems to have produced sportswear.[46] Calder would never again pursue jewelry as a moneymaking proposition with the singular intensity that he did in the late 1930s and early 1940s, although even then, as we have seen in his discussions with Cordelia Pond, he had grave reservations about exhibiting his jewelry alongside his sculpture. In 1938, when Aalto returned to Finland, Calder sent a significant number of pieces of jewelry along with him, and Maire Gullichsen exhibited them at the Artek Gallery. In the early 1940s, Wallace Harrison's wife, Ellen, made efforts to find an outlet in Washington, D.C., where they were living at the time. There was a show of jewelry at the Arts Club of Chicago in 1943.

The most sustained efforts to sell jewelry in New York were mounted by Marian Willard, in the gallery she opened on West Fifty-seventh Street in 1936, when she was in her early thirties. Willard had gotten to know and begun to collect Paul Klee's work while attending lectures by Carl Jung in Switzerland. In the 1940s, Willard introduced the work of Morris Graves and Mark Tobey to New York; she was also an important earlier supporter of the sculptor David Smith. She mounted two shows of Calder's jewelry, in December 1940 and December 1941, unabashedly directed toward the holiday shopper. She was a member of Calder's circle, explaining to him in a letter in November 1940 that she'd been at dinner at Josep Lluís Sert's, where Léger had begun to talk about how Calder's jewelry might best be displayed. Apparently Léger had been at Paul and Francine Nelson's, and Francine, who was a weaver, had suggested that Calder's necklaces might be hung on panels of handwoven material. The prices for the pieces, many in brass and silver wire, ranged from ten or fifteen dollars for rings and cuff links to more than a hundred dollars (nearly $1,700 in 2017 currency) for elaborate necklaces. But as Willard pointed out to Calder in the run-up to the second show, in the fall of 1941, it was best to focus on the smaller items, as those were what sold. Willard managed to get some coverage in *Harper's Bazaar* and other fashion magazines. George Hoyningen-Huene photographed a model in a matching necklace and cuff. And there is a charming photograph by Herbert Matter of his beautiful wife, Mercedes, doing the honors as a fashion model with a spiral pin close to her neck.

The list of people who bought jewelry from the 1940 show is a fascination. Paul Rand, the young man destined to be America's most original graphic designer, purchased silver cuff links and a circular brass pin for twenty dollars. Gerald Murphy, the friend of Picasso's and Noël Coward's who had

designed the sets and costumes for the Swedish Ballet's *Within the Quota*, bought a silver bracelet and a comb. The collector Paul Mellon bought gold cuff links. By the time all the receipts from the December 1940 show were counted, in March 1941, Calder had netted something in the neighborhood of $1,000, considerably more than he was making from his sales of sculpture with Pierre Matisse. By the time of his Museum of Modern Art retrospective in 1943 (which did include a selection of jewelry), Calder was less inclined to have exhibitions of the jewelry. He had always prided himself on the pieces being unique. In 1941, when Willard suggested having duplicates made, he wrote to her, "I really don't like the idea of having things duplicated and made up by other people. . . . I would rather keep the thing on the 'objet d'art' basis even if some people have to go without."[47] To his sister, he commented that "the idea is that they are not manufactured and so there are comparatively few of them."[48]

Calder was still very much an heir of the Arts and Crafts traditions he had first encountered as a boy in Pasadena. He believed in the unique object, its form emerging from the hands of a skilled artist or craftsman. His parents had collected Native American jewelry, so those forms were familiar to him. Years later, when he visited an exhibition of small metal objects from the Russian steppes with his friend the Italian critic and curator Giovanni Carandente, he admired some fibulae and amulets in spiral-shaped bronze

Installation view of the exhibition of Calder's jewelry at the Marian Willard Gallery in New York in 1940.

and announced, "The first sign man traced as a symbol was the spiral." In his book about Calder's work, Carandente went on to point out that this was the same spiral "that reappears so variously and successfully in his own jewelry, gouaches and objects."[49] By the late 1940s, Calder was making jewelry mostly as gifts for family and friends. But there were exceptions. In 1946, Keith Warner, who owned a leather manufacturing company and was both a collector and a friend, wanted something for his wife in gold, which Calder told him was much more difficult to work with than silver or brass. Calder proposed as payment to double the needed amount of gold wire, so he could fashion "some more things of gold for Louisa, and for the kids (as 'heirlooms')."[50] Over the years, Calder took a particular delight in making pins with elaborate designs that somehow incorporated the initials of the women for whom they were destined. When he was profiled in *The New Yorker* in 1941 by Geoffrey T. Hellman, "a young matron customer of his" was quoted as announcing, "with perceptible relief," that "his initialed things are so complicated that you can remarry and it's still all right."[51]

Mercedes Matter wearing a Calder brooch (c. 1938) in a photograph taken around 1940. Photograph by Herbert Matter.

Writing in the catalog of the Museum of Modern Art retrospective in 1943, Sweeney—whose wife, Laura, naturally owned a good deal of Calder jewelry and had, in fact, bought something at Willard—suggested that for Calder, jewelry was an integral part of his artistic ecology. Making jewelry provided an escape valve for the comic and whimsical impulses Calder's major work couldn't always contain. Sweeney wrote that "the beauty of his jewelry lies primarily in its decorative linear qualities." But he went on to argue that "just as its technique and its linearism had roots in Calder's early wire sculptures, the grace of its lines and the fantasy of its forms had their echo in a new departure in Calder's constructions of 1941 and 1942," in what he described as a turn toward increasingly playful and biomorphic or zoomorphic forms. Sweeney suggested that "the fantasy of some of the finest jewelry has its larger realization in mobiles such as the *Cockatoo*, or the delicate mobile bars of the *Hour Glass*."[52] To turn to jewelry—or to the making of kitchen utensils and hardware, as Calder would so often in Roxbury in the 1940s—was to reengage with the primal act of creation, to experience the mystery of *Homo faber* in its most elemental form. Jewelry, which helped to pay the bills in the 1930s and 1940s, was also shaking up

Calder's imagination, suggesting fresh avenues of exploration.

VIII

Before the exhibitions of jewelry at Marian Willard's gallery, amid the creation of *Lobster Trap and Fish Tail* for the Museum of Modern Art and the *Water Ballet* for the World's Fair, there was the birth of Mary Calder on May 25, 1939. She was named after the sister Louisa loved the most, the sister who married E. E. Cummings's great bohemian buddy William Slater Brown. Sandra was already four years old, so it must have seemed a good time to have another child. Calder claimed in his *Autobiography* that Sandra "had wanted a baby for the last four years"—surely an exaggeration.[53] Louisa, naturally, didn't want to

ABOVE *Calder. Necklace for Louisa, 1937. Gold wire and cord, diam. 11¾ in. Choker for Louisa, c. 1948. Gold wire, 5¼ x 4¾ x 1 in.*

OPPOSITE, TOP LEFT *Calder. Earrings, c. 1940. Silver wire, 4¹⁵⁄₁₆ x 2⁹⁄₁₆ in. each. Display head for jewelry, 1940. Sheet metal, wood, and paint, 15¼ x 5½ x 3¼ in.*

OPPOSITE, TOP RIGHT *Calder. Bug brooch, c. 1942. Silver and steel wire, 5⅜ x 2¾ in.*

OPPOSITE, BOTTOM *Calder. Bracelet, c. 1932. Brass wire, 5½ x 2 x 3⅜ in.*

be in remote Roxbury for the pregnancy—nor, now a mother with a daughter, did she consider retreating to her own mother in Concord—so they spent the winter of 1938–39 in New York, on East Eighty-sixth Street.

Years later, Calder remembered the name of the doctor Louisa had, as he said, "chosen" for this second delivery: Dr. Richard N. Pierson of Doctors Hospital. After all the troubles that had accompanied Sandra's birth, Calder was depending on Dr. Pierson to see Louisa safely through the new child's arrival. A cesarean was planned, and Louisa's recovery was so speedy that she was home in two days. Louisa's mother, a Christian Scientist, had obtained the services of a healer in Massachusetts, as Calder remembered

it, "to 'work on Louisa' in absentia." Sandy and Louisa didn't object—they would take whatever they could, medicine or magic, to get Louisa through this pregnancy and delivery—but they were anything but Christian Scientists, and Louisa, as Calder recalled, "never dared tell Pierson of this treachery."[54] To his sister, Peggy, in California, Calder sent a birth announcement in the form of an illustration, the page divided into six horizontal zones. At the top was the knife with which the cesarean would be performed. Below was Louisa, cut open. Below that was the crying baby. Then the needle and thread that closed the incision. Then "O.K. o.k." And then a circle enclosing Calder's round, smiling face, and his signature—"Sandy." As playful as that little picture story was, it also suggested all of Calder's perfectly understandable fears, with the woman he loved more than anybody else on earth literally under the knife.

Sandy and Louisa wanted to have somebody in the house to care for Sandra while Louisa was in the hospital as well as in the aftermath of Mary's birth. The first woman they hired, an old Scottish lady (perhaps Calder, with his Scottish background, thought that a good omen), seemed to be frightening Sandra and was quickly let go. The second one, a pretty young blond German by the name of Senta—who apparently got Sandra out of bed in the morning by plying her with candy—left not long after, saying that "she

Calder. Illustrated letter to Peggy about the birth of Mary, 1939.

had to leave, because Der Führer was calling everybody back into Germany." That spring, they were mostly back in Roxbury, now with their two little girls, the family complete. Calder commented that it might have been because of the cesarean that Mary's head was "so round."[55] As time passed, but maybe even at the beginning, it seemed that each of the girls embodied more of one of her parents' characteristics. Sandra certainly had Louisa's aristocratic physical beauty, as well as her emotional reticence. Mary seemed to be more her father's child—with her open, almost comical air, and the what-the-hell impulsive manner that perhaps went back to Calder's mother. Herbert Matter took a great many baby photographs, beginning with a classic shot of the buck-naked Mary on her stomach on a sheet, her head already raised, supported by a strong neck; that must have been some months after she was born.

Perhaps most memorable was a photograph Matter took in Manhattan in the last months of 1939. Mary was in a carriage, a teething toy in her mouth, looking at her

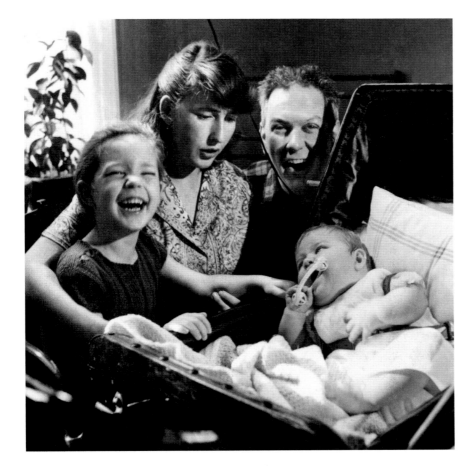

sister. Sandra, who now has the baby her father said she'd yearned for, is laughing at the camera, while Calder cracks a big smile and Louisa, always the meditative one, looks pensively down at her younger daughter. As Seán Sweeney, one of James Johnson Sweeney's children, would recall many years later, "From the beginning, at the beginning of the war, baby Mary was always there. First, with her big sister, Sandra, as I was with my big sister, Ann. That was when the Calders had an apartment on the Upper East Side in Yorkville. There was a Christmas party with a real tree with real Christmas candles in tin holders which Mr. Calder had made and attached to the branches."[56] A new generation was joining the parties that had already been going on for a decade.

Calder with Louisa, Sandra, and Mary Calder, 1939. Photograph by Herbert Matter.

THE CLASSICAL STYLE

I

There is a time in the lives of a few lucky artists when everything they've been grappling with—all the images, motifs, themes, structures, ideas, and ideals—comes together in a singular, purified, clarified form. That's what happened to Calder at the very beginning of the 1940s, when an already extraordinarily rich and variegated achievement resolved into what can only be called a classical style. Some of Calder's earlier work has a rambunctious immediacy and urgency that occasionally disappears in this high, classical moment. And in the years to come, even as he continued to build on the discoveries of the early 1940s, Calder managed to infuse his work with fresh complexities and even achieve effects perhaps emotionally deeper or more dramatic. But whatever he'd done before and whatever he would do after— and that before and after contain some of his masterpieces—the avowals of the early 1940s, ranging from the plunging mobile *Eucalyptus* (1940) to the imposing stabile *Black Beast* (1940), have a stand-alone authority. A personal vision has been honed to an essentialism that includes everything and, thus, suggests a univeralism. In *A Portrait of the Artist as a Young Man,* Joyce described the process in this way: "The personality of the artist, at first a cry or a cadence or a mood and then a fluid and lambent narrative, finally refines itself out of existence, impersonalises itself, so to speak. The esthetic image in the dramatic form is life purified in and reprojected from the human imagination."[1]

The creation of a classical style—sometimes the style of an individual, sometimes the style of a group of artists or of a time or a place—is among the most mysterious of all artistic developments. Charles Rosen, in *The Classical Style,* his study of Haydn, Mozart, and Beethoven, argued that "the creation of a classical style was not so much the achievement of an ideal as the recon-

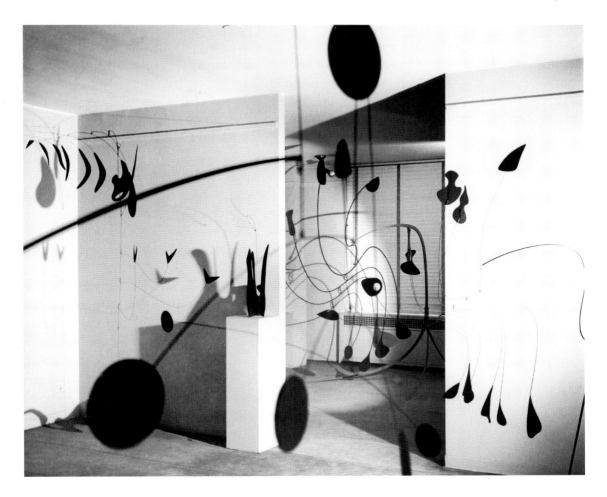

Installation view of Calder's exhibition at the Pierre Matisse Gallery in New York in 1940. Photograph by Herbert Matter.

ciliation of conflicting ideals—the striking of an optimum balance between them."[2] And that surely makes some sense when one thinks about Calder, who had experimented in the 1930s with the ideal of pure geometric forms as well as with an abstraction that alluded to nature (to trees, insects, animals). The art historian Sydney Freedberg, writing about Leonardo da Vinci and classicism in his *Painting of the High Renaissance in Rome and Florence* could almost have been describing Calder's art when he wrote of Leonardo's late drawings of catastrophes as presenting "a unity of substances and energies inextricably intertwined, and moved by terrible and splendid forces." Freedberg offered a somewhat different and more metaphysical definition of classical style than Rosen; this also finds echoes in Calder's art. Freedberg spoke of the need "to achieve a harmony of regular, clear and proportionate relations that is not evident in nature and, at the same time, to assert that this harmony pertains to an existence which is compellingly true."[3] Freed-

berg, contemplating the idealized figures of Leonardo, Michelangelo, and Raphael, was of course dealing with an entirely different formal language than Calder's. But there is little doubt that *Black Beast* and *Eucalyptus* offer a harmony that is not evident in nature and yet feels compellingly true. The "optimum balance," the "compellingly true" harmony—these are reclaimed in different ways through the centuries, in Raphael's *Stanze* in the Vatican, in Poussin's Sacraments, in Chardin's still lifes, in Corot's figures, in Braque's *Homage to J. S. Bach,* in Brancusi's *Bird in Space,* in Mondrian's Neo-Plastic compositions of the mid-1920s—and in certain Calders of these years.

It was in exhibitions at the Pierre Matisse Gallery in May 1940 and then again in May 1941 that this new force and lucidity in Calder's work became apparent. Robert Coates, Calder's neighbor and friend in Connecticut, described it in *The New Yorker* as an "imaginative elasticity."[4] And a reviewer in *Art News* described the mobiles in the 1941 show as "bigger, simpler, more plastic, and somehow more important than any he has shown to date."[5] These new avowals were at once infinitely complicated and astonishingly direct. Although Calder had been an original from the first appearance of his wire figures in Paris roughly a dozen years earlier, it was only now, after his fortieth birthday, that all the competing impulses in his imagination were settling into a classical pattern. The new studio in Roxbury—larger, more open, more light-filled than any he'd had before—played a part in this heroic turn. And Calder's physical distance, at least during the long summer months, from the urban artistic centers that had nourished him may have played a part as well, allowing him to dig deeper into the pressures and counterpressures of his own imagination. Calder rarely spoke about the keen attention he paid to the rural settings in which he would pass much of the rest of his life. But at least on a couple of occasions, decades later, when he lived in a village in the Touraine, the young French photographer Clovis Prévost found Calder pointing out to him the way a vine wrapped around a tree or a farmer locked a gate with a tiny piece of wire or the moon shone in the night sky.[6] We know that Calder noticed such things and that they nourished the purified naturalism of his art.

II

By 1940, Calder had pretty much abandoned the use of motorized or crank-driven mechanisms for his kinetic objects. He may well have been feeling, as his friend Sweeney suggested in the brochure for the Springfield show, that among artists there was all too much of "a romantic adulation of the machine."[7] The avant-garde fascination with the poetic possibilities of

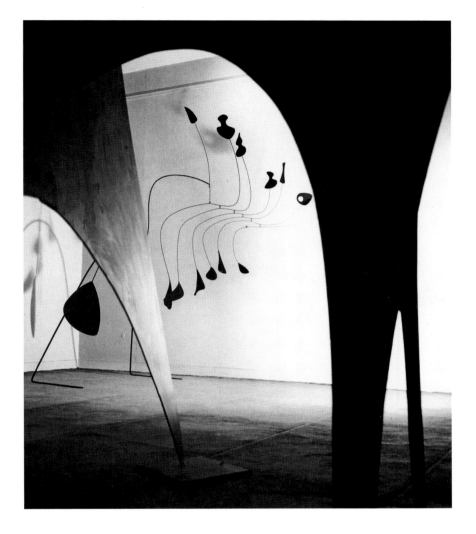

mechanized and even robotized movement, both at the Bauhaus and among Constructivists all across Europe, had inspired a machine age style that was by now being embraced by captains of industry for their marketing campaigns. The 1939 New York World's Fair made this abundantly clear. Although Calder craved a larger role in those goings-on, he could also see that technology was outrunning art. He didn't approve.

In the August 1939 issue of *Theatre Arts Monthly* that included Calder's essay about his *Water Ballet*, there was a more general report on events at the fair. The fair was described as "a show—this World of Tomorrow—of mechanical men, beasts, buildings and machines; of animated puppets, murals, dioramas and aquaramas; of engineering and electrical marvels; of light and color; crowds and carnivals, waving flags and martial music." It was, Morton Eustis wrote, "a show which has gone to the theatre, and to the

Installation view of Calder's exhibition at the Pierre Matisse Gallery in New York in 1940. Photograph by Herbert Matter.

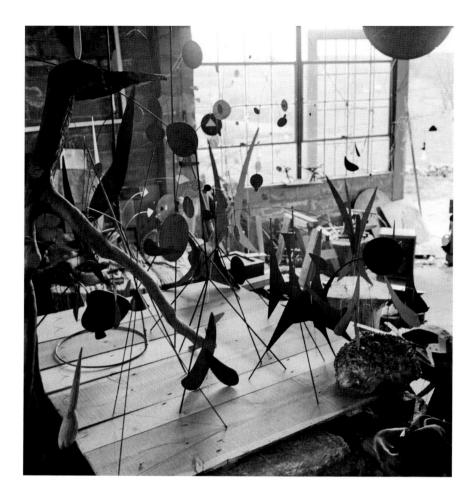

The Roxbury studio in 1941, with Apple Monster *(1938),* Yucca *(1941),* Black Beast *(maquette, 1939), and* Myrtle Burl *(1941). Photograph by Herbert Matter.*

men of the theatre, for inspiration," but which also trumped most of what a theater person would think of as theater through the overwhelming scale of its effects.[8] Calder was a master of the animated puppet, of engineering marvels, of light and color, of men and beasts. Years later, he created stabiles imposing enough to easily hold their own amid all the spectacles, blandishments, and confusions of a world's fair. But Calder's unshakable allegiance to older forms of artisanal technology left him utterly unsympathetic—and totally immune—to what had already become machine age clichés.

In his Roxbury studio, in the midst of a community where farmers who were still working the land had barns full of machinery dating back to an age before electricity and the automobile, Calder was simultaneously simplifying his means and purifying and deepening his meanings. He was still the little boy tinkering in the shop his parents had provided for him, but now with the artistic imagination of a mature man. Writing in 1939 in *Plus,* a magazine

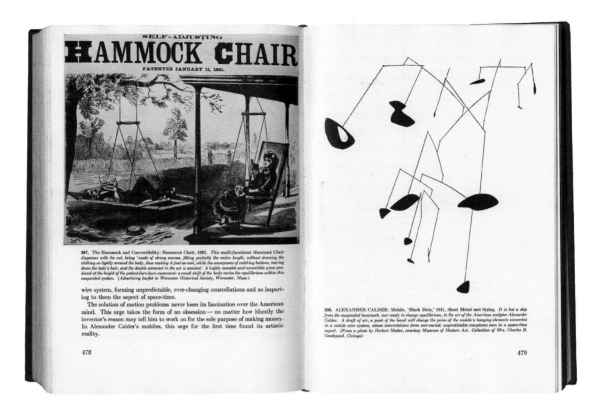

wire system, forming unpredictable, ever-changing constellations and so imparting to them the aspect of space-time.

The solution of motion problems never loses its fascination over the American mind. This urge takes the form of an obsession — no matter how bluntly the inventor's reason may tell him to work on for the sole purpose of making money. In Alexander Calder's mobiles, this urge for the first time found its artistic reality.

478

479

Double-page spread from Sigfried Giedion's Mechanization Takes Command *(1948) with Calder's* Black Dots *(1941) reproduced with a nineteenth-century illustration of hammocks.*

with which Herbert Matter was involved that was published as a supplement to *Architectural Forum,* Sweeney reiterated his comments about the romantic fascination with the machine age, which had begun early in the nineteenth century. "New materials, new forms, unlimited possibilities opened up toward a new plastic idiom were clearly recognized; but the romantic adulation of the machine . . . made an honest plastic approach, for the time, next to impossible." Sweeney emphasized "Calder's recognition of the potentialities of the surprise-factor in free rhythms," and the way his "ingenious, yet unaffected use of it served at once as a tonic and purge."[9] Some years later, when Katharine Kuh asked Calder what had influenced him more, "nature or modern machinery," he said, without hesitation, "Nature. I haven't really touched machinery except for a few elementary mechanisms like levers and balances." Looking back on the mechanized mobiles, he remarked, "The motorized ones are too painful—too many mechanical bugaboos. Even the best are apt to be mechanically repetitious."[10]

To Sigfried Giedion, the architectural historian who had been Cordelia Pond's guest for the opening at the Springfield show, the Calder emerging in the early 1940s "was rooted in the nature of American experience. America

had produced a tremendous body of inventions strongly affecting American life. But artistically, on the emotional side, they had not spoken"—at least not until now, not until Calder.[11] In a curious, brilliant, and too little known essay, "The Hammock and Alexander Calder," published in *Interiors* in 1947—it was in large part incorporated into Giedion's book *Mechanization Takes Command* the next year—Giedion began by writing about the hammock, "with its airy network and continuous ventilation," and the fascination this floating furniture inspired among the first visitors from Europe to the Americas, including none other than Christopher Columbus.[12] Giedion—a European who was becoming, at least for the time being, an American—was fascinated by the hammock, which by many reckonings was an indigenous American invention. He traced with some humor nineteenth-century attempts to improve upon what was a very old idea and in the process nearly wreck it, including a mechanized hammock, a hammock combined with mosquito netting, and a hammock merged with a tricycle. From all this Giedion shifted—with evident relief—to Calder. He wrote that "from this hovering system, ever ready to change its poise, there is but a step to the art of the American sculptor, Alexander Calder. Both are intimately rooted in American surroundings."[13]

Giedion was far too scrupulous and sober a student of the history of art to argue for some causal relationship between the free-floating movements of the hammock and the free-floating forms in Calder's mobiles. He wanted to suggest some deeper affinity in terms of the elegance and simplicity of New World innovations. "The inventions were at hand," Giedion wrote. "They were useful. They yielded returns. But no one had pointed to them. No one had hit upon the symbolic content underlying their everyday usefulness."[14] The ease of the hammock—this suspended bed designed for comfortable sleep in the warm Caribbean climate—suggested the poetic ease of the mobile, a floating world coming to fruition in the New World.

III

Now as never before, Calder was joining science with sensibility, the engineered with the empathetic. Very few artists had ever really done that, and no artist since Leonardo da Vinci had studied as closely not only the poetics but also the mechanics of forms moving through air. The idea of reimagining the scientific method in a more intuitive and lyrical spirit certainly interested the Surrealists, and Calder may have been emboldened by discussions going on among his Surrealist friends and their friends in the 1930s. André Breton

liked a term coined by the philosopher Gaston Bachelard in his essay "The New Scientific Spirit," where he spoke of an "open rationalism," which he contrasted with a "closed" or "ossified rationalism." Calder's friend Christian Zervos wrote that "In the science of our day, which holds some points in common with Greek science before the Platonic era, a greater poetry is revealed. Excessive precision is suppressed." And in an essay entitled "Celestial Bodies" published in the luxurious art magazine *Verve* in 1938, Georges Bataille wrote of "the galaxy's whirlwind" and the mistake men had for so long made in imagining a "stationary earth."[15]

For Calder, physics was not a matter of theories in a textbook—although he certainly grasped the theories—but of sensations registered through the immediacy of nature. Physics was physicality. It was as simple as that. Physics wasn't something he picked up as an adult, as was probably the case with some of his Surrealist friends, who regarded scientific ideas as intellectual baubles. Calder had been grappling with the fundamentals of physics since he was a boy. The scientific imagination and the artistic imagination had developed side by side in his life, and both of them had been grounded in the experience of nature, in what could be seen or at least deduced with the naked eye. If you have any doubt on that score, you have only to consult a textbook called *First Principles of Physics,* published in 1912, four years before Calder was studying elementary physics at the Stevens Institute. The authors began by arguing that "countless physical *phenomena* are taking place around us every day" and that all of them "are examples of matter and associated energy." They cataloged a number of everyday occurrences: "a girl playing tennis, a boy rowing a boat, the school bell ringing, the sun giving light and heat, the wind flapping a sail, an apple falling from a tree."[16] These were precisely the varieties of experience that Calder evoked in his art—sometimes literally, as in an early wire sculpture of a woman playing tennis, but more usually metaphorically, for what are the elements in a mobile if not sails flapping in the wind, fruits falling from a tree, one piece of metal clanging against another?

The lyricism of the works that Sweeney referred to as Calder's "wind mobiles" confirmed Calder's genius for turning to art's advantage an investigation of the nature of the world generally believed to be the purview of physics.[17] This investigative process had philosophical implications as well, fueled as it was by the desire, characteristic of early-twentieth-century thinkers, to see the poetry of everyday life as shaped by theretofore invisible principles and laws. Writing in his *Occult Diary* around 1900, the Swedish playwright August Strindberg, who took an interest in alchemy, remarked, "If you would know the invisible, look carefully at the visible."[18] Surely

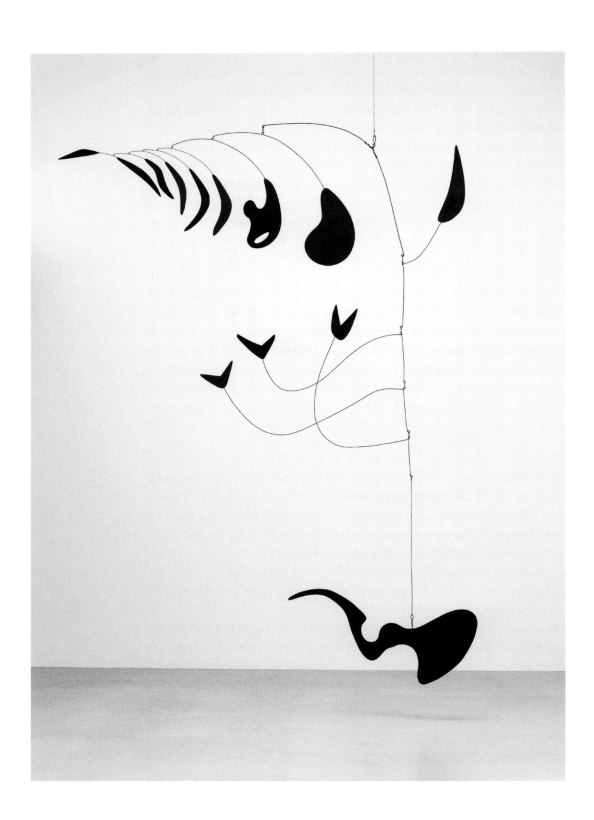

the elusive movements in the mobiles Calder began producing around 1940 were echoes or afterimages—if not indeed embodiments—of the invisible. That fascination with the hidden sources of appearances, which animated Einstein's theories about the nature of matter and Freud's, Jung's, and Bergson's investigations of the human mind, animated Calder's art as well.

IV

Consider three masterworks from the early 1940s. Each engages us at first as a singular image, with a visual rhetoric that is streamlined and bold. *Eucalyptus* (1940) is a mobile that brings together an extraordinarily heterogenous group of elements in a dramatic eight-foot plunge, with the lowest element almost grazing the ground. *Vertical Foliage* (1941), a mobile some sixty inches wide, joins nineteen closely related shapes in a trembling S-curve of a descent that is simultaneously an ascent. *Black Beast* (1940), a nine-foot-wide stabile, juxtaposes dramatically angled and subtly curved forms to suggest a tranquil muscularity—athleticism at rest. All three works are made of sheet metal and painted entirely in black, the elements held together by wire (in the case of the mobiles) or bolts (for the stabile). The methods and materials used in these works may at first appear remarkably simple. But at every point they're animated by a complicating intelligence. There are metaphors sunk into the titles and realized in the objects themselves—animal in the case of the stabile, vegetable in the case of the mobiles. But like the fragments of a violin or a sheet of music that appear in Braque's *Homage to J. S. Bach*, the metaphors burst forth only to be reintegrated into the drive toward abstraction and its purifications, so that the leaves in *Eucalyptus* and *Vertical Foliage* and the spreading limbs of *Black Beast* are evoked without ever exactly being fully defined.

Calder's comments in a number of interviews—as well as some photographs and even a few films of the artist in the Roxbury studio—give us some sense of how he arrived at this supple balance of the abstract and the nearly naturalistic. He had always been something of an improvisatory artist—you can see that in the film of him creating a wire portrait of Kiki in 1929. And as he went on, he became more and more of an improviser, employing a wide variety of formal strategies in constantly shifting patterns. Speaking with the critic Selden Rodman in the 1950s, Calder said, "I used to begin with fairly complete drawings, but now I start by cutting out a lot of shapes." He described filing and smoothing the shapes: "Some I keep because they're pleasing or dynamic. Some are bits I just happen to find. Then I arrange

OPPOSITE *Calder. Eucalyptus, 1940. Sheet metal, wire, and paint, 94½ x 61 in.*

them, like *papier collé*, on a table, and 'paint' them—that is, arrange them, with wires between the pieces if it's to be a mobile, for the overall pattern. Finally I cut some more on them with my shears, calculating for balance this time."[19] It's by no means clear when the move away from preparatory drawings began, but it's reasonable to assume that it was facilitated by the size of the Roxbury studio, where Calder could lay a great many shapes out and then pick and choose and easily move things around. *Papier collé* referred, of course, to the collages that Picasso and Braque had made by cutting shapes out of paper—sometimes including newspaper and wallpaper—and then gluing them together into compositions.

You can see the extraordinary profusion of the Roxbury studio in photographs as well as in a film made in the later 1940s. The studio had begun to suggest a sort of self-created, sublime scrap heap or excavation site, from which Calder retrieved forms that a few years later, he told another interviewer, the critic Katharine Kuh, were employed almost like *objets trouvés*—the found objects of the Surrealists. Calder also said to Kuh that if he were "seeking a new form," he still might begin by drawing, but in most instances preliminary sketches weren't necessary, because "I've made so many mobiles that I pretty well know what I want to do."[20] In the years around 1940, the act of creation began to seem effortless, inevitable—becoming and being now one.

V

A word that came up time and again in Calder's writing and in Calder's conversations was *disparity*. No term tells us more about the inner logic of Calder's studio practice in the years when he was evolving his classical style. The principle of disparity guided him as he produced and drew together the various shapes, imposing an ordering intelligence on their suggestibility. In an unpublished statement from 1943, Calder announced: "To me the most important thing in composition is <u>disparity</u>. . . . Anything suggestive of symmetry is decidedly undesirable, except possibly where an approximate symmetry is used in a detail to enhance the inequality with the general scheme."[21] Some years later, speaking to Katharine Kuh, Calder said, "My whole theory about art is the disparity that exists between form, masses and movement."[22]

The word *disparity* doesn't crop up that often in the conversation of other artists; they're more inclined to speak of asymmetries and dynamics. At this point, it's worth considering that when Calder was still living with his par-

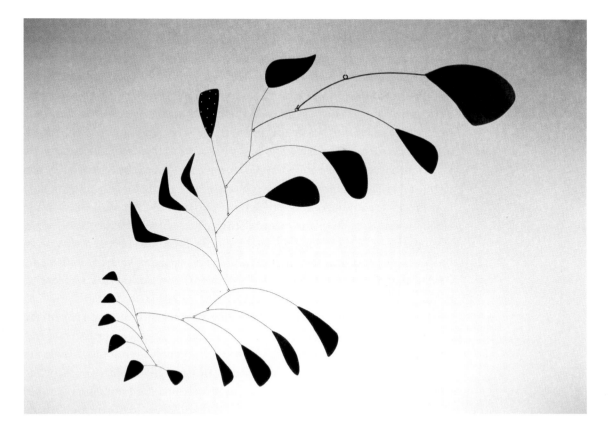

Calder. Vertical Foliage, *1941. Sheet metal, wire, and paint, 53½ x 66 in.*

ents in New York and studying at the Art Students League, his father urged him to go hear the artist Jay Hambidge lecture on dynamic symmetry, an idea about the grounding of even naturalistic art in certain geometric laws that went back to the classical temples of the ancient Greeks. At the time, Calder found Hambidge's ideas stuffy and academic, and he later recalled dismissing Hambidge and his interest in the golden ratio, mocking it as "a lot of bunk," supposedly "arrived at by combining the Parthenon with a Sunflower—or something."[23] That may not be far from the truth, and yet thirty years later, Calder remembered going to hear Hambidge, and he wrote about it in the autobiographical notes he prepared for Bill Rogers. My guess is that what Calder objected to in Hambidge wasn't the focus on symmetry or even on the dynamics of symmetry so much as the systemization of artistic dynamics. "There's no formula—but using your senses," he wrote in his autobiographical notes.[24] "My fingers," he continued, "always seem busier than my mind."[25]

What's so interesting about Calder's preference for disparity over asymmetry or some such related concept is that disparity brings to mind a concept

essential to the thinking of physicists and mathematicians: that of parity. In physics, parity refers to the relationship between a phenomenon and its mirror image, most simply described as P: (a) → (–a). One need not grasp much about the physics of such an idea—the idea goes as far back as Newton but also figures in quantum mechanics—to see that Calder was always playing with parity and disparity. And when he linked this, as he did in a conversation with Kuh, with "masses and movements"—which is close to the physicist's twin essentials of mass and energy—we have an essential key to how Calder proceeded in his work. Consider the ceaseless workings of parity and disparity in *Eucalyptus* and *Vertical Foliage*. The string on which the mobile is suspended from the ceiling precipitates a first lesson in parity, because the elements on one side of that central string must balance those on the other. That parity is, in turn, complicated by all the disparities between what is on one side and what's on the other. The value of a particular shape with a particular mass is reshaped by its relationship with the central axis, because its distance from that axis affects the amount of energy it exerts.

In *Eucalyptus,* eight elements hovering horizontally on one side of the central axis balance five elements on the other side of the central axis; the five elements follow a decidedly downward path, even though four of them are attached to wires that turn gently upward. In *Vertical Foliage,* it's practically two against seventeen, with only the largest element and one other arrayed on one side of the central axis. Likeness and unlikeness perform an intricate dance in these works. Most of the shapes are attached to one end of a wire that at its other end is attached to another wire, which bears a shape at one end and at the other end attaches to yet another wire. So a pattern is repeated. But nearly every wire is a different length, with a somewhat differing arc angled somewhat differently. The forms that rise are often arranged on wires that descend, so that the going up is also a going down—and vice versa. The dynamics are always shifting. In *Eucalyptus,* one might identify four or five clusters of forms: six or seven long, podlike leaves; three V-shaped elements; one element with a hole; and one far more complex element, the slithering, curvilinear shape that suggests the liquidity of Toulouse-Lautrec's Art Nouveau arabesques. In *Vertical Foliage,* one element is distinguished from the eighteen others because it has been drilled with thirteen tiny holes. Such groupings are complicated by the shifting alignments and realignments of forms. Groupings lead to regroupings; no group holds for long.

Calder's fascination with disparity helps us understand how he created his greatest mobiles. It also helps us grasp the fundamental dynamic in his work between mobiles and stabiles, and the particular place in his art of the standing mobiles, which are both stable and mobile. Speaking to Kuh, he said that

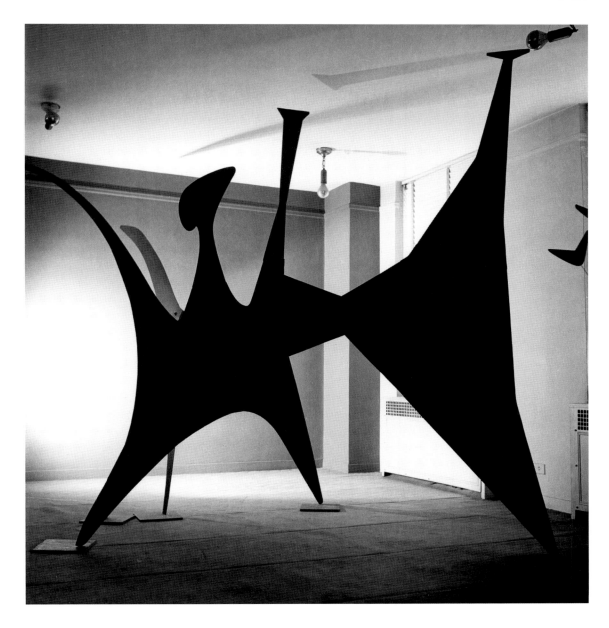

the stabile "is back at the old painting idea of implied movement. You have to walk around a stabile or through it—a mobile dances in front of you."[26] The stabile allowed Calder to emphasize the immobility of sculpture, a sense of stasis and stillness, which left some commentators in the early 1940s baffled, because they had come to expect his work to always move. A generation later, this renewed emphasis on the immobility and maybe even the imperturbability of sculpture found a sympathetic audience among younger

Calder's Black Beast *(1940) installed at the Pierre Matisse Gallery in New York in 1940. Photograph by Herbert Matter.*

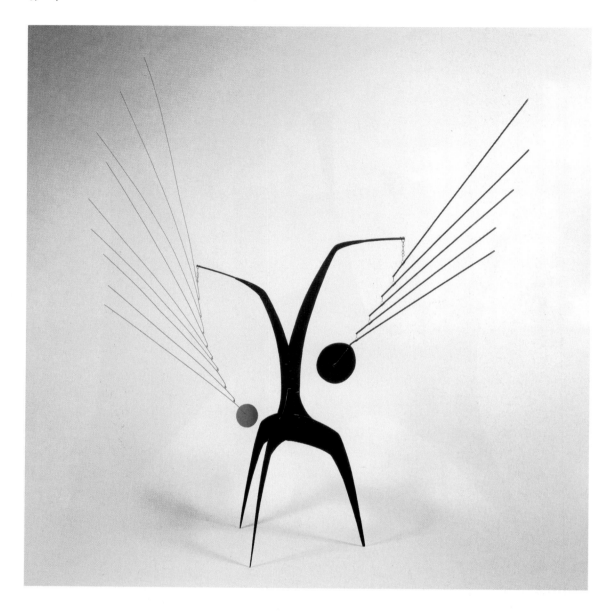

ABOVE *Calder.* Un effet du japonais, *1941. Sheet metal, wire, and paint, 80 x 80 x 48 in.*

OPPOSITE *Calder.* Red Petals, *1942. Sheet metal, wire, and paint, 102 x 36 x 48 in. Photographed in the Arts Club of Chicago in 1942.*

artists, critics, and gallerygoers, some of whom were associated with the movement that was coming to be known as Minimalism or ABC Art. What Calder may have suggested to sculptors as different as Donald Judd, Mark di Suvero, and Richard Serra was the dramatic power of stillness. In *Black Beast*, the thrusting metal planes are muscular, but the muscularity is held in check. Calder's subject might be the limits of power. When *Black Beast* was exhibited at the Pierre Matisse Gallery—and photographed by Matter—it nearly filled the room it occcupied, reaching all the way to the ceiling and

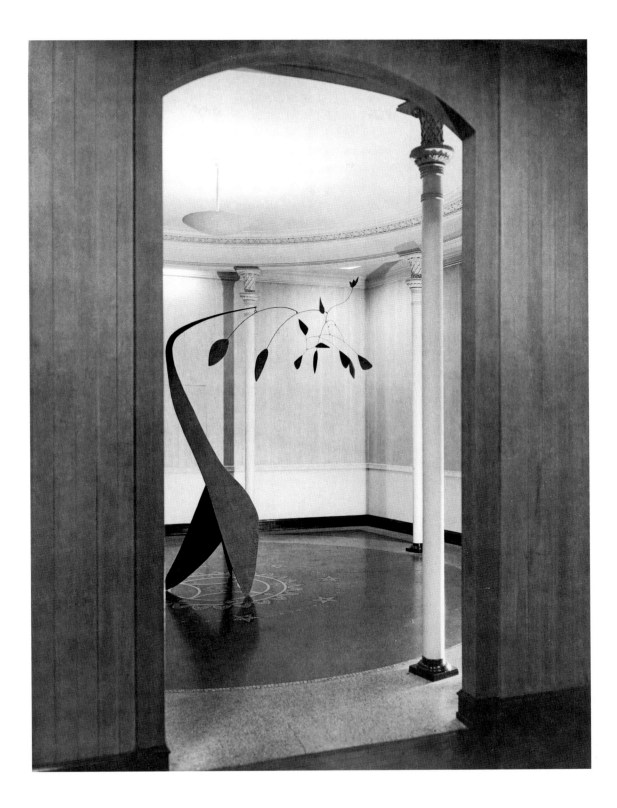

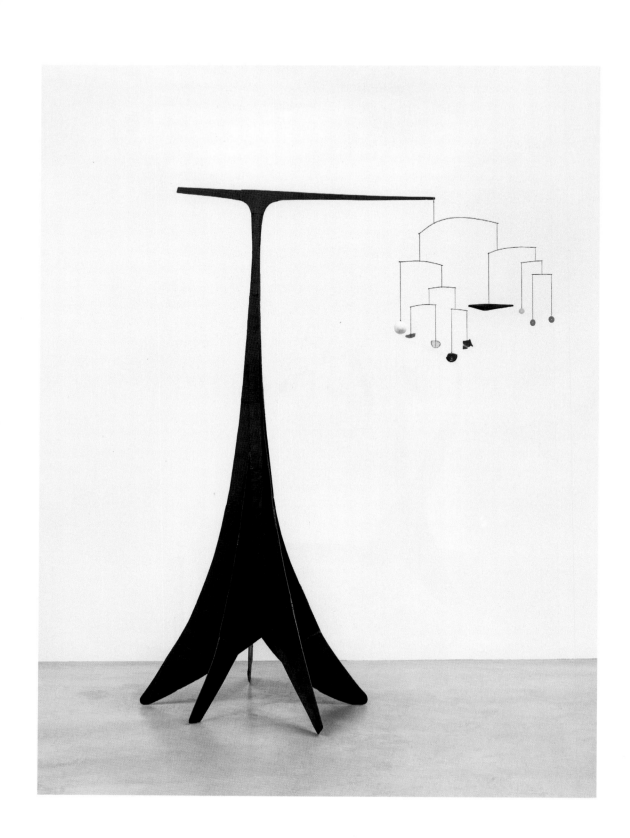

practically touching the walls. The thwarted heroicism of *Black Beast* brings to mind one of the greatest of all Hellenistic sculptures, *Laocoön*, in which the muscular figure of the Trojan priest is no match for the serpents wrapped around him and his two sons. If *Black Beast* and *Vertical Foliage* defined the most extreme disparities of Calder's art at the very beginning of the 1940s, he was also making many works during those years, especially the standing mobiles, in which he played with different kinds of disparity. *Un effet du japonais*, from 1941, is a three-legged, two-branched black stabile, from the branches of which are suspended two mobiles—one black, with five long rods and a disk; one red, with nine long wires and a smaller disk. Here we have precisely the orchestration of "approximate symmetry" that Calder discussed with Kuh some years later, the mobility of the free elements checked by the immobility of the base. Sometimes, as in *Red Petals* (1942), the biomorphism of the base is close kin to the floral shapes it proffers with its extended arm. At other times, as in *Tree* (1941), the disparity is so extreme as to become almost a form of comedy; the imposing, five-legged black base supports a horizontal arm that holds a relatively tiny mobile composed of nine variegated forms, some of them fragments of found glass. A frolicsome little mobile has been attached to a stolid, eight-foot-high post. So it's not that there aren't eccentric images among the works of the years around 1940. There are. But their idiosyncrasies are crisper and clearer than many had been a few years earlier. Calder's classical composure is now the perfect foil for his contrarian imagination.

VI

It is in the nature of classicism that its distillations remain related, in the liveliest and most vital way imaginable, to the most basic human experiences. Mozart's music, for all its elaborate sophistication, is not so far from the pleasures of folk songs or the cries of birds. The architecture of the Parthenon, for all its geometric subtleties, evokes the humblest kind of dwelling. At Calder's memorial service in 1976, the playwright Arthur Miller confessed that it had taken him time to understand his friend Sandy's art. He spoke of how "it only slowly dawned on me that this work of cold wire and sheet metal was sensuous, that the ever-shifting relationships within a mobile were refracting the same elemental and paradoxical forces in physics and human relations. Then I could begin to grasp what he seemed to be about. And of course when I told him my discoveries he looked up from his anvil and said, 'Ercaberk.' "[27] Nobody who knew Calder would have been surprised to

OPPOSITE *Calder.* Tree, *1941. Sheet metal, wood, glass, mirror, plastic, wire, string, and paint, 94 x 54 x 51 in.*

hear him mutter a dismissive, mocking "Ercaberk" when a friend hazarded a comment about the deeper meanings of his art. If he resisted such talk, it was at least in part because he had the classical temperament; he believed that the deepest meanings were rarely the hidden or buried meanings.

Nietzsche associated maturity with an ability "to recover the seriousness one had as a child at play"—which was a frank, unabashed seriousness, and thus in some sense a classical seriousness.[28] Calder's classicism grew out of his most basic feelings as a person who both early and late, as a child and as a man, knew how to play. For a man who felt that he had been framed by his parents—first by the sculptures and paintings that they made of him and later by the impact of their artistic careers, which set the stage for his—the mobile was an art form that refused to be framed. Calder's art, the art of a heavy man who was light on his feet and extraordinarily agile with his hands, was grounded in a desire to escape the frame-up and find his proper place, his proper balance in the world. The stabile and the mobile, the one always inclining toward heaviness, the other always inclining toward lightness, were his way of keeping the possibilities open. He was a man whose fierce individualism was united with an equally fierce loyalty to family and friends, and a mobile, which was by its very nature a family of forms, was also a study in familial and social relationships, something Calder made perfectly clear when, on at least two occasions, he created mobiles in which each element stood for a member of a family. The first and most interesting of these was constructed in the late 1930s for Ben Nicholson and Barbara Hepworth, who, when they were married, not only had triplets together but also raised children from Nicholson's previous marriage.

Calder's art, an abstraction of life's everyday dynamics, is absolutely autobiographical, just so long as we understand that this autobiography, as Joyce wrote in *A Portrait of the Artist as a Young Man*, "finally refines itself out of existence, impersonalises itself, so to speak."[29] What remains is Calder's abiding optimism, his belief that lightness and heaviness and the one and the many can live if not in harmony then in a disharmony that is, after its own fashion, harmonious. That optimism is the key to Calder's enduring classicism, for classicism is always inherently optimistic, a conviction that the center will indeed hold, that things, no matter how complex they become, will not finally fall apart. In the years around 1940, Calder was embracing this extraordinary optimism even as World War II was erupting and his and Louisa's beloved Europe seemed headed for the abyss. To make such an affirmation at such a tragic time was an act of artistic heroism. That optimism—a classicist's steadying, imperturbable optimism—sustained Calder through the war years. That same optimism emboldened him after the war, when he and Louisa found themselves confronting the entirely dif-

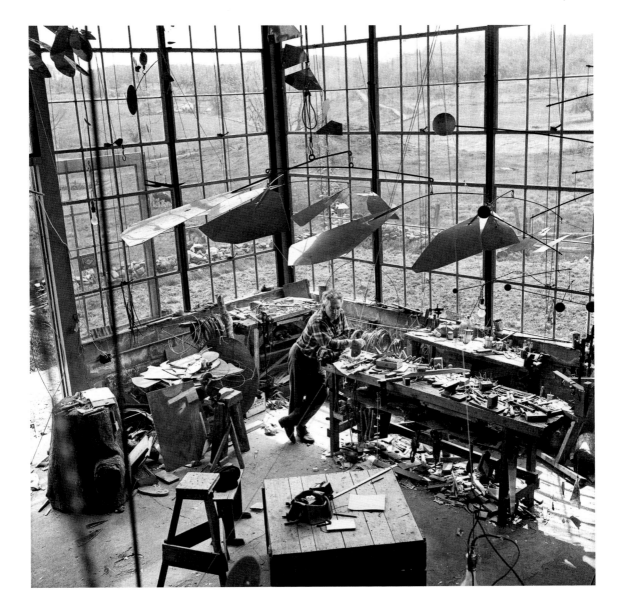

ferent challenges that came with an ever-growing international reputation. Calder embraced his unassailable position without letting it go to his head. He seized fresh opportunities while inoculating himself against the hype that fame fueled. He never abandoned the hell-bent, idealistic spirit that had animated the international avant-garde in the treacherous years between the wars. Sandy and Louisa remained to the end the bohemian optimists they had been when they first set up house together on the rue de la Colonie in Paris in 1931.

Calder in the Roxbury studio in 1941. Photograph by Herbert Matter.

ACKNOWLEDGMENTS

Carol Brown Janeway, who died on August 3, 2015, only two weeks after receiving a cancer diagnosis, knew from the moment I began work on this book in 2008 that it was going to be dedicated to her. I miss Carol's wit, spirit, trust, warmth, energy, and seriousness. She was my editor at Knopf for a decade. We became the very best of friends. She's irreplaceable.

Sandra Calder Davidson, Calder's older daughter, has been unfailing in her support. Without Sandra's generous friendship I couldn't have begun to grasp her father's character. Thank you, Sandra, from the bottom of my heart. I only wish I had had the opportunity to really get to know Sandra's younger sister, Mary Calder Rower, who died when I was only beginning work on this book.

Alexander Stirling Calder Rower—the youngest of the four Calder grandchildren, and known to one and all as Sandy—began as a collaborator and has become a great friend. Sandy's drive and discernment are matched by his openness, playfulness, and kindness. Without Sandy, the president of the Calder Foundation, none of this would be possible.

The Calder family has been tremendously welcoming. My thanks go to the three other grandchildren: Sandy's brother, Holton Rower, and Sandra's children, Andréa Davidson and Shawn Davidson. Among the great-grandchildren, I want to thank especially Gryphon Rower-Upjohn. My appreciation as well to Elan Gentry.

Among the staff of the Calder Foundation, my deepest thanks go to Susan Braeuer Dam, Director of Research and Publications, who has been and continues to be an essential partner in this ongoing biography. Alexis Marotta, Director of Archives, has made invaluable contributions. Lily Lyons, Director of Exhibitions and External Affairs, has been a tremendous friend to this project. Thanks as well to Jessica Holmes, John Sapp, Flora Irving, Jane Pakenham, Meghan Wilcox, and Beryl Gilothwest. I also want to remember Terry Erskine Roth, with whom I was already working closely at the time of her tragic death.

At Knopf, in the wake of Carol's sudden death, Sonny Mehta, chairman and editor-in-chief, and Dan Frank, my new editor, embraced this enormous

project with unparalleled vigor and determination. I am forever grateful to Sonny and Dan for being there for me—and for Calder. To the Knopf production team—this is our third outing together—I must once again pronounce myself awestruck. You're incomparable. My gratitude goes to Ellen Feldman, Maggie Hinders, Roméo Enriquez, Kathy Hourigan, Peter Mendelsund, and Andy Hughes. Many thanks as well to Betsy Sallee. And to Paul Bogaards and Jess Purcell.

Jennifer Lyons, my agent, pushed me into a meeting years ago that led to this book—that's no small thing.

If Deborah Rosenthal didn't admire Alexander Calder so much, I wouldn't have taken this on. Love, gratitude, and thanks to Nathan Perl-Rosenthal, Jessica Marglin, and Suzanne Perl-Marglin. Cheers on the birth of Emmanuelle Lila Marglin-Rosenthal. In the last year or so of his life, I had valuable conversations with my father, Martin Perl, about the engineering and physics of Calder's art. It's my mother, Teri Perl, who introduced me to the Museum of Modern Art—and thus to modern art and to Calder.

A big thank you to Duane Michals and his camera magic.

I gratefully acknowledge the support I've received while working on this book from the John Simon Guggenheim Memorial Foundation, the Leon Levy Biography Center at the City University of New York, the Center for Ballet and the Arts at New York University, the Board of Trustees of the Calder Foundation, and the Fundación Cisneros.

Some of the ideas in this book were developed in lectures presented at the National Academy Museum and School, the Princeton Art Museum, the Bard Graduate Center, and in catalog essays written for the Los Angeles County Museum of Art; Leeum, the Samsung Museum of Art; Cahiers d'Art; and the Dominique Lévy Gallery. I am grateful for the resources of the Avery Library at Columbia University, the Elmer Holmes Bobst Library at New York University, the Cooper Union Library, the New School libraries, the Museum of Modern Art Library, and the libraries and archives of the Calder Foundation, the California Institute of Technology, the Milwaukee Historical Society, the Stevens Institute of Technology, the Art Students League, and the University of the Arts in Philadelphia.

Thanks go to: Jimmy Alcock, Rebecca Allan, Hans Bak, Vivian Barnett, Stephanie Barron, André Bernard, Guillaume Blanc, Douglas Blau, Edward R. Bosley, Aube Breton, Vanvis Buñuel, Stephanie Cassidy, Vicky Chess, Patricia Phelps de Cisneros, Stanley Cohen, Robert Cowley, Douglas Crase, Arlene Croce, Victoria Dailey, Rachael DiEleuterio, Jean-Claude Drouin, Elfreid Dumiot, Catherine H. Ellis, Charlotte Erwin, Alice Federico, Sal Federico, Yona Fischer, Milton Gendel, Barbara Gingold, Romy

Golan, Christopher Gray, Walter Hatke, Kenneth Hayes Jr., Megan Hayes, Jacqueline Hélion, John T. Hill, Tony Hiss, Madalena Holtzman, Jennifer Homans, Bérénice Jacobs, Harold Jacobs, Mariah Josephy, Adina Kamien-Kazhdan, Wendy Kaplan, Loma Karklins, Peter Kayafas, Karen Kennerly, Silvia Lasala, Aleca Le Blanc, Al Lederer, Daniel Lelong, Emily Lenz, Neil Levine, Dominique Lévy, Peter Lipman, Nick Lyons, Paul Matisse, Felix Meyer, James Miller, Peter Benson Miller, Alessandra Mulas, Francis Nauman, Kika Nitzschke, the late Leonie Parsons, Rafael Pereira, Marc Plate, Frank Polach, Frans Postma, Marla Prather, Clovis Prévost, John Richardson, Stephen Robeson-Miller, Rafael Romero, Ingrid Rowland, Irving Sandler, Martica Sawin, Nan Sexton, Beverly Schneider, Joan Simon, Maeve Slavin, Paul Smith, James Snyder, Aoibheann Sweeney, Seán Sweeney, Tadhg Sweeney, Elizabeth Hutton Turner, Nancy Tweddale, Agnès Varda, Paulina Villanueva, Bruce Weber, Martin Weyl, Brenda Wineapple, Adam Winger, Robert Winter, Tom Wolf, Guy Wolff, Kelly Zinkowski.

I would like to salute Leon Wieseltier and Marty Peretz, who made a home for me at *The New Republic* for so many years. And thanks to the late Robert Silvers and *The New York Review of Books* for their support.

Finally, I want to remember a few dear friends who cared about this project and died too soon to see it finished: Barbara Goodstein, Mari Lyons, Adrienne Weiss, and Marty Schulman.

NOTES

PROLOGUE "I WAS FRAMED"

1. Alexander Calder, "The Evolution," manuscript, Calder Foundation archives, 1955–56, p. 114.
2. L. R. E. Paulin, "Alex. Stirling Calder: A Young Philadelphia Sculptor," *House and Garden*, June 1903, p. 319.
3. Calder, "The Evolution," p. 114.
4. Ibid., p. 14.
5. Alexander Stirling Calder, reference for Alexander Calder's application for a Guggenheim fellowship, fall 1928, John Simon Guggenheim Memorial Foundation archives.
6. Margaret Calder Hayes, *Three Alexander Calders: A Family Memoir* (Middlebury, VT: Paul S. Eriksson, 1977), pp. 106, 108.
7. Calder, "The Evolution," p. 156.
8. Ibid., p. 111.
9. William Dean Howells, *The Coast of Bohemia* (New York: Harper & Brothers, 1893), p. 154.
10. Ezra Pound, *Ezra Pound and the Visual Arts*, ed. and intro. Harriet Zinnes (New York: New Directions, 1980), pp. 210–11.
11. Malcolm Cowley, introduction to Hayes, *Three Alexander Calders*, p. xviii.

CHAPTER 1 PHILADELPHIA

1. Margaret Calder Hayes, *Three Alexander Calders: A Family Memoir* (Middlebury, VT: Paul S. Eriksson, 1977), p. xii. Calder seems to have assumed that his mother made a mistake and the date the city of Philadelphia had was correct. He had several theories as to why this might be. He thought his mother could have somehow conflated his own birth date with that of his paternal grandfather, which was August 23. Alternatively, he suggested that as he had been an enormous baby, eleven pounds, his mother had taken some time to recuperate and therefore been delayed in registering the birth. (See Alexander Calder, *Calder: An Autobiography with Pictures*, ed. Jean Davidson [New York: Pantheon Books, 1966], pp. 11–12.) Everybody in the family except for Calder thought the city of Philadelphia had made a mistake. At least that was what Calder's sister suggested in the 1970s when she published her memoir, *Three Alexander Calders*. Nanette Calder was certainly justified in regarding herself as the ultimate authority on the matter. Perhaps Calder's inclination to accept the official record was his way of raising doubts about the veracity of his highly opinionated mother. He was still engaged in some friendly sparring with her when she was elderly and living with Sandy and Louisa in Connecticut, where she'd settled sometime after her husband's death in 1945. Peggy, in any event, found it incredible that their mother and father could have confused the birthday of their second child and only son. There was a theory in the family that "the clerk just flipped open the wrong month when the birth was first recorded." (Hayes, *Three Alexander Calders*, p. xii.) Stranger things have happened. But half a century later, when Alexander S. C. ("Sandy") Rower, the youngest of the four Calder grandchildren, investigated further with Philadelphia's Board of Health, it began to look as if a mistake had been made by Dr. George Stewart, the friend of the family who'd delivered the boy. It was the doctor's responsibility to fill out a Registry of Births form and send it to the city. Apparently Dr. Stewart, who did not regularly perform obstetrical duties and had delivered only this one baby in the later part of the summer of 1898, didn't file a Registry of Births form until the end of September. On the form—which still exists at the Philadelphia Board of Health—Dr. Stewart first filled in "Septem-

ber" as the month of the baby's birth, then crossed that word out and wrote "July." (Birth Registry file, Calder Foundation archives.) It seems likely that by the time Dr. Stewart got around to recording Calder's birth, he was in some confusion as to how long ago it had actually occurred.

2. Hayes, *Three Alexander Calders*, p. xii.
3. Ibid., p. 118.
4. James Gibbons Huneker, *Steeplejack*, vol. 1 (New York: Charles Scribner's Sons, 1920), p. 99.
5. Ibid.
6. Calder, *Autobiography*, p. 11.
7. Ibid.
8. Ibid., pp. 13–14.
9. Mário Pedrosa, "Calder, Sculptor of Wind-Catchers," in Roberta Saraiva, ed., *Calder in Brazil: The Tale of a Friendship*, trans. Juliet Attwater (São Paulo: Pinacoteca do Estado de São Paulo, 2006), p. 37.
10. Hayes, *Three Alexander Calders*, p. 100.
11. Ibid., pp. 105–6.
12. Alexander Calder, "The Evolution," manuscript, Calder Foundation archives, p. 22.
13. Nanette Lederer Calder to Margaret Calder Hayes, c. 1955, Calder Foundation archives.
14. See Wayne Craven, *Sculpture in America* (Newark: University of Delaware Press, 1983), pp. 483–86.
15. Hayes, *Three Alexander Calders*, p. 100.
16. Malcolm Cowley, introduction to ibid., p. xv.
17. Hayes, *Three Alexander Calders*, pp. 104–5.
18. Ibid., p. 104.
19. Ibid., p. 105.
20. Eric M. Zafran, *Calder in Connecticut* (New York: Rizzoli, 2000), p. 57.
21. Jean-Paul Sartre, "Les Mobiles de Calder," *Alexander Calder: Mobiles, Stabiles, Constellations* (Paris: Galerie Louis Carré, 1946); trans. Chris Turner in Jean-Paul Sartre, *The Aftermath of War* (Calcutta: Seagull, 2008).
22. Hayes, *Three Alexander Calders*, p. 114.
23. Craven, *Sculpture in America*, p. 486.
24. Alexander Stirling Calder, *Thoughts of A. Stirling Calder on Art and Life*, ed. Nanette Lederer Calder (New York: Privately printed, 1947), pp. 3–4.
25. Henry Rankin Poore, "Stirling Calder, Sculptor," *The International Studio*, April 1919, p. xlv.
26. Hayes, *Three Alexander Calders*, p. 115.
27. Alexander Stirling Calder to Joseph T. Fraser, September 3, 1939, Calder Foundation archives.
28. Ibid.
29. Robert Henri, *The Art Spirit* (1923; repr., New York: J. B. Lippincott, 1939), p. 9.
30. Hayes, *Three Alexander Calders*, p. 115.
31. Nanette Lederer Calder, autobiographical notes, February 22, 1949, Calder Foundation archives.
32. Calder, *Autobiography*, p. 20.
33. Nanette Calder to Margaret Hayes, December 19, 1928, Calder Foundation archives.
34. Nanette Calder to her children, May 7–9, 1924, Calder Foundation archives.
35. Nanette Calder, autobiographical notes, January 23, 1951, and c. 1955, Calder Foundation archives.
36. Stirling Calder, *Thoughts of A. Stirling Calder*, pp. 31, 51.
37. Nanette Calder, autobiographical notes, February 22, 1949, Calder Foundation archives.
38. Ibid., c. 1955.
39. John Sloan diaries, January 19, 1909, John Sloan Manuscript Collection, Helen Farr Sloan Library and Archives, Delaware Art Museum.
40. Dictated by Calder Hayes (the younger of Peggy's two sons), January 1999, Calder Foundation archives.

CHAPTER 2 STIRLING AND NANETTE

1. Oscar Wilde, *Intentions* (1891; repr. Portland, ME: Thomas B. Mosher, 1904), p. 60.
2. See Meryle Secrest, *Being Bernard Berenson* (New York: Holt, Rinehart and Winston, 1979), p. 125.

3. Nanette Lederer Calder to Calder, August 17, 1945, Calder Foundation archives.

4. Wilde, *Intentions*, p. 48.

5. Alexander Stirling Calder, *Thoughts of A. Stirling Calder on Art and Life*, ed. Nanette Lederer Calder (New York: Privately printed, 1947), pp. 24, 26.

6. Margaret Calder Hayes, *Three Alexander Calders: A Family Memoir* (Middlebury, VT: Paul S. Eriksson, 1977), p. 130.

7. Wilde, *Intentions*, p. 26.

8. Alexander Stirling Calder to Joseph T. Fraser, November 21, 1942, Calder Foundation archives.

9. Calder to James Thrall Soby, September 17, 1936, Calder Foundation archives.

10. Van Wyck Brooks, *John Sloan: A Painter's Life* (New York: E. P. Dutton, 1955), p. 13.

11. James Johnson Sweeney, *Alexander Calder* (New York: Museum of Modern Art, 1943), p. 10.

12. Marla Prather, ed., *Alexander Calder: 1898–1976* (Washington, DC: National Gallery of Art, 1998), p. 15.

13. Stirling Calder, *Thoughts of A. Stirling Calder*, p. 18.

14. Mark Haine and Alex Baker, *Pennsylvania Academy of the Fine Arts, 1805–2005: 200 Years of Excellence* (Philadelphia: Pennsylvania Academy of the Fine Arts, 2005), p. 72.

15. Stirling Calder, *Thoughts of A. Stirling Calder*, p. 5.

16. Ibid., p. 3.

17. Ibid., pp. 3–4.

18. Stirling Calder to John Andrew Myers, March 31, 1921, Calder Foundation archives.

19. Stirling Calder, *Thoughts of A. Stirling Calder*, p. 6.

20. Dorothy Grafly Drummond, *The Sculptor's Clay: Charles Grafly (1862–1929)* (Wichita, KS: Edwin A. Ulrich Museum of Art, 1996), p. 44.

21. "Sees Her Head on Nude Statue; Sues," *Indianapolis Star*, June 25, 1923; and "Model's Right to Sue Upheld," *New York Evening Post*, March 22, 1924.

22. Randall C. Griffin, *Thomas Anshutz: Artist and Teacher* (Seattle: University of Washington Press, 1994), p. 92.

23. Drummond, *The Sculptor's Clay*, p. 13.

24. Stirling Calder to Joseph T. Fraser, September 3, 1939, Calder Foundation archives.

25. Stirling Calder, *Thoughts of A. Stirling Calder*, p. 52. Stirling had read Dostoevsky's *Notes from Underground*.

26. Drummond, *The Sculptor's Clay*, p. 16.

27. Rainer Maria Rilke, *Rodin*, trans. Jessie Lemont and Hans Trausil, intro. Padraic Colum (1903; repr., London: Grey Walls Press, 1946), p. 10.

28. Ibid., p. 30.

29. Truman H. Bartlett, "Auguste Rodin," *American Architect and Building News*, January–May 1889, quoted in Albert Elsen, *Rodin* (New York: Museum of Modern Art, 1967), p. 25.

30. Alexander Calder, *Calder: An Autobiography with Pictures*, ed. Jean Davidson (New York: Pantheon Books, 1966), p. 79.

31. André Masson, "About the Drawings," in *Auguste Rodin* (New York: Curt Valentin Gallery, 1954), unpaged.

32. In the fall of 1890, Stirling and Grafly shared a studio at 17 rue Campagne-Première in Paris. Grafly modeled a life-sized nude, *Mauvais Présage*, which was accepted at the Salon of 1891 and received an honorable mention. Grafly met his future wife, Frances Sekeles, when, back in Philadelphia, he visited Nanette, who was already a friend of Frances's. They were all together in Philadelphia between 1892 and 1895. The two couples were married at almost the same time—Grafly was at Stirling and Nanette's wedding—and the Graflys' daughter, Dorothy, was, like Peggy, born in Paris the following year. Grafly may have been instrumental in arranging for Stirling's first teaching job, at the Pennsylvania Museum and School of Industrial Art. Grafly's daughter recalled in a memoir that her father and Stirling "for years had worked side by side and were, in every sense, brother artists"—exactly as Henri described the students in *The Art Spirit*. "When funds were needed," she noted, "they even worked all night on a plaster display figure for the Wanamaker Store." (Drummond, *The Sculptor's Clay*, p. 25.) Nanette, in affectionate letters to Dorothy, signed herself Aunty Net.

33. Stirling Calder, *Thoughts of A. Stirling Calder*, p. 59.

34. Hayes, *Three Alexander Calders*, p. 180.

35. Nanette Calder to Calder, c. April 1952, Calder Foundation archives.

36. Nanette Calder to Calder, c. 1957, Calder Foundation archives.

37. Stirling Calder, *Thoughts of A. Stirling Calder*, p. 5.

38. Hayes, *Three Alexander Calders*, pp. xii, 11.

39. William Dean Howells, *The Coast of Bohemia* (New York: Harper & Brothers, 1893), pp. 332–33.

40. Nanette Calder to Margaret Hayes, March 5 and February 13, 1929, Calder Foundation archives.

41. Anthony E. Anderson, "Art and Artists," *Los Angeles Times*, October 6, 1907, p. 2.

42. For the Plastic Club, see "Plastic Club records, 1897–1972," microfilm reels 2536–37, Archives of American Art; Helen Goodman, "The Plastic Club," *Arts Magazine*, March 1985, pp. 100–103. For Charlotte Harding, see Helen Goodman, "Women Illustrators of the Golden Age of American Illustration," *Woman's Art Journal*, Spring–Summer 1987, pp. 13–22.

43. Hayes, *Three Alexander Calders*, p. 167.

44. John Sloan diaries, September 13, 1910, John Sloan Manuscript Collection, Helen Farr Sloan Library and Archives, Delaware Art Museum.

45. Ibid., October 8, 1910.

46. Alexander Calder, "The Evolution," manuscript, Calder Foundation archives, 1955–56, p. 145.

CHAPTER 3 FATHER AND SON

1. L. R. E. Paulin, "Alex. Stirling Calder: A Young Philadelphia Sculptor," *House and Garden*, June 1903, pp. 325, 320.

2. Ibid., p. 320.

3. Alexander Calder, "The Evolution," manuscript, Calder Foundation archives, 1955–56, p. 88.

4. Margaret Calder Hayes, *Three Alexander Calders: A Family Memoir* (Middlebury, VT: Paul S. Eriksson, 1977), p. 130.

5. Ibid., p. 84.

6. Ibid., p. 10.

7. Ibid., p. 14.

8. Helen Hay, "The Circus," *Verses for Jock and Joan*, with pictures by Charlotte Harding (New York: Fox, Duffield, 1905), p. 10.

9. Hayes, *Three Alexander Calders*, p. 114.

10. Alexander Calder, *Calder: An Autobiography with Pictures*, ed. Jean Davidson (New York: Pantheon Books, 1966), p. 15.

11. Ibid., p. 13.

12. Edward Otis, *The Great White Plague: Tuberculosis* (New York: Thomas Y. Crowell, 1909), p. 7.

13. Ibid., p. 12.

14. Ibid., p. 14.

15. Ibid., p. 75.

16. Calder, *Autobiography*, p. 39.

17. John Sloan diaries, March 6, 1908, John Sloan Manuscript Collection, Helen Farr Sloan Library and Archives, Delaware Art Museum. In 1907, Lambert, after going blind on a trip to Spain, met an early death from what the *New York Times* reported was "the result of nervous breakdown"; he left money and property to various artist friends, including $10,000 to Stirling.

18. Ibid., February 5, 1906.

19. Calder, *Autobiography*, p. 15.

20. Hayes, *Three Alexander Calders*, p. 16.

21. Calder, *Autobiography*, p. 80.

22. Calder to Nanette Lederer Calder, November 11, 1905, Calder Foundation archives.

23. Hayes, *Three Alexander Calders*, p. 128.

24. Calder to Nanette Calder, February 11, 1906, Calder Foundation archives.

25. Hayes, *Three Alexander Calders*, pp. 17–18.

26. Ibid., p. 16.

27. Ibid., p. 18.

28. Calder, *Autobiography*, p. 15.

29. Ibid.

30. Hayes, *Three Alexander Calders*, p. 21.

31. Alexander Stirling Calder, *Thoughts of A. Stirling Calder on Art and Life*, ed. Nanette Lederer Calder (New York: Privately printed, 1947), p. 46.

32. Ibid., p. 1.

33. Calder, *Autobiography*, p. 16.

34. Ibid., p. 17.

35. Calder, "The Evolution," p. 2.

36. Hayes, *Three Alexander Calders*, p. 23.

37. Martha Evans Martin, *The Friendly Stars* (New York: Harper & Brothers, 1907), p. 219.

38. Frank Lloyd Wright to Alexander Woolcott, quoted in David G. De Long, ed., *Frank Lloyd Wright: Designs for an American Landscape 1922–1932* (New York: Harry N. Abrams, 1996), p. 111.

39. Frank Lloyd Wright, *An Autobiography* (1943; repr., Petaluma, CA: Pomegranate Communications, 2005), p. 313.

40. Ibid., p. 309.

CHAPTER 4 PASADENA

1. Alexander Calder, *Calder: An Autobiography with Pictures*, ed. Jean Davidson (New York: Pantheon Books, 1966), p. 21.

2. Margaret Calder Hayes, *Three Alexander Calders: A Family Memoir* (Middlebury, VT: Paul S. Eriksson, 1977), p. 129.

3. Already on October 14, 1906, when the family was barely settled, the *Los Angeles Times* reported on a presentation of photographs of his sculpture that Stirling had given; an earlier reception had apparently been so crowded that very few people had had much of an opportunity to examine the work. Stirling Calder was said to be "a sculptor of splendid attainments." He had already begun to build himself a studio, and would be, the paper noted, remaining in Los Angeles permanently— "a most gratifying bit of news," the *Times* reported, although Stirling was probably not being entirely straightforward if he did indeed leave the impression that he was in Southern California for good. ("Art Notes," *Los Angeles Times*, October 14, 1906.) Nanette was also mentioned in the *Los Angeles Times* notice, as "a painter of reputation who has studied for many years in Paris." A year later, she was profiled in the *Times*, when she opened her Pasadena studio to the public before sending a group of paintings back to Philadelphia for an exhibition at the Pennsylvania Academy. (Antony E. Anderson, "Art and Artists," *Los Angeles Sunday Times*, October 6, 1907.)

4. Hayes, *Three Alexander Calders*, p. 36.

5. Alexander Stirling Calder, *Thoughts of A. Stirling Calder on Art and Life*, ed. Nanette Lederer Calder (New York: Privately printed, 1947), p. 17.

6. Kevin Starr, *Inventing the Dream* (New York: Oxford University Press, 1985), p. 107.

7. Calder, *Autobiography*, p. 26.

8. Starr, *Inventing the Dream*, p. 107.

9. John Ruskin, *The Stones of Venice: Volume the Second: The Sea Stories* (London: Smith, Elder, 1867), p. 163.

10. Calder, *Autobiography*, p. 25.

11. Vivian Barnett interviewed by Jed Perl, September 9, 2015.

12. Part of his art collection eventually went to the Art Institute of Chicago.

13. Calder, *Autobiography*, p. 25.

14. See W. L. B. Jenney, "A Remarkable Dwelling," *Inland Architect and News Record*, May 1906, pp. 57–60, and "A California House Modeled on the Simple Lines of the Old Mission Dwelling," *Craftsman*, November 1906, pp. 208–22; the latter article is uncredited but was largely written by Arthur Jerome Eddy. According to these accounts, the building's lean, low profile was based not only on Spanish-American models, as Calder recalled in his *Autobiography*, but on a Native American tradition that went back to the pueblos in New Mexico and included a one-story home Eddy had seen near San Diego.

15. [Eddy], "A California House," p. 212.

16. Arthur Jerome Eddy, "Sincerity in Art," *Craftsman*, October 1905, p. 22.

17. Hayes, *Three Alexander Calders*, pp. 31–33.

18. Alexander Calder, "The Evolution," manuscript, Calder Foundation archives, 1955–56, p. 1.

19. Charles Baudelaire, *The Painter of Modern Life, and Other Essays*, ed. and trans. Jonathan Mayne (London: Phaidon, 1964), p. 199.

20. Calder, "The Evolution," p. 27.

21. Ibid., p. 36.

22. Calder, "Voici une petite histoire de mon cirque," *Permanence du Cirque* (Paris: Revue Neuf, 1952), p. 37.

23. James Johnson Sweeney, *Alexander Calder* (New York: Museum of Modern Art, 1943), p. 9.

24. L. R. E. Paulin, "Alex. Stirling Calder: A Young Philadelphia Sculptor," *House and Garden*, June 1903, p. 320.

25. Stirling Calder, *Thoughts of A. Stirling Calder*, p. 33.

26. John Richardson, *A Life of Picasso: The Prodigy, 1881–1906* (New York: Alfred A. Knopf, 2007), p. 41.

27. Calder, *Autobiography*, p. 21.

28. Ibid., p. 26.

29. Calder, "The Evolution," p. 155; and many other places. This was not so far from the thinking of Picasso and Braque, in the years of their most intense collaboration, when they liked to imagine themselves as involved in "manual labor" and sported outfits associated not with artists but with workingmen. See William Rubin, *Picasso and Braque: Pioneering Cubism* (New York: Museum of Modern Art, 1989), p. 19.

30. Hugo B. Froehlich and Bonnie E. Snow, *Text Books of Art Education: Book III* (New York: Prang Educational, 1904), pp. 38, 43.

31. For the authors of the *Text Books of Art Education*, play was serious business, a way of teaching children basic principles of structure, construction, and design—of giving them the keys that would unlock the imagination. The activities and projects described in the textbooks and magazines of the period, sometimes designed for consumption by both teachers and children, are echoed in the projects that absorbed Sandy in Pasadena—and even a few years later. The anonymous author of an article on the benefit of "simple toys," published in *The Craftsman* in 1903, observed that children "happily pursue their games with the aid of the crude objects which they have fashioned for themselves out of a board, a stick, a piece of string, or whatever else may have been available in completing some comprehensive plan." ("The Child Benefited by Simple Toys," *Craftsman*, December 1903, pp. 298–99.) The little game, made of wood and four penny nails, that Sandy made for his father's birthday in January 1910 is certainly reminiscent of projects in these textbooks and magazines. Five animals cut from pieces of wood—a tiger, a lion, and three bears—are meant to be moved between six pens, separated by fences made of nails, so that no two are in the same pen at once, as Peggy recalled in *Three Alexander Calders*, "thus avoiding bloodshed" (p. 42).

32. A. Neely Hall, *Handicraft for Handy Boys: Practical Plans for Work and Play with Many Ideas for Earning Money* (Boston: Lothrop, Lee & Shepard, 1911), p. vi.

33. Calder, "The Evolution," p. 89.

34. [Anonymous], "The Child Benefited by Simple Toys," *Craftsman*, December 1903, pp. 299, 302.

35. Ibid., p. 298.

36. Harris W. Moore, *Manual Training Toys for the Boy's Workshop* (Peoria, IL: Manual Arts Press, 1912).

37. When James Johnson Sweeney visited Calder's parents in Brooklyn to borrow works for the Museum of Modern Art retrospective in 1943, he listed the *Dog* as having been done in Pasadena in 1909; that must have been Stirling and Nanette's recollection. There is also a tradition in the family that says *Dog* and *Duck* were made as gifts for Calder's parents for Christmas. In his *Autobiography*, Calder remembered that the family had moved back east in 1910, but they actually went back east in the fall of 1909—which would make one wonder if he had indeed made *Dog* and *Duck*, or at least *Dog*, for Christmas 1909, although he might have made them late in the summer or very early in the fall and kept them as gifts to be given later. It is also possible that they were done at different times. It may be worth noting that the idea of relating a child's precocious representation of an animal to a grown artist's genius goes back to the beginnings of art history. Perhaps Sweeney, in turning his attention to Calder's *Dog*, was thinking of Vasari, by most reckonings the first historian of art, whose life

of Giotto begins with the image of the artist as a child, drawing a sheep on a rock with a pointed stone.

38. Ernest A. Batchelder, "Design in Theory and Practice: A Series of Lessons: Number III," *Craftsman*, December 1907, p. 332. Batchelder also spoke of a "live curve."

39. Hayes, *Three Alexander Calders*, p. 8.

40. Batchelder, "Design in Theory and Practice: A Series of Lessons: Number IV," *Craftsman*, March 1908, p. 689; Batchelder, "The Arts and Crafts Movement in America: Work or Play?," *Craftsman*, August 1909, pp. 544–49.

41. James Johnson Sweeney, "Alexander Calder: Work and Play," *Art in America*, Winter 1956–57, pp. 8–13.

42. Hayes, *Three Alexander Calders*, pp. 8, 9.

43. Stirling Calder, typescript, 1910, Caltech Archives; the essay is accompanied by a note saying that it was published in *The American Architect*, June 22, 1910, pp. 236–37.

44. Stirling Calder to John E. D. Trask, August 19, 1906, Calder Foundation archives.

45. Roger Stanton, "Reported by Roger Stanton After a Visit with Elmer Grey, August 23, 1957," typescript, Caltech Archives.

46. Stirling Calder to John Trask, November 28, 1908, Calder Foundation archives.

47. Nanette Calder to John Trask, March 30, 1909, Calder Foundation archives.

48. Stirling Calder, typescript, 1910, Caltech Archives.

49. David Starr Jordan, "Remarks by David Starr Jordan," *Throop Institute Bulletin*, March 1910, p. 15.

50. Hayes, *Three Alexander Calders*, p. 36.

51. Calder, "Voici une petite histoire de mon cirque," p. 37.

52. Hayes, *Three Alexander Calders*, p. 36.

53. Jean Lipman, *Calder's Universe* (New York: Viking Press, 1976), p. 17.

54. John Sloan diaries, October 25, 1909, John Sloan Manuscript Collection, Helen Farr Sloan Library and Archives, Delaware Art Museum.

CHAPTER 5 CROTON-ON-HUDSON

1. John Sloan diaries, June 18, 1910, John Sloan Manuscript Collection, Helen Farr Sloan Library and Archives, Delaware Art Museum.

2. Alexander Calder, *Calder: An Autobiography with Pictures*, ed. Jean Davidson (New York: Pantheon Books, 1966), p. 28.

3. Margaret Calder Hayes, *Three Alexander Calders: A Family Memoir* (Middlebury, VT: Paul S. Eriksson, 1977), p. 39.

4. Calder, *Autobiography*, pp. 29–30.

5. D. C. Beard, *The Outdoor Handy Book: For Playground, Field, and Forest* (New York: Charles Scribner's Sons, 1907), p. 187.

6. Ibid., p. 86.

7. Hayes, *Three Alexander Calders*, p. 40.

8. Calder, *Autobiography*, p. 36.

9. Alexander Calder, *The One Hundred and Fiftieth Anniversary Exhibition* (Philadelphia: Pennsylvania Academy of the Fine Arts, 1955), p. 92.

10. Calder, *Autobiography*, p. 34.

11. Ibid., p. 29.

12. Hayes, *Three Alexander Calders*, p. 41.

13. Calder, *Autobiography*, p. 29.

14. Hayes, *Three Alexander Calders*, p. 41.

15. Ibid., pp. 47, 142.

16. Ibid., p. 41.

17. Ibid., p. 120.

18. Nanette Lederer Calder, autobiographical notes, August 4, 1952, Calder Foundation archives.

19. Hayes, *Three Alexander Calders*, p. 144.

20. Alexander Calder, "The Evolution," manuscript, Calder Foundation archives, 1955–56, p. 8.

21. Calder, *Autobiography*, p. 35.
22. Wyatt Hibbs (a colleague of Ralph Calder's) in a memoir he apparently sent to Margaret Calder Hayes after reading *Three Alexander Calders*, c. 1980s, Calder Foundation archives. Ralph Calder's work was profiled in Rayne Adams, "A Lesson from the Drawings of Ralph Calder," *Pencil Points*, January 1928, pp. 2–15.
23. Ralph Calder to Calder, January 21, 1945, Calder Foundation archives.
24. Hayes, *Three Alexander Calders*, p. 147.
25. Van Wyck Brooks, *John Sloan: A Painter's Life* (New York: E. P. Dutton, 1955), p. 45.
26. Hayes, *Three Alexander Calders*, pp. 147–48.
27. John Sloan Diaries, June 18, 1910, John Sloan Manuscript Collection, Helen Farr Sloan Library and Archives, Delaware Art Museum. In December 1910, Calder had several small sculptures—including the one of Nanette—in a show at the Macbeth Gallery. Exhibiting a little at the Macbeth Gallery, teaching alongside Sloan and others at the Art Students League for a time, Stirling was hardly out of step with his progressive friends.
28. Hayes, *Three Alexander Calders*, p. 146.
29. Ibid.
30. Brooks, *John Sloan*, p. 45.
31. John Sloan, *The Gist of Art: Principles and Practise Expounded in the Classroom and Studio* (1939; repr., New York: Dover Publications, 1977), p. 15.
32. Bernard B. Pearlman, "The Years Before," *Art in America* 1 (1963): 42.
33. William Carlos Williams, "Recollections," *Art in America* 1 (1963): 52.
34. Dorothy Grafly Drummond, *The Sculptor's Clay: Charles Grafly (1862–1929)* (Wichita, KS: Edwin A. Ulrich Museum of Art, 1996), p. 45. If Stirling and his friends finally felt that they had been eclipsed by the Armory Show—and ultimately they weren't wrong—one imagines that for them the point was not that Matisse and Brancusi were a misunderstanding of Manet and Rodin so much as these newer artists did not represent the path they wished to take. Walter Pach, an art critic who was involved in the Armory Show and was friends with not only Henri, Sloan, and Shinn but also Duchamp, wrote in his memoir, *Queer Thing, Painting*, of Henri's frustration that when he was a student in Paris, "We never were allowed to hear about men like Cézanne and Gauguin." (Walter Pach, *Queer Thing, Painting: Forty Years in the World of Art* [New York: Harper & Brothers, 1938], p. 47.) Henri announced: "My work is not realistic. My work is pure abstraction. I abstract from what I see—men, rivers, lights, women—the ideas of those things, and that's what I paint." (Ibid.) Stirling himself wrote, "Art to be alive must be continually arriving at new forms." (Alexander Stirling Calder, *Thoughts of A. Stirling Calder on Art and Life*, ed. Nanette Lederer Calder [New York: Privately printed, 1947], p. 29.) On March 5, 1929, Nanette wrote to her daughter about Arthur B. Davies, the painter instrumental in the organization of the Armory Show, that he was "one of our most interesting painters with a poet's sense." (Nanette Calder to Margaret Calder Hayes, March 5, 1929, Calder Foundation archives.)
35. Calder, *Autobiography*, pp. 34, 35.
36. Hayes, *Three Alexander Calders*, p. 43.
37. Calder to Margaret Hayes, May 17, 1924, Calder Foundation archives.
38. Hayes, *Three Alexander Calders*, p. 43.

CHAPTER 6 THE PANAMA-PACIFIC INTERNATIONAL EXPOSITION

1. Alexander Stirling Calder, introduction to *The Sculpture and Mural Decorations of the Exposition: A Pictorial Survey of the Art of the Panama-Pacific International Exposition*, by Stella G. S. Perry (San Francisco: Paul Elder, 1915), p. 9.
2. Ibid., pp. 5, 6.
3. Margaret Calder Hayes, *Three Alexander Calders: A Family Memoir* (Middlebury, VT: Paul S. Eriksson, 1977), p. 39.
4. For the fine arts at the Panama-Pacific International Exposition, see James A. Ganz, ed., *Jewel City: Art from San Francisco's Panama-Pacific International Exposition* (San Francisco: Fine Arts Museums of San Francisco, 2015).

5. Jules Guérin, "The Magic City of the Pacific," *Craftsman*, August 1914, pp. 477–78.

6. Ibid., p. 471.

7. A fine account of the exposition as a whole is John D. Barry, *The City of Domes* (San Francisco: John J. Newbegin, 1915).

8. Barry, *The City of Domes*, p. 15.

9. Stirling Calder, introduction to *Sculpture and Mural Decorations*, p. 6. Calder brought help from New York, including the young Beniamino Bufano, who became San Francisco's best-known and best-loved sculptor. He also tried to give some direction to local artists. Douglas Tilden, born in 1860, had been one of the first students at the California School for the Deaf, attended the University of California at Berkeley, and studied sculpture in Paris. From December 1913 through the early months of 1914, Stirling fired off letters to Tilden, who was working in Oakland, urging him to consider his work in relation to its architectural setting, encouraging "a splendid straight-forward simplicity." (Stirling Calder to Douglas Tilden, December 26, 1913, Calder Foundation archives.)

10. Stirling Calder, introduction to *Sculpture and Mural Decorations*, p. 4.

11. Victoria Kastner, "The Power of Beauty: Bernard Maybeck's Palace of Fine Arts," in Ganz, *Jewel City*, p. 56.

12. Perry, *Sculpture and Mural Decorations*, p. 16.

13. Barry, *City of Domes*, pp. 37–38.

14. Stirling Calder, introduction to *Sculpture and Mural Decorations*, p. 7.

15. Quoted in Michele H. Bogart, *Public Sculpture and the Civic Ideal in New York City, 1890–1930* (Chicago: University of Chicago Press, 1997), p. 279.

16. "America, Sculpture and War: From an Interview with A. Stirling Calder," *The Touchstone*, May 1917, pp. 29, 99.

17. Nanette Lederer Calder to Calder, c. 1939, Calder Foundation archives.

18. Barry, *City of Domes*, p. 15.

19. Alexander Calder, *Calder: An Autobiography with Pictures*, ed. Jean Davidson (New York: Pantheon Books, 1966), p. 36.

20. Hayes, *Three Alexander Calders*, p. 45.

21. Ibid., p. 49.

22. Ibid., p. 52.

23. Ibid., p. 49.

24. Howard Payson, *The Boy Scouts at the Panama-Pacific Exposition* (New York: A. L. Burt, 1915), pp. 140, 141.

25. Ibid., p. 147.

26. Kevin Starr, *Americans and the California Dream, 1850–1915* (New York: Oxford University Press, 1973), p. 124.

27. Nanette Calder to Dorothy Sills Lindsley, October 2, 1957, Calder Foundation archives.

28. Calder, *Autobiography*, pp. 36–37.

29. Hayes, *Three Alexander Calders*, p. 46.

30. Barry, *City of Domes*, pp. 12–13.

31. Calder, *Autobiography*, p. 38.

32. Hayes, *Three Alexander Calders*, p. 48.

33. Ibid.

34. Ibid., p. 54.

35. *In Tribute to Kenneth Aurand Hayes by His 1916 Classmates* (n.p.: n.d.), unpaged. Some information about Kenneth Hayes and his family comes from his granddaughter, Megan Hayes, in emails to Jed Perl on February 2, 2017.

36. Calder, *Autobiography*, pp. 38–39.

37. Alexander Calder, "The Evolution," manuscript, Calder Foundation archives, 1955–56, p. 13.

38. William G. Rogers, "Calder: Man and Mobile," manuscript, Calder Foundation archives, 1956, p. 76.

39. Ibid., p. 78.

40. H. J. Gille, "Business Qualifications of the Engineer," *Minnesota Engineer*, January 1909, quoted in Monte A. Calvert, *The Mechanical Engineer in America, 1830–1910* (Baltimore: Johns Hopkins Press, 1967), p. 59.

41. Hayes, *Three Alexander Calders*, p. 52.

CHAPTER 7 THE STEVENS INSTITUTE OF TECHNOLOGY

1. Alexander Calder, *Calder: An Autobiography with Pictures*, ed. Jean Davidson (New York: Pantheon Books, 1966), p. 39.
2. *Annual Catalogue: Stevens Institute of Technology 1915–1916* (Hoboken, NJ: Stevens Institute of Technology, 1915), p. 36.
3. *The Link of 1918* (Hoboken, NJ: Stevens Institute of Technology, 1918), p. 75.
4. William G. Rogers, "Calder: Man and Mobile," manuscript, Calder Foundation archives, 1956, p. 13.
5. Calder, *Autobiography*, p. 43.
6. Ibid., p. 39.
7. Ibid., p. 42.
8. Ibid., p. 41.
9. Jean Lipman, *Calder's Universe* (New York: Viking Press, 1976), p. 19.
10. Nichol H. Memory to Calder, March 1, 1956, Calder Foundation archives.
11. Rogers, "Calder: Man and Mobile," p. 82.
12. Calder, *Autobiography*, p. 41.
13. Alexander Calder, "The Evolution," manuscript, Calder Foundation archives, 1955–56, p. 31.
14. Calder, *Autobiography*, p. 46.
15. Calder, "The Evolution," p. 28.
16. *The Link of 1918*, p. 75.
17. Rogers, "Calder: Man and Mobile," p. 82.
18. Calder, "The Evolution," pp. 28, 30.
19. Ibid., p. 20.
20. Calder loved to watch college games. He announced to his sister in his junior year, in a couple of galloping, picaresque letters, that "the basketball team cleaned on Drexel 45–29 and Temple 50–19" and, a month later, that the basketball team has "won its eleventh game straight from Brooklyn Poly last Thursday 29–14." (Calder to Margaret Calder Hayes, January 4 and February 25, 1918, Calder Foundation archives.) After losing a lacrosse game against Swarthmore, 6–1, the Stevens team was invited to stay for a party, "and were able to show them some new steps," though elsewhere in Calder's unpublished recollections he remembers how his dancing led a girl to make "a sign of despair." Some of the young men he studied and played with at Stevens were recalled vividly through the years, like Reginald (Rex) Philippe Deghuée, "short and very stocky," who somehow managed to be a football star and class president for three years. (Calder, *Autobiography*, p. 46; Calder, "The Evolution," p. 71; Calder, *Autobiography*, p. 42.)
21. Calder, "The Evolution," p. 55.
22. Calder, *Autobiography*, p. 41.
23. Calder, "The Evolution," p. 55.
24. James Johnson Sweeney, "The Position of Alexander Calder," *Magazine of Art*, May 1944, p. 182.
25. Geoffrey W. Clark, *History of Stevens Institute of Technology: A Record of Broad-Based Curricula and Technogenesis, 1870–2000* (Jersey City, NJ: Jensen/Daniels, 2000), pp. 82–84.
26. See Monte A. Calvert, *The Mechanical Engineer in America, 1830–1910* (Baltimore: Johns Hopkins Press, 1967).
27. Quoted ibid., p. 240.
28. Clark, *History of Stevens Institute*, p. 346.
29. Ibid., p. 347.
30. Alfred S. Kinsey, "Notes on Shop Practice Prepared for the Use of the Freshman Class at Stevens," 1910, photocopied typescript, S. C. Williams Library, Stevens Institute of Technology.
31. This and Martin's course quoted in Clark, *History of Stevens Institute*, pp. 348–49.
32. Clark, *History of Stevens Institute*, p. 349.
33. Rosario Drew interviewed by Jed Perl, November 25, 2011.
34. Calder, *Autobiography*, p. 43.
35. Calder to Margaret Hayes, February 1918, Calder Foundation archives.
36. Lipman, *Calder's Universe*, p. 19.
37. *The Link of 1918*, p. 78.
38. Lipman, *Calder's Universe*, pp. 19–20.

39. Clark, *History of Stevens Institute*, p. 208.
40. Calder, *Autobiography*, p. 46.
41. Ibid.
42. Ibid., pp. 47, 48.
43. *The Link of 1919* (Hoboken, NJ: Stevens Institute of Technology, 1919), pp. 281–86.
44. Ibid.
45. Calder to Margaret Hayes and Kenneth Hayes, February 25, 1918, Calder Foundation archives.
46. *1915–1916 Student Handbook, Stevens Institute of Technology* (Hoboken, NJ: Stevens Institute of Technology, 1915), p. 93.
47. Myfanwy Evans, ed., *The Painter's Object* (London: Gerald Howe, 1937), p. 63.
48. Calder, "The Evolution," p. 110.
49. Calder to Harold R. Fee, June 13, 1953, Calder Foundation archives.
50. Calder, "The Evolution," p. 70.
51. Calder to Harold R. Fee, June 13, 1953, Calder Foundation archives.

CHAPTER 8 ENGINEERING

1. Max Beerbohm, "Aubrey Beardsley," in *The Prince of Minor Writers: The Selected Essays of Max Beerbohm*, ed. Phillip Lopate (New York: New York Review Books, 2015), p. 358.
2. Alexander Calder, "The Evolution," manuscript, Calder Foundation archives, 1955–56, p. 166.
3. Beerbohm, "Aubrey Beardsley," p. 358.
4. Malcolm Cowley, introduction to Margaret Calder Hayes, *Three Alexander Calders: A Family Memoir* (Middlebury, VT: Paul S. Eriksson, 1977), p. xvi.
5. Jean Lipman, *Calder's Universe* (New York: Viking Press, 1976), p. 32.
6. Alexander Calder, autograph manuscript, Calder-Hayes Family Papers 1907–1985, Bancroft Library, University of California, Berkeley.
7. Alexander Calder, *Calder: An Autobiography with Pictures*, ed. Jean Davidson (New York: Pantheon Books, 1966), p. 49.
8. Ibid., p. 51.
9. Ibid., p. 48.
10. Ibid., p. 50.
11. Ibid., p. 49.
12. Calder to his parents, September 1920, Calder Foundation archives.
13. Hayes, *Three Alexander Calders*, p. 69.
14. Calder to Margaret Calder Hayes, January 19, 1921, Calder Foundation archives.
15. David Amram, *Vibrations* (New York: Macmillan, 1968), p. 182.
16. Sandra Davidson, when reminded of this story, commented that her father always seemed to be worried about his eyes. Sandra Davidson interviewed by Jed Perl, April 11, 2016.
17. William G. Rogers, "Calder: Man and Mobile," manuscript, Calder Foundation archives, 1956, pp. 92–93.
18. Calder, *Autobiography*, p. 51.
19. Ibid.
20. Ibid.
21. Ibid.
22. Calder to Margaret Hayes, May 17, 1924, Calder Foundation archives.
23. Calder, "The Evolution," p. 27.
24. Calder, *Autobiography*, pp. 54–55.
25. *The Dialogues of Creatures Moralysed: A Critical Edition*, ed. Gregory Kratzmann and Elizabeth Gee (New York: E. J. Brill, 1988), p. 69.
26. Calder, *Autobiography*, p. 55.
27. Hayes, *Three Alexander Calders*, p. 66.
28. Ibid., p. 68.
29. Ibid., p. 72. There had been tremendous labor turmoil in the logging industry in the Pacific Northwest during World War I and immediately after, with violent confrontations between industry, gov-

ernment, and the radical International Workers of the World (known as the Wobblies). Certainly Peggy, who had studied social work and been under the influence of Jane Addams, would have been troubled by all of this. Calder had an idea of reading to the workingmen, bringing Jack London stories, *Bob, Son of Battle*, and Kipling's *The Naulahka*. But Peggy recalled that "Cranky Jack was scornful, claiming all books were lies, that only the Bible and the newspaper could be trusted." (Hayes, *Three Alexander Calders*, p. 72.) With Jack, and then at a later logging job, Calder always wanted the windows open, but others almost invariably wanted them firmly closed. The food, however, was plentiful, albeit much of it straight out of a can. "There were pies, jam, bacon, eggs galore," Calder recalled. "The idea was to feed the men as much as possible with no waiting periods in between, so that they could not argue and talk themselves into a fight." (Calder, *Autobiography*, p. 58.)

30. Hayes, *Three Alexander Calders*, p. 72.
31. Calder, *Autobiography*, p. 56.
32. Rogers, "Calder: Man and Mobile," p. 96.
33. Ibid., pp. 94–95.
34. Ibid., p. 95.
35. Ibid., p. 97.
36. Ibid.
37. Calder, *Autobiography*, p. 59.
38. Ibid.

CHAPTER 9 THE ART STUDENTS LEAGUE

1. Alexander Stirling Calder to Jane Davenport, August 11, 1921, Calder Foundation archives.
2. Nanette Lederer Calder to Margaret Calder Hayes, c. fall 1924, Calder Foundation archives.
3. William G. Rogers, "Calder: Man and Mobile," manuscript, Calder Foundation archives, 1956, p. 102.
4. Ibid., p. 103.
5. Alexander Calder, "The Evolution," manuscript, Calder Foundation archives, 1955–56, p. 115.
6. Bernard B. Perlman, ed., *Revolutionaries of Realism: The Letters of John Sloan and Robert Henri* (Princeton: Princeton University Press, 1997), p. 97.
7. Alexander Calder, *Calder: An Autobiography with Pictures*, ed. Jean Davidson (New York: Pantheon Books, 1966), p. 66.
8. Van Wyck Brooks, *John Sloan: A Painter's Life* (New York: E. P. Dutton, 1955), p. 145.
9. Ibid.
10. Calder, *Autobiography*, p. 67.
11. Rogers, "Calder: Man and Mobile," p. 98.
12. Calder, *Autobiography*, p. 61.
13. Calder to Margaret Calder Hayes, May 26, 1924, Calder Foundation archives.
14. Joan M. Marter, *Alexander Calder* (New York: Cambridge University Press, 1991), p. 69.
15. John Sloan, *The Gist of Art: Principles and Practise Expounded in the Classroom and Studio* (1939; repr., New York: Dover Publications, 1977), p. 81.
16. Ibid., p. 11.
17. Calder, *Autobiography*, p. 66.
18. Rogers, "Calder: Man and Mobile," pp. 102–3.
19. Benjamin De Caseres, "The Fantastic Life of George Luks," *New York Herald Tribune* (September 10, 1933), quoted in Judith Hansen O'Toole, "George Luks: Rogue, Raconteur, and Realist," in Elizabeth Kennedy, ed., *The Eight and American Modernisms* (Chicago: University of Chicago Press, 2009), p. 96.
20. James Gibbons Huneker quoted in O'Toole, "George Luks," p. 91.
21. Calder, *Autobiography*, p. 66.
22. Calder, "The Evolution," p. 41.
23. Calder, *Autobiography*, p. 61.
24. See Eleanro Green, *John Graham: Artist and Avatar* (Washington, DC: The Phillips Collection, 1987), p. 19.

25. Oral history interview with Clay Spohn, January 9 and February 5, 1976, conducted by Paul Cummings, Archives of American Art, Smithsonian Institution.

26. Graham and Calder might have overlapped in Paris at the end of the summer of 1926 and were definitely both in Paris in the summer of 1927. When Calder had a show at the Weyhe Gallery in New York early in 1928, Graham had just sold some paintings to the gallery, so they may have crossed paths there as well.

27. Interview with Clay Spohn, Archives of American Art.

28. Calder, "The Evolution," p. 158.

29. Interview with Clay Spohn, Archives of American Art.

30. Selden Rodman, *Conversations with Artists* (New York: Devin-Adair, 1957), p. 140.

31. "Announcing the Birth of Playboy," *Playboy: A Portfolio of Art and Satire*, January 1919, p. 5.

32. Margaret Calder Hayes, *Three Alexander Calders: A Family Memoir* (Middlebury, VT: Paul S. Eriksson, 1977), p. 294.

33. Leslie Katz, "The Pertinence of Glackens," in *William Glackens in Retrospect* (New York: Whitney Museum of American Art, 1966), unpaged.

34. Calder, "The Evolution," p. 85.

35. Interview with Clay Spohn, Archives of American Art.

36. I am indebted to Christopher Gray for his observations, during a visit to the Calder Foundation, about the particular sites that Calder painted.

37. Hayes, *Three Alexander Calders*, p. 83.

38. Calder, *Autobiography*, p. 67.

39. Edmund Wilson, *The Twenties*, ed. and intro. Leon Edel (New York: Farrar, Straus and Giroux, 1975), p. 190.

40. John Dos Passos, *The Best Times* (New York: Signet Books, 1968), p. 147.

41. Calder, *Autobiography*, p. 67.

42. Ibid.

43. Alexander Calder, "Seeing the Circus with 'Sandy' Calder," *National Police Gazette*, May 23, 1925.

44. Edmund Wilson, *The American Earthquake* (Garden City, NY: Doubleday, 1958), p. 42.

45. John Sloan, *Gist of Art*, pp. 81, 106, 18.

46. Nanette Calder to Calder, August 6, 1924, Calder Foundation archives.

47. James Huneker, *Promenades of an Impressionist* (New York: Charles Scribner's Sons, 1910), pp. 222–23, 225.

48. Charles Baudelaire, *The Painter of Modern Life and Other Essays*, ed. and trans. Jonathan Mayne (London: Phaidon, 1964), p. 9.

49. Hayes, *Three Alexander Calders*, p. 83.

50. Élie Faure, *History of Art: Modern Art*, trans. Walter Pach (1924; repr., Garden City, NY: Garden City Publishing Co., 1937), p. 1.

51. Ibid., p. 489.

CHAPTER 10 *ANIMAL SKETCHING*

1. Nanette Lederer Calder to Kenneth Hayes, June 16, 1924, Calder Foundation archives.

2. Calder to Margaret Calder Hayes, May 17, 1924, Calder Foundation archives.

3. Calder to Margaret Hayes, May 26, 1924, Calder Foundation archives.

4. Margaret Calder Hayes, *Three Alexander Calders: A Family Memoir* (Middlebury, VT: Paul S. Eriksson, 1977), pp. 82–83.

5. Ibid., p. 83.

6. Nanette Calder to Calder, July 30, 1924, Calder Foundation archives.

7. Calder to Frances Hayes, c. April 1924, Calder Foundation archives.

8. Oral history interview with Clay Spohn, October 5, 1964, and September 25, 1965, conducted by Harlan Phillips, Archives of American Art, Smithsonian Institution; oral history interview with Clay Spohn, January 9 and February 5, 1976, conducted by Paul Cummings, Archives of American Art, Smithsonian Institution.

9. Nanette Calder to Calder, July 30, 1924, Calder Foundation archives.

10. Nanette Calder to Calder, September 10, 1924, Calder Foundation archives.
11. Nanette Calder to her children, May 17, 1924, Calder Foundation archives.
12. Calder to Margaret Hayes, September 24, 1924, Calder Foundation archives.
13. Calder to Stirling Calder and Nanette Calder, September 1920, Calder Foundation archives.
14. Nanette Calder to Calder, May 5, 1924, Calder Foundation archives.
15. Nanette Calder to Calder, July 3, 1924, Calder Foundation archives.
16. Hayes, *Three Alexander Calders*, p. 85.
17. Calder to Margaret Hayes, c. November 1924, Calder Foundation archives.
18. Hayes, *Three Alexander Calders*, p. 85.
19. Alexander Calder, "The Evolution," manuscript, Calder Foundation archives, 1955–56, p. 93.
20. See Helen Deutsch and Stella Hanau, *The Provincetown: A Story of the Theater* (1931; repr., New York: Russell & Russell, 1972), p. 69.
21. Edmund Wilson, *The Twenties*, ed. and intro. Leon Edel (New York: Farrar, Straus and Giroux, 1975), p. 274.
22. Marc Robinson, *The American Play: 1787–2000* (New Haven, CT: Yale University Press, 2010), p. 158.
23. See Pepe Karmel, "The Alchemist: Alexander Calder and Surrealism," in Joan Simon and Brigitte Leal, eds., *Alexander Calder: The Paris Years 1926–1933* (New York: Whitney Museum of American Art, 2009), pp. 213–14.
24. Frederick Kiesler, "Debacle of the Modern Theatre," in Frederick Kiesler and Jean Heap, eds., *International Theatre Exposition New York 1926* (New York: Steinway Building, 1926), pp. 18, 22.
25. Adolf Loos, "The Theatre," in Kiesler and Heap, *International Theatre Exposition*, p. 7.
26. Lee Simonson, *Theatre Art: International Exhibition* (New York: Museum of Modern Art, 1934), p. 19.
27. By the end of the 1920s, Calder knew at least one more important set designer, Jo Mielziner. Simonson's 1934 theater show at the Museum of Modern Art included work by Throckmorton, as well as Mielziner and Aline Bernstein, who hosted the *Cirque Calder* performance about which Thomas Wolfe would write in *You Can't Go Home Again*. Calder would have probably seen Gilbert and Sullivan's *Patience* at the Provincetown Playhouse in December 1924, for which Throckmorton collaborated with Robert Edmond Jones, yet another legendary figure in the new stage design, who would be one of the key figures in Simonson's 1934 Museum of Modern Art exhibition. In the Museum of Modern Art catalog, Simonson praised Appia's late-nineteenth-century work for the way "a setting became a composition of forms related in space by the quality of the light that bound them together; its fluctuations, by the dramatic opposition of vast shadows and concentrated high lights, created monumental masses and then blotted them out until they were towering silhouettes or hung like mirages in the heavens." (Simonson, *Theatre Art*, p. 18.) Was there not a foretaste of Calder's mobiles in these ideas?
28. Lee Simonson in Theodore Komisarjevsky and Lee Simonson, *Settings & Costumes of the Modern Stage* (London: Studio Limited, 1933), pp. 98, 96.
29. Nanette Calder to Margaret Hayes, February 1, 1926, Calder Foundation archives.
30. Murdock Pemberton, "Review of Exhibitions," *New Yorker*, January 2, 1926, p. 21.
31. Calder to Frances Hayes, April 1924, Calder Foundation archives.
32. Calder, "The Evolution," p. 53.
33. Malcolm Cowley to Harriet Monroe, June 3, 1926, in *The Long Voyage: Selected Letters of Malcolm Cowley, 1915–1987*, ed. Hans Bak (Cambridge, MA: Harvard University Press, 2014), p. 139.
34. Robert Cowley in an email to Jed Perl, September 20, 2015.
35. Glenway Wescott, *A Heaven of Words: Last Journals, 1956–1984*, ed. and intro. Jerry Rosco (Madison: University of Wisconsin Press, 2013), p. 206.
36. Calder, "The Evolution," p. 177.
37. Ibid., pp. 177–78.
38. Ibid., p. 174.
39. Alexander Calder, *Calder: An Autobiography with Pictures*, ed. Jean Davidson (New York: Pantheon Books, 1966), p. 70.
40. Sandra Davidson interviewed by Jed Perl, September 14, 2016.
41. Calder, *Autobiography*, p. 72.
42. Élie Faure, *History of Art*, vol. 1, *Ancient Art*, trans. Walter Pach (New York: Harper & Brothers, 1921), pp. 18, 21.

43. Ibid., p. 9.

44. Élie Faure, *History of Art*, vol. 4, *Modern Art*, trans. Walter Pach (New York: Harper & Brothers, 1924), p. 405.

45. Ernest Thompson Seton—the artist whose books about animals of the western United States had fascinated Sandy and Peggy as children—had urged the director of the Bronx Zoo, when it was being designed in the 1890s, to make it artist friendly, and Calder certainly went there to learn, as Thompson Seton had hoped artists would. There is no question that Calder was aware of the appeal of these animal drawings for children. He gave an album to one of his nephews and sold several sheets to his old friend Marjorie (née Acker), now married to Duncan Phillips and beginning their museum in Washington; she wanted them for her son.

46. Joan M. Marter, *Alexander Calder* (New York: Cambridge University Press, 1991), p. 23. Calder might also have had in mind some words from Faure's *History of Art:* "Japanese art would grasp in universal change the characteristics of the object, but of the object in motion, which is alive, moves and gives— despite its nearly constant form—the impression of instability." (This is cited by Arnaud Pierre in his postface for the French edition of *Animal Sketching* [Paris: Éditions Dilecta, 2009], p. 90.)

47. It is not, however, only Bonnard's illustrations but also Renard's text that arouses attention. The very first tale in Renard's book, "Cocks," is about three cocks, two of which are sculptures, one of wood atop an old church, the next a metal one meant for the new church steeple, "his tail high . . . shiny new . . . he sparkles in the sunlight." (Jules Renard, *Natural Histories*, trans. Elizabeth Roget [New York: George Braziller, 1966], p. 13.) We might see here an allegory, relevant to Calder's work, of the transformation of the living animal into the wood and, finally, the metal animal. The sketch Calder included in his *Autobiography* of his lost bird sundial might be a distant cousin of Bonnard's ink drawing of the bird atop the church steeple. Throughout his life, Calder would create metal birds that sparkled in the sunlight.

48. Elmer E. Scott, *The P-culiar Dog, or The Piddling Pup* (New York: Calder Foundation, 2001), unpaged. Originally prepared for printing in 1925.

49. Nanette also seems to have taken an interest in producing telegraphic drawings of birds. She may have done some in Washington State—which Calder would have known and maybe even seen her make.

50. Calder was not the only Sloan student to publish a drawing manual. Kimon Nicolaïdes—a student of Sloan's who, although not mentioned by Calder, was known to Clay Spohn—was at the time of his death, a decade later, working on *The Natural Way to Draw;* it has never gone out of print.

51. Alexander Calder, *Animal Sketching* (New York: Dover, 1973), pp. 7, 9. Originally published by Bridgman Publishers in 1926.

52. Calder to Nanette Calder, April 13, 1927, Calder Foundation archives.

53. Calder, *Animal Sketching*, p. 13.

54. Calder to Nanette Calder, April 13, 1927, Calder Foundation archives.

55. Calder, *Animal Sketching*, p. 9.

56. Edna Warner Allen's memoir, p. 3, Calder Foundation archives.

57. Calder, "The Evolution," p. 161.

58. Calder, *Autobiography*, p. 76.

CHAPTER 11 PARIS

1. Alexander Calder, *Calder: An Autobiography with Pictures*, ed. Jean Davidson (New York: Pantheon Books, 1966), p. 78.

2. Stanley William Hayter "Alexander Calder at Paris," in *Homage to Alexander Calder*, ed. Gualtieri di San Lazzaro (New York: Tudor Publishing Co., 1972), p. 6.

3. Joan M. Marter, *Alexander Calder* (New York: Cambridge University Press, 1991), p. 45.

4. Clay Spohn, quoted ibid.

5. Anthony Powell, *To Keep the Ball Rolling*, quoted in Adrian Clark and Jeremy Dronfield, *Queer Saint: The Cultured Life of Peter Watson* (London: Metro, 2015), p. 26.

6. John Glassco, *Memoirs of Montparnasse* (1970; repr. New York: Viking Press, 1973), pp. 14–15.

7. Calder to Alexander Stirling Calder and Nanette Lederer Calder, October 1926, Calder Foundation archives.

8. Ernest Hemingway, *A Moveable Feast* (New York: Scribner, 1964), p. 101.

9. Ibid., pp. 101–4.

10. Ernest Hemingway, introduction to Kiki, *Kiki's Memoirs*, ed. and foreword by Billy Klüver and Julie Martin (1929; repr., Hopewell, NJ: Ecco Press, 1996), p. 48.

11. Malcolm Cowley, *Exile's Return* (New York: Viking Press, 1951), p. 221.

12. Calder, *Autobiography*, p. 77.

13. Ibid.

14. Margaret Calder Hayes, *Three Alexander Calders: A Family Memoir* (Middlebury, VT: Paul S. Eriksson, 1977), p. 191.

15. Calder to his parents, July 18, 1926, Calder Foundation archives.

16. Eugène Brieux, *Artists' Families* (New York: Doubleday, Page, 1918), pp. 32–33.

17. Calder to his parents, July 18, 1926, Calder Foundation archives.

18. Calder to his parents, July 26, 1926, Calder Foundation archives.

19. Calder, *Autobiography*, p. 42.

20. Ibid.

21. Calder to his parents, July 26, 1926, Calder Foundation archives.

22. Ibid.

23. Ibid.

24. Ezra Pound, *Ezra Pound and the Visual Arts*, ed. and intro. Harriet Zinnes (New York: New Directions, 1980), p. 13.

25. Calder to his parents, July 26, 1926, Calder Foundation archives.

26. Ibid.

27. Calder to Nanette Calder, August 8, 1926, Calder Foundation archives.

28. Calder to his parents, July 26, 1926, Calder Foundation archives.

29. Calder, *Autobiography*, p. 78.

30. Calder to his parents, July 26, 1926, Calder Foundation archives.

31. Calder to Nanette Calder, August 8, 1926, Calder Foundation archives.

32. Calder to his parents, August 26, 1926, Calder Foundation archives.

33. Ibid.

34. Calder, *Autobiography*, p. 79; Calder to his parents, August 26, 1926, Calder Foundation archives.

35. Calder to his family, September 25 and 27, 1926, Calder Foundation archives.

36. Calder, *Autobiography*, p. 79.

37. Calder, statement on wire sculpture, manuscript, Calder Foundation archives, 1929.

38. Calder to his parents, August 8, 1926, Calder Foundation archives.

39. Calder to Nanette Calder, August 23, 1926, Calder Foundation archives.

40. There is a group of eight paintings in tempera on inexpensive thick paperboard that is dated circa 1926 and almost certainly done in Paris. The preponderance are circus scenes, some presented with deep, dramatic, dreamlike perspectives. There is a chilly, almost nightmarish anonymity about certain of these compositions, which seems to relate to the untitled lithograph of Washington Square Park that Calder made not long before leaving New York.

41. Calder, *Autobiography*, p. 80.

42. Hayes, *Three Alexander Calders*, p. 199; Calder to his parents, August 26, 1926, Calder Foundation archives.

43. Calder, *Autobiography*, p. 83.

44. Calder to his parents, November 12, 1926, Calder Foundation archives. A copy of a basic text, *Cours de langue française*, published in 1923, is still to be found in the Calder house, although its fairly clean condition suggests that it was never much used and may not be the book Calder had at the time.

45. Calder to his parents, December 10, 1926, Calder Foundation archives.

46. Paul Matisse interviewed by Jed Perl, March 21, 2012.

47. James Johnson Sweeney, *Calder: The Artist, the Work* (Boston: Boston Book and Art Publisher, 1971), p. 8.

48. Alexander Calder, "The Evolution," manuscript, Calder Foundation archives, 1955–56, p. 46.

49. Calder to Nanette Calder, December 1, 1926, Calder Foundation archives.

50. John Partridge, son of Jean Partridge, interviewed by Jed Perl, January 6, 2013.

51. Calder to Nanette Calder, December 1, 1926, Calder Foundation archives.

52. Robert Osborn to Calder and Louisa Calder, April 12, 1963, Calder Foundation archives.

53. Calder to Nanette Calder, August 23, 1926, Calder Foundation archives.

54. Calder to Malcolm Cowley, January 31, 1956, Calder Foundation archives.

55. Hayes, *Three Alexander Calders*, p. 194.

56. Ibid.

57. Calder to his parents, August 8, 1926, Calder Foundation archives.

58. Nanette Calder to Calder, July 30, 1924, Calder Foundation archives.

59. Elizabeth Hawes, *Fashion Is Spinach* (New York: Random House, 1938), p. 33.

60. Ibid., p. 51.

61. Marc Plate, Marion Greenwood's nephew, in an email on April 14, 2017, wrote that although his aunt "had met many artists with whom she had affairs"—and talked about it—he hadn't had the impression that she had an affair with Calder, although he knew that they had been fellow students at the League and had socialized to some extent. Nick Lyons, in an email on March 26, 2017, recalled Plate describing Greenwood as "spectacularly beautiful"; this was confirmed by Manny Bromberg, a painter who, at the age of one hundred, is old enough to have known Greenwood when she was still close to her prime. For Marion Greenwood and Noguchi, see Amy Wolf, *On Becoming an Artist: Isamu Noguchi and His Contemporaries, 1922–1960* (Long Island City, NY: The Isamu Noguchi Museum Foundation and Garden Museum, 2010), pp. 42–45; Nancy Grove, *Isamu Noguchi: Portrait Sculpture* (Washington, DC: Smithsonian Institution Press, 1989), pp. 48–49.

62. Stanley William Hayter, "Alexander Calder at Paris," p. 6.

63. Calder, *Autobiography*, p. 77.

64. Ibid., p. 88.

65. Carol Loeb Schloss, *Lucia Joyce: To Dance in the Wake* (New York: Farrar, Straus and Giroux, 2005), p. 202.

66. Calder to his parents, October 1926, Calder Foundation archives.

67. Calder to his parents, January 10, 1927, Calder Foundation archives.

68. Glenway Wescott, *Continual Lessons: The Journals of Glenway Wescott, 1937–1955*, ed. Robert Phelps and Jerry Rosco (New York: Farrar, Straus and Giroux, 1990), p. 149.

69. Calder to Nanette Calder, April 13, 1927, Calder Foundation archives; Hayes, *Three Alexander Calders*, p. 214.

CHAPTER 12 *CIRQUE CALDER*

1. Alexander Calder, *Calder: An Autobiography with Pictures*, ed. Jean Davidson (New York: Pantheon Books, 1966), p. 83.

2. Legrand-Chabrier, "Un petit cirque à domicile," *Candide*, June 23, 1927, p. 7.

3. Legrand-Chabrier, "Alexandre Calder et son cirque automate," *La volonté*, May 19, 1929.

4. Legrand-Chabrier, "Un petit cirque."

5. Legrand-Chabrier, "Alexandre Calder et son cirque automate."

6. Ibid.

7. Jean Clair, ed., *The Great Parade: Portrait of the Artist as Clown* (New Haven, CT: Yale University Press: 2004), p. 215.

8. Gilbert Seldes, *The Seven Lively Arts* (New York: Harper & Brothers, 1924), p. 309.

9. Edmund Wilson, *The American Earthquake* (New York: Doubleday, 1958), pp. 57, 42.

10. E. E. Cummings, *A Miscellany*, revised and intro. George J. Firmage (New York: October House, 1964), p. 111.

11. Cleve Gray, "Calder's Circus," *Art in America*, October 1964, p. 23.

12. Harry Crosby, *Shadows of the Sun: The Diaries of Harry Crosby*, ed. Edward Germain (Santa Barbara, CA: Black Sparrow Press, 1977), pp. 163–64.

13. Ramón Gómez de la Serna, *Le Cirque*, trans. from Spanish to French by Adolphe Falgairolle, intro. by the Fratellini Brothers (Paris: Simon Kra, 1927), pp. 151, 214. The copy in Roxbury is inscribed: *"en souvenir des bons moments passes au cirque Calder 30-6-31";* the signature can't be made out.

14. Mary Butts, *The Journals of Mary Butts*, ed. Nathalie Blondel (New Haven, CT: Yale University Press, 2002), p. 256.

15. Douglas Goldring, *South Lodge: Reminiscences of Violet Hunt, Ford Madox Ford and the English Review Circle* (London: Constable & Co., 1943), p. 148.

16. Nina Hamnett, *Laughing Torso* (London: Constable & Co., 1932), p. 174.

17. Charles Baudelaire, "On the Essence of Laughter," in *Mirror of Art: Critical Studies*, ed. and trans. Jonathan Mayne (New York: Doubleday, 1956), p. 137.

18. Alexander Calder, "The Evolution," manuscript, Calder Foundation archives, 1955–56, p. 149.

19. Matthew Josephson, *Life Among the Surrealists* (New York: Holt, Rinehart and Winston, 1962), p. 102.

20. Ezra Pound, *The Pisan Cantos*, ed. Richard Sieburth (1948; repr., New York: New Directions, 2003), p. 31.

21. Jean Cocteau quoted in T. S. Eliot, *The Letters of T. S. Eliot*, vol. 2, *1923–1925*, ed. Valerie Eliot and Hugh Haughton (New Haven, CT: Yale University Press, 2011), p. 312n6.

22. Quoted in Francis Steegmuller, *Cocteau: A Biography* (Boston: Little, Brown, 1970), p. 183.

23. Calder, "The Evolution," p. 149.

24. Elizabeth Hawes, "More Than Modern—Wiry Art: Sandy Calder Sculptures in a New Medium," *Charm*, 9, no. 3 (April 1928), p. 68.

25. Calder, "The Evolution," p. 149.

26. It is not beyond possibility that Cocteau taught Calder a few tricks, too. For years, art historians have aimed to link some beautiful calligraphic drawings of circus scenes that Picasso made in 1921 with the beginnings of Calder's wire sculpture. Those Picasso drawings were probably unpublished at the time. True, Picasso had done a cover for Stravinsky's *Ragtime* in the same calligraphic style; this was published in 1922, and Calder might have seen it. But Calder may also have known Cocteau's book of more than a hundred drawings, *Dessins*, first published in 1923 in a limited edition and then in several larger editions in 1924. E. E. Cummings wrote an enthusiastic review of *Dessins* in *Vanity Fair* in 1925, praising Cocteau as a "poetic ironist" and observing that the book "is on sale in most of the New York book stores." (Cummings, *A Miscellany*, p. 99.) Cocteau's caricatures of artists, dancers, and musicians, while lacking the peerless lucidity of either Picasso's drawings or Calder's wire sculptures, were in a linear style that Cocteau had surely derived from Picasso and that Calder might well have found intriguing. The book contained some of Cocteau's most famous drawings of Diaghilev and the Ballets Russes circle, which have a caricaturist's energy that can bring to mind the wire portraits Calder began making of friends and notables a couple of years later. Most suggestive of Calder's subsequent work is Cocteau's drawing of a young woman, her head and torso composed of lines that keep breaking into curlicues. Cocteau's *Dessins* also contains a drawing of a woman riding a horse in what looks like a circus ring and another of a woman playing tennis; although graphically quite inert, the drawings do suggest Calder's thematic interests, especially his portrait of the tennis champion *Helen Wills* (1927).

27. Calder, *Autobiography*, p. 80.

28. Harry Schoenhut—one of six sons of the company's founder, Albert Schoenhut—had studied at the Pennsylvania Academy with Stirling's old friend Charles Grafly before becoming the head of the Schoenhut art department around 1916.

29. Evelyn Ackerman, *Under the Bigtop with Schoenhuts Humpty Dumpty Circus* (Annapolis, MD: Gold Horse, 1996), pp. 17–18.

30. See Joan Simon, "Modern Magician: Calder's Circus and the Invention of the Mobile," lecture given at the Bard Graduate Center in New York, December 18, 2012.

31. Already in 1872, the American novelist William Dean Howells, living in Venice at the time, commented, "For my own part, I find few things in life equal to the Marionette. I am never tired of their bewitching absurdity, their inevitable defects, their irresistible touches of verisimilitude." (William Dean Howells, *Venetian Life* [Boston: James R. Osgood, 1872], p. 80.) The shadow puppet plays mounted in the last years of the nineteenth century at a Parisian night stop, Le Chat Noir, had a powerful impact on the strongly silhouetted forms in prints and paintings by Toulouse-Lautrec, Degas, and Bonnard—and may well have been in Legrand's mind when he spoke of Calder's "stylized silhouettes." The dramatist Jules Lemaître said of the shadow plays that they "are truly the shadows of Plato's cave." (Quoted in Harold B. Segel, *Pinocchio's Progeny: Puppets, Marionettes, Automatons, and Robots in Modernist and Avant-Garde Drama* [Baltimore, MD: Johns Hopkins University Press, 1995], p. 68.)

32. James Johnson Sweeney, *Alexander Calder: Sculpture Mobiles* (London: Arts Council of Great Britain, 1962), p. 8.

33. Nanette Lederer Calder to Kenneth Hayes, June 16, 1924, Calder Foundation archives.

34. Nanette Calder to Margaret Calder Hayes, January 21, 1931, Calder Foundation archives.

35. Margaret Calder Hayes, *Three Alexander Calders: A Family Memoir* (Middlebury, VT: Paul S. Erikson, 1977), p. 208.

36. Ibid., p. 219.

37. Alexander Stirling Calder to Nanette Calder, June 10, [no year but almost certainly 1923], Calder Foundation archives.

38. F. J. McIsaac, *The Tony Sarg Marionette Book* (New York: B. W. Huebsch, 1921), pp. 5, 2.

39. Alfred Kreymborg, *Troubadour: An Autobiography* (New York: Boni and Liveright, 1925), p. 342. When, in his autobiography, Kreymborg mused that puppets "are given a share in artificial time and space embryonic of the life allotted to people by the familiar fate directing the strings that keep them in motion," he might well have been prefiguring Calder's manipulation of the wires of his trapeze artists. (Ibid.)

40. Ibid.

41. Ibid., p. 308.

42. Segel, *Pinocchio's Progeny*, pp. 57–58; and George Nash, *Edward Gordon Craig: 1872–1966* (London: Her Majesty's Stationery Office, 1967). The fascination of puppets was the subject of one of Diaghilev's greatest collaborations, the 1911 *Petrushka*, with a score by Stravinsky, choreography by Fokine, and Nijinsky as the puppet who is capable of love. "In *Petrouchka*," the American novelist, critic, and photographer Carl Van Vechten wrote, Nijinsky "is a puppet, and—remarkable touch—a puppet with a soul." He commented that the great dancer gave "a more poignant expression of grief than most Romeos can give us." (Carl Van Vechten, *Music After the Great War* [New York: G. Schirmer, 1915], pp. 78–79.)

43. Either before or after his arrival in Paris, Calder may have seen a 1921 issue of the Dutch avant-garde magazine *Wendingen* devoted to marionettes and including work ranging from Indonesian shadow puppets to works by contemporary European artists. He might have known at some point of the marionettes of Cläre Paech; there is one reproduced in Max von Boehn's 1929 *Puppen und Puppenspiele* that has a metal wire body and a wire spring arm that resembles Calder's work of the same years. In any event, the list of modern artists who either represented or created puppets or marionettes of one sort or another is very long: Lyonel Feininger drew a puppet master as part of a comic strip in 1906; Balthus's father, the painter, art historian, and stage designer Erich Klossowski, produced sumptuous lithographic illustrations for Julius Meier-Graefe's puppet play *Orlando and Angelica* in 1912.

44. Helen Haiman Joseph, *A Book of Marionettes* (New York: B. W. Huebsch, 1920), p. 109.

45. Segel, *Pinocchio's Progeny*, p. 48.

46. Anatole France, *On Life and Letters: Second Series* (London: John Lane, 1914), p. 137.

47. Shaw's last play, *Shakes Versus Shav* (1949), was written for puppets; Edmund Wilson discussed it briefly in an essay published in 1951.

48. Joseph, *Book of Marionettes*, p. 209.

49. George Bernard Shaw, "Note on Puppets," in Max von Boehn, *Puppets and Automata* (New York: Dover Publications, 1972), p. vi.

50. Calder to Margaret Hayes, May 1931, Calder Foundation archives.

51. Letter from Isamu Noguchi to Jean Lipman, August 21, 1971, Calder Foundation archives. The first two paragraphs are in Lipman, *Calder's Universe*, pp. 61–63. She does not include the third paragraph.

52. Years later, Stanley William Hayter, who was already a friend in Paris in 1926, would illustrate an edition.

53. Jean-Paul Sartre, "Les Mobiles de Calder," *Alexander Calder: Mobiles, Stabiles, Constellations* (Paris: Galerie Louis Carré, 1946); trans. Chris Turner in Jean-Paul Sartre, *The Aftermath of War* (Calcutta: Seagull, 2008).

54. Christopher Isherwood, *Lions and Shadows* (1938; repr., Norfolk, CT: New Directions, 1947), p. 215.

55. Legrand-Chabrier, "Alexandre Calder et son cirque automate."

56. Legrand-Chabrier, "Un petit cirque à domicile."

CHAPTER 13 WIRE SCULPTURE

1. William G. Rogers, "Calder: Man and Mobile," manuscript, Calder Foundation archives, 1956, p. 129.

2. Nanette Lederer Calder to Margaret Calder Hayes, summer 1927, Calder Foundation archives.

3. Calder to Nanette Calder, April 13, 1927, Calder Foundation archives.

4. Calder to his parents, February 1927, Calder Foundation archives.

5. Calder to Nanette Calder, April 13, 1927, Calder Foundation archives.

6. Calder was in possession of a sheaf of letters from manufacturers in response to his inquiries, with a few possibilities worth pursuing. J. K. Farnell and Co., Ltd., in London, explained that the firm mostly produced soft, stuffed toys and, in any event, felt his designs were "impractical from the point of view of factory production." The Krieger Novelty Company in Lodi, California, expressed mild interest, as did Charles Pajeau, the inventor of Tinkertoys, in a letter from the factory in Evanston, Illinois, which Calder was invited to come and visit. See letters in the Calder Foundation archives.

7. In his *Autobiography,* Calder rather left the impression that he had somehow inspired the Gould Manufacturing Company to go into the toy business, but the truth was that it was well into it already.

8. Alexander Calder, *Calder: An Autobiography with Pictures,* ed. Jean Davidson (New York: Pantheon Books, 1966), p. 84.

9. Walter Benjamin, "Toys and Play," in *Selected Writings,* vol. 2, *1927–1934,* ed. Michael W. Jennings, Howard Eiland, and Gary Smith, trans. Rodney Livingstone et al. (Cambridge, MA: Harvard University Press, 1999), p. 119.

10. Begun in 1921, the company exhibited some of its products at the Whitney Studio Club in 1922, established offices on Wooster Street early in 1924, but lost its entire inventory in a fire a year later.

11. See Cecilia de Torres, "Torres-García's Toys: The Deconstruction of the Object," in José Lebrero Stals and Carlos Pérez, eds., *Toys of the Avant-Garde* (Málaga: Museo Picasso, 2010).

12. Charles Baudelaire, *The Painter of Modern Life, and Other Essays,* ed. and trans. Jonathan Mayne (London: Phaidon, 1964), p. 199.

13. Margaret Calder Hayes, *Three Alexander Calders: A Family Memoir* (Middlebury, VT: Paul S. Eriksson, 1977), pp. 33–34.

14. *Liberté,* March 5, 1927.

15. Man Ray, *Self Portrait* (1963; repr., Boston: Little, Brown, 1988), p. 115.

16. Calder, *Autobiography,* p. 80.

17. Oral history interview with Clay Spohn conducted by Paul Cummings, January 9 and February 5, 1976, Archives of American Art, Smithsonian Institution.

18. Clay Spohn to Alexander Calder, June 19, 1970, Calder Foundation archives.

19. Alexander Calder, "The Evolution," manuscript, Calder Foundation archives, 1955–56, p. 88.

20. Ibid., p. 63.

21. Ibid., p. 172.

22. Hayes, *Three Alexander Calders,* p. 155.

23. Hans Cürlis, "Creative Hands," in Karl Kiesel and Ernst O. Thiele, eds., *Art and Germany* (Bremen: University Travel Department of the North German Lloyd, 1928), p. 58.

24. André Levinson, *André Levinson on Dance: Writings from Paris in the Twenties,* ed. and intro. Joan Acocella and Lynn Garafola (Hanover, NH: Wesleyan University Press, 1991), p. 74.

25. Hayes, *Three Alexander Calders,* p. 277.

26. Calder, *Autobiography,* p. 85.

27. Carl Zigrosser, *My Own Shall Come to Me: A Personal Memoir and Picture Chronicle* (Haarlem: Casa Laura, 1971), p. 15.

28. Ibid., p. 181.

29. Ibid., p. 94.

30. Rockwell Kent, the painter and illustrator with a taste for Transcendentalist thought and left-wing causes, had designed a cover and decorative initials for *The Modern School* magazine. Zigrosser exhibited Kent's work at Weyhe, and they remained close, lifelong friends. Apparently Calder wasn't impressed by Kent's rather bombastic graphic style. Calder remembered his friend Robert Josephy being quite annoyed when he put pins through an invitation that Josephy had received to a banquet in Kent's honor.

31. Rogers, "Calder: Man and Mobile," p. 136.

32. Unsigned review, *Creative Art,* April 1928.

33. Rogers, "Calder: Man and Mobile," p. 137.

34. Calder to his parents, March 17, 1929, Calder Foundation archives.

35. Nanette Calder to Margaret Hayes, c. January 1928, Calder Foundation archives.

36. Calder, *Autobiography*, pp. 86–87.

37. See the class notes of the *Stevens Indicator*, 1928, p. 110: "A little clipping from the *New York Times* comes to tell us that Alexander Calder created somewhat of a panic on 5th Avenue not so long ago by walking down that highway closely followed by an eleven foot wolf." It isn't clear that the "little clipping" was actually from *The New York Times*.

38. Calder, *Autobiography*, p. 88.

39. For a discussion of Jean Crotti's head of Marcel Duchamp, see Joan M. Marter, *Alexander Calder* (New York: Cambridge University Press, 1991), pp. 49–52.

40. James Joyce, *A Portrait of the Artist as a Young Man* (1916; repr., New York: Penguin, 1977), p. 185.

41. James Johnson Sweeney, *Calder: The Artist, the Work* (Boston: Boston Book and Art Publisher, 1971), p. 8.

42. Marter, *Alexander Calder*, p. 70; Calder, *Autobiography*, p. 87.

43. Alexander Stirling Calder to Joseph T. Fraser, September 13, 1939, Calder Foundation archives.

44. Calder, "The Evolution," p. 156.

45. Calder to his parents, March 5, 1929, Calder Foundation archives.

46. Calder, application for a Guggenheim fellowship, fall 1928. John Simon Guggenheim Memorial Foundation archives.

47. Calder to Stirling Calder and Nanette Calder, March 5 [1929], typescript probably by Margaret Calder Hayes, Calder Foundation archives.

48. John Sloan, Boardman Robinson, and Samuel Chamberlain, references for Calder's application for a Guggenheim fellowship, fall 1928, John Simon Guggenheim Memorial Foundation archives.

49. Stirling Calder, reference letter for Calder's application for a Guggenheim fellowship, fall 1928, John Simon Guggenheim Memorial Foundation archives.

CHAPTER 14 RUE CELS

1. Alexander Calder, *Calder: An Autobiography with Pictures*, ed. Jean Davidson (New York: Pantheon Books, 1966), p. 91.

2. John Dos Passos, *The Best Times* (New York: Signet Books, 1968), p. 14.

3. Calder to Nanette Lederer Calder, October 31, 1928, Calder Foundation archives.

4. Calder, *Autobiography*, p. 91.

5. Ibid., p. 110.

6. Gabrielle Buffet-Picabia, "Alexandre Calder, ou Le roi du fil de fer," *Vertigral* 1, July 15, 1932.

7. Calder, *Autobiography*, p. 91.

8. Calder to his parents and the Hayes family, December 27, 1928, Calder Foundation archives.

9. Alexander Calder, "The Evolution," manuscript, Calder Foundation archives, 1955–56, p. 92. László Moholy-Nagy had worn red worker's overalls at the Bauhaus, to suggest his sympathies with the workingman.

10. Much of the action in one of Georges Simenon's earlier Maigret mysteries, *A Man's Head*, originally published in 1931, took place in La Coupole, one of Calder's hangouts. "People talked to each other without being introduced, like old friends," Simenon wrote. "A German spoke English with an American, and a Norwegian used a mix of three different languages as he tried to make himself understood by a Spaniard." (Georges Simenon, *A Man's Head*, trans. David Coward [1931; repr., London: Penguin, 2014], p. 53.)

11. Calder to his parents and the Hayes family, December 27, 1928, Calder Foundation archives.

12. Gaston de Pawlowski, *Le Journal*, January 19, 1929.

13. Calder to his parents, March 5, 1929, Calder Foundation archives.

14. Calder to Nanette Calder, c. January 1929, Calder Foundation archives.

15. Calder to his parents, April 1929, Calder Foundation archives.

16. Quoted in Elizabeth Hutton Turner, "Calder and Miró: A New Space for the Imagination," in Elizabeth Hutton Turner and Oliver Wick, eds., *Calder/Miró* (London: Philip Wilson Publishers, 2004), p. 27.

17. Sandra Davidson interviewed by Jed Perl, August 25, 2015.

18. Joan Miró, statement in *Miró/Calder* (New York: Perls Galleries, 1961), unpaged.

19. Quoted in James Thrall Soby, *Joan Miró* (New York: Museum of Modern Art, 1959), p. 39.

20. Joan Miró, "Memories of the rue Blomet," in *Joan Miró: A Retrospective* (New York: Guggenheim, 1987), p. 32.

21. Calder, *Autobiography,* p. 96.

22. Ibid., p. 92.

23. We know that Calder wrote to Miró in early December. And in his *Autobiography,* he describes their becoming friends before his return to New York in June. But in the *Autobiography* he also says that he first saw Miró's work in his studio when most of his paintings were at a show in Belgium, which was in May. So it may be that they were getting to know each other at the gym and over dinners before Calder actually took a look at Miró's work.

24. Jean Cocteau, "Le mystère laïc," in *My Contemporaries,* ed. and trans. Margaret Crosland (New York: Chilton Book Company, 1968), p. 104.

25. David Gascoyne, *A Short Survey of Surrealism* (London: Cobden-Sanderson, 1935), p. 59.

26. André Breton, quoted ibid., pp. 61–62.

27. Joan Miró to René Gaffé, June 19, 1929, in *Joan Miró: Selected Writings and Interviews,* ed. Margit Rowell, trans. Paul Auster (New York: Da Capo Press, 1992), p. 113.

28. Quoted in Gérard Durozoi, *History of the Surrealist Movement,* trans. Alison Anderson (Chicago: University of Chicago Press, 2002), p. 193.

29. André Masson, "45, rue Blomet" (originally written in 1968), in *Surrealism and the rue Blomet* (New York: Eykyn Maclean, 2013), p. 47.

30. Anonymous contributor's note, *Transition: A Quarterly Review,* Fall 1936, p. 5.

31. Quoted in Joan Punyet Miró, "Alexander Calder and Joan Miró: A Friendship, a Complicity," in *Calder* (Barcelona: Fundació Joan Miró, 1997), p. 168.

32. Joan Miró speaking at Fondation Maeght in 1969, quoted in "For a Big Show in France, Calder 'Oughs' His Works," *New York Times,* April 3, 1969.

33. Calder to Nanette Calder, c. January 1929, Calder Foundation archives.

34. James Joyce, *A Portrait of the Artist as a Young Man* (1916; repr., New York: Penguin, 1977), p. 212.

35. Writing in 1923 about the importance of truth to materials in a little book about the Irish painter William Orpen, a critic identified only as "R.P." observed that the artist who worked in metals faced particular challenges, commenting that "it is a curious and inevitable fact that expressive reality is always gained more fully when the limits of easy tractability are recognized and used, rather than when the material is tortured beyond its limit of expressive usefulness." (R.P[ickle?], *Sir William Orpen* [London: Ernest Benn, 1923], p. 9.)

36. "A Connecticut Constructivist Sets a Challenge," *Interiors,* November 1943, p. 37.

37. Calder, statement on wire sculpture, 1929, Calder Foundation archives.

38. William G. Rogers, "Calder: Man and Mobile," manuscript, Calder Foundation archives, 1956, p. 142.

39. Calder to Nanette Calder, January 1929, Calder Foundation archives.

40. Stuart Davis to Mrs. Davis, January 25, 1929, Calder Foundation archives; estate of Stuart Davis.

41. Calder, "The Evolution," p. 57.

42. Jules Pascin, *Sculptures bois et fil de fer de Alexandre Calder* (Paris: Galerie Billiet–Pierre Vorms, 1929). Translation courtesy of the Calder Foundation, New York.

43. Calder to his parents, March 5, 1929, Calder Foundation archives.

44. Calder, *Autobiography,* p. 92.

45. Calder to his parents, April 1929, Calder Foundation archives.

46. Walter Benjamin, "Little History of Photography," in *Walter Benjamin, Selected Writings,* vol. 2, *1927–1934,* ed. Michael W. Jennings, Howard Eiland, and Gary Smith, trans. Rodney Livingstone et al. (Cambridge, MA: Harvard University Press, 1999), p. 526.

47. Whatever Stone's part was in making the connection, there is certainly reason to believe that the show at Weyhe and Carl Zigrosser's connections would have led Calder to see a show in Berlin as a possibility. J. B. Neumann had left his business in the hands of Karl Nierendorf when he immigrated to the United States in 1923 and set up a gallery in New York, and he definitely knew and over the years would be involved in business transactions with Zigrosser and may well have seen Calder's first show at Weyhe. As for Erhard Weyhe, he certainly had contact with Nierendorf, who had written the introduction to Karl Blossfeldt's immensely influential book of close-up photographs of natural

forms, *Art Forms in Nature,* which Weyhe published in an American edition in 1929. One might even argue that anybody who was attracted to the curving and curling nature forms that Blossfeldt submitted to the attentions of his camera—as Nierendorf, who promoted Blossfledt's work beginning in 1926, clearly was—would have naturally take an interest in Calder's wire arabesques, which bristled with their own curves and curls. Calder had a copy of Blossfeldt's book in Roxbury.

48. Adolf Behne, "Plastik als Lustakt," *Welt Am Abend,* April 11, 1929. Translated by Ross Benjamin; English translation copyright © 2016 Ross Benjamin.

49. Calder, *Autobiography,* p. 98.

50. André Gide, "Classicism," trans. Jeffrey J. Carre in *Pretexts: Reflections on Literature and Morality,* ed. Justin O'Brien (n.p.: Meridian Books, 1959), p. 199.

51. Calder, statement on wire sculpture, 1929, Calder Foundation archives.

52. Although there is nothing simple about James Joyce's *Ulysses,* Joyce was also, as T. S. Eliot wrote in 1923, "manipulating a continuous parallel between contemporaneity and antiquity" as "a way of controlling, of ordering, of giving a shape and a significance to the immense panorama of futility and anarchy which is contemporary history." (T. S. Eliot, "Ulysses, Order, and Myth," *Dial,* November 1923, pp. 480–83.)

53. Jean Cocteau, *A Call to Order,* trans. Rollo H. Myers (London: Faber and Gwyer, 1926), p. 5.

54. Ibid., p. 20.

55. Paul Rosenfeld, "Satie and Impressionism," in *Musical Chronicle (1917–1923)* (New York: Harcourt, Brace and Company, 1923), p. 178.

56. Cocteau, *A Call to Order,* p. 7.

57. Jean Cocteau, "Beauty Secrets," in *Cocteau's World: An Anthology of Writings by Jean Cocteau,* ed. and trans. Margaret Crosland (New York: Dodd, Mead, 1973), p. 476.

58. Kiki de Montparnasse, quoted in Barbara Zabel, *Calder's Portraits: A New Language* (Washington, DC: Smithsonian Institution Scholarly Press, 2011), p. 64.

59. Quoted in Herbert R. Lottman, *Man Ray's Paris* (New York: Harry N. Abrams, 2001), p. 53.

60. Kenneth E. Silver, *Paris Portraits: Artists, Friends, and Lovers* (Greenwich, CT: Bruce Museum, 2008), p. 42.

61. *New York Herald* (Paris edition), May 21, 1929.

CHAPTER 15 LOUISA JAMES

1. Alexander Calder, *Calder: An Autobiography with Pictures,* ed. Jean Davidson (New York: Pantheon Books, 1966), p. 101.

2. Ibid.

3. Edward Holton James to Louisa James, March 13, 1929, Calder Foundation archives.

4. James Joyce, quoted in Cyril Connolly, *The Evening Colonnade* (London: David Bruce & Watson, 1973), p. 303.

5. Calder, untitled manuscript, Calder Foundation archives, 1956, p. 28.

6. Margaret Calder Hayes, *Three Alexander Calders: A Family Memoir* (Middlebury, VT: Paul S. Eriksson, 1977), p. 225.

7. Barbara Zabel, *Calder's Portraits: A New Language* (Washington, DC: Smithsonian Institution Scholarly Press, 2011), p. 34.

8. Alexander Stirling Calder to Calder and Louisa, November 22, 1933, Calder Foundation archives.

9. Nina Hamnett, *Laughing Torso* (London: Constable & Co., 1932), p. 315.

10. Alexander Calder, "The Evolution," manuscript, Calder Foundation archives, 1955–56, p. 50.

11. Hayes, *Three Alexander Calders,* p. 224.

12. Sandra Davidson interviewed by Jed Perl, May 12, 2013.

13. Stephen Robeson-Miller interviewed by Jed Perl, September 16, 2015.

14. Louisa James to Louisa Cushing James, August 19, 1929, Calder Foundation archives.

15. Louisa James to Louisa Cushing James, (undated; refers to "today" as Calder's birthday, i.e., August 22, 1929, although in an envelope postmarked September 10, 1929), Calder Foundation archives.

16. Henry James, *Notes of a Son and Brother* (1914; repr., New York: Criterion Books, 1951), p. 261.

17. Robert Osborn to the Calders, April 12, 1963, Calder Foundation archives.

18. Sandra Davidson in an email to Jed Perl, October 12, 2015.

19. Stirling Calder to the Hayes family, December 29, 1931, Calder Foundation archives.

20. Edward Holton James, *I Am a Yankee* (Concord, MA: Yankee Freemen Movement, 1943), p. 27.

21. Ibid., pp. 25, 26, 28.

22. Hayes, *Three Alexander Calders*, p. 245.

23. Ibid.

24. Stirling Calder to Margaret Calder Hayes, September 5, 1929, Calder Foundation archives.

25. Calder, *Autobiography*, p. 103.

26. Nanette Lederer Calder to Margaret Hayes, c. December 1929, Calder Foundation archives.

27. Nanette Calder to Margaret Hayes, December 1929, Calder Foundation archives.

28. Nanette Calder to Margaret Hayes, January 13, 1930, Calder Foundation archives.

29. Sandra Davidson interviewed by Jed Perl, February 9, 2012.

30. Elizabeth Hawes, *Fashion Is Spinach* (New York: Random House, 1938), p. 142.

31. Zabel, *Calder's Portraits*, p. 106.

32. Hawes, *Fashion Is Spinach*, p. 156.

33. Calder, "The Evolution," pp. 46–47.

34. Nanette Calder to Margaret Hayes, January 13, 1930, Calder Foundation archives.

35. Oral history interview with Isamu Noguchi conducted by Paul Cummings, November 7–December 26, 1973, Archives of American Art, Smithsonian Institution.

36. Murdock Pemberton, "The Art Galleries: Pigment and Tea Leaves," *New Yorker*, February 23, 1929.

37. Calder, *Autobiography*, p. 103.

38. Lincoln Kirstein, "Hound and Horn: Forty-eight Years After," in Mitzi Berger Hamovitch, ed., *The Hound and Horn Letters* (Athens: University of Georgia Press, 1982), p. xii.

39. Lincoln Kirstein, *Mosaic: Memoirs* (New York: Farrar, Straus and Giroux, 1994), p. 169.

40. Calder, *Autobiography*, p. 108.

41. Nanette Calder to Margaret Hayes, January 13, 1930, Calder Foundation archives.

42. Kirstein, *Mosaic*, p. 175.

43. Ibid., p. 169.

44. Ibid., p. 175.

45. Ibid.

46. Russell Lynes, *Good Old Modern* (New York: Atheneum, 1973), p. 24.

47. Kirstein, *Mosaic*, p. 175.

48. Calder, "The Evolution," pp. 25, 79.

49. Lynes, *Good Old Modern*, p. 25.

50. Hawes, *Fashion Is Spinach*, p. 156.

51. "Mildred Harbeck a Suicide at Home," *New York Times*, November 8, 1932.

52. Calder, "The Evolution," p. 62.

53. Calder had, in 1926, done a drawing of a prehistoric couple, the man carrying off the woman as she brandished a knife, for the cover of a novel called *Bison of Clay*, by Max Begouën, which was billed as describing "men and women of 25,000 years ago."

54. Nanette Calder to Margaret Hayes, c. March 1930, Calder Foundation archives.

55. Calder, "The Evolution," p. 59.

CHAPTER 16 VILLA BRUNE

1. Apparently Calder studied Spanish at Stevens. Among the books in the Calder house in Roxbury is Benito Perez Galdós, *Electra*, trans. Otis Gridley Bunnell (New York: American Book Co., 1902). This Spanish play with vocabulary and notes by Bunnell bears the inscription "CALDER '19 Stevens Tech Hoboken N.J."

2. Alexander Calder, *Calder: An Autobiography with Pictures*, ed. Jean Davidson (New York: Pantheon Books, 1966), p. 109.

3. Calder, untitled manuscript, Calder Foundation archives, 1956, p. 9.

4. Calder, *Autobiography*, p. 147.

5. Julian Trevelyan, *Indigo Days: The Art and Memoirs of Julian Trevelyan* (1957; repr., Aldershot, UK: Scolar Press, 1996), p. 24.

6. Ibid.

7. Calder, *Autobiography*, p. 110.

8. Calder to his parents, July 27, 1930, Calder Foundation archives.

9. Calder to Isamu Noguchi, November 23, 1930, Calder Foundation archives.

10. Calder to his parents, July 27, 1930, Calder Foundation archives.

11. Calder to Isamu Noguchi, November 23, 1930, Calder Foundation archives.

12. Cyril Connolly, *The Rock Pool* (1936; repr., Norfolk, CT: New Directions Books, n.d.), p. 32.

13. Calder, *Autobiography*, p. 111.

14. Francis Steegmuller, *Cocteau: A Biography* (Boston: Atlantic Monthly Press, 1970), p. 372.

15. Calder to his parents, July 27, 1930, Calder Foundation archives.

16. Calder to Isamu Noguchi, November 23, 1930, Calder Foundation archives. In his *Autobiography*, however, Calder says he'd met her earlier: "I had met Mary Reynolds when I went to pick up some photographs, rue de Montessuy, and again in Villefranche when I came off Fordham's boat" (p. 126).

17. Calder, *Autobiography*, p. 112.

18. Louisa James to Louisa Cushing James, July 21, 1930, Calder Foundation archives.

19. Louisa James to Louisa Cushing James, September 3, 1930, Calder Foundation archives.

20. Louisa James to Louisa Cushing James, September 7, 1930, Calder Foundation archives.

21. Ibid.

22. Louisa James to Louisa Cushing James, November 1930, Calder Foundation archives.

23. Calder, *Autobiography*, p. 114.

24. Nanette Lederer Calder to Margaret Calder Hayes, December 1930, Calder Foundation archives. "And though I have not asked I surmise that things came to a climax when Louisa went to Paris this fall after cycling around <u>Ireland</u>—I think she would have stayed and married him then—but consideration for her mother and the promise to Mary . . ."

25. Margaret Calder Hayes, *Three Alexander Calders: A Family Memoir* (Middlebury, VT: Paul S. Eriksson, 1977), p. 241.

26. Louisa Calder to Robert and Elodie Osborn, July 26, 1961, Calder Foundation archives.

27. Louisa James to Louisa Cushing James, 1930, Calder Foundation archives.

28. Calder, *Autobiography*, p. 112.

29. Trevelyan, *Indigo Days*, p. 27.

30. Calder, *Autobiography*, p. 113.

31. See Richard Whelan, *Alfred Stieglitz: A Biography* (New York: Little, Brown, 1995), pp. 558–59, and *Abstraction création, 1931–1936* (Münster, Ger.: Westphalian State Museum of Art and Cultural History, 1978).

32. Julian Trevelyan did printmaking alongside Calder's friend (and Trevelyan's fellow Englishman) Hayter, whose printmaking workshop would become a gathering place for some of the Surrealists. Vaclav Vytlacil, who was six years older than Calder, had been born in New York and studied in Munich in the 1920s with Hans Hofmann, whose ideas about modernism were already inspiring an international following and who would a decade later have a tremendous reputation as a teacher among the Abstract Expressionists in New York. Vytlacil became a much admired teacher at the Art Students League.

33. Trevelyan, *Indigo Days*, pp. 30–31.

34. Piet Mondrian, quoted in Stephen Bann, ed., *The Tradition of Constructivism* (New York: Viking Press, 1974), pp. xxviii–xxix.

35. Jean Hélion, *À perte de vue* (Paris: IMEC Éditions, 1996), p. 52.

36. Jean Hélion, "Art Concret 1930," *Art and Literature*, Winter 1967, p. 137.

37. John Ashbery, *Reported Sightings: Art Chronicles, 1957–1987* (New York: Alfred A. Knopf, 1989), p. 66.

38. Jacqueline Hélion interviewed by Jed Perl, November 12, 2015.

CHAPTER 17 MONDRIAN'S STUDIO

1. Calder to his parents, May 23, 1930, Calder Foundation archives.

2. Calder to Isamu Noguchi, November 23, 1930, Calder Foundation archives.

3. Joost Baljeu, *Theo van Doesburg* (New York: Macmillan, 1974), p. 74.

4. John Dos Passos, *The Best Times* (New York: Signet Books, 1968), p. 164.

5. Jean Clair, ed., *The Great Parade: Portrait of the Artist as Clown* (New Haven, CT: Yale University Press, 2004), p. 119.

6. Baljeu, *Theo van Doesburg*, p. 123.

7. Ibid., p. 125.

8. Hélion, "Art Concret 1930," *Art and Literature*, Winter 1967, p. 136.

9. Calder, untitled manuscript, Calder Foundation archives, 1956, p. 19. James Johnson Sweeney, who would have known the story from the 1930s, says that Einstein, who was in charge of the phonograph, "recognized Mondrian and afterward explained to Calder who he was." Sweeney, *Alexander Calder* (New York: Museum of Modern Art, 1943), p. 26.

10. Alexander Calder, *Calder: An Autobiography with Pictures*, ed. Jean Davidson (New York: Pantheon Books, 1966), p. 113.

11. Ibid., p. 112.

12. Hélion, "Art Concret 1930," p. 134.

13. Frederick Kiesler, *Contemporary Art Applied to the Store and Its Display* (New York: Brentano's, 1930), pp. 118, 48.

14. When Kiesler wrote to Calder on April 4, 1957, about their friendship, he referred to its thirty-year standing, and although that could be approximate, it also leaves one with the suspicion that they might well have known each other in the late 1920s. Kiesler was designing avant-garde window displays for Saks between 1928 and 1930, around the time Calder, probably through Mildred Harbeck, had the *Cirque Calder* advertised through an entertainment service at Saks Fifth Avenue. In 1929, Kiesler wrote a book called *The Modern Show Window and Storefront* (it was published by Brentano's and expanded the next year as *Contemporary Art Applied to the Store and Its Display*), with a dashing Constructivist typography and illustrations of work by Van Doesburg, Mondrian, Klee, Brancusi, and Vantongerloo, along with architecture by Mies van der Rohe, J. J. P. Oud, and others.

15. Adolf Loos, "The Theatre," in *International Theatre Exposition New York 1926*, ed. Frederick Kiesler and Jane Heap (New York: Steinway Building, 1926), p. 7.

16. Lisa Phillips and Dieter Bogner, *Frederick Kiesler* (New York: Whitney Museum of American Art, 1989), p. 110.

17. Baljeu, *Theo van Doesburg*, p. 83.

18. Frederick Kiesler to Calder, April 4, 1957, Calder Foundation archives.

19. Calder to Frederick Kiesler, April 6 and 13, 1957, Calder Foundation archives.

20. Calder, untitled manuscript, 1956, p. 22.

21. Calder, *Autobiography*, p. 113.

22. Calder to Albert Gallatin, November 4, 1934, Calder Foundation archives.

23. Calder, *Autobiography*, p. 113.

24. Michel Seuphor, "Seuphor's Hat," in Frans Postma, *26, rue du Départ: Mondrian's Studio in Paris, 1921–1936*, ed. Cees Boekraad (Berlin: Ernst & Sohn, 1995), p. 9.

25. Ibid., p. 51.

26. Ibid., p. 53.

27. Ibid., p. 55.

28. Louise Daura to her family, April 17, 1930, quoted in Lynn Boland, "Inscribing a Circle," in Lynn Boland, ed., *Cercle et Carré and the International Spirit of Abstract Art* (Athens: Georgia Museum of Art, 2013), p. 28.

29. Ibid.

30. Louise Daura to her family, April 17, 1930, in Boland, "Inscribing a Circle," p. 29. She wrote in the same letter that Mondrian "is as pre-occupied with the proportions of one square in reference to another as ever Rubens was to suspend the chariot of Victory in air above a riotous scene of battle" (p. 30).

31. Calder, *Autobiography*, p. 113.

32. Calder, untitled manuscript, 1956, pp. 20–21.

33. Calder, *Autobiography*, p. 113.

34. Calder, untitled manuscript, 1956, p. 21.

35. Piet Mondrian, *Pure Art and Pure Plastic Art* (1945; repr., New York: Wittenborn, Schultz, 1947), p. 50.

36. Edna Warner Allen, memoir, Calder Foundation archives, p. 4.

37. Hélion, "Art Concret 1930," pp. 139–40.

38. Ibid., p. 139.

39. It was arguably in Paris in these years that Mondrian became an artist of international importance (while in many respects remaining an underground figure). See the discussion of later arguments about Mondrian's place in Catherine Dossin, "Permutation on the Circle and the Square: Michel Seuphor's Historicization of Cercle et Carré, 1930–1970," in Boland, *Cercle et Carré*, pp. 272–91.

40. Alexander Stirling Calder, *Thoughts of A. Stirling Calder on Art and Life*, ed. Nanette Lederer Calder (New York: Privately printed, 1947), p. 29.

41. Calder, *Autobiography*, p. 113.

42. Alexander Calder, "The Evolution," manuscript, Calder Foundation archives, 1955–56, p. 78.

CHAPTER 18 MARRIAGE

1. Nanette Lederer Calder to Margaret Calder Hayes, late December 1930, Calder Foundation archives.

2. Ibid.

3. Nanette Calder to Margaret Hayes, late December 1930, Calder Foundation archives.

4. Alexander Stirling Calder to Margaret Hayes, January 12, 1931, Calder Foundation archives.

5. Nanette Calder to Margaret Hayes, late December 1930, Calder Foundation archives.

6. Stirling Calder to Margaret Hayes, January 12, 1931, Calder Foundation archives.

7. Nanette Calder to Margaret Hayes, January 19, 1931, Calder Foundation archives.

8. Ibid.

9. Ibid.

10. Alexander Calder, *An Autobiography with Pictures*, ed. Jean Davidson (New York: Pantheon Books, 1966), p. 115.

11. Nanette Calder to Margaret Hayes, January 19, 1931, Calder Foundation archives.

12. Ibid.

13. Ibid.

14. Margaret Calder Hayes, *Three Alexander Calders: A Family Memoir* (Middlebury, VT: Paul S. Eriksson, 1977), p. 248.

15. Calder, *Autobiography*, p. 116.

16. Calder and Louisa Calder to his parents, February 3, 1931, Calder Foundation archives.

17. Calder to the Hayes family, February 1, 1931, Calder Foundation archives.

18. Calder and Louisa Calder to his parents, February 3, 1931, Calder Foundation archives.

19. Guy Krogh cited in Elizabeth Hutton Turner, *Americans in Paris: Man Ray, Gerald Murphy, Stuart Davis, Alexander Calder* (Washington, DC: Counterpoint, 1996), p. 44.

20. Julian Trevelyan, *Indigo Days: The Art and Memoirs of Julian Trevelyan* (1957; repr., Aldershot, UK: Scolar Press, 1996), pp. 29–30.

21. Calder, *Autobiography*, p. 117.

22. Calder to his parents, March 3, 1931, Calder Foundation archives.

23. Louisa Calder to Nanette Calder, March 15, 1931, Calder Foundation archives.

24. Calder to his parents, April 21, 1931, Calder Foundation archives.

25. Ibid.

26. Sandra Davidson interviewed by Jed Perl, February 22, 2010.

27. Nanette Calder to Margaret Hayes, January 19, 1931, Calder Foundation archives.

28. Nanette Calder to Margaret Hayes, January 21, 1931, Calder Foundation archives.

29. Calder, *Autobiography*, p. 121.

30. Calder to the Hayes family, c. May 1931, Calder Foundation archives.

31. Louisa Calder to Louisa Cushing James, January 3, 1932, Calder Foundation archives.

32. Calder to his parents, May 19, 1931, Calder Foundation archives.

33. Calder quoted in Jean Lipman, *Calder's Universe* (New York: Viking Press, 1976), p. 32.

34. Louisa Calder to Louisa Cushing James, June 15, 1931, Calder Foundation archives.

35. Calder to Louisa Cushing James, January 18, 1932, Calder Foundation archives.

36. Calder to his parents, March 1932, Calder Foundation archives.

37. Calder, *Autobiography*, p. 122.

38. Louisa Calder to Louisa Cushing James, c. spring 1931, Calder Foundation archives.

39. Louisa to Nanette Calder and Stirling Calder, June 1, 1931, Calder Foundation archives.

40. Calder to his parents, July 12, 1931, Calder Foundation archives.

41. Calder to Louisa Cushing James, January 18, 1932, Calder Foundation archives.

42. Calder to his parents, June 5, 1931, Calder Foundation archives.

43. Calder to his parents, March 1932, Calder Foundation archives.

44. Alexander Calder, "The Evolution," manuscript, Calder Foundation archives, 1955–56, p. 32.

45. Hayes, *Three Alexander Calders*, p. 258.

46. Louisa Calder to Louisa Cushing James, June 15, 1931, Calder Foundation archives.

47. Calder to his parents, July 1, 1931, Calder Foundation archives.

48. Henry James, *Roderick Hudson* (1875); repr. in *Henry James: Novels, 1871–1880* (New York: Library of America, 1983), p. 233.

49. Henry James, *William Wetmore Story and His Friends*, vol. 1 (Boston: Houghton, Mifflin, 1903), p. 329.

50. Stirling Calder to Joseph T. Fraser, September 3, 1939, Calder Foundation archives.

51. Henry James, *The Ambassadors* (1903; repr. New York: New American Library, 1960), pp. 212–22.

52. Henry James, *The Painter's Eye: Notes and Essays on the Pictorial Arts*, ed. and intro. John L. Sweeney (Cambridge, MA: Harvard University Press, 1956), p. 196.

CHAPTER 19 *VOLUMES—VECTEURS—DENSITÉS*

1. Louisa Calder to Louisa Cushing James, May 4, 1931, Calder Foundation archives.

2. There were also works entitled *Circulation* and *Gémissement Oblique* (a strange locution, this phrase might be translated as "Oblique Groan" or "Oblique Groaning").

3. See Robert Lorin Calder, *W. Somerset Maugham and the Quest for Freedom* (London: Heinemann, 1972), p. 147.

4. Piet Mondrian, *Plastic Art and Pure Plastic Art* (1945; repr., New York: Wittenborn, Schultz, 1947), p. 54; the italics are Mondrian's.

5. Ibid., pp. 54–57.

6. Paul Klee, "Creative Credo" (1920), in Klee, *Notebooks*, vol. 1, *The Thinking Eye*, ed. Jurg Spiller, trans. Ralph Mannheim (Woodstock, NY: Overlook Press, 1992), p. 79.

7. Alexander Calder, *Calder: An Autobiography with Pictures*, ed. Jean Davidson (New York: Pantheon Books, 1966), p. 118.

8. Alfred H. Barr Jr., "Cubism and Abstract Art: Introduction," in *Defining Modern Art: Selected Writings of Alfred H. Barr, Jr.*, ed. Irving Sandler and Amy Newman (New York: Harry N. Abrams, 1986), p. 87.

9. James Joyce, *A Portrait of the Artist as a Young Man* (1916; repr., New York: Penguin, 1977), pp. 191, 16. Stephen Dedalus also hears the professor explain, "So we must distinguish between elliptical and ellipsoidal" (p. 191)—a remark that finds an echo in Calder's discussion of technical terms for shapes and forms.

10. Don Brown, "American Artist Wins Praise for His Work in Wire," *Chicago Tribune* (Paris edition), May 2, 1931.

11. Calder to the Hayes family, c. May 1931, Calder Foundation archives.

12. Fernand Léger, *Alexandre Calder: Volumes—Vecteurs—Densités / Dessins—Portraits* (Paris: Galerie Percier, 1931), unpaged.

13. Nanette Lederer Calder, annotation to Margaret Calder Hayes, April 21, 1931, Calder Foundation archives.

14. Calder to his parents, April 21, 1931, Calder Foundation archives. Sweeney, writing some twelve years later in the catalog of the Museum of Modern Art retrospective, was equally reluctant to argue that the sculptures contained some particular allusions or references; he was more interested in discussing the introduction of color into Calder's sculpture, in the form of balls painted red or blue.

15. Calder to Albert Gallatin, November 4, 1934, Calder Foundation archives.

16. James Johnson Sweeney, "L'art contemporain: Allemagne, Angleterre, États-Unis," *Cahiers d'Art* 13,

nos. 1–2 (1938): 52. For an excellent discussion of this, see Arnauld Pierre, "Painting and Working in the Abstract: Calder's Oeuvre and Constructive Art," in *Alexander Calder: The Paris Years*, ed. Joan Simon and Brigitte Leal (New York: Whitney Museum of Art, 2008), pp. 227–35. See also Arnauld Pierre, "Peindre et travailler dans l'abstrait," *Calder: Mouvement et Réalité* (Paris: Éditions Hazan, 2009), pp. 111–37.

17. Calder to Nan Sexton, undated [1960s or 1970s], Calder Foundation archives.

18. Pierre, "Painting and Working in the Abstract," pp. 231–32.

19. Naum Gabo and Antoine Pevsner, "The Realistic Manifesto," in Stephen Bann, ed., *The Tradition of Constructivism* (New York: Viking Press, 1974), p. 10. Part of the manifesto was reprinted in the Abstraction-Création yearbook in 1932, to which Calder also contributed.

20. Waldemar George, in the catalog, noted that the works were "constructed from celluloid" and "appear at first like diagrams. Light and transparent, they can seem confusing to someone who cannot read the precise and spontaneous drawing of viaducts and metal bridges." (Martin Hammer and Christina Lodder, *Constructing Modernity: The Art and Career of Naum Gabo* [New Haven, CT: Yale University Press, 2000], p. 117.)

21. See Susan Braeuer Dam, "Liberating Lines," in *Calder and Picasso* (New York: Almine Rech Gallery, 2017), pp. 35–57.

22. Giovanni Carandente, *Calder: Mobiles and Stabiles* (New York: New American Library, 1968), p. 12.

23. Alexander Stirling Calder, *Thoughts of A. Stirling Calder on Art and Life*, ed. Nanette Lederer Calder (New York: Privately printed, 1947), p. 29.

24. John Sloan, *The Gist of Art* (1939; repr., New York: Dover Publications, 1977), p. 13.

25. Among the books in the Roxbury house are: James Jeans, *The Mysterious Universe* (New York: Macmillan, 1930), with illustrations by Walter Murch, and Dr. W. Villiger, *El Planetario Zeiss* (Barcelona: Gustavo Gili, 1927). Interviewed by NBC in 1964, Calder had this to say: "Well, I'm no astronomer, but I love the universe. I wish I could control a little bit of it. But—uh—I do the next best thing. I try to make things move around each other in space." Also: "I remember seeing the planetarium once and they didn't have it in order so they ran it fast and Neptune came along like this [shows with hands—sort of loop around self—and out] and went that way and that way and off again. And I would accomplish that in my objects. But I didn't know quite how. But I've been doing the best I could."

26. Joan M. Marter, *Alexander Calder* (New York: Cambridge University Press, 1991), pp. 109–10. A new planet was identified on March 14, 1930; it was named Pluto that May. By the fall of 1930, astronomers were proposing that a dozen more planets might exist. Marter also cites Hayter as saying that Calder had visited a planetarium in Paris (p. 272).

27. Calder quoted in Jean Lipman, *Calder's Universe* (New York: Viking Press, 1976), p. 17.

28. Harry Crosby, *Shadows of the Sun: The Diaries of Harry Crosby*, ed. Edward Germain (Santa Barbara, CA: Black Sparrow Press, 1977), pp. 196–97.

29. Jean Clair, "Parade and Palingenesis," in Clair, ed., *The Great Parade: Portrait of the Artist as Clown* (New Haven, CT: Yale University Press, 2004), p. 21.

30. James Johnson Sweeney, *Alexander Calder* (New York: Museum of Modern Art, 1943), pp. 30, 33.

31. Pierre Berthelot, "Calder," *Beaux-Arts* 9 (May 1931): 24.

32. Margaret Calder Hayes, *Three Alexander Calders: A Family Memoir* (Middlebury, VT: Paul S. Eriksson, 1977), p. 250.

33. Marter, *Calder*, p. 97.

34. Virgil Thomson, *Virgil Thomson* (New York: Alfred A. Knopf, 1966), p. 156.

35. Carole Klein, *Aline* (New York: Harper & Row, 1979), p. 248.

36. Calder, *Autobiography*, p. 107.

37. Thomas Wolfe, *You Can't Go Home Again* (1940; repr., New York: Harper Perennial, 1989), p. 219.

38. Ibid., p. 220.

39. Ibid., p. 218.

40. Calder, *Autobiography*, p. 107.

41. Wolfe, *You Can't Go Home Again*, p. 221.

42. Alfred Kazin, *On Native Grounds* (New York: Reynal and Hitchcock, 1942), p. 482.

43. Ibid., p. 478.

44. Wolfe, *You Can't Go Home Again*, p. 319.

45. Cyril Connolly, *The Rock Pool* (1936; repr., Norfolk, CT: New Directions, n.d.), pp. 65–66.

46. Calder to Gertrude Stein, March 9, 1932, Calder Foundation archives. "Would you and Miss Toklas care to come to tea next Monday (Mar. 14). We liked very much meeting you, and would like to do so again. I have arranged a few of the things from the show so that they work here. Will you please drop us a card as to whether you will come or not."

47. Sweeney, *Alexander Calder*, p. 33.

48. *Fables of Aesop According to Sir Roger L'Estrange* (Paris: Harrison of Paris, 1931), p. 7.

49. Calder to his parents, February 16, 1931, Calder Foundation archives.

50. Legrand-Chabrier, *Art et Décoration*, February 1932.

CHAPTER 20 MOBILES

1. Calder on Duchamp: "I don't think he liked the Circus—I don't think so." From Robert Osborn, "A Conversation with Alexander Calder," *Art in America* 57 (July–August 1969): 31.

2. Alexander Calder, *Calder: An Autobiography with Pictures*, ed. Jean Davidson (New York: Pantheon Books, 1966), pp. 126–27.

3. See Susan Glover Godlewski, "Warm Ashes: The Life and Career of Mary Reynolds," in *Mary Reynolds and the Spirit of Surrealism* (Chicago: Art Institute of Chicago, 1996), pp. 102–29.

4. Virgil Thomson, *Virgil Thomson* (New York: Alfred A. Knopf, 1966), pp. 110, 204.

5. Robert McAlmon, *Being Geniuses Together, 1920–1930*, revised, supplementary chapters, and new afterword by Kay Boyle (London: Hogarth Press, 1984), p. 93.

6. Godlewski, "Warm Ashes," p. 106.

7. Ibid., p. 115.

8. Thomson, *Thomson*, p. 204.

9. Anne D'Harnoncourt and Kynaston McShine, *Marcel Duchamp* (New York: Museum of Modern Art, 1973), p. 190.

10. In *After Picasso*—a book published in 1935 by the curator, critic, and collector James Thrall Soby—there was an effort to find some common ground between the Neo-Romantics and the Surrealists in their response to Cubism. Soby suggested that the two groups were linked by a reaction "against the Cubists' principle of 'painting as architecture.'" (James Thrall Soby, *After Picasso* [Hartford: Edwin Valentine Mitchell, 1935], p. 1.)

11. Lincoln Kirstein, *Tchelitchev* (Santa Fe, NM: Twelvetrees Press, 1994), p. 72.

12. Ibid., p. 48.

13. J[ean] L[ebeuf], "Les Ballets 1933," *Mouvement*, June 1933, p. 51. The French is *"apôtre du dynamisme."*

14. Sandra Davidson interviewed by Jed Perl, February 12, 2014.

15. Margaret Calder Hayes, *Three Alexander Calders: A Family Memoir* (Middlebury, VT: Paul S. Eriksson, 1977), p. 263.

16. Marcel Duchamp to Katharine Kuh, *The Artist's Voice: Talks with Seventeen Artists* (New York: Harper & Row, 1962), p. 83.

17. Yvon Taillandier, "Calder: Personne ne pense à moi quand on a un cheval à faire," *XX^e siècle*, March 15, 1959, p. 5.

18. "In the Latin Quarter," *New York Herald*, May 9, 1929.

19. Francis M. Naumann, *Marcel Duchamp: The Art of Making Art in the Age of Mechanical Reproduction* (Ghent, Neth.: Ludion Press, 1999), p. 48.

20. Tom Gunning, "Cinema and the New Spirit in Art within a Culture of Movement," in Berenice Rose, ed., *Picasso, Braque and Early Film in Cubism* (New York: Pace Gallery, 2007), pp. 18, 17.

21. Giovanni Carandente, "Work in Progress," in Alexander S. C. Rower, ed., *Calder: Sculptor of Air* (Milan: 24 ORE, 2009), p. 235.

22. Alexander Calder, "The Evolution," manuscript, Calder Foundation archives, 1955–56, p. 129.

23. G.O., "Une prise de vue chez le monsieur qui fait des femmes en fil der fer," *Paris-Midi*, May 22, 1929; *New York Herald* (Paris edition), May 21, 1929.

24. James Johnson Sweeney, *Alexander Calder* (New York: Museum of Modern Art, 1943), p. 26.

25. Calder, *Autobiography*, p. 118.

26. Calder, untitled manuscript, Calder Foundation archives, 1956, p. 24.

27. Meyer Schapiro, "Einstein and Cubism: Science and Art," in Schapiro, *The Unity of Picasso's Art* (New York: George Braziller, 2000), p. 87.

28. Waverly Lewis Root, "Calder Makes Some New Gadgets, Puts 'Em on Exhibit," *Chicago Tribune* (Paris edition), February 1932.

29. Calder to Julien Levy, March 10, 1932, Calder Foundation archives.

30. Calder, *Autobiography,* p. 169.

31. Calder to Louisa Cushing James, January 18, 1932, Calder Foundation archives.

32. Calder, *Autobiography,* p. 127.

33. Gabrielle Buffet-Picabia, "Alexandre Calder, ou Le roi du fil de fer," *Vertigral* 1, July 15, 1932; Marius Richard, "Mobiles: Sculptures à moteur," *Patrie,* February 1932.

34. Writing about Léger in an essay entitled "The Painter and the Dynamo" in *Vanity Fair* in 1923, the poet John Peale Bishop, a friend of Edmund Wilson's, speculated that Americans tended to have a less reverent attitude toward the machine than Europeans. Calder was very much the American.

35. Paul Klee, *Pedagogical Sketch Book* (New York: Nierendorf Gallery, 1944 [first published in 1925 under the title *Paedagogisches Skizzenbuch*]), unpaged; see "Section IIII: Symbols of Movement."

36. Alexander Calder, "Mobiles," in Myfanwy Evans, ed., *The Painter's Object* (London: Gerald Howe, 1937), p. 64.

37. Alexander Calder, in *Abstraction-Création: Art non figuratif 1932* (Paris: Abstraction-Création, 1931), p. 6.

38. Pierre Cabanne, *Dialogues with Marcel Duchamp,* trans. Ron Padgett (New York: Da Capo Press, 1987), pp. 18–19.

39. Legrand-Chabrier, *Art et Décoration,* February 1932.

40. Alexander Calder, "A Mobile," in *Abstraction-Création: Art non figuratif 1933* (Paris: Abstraction-Création, 1933), p. 7.

41. Alexander Calder, *Modern Painting and Sculpture* (Pittsfield, MA: Berkshire Museum, 1933), unpaged.

42. Quoted in Schapiro, *The Unity of Picasso's Art,* pp. 50–51.

43. Calder to Frederick Kiesler, March 12, 1932, Calder Foundation archives.

44. Anonymous clipping, February 1932, Calder Foundation archives.

45. Calder, *Autobiography,* p. 130.

46. William G. Rogers, "Calder: Man and Mobile," manuscript, Calder Foundation archives, 1956, p. 163.

47. Calder to Frederick Kiesler, March 12, 1932, Calder Foundation archives.

48. Arnauld Pierre, *Calder: Mouvement et Réalité* (Paris: Éditions Hazan, 2009), p. 157. "Dans l'optique de Mondrian, les rapports, pour être généraux et universels, doivent être fixes; dans celle de Calder, c'est exactement le contraire."

49. Piet Mondrian, *Le Néo-Plasticisme* (Paris: Editions de L'Effort Moderne, 1920), p. 1.

50. Piet Mondrian, "Liberation from Oppression in Art and Life," in Piet Mondrian, *Plastic Art and Pure Plastic Art* (1945; repr., New York: Wittenborn, Schultz, 1947), p. 47.

51. Calder, untitled manuscript, 1956, pp. 26–27.

52. Roman Jakobson, *My Futurist Years,* ed. Bengt Jangfelt, trans. Stephen Rudy (New York: Marsilio Publishers, 1997), p. 148.

53. Linda Henderson, *The Fourth Dimension and Non-Euclidean Geometry in Modern Art,* rev. ed. (Cambridge, MA: MIT Press, 2013), p. 286. It should be noted that in the 1960s or 1970s, Calder commented in a letter to Nan Sexton, his grandniece, "I knew Duchamp, but did not know what he had done." (Calder to Nan Sexton, c. 1960s or 1970s, Calder Foundation archives.)

54. Henderson, *Fourth Dimension,* p. 257.

55. Many years later, when Calder and Duchamp were having lunch with Calder's daughter Sandra, Duchamp commented about a silver pin in the shape of an S that Calder had made for Sandra; he pointed out that upright it stood for "Sandra," but if put on its side it became a figure eight, and thus a symbol of infinity. (Sandra Davidson interviewed by Jed Perl, February 12, 2014.)

56. Giovanni Carandente, *Calder: Mobiles and Stabiles* (New York: New American Library, 1968), p. 5.

57. Henderson, *Fourth Dimension,* pp. 292–93.

58. Mary Butts, *The Journals of Mary Butts,* ed. Nathalie Blondel (New Haven, CT: Yale University Press, 2002), p. 233.

59. Ibid., p. 242. The next year, Butts saw a new ballet, *The Midnight Sun*, and described the dancer Massine entering with "the sun on one hand the moon on the other"—an image like the one Calder saw on the sea off Guatemala a few years earlier, and would incorporate into his ballet without dancers, *Work in Progress*, some forty years later. (Butts, *Journals*, p. 283.)

60. Chou Wen-chung, "Varèse: A Sketch of the Man and His Music," *Musical Quarterly*, April 1966, p. 155.

61. Malcolm MacDonald, *Varèse: Astronomer in Sound* (London: Kahn & Averill, 2003), p. xi.

62. Nanette Lederer Calder to Margaret Calder Hayes, April 1934, Calder Foundation archives. The letter is undated, but the only performance of a work by Varèse in New York at a time when the Calders were in the United States was the performance of *Ionisation* at Town Hall on April 15, 1934. The work had first been performed at Steinway Hall in New York the previous March.

63. Louisa Calder to Nanette Calder, March 15, 1931, Calder Foundation archives.

64. Virgil Thomson, *Music Right and Left* (New York: Henry Holt, 1951), p. 106.

65. Chou Wen-chung, "Varèse," pp. 157, 165.

66. Some who have looked at texts that relate to this unfinished work say it has connections with earlier interests of Varèse's, including Rosicrucianism and the work of the Swiss Renaissance physician and alchemist Paracelsus, some of whose ideas had fueled *Arcana*, Varèse's work for a large symphony orchestra, which was completed in 1927 and had its premiere at Carnegie Hall that April; its Parisian premiere came in 1932. Commentators have long argued as to the significance of a quotation on the title page of the printed score of *Arcana*, which attributes to Paracelsus a vision of seven stars, the climactic one being "imagination, which begets a new star and a new heaven." Varèse, although at times downplaying his interest in occult or hermetic ideas as an enthusiasm of his youth, did later say that "an amusing analogy occurred to me between the transmutation of base metals into gold and the transmutation of sounds in music, and also that the process of musical composition is the discovery of the arcana—the hidden secrets in sounds and in noises." In a study of Varèse, the musical historian Malcolm MacDonald has suggested that these seven stars relate to the seven planets of astrology and the most famous seven-starred object in the night sky, the Pleiades cluster in the constellation Taurus; MacDonald related all of this to imagery in Keats, Tennyson, and a fifth-century Neoplatonist by the name of Proclus. Did any of this figure in Calder's friendship with Varèse? Whatever Calder thought about astrology—which was probably very little—the poetic power of the night sky and the constellations were things that had interested him since his mother bought him and Peggy a book about the stars. See MacDonald, *Varèse*, pp. 189–94.

67. Ibid., p. 225.

68. Louise Varèse, *Varèse: A Looking-Glass Diary*, vol. 1, *1883–1928* (New York: W. W. Norton, 1972), p. 238.

69. P. D. Ouspensky, *A New Model of the Universe* (New York: Alfred A. Knopf, 1931), pp. 425, 430, 449–50.

70. Paul Recht, "Dans le mouvement, les sculptures mouvantes," *Mouvement* 1 (June 1933): 49.

71. Paul Recht quoted in Marter, *Alexander Calder*, p. 138.

72. There are three versions of this work. *Small Sphere and Heavy Sphere* (1932), shown at Pierre Colle in 1933, no longer exists. *Small Sphere and Heavy Sphere* (1932/33), which Calder made either before or after leaving France in 1933, remained in Calder's possession and was little known until recent years, when it has been in a number of major exhibitions. There is a third version, *Une boule noire, une boule blanche* (*1932/1969*), in which the found objects have been replaced by bowl-shaped sheet metal elements; this is in the collection of the Fondation Maeght.

73. James Johnson Sweeney, "Alexander Calder," *Alexander Calder: Sculpture Mobiles* (London: Arts Council of Great Britain, 1962), p. 10.

74. Chou Wen-chung, "Varèse," p. 166.

75. Rogers, "Calder: Man and Mobile," pp. 161–62. That line of thinking would be reflected in comments Calder occasionally made to collectors years later, when if they came up to him and said that they would prefer that the red mobile they had be black, or vice versa, he apparently gave them permission to change the color.

76. Calder, "The Evolution," p. 108.

CHAPTER 21 RUE DE LA COLONIE

1. Calder to Louisa Cushing James, January 18, 1932, Calder Foundation archives.
2. Jean Hélion to James Johnson Sweeney, 1930s, Calder Foundation archives.
3. Alexander Calder, *Calder: An Autobiography with Pictures*, ed. Jean Davidson (New York: Pantheon Books, 1966), p. 130.
4. Calder to his parents, May 19, 1931, Calder Foundation archives.
5. Calder, *Autobiography*, p. 130.
6. Lynn Boland, "Inscribing a Circle," in Boland, ed., *Cercle et Carré and the International Spirit of Abstract Art* (Athens: Georgia Museum of Art, 2013), p. 35.
7. Michel Seuphor, *Douce Province* (Lausanne: Jean Marguerat, 1941), pp. 53, 50.
8. Jean Hélion, "Art Concret 1930," *Art and Literature*, Winter 1967, p. 139.
9. Julien Levy, *Memoir of an Art Gallery* (1977; repr., Boston: Museum of Fine Arts, 2003), p. 118.
10. "The Abstract Artist in Society: Interview with Jean Hélion" (*Partisan Review*, April 1938), in Jean Hélion, *Double Rhythm: Writings About Painting*, ed. and intro. Deborah Rosenthal (New York: Arcade Publishing, 2014), p. 77.
11. Joost Baljeu, *Theo van Doesburg* (New York: Macmillan, 1974), p. 135.
12. Art Concret included an Armenian by the name of Léon Arthur Tutundjian, whose 1929 reliefs, with circular and angular forms, might well have triggered one of the impulses behind Calder's turn to abstraction; this was a thought that Hélion voiced years later.
13. Hélion, "Art Concret 1930," pp. 128, 133.
14. Calder, "Comment réaliser l'art?" *Abstraction-Création: Art non figuratif 1932* (Paris: Abstraction-Création, 1931), p. 6. Translation courtesy of the Calder Foundation, New York.
15. Ibid., p. 139.
16. [Jean Hélion], introduction to *Abstraction-Création: Art non figuratif 1932*, p. 1.
17. Carl Einstein, preface to *Exhibition of Bronze Statuettes B.C.* (New York: Stora Art Galleries, [1933]), pp. 6, 3, 14.
18. Calder, *Autobiography*, pp. 136–37.
19. Calder to his parents, March 1932, Calder Foundation archives.
20. Calder, *Autobiography*, p. 138.
21. Nanette Lederer Calder to Margaret Calder Hayes, after July 11, 1932, Calder Foundation archives.
22. Katherine Ware, "Between Dadaism and MoMA-ism at the Julien Levy Gallery," in Katherine Ware and Peter Barberie, eds., *Dreaming in Black and White: Photography at the Julien Levy Gallery* (New Haven, CT: Yale University Press, 2006), p. 18.
23. Levy, *Memoir of an Art Gallery*, p. 18.
24. Ibid., p. 118.
25. Lincoln Kirstein, *Mosaic: Memoirs* (New York: Farrar, Straus and Giroux, 2007), p. 235.
26. Levy, *Memoir of an Art Gallery*, pp. 115–16. Levy remembered seeing Calder's work "in the Villa Seurat, near Campigli's." The villa Seurat was not that far from the villa Brune, so it's possible that Levy had also visited Calder at some earlier point at the villa Brune.
27. Calder to Julien Levy, March 10, 1932, Calder Foundation archives.
28. Julien Levy to Calder, March 1932, Calder Foundation archives.
29. Julien Levy to Calder, March 1932, Calder Foundation archives.
30. Calder to Julien and Joella Levy, April 4, 1932, Calder Foundation archives.
31. Levy, *Memoir of an Art Gallery*, p. 116; Joella Levy to Julien Levy, May 8 and 13, 1932, Calder Foundation archives.
32. Calder, *Autobiography*, p. 137.
33. Calder to Julien Levy, March 10, 1932, Calder Foundation archives.
34. Joella Levy to Julien Levy, May 13, 1932, Calder Foundation archives.
35. Press release, Julien Levy Gallery, 802 Madison Ave., New York, NY, undated (1932), Calder Foundation archives.
36. "Objects to Art Being Static, So He Keeps It in Motion," *New York World-Telegram*, June 11, 1932.
37. Henry McBride, "Art of Alexander Calder Proves Puzzling to Americans," *New York Sun*, May 21, 1932.
38. Calder, *Autobiography*, p. 137.

39. Edward Alden Jewell, " 'Mobiles' That Startled Paris," *New York Times*, May 13, 1932.

40. Alexander Stirling Calder to Margaret Hayes, July 16, 1934, Calder Foundation archives. He also told her "they should have photographs of the drawings of some of the strong old boys like Michel Ange and Durer whose technique it is helpful to realize even if you disdain it like Sandy. I have been a teacher and could do it again. I found it stimulating for the first year or two, after which it became something of a drag, unless you can go on and apply it. I had about 4 years of it in Ph. at the School of Industrial Art. 2 at the Art Students League and a year or too at the N[ational] A[cademy of] D[esign]."

41. Julien Levy, *Surrealism* (1936; repr., New York: Da Capo Press, 1995), p. 28.

42. Calder, *Autobiography*, p. 146.

43. Levy, *Memoir of an Art Gallery*, p. 117.

44. Ibid., p. 116.

45. Calder to Julien Levy, March 10, 1932, Calder Foundation archives.

46. Calder, *Autobiography*, p. 138.

47. Ernest Hemingway in Clement Greenberg, *Miró* (New York: Quadrangle Press, 1948), p. 5.

48. Joan Miró in Cleve Gray, "Calder's Circus," *Art in America* 52, no. 5 (October 1964): 23.

49. Calder, *Autobiography*, pp. 139–40.

50. Joan Miró, statement in *Variétés*, June 1929, in *Joan Miró: Selected Writings and Interviews*, ed. Margit Rowell (New York: Da Capo Press, 1992), p. 108.

51. William Jeffett, "Joan Miró and ADLAN," in William H. Robinson, Jordi Falgàs, and Carmen Belen Lord, eds., *Barcelona and Modernity: Picasso, Gaudí, Miró, Dalí* (New Haven, CT: Cleveland Museum of Art in association with Yale University Press, 2007), pp. 369–74.

52. Calder to James Thrall Soby, February 28, 1936, Calder Foundation archives.

53. In the Roxbury house, there are two books about Gaudí's architecture, published by Prats, with dedications from Prats. These read, *"Pour Sandy avec mon enthousiasme, admiration, et amitié Barcelona 7 octobre 1966 Joan Prats"* and *"Très cordialment très amicalment, grande admiration Joan Prats."*

54. Jeffett, "Joan Miró and ADLAN," p. 369.

55. Louisa Calder to Louisa Cushing James, February 11, 1933, Calder Foundation archives.

56. Alexander Calder, "The Evolution," manuscript, Calder Foundation archives, 1955–56, p. 122.

57. Calder, *Autobiography*, p. 142.

58. Calder to his parents, March 23, 1932, Calder Foundation archives.

59. See *Calder à la Roche-Jaune: Mobiles, gouaches, bijoux* (Côtes-du-Nord, France: Ancienne École, bourg de Plouguiel, 1986), unpaged.

60. Louisa Calder to Louisa Cushing James, January 17, 1932, Calder Foundation archives.

61. Louisa Calder to Louisa Cushing James, February 11, 1933, Calder Foundation archives.

62. Louisa Calder to Louisa Cushing James, December 1932, Calder Foundation archives.

63. Calder wrote, "1932–3 Miró + I were going to make an 'object' together—but it never came about." (Calder, "The Evolution," p. 122.)

64. Calder, *Autobiography*, pp. 142–43.

65. Meyer Schapiro to Alfred H. Barr Jr., March 8, 1935, Alfred H. Barr Jr. Papers, Museum of Modern Art, New York.

CHAPTER 22 PAINTER HILL ROAD

1. John Richardson interviewed by Jed Perl, May 22, 2014.

2. Alexander Calder, *Calder: An Autobiography with Pictures*, ed. Jean Davidson (New York: Pantheon Books, 1966), p. 144.

3. Margaret Calder Hayes, *Three Alexander Calders: A Family Memoir* (Middlebury, VT: Paul S. Eriksson, 1977), p. 267.

4. Calder, *Autobiography*, p. 145.

5. Louisa Calder, First National Bank statements, Calder Foundation archives, 1933–34.

6. Calder, *Autobiography*, pp. 145–46.

7. Ibid., p. 147; see also Alexander S. C. Rower, "The Roxbury Home and Studio," in Eric M. Zafran, *Calder in Connecticut* (New York: Rizzoli, 2000), pp. 13–19.

8. Arthur Miller, *Timebends: A Life* (New York: Penguin, 1987), p. 503.

9. Malcolm Cowley, *Exile's Return* (New York: Viking Press, 1951), p. 210.

10. Ibid., p. 227.

11. Ibid., pp. 228, 233.

12. Slater Brown, *The Burning Wheel* (Indianapolis: Bobbs-Merrill, 1942). " 'You got a lot of attractive neighbors around here,' Willie said. 'If they don't give you the twist they give you the evil eye. And you've got me all steamed up about moving up here. What'll I turn into if I settle down in the valley—a lush? An acrobat?' 'Up here, I guess, you can turn into whatever thing you like,' Diana remarked. 'Free-for-all,' Evan said, 'and no holds barred.' " (Ibid., p. 80.)

13. Eugene R. Gaddis, *Magician of the Modern: Chick Austin and the Transformation of the Arts in America* (New York: Alfred A. Knopf, 2000), p. 244.

14. Eric M. Zafran, "Collectors and Friends," in *Calder in Connecticut*, p. 84.

15. Alexander Calder, "Mobiles," in Myfanwy Evans, ed., *The Painter's Object* (London: Gerald Howe, 1936), p. 67.

16. Mário Pedrosa, "Calder's About-Turn," in *Calder in Brazil: The Tale of a Friendship*, ed. Roberta Saraiva, trans. Juliet Attwater (São Paulo: Pinacoteca do Estado de São Paulo, 2006), p. 234.

17. Cowley, *Exile's Return*, p. 198.

18. Calder, *Autobiography*, p. 144.

19. Calder to Charlotte Whitney Allen, April 1, 1935, Calder Foundation archives.

20. Calder to Margaret Calder Hayes, October 12, 1935, Calder Foundation archives.

21. Calder to Charlotte Whitney Allen, [after February 11, 1936], Calder Foundation archives.

22. Statement by Calder in *Modern Painting and Sculpture* (Pittsfield, MA: Berkshire Museum, 1933), unpaged.

23. Calder to Ben Nicholson, December 21, 1934, Calder Foundation archives.

24. Calder, *Autobiography*, p. 148.

25. Cowley, introduction to *Three Alexander Calders*, p. xvii.

26. Calder to Pierre Matisse, February 14, 1934, Calder Foundation archives.

27. Pierre Matisse to Calder, February 15, 1934, Calder Foundation archives.

28. Calder to Matisse, [February 1934], Calder Foundation archives.

29. Alexander Calder, "The Evolution," manuscript, Calder Foundation archives, 1955–56, p. 103.

30. At least later that year, Pierre sent a telegram to Louisa, asking if she might knit gloves for his wife, Teeny, for Christmas. See Matisse to Louisa Calder, December 18, 1934, Calder Foundation archives.

31. Calder to Matisse, [March 1934], Calder Foundation archives.

32. Calder to Matisse, May 7, 1934; Matisse to Calder, May 17, 1934, Calder Foundation archives.

33. Calder to Matisse, May 21, 1934, Calder Foundation archives.

34. Calder to Matisse, May 7, 1934; Matisse to Calder, May 17, 1934, Calder Foundation archives.

35. Nanette Lederer Calder to Margaret Hayes, April 5, 1934, Calder Foundation archives.

36. Charles E. Pierce Jr., ed., *Pierre Matisse and His Artists* (New York: Pierpont Morgan Library, 2002), pp. 48, 162–63. One also wonders if Matisse was somehow involved in the designer Donald Deskey asking Calder to contribute two objects to an exhibition of decorative art at the Metropolitan Museum in 1934 (Calder, "The Evolution," p. 133.)

37. Brenner, "Alexander Calder's 'Mobiles,' " *Brooklyn Eagle*, April 22, 1934.

38. Lewis Mumford, "Toyshop," in *Mumford on Modern Art in the 1930s*, ed. with an introduction by Robert Wojtowicz (Berkeley: University of California Press, 2007), p. 123. (The review appeared in *The New Yorker*, April 28, 1934.)

39. Mumford, "Portrait of the Mechanic as a Young Man," in *Mumford on Modern Art*, pp. 113–14.

40. Mumford, "Toyshop," in *Mumford on Modern Art*, p. 124.

41. See *Joan Miró: Selected Writings and Interviews*, ed. Margit Rowell (New York: Da Capo Press, 1992), p. 25.

42. Richard Ellmann, *James Joyce* (New York: Oxford University Press, 1966), p. 720.

43. Gordon Bowker, *James Joyce* (New York: Farrar, Straus and Giroux, 2011), p. 528.

44. See *Property from the Estate of the late James Johnson Sweeney* (New York: Sotheby's, November 18, 1986).

45. Marcia Brennan, *Curating Consciousness: Mysticism and the Modern Museum* (Cambridge, MA: MIT Press, 2010), p. 8.

46. Calder, "The Evolution," pp. 61, 167.

47. Calder to James Johnson Sweeney, September 3, 1934, Calder Foundation archives: "The volume

addressed to me arrived today. Thank you very much! I also saw, at the Berkshire Museum Pittsfield, the objects brought back from the orient by Geo Morris. Their sadness is appalling! (You had better send him your lectures) Our love to you both, Sandy."

48. James Johnson Sweeney, *Mobiles by Alexander Calder* (New York: Pierre Matisse Gallery, 1934), unpaged.

49. James Johnson Sweeney, "Sculpture Today," in *Byrdcliffe Afternoons: A Series of Lectures Given at Byrdcliffe, Woodstock, NY, July 1939* (Woodstock, NY: Overlook Press, 1940), p. 72. This is a too-little-known essay; Sweeney discusses Rodin, Tatlin, and Gabo, emphasizing the "turn from an interest in mass-in-space to an interest in volume and the definition of volume-in-space" (p. 71).

50. James Johnson Sweeney, "Alexander Calder's Mobiles," in *"Mobiles" by Alexander Calder* (Chicago: Arts Club of Chicago, 1935).

51. In a letter to Matisse dated December 17, 1934, Calder asked him to send a copy of Sweeney's essay for the 1934 show to Mrs. Martin Schütze; it sounds like Calder was actively involved.

52. James Johnson Sweeney, *Alexander Calder* (New York: Museum of Modern Art, 1943), p. 40.

CHAPTER 23 FROM SANDRA TO *SOCRATE*

1. Dust jacket text (probably by Alfred H. Barr Jr.) for Alfred H. Barr Jr., ed., *Fantastic Art, Dada, Surrealism*, rev. ed. (New York: Museum of Modern Art, 1937). For Peter Blume, see Robert Cozzdino, ed., *Peter Blume: Nature and Metamorphosis* (Philadelphia: Pennsylvania Academy of the Fine Arts, 2014).

2. Calder to Louisa Calder, October 22, 1935, Calder Foundation archives. They had an apartment at 244 East Eighty-sixth Street as of November 1. In the same letter, Calder urges Pierre and Teeny Matisse to come out to Roxbury with Léger by train or automobile.

3. Alexander Calder, *Calder: An Autobiography with Pictures*, ed. Jean Davidson (New York: Pantheon Books, 1966), pp. 150–51.

4. Pierre Matisse to Calder, April 8, 1935, Calder Foundation archives.

5. Calder to Matisse, April 10, 1935, Calder Foundation archives.

6. Calder, *Autobiography*, pp. 151–52.

7. Ibid., p. 152.

8. Louisa James to Nanette Lederer Calder, April 21, 1935, Calder Foundation archives.

9. Calder to his parents, April 22, 1935, Calder Foundation archives.

10. Calder, *Autobiography*, pp. 152–53.

11. Vera Pedrosa Martins Almeida, interviewed by Jed Perl, July 23, 2014.

12. James Johnson Sweeney, *Alexander Calder* (New York: Museum of Modern Art, 1943), p. 45.

13. Alexander Calder, "The Evolution," manuscript, Calder Foundation archives, 1955–56, p. 127.

14. Clement Greenberg, "Modernist Painting," in Greenberg, *The Collected Essays and Criticism*, vol. 4, *Modernism with a Vengeance, 1957–1969*, ed. John O'Brian (Chicago: University of Chicago Press, 1993), p. 86.

15. Calder, "The Evolution," p. 106.

16. Alexander Calder, "Mobiles," in Myfanwy Evans, ed., *The Painter's Object* (London: Gerald Howe, 1937), p. 64.

17. Robert McAlmon, *Being Geniuses Together, 1920–1930*, revised, supplementary chapters, and new afterword by Kay Boyle (London: Hogarth Press, 1984), p. 275.

18. Lincoln Kirstein, June 16, 1933, typescript of Lincoln Kirstein 1933–34 Diaries, Eakins Press Foundation archives.

19. Virgil Thomson, *Virgil Thomson* (New York: Alfred A. Knopf, 1966), p. 153.

20. Joyce offered Thomson, "for the final spectacle, production at the Paris Opéra with choreography by Léonide Massine"—the choreographer Calder would aim to work with a few years later. Thomson, who felt a choreographed cantata would better serve Joyce's art, did not take up the challenge. But his *Four Saints in Three Acts*, created in Paris in collaboration with Gertrude Stein, was a work that he unabashedly regarded as "choreographic theater in the Diaghilev tradition"; the choreography was by Frederick Ashton, who had studied with Bronislava Nijinska, who had worked with Diaghilev. (Thomson, *Thomson*, p. 149.)

21. Robert McAlmon, "Mr. Joyce Directs an Irish Word Ballet," in Samuel Beckett et al., *Our Exagmina-*

tion Rund His Factification for Incamination of Work in Progress (1934; repr. New York: New Directions, n.d.), pp. 105–6.

22. Havelock Ellis, *The Dance of Life* (Boston: Houghton Mifflin, 1923), pp. 38, 34, 34–35. A great many passages in this book are of interest to anybody thinking about Calder. "The dance is the rule of number and of rhythm and of measure and of order, of the controlling influence of form, of the subordination of the parts to the whole. That is what a dance is" (p. xi). "In our own time, Nietzsche, from first to last, showed himself possessed by the conception of the art of life as a dance, in which the dancer achieves the rhythmic freedom and harmony of his soul beneath the shadow of a hundred Damoclean swords. He said the same thing of his style, for to him the style and the man were one: 'My style,' he wrote to his intimate friend Rohde, 'is a dance.' 'Every day I count wasted,' he said again, 'in which there has been no dancing'" (p. 306).

23. Calder to his parents, March 1932, Calder Foundation archives.

24. Calder to James Johnson Sweeney, July 19, 1934, Calder Foundation archives.

25. "Stabiles and Mobiles," *Time* 29, no. 9 (March 1, 1937).

26. Lincoln Kirstein, June 16, 1933, typescript of Lincoln Kirstein's 1933–34 Diaries, Eakins Press Foundation archives.

27. Calder to Ben Nicholson, May 26 and July 28, 1934, Calder Foundation archives.

28. Nanette Lederer Calder to Margaret Calder Hayes, April 6, 1934, Calder Foundation archives.

29. See Alfred H. Barr Jr., *Matisse: His Art and His Public* (New York: Museum of Modern Art, 1951), pp. 253–54.

30. Kirstein, April 10, 1934, typescript of Lincoln Kirstein's 1933–34 Diaries, Eakins Press Foundation archives.

31. Kirstein, October 19, 1934, typescript of Lincoln Kirstein's 1933–34 Diaries, Eakins Press Foundation archives.

32. Calder, "The Evolution," p. 120.

33. Bérénice Jacobs interviewed by Jed Perl, February 14, 2013.

34. Karen Bell-Kanner, *Frontiers: The Life and Times of Bonnie Bird* (Amsterdam: Harwood Academic, 1998), p. 62; Francis Mason, "Bonnie Bird on Graham," *Ballet Review*, Fall 2013, pp. 69–73.

35. Martha Graham, *Blood Memory: An Autobiography* (New York: Doubleday, 1991), p. 166.

36. Bell-Kanner, *Frontiers*, p. 79.

37. Jerome D. Bohm, "Festival Ends Dance Session at Bennington: Interesting Program Is Presented by Groups Led by Martha Graham," *New York Herald Tribune*, August 18, 1935.

38. John Martin, "The Dance: 'Panorama.'" *New York Times*, September 1, 1935, p. 127.

39. Graham, *Blood Memory*, p. 166.

40. *New York Telegraph*, February 25, 1936.

41. John Martin, "Martha Graham's Recital," *New York Times*, February 24, 1936; *New York Herald Tribune*, February 24, 1936.

42. "Martha Graham and Dance Group," *Dance Observer* (April 1936).

43. Thomson, *Thomson*, p. 254.

44. Henry-Russell Hitchcock quoted in *Avery Memorial Wadsworth Atheneum: The First Modern Museum*, ed. Eugene R. Gaddis (Hartford, CT: Wadsworth Atheneum, 1984), p. 14.

45. Thomson, *Thomson*, pp. 152–53.

46. Calder to Virgil Thomson, December 27, 1934, Calder Foundation archives.

47. Calder to Virgil Thomson, February 26, 1935, Calder Foundation archives.

48. See Calder to Chick Austin, November 27, 1935, Pierre Matisse Archives, Department of Literary and Historical Manuscripts, Morgan Library and Museum, New York; and Chick Austin to Calder, December 4, 1935, Calder Foundation archives.

49. Alfred H. Barr Jr., *Cubism and Abstract Art* (New York: Museum of Modern Art, 1936), p. 14.

50. Virgil Thomson, *Music Reviewed: 1940–1954* (New York: Vintage Books, 1967), p. 33.

51. Virgil Thomson, statement recorded on March 25, 1965, at the University of California in Los Angeles.

52. John Cage to Merce Cunningham, postmarked July 3, 1944, *The Selected Letters of John Cage*, ed. Laura Kuhn (Middletown, CT: Wesleyan University Press, 2016), p. 66.

53. Evans, ed., *The Painter's Object*, p. 64.

54. Thomson, *Thomson*, pp. 256–57.

55. Ibid., p. 257.

56. Virgil Thomson, "The Friends and Enemies of Modern Music," in *A. Everett Austin, Jr.: A Director's Taste and Achievement* (Hartford, CT: Wadsworth Atheneum, 1958), p. 61.

CHAPTER 24 A VERY GOOD YEAR

1. In the catalog of Alfred H. Barr Jr.'s *Cubism and Abstract Art* (New York: Museum of Modern Art, 1936), Calder is identified as a city resident: "Lives in New York" (p. 206).
2. Calder to Pierre Matisse, July 4, 1935, Calder Foundation archives.
3. See Edwin Denby, "The World's Fair," *Modern Music*, May–June 1938, reprinted in Edwin Denby, *Dance Writings*, ed. Robert Cornfield and William Mackay (New York: Alfred A. Knopf, 1986), p. 27.
4. James Johnson Sweeney, "Herbert Matter: Photography" (New York: Pierre Matisse Gallery, 1943).
5. Calder quoted in "Stabiles and Mobiles," *Time*, March 1, 1937.
6. Bill Holman, "Sculpture Taken on Electric Ride," *New York Post*, February 15, 1936.
7. Friedrich Nietzsche, *Thus Spake Zarathustra* (1911; repr., New York: Cosimo Classics, 2009), p. 4. See Janice McCullagh, "The Tightrope Walker: An Expressionist Image," *The Art Bulletin*, December 1984, pp. 633–44.
8. Robert Frankel, "Calder: A Humorous and Inventive Artist," *Art News*, March 13, 1937.
9. Calder to James Thrall Soby, August 8, 1943, Getty Research Center.
10. James Johnson Sweeney, *Alexander Calder* (New York: Museum of Modern Art, 1943), p. 36.
11. W. H. Auden, "Notes on the Comic," in *The Complete Works of W. H. Auden: Prose*, vol. 3, *1949–1955*, ed. Edward Mendelson (Princeton: Princeton University Press, 2008), p. 309.
12. A reviewer of the 1936 show in the *New York World-Telegram* observed of the mobiles that "they are very much like Miró abstractions come to life—simple, naïve and yet immeasurably subtle—but with the bright spots of reds, yellows and blues imbued not with plastic implied movement but actual physical movement." (Emily Genauer, "Calder's 'Mobiles' Are Like Living Miro Abstractions," *New York World-Telegram*, February 15, 1936.)
13. Frankel, "Calder: A Humorous and Inventive Artist."
14. James Thrall Soby, *Contemporary Painters* (New York: Museum of Modern Art, 1948), p. 103.
15. Quoted in Joan Punyet Miró, "Alexander Calder and Joan Miró: A Friendship, a Complicity," in *Calder* (Barcelona: Fundació Joan Miró, 1997), p. 173.
16. Alexander Calder, *Modern Painting and Sculpture* (Pittsfield, MA: Berkshire Museum, 1933), unpaged.
17. Joan Miró to Pierre Matisse, September 28, 1936, in Joan Miró, *Selected Writings and Interviews*, ed. Margit Rowell, trans. Paul Auster and Patricia Mathews (Cambridge, MA: Da Capo Press, 1986), p. 126.
18. See Russell Lynes, *Good Old Modern* (New York: Atheneum, 1973), pp. 137–40.
19. Barr, *Cubism and Abstract Art*, p. 197.

CHAPTER 25 *MERCURY FOUNTAIN*

1. Sert's statement in Jean Lipman, *Calder's Universe* (New York: Viking Press, 1976), pp. 26, 28.
2. Alexander Calder, *Calder: An Autobiography with Pictures*, ed. Jean Davidson (New York: Pantheon Books, 1966), p. 156.
3. James Johnson Sweeney to Calder, January 1, 1935, Calder Foundation archives.
4. See Calder to Ben Nicholson, July 28, 1934, Calder Foundation archives. "As a matter of fact, I wrote to Cooper just before we left Paris last year."
5. Calder to his parents, April 26, 1937, Calder Foundation archives.
6. Ibid.
7. Ibid.
8. Calder to Saul and Hedda Steinberg, June 16, 1956, Calder Foundation archives.
9. Calder to Sweeney, September 26, 1937, Calder Foundation archives.
10. Calder, *Autobiography*, p. 157.
11. Ibid., p. 158.
12. Calder to James Thrall Soby, June 2, 1937, Calder Foundation archives.

13. See Terence Riley and Joseph Abram, eds., *The Filter of Reason: Work of Paul Nelson* (New York: Rizzoli, 1990).

14. Roger Shattuck, *The Banquet Years* (New York: Harcourt, Brace, 1958), p. 181.

15. There is a copy of the playbill in the Roxbury house.

16. Douglas Cooper to Pierre Matisse, May 6, 1937, Pierre Matisse Archives, Department of Literary and Historical Manuscripts, Morgan Library and Museum, New York.

17. Alexander Calder, "The Evolution," manuscript, Calder Foundation archives, 1955–56, p. 95.

18. Alexander Calder, "Mercury Fountain," *Stevens Indicator* 55, no. 3 (May 1938): 3.

19. See Catherine Blanton Freedberg, *The Spanish Pavilion at the Paris World's Fair* (New York: Garland Publishing, 1986), pp. 471–524.

20. Calder, "The Evolution," p. 96.

21. Joan Miró to Matisse, January 12, 1937, Pierre Matisse Archives, Department of Literary and Historical Manuscripts, Morgan Library and Museum, New York.

22. James Thrall Soby, *Joan Miró* (New York: Museum of Modern Art, 1959), p. 83.

23. David Gascoyne, *Journal 1936–37* (London: Enitharmon Press, 1990), pp. 44–45.

24. Calder to Willem Sandberg, January 12, 1956, Calder Foundation archives.

25. *Henry Moore: Writings and Conversations*, ed. and intro. by Alan Wilkinson (Berkeley: University of California Press, 2002), p. 166.

26. See Freedberg, *The Spanish Pavilion*, for a detailed discussion of the pavilion.

27. See Josep M. Rovira, *José Luis Sert, 1901–1983* (Milan: Electa, 2000).

28. Viola Wahlstedt-Guillemaut, quoted in Göran Schildt, *Alvar Aalto: His Life*, trans. Timothy Binham and Nicholas Mayow ([Jyväskylä], Finland: Alvar Aalto Museum, 2007), p. 276.

29. Schildt, *Alvar Aalto*, pp. 347–48.

30. Ibid., p. 394.

31. Freedberg, *The Spanish Pavilion*, p. 484.

32. Calder, "Mercury Fountain," p. 3.

33. André Beucler, *Arts et métiers graphiques*, no. 62, March 15, 1938, pp. 30, 32, quoted and trans. in Freedberg, *The Spanish Pavilion*, p. 485.

34. Calder, *Autobiography*, p. 159.

35. Calder, "The Evolution," p. 96.

36. See Andrew Hemingway, *Artists on the Left: American Artists and the Communist Movement, 1926–1956* (New Haven, CT: Yale University Press, 2002), pp. 123ff.

37. Louis Lozowick, "Government in Art: Status of the Artist in the U.S.S.R.," in *First American Artists' Congress* (New York: American Artists' Congress, 1936), p. 70.

38. Peter Blume, "The Artist Must Choose," in *First American Artists' Congress*, p. 29.

39. Louis Aragon, "Painting and Reality," trans. James Johnson Sweeney, *Art Front*, January 1937, p. 10; Fernand Léger, "The New Realism Goes On," trans. Samuel Putnam, *Art Front*, February 1937, p. 7.

40. Myfanwy Evans, ed., *The Painter's Object* (London: Gerald Howe, 1937), p. 6.

41. James Johnson Sweeney, *Miró* (New York: Museum of Modern Art, 1941), p. 68.

42. James Johnson Sweeney, *Alexander Calder* (New York: Museum of Modern Art, 1943), pp. 52–53.

43. Soby, *Miró*, p. 88.

44. Calder to James Johnson Sweeney, August 13, 1943, Calder Foundation archives.

45. Juan Luis Buñuel, *Good Films, Cheap Wine, Few Friends: A Memoir* (Shaker Heights, OH: Shika Press, 2014), p. 438. See Luis Buñuel to Calder and Louisa Calder, July 16, 1941, Calder Foundation archives.

46. Nancy Macdonald, *Homage to the Spanish Exiles: Voices from the Spanish Civil War* (New York: Human Sciences Press/Insight Books, 1987). Nancy Macdonald sent a copy of *Homage to the Spanish Exiles* to Louisa, writing inside, "Always with fond memories of Sandy's generosity & concern for our Spanish exiles. And to you our warm thanks always Nancy Macdonald." There are three pages about Calder, pp. 146–48.

CHAPTER 26 A LONDON SEASON

1. Alexander Calder, *Calder: An Autobiography with Pictures*, ed. Jean Davidson (New York: Pantheon Books, 1966), p. 162.

2. Quoted in Alex Danchev, *Georges Braque: A Life* (New York: Arcade, 2005), p. 185.

3. Mark Polizzotti, *Revolution of the Mind: The Life of André Breton* (New York: Farrar, Straus and Giroux, 1995), p. 281.

4. Calder to James Johnson Sweeney, September 26, 1937, Calder Foundation archives.

5. Ibid.

6. Ibid.

7. Douglas Cooper to Pierre Matisse, November 2, 1937, Pierre Matisse Archives, Department of Literary and Historical Manuscripts, Morgan Library and Museum, New York.

8. Judith Applegate, "Paul Nelson: An Interview," *Perspecta 13/14* (1971): 77.

9. John Richardson, *A Life of Picasso: The Cubist Rebel, 1907–1916* (New York: Alfred A. Knopf, 1996), p. 228.

10. Calder, *Autobiography*, p. 163.

11. Alexander Calder, "Mobiles," in Myfanwy Evans, ed., *The Painter's Object* (London: Gerald Howe, 1937), p. 63.

12. Calder, *Autobiography*, p. 162.

13. Myfanwy (Evans) Piper, "Back in the Thirties," *Art and Literature*, Winter 1965, p. 140.

14. Martin Hammer and Christina Lodder, *Constructing Modernity: The Art and Career of Naum Gabo* (New Haven, CT: Yale University Press, 2000), p. 245.

15. Evans, *The Painter's Object*, p. 28.

16. Douglas Cooper to Pierre Matisse, November 2, 1937, Pierre Matisse Archives, Department of Literary and Historical Manuscripts, Morgan Library and Museum, New York.

17. Calder to Ben Nicholson, July 28, 1934, Calder Foundation archives.

18. Ibid.

19. Letter from John Piper to Myfanwy Evans, July 1934, quoted in David Fraser Jenkins and Frances Spalding, *John Piper in the 1930s: Abstraction on the Beach* (London: Merrell, 2003), p. 19.

20. James Johnson Sweeney, "Alexander Calder," *Axis* 1, no. 3 (July 1935): 19.

21. Calder to Nicholson, November 28, 1936, Calder Foundation archives.

22. Barbara Hepworth to Calder, January 12, 1936, Calder Foundation archives.

23. Hepworth to Calder, April 27, 1936, Calder Foundation archives.

24. (Evans) Piper, "Back in the Thirties," p. 139.

25. Margaret Gardiner, *Barbara Hepworth: A Memoir* (Edinburgh: The Salamander Press, 1982), pp. 47–48.

26. Ibid., p 48.

27. See Michael Collins and Jeanette Jackson, eds., *Hampstead in the Thirties: A Committed Decade* (London: Hampstead Artists' Council, 1975).

28. Calder to Sweeney, September 28, 1937, Calder Foundation archives.

29. Alfred H. Barr Jr., *Cubism and Abstract Art* (New York: Museum of Modern Art, 1936), p. 200.

30. Calder had hoped to have a little show in the gallery that was attached to the offices of the magazine *Cahiers d'art*, on the rue du Bac. But as it turned out, Christian and Yvonne Zervos, who operated the magazine, had more pressing matters to attend to: preparing a book about Picasso's *Guernica*. (Calder to Sweeney, September 26, 1937, Calder Foundation archives.) Calder was included in the important show of twentieth-century art that Yvonne Zervos mounted at the Petit Palais to run concurrently with the Paris exposition, but Calder's one sculpture ended up sidelined outdoors, where nobody seems to have seen it. Calder was also included in the "Exhibition of Constructive Art" at the London Gallery in July. And Maire Gullichsen had inaugurated, as part of the Artek operations in Helsinki, a little art gallery where after the first exhibition, of modern Moroccan rugs in the fall of 1936, the second, at the very end of 1937, was of work by Calder and Léger. Over the next few years, Gullichsen's gallery would feature work, mostly graphic work, by Gauguin, Toulouse-Lautrec, and Picasso. A Calder mobile from the 1937 show ended up in the Ateneum Art Museum in Helsinki.

31. Calder to Ben Nicholson, November 28, 1936, Calder Foundation archives.

32. Kenneth Clark, *Another Part of the Wood* (New York: Harper & Row, 1975), p. 211.

33. "Shop-Hound Goes to a Party," *Vogue*, December 22, 1937.

34. [Marigold], *Sketch*, December 22, 1937.

35. Peterborough, "Post-Giorgione Objects," *Daily Telegraph*, December 16, 1937.

36. "Alexander Calder, at the Mayor Gallery," *New Statesman and Nation*, December 11, 1937, p. 1016.

37. *Listener*, December 15, 1937.

38. *Architects' Journal*, December 23, 1937.

39. Barbara Hepworth, *A Pictorial Autobiography* (New York: Praeger, 1970), p. 39.

40. Barbara Hepworth to Calder and Louisa Calder, March 26, 1939, Calder Foundation archives.

41. Ben Nicholson to Calder, October 1941, Calder Foundation archives.

42. Calder to Ben Nicholson and Barbara Hepworth, February 23, 1941, Calder Foundation archives.

43. Clark, *Another Part of the Wood*, pp. 255–56.

44. (Evans) Piper, "Back in the Thirties," pp. 148–49.

45. Ibid., pp. 150, 141.

CHAPTER 27 TURNING FORTY

1. Calder to Malcolm Cowley, September 2, 1942, Calder Foundation archives.

2. Alexander Calder, *Calder: An Autobiography with Pictures*, ed. Jean Davidson (New York: Pantheon Books, 1966), p. 168.

3. Alexander Calder, "The Evolution," manuscript, Calder Foundation archives, 1955–56, pp. 161–63.

4. Ibid., p. 126.

5. Calder, *Autobiography*, p. 169.

6. Muriel Cowley to Calder and Louisa Calder, April 7, [1957], Calder Foundation archives.

7. Malcolm Cowley, *Blue Juniata: Poems* (New York: Jonathan Cape, 1929), with the dedication "To Sandy Calder on his XLth birthday Malcolm Cowley in memory of 1 mad night"—so this would be 1938.

8. Matthew Josephson, *Infidel in the Temple* (New York: Alfred A. Knopf, 1967), p. 213.

9. Ibid., p. 221.

10. Ibid. Josephson also writes, "Some of these old acquaintances met in the cafés had a way of shaking my hand with the utmost languor while their eyes looked beyond me to admire themselves in the mirrors on the walls. Those hands sometimes felt like the appendages of Egyptian mummies" (p. 222). Of Aragon, now the editor of a "large newspaper": "In a word, he was no longer addicted to 'mere literature' but was a public figure, one of the big wheels of what was becoming the largest political party in France. Consequently I felt a new kind of constraint in speaking with him; his was now the voice of an organization; the old easy exchange of confidences was no longer possible. I was (and am) extremely fond of him, and I honored him for his public spirit; but I saw that I could not, like him, surrender myself wholly to the discipline of any political body" (p. 225).

11. Alfred Kazin, *Starting Out in the Thirties* (New York: Little, Brown, 1965), p. 15.

12. Ibid., p. 17.

13. Malcolm Cowley, *Exile's Return* (New York: Viking Press, 1956), p. 211.

14. Edmund Wilson to Malcolm Cowley, quoted in *The Long Voyage: Selected Letters of Malcolm Cowley, 1915–1987*, ed. Hans Bak (Cambridge, MA: Harvard University Press, 2014), pp. 240–41.

15. Malcolm Cowley to Edmund Wilson, quoted ibid., pp. 243, 245.

16. Malcolm Cowley, introduction to Margaret Calder Hayes, *Three Alexander Calders: A Family Memoir* (Middlebury, VT: Paul S. Eriksson, 1977), p. xix; the ellipses are Cowley's.

17. Calder, *Autobiography*, p. 170.

18. Calder, "The Evolution," p. 113.

19. Hayes, *Three Alexander Calders*, p. 285.

20. Ibid., p. 284.

21. Calder, *Autobiography*, p. 170.

22. Hayes, *Three Alexander Calders*, pp. 281–84.

23. Selden Rodman, *Conversations with Artists* (New York: Devin-Adair, 1957), p. 137.

24. Calder to Cordelia Sargent Pond, October 3, 1938, Calder Foundation archives.

25. James Johnson Sweeney, *Alexander Calder* (New York: Museum of Modern Art, 1943), p. 53. "Eighty-four items were included, from his earliest wire and wood sculpture, water-colors and drawings to several large mobiles and stabiles of that autumn."

26. Calder to Cordelia Sargent Pond, August 9, 1938, Calder Foundation archives.

27. Calder to Cordelia Pond, November 17, 1938, Calder Foundation archives.

28. Sigfried Giedion to Cordelia Pond, November 10, 1938, Calder Foundation archives.

29. Cordelia Pond to Sigfried Giedion, November 17, 1938, Calder Foundation archives.

30. William G. Rogers, "Local Color," *Springfield Union*, November 9, 1938.

31. James Johnson Sweeney, foreword to *Calder Mobiles* (Springfield, MA: George Walter Vincent Smith Art Gallery, 1938), unpaged.

32. Pond to Calder, November 15, 1938, Calder Foundation archives.

33. Edwin Denby, "The World's Fair," *Modern Music*, May–June 1938, in Denby, *Dance Writings*, ed. Robert Cornfield and William Mackay (New York: Alfred A. Knopf, 1986), p. 49.

34. Henry-Russell Hitchcock to Calder, August 29, 1938, Calder Foundation archives.

35. Alexander Calder, "A Water Ballet," *Theatre Arts Monthly* 23, no. 8 (August 1939): 578.

36. Oral history interview with Alexander Calder conducted by Paul Cummings, October 26, 1971, Archives of American Art, Smithsonian Institution.

37. Calder, "Water Ballet," pp. 578–79.

38. Interview with Alexander Calder, Archives of American Art.

39. Russell Lynes, *Good Old Modern: An Intimate Portrait of the Museum of Modern Art* (New York: Atheneum, 1973), p. 200. According to Lynes, this dinner in the Trustees' Room, with Calder's candelabra on the table, "marked the end of an era and of a regime, and the beginning of a new manner of life for the Museum and its staff. . . . It was on the occasion of this dinner and meeting that Conger Goodyear stepped down from the presidency of the Museum and turned it over to Nelson Rockefeller who was then thirty years old" (pp. 199–201).

40. Hayes, *Three Alexander Calders*, p. 286.

41. Göran Schildt, *Alvar Aalto: His Life*, trans. Timothy Binham and Nicholas Mayow ([Jyväskylä], Finland: Alvar Aalto Museum, 2007), p. 440.

42. Sweeney, *Alexander Calder*, p. 54.

43. Hayes, *Three Alexander Calders*, p. 285.

44. Nanette Calder to Margaret Hayes, c. 1937, Calder Foundation archives.

45. Nanette Calder, autobiographical notes, undated, Calder Foundation archives.

46. Calder to Margaret Calder Hayes, October 12, 1935, Calder Foundation archives.

47. Calder to Marian Willard, October 23, 1941, Calder Foundation archives.

48. Calder to Margaret Hayes, October 12, 1935, Calder Foundation archives.

49. Giovanni Carandente, *Calder: Mobiles and Stabiles* (New York: New American Library, 1968), p. 20.

50. Calder to Keith Warner, August 30, 1946, Calder Foundation archives.

51. Geoffrey T. Hellman, "Profiles: Everything Is Mobile," *New Yorker*, October 4, 1941, p. 26.

52. Sweeney, *Alexander Calder*, p. 56.

53. Calder, *Autobiography*, p. 174.

54. Ibid.

55. Ibid.

56. Seán Sweeney, "Mary," in *Mary Calder Rower, 1939–2011: In Memoriam* (New York: Calder Foundation, 2011), p. 37.

CHAPTER 28 THE CLASSICAL STYLE

1. James Joyce, *A Portrait of the Artist as a Young Man* (1916; repr., New York: Penguin, 1977), p. 215.

2. Charles Rosen, *The Classical Style: Haydn, Mozart, Beethoven*, expanded ed. (New York: W. W. Norton, 1997), p. 43.

3. S. J. Freedberg, *Painting of the High Renaissance in Rome and Florence* (1961; repr. New York: Harper & Row, 1972), pp. 187, 4.

4. Robert M. Coates, "The Art Galleries: Windup," *New Yorker*, June 14, 1941, p. 54.

5. Robert Frankel, "Alexander Calder," *Art News*, June 1941, p. 30.

6. Clovis Prévost, interviewed by Jed Perl, February 21, 2013.

7. James Johnson Sweeney, foreword to *Calder Mobiles* (Springfield, MA: George Walter Vincent Smith Art Gallery, 1938), unpaged.

8. Morton Eustis, "Big Show in Flushing Meadows," *Theatre Arts Monthly*, August 1939, p. 568.

9. James Johnson Sweeney, "Alexander Calder: Movement as a Plastic Element," *Plus* 2 (February

1939): 28. Sweeney continues: "The critics of the Romantic movement"—even as they sometimes romanticized the machine—"had been attracted to the unpredictable features of nature and had rediscovered through them the esthetic of the unexpected. Calder in adapting the natural rhythms also recognized the dramatic value of the surprise element."

10. Katharine Kuh, *The Artist's Voice: Talks with Seventeen Artists* (New York: Harper & Row, 1962), pp. 39, 44.

11. Sigfried Giedion, "The Hammock and Alexander Calder," *Interiors*, May 1947, p. 104.

12. Ibid., p. 100.

13. Ibid., p. 102.

14. Ibid., p. 104.

15. See Gavin Parkinson, *Surrealism, Art and Modern Science* (New Haven, CT: Yale University Press, 2008). Gaston Bachelard is quoted on pp. 63–64; Christian Zervos on p. 72; Georges Bataille on p. 139.

16. Henry S. Carhart and Horatio N. Chute, *First Principles of Physics* (Boston: Allyn and Bacon, 1912), p. 1.

17. James Johnson Sweeney, *Alexander Calder* (New York: Museum of Modern Art, 1943), p. 38.

18. Quoted in Sue Prideaux, *Strindberg: A Life* (New Haven, CT: Yale University Press, 2012), p. 11.

19. Selden Rodman, *Conversations with Artists* (New York: Devin-Adair, 1957), p. 140.

20. Kuh, *Artist's Voice*, p. 41.

21. Alexander Calder, "À Propos of Measuring a Mobile," manuscript, Calder Foundation archives, 1943.

22. Kuh, *Artist's Voice*, p. 39.

23. Alexander Calder, "The Evolution," manuscript, Calder Foundation archives, 1955–56, pp. 83–84.

24. Ibid., p. 84.

25. Ibid., p. 85.

26. Kuh, *Artist's Voice*, p. 42.

27. Arthur Miller, *Alexander Calder: July 22, 1898–November 11, 1976, Memorial Service* (New York: Whitney Museum of American Art, December 6, 1976), unpaged.

28. Friedrich Nietzsche quoted in W. H. Auden, "Squares and Oblongs," in *The Complete Works of W. H. Auden: Prose*, vol. 2, *1939–1948*, ed. Edward Mendelson (Princeton: Princeton University Press, 2002), p. 339.

29. Joyce, *Portrait of the Artist as a Young Man*, p. 215.

INDEX

ILLUSTRATION CREDITS

3 Photograph by Ugo Mulas © Ugo Mulas Heirs. All rights reserved.

4 Nanette Lederer Calder. *Calder in Scottish Cap and Cape*. Collection Calder Foundation, New York.

22 Stirling Calder and friends at the Pennsylvania Academy. Courtesy Wichita State University Libraries, Special Collections and University Archives.

25 (left) Photograph by S. L. Stein.

25 (right) Photograph by Frederick Gutekunst.

39 Calder. *Dancer*. Collection Calder Foundation, New York. Photograph by Tom Powel Imaging © 2017 Calder Foundation, New York.

42 Catalog of an exhibition at the Plastic Club. Courtesy Historical Society of Pennsylvania.

57 Calder. *Bird Cigarette Holder*. Collection Calder Foundation, New York.

63 Calder. Butterfly brooch. Collection Calder Foundation, New York.

69 Interior of Arthur Jerome Eddy's house. Courtesy Ryerson & Burnham Archives, The Art Institute of Chicago.

70 Calder. *Dog*. Collection Calder Foundation, New York; Mary Calder Rower Bequest, 2011. Photograph by Tom Powel Imaging © 2017 Calder Foundation, New York.

71 Calder. *Self-Portrait*. Collection Calder Foundation, New York; Mary Calder Rower Bequest, 2011.

74 Picasso. *Bullfight*. © 2017 Estate of Pablo Picasso / Artists Rights Society (ARS), New York.

74 Balthus. © Balthus, Drawing from *Mitsou*, 1921.

78 Calder. *Dog* and *Duck*. Collection Calder Foundation, New York; Mary Calder Rower Bequest, 2011. Photograph by Tom Powel Imaging © 2017 Calder Foundation, New York.

80 Madeline Yale Wynne. Watch fob. Courtesy Memorial Hall Museum, Deerfield, MA.

80 Calder. Brooches. Photograph by Maria Robledo © 2017 Calder Foundation, New York.

81 Maynard Dixon. Decorative ironwork. Courtesy Braun Research Library Collection, Autry Museum, Los Angeles.

81 Calder. Napkin clip. Collection Calder Foundation, New York.

82 A. Stirling Calder. Relief sculpture. Courtesy Archives, California Institute of Technology.

87 Calder. Untitled. Collection National Gallery of Art, Washington, DC, Gift of Mr. and Mrs. Klaus G. Perls 1996.120.7.

103 The Palace of Fine Arts. Courtesy Bancroft Library, University of California, Berkeley.

104 A. Stirling Calder's *Fountain of Energy*. Courtesy Bancroft Library, University of California, Berkeley.

108 Street scene in the Zone. Photograph by Cardinell-Vincent Company. Courtesy Special Collections, University of California Library, Davis.

118 The Castle at the Stevens Institute of Technology. Courtesy S. C. Williams Library, Stevens Institute of Technology, Hoboken, NJ.

122 Students working in the machine shop. Courtesy S. C. Williams Library, Stevens Institute of Technology, Hoboken, NJ.

137 Calder. Illustrated envelope. Courtesy Bancroft Library, University of California, Berkeley.

140 (bottom) Film by Giulio Gianini.

146 Calder. *Logging Scene*. Collection Calder

Foundation, New York; Mary Calder Rower Bequest, 2011.

147 The Art Students League. Courtesy Art Students League of New York.

148 Calder. *Self-Portrait*. Collection Calder Foundation, New York.

152 Calder. *John Graham*. Collection Calder Foundation, New York. Photograph by Tom Powel Imaging © 2017 Calder Foundation, New York.

154 Ilonka Karasz. Cover for *Playboy*. Photograph courtesy Archives of American Art, Smithsonian Institution, Washington, DC.

156 Calder. Untitled (Excavation). Collection Calder Foundation, New York.

158 Calder. *St. Regis Restaurant*. Collection Calder Foundation, New York.

159 Calder. *Old Madison Square Garden and Democrats*. Collection Calder Foundation, New York.

160 Calder. Untitled (Forest Hills Tennis Stadium). Collection Calder Foundation, New York.

161 Calder. Untitled (Cover drawing for *New Masses*). Collection Calder Foundation, New York; Mary Calder Rower Bequest, 2011.

162 Calder. "Seeing the Circus." Collection Calder Foundation, New York.

163 Calder. "On a Sketching Stroll." Collection Calder Foundation, New York.

176 Picasso. Set for *Mercure*. © 2017 Estate of Pablo Picasso / Artists Rights Society (ARS), New York.

179 Calder. Untitled. Collection Calder Foundation, New York.

181 Calder. *Firemen's Dinner for Brancusi*. Collection Whitney Museum of American Art, New York; gift of the artist 63.58. Digital Image © Whitney Museum, New York.

186 Calder. *Very Flat Cat*. Courtesy Memorial Art Gallery, University of Rochester.

188 Calder. Untitled (Rooster). Collection Calder Foundation, New York; Mary Calder Rower Bequest, 2011.

188 Bonnard. Illustration for *Histoires naturelles*. © 2017 Artists Rights Society (ARS), New York / ADAGP, Paris.

212–13 Calder. *M. Loyal; Cowboy, Cowgirl and Horse; Prima Donna and Woman with Bow. Cirque Calder*. Collection Whitney Museum of American Art, New York; Purchase, with funds from a public fund-raising campaign in May 1982. One half the funds were contributed by the Robert Wood Johnson Jr.

Charitable Trust. Additional major donations were given by The Lauder Foundation; the Robert Lehman Foundation, Inc.; the Howard and Jean Lipman Foundation, Inc.; an anonymous donor; The T. M. Evans Foundation, Inc.; MacAndrews & Forbes Group, Incorporated; the DeWitt Wallace Fund, Inc.; Martin and Agneta Gruss; Anne Phillips; Mr. and Mrs. Laurance S. Rockefeller; the Simon Foundation, Inc.; Marylou Whitney; Bankers Trust Company; Mr. and Mrs. Kenneth N. Dayton; Joel and Anne Ehrenkranz; Irvin and Kenneth Feld; Flora Whitney Miller. More than 500 individuals from 26 states and abroad also contributed to the campaign. 83.36.2. Photographs by Sheldan C. Collins.

214 Photograph by Brassaï. © Estate Brassaï-RMN-Grand Palais-Paris, Fonds Gilberte Brassaï. Photo © RMN-Grand Palais/ Brassaï.

215 Photograph by Brassaï. © Estate Brassaï-RMN-Grand Palais-Paris, Fonds Gilberte Brassaï. Photo © RMN-Grand Palais/ Brassaï.

218 Photograph by André Kertész. © Estate of André Kertész / Higher Pictures.

220 Calder. *Circus Scene*. Photograph courtesy Collection of the University of California, Berkeley Art Museum and Pacific Film Archive.

221 Calder. Untitled (Nets and rigging). Collection Calder Foundation, New York.

223 Cocteau. *Baigneuse se coiffant*. © 2017 ADAGP, Paris / Avec l'aimable autorisation de M. Pierre Bergé, président du Comité Jean Cocteau.

233 Calder. *Josephine Baker IV*. Photograph © CNAC / MNAM / Dist.RMN-Grand Palais / Art Resource, New York.

240 Calder. *Blue Velvet Cow*. Photograph courtesy Collection of the University of California, Berkeley Art Museum and Pacific Film Archive.

242 Photograph by Thérèse Bonney. © The Regents of the University of California, The Bancroft Library, University of California, Berkeley.

244 Photograph by Peter A. Juley & Son © Peter A. Juley & Son Collection, National Museum of American Art, Smithsonian Institution, Washington, DC.

245 Photograph by Peter A. Juley & Son © Peter A. Juley & Son Collection, National Museum of American Art, Smithsonian Institution, Washington, DC.

250 Calder. *Jimmy Durante*. Collection Calder Foundation, New York; Gift of The Lipman Family Foundation in memory of Jean & Howard Lipman, 2016. Photograph by Tom Powel Imaging © 2017 Calder Foundation, New York.

251 Calder. *Calvin Coolidge*. Collection Calder Foundation, New York.

252 Calder. *Wire Sculpture by Calder*. Collection Whitney Museum of American Art, New York; purchase, with funds from Howard and Jean Lipman. 72.168. Digital Image © Whitney Museum, New York.

253 Photograph by Peter A. Juley & Son © Peter A. Juley & Son Collection, National Museum of American Art, Smithsonian Institution, Washington, DC.

255 Calder. *Carl Zigrosser*. Courtesy the Philadelphia Museum of Art.

255 Calder. *Marion Greenwood*. Photograph by Herbert Matter © 2017 Calder Foundation, New York.

258 Calder. *Horse*. Collection Museum of Modern Art, New York. Acquired through the Lillie P. Bliss Bequest. The Museum of Modern Art, Digital Image ©The Museum of Modern Art / Licensed by SCALA / Art Resource, New York.

259 Calder. *Nymph*. Collection Calder Foundation, New York.

266 Photograph by Jacques Robert.

268 Miró. *Painting (The Fratellini Brothers)*. © Successió Miró / Artists Rights Society (ARS), New York / ADAGP, Paris 2017.

269 Miró. *Spanish Dancer*. © Successió Miró / Artists Rights Society (ARS), New York / ADAGP, Paris 2017.

270 Calder. *Aquarium*. The Doris and Donald Fisher Collection at the San Francisco Museum of Modern Art. Photograph: Katherine Du Tiel.

272 Calder. *The Brass Family*. Collection Whitney Museum of American Art, New York; gift of the artist 69.255. Digital Image © Whitney Museum, New York.

273 Diederich. *Fighting Cocks Fire Screen*. Photo Mark Ostrander courtesy Conner Rosenkranz, New York.

276 Pascin. *Visite chez Mr. Calder fils*. Private Collection, New York.

279 Photograph by André Kertész. © Estate of André Kertész / Higher Pictures.

283 Calder. *Hercules and Lion*. Collection Calder Foundation, New York; Promised Gift of Alexander S. C. Rower.

286 Photograph by Marc Vaux. © Centre Pompidou-MNAM-Bibliothèque Kandinsky-Fonds Marc Vaux-Dist. RMN-Grand Palais.

292 Calder. *Medusa*. Collection Calder Foundation, New York. Photograph by Tom Powel Imaging © 2017 Calder Foundation, New York.

292 Calder. Untitled (Self-Portrait with Medusa). Collection Calder Foundation, New York; Mary Calder Rower Bequest, 2011. Photo by Jimi Billingsley © 2017 Calder Foundation, New York.

293 Calder. *Medusa*. Collection Calder Foundation, New York; Promised Gift of Alexander S. C. Rower. Photograph by Tim Nighswander / IMAGING4ART © 2017 Calder Foundation, New York.

299 Photograph by S. G. Weiner © S. G. Weiner.

301 Calder. Calder's Circus Invitation. Collection Calder Foundation, New York.

302 Calder. *Fish*. Collection Calder Foundation, New York. Photograph by Tom Powel Imaging © 2017 Calder Foundation, New York.

303 Calder. *Goldfish Bowl*. Collection Calder Foundation, New York; Promised Gift of Alexander S. C. Rower.

305 Isamu Noguchi and Grace Greenwood. Photograph by Coursens Studio. The Gaede/Striebel Archives, Center for Photography at Woodstock Permanent Print Collection, on extended loan to the Samuel Dorsky Museum of Art, State University of New York, New Paltz.

307 Noguchi. *Portrait of Lincoln Kirstein*. © The Isamu Noguchi Foundation and Garden Museum, New York / Artists Rights Society (ARS), New York. Photograph by Joseph Szaszfai.

316 Calder. *Cow*. Collection Calder Foundation, New York. Photograph by Tom Powel Imaging © 2017 Calder Foundation, New York.

319 Calder. Necklace. Calder Foundation, New York; Promised Gift of Holton Rower. Photograph by Maria Robledo © 2017 Calder Foundation, New York.

320 Calder. Ring. Private Collection, Mallorca. Photograph by Maria Robledo © 2017 Calder Foundation, New York.

323 Hôtel Foyot. Paris, Musée Carnavalet. © Eugène Atget / Musée Carnavalet / Roger-Viollet.

329 Photograph by Jean Blair-Hélion © ADAGP, Paris.

331 Calder. *My Shop*. Collection Calder Foundation, New York. Photograph by Jimi

Billingsley © 2017 Calder Foundation, New York.

331 Hélion. *Studio.* © 2017 Artists Rights Society (ARS), New York / ADAGP, Paris.

336 Kiesler. Courtesy Austrian Frederick and Lillian Kiesler Private Foundation.

340 Photograph by Paul Delbo. *Composition No. VI* (1920) and *Composition No. II* (1920) © 2017 Mondrian/Holtzman Trust.

342 Photograph by Charles Karsten. Collection Het Nieuwe Instituut. *Lozenge Composition with Four Yellow* Lines (1933) and *Composition with Double Lines and Yellow* (1934) © 2017 Mondrian/Holtzman Trust.

343 Mondrian. *Composition with Red, Blue, and Yellow.* © 2017 Mondrian/Holtzman Trust.

344 Calder. Untitled. Collection Calder Foundation, New York; Promised Gift of Alexander S. C. Rower.

345 Calder. Untitled. Collection Calder Foundation, New York.

346 Calder. Untitled. Collection Calder Foundation, New York.

347 Calder. Untitled. Collection Calder Foundation, New York.

349 Calder. *Cow.* Collection Calder Foundation, New York.

353 Photograph by Bachrach.

363 Photograph by Marc Vaux. © Centre Pompidou-MNAM-Bibliothèque Kandinsky-Fonds Marc Vaux-Dist. RMN-Grand Palais.

364 Photograph by Marc Vaux. © Centre Pompidou-MNAM-Bibliothèque Kandinsky-Fonds Marc Vaux-Dist. RMN-Grand Palais.

366 Calder. *Sphérique I.* Photograph by Marc Vaux. © Centre Pompidou-MNAM-Bibliothèque Kandinsky-Fonds Marc Vaux-Dist. RMN-Grand Palais.

367 Calder. *Croisière.* Collection Calder Foundation, New York. Photograph by Tom Powel Imaging © 2017 Calder Foundation, New York.

371 Calder. *Fernand Léger.* Photograph by Marc Vaux. © Centre Pompidou-MNAM-Bibliothèque Kandinsky-Fonds Marc Vaux-Dist. RMN-Grand Palais.

374 Gabo and Pevsner. The Work of Naum Gabo © Nina and Graham Williams. Anton Pevsner © 2017 Artists Rights Society (ARS), New York / ADAGP, Paris.

376 Calder. *Many.* Collection of Museum of Modern Art, New York. Gift of Mr. and Mrs. Klaus G. Perls. (1575.1968) Digital Image © The Museum of Modern Art / Licensed by SCALA / Art Resource, New York.

377 Calder. *Ninety Degrees in View.* Collection Calder Foundation, New York.

384 Calder. *Noble Chevalier.* Collection Calder Foundation, New York.

387 Calder. *El Sol Rojo.* Photograph by Pedro Guerrero © Pedro Guerrero.

388 Photograph by Marc Vaux. © Centre Pompidou, MNAM-Bibliothèque Kandinsky, Fonds Marc Vaux, Paris.

389 Calder. Untitled. Photograph by Marc Vaux. © Centre Pompidou-MNAM-Bibliothèque Kandinsky-Fonds Marc Vaux-Dist. RMN-Grand Palais.

390 Reynolds and Duchamp. Gift of Frank B. Hubachek, 1970.796. © Man Ray Trust / Artists Rights Society (ARS), New York / ADAGP, Paris 2017. The Art Institute of Chicago, Chicago, U.S.A. Photograph courtesy The Art Institute of Chicago / Art Resource, New York.

393 Calder. Untitled. Photograph by Marc Vaux. © Centre Pompidou-MNAM-Bibliothèque Kandinsky-Fonds Marc Vaux-Dist. RMN-Grand Palais.

396 Duchamp. *Bicycle Wheel.* © Succession Marcel Duchamp / ADAGP, Paris / Artists Rights Society (ARS), New York 2017.

397 Calder. *Six Day Bike Race.* Collection Calder Foundation, New York. Photograph by Jerry L. Thompson © 2017 Calder Foundation, New York.

398 Film by Giulio Gianini.

399 Calder. *Two Spheres Within a Sphere.* Collection Calder Foundation, New York; Mary Calder Rower Bequest, 2011. Photograph by Tom Powel Imaging © 2017 Calder Foundation, New York.

401 Calder. *Pantograph.* Courtesy Moderna Museet, Stockholm.

401 Calder. *Dancing Torpedo Shape.* Photograph by Marc Vaux. © Centre Pompidou-MNAM-Bibliothèque Kandinsky-Fonds Marc Vaux-Dist. RMN-Grand Palais.

402 Calder. *Object with Red Discs.* Photograph by Marc Vaux. © Centre Pompidou-MNAM-Bibliothèque Kandinsky-Fonds Marc Vaux-Dist. RMN-Grand Palais.

403 Calder. Chess set. Collection Calder Foundation, New York; Mary Calder Rower Bequest. Photograph by Bonnie Morrison. © 2017 Calder Foundation, New York.

404 Calder. *Cadre rouge.* Photograph by Marc Vaux. © Centre Pompidou-MNAM-Bibliothèque Kandinsky-Fonds Marc Vaux-Dist. RMN-Grand Palais.

411 Calder. *Musique de Varèse.* Photograph by

Marc Vaux. Photograph © CNAC/MNAM/ Dist. RMN-Grand Palais / Art Resource, New York.

412 Calder. Untitled. Collection Calder Foundation, New York.

413 Calder. *Movement in Space*. Collection National Gallery of Art, Washington, DC. Gift of Mr. and Mrs. Klaus G. Perls, 1996.120.20.

415 Calder. *Small Sphere and Heavy Sphere*. Collection Calder Foundation, New York; Mary Calder Rower Bequest, 2011. Photograph by Jerry L. Thompson © 2017 Calder Foundation, New York.

421 Hélion. *Composition*. © 2017 Artists Rights Society (ARS), New York / ADAGP, Paris.

426 Noguchi. *Julien Levy*. © The Isamu Noguchi Foundation and Garden Museum, New York / Artists Rights Society (ARS), New York. Photo courtesy of the Philadelphia Museum of Art.

428 Calder. *Two Spheres*. Collection Calder Foundation, New York; Promised Gift of Holton Rower.

429 Calder. *Double Arc and Sphere*. Photograph by Marc Vaux. © Centre Pompidou-MNAM-Bibliothèque Kandinsky-Fonds Marc Vaux-Dist. RMN-Grand Palais.

430 Calder. *Small Feathers*. Collection Calder Foundation, New York; Promised Gift of Holton Rower. Photograph by Tom Powel Imaging © 2017 Calder Foundation, New York.

432 Miró. *The Farm*. Collection the National Gallery of Art, Washington, DC. Gift of Mary Hemingway, 1987.18.1. © Successió Miró / Artists Rights Society (ARS), New York / ADAGP, Paris 2017.

433 Calder. *À bas la Méditerannée*. Collection Calder Foundation, New York. Photograph by Maria Robledo © 2017 Calder Foundation, New York.

436 Calder. *Cône d'ébène*. Photograph by Marc Vaux. © Centre Pompidou-MNAM Bibliothèque Kandinsky-Fonds Marc Vaux-Dist. RMN-Grand Palais.

440 Steinberg. *Calder and His Daughter Mary in the LaSalle*. © The Saul Steinberg Foundation / Artists Rights Society (ARS), New York.

443 Photograph by James Thrall Soby © 2017 Calder Foundation, New York.

446 *Four Saints in Three Acts*. Photograph courtesy Florine and Ettie Stettheimer papers, Beinecke Rare Book and Manuscript Library, Yale University.

449 Calder. *Steel Fish*. Collection Calder Foundation, New York; Promised Gift of Holton Rower.

450 Photograph by James Thrall Soby © 2017 Calder Foundation, New York.

451 Photograph by James Thrall Soby © 2017 Calder Foundation, New York.

453 Calder. *Air Vent Mobile*. Courtesy of the Berkshire Museum, Pittsfield, MA.

454 Balthus. © Balthus, Pierre Matisse.

455 Calder. *A Universe*. Collection the Museum of Modern Art, New York; Gift of Abby Aldrich Rockefeller (by exchange). The Museum of Digital Image ©The Museum of Modern Art / Licensed by SCALA / Art Resource, New York.

459 Photograph by DeWitt Ward.

460 Calder. Untitled. Collection Calder Foundation, New York.

461 Calder. *Red, White, Black and Brass*. Collection Calder Foundation, New York; Promised Gift of Alexander S. C. Rower. Photograph by Stalsworth/Blanc © 2017 Calder Foundation, New York.

467 Photograph by Herbert Matter © 2017 Calder Foundation, New York.

468 (top) Photograph by Herbert Matter © 2017 Calder Foundation, New York.

468 (bottom) Photograph by James Thrall Soby © 2017 Calder Foundation, New York.

473 Calder. *Black Frame*. Collection Calder Foundation, New York.

475 Photograph by Marc Vaux. © Centre Pompidou-MNAM-Bibliothèque Kandinsky-Fonds Marc Vaux-Dist. RMN-Grand Palais.

477 Miró. Set and costume for *Jeux d'enfants*. © Successió Miró / Artists Rights Society (ARS), New York / ADAGP, Paris 2017.

481 Martha Graham in *Frontier;* set design by Noguchi. © The Isamu Noguchi Foundation and Garden Museum, New York / Artists Rights Society (ARS), New York. Photo by Barbara Morgan. Barbara and Willard Morgan photographs and papers, Library Special Collections, Charles E. Young Research Library, UCLA.

486 Virgil Thomson. Courtesy the Gertrude Stein and Alice B. Toklas papers, Beinecke Rare Book and Manuscript Library, Yale University.

487 Paper Ball. Photograph courtesy Wadsworth Atheneum Archives, Hartford, CT.

489 Picasso. *Erik Satie*. © 2017 Estate of Pablo Picasso / Artists Rights Society (ARS), New York.

495 Photograph by Herbert Matter © 2017 Calder Foundation, New York.

496 Photograph by Herbert Matter © 2017 Calder Foundation, New York.

497 Photograph by Herbert Matter © 2017 Calder Foundation, New York.

498 Photographs by Herbert Matter © 2017 Calder Foundation, New York.

499 Photograph by Herbert Matter © 2017 Calder Foundation, New York.

500 Photograph by Herbert Matter © 2017 Calder Foundation, New York.

501 Photograph by Herbert Matter © 2017 Calder Foundation, New York.

504 Calder. *Apple Monster*. Collection Calder Foundation, New York; Gift of Alexander S. C. Rower in memory of Mary Calder Rower, 2015. Photograph by Tom Powel Imaging © 2017 Calder Foundation, New York.

505 Calder. *Red Panel*. Collection Calder Foundation, New York.

506 Miró. Untitled. Private Collection, New York. © Successió Miró / Artists Rights Society (ARS), New York / ADAGP, Paris 2017.

507 Calder. Untitled. Photograph by Tom Powel Imaging © 2017 Calder Foundation, New York.

508 Calder. Untitled. Collection Calder Foundation, New York. Photograph by Tom Powel Imaging © 2017 Calder Foundation, New York.

511 Calder. *The Praying Mantis*. Photograph by Soichi Sunami © The Museum of Modern Art, Soichi Sunami.

517 Calder. Postcard. Photograph courtesy Getty Research Institute.

518 Spanish Pavilion. Photograph by François Kollar © Ministère de la culture-Médiathèque du Patrimoine / François Kollar / dist. RMN / Art Resource, New York.

520 Miró. *Still Life with Old Shoe*. © Successió Miró / Artists Rights Society (ARS), New York / ADAGP, Paris 2017.

524 Calder. *Alvar Aalto*. Photograph courtesy Alvar Aalto Foundation.

525 Aalto. Finnish Pavilion. Photograph courtesy Alvar Aalto Foundation.

527 Miró. *The Reaper I*. © Successió Miró / Artists Rights Society (ARS), New York / ADAGP, Paris 2017. Photograph courtesy Successió Miró C.B.

530 Picasso. *Guernica* in a photograph of the Spanish Pavilion. © 2017 Estate of Pablo Picasso / Artists Rights Society (ARS),

New York. Photograph by Hugo P. Herdeg © Christian Herdeg.

537 Miró and Calder. Photograph courtesy Successió Miró C.B. Photograph by Paul Nelson.

538 Hepworth. *Cup and Ball*. © Bowness.

540 Braque. Photograph by Albert Gallatin.

541 Braque. *A Table with Birds*. © 2017 Artists Rights Society (ARS), New York / ADAGP, Paris.

545 Nicholson. *1936 (relief)*. Private Collection, New York. © Angela Verren Taunt 2017 / All rights reserved / ARS, NY / DACS, London.

550 Calder. *Lady Clark with Sir Kenneth in Her Arm*. Photograph courtesy Archives of American Art, Smithsonian Institution, Washington, DC.

554 Photograph by Chester from *Black Star*.

555 Cowley. Photograph courtesy Robert Cowley.

560 Photograph by Herbert Matter © 2017 Calder Foundation, New York.

561 Photograph by Herbert Matter © 2017 Calder Foundation, New York.

570 Calder. Untitled. Collection Calder Foundation, New York.

571 Calder. *The Four Elements*. Photograph by Pedro Guerrero. © Pedro Guerrero.

572 Calder. Six maquettes. Collection Calder Foundation, New York; Mary Calder Rower Bequest, 2011. Photograph by Tom Powel Imaging © 2017 Calder Foundation, New York.

576 Photograph by Fred Hamilton.

577 Photograph by Herbert Matter © 2017 Calder Foundation, New York.

578 Calder. Earrings, bug brooch, bracelet. Collection Calder Foundation, New York. Photographs by Maria Robledo © 2017 Calder Foundation, New York.

579 Calder. Necklace and choker. Collection Calder Foundation, New York. Photograph by Maria Robledo © 2017 Calder Foundation, New York.

580 Calder. Illustrated letter. Collection Calder Foundation, New York; Mary Calder Rower Bequest, 2011.

581 Photograph by Herbert Matter © 2017 Calder Foundation, New York.

583 Photograph by Herbert Matter © 2017 Calder Foundation, New York.

585 Photograph by Herbert Matter © 2017 Calder Foundation, New York.

586 Photograph by Herbert Matter © 2017 Calder Foundation, New York.

590 Calder. *Eucalyptus*. Collection Calder Foundation, New York; Gift of Andréa Davidson, Shawn Davidson, Alexander S. C. Rower, and Holton Rower, 2010. Photograph by Tom Powel Imaging © 2017 Calder Foundation, New York.

593 Calder. *Vertical Foliage*. Collection Calder Foundation, New York.

595 Photograph by Herbert Matter © 2017 Calder Foundation, New York.

596 Calder. *Un effet du japonais*. Calder Foundation, New York; Promised Gift of Alexander S. C. Rower.

597 Calder. *Red Petals*. Photograph by Frederick O. Bemm.

598 Calder. *Tree*. Collection Calder Foundation, New York; Gift of Holton Rower and Anna Maria Segretario, 2008. Photograph by Tom Powel Imaging © 2017 Calder Foundation, New York.

601 Photograph by Herbert Matter © 2017 Calder Foundation, New York.

A NOTE ON THE TYPE

This book was set in Fournier, a typeface named for Pierre Simon Fournier *le jeune* (1712–1768). Fournier was the author of the important *Manuel typographique* (1764–1766) in which he attempted to work out a system standardizing type measurement in points, a system that is still in use internationally. In 1925 his type was revived by the Monotype Corporation of London.

COMPOSED BY NORTH MARKET STREET GRAPHICS, LANCASTER, PENNSYLVANIA

PRINTED AND BOUND BY MOHN MEDIA, GÜTERSLOH, GERMANY

DESIGNED BY MAGGIE HINDERS